THE LIBRARY OF LIVING PHILOSOPHERS

PAUL ARTHUR SCHILPP, FOUNDER AND EDITOR 1939–1981
LEWIS EDWIN HAHN, EDITOR 1981–

Paul Arthur Schilpp, Editor
THE PHILOSOPHY OF JOHN DEWEY (1939, 1971, 1989)
THE PHILOSOPHY OF GEORGE SANTAYANA (1940, 1951)
THE PHILOSOPHY OF ALFRED NORTH WHITEHEAD (1941, 1951)
THE PHILOSOPHY OF G. E. MOORE (1942, 1971)
THE PHILOSOPHY OF BERTRAND RUSSELL (1944, 1971)
THE PHILOSOPHY OF ERNST CASSIRER (1949)
ALBERT EINSTEIN: PHILOSOPHER-SCIENTIST (1949, 1970)
THE PHILOSOPHY OF SARVEPALLI RADHAKRISHNAN (1952)
THE PHILOSOPHY OF KARL JASPERS (1957; AUG. ED., 1981)
THE PHILOSOPHY OF C. D. BROAD (1959)
THE PHILOSOPHY OF RUDOLF CARNAP (1963)
THE PHILOSOPHY OF C. I. LEWIS (1968)
THE PHILOSOPHY OF KARL POPPER (1974)
THE PHILOSOPHY OF BRAND BLANSHARD (1980)
THE PHILOSOPHY OF JEAN-PAUL SARTRE (1981)

Paul Arthur Schilpp and Maurice Friedman, Editors
THE PHILOSOPHY OF MARTIN BUBER (1967)

Paul Arthur Schilpp and Lewis Edwin Hahn, Editors
THE PHILOSOPHY OF GABRIEL MARCEL (1984)
THE PHILOSOPHY OF W. V. QUINE (1986)
THE PHILOSOPHY OF GEORG HENRIK VON WRIGHT (1989)

Lewis Edwin Hahn, Editor
THE PHILOSOPHY OF CHARLES HARTSHORNE (1991)
THE PHILOSOPHY OF A. J. AYER (1992)
THE PHILOSOPHY OF PAUL RICOEUR (1995)
THE PHILOSOPHY OF PAUL WEISS (1995)
THE PHILOSOPHY OF HANS-GEORG GADAMER (1997)
THE PHILOSOPHY OF RODERICK M. CHISHOLM (1997)
THE PHILOSOPHY OF P. F. STRAWSON (1998)

In Preparation:
Lewis Edwin Hahn, Editor
THE PHILOSOPHY OF DONALD DAVIDSON
THE PHILOSOPHY OF JÜRGEN HABERMAS
THE PHILOSOPHY OF SEYYED HOSSEIN NASR
THE PHILOSOPHY OF MARJORIE GRENE

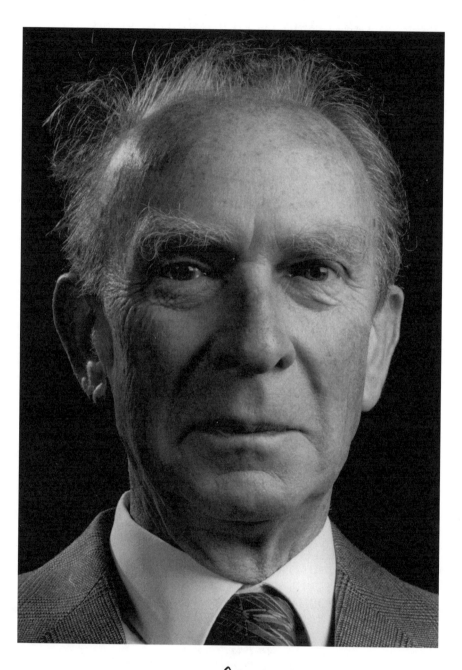

P. F. Strawson

THE PHILOSOPHY OF
P. F. STRAWSON

THE LIBRARY OF LIVING PHILOSOPHERS
VOLUME XXVI

THE PHILOSOPHY OF
P. F. STRAWSON

EDITED BY

LEWIS EDWIN HAHN

SOUTHERN ILLINOIS UNIVERSITY AT CARBONDALE

CHICAGO AND LASALLE, ILLINOIS • OPEN COURT • ESTABLISHED 1887

To order books from Open Court, call 1-800-815-2280.

THE PHILOSOPHY OF P. F. STRAWSON

Open Court Publishing Company is a division of Carus Publishing Company.

Library of Congress Cataloging-in-Publication Data

The philosophy of P. F. Strawson / edited by Lewis Edwin Hahn.
 p. cm. — (The library of living philosophers : v. 26)
 Includes bibliographical references and index.
 ISBN 0-8126-9377-9 (hardcover : alk. paper). — ISBN 0-8126-9378-7
(pbk. : alk. paper)
 1. Strawson, P. F. I. Hahn, Lewis Edwin, 1908– . II. Series.
B1667.S384P47 1998
192—dc21 98-22805
 CIP

The Library of Living Philosophers is published under the sponsorship of Southern Illinois University at Carbondale.

GENERAL INTRODUCTION TO THE LIBRARY OF LIVING PHILOSOPHERS

Founded in 1938 by Professor Paul Arthur Schilpp and edited by him until July 1981, when the present writer became editor, the Library of Living Philosophers is devoted to critical analysis and discussion of some of the world's greatest living philosophers. The format for the series provides for setting up in each volume a dialogue between the critics and the great philosopher. The air is not refutation or confrontation but rather fruitful joining of issues and improved understanding of the positions and issues involved. That is, the goal is not overcoming those who differ from us philosophically but interacting creatively with them.

The basic idea for the series, according to Professor Schilpp's general introduction to each to the earlier volumes, came from the late F.C.S. Schiller, who declared in his essay on "Must Philosophers Disagree?" (in *Must Philosophers Disagree?* London: Macmillan, 1934) that the greatest obstacle to fruitful discussion in philosophy is "the curious etiquette which apparently taboos the asking of questions about a philosopher's meaning while he is alive." The "interminable controversies which fill the histories of philosophy," in Schiller's opinion, "could have been ended at once by asking the living philosophers a few searching questions." And while he may have been overly optimistic about ending "interminable controversies" in this way, it seems clear that directing searching questions to great philosophers about what they really mean or how they think certain difficulties in their philosophy can be resolved while they are still alive can produce far greater clarity of understanding and more fruitful philosophizing than might otherwise be had.

And to Paul Arthur Schilpp's undying credit, he acted on this basic thought in launching in 1938 the Library of Living Philosophers. It is planned that each volume in the Library of Living Philosophers include preferably an intellectual autobiography by the principal philosopher or an authorized biography as well as a bibliography of that thinker's publications, a series of expository and critical essays written by leading exponents and opponents of the philosopher's thought, and the philoso-

pher's replies to the interpretations and queries in these articles. The intellectual autobiographies usually shed a great deal of light on both how the philosophies of the great thinkers developed and the major philosophical movements and issues of their time; and many of our great philosophers seek to orient their outlook not merely to their contemporaries but also to what they find most important in earlier philosophers. The bibliography will help provide ready access to the featured scholar's writings and thought.

With this format in mind, the Library expects to publish at more or less regular intervals a volume on one of the world's greater living philosophers.

In accordance with past practice, the editor has deemed it desirable to secure the services of an Advisory Board of philosophers to aid him in the selection of subjects of future volumes. The names of eight prominent American philosophers who have agreed to serve appear on the page following the General Introduction. To each of them the editor is most grateful.

Future volumes in this series will appear in as rapid succession as is feasible in view of the scholarly nature of this library. The next volume in the series will be devoted to the philosophy of Donald Davidson, and it will be followed by ones on Jürgen Habermas, Seyyed Hossein Nasr, and Marjorie Grene.

Throughout its career, since its founding in 1938, the Library of Living Philosophers, because of its scholarly nature, has never been self supporting. We acknowledge gratefully that the generosity of the Edward C. Hegeler Foundation has made possible the publication of many volumes, but for support of future volumes additional funds are needed. On 20 February 1979 the Board of Trustees of Southern Illinois University contractually assumed sponsorship of the Library, which is therefore no longer separately incorporated. Gifts specifically designated for the Library, however, may be made through the Southern Illinois University Foundation, and inasmuch as the latter is a tax-exempt institution, such gifts are tax-deductible.

LEWIS E. HAHN
EDITOR

DEPARTMENT OF PHILOSOPHY
SOUTHERN ILLINOIS UNIVERSITY AT CARBONDALE

FOUNDER'S GENERAL INTRODUCTION*
TO
THE LIBRARY OF LIVING PHILOSOPHERS

According to the late F.C.S. Schiller, the greatest obstacle to fruitful discussion in philosophy is "the curious etiquette which apparently taboos the asking of questions about a philosopher's meaning while he is alive." The "interminable controversies which fill the histories of philosophy," he goes on to say, "could have been ended at once by asking the living philosophers a few searching questions."

The confident optimism of this last remark undoubtedly goes too far. Living thinkers have often been asked "a few searching questions," but their answers have not stopped "interminable controversies" about their real meaning. It is nonetheless true that there would be far greater clarity of understanding than is now often the case if more such searching questions had been directed to great thinkers while they were still alive.

This, at any rate, is the basic thought behind the present undertaking. The volumes of the Library of Living Philosophers can in no sense take the place of the major writings of great and original thinkers. Students who would know the philosophies of such men as John Dewey, George Santayana, Alfred North Whitehead, G. E. Moore, Bertrand Russell, Ernst Cassirer, Karl Jaspers, Rudolf Carnap, Martin Buber, et al., will still need to read the writings of these men. There is no substitute for first-hand contact with the original thought of the philosopher himself. Least of all does this Library pretend to be such a substitute. The Library in fact will spare neither effort nor expense in offering to the student the best possible guide to the published writings of a given thinker. We shall attempt to meet this aim by providing at the end of each volume in our series as nearly complete a bibliography of the published work of the philosopher in question as possible. Nor should one overlook the fact that essays in each volume cannot but finally lead to this same goal. The interpretative and critical discussions of the various phases of a great thinker's work and, most of all, the reply of the thinker himself, are bound to lead the reader to the works of the philosopher himself.

*This General Introdcution sets forth in the founder's words the underlying conception of the Library. L.E.H.

At the same time, there is no denying that different experts find different ideas in the writings of the same philosopher. This is as true of the appreciative interpreter and grateful disciple as it is of the critical opponent. Nor can it be denied that such differences of reading and of interpretation on the part of other experts often leave the neophyte aghast before the whole maze of widely varying and even opposing interpretations. Who is right and whose interpretation shall he accept? When the doctors disagree among themselves, what is the poor student to do? If, in desperation, he decides that all of the interpreters are probably wrong and that the only thing for him to do is to go back to the original writings of the philosopher himself and then make his own decision—uninfluenced (as if this were possible) by the interpretation of anyone else—the result is not that he has actually come to the meaning of the original philosopher himself, but rather that he has set up one more interpretation, which may differ to a greater or lesser degree from the interpretations already existing. It is clear that in this direction lies chaos, just the kind of chaos which Schiller has so graphically and inimitably described.[1]

It is curious that until now no way of escaping this difficulty has been seriously considered. It has not occurred to students of philosophy that one effective way of meeting the problem at least partially is to put these varying interpretations and critiques before the philosopher while he is still alive and to ask him to act at one and the same time as both defendant and judge. If the world's greatest living philosophers can be induced to cooperate in an enterprise whereby their own work can, at least to some extent, be saved from becoming merely "desiccated lecture-fodder," which on the one hand "provides innocuous sustenance for ruminant professors," and on the other hand gives an opportunity to such ruminants and their understudies to "speculate safely, endlessly, and fruitlessly, about what a philosopher must have meant" (Schiller), they will have taken a long step toward making their intentions more clearly comprehensible.

With this in mind, the Library of Living Philosophers expects to publish at more or less regular intervals a volume on each of the greater among the world's living philosophers. In each case it will be the purpose of the editor of the Library to bring together in the volume the interpretations and criticisms of a wide range of that particular thinker's scholarly contemporaries, each of whom will be given a free hand to discuss the specific phase if the thinker's work that has been assigned to him. All contributed essays will finally be submitted to the philosopher

[1] In his essay "Must Philosophers Disagree?" in the volume of the same title (London: Macmillan, 1934), from which the above quotations were taken.

with whose work and thought they are concerned, for his careful perusal and reply. And, although it would be expecting too much to imagine that the philosopher's reply will be able to stop all differences of interpretation and of critique, this should at least serve the purpose of stopping certain of the grosser and more general kinds of misinterpretations. If no further gain than this were to come from the present and projected volumes of this Library, it would seem to be fully justified.

In carrying out this principal purpose of the Library, the editor announces that (as far as is humanly possible) each volume will contain the following elements:

First, an intellectual autobiography of the thinker whenever this can be secured; in any case an authoritative and authorized biography;

Second, a series of expository and critical articles written by the leading exponents and opponents of the philosopher's thought;

Third, the reply to the critics and commentators by the philosopher himself; and

Fourth, a bibliography of writings of the philosopher to provide a ready instrument to give access to his writings and thought.

PAUL ARTHUR SCHILPP
FOUNDER AND EDITOR, 1939–1981

DEPARTMENT OF PHILOSOPHY
SOUTHERN ILLINOIS UNIVERSITY AT CARBONDALE

ADVISORY BOARD

ACKNOWLEDGMENTS

The editor hereby gratefully acknowledges his obligation and sincere gratitude to all the publishers of P. F. Strawson's books and publications for their kind and uniform courtesy in permitting us to quote—sometimes at some length—from Professor Strawson.

Lewis E. Hahn

#Added to Board after the subject of this volume was chosen.

TABLE OF CONTENTS

PREFACE

Sir Peter, now emeritus professor at Magdalen College, Oxford University, has interacted with an exceptional number of diverse philosophers and has lectured or served as visiting professor in an unusually broad range of universities in many countries, including the United States, Canada, Argentina, Mexico, India, China, Israel, Yugoslavia, France, Germany, Belgium, Denmark, Sweden, Spain, Italy, the Czech Republic, and Switzerland. His distinction as a teacher and author is doubtless largely responsible for his global popularity, as are also his conceptions of philosophy and philosophical analysis. For him a philosopher aims to make clear the character of our fundamental, general, pervasive concepts and their interconnections, and he is a master at this. As he notes in his intellectual autobiography, he shares with Wittgenstein the notion that the essential business of philosophers is to get a clear view of our concepts and their place in our lives. In the same essay he also speaks of resisting the reductive tendency in philosophical analysis, which might well place him at odds with two of his major influences, Bertrand Russell and G. E. Moore, whom he views as the founding fathers of contemporary analytical philosophy. But one of Sir Peter's strengths is his ability to learn from such outstandingly great but diverse philosophers as Aristotle, Hume, Kant, and Wittgenstein while still dissenting from various of their particular doctrines. The traditional answer to the question of what it is to analyze anything, from the Greeks to Russell, has been that analysis is an affair of reducing a complex to fixed and permanent elements. But Sir Peter, himself a leading philosophical analyst, vigorously rejects element analysis of the important or interesting concepts. Such concepts cannot be broken down without remainder into simples or irreducible constituents. Accordingly, understanding or interpreting a situation is primarily an affair of clarifying, tracing interconnections, or putting it in an appropriate context.

His intellectual autobiography provides a helpful sketch not merely of his intellectual development but also of his methods of teaching and writing and some of his many honors. It also provides a better understanding of his interests, from writing schoolboy verse for publication to an abiding love of great literature, both poetry and prose, a fondness for traveling, and a keen interest in the landscape and architecture found in many parts of the world. In addition, it sheds fresh light both on contemporary philosophy and the history of philosophy.

Although I regret that several able critics were unable for one reason or another to meet our deadline, I am grateful to Professor Strawson and his twenty or so critics for making this volume possible.

The support, encouragement, and cooperation of our publisher, Open Court Publishing Company, especially David R. Steele, Kerri Mommer, Jeanne Kerl, Jennifer Asmuth, and Kevin Heubusch, both facilitate my work and make it more enjoyable. And I am also most grateful for continued support, understanding, and encouragement from the administration of Southern Illinois University.

As always, moreover, it is a pleasure to express my gratitude to the staff of the Morris Library for their friendly and unfailing help in a number of ways. My warm gratitude goes also to Christine Martin, Loretta Smith, and the Philosophy Department secretariat for help with many projects; and I give my special thanks to Sharon R. Langrand for help with manuscripts and proofs and all she does to keep our office functioning efficiently.

Finally, for warm support, stimulation, and friendly counsel I am deeply grateful to my pluralistic colleagues whose resourcefulness and diversity in a common cause continue to make better things happen for all of us.

LEWIS EDWIN HAHN
EDITOR

DEPARTMENT OF PHILOSOPHY
SOUTHERN ILLINOIS UNIVERSITY AT CARBONDALE
MARCH 1998

PART ONE

INTELLECTUAL AUTOBIOGRAPHY OF P. F. STRAWSON

The Problem of Realism and the A Priori

The term 'realism' has, in philosophy, a number of senses or applications. Two of them only will be considered here. Both concern the same question: that of the relation between the nature of reality (variously conceived) on the one hand, and human cognitive and intellectual powers on the other; i.e. between how things really are, and what we can, in principle, know or understand about how they are.

It is a question on which opinion is relatively clearly, and deeply, divided. On the one hand we have many philosophers, perhaps the majority of our contemporaries, who utterly repudiate, or find no sense in, what they are prone to call 'metaphysical', or perhaps 'transcendent' realism – i.e. the belief in a reality which in principle transcends all possible human knowledge or understanding. These same philosophers would, for the most part, call themselves realists, while qualifying their realism (as Putnam does) as an 'internal' or 'human', or (as Quine might) as a 'scientific', realism. They could even be reasonably called, borrowing Kant's phrase, 'empirical' realists. There is evidently something ironical, even perverse, in this borrowing from Kant; for Kant combines, or seems to combine, his empirical realism with a commitment to a very strong form of precisely the metaphysical variety which our contemporaries reject – indeed to the doctrine that reality as it is in itself is something of which we can have no knowledge at all. Of course, even if he is thus committed to a combination of two varieties of realism, this is not how he describes his position; he calls it, instead, transcendental idealism.

Here is one place in which we can locate the, or at least a, problem of realism. Does Kant indeed combine the two kinds of realism? Is it possible to do so? Or must the claim of one or the other to such a title be disallowed?

We must turn for an answer to Kant's transcendental investigations, his investigations into the a priori conditions of the possibility of experience or empirical knowledge. It is a Kantian thesis which few will dispute that human intuition is sensible and human intellect or understanding discursive; or, in other words, that we are passively, or sensibly,

P. F. Strawson

INTELLECTUAL AUTOBIOGRAPHY

I was born, on 23 November 1919, in one London suburb, Ealing, and was brought up in another, Finchley. I was the second child, with two brothers and one much younger sister. My parents were both school teachers, though my mother gave up teaching on marriage. They had met when studying English literature at Goldsmith's College, London. My mother retained an excellent memory for verse, which I inherited. My father's parents came from Lincolnshire and Yorkshire, my mother's from Hampshire and Gloucestershire. Unlike many English people, I know of no Scottish, Welsh, or Irish ancestry. After my first year's secondary education at the Finchley County School my parents transferred me to the boys-only Christ's College, Finchley (motto: 'Usque proficiens'), where academic standards were higher and where my elder brother, four years my senior, was already being educated. Unlike him, I declined to join the Cadet Corps. I still feel grateful to the French teacher (Miss Jacobi) at the earlier school, who required us to learn the phonetic alphabet and strove to inculcate a correct pronunciation of the language she taught.

At Christ's College I had good teachers and flourished academically. When the time came to choose specialist subjects for what was then called 'Higher Certificate' (modern 'A-Level') I chose English, French, Latin, and History, to the disapproval of my math master who claimed, incorrectly, that mathematics was my best subject. In fact, my best subjects were the literary ones, and especially English, in which an excellent teacher, J. H. Taylor, gave me much encouragement. I developed a liking for grammar and a devotion to English poetry and prose, neither of which has left me. With Mr. Taylor's support I entered for and won an open scholarship in English at St. John's College, Oxford. My Higher Certificate examination results had additionally secured for me a State Scholarship, and an anonymous benefactor had undertaken to supplement my undergraduate income. So I went up to Oxford in October 1937, at the age of 17, with adequate financial provision. This was necessary, since my father's salary, as Headmaster of a poor London school, had been modest, and his early death in 1936—he had suffered

bad health ever since the 1914–18 war—had left my mother a widow. So we were rather poor.

Before I joined my college, I had decided to change my course, if possible, from the Honour School of English to that of Philosophy, Politics and Economics (P.P.E.); and when I arrived in Oxford I succeeded, against some mild resistance, in persuading the Fellows to allow me to do this. My motives for wishing to change were various. One was the perhaps rather priggish thought that since, at that period, the political future and the civilization of Europe seemed threatened, I ought to be better equipped than I was with understanding of politics and economics. More important was the fact that I had already begun to feel the intellectual pull of philosophy. This was partly due to my having read Rousseau's *Du Contrat Social* and been captivated by its combination of passion with what I then mistook for rigor; partly because I had already discovered in myself some capacity for argument and for detecting the flaws, confusions, and inconsistencies in the discourse of others; and partly to reading some popular books on philosophy (notably by the not contemptible C. E. M. Joad) and being taken with the irresistible fascination of the questions, problems, and theories there recorded. It was not that my love of literature had in any way diminished. On the contrary. I had read much, including modern, poetry (particularly T. S. Eliot); and I thought and continue to think of great poetry as the greatest of human achievements. I had contributed poems myself to issues of an anthology of schoolboy verse, called *The Threshold*, published in the 1930s. I am, or was, a competent versifier, and if I had been able to choose my talents, I would have chosen to be a poet. But of course I could not, and am not. So it was rather the assurance, perhaps mistaken, that my enjoyment and appreciation of good writing would not be enhanced—might even be injured—by making a profession or a career of it.

After one preliminary term of eight weeks at Oxford, concluding with a simple examination, for which I read with enjoyment some Tacitus and Pliny, Tocqueville and Corneille, the serious work of the P.P.E. school began. Economics, I found, interested me hardly at all, the historical part of politics much more; philosophy I found congenial and absorbing from the start. Besides the required subjects of moral and 'general' philosophy I chose the only two options then allowed to P.P.E. students specializing in philosophy, viz. Logic (broadly understood to include what would now be called Philosophy of Language, and some metaphysical and epistemological questions) and the philosophy of Kant (*The Critique of Pure Reason* and the *Grundlegung*). My principal philosophy tutor throughout was J. D. Mabbott, a very reasonable, courteous, and helpful teacher, whose main interest was in moral and political philosophy and

who subsequently became an excellent head of the college. But I also enjoyed one term's tuition by H. P. Grice, the other philosophy tutor at St. John's and one of the cleverest and most ingenious thinkers of our time. Tutorials with him regularly extended long beyond the customary hour, and from him I learned more of the difficulty and possibilities of philosophical argument than from anyone else. His resourcefulness seemed inexhaustible.

By the end of my three undergraduate years in Oxford I knew that, of all the world's possible occupations, the one I most desired was that of a Fellow and Tutor in Philosophy in a college of that University. But the result of my final examination, though it did not greatly surprise me, was a disappointment both to myself and my tutors; so I had no very high hopes of achieving such an ambition. In any case, by then, we were in the summer of 1940. The war was going badly. I was duly called up into the army (the Royal Artillery), and I was sent for basic training to a territorial searchlight battery in Sussex, where, in between learning to drill and to shoot I had an excellent view of the aerial Battle of Britain during the day, and, at night, of the red glow of the Northern sky where London was undergoing bombardment by the Luftwaffe. Fairly soon I was selected for instruction in the mysteries of radar and attended a number of courses, in London and elsewhere, at which I learned a great deal, now forgotten, about electronics. Having no difficulty with examinations in this subject, I was, to the reasonable surprise of senior NCOs, fairly rapidly promoted through the ranks, briefly commanded a small radar station near the Sussex shore, and in 1942 was commissioned in the newly formed corps of the Royal Electrical and Mechanical Engineers.

I eventually attained the rank of captain; but my military career was in no way distinguished. The only part of it in which I took much satisfaction was that of discharging the duty of defending officer at the courts martial of putatively delinquent soldiers, where, though I only once secured an acquittal (of a senior NCO charged with a serious offense of disobedience to orders) I flatter myself I may often have reduced the severity of sentences by the persuasive power of my 'pleas in mitigation'. In 1945, before being posted abroad to the occupying army in Italy, and then Austria, I had the great good fortune of persuading Grace Hall Martin, my girlfriend of some years' standing—whom I had renamed 'Ann'—to marry me: probably the most judicious action of my life.

In the summer of 1946, having unhesitatingly declined the bait of further promotion, I was demobilized. I had served for six years, thinking a little, but not much, about philosophy and devoting most of such private leisure as I had enjoyed to reading the greater French and

English novelists. My ambitions, however, for a career as an academic philosopher, had not changed. I contemplated returning to Oxford to read for a further degree (a B.Phil. in philosophy); but there were difficulties in the way of that; and my future was in effect decided by the intervention of my former tutor, John Mabbott—in this my guardian angel—who suggested that I apply for the post of Assistant Lecturer in Philosophy at the University College of N. Wales, Bangor, where he himself had taught for a short time before becoming a Fellow of St. John's. It was no doubt largely due to his support that, when I did apply, I was elected on interview. So I set myself to some hard reading in subjects on which I was to lecture—particularly philosophy of logic (for which I read Russell, Moore, Ramsey, C. I. Lewis, and an introductory book by Susan Stebbing) and Kant's moral philosophy. In the course of my year at Bangor I also lectured on the philosophy of Leibniz (studied mainly in the Gerhardt edition) and on ethics in general; and wrote two papers, one an attempt to solve the problem of the 'paradoxes of entailment', the other an attack on ethical intuitionism. The first I submitted to *Mind*, where it appeared, as 'Necessary Propositions and Entailment Statements', my first published article, in 1948. Though it contained the germ of a fruitful idea, it also contained a serious mistake and so failed in its declared aim. The second was much too long and too involved, therefore tedious; so I later recast it in the crisper, dialogue form in which it appeared as 'Ethical Intuitionism' in *Philosophy* 1949.

During the same academic year I visited Oxford, where Ann and I shared a flat—she having entered St. Anne's College to read English as an undergraduate—to take the competitive examination for the John Locke Scholarship, as it was then called. My success in winning this had two beneficial results: first, the prize of £80, then worth many times its present value, was extremely welcome to an impoverished couple; second, my papers sufficiently impressed Gilbert Ryle, one of the examiners, for him to recommend me to University College, then in need of a second teacher of philosophy. So, in 1947, I returned to Oxford as, in effect, a philosophy tutor, though bearing the inappropriate title of 'College Lecturer' until, in the following year, I was elected a Fellow. Ann and I were then fortunate enough to be able to leave our North Oxford flat and take up residence in an apartment in the College itself, where we lived until we moved, in 1950, on the birth of our first child, to an elegant College house of the 1840s.

Having thus achieved, at the age of 28, my prewar ambition, I set seriously to work at the two tasks of tutorial teaching and of thinking my own thoughts. They are not unconnected tasks, for the first is of immense benefit to the second, as the second is to the first. Indeed I think there is no better or more mutually profitable method of philosophical instruc-

tion than the one-to-one tutorial exchange. The pupil, who brings and reads to his tutor a weekly essay, prepared on the basis of recommended reading, gains from the attention and criticism of his more experienced listener. The tutor, striving to understand and clarify his pupil's thoughts, will frequently succeed in clarifying his own. This admirable system, like many good things, is under threat.

My colleague, George Paul, and I divided the tutorial teaching between us in a way satisfactory to both. He undertook the teaching of moral and political and ancient philosophy (Plato and Aristotle), while logic and general modern philosophy from Descartes onwards fell to me. The questions which at the time most seriously engaged my attention were questions in the philosophy of logic and the philosophy of language. While still at Bangor, lecturing on these matters, I had become deeply concerned with the matter of singular reference and predication, and their objects—a topic which has remained central in my thought throughout my working life. Now in Oxford I proceeded, beginning in 1948, to supplement my college teaching with a series of University lectures under the title 'Names and Descriptions', in which I referred to and criticized the work of Russell, Moore, Kneale, and some few others. From these I extracted two lectures, given to an American Summer School, in which I concentrated on my critique of Russell's Theory of Descriptions; and the report of these induced Gilbert Ryle, then editor of *Mind*, to say, bluntly, that he wanted them as an article for that journal. Hence 'On Referring' (*Mind*, 1950), which remains, probably, the best known of my writings.

Russell's theory, elegant and ingenious as it is—a 'paradigm of philosophy' according to F. P. Ramsey—seemed to me then, and still does, to misrepresent the true character and function of singular definite descriptive phrases, as, for the most part, we actually use and understand them. It does so by overlooking or neglecting the pragmatic, contextual, and communicative aspects of their use. To the objection that this is to introduce merely pragmatic considerations into what is essentially a semantic question, the answer must be that no serious semantic theory can afford to ignore the points—and their consequences—to which I drew attention. I think my view, with variations, is now generally accepted by linguists, though the issue remains, to some extent, controversial among philosophers. I should add that I had not at the time read Frege and was, regrettably enough, completely ignorant of the work of that great figure; so subsequent references to the 'Frege-Strawson' view of the matter I found, at first, surprising, though in no way disturbing.

I had, after all, jumped straight, with six years military service intervening, from undergraduate to university teacher; so serious gaps in my knowledge were perhaps pardonable. My major influences remained

Russell and Moore, whom I viewed, and still view, as the founding fathers of contemporary analytical philosophy. Other influences, of course, were soon to be added: locally Ryle, whose verve and brilliance might excuse, if they sometimes masked, a certain lack of rigor in thought, and Austin, consistently clear, precise, witty, and formidable; more remotely, Wittgenstein, whose Blue and Brown Books began to circulate in pirated copies at the beginning of the 1950s, at once breathtakingly impressive and profoundly enigmatic; and Frege himself, whose articles on Sense and Reference and Concept and Object were made available in English translation by Geach and Black in 1952. Nor should I fail to mention A. J. Ayer whose *Language, Truth and Logic* I had read, enthralled, in the gardens of St. John's as an undergraduate—even though, by now, I no longer found satisfying his undiluted classical empiricism.

Austin did me the honor of proposing that I should reply to his paper on Truth at the Joint Session of the Mind and Aristotelian Society in 1950. I was already convinced that Ramsey had got the matter essentially right a long time ago, and hence thought that Austin had got it essentially wrong. Though I tried to convey as much in my reply, I also spoiled the effect, and diverted general attention, with a gratuitous flourish of my own, which was itself due in part to Austin's own observation of the 'performatory' function of speech. That little flourish had itself formed the substance of a short article in *Analysis* the year before (a propos of which I remember fatuously announcing to George Paul that I had a new theory of truth; to which he sensibly and characteristically replied: "Come on now, which of the old ones is it?"). The issue, of course, persists; and, much later, I was able to make my considered position clear and to finalize my critique of Austin in the two articles 'A Problem about Truth: A Reply to Mr. Warnock' (1964) and 'Truth: A Reconsideration of Austin's Views' (1965), both of which were reprinted in *Logico-Linguistic Papers* (1971).

Meanwhile, I had been invited to give regular introductory lectures on logic in the University for the benefit of undergraduates studying for the Preliminary Examination in P.P.E. This I did, and as a result was further invited by a publisher, again, I think, at Ryle's prompting, to write a book on the subject. It duly appeared as *Introduction to Logical Theory* in 1952 and received the accolade of a lengthy review in *Mind* by Quine, in which he deplored my use of the notion of analyticity but pleased me by his slightly ironical reference to my 'lucid vernacular'. My double concern in the book was to explain the nature of standard elementary logic while at the same time emphasizing the point that, perspicuous, powerful, and elegant as it is, modern formal logic is not an adequate instrument for revealing clearly all the structural features of

language as we use it. Rather, it is an idealized abstraction of great power and beauty, an indispensable tool indeed for clarifying much of our thought, but not, as some are tempted to suppose, the unique and sufficient key to the functioning of language and thought in general.

The early 1950s in general were a busy and productive time. For a few years in the first half of the decade Grice and I together held a graduate seminar at which we took it in turn to read papers, some of them (e.g. that which surfaced later as 'In Defence of a Dogma' [1954]) actually produced in collaboration. Among those at different times attending the seminar were a number of senior members, including, on his first visit to Oxford, Quine. At about this time I was charged by Ryle with the task of reviewing Wittgenstein's *Philosophical Investigations* for *Mind*, a task to which I devoted a considerable amount of time and effort, with results (1954) which, though they recorded my sense of the work's genius, also recorded some perplexity, even dissatisfaction, and was accordingly not received with entire approval by the committed disciples. It might not be quite coincidental that Norman Malcolm, as an epigraph to his own review, quoted Lichtenberg: 'Ein Buch ist ein Spiegel. Wenn ein Affe hineinguckt, dann kann freilich kein Apostel heraussehen'.

The birth of my daughter, Julia, in 1950 was followed by the birth of my two sons, Galen (named after his uncle who was named after his) in 1952, and Robert in 1954. Soon after the publication of 'Logical Theory' I ceased to give the introductory lectures on formal logic and began instead to think and lecture on the lines which led, ultimately, to *Individuals*. This was a natural development from my already established concern with the operation, fundamental in thought and speech, of reference and predication; an operation fundamental also, as many, from Aristotle to Quine, have thought and stressed, in ontology or metaphysics. So it was natural to address the question of what the most basic or primitive or fundamental objects of reference, or subjects of predication, are. In the first part of *Individuals* I argued that they are—and necessarily are—relatively enduring space-occupying individuals, falling under substance-concepts. Here was an at least partial echo of Aristotle. In the same part I speculated on the theoretical possibility of reproducing the essential structure of our scheme with a greatly attenuated ontology (sounds); sought, perhaps by then unnecessarily, to deliver a coup de grâce to Cartesianism and to dispose of the pseudo-problem of other minds; and concluded by examining the brilliantly conceived and finally impossible Leibnizian ontology of monads.

All of this and more I made the topic of one of the seminars I conducted at Duke University, North Carolina, throughout the fall semester of 1955. This was my first visit to the United States. The other seminar I conducted there was devoted to a series of papers in the

philosophy of logic and language: on such topics as reference again, propositions, the constants of logic and their analogues in natural language, necessity, etc. While at Duke, I had the opportunity of visiting and reading papers at a number of other American Universities, on the West and East coasts and in between. The visit which stays most vividly in my mind, and that for a bizarre reason, is the one I paid to Seattle, Washington State. The paper I read there contained the substance of what became the chapter on Persons in *Individuals*; and one member of my audience stood throughout, with his back turned to me, evidently more willing to hear what I had to say than to contemplate the sight of me saying it.

Another event which occurred, I think, earlier in the 1950s was an assembly of French and Anglophone philosophers at one of the Colloques de Royaumont, which was designed to bring about a meeting of minds between representatives of the continental and analytical traditions. Whether this desirable result was actually achieved remains uncertain. But Austin at least made an impression with his paper, delivered in French, on 'Performatifs'. In a paper entitled 'Analysis, Science and Metaphysics' I gave an account of the relations between these three, as I then conceived of them; and this, later published in French in *La Philosophie Analytique* (Cahiers de Royaumont, 1962), appeared later still in English in *The Linguistic Turn* edited by Rorty in 1967. At about this time I wrote my contribution to the Schilpp volume on Carnap, under the title 'Carnap's Views on Constructed Systems versus Natural Languages in Analytical Philosophy'. Completed to a deadline in 1954, it did not appear until the volume was published, nine years later, in 1963.

Philosophical disagreements with Quine—which have in no way impaired a personal friendship of some forty years' standing—surfaced again in 'Propositions, Concepts and Logical Truth' (1957). The disagreements, both then and later, turn on my more than permissive attitude towards a whole range of intensional notions which Quine is unable to countenance; and of which, I then argued, his own account of truths of logic compelled recognition. My next major undertaking was that of getting my lectures on Individuals into shape as a book. This did not take me very long, since the lectures were already pretty complete; but I did rewrite the first chapter and add an introduction about the general character of the enterprise, in which I introduced the term 'descriptive metaphysics'. In the second part of the lectures and of the book I sought both to explain the basic association of two distinctions—the logical or grammatical distinction between subject and predicate (reference and predication) on the one hand and the ontological distinction between spatio-temporal particular and universal on the

other—and at the same time to show that and why this association, though fundamental, is not exclusive. Particulars indeed can never be predicated, but universals, and abstract and intensional objects generally, can certainly be objects of reference or subjects of predication; and given the acknowledged connection between being an object of reference and being an entity, we should abandon, if we suffer from them, any natural but ill-founded nominalistic anxieties and recognize such objects in our ontology.

Individuals was published in 1959, and in the same year A. J. Ayer was elected to the Wykeham Chair of Logic, for which I too, encouraged by colleagues, had applied. The result of the election, so far from being a disappointment to me, was a profound relief. I did not yet feel ready for an Oxford Chair, and was perfectly satisfied to continue with undergraduate tutorial teaching. The weekly discussion group for selected dons which Ayer established replaced, in a totally different but equally stimulating style, the Saturday morning meetings over which Austin, before his untimely and much lamented death, had so brilliantly presided. With Austin, proceedings were informal and no standard philosophical issues were tackled head-on; instead, particular specific concepts or concept-groups (words or word-groups), and the conditions of their use, were examined in detail, with results that were always fascinating, and often philosophically suggestive or illuminating. With Ayer, a different member of the group each week would read a paper on a philosophical topic of his choice; then drinks would be served by the host for the term and discussion, usually spirited, never acrimonious, would begin. 'Freddie's group', as it was and is called, survived and survives the death of its founder.

1960 was a full year. I was elected to the British Academy and delivered there a lecture, 'Freedom and Resentment', which is one of my very few ventures into moral philosophy. Another such venture, written about the same time, and published in 1961 (the year of the birth of my younger daughter, Virginia), I entitled 'Social Morality and Individual Ideal'. Between them, these two papers effectively embody all I have thought or have to say in a philosophical area which, important as I recognize it to be, I have never found as intellectually gripping as those to which I have given more attention. The 1961 paper I had previously given as a public lecture in Princeton University, where I had been invited for the fall semester of 1960. There I conducted a seminar attended by some extremely able graduates and, from time to time, by such teachers as Hempel, Benacerraf, and Vlastos. My subjects were, again, generally in the region of philosophy of logic and language, e.g. singular reference and predication, logical constants and logical form. Colleagues and students were friendly and the standard of discussion

was high. While at Princeton I again visited and read papers at a number of other universities.

1960 also saw the publication, in the *Times Literary Supplement*, of a series of articles under the general heading, 'The British Imagination'. I contributed the article on philosophy. It was given the title, 'The Post-Linguistic Thaw'—a title not chosen by me and which I deplored. The title was not without point in that, as I indicated in the article, concentration on the actual use of words in ordinary linguistic prac-tice—a philosophical method largely inspired by Austin and cultivated by at least a substantial minority of British, and especially Oxford, philosophers in the postwar period—was already, before 1960, begin-ning to loosen its grip in favor of more systematic and 'theoretical' approaches. Yet the title metaphor was objectionable in its suggestion of emergence from a period of frozen sterility; whereas in fact the gains and advances in philosophical understanding made in that period were probably as great as any that have been made in a comparably short time in the history of the subject; and the intellectual pleasure and excitement of living through it were correspondingly intense.

In the immediately succeeding years, besides lecturing and writing papers in the philosophy of language—on truth, reference, speech-acts, etc.—I began to lecture on Kant's *Critique of Pure Reason*, a book on which I had regularly tutored those undergraduates, or supervised those graduates, who had chosen to study it, finding it, as most of them did, both baffling and profound. There was a link here, too, with *Individuals*. In that book I had found myself frequently enquiring into the conditions that make possible certain kinds of knowledge and experience that we in fact have, or certain kinds of distinction that we in fact draw; and Kant, in the Critique, addresses this kind of question in its most general form, investigating the conditions of the possibility of experience, or empirical knowledge, in general. My lectures on the Critique, given in alternate years from 1959 and modified or added to from year to year, finally formed the basis of my book, *The Bounds of Sense*, published in 1966. My endeavor, in that work, was to separate Kant's brilliant and profound account of the structure of necessarily interconnected ideas and concepts which form the limiting framework of all human thought about the world and experience of the world from the overarching theory which he saw as the explanation of the possibility of any such account; and at the same time to explain that explanation and to show why it should be rejected. But I am aware that the last word on what remains the greatest single work of modern Western philosophy has not yet been, and probably never will be, spoken.

This publication naturally did not end my concern with Kant. On the first Critique, over the next twenty years, I regularly conducted a

graduate seminar which never failed to attract graduate students, many of whom made excellent contributions to it. In an article, 'Imagination and Perception', first published in 1970 and subsequently reprinted, I made some amends for my cavalier treatment of the notion of synthesis in *The Bounds of Sense*. In 1987 I contributed papers to conferences in both Stanford and Stuttgart ('Sensibility, Understanding and the Doctrine of Synthesis' at the former, 'Kant's New Foundations of Metaphysics' at the latter), the proceedings of which were subsequently published. In 1987 again I contributed a paper on Kant's Paralogisms to a volume in honor of Dieter Henrich on his sixtieth birthday. In 1992 I gave a talk on 'The Problem of Realism and the A Priori in Kant' at a conference in Florence on Kant and Modern Epistemology. More recently I paid tribute to his insight into the nature of aesthetic judgment (in the *European Journal of Philosophy*, 1993).

In 1968 I succeeded Ryle in the Waynflete Chair of Metaphysical Philosophy at Oxford. Before taking up my duties in October of that year I worked hard at preparing a set of introductory lectures on philosophy. My aims were, first, to explain the general nature of the discipline as I conceived and tried to practice it; then to demonstrate the interdependence of ontology, epistemology, and logic; and finally to show how certain central philosophical issues should, in my view, be resolved. I was incidentally concerned both to lay classical empiricism to rest and, in rejecting at least one favored conception of analysis, to resist the reductive tendency in philosophy in general. I gave the same series of lectures, under the title, 'Analysis and Metaphysics: an Introduction to Philosophy', in almost every succeeding year until my retirement in 1987, keeping the earlier and more general parts substantially unchanged, while varying the choice of particular issues to be treated in more detail in the later parts.

The initial investment of effort in the preparation of these lectures has served me well. Much of a late version I translated into French and delivered as a course at the Collège de France in the spring of 1985; I delivered substantially the same lectures in English, with some variations, as the Immanuel Kant lectures in Munich in the summer of that year; in the Catholic University of America in Washington in September 1987; and as my contribution to the Sino-British Summer School in Philosophy in Beijing in 1988. The French version was published in Paris in 1985 as *Analyse et Metaphysique* and the final English version in Oxford in 1992.

It is customary, though not obligatory, for one newly elected to an Oxford Chair to give an Inaugural Lecture. I was glad of the opportunity to pay tribute to my predecessor, Gilbert Ryle, who, by reason of his energy, his authority and his vision—besides the brilliance and inven-

tiveness displayed in his own philosophical writing—contributed per-
haps more than any other single person to the flowering of the subject in
England in the years after the war. I was glad, too, to return in the
lecture, 'Meaning and Truth', to my abiding concern with language as an
instrument of human communication. Although, in this lecture, I too
blithely acquiesced, as John McDowell subsequently pointed out (1980),
in an approach suggested by Grice's well-known article on Meaning of
1957, yet the centrality of the notion of fully overt communication-
intention to any general understanding of the notion of linguistic
meaning remains indisputable. Hence the failure of all inevitably self-
frustrating attempts to expel all considerations dismissed as merely
'pragmatic' from the sacred area of semantic theory.

Philosophy of language was indeed a dominant, though not an
exclusive, concern in the papers written about this time and in the next
few years. Reading Chomsky's *Aspects of the Theory of Syntax* (and
attending the John Locke lectures which he gave in the late 1960s) had
led me to write 'Grammar and Philosophy', which I gave as the
Presidential address to the Aristotelian Society in 1969, and in which I
argued that no general explanatory theory of grammar was possible
which did not intimately link semantic considerations to syntactic
classifications and relations. At the conclusion of this essay I looked
forward to the notion of a 'perspicuous grammar' which I developed,
though only in a limited fashion, in my next book, *Subject and Predicate
in Logic and Grammar* (1974). Though representing a new departure for
me insofar as it was explicitly concerned, in its second part, with the
theory of grammar, the book also showed its continuity with earlier work
in that I began from the basic case of definite singular reference and pre-
dication and then proceeded, on this basis, to offer an explanatory ac-
count of the grammatical notions of subject and predicate in general. So
a central theme of *Individuals*, further developed and exploited in 'The
Asymmetry of Subjects and Predicates' (1970), lay at its foundation.

Asked to contribute to a volume of essays on the work of Gilbert
Ryle, I chose as my topic the notions of category and category-mistake,
which Ryle had frequently invoked and which had long interested me. I
showed that the theoretical accounts he had earlier given of these ideas
(and later viewed with distrust) were in fact indefensible and offered a
less striking but, as it seemed to me, more plausible alternative ('Catego-
ries', 1970). I wrote other articles in a similarly critical vein: thus I
argued that Austin, in *How to Do Things with Words*, had failed to give a
consistent account of what he called the 'locutionary' aspect of speech-
acts (1973); anticipated my later contention that the Tarskian truth-
theoretical model favored by Davidson as a means of elucidating the
semantically significant structural features of natural language was not

adequate to the task (1974); and argued that the positions available for nonsubstitutional quantification were more than Quine allowed for, in that they included predicate-position ('Positions for Quantifiers', 1974). I later came to think that I had not fully understood at the time the full implications of this last article; and that a fully developed view would in fact bring me in one respect closer to Quine (all such positions being indeed referential), while in another leaving me equally remote from him (since properties and other intensional entities could properly occupy those positions). This development emerges implicitly in my 'Concept and Property or Predication and Copulation' (1987); but the most general defense of intensional or abstract entities is to be found in my 'Entity and Identity' (1976), 'Universals' (1979) and 'Two Conceptions of Philosophy' in *Perspectives on Quine* (1990).

In the winter of 1975-76 I made my first visit to India, where I already had friends, including Ramchandra Gandhi, who had written an admirably lucid doctoral thesis under my supervision in Oxford, and Roop Rekha Verma, who had spent a year in Oxford under the auspices of the British Council. While there, I lectured, read papers, and took part in discussions in Delhi, Lucknow, Santiniketan, and Calcutta. In general I was enchanted by this great and various country, by the beauty to be found there and by the warmth and vivacity of my hosts; and was delighted to repeat my visit, this time accompanied by Ann, in 1979-80.

Issues in the philosophy of language and ontology were not the only ones that occupied me in the 1970s. At a conference in Valencia, Spain, in the spring of 1973, I criticized foundationalist theories of knowledge ('Does Knowledge Have Foundations?', 1974); at the Joint Session of the Mind and Aristotelian Societies in 1975 I differed sharply from the antirealist views previously expounded by Dummett and there defended by Wright ('Scruton and Wright on Anti-Realism', 1976); for volumes in honor of Charles Baylis and Ayer I wrote two papers on the ever-challenging topic of perception ('Causation in Perception', 1975, and 'Perception and its Objects', 1979); at a high-powered conference held in Jerusalem in 1976 I delivered a paper on the concept of possibility, concentrating on its epistemic use, so frequently overlooked in discussions of modality in general ('May Bes and Might Have Beens', 1979); and on a second visit to Israel in 1977, at a conference commemorating the tercentenary of the death of Spinoza, I spoke on Liberty and Necessity, complementing the views I had advocated in 'Freedom and Resentment' by adding what I took to be a decisive demonstration that the thesis of determinism, in any form in which it was defensible, had no bearing on the issues of moral judgment and moral responsibility.

In 1977 I received the honor of knighthood; immediately after the investiture in December I departed for Yugoslavia, where I gave lectures

in Belgrade, Sarajevo, and Zagreb. I registered a certain difference in atmosphere in the three places. At least in academic circles the intellectual style seemed relatively untrammeled in Belgrade and Zagreb, though the political tone was different. In Sarajevo, where I was only allowed to give one of my two scheduled lectures and had minimal contact with fellow academics, one perhaps time-serving young man in my audience suggested that my lecture revealed an essentially bourgeois outlook. I replied, 'But I *am* bourgeois—an élitist liberal bourgeois'. My interpreter commented, *sotto voce*, 'They envy you'.

In the early 1980s there appeared two collections of critical essays about my work, both of which elicited, and contained, replies by me. One was the book, *Philosophical Subjects* (Oxford, 1980), the other a special number of the Israeli journal, *Philosophia* (1981). Three articles in the first I must particularly mention: the one by John McDowell already referred to; an excellent piece by Gareth Evans, a Fellow of University College and formerly the brightest pupil I ever had there, whose early death can never be too greatly lamented; and that of Hidé Ishiguro, one of the most sensitive and discerning of philosophers. The topics discussed in these collections were as various as those I had myself previously written on. Later in the decade I published two more papers on singular reference, one a contribution to the Library of Living Philosophers volume devoted to the work of Quine ('Reference and its Roots', 1986), the other as summary a statement as I could make of my current views on the question ('Direct Singular Reference: Intended Reference and Actual Reference', 1986). The latter I had already delivered as my contribution to a round table on the subject, at which Quine and Kripke also spoke, at the World Congress in Montreal in 1983. In 1982 I also published two papers, written long before, but hitherto used only in lectures or seminars, one on logical constants, the other on conditionals. The latter ('If and ⊃') had been written many years earlier as a riposte to Grice's ingenious and long unpublished attempt to demonstrate that the meaning of the ordinary conditional was in fact identical to that of the material conditional of standard logic—an application or anticipation of his later elaborated theory of conversational implicature, which, profound and fruitful as it is, is also capable, like most good ideas, of misapplication such as it suffered, I argued, in this case. The other article ('Logical Form and Logical Constants'), which aimed to give a general characterization of the constants of standard logic, I submitted as my contribution to a collection of essays, *Logical Form, Predication and Ontology*, published in India and edited by Pranab Kumar Sen, Professor of Philosophy at Jadavpur University, Calcutta, a leading Indian philosopher and my very good friend.

In the same decade, besides the travels, already mentioned, to France, Germany, Canada, the U.S.A., and China, I made a second visit to Spain, two more to America, spoke for the first time in Switzerland and went for the third time to India. At Valencia, in Spain, I repeated the arguments which formed the substance of the Woodbridge Lectures I gave at Columbia University in 1983 and of the book based on them which was published in 1985 as *Skepticism and Naturalism: Some Varieties*. In that book I had two different, though not unrelated aims. The first chapter was concerned with traditional philosophical skepticisms about, e.g., the external world and induction. In common with Hume and Wittgenstein (and even Heidegger) I argued that the attempt to combat such doubts by rational argument was misguided: for we are dealing here with the presuppositions, the framework, of all human thought and enquiry. In the other chapters my target was different. It was that species of naturalism which tended to discredit, or somehow to reduce to more scientifically acceptable, physicalistic terms, whole regions of ordinary human thought, language, and experience—in particular the regions of moral discourse, of the subjectively mental and of the intensional. Here my reaction, as well as my target, was different. I did not merely stress the inescapability of the natural or common human standpoint from which we normally take for granted all that is called in question by scientistic naturalism. I also allowed the latter its own validity from its own limited standpoint. Each standpoint could be called a form of naturalism—one with a pronounced bias towards natural science, the other of a more humanistic or, as I called it, 'liberal' variety. But to those—not few—in whom the drive for completely unified philosophical explanation is strong this tolerance may well seem unacceptable.

While in America for the Quine conference at St. Louis (1988) I also read papers elsewhere: at Vassar I distinguished and elaborated different senses or applications of the phrase 'the meaning of what was said'; at Columbia I repeated my views on 'Kant's New Foundations of Metaphysics,' and also critically discussed that philosopher's treatment of the concept of substance; and did the same at Bloomington, Indiana, where I had the pleasure of renewing ties with old friends from Duke, more than thirty years before.

My third visit to India, in the winter of 1987-88, was occasioned by a conference on my work organized at Lucknow by the Indian Council of Philosophical Research. I prepared a paper on my own philosophical development, and there were several seminar meetings at which pertinent points were made. I also gave talks at Calcutta, Delhi, and Hyderabad. Privileged, in the company of Ann and an Indian philosopher from Delhi, to visit many of the great Indian sites in North, South,

and Central India which I had not seen before, I was again struck by the inexhaustible variety and great cultural and artistic wealth of the country.

In the autumn of 1987 I retired, under the age limit, from my Chair at Magdalen; but because of the generosity of a former pupil at University College and of the College itself, I have a room there in which I can, and do, continue to work. As already indicated, retirement by no means brought an end to academic travel or to philosophical discussion and composition. My most protracted visit was to the University of Colorado at Boulder in the Fall semester of 1991. There I lectured twice a week to an undergraduate class and conducted a weekly graduate seminar. For the undergraduate class I drew partly on my Oxford lectures, which had already served me well elsewhere, and partly improvised on the basis of other papers of mine. For the first time in my life I had the invaluable help of a 'teaching assistant'—a highly intelligent graduate student who relieved me of much of the burden of grading papers and stood in for me when I was reading papers at other universities, as I did in Seattle, at Yale, and in two states, Wyoming and Wisconsin, which I had never visited before. This was my first experience of undergraduate teaching in the United States, having previously, on semester-long visits, been in contact only with graduate students and faculty members. I found the informality of the proceedings and the enquiring receptiveness of my audience most refreshing, though I was also struck by the surprising difference in level of literary and philosophical sophistication between the undergraduate and graduate students. At the graduate seminar I generally announced in advance which paper of my own was to form the topic of discussion at the next meeting, and then introduced the subject briefly myself; but on the last occasion I read a new paper, entitled 'Individuals', in which I attempted a synthesis of all the matters in the book of that name and subsequent writings, giving special prominence to the union of logic, epistemology, and ontology and to that realist view of universals and of abstract objects in general which I am ready to call a demythologized Platonism. My most abiding memory of Boulder, however, is of the perfection of the climate, the beauty of the mountains, and the courtesy and kindness of the inhabitants.

My most recent journeys, in 1992, were to the Kant conference in Florence in April and, in November, to Kingston, Ontario, where the Queen's University, in celebration of its sesquicentenary, had organized a series of philosophical lectures. My own was entitled 'Philosophy: a Personal View' and substantially followed the line traced in the account of my philosophical development which I had prepared for the 1987 Indian conference on my work. In the course of my career, academic occasions have taken me to all the world's continents except Australasia,

to most of the countries of Western Europe, to about half the States of the Union, to Argentina, and to Mexico. These extensive travels, as others of my profession will agree, are among the uncovenanted benefits of an abiding passion for philosophy.

It remains to say something about my methods of work, the influences I am most aware of, my relations with other philosophers and, perhaps, my general conception of philosophy. I certainly did not initially approach the subject with any large general plan of campaign; and I have never achieved, or aimed at, any such comprehensive, integrated system as the great metaphysicians, e.g., Kant and Spinoza, have constructed. Rather I have been moved—often, as Moore reported, provoked by philosophical views that have struck me as preposterous or obviously false or one-sided—by the wish to understand better some particular concept or range of concepts, or the views of some particular philosophers; or by the rare exciting occurrence of one of those moments of what at least at the time seems like a blinding flash of insight into connections of which one had been previously but imperfectly, if at all, aware. Such moments as these are not altogether pleasant: mingled with exhilaration is a slightly disagreeable, even physical, sense of agitation or discomfort, only to be alleviated as the exhilaration also subsides into a cooler and more laborious consideration of how it is to be controlled and the truth, if there is one, conveyed. Such experiences are infrequent indeed. More often, it is a matter of arriving, without excessive excitement, at a reasonably clear idea of the general line one intends to follow and the setting about the task of organizing it, and working out the detail, in readily comprehensible and tolerably harmonious prose. Excitement or not, the working out sometimes requires a good deal of hard and continuous thinking, which can keep one awake for hours. But this too I have found to be infrequent. Usually, when the general line is reasonably clear, the writing, though it calls for care, follows without much strain or is even attended with pleasure.

I have, of course, found philosophical discussion with others, in small groups, enjoyable and stimulating, even sometimes amusing. But except for a brief period in the early 1950s, when Grice and I collaborated in a seminar, I have found it best, indeed necessary, to think and work independently. In this, as in other ways, philosophy differs from natural science, where teamwork is apparently a quite regular thing. Austin, it is true, was attracted by this model, by the *idea* of cooperative endeavor; but what he actually *did* was as essentially individual as Ryle rightly held that all fruitful philosophical enterprise must be. Why this is so I tried to explain in a few lines in the preface to *Skepticism and Naturalism*. What, perhaps surprisingly, I have in the past found most helpful in the way of discussion is the one-to-one tutorial exchange with undergradu-

ates—when one finds oneself obliged to clarify one's own half-formed thoughts in order to make things clear to one's pupil. Seeking a way past, or through, his or her mistakes and confusions, one may find a path past, or through, one's own.

Many philosophers in the past—among them some of the greatest—have seen themselves as starting afresh, as setting out on a new path which they conceive to be the only sure one; and thus as freeing themselves, and us, from fundamental mistakes or misconceptions which have hitherto impeded the discovery of the true way. It is unlikely that any of us, in the second half of the twentieth century, will be buoyed up by any such glad, confident assurance—or, if you prefer, will be the victim of any such vainglorious delusion. Philosophers today tend to be more soberly and modestly aware of the greatness of the achievements of their illustrious predecessors and of the possibility of learning from them. Yet I think it is evident that there is a notable selectiveness in these appreciative responses. It is in no way surprising that this should be so; that each philosopher should respond most positively to those of his predecessors whose work is most in harmony with his own intellectual bent. And this in its turn will imply a certain further selectiveness within the domain of the favored predecessor's teaching.

So at least I have found it to be. Thus in the case of Wittgenstein, an acknowledged philosophical genius—perhaps the only one in our century—it must be that I am influenced by, for I profoundly share, the view that our essential, if not our only, business is to get a clear view of our concepts and their place in our lives. Such a clearing of the view, freeing it from the seductive illusions of whose fascination he was himself so vividly aware, Wittgenstein in his later work did more than anyone to promote. Yet, at the same time, the very strength of his resistance to the myths and fictions of theory seemed to me to lead to a certain loss of balance in two ways. First, the most general concepts and categories of the human conceptual scheme do form, in their connections and interdependences, an articulated structure which it is possible to describe without falsification; and this possibility Wittgenstein's distrust of systematic theorizing in general seems to lead him to dismiss. Second, at the root of some of the false pictures which earned his particular animus there sometimes lie harmless, commonplace elements of truth which receive in him too little acknowledgment.

The cases of Aristotle and Kant—the two whom I see, without qualification, as the very greatest of our predecessors—are quite different. Neither shrank from systematic theory. If I found, in Kant in particular, much to discard, I also found much to embrace, as answering, with modification, to my own natural prejudices or half-formed ideas,

which is why I am presumptuous enough to enroll them both under the banner of 'descriptive metaphysics'.

Finally, a few personal observations. I have no religious beliefs. When asked whether I believe in God, I am obliged to answer 'No'; I have difficulty with the concept. But I am sometimes tempted to add that I believe in grace—a quality which eludes precise description, but is sometimes manifested in the words and actions of human beings. My political views are centrist: I am conservative in my tastes, liberal in my sentiments (principles?). I am of a conciliatory temper—which sometimes extends, in philosophy, into an attempt to reconcile views which appear to be sharply opposed to each other. I am very little, perhaps too little, prone to anger.

I have sometimes criticized the views of other philosophers, dead or living. Such adverse criticism is a form of compliment. It is only the very best with whom it is worth while to differ. My own philosophical views I am prepared to defend, or modify, when required; but their neglect or rejection leaves me relatively indifferent. I enjoy applause, but have no expectation of, or wish for, disciples.

All in all, I count myself extremely lucky. Above all, I am fortunate in my friends and my family; friends whom I made as an undergraduate and to whom I am still close, and others, of many nationalities, whom I have come to know since; a family of wife and four children, all variously gifted and all, to my mind, invariably charming. Philosophy, friends, and family apart, my life has been enriched by the enjoyment of literature, landscape, architecture, and the company of clever and beautiful women. So far every decade has been better than the one before, though I recognize that, in the nature of things, this cannot continue indefinitely.

PART TWO

DESCRIPTIVE AND CRITICAL ESSAYS WITH REPLIES

1

Ruth Garrett Millikan

PROPER FUNCTION AND CONVENTION IN SPEECH ACTS

Strawson's "Intention and Convention in Speech Acts" (1964) intro-
duced into speech act theory two of its most characteristic contempo-
rary themes. Strawson applied Grice's theory of communication to
speech act theory (Grice 1967). With the use of this tool, he then drew a
distinction between two kinds of illocutionary act. I will prosaically call
these two "K-I (kind I) speech acts" and "K-II (kind II) speech acts."
Strawson claimed that contrary to Austin's views, only K-II acts are
"essentially conventional." Elsewhere I have complained against the first
of Strawson's innovations, indeed, against the whole of the Gricean
theory of communication (Millikan 1984 chapter 3).[1] But it is not
necessary to embrace the details of Grice's theory to appreciate the main
shift of view from Austin to Strawson on K-I acts.

Austin had taken all illocutionary acts to be differentiated and
defined according to conventional roles they are playing: in the absence
of conventions to determine these roles, performances of these acts
would be strictly impossible. Strawson claims that there is a large class of
illocutionary acts, the K-I acts, that are differentiated not by reference to
conventional roles of any sort, but by reference to the purpose of the
speaker in speaking. Other philosophers soon took sides with Austin or
Strawson. For example, Schiffer (1972), Bach and Harnish (1979), and
Recanati (1987) agree with Strawson that K-I acts are defined according
to certain kinds of Gricean intentions expressed by speakers, while
Warnock (1973) and Searle (1989) side with Austin, claiming that the
difference between K-I and K-II acts is only that the former invoke
merely linguistic conventions while the latter invoke wider social con-
ventions. All seem to agree, however, that despite some borderline cases,
there is a fundamental difference between the kinds.

In this paper I will explore certain relations between *purpose* and

convention, intention being, of course, a kind of purpose. I will describe a series of speech act aspects which are characteristically (and for good reason) tightly interlocked: (1) speaker intention, (2) (conventional) purpose or function of the expression used or as used in the context, and (3) conventional move made as classified by conventional outcome. In the case of many of the speech acts that Austin had centrally in mind when he coined the term "illocutionary act," these three aspects are all present and tend to coincide in content, but there are also cases in which these aspects come apart. The names and descriptions offered by Austin as designating specific "illocutionary acts" sometimes emphasize one end or the other of this series, either the purpose end or the conventional outcome end. Strawson's description of K-I and K-II categories roughly corresponds to this difference. But where Strawson argued for a distinction despite some borderline cases, I will argue for a strong continuum, with many cases falling in the center.

To make this argument, I will need to call in a model of purposiveness under which purposes can be univocally attributed to linguistic expressions and forms, to conventions, and to persons. And I will need to call in a different model of conventionality than has generally been employed. The model of purpose that I will use is developed in detail under the label "proper function" in (Millikan 1984); the theory of convention is detailed in (Millikan 1998). Here space will permit sketching these models only with very broad strokes.

I. Strawson's Distinction

Strawson's original suggestion was this. K-I illocutionary acts are completed when the hearer recognizes that the speaker has a certain kind of intention in speaking. This intention is to secure a certain response from the hearer, such as an action (typical imperatives) or the forming of a belief (typical indicatives). Further, in Gricean fashion, the speaker's, S's, intention is to procure this response by means of the hearer's, H's, recognizing that S intends or wishes to procure it, and recognizing that S also intends H to recognize this latter intention, and so forth. For example (I am interpolating here; the examples are not Strawson's) differences among the illocutionary acts of reminding, informing, asking, and warning lie in the responses or effects the speaker intends to produce in the hearer. In the case of reminding the intended effect might be getting H to recall, for informing getting H to believe, for asking getting H to impart certain information to S, and for warning bracing H against dangers that S describes. Various K-I acts that involve intending identical hearer responses are then further differentiated in accordance

with more exact mechanisms by which the speaker intends or expects to procure the intended response. For example, in the case of requests versus entreaties (these are Strawson's examples), S intends H to understand *how* he holds the intention that H comply, whether "passionately or lightly, confidently or desperately" (1964, p. 610), and S intends that this knowledge should motivate H to comply; in the case of orders, S intends that H understand that the context of utterance taken together with certain social conventions implies that certain consequences may follow if H does not comply, intends that this knowledge should motivate H, and so forth.

K-I acts, Strawson says, are not "essentially conventional." It is not true that acts of warning, acts of entreaty, acts of requesting and so forth

> can be performed only as conforming to . . . conventions . . . to suppose that there is always and necessarily a convention conformed to would be like supposing that there could be no love affairs which did not proceed on lines laid down in the *Roman de la Rose* or that every dispute between men must follow the pattern specified in Touchstone's speech about the countercheck quarrelsome and the lie direct. (p. 603)

Nor, when a speaker disagrees with someone, is there, in general, some "*convention* that constitutes" his act as an act of raising objections. On the other hand, the speaker may explicitly avow his illocutionary intention, thus conveying the force of his utterance conventionally, saying, for example, "I warn you that . . ." or "I entreat you to . . ." or "I object to" In the case of these "explicit performatives," the "conventional meaning" of the expression used may "completely exhaust the illocutionary force" of the utterance.

As examples of K-II illocutionary acts, Strawson lists "an umpire giving a batsman out, a jury bringing in a verdict of guilty, a judge pronouncing sentence, a player redoubling at bridge, a priest or civil officer pronouncing a couple man and wife" (p. 611). Here, Strawson says, the intention of the speaker is not to secure a particular response from the audience. Such acts are performed according to the rules of certain conventional procedures (for example, the marriage ceremony) as acts "required or permitted by those rules . . . done as falling under the rules . . . the speaker's utterance is not only *intended* to further, or affect the course of, the practice in question in a certain conventional way; in the absence of any breach of the conventional conditions for furthering the procedure in this way, it cannot fail to do so" (p. 612). Unlike K-I acts, K-II acts do not have ingredient in them, as such, speaker intentions whose fulfillment is dependent on hearer cooperation. Reciprocally, unlike K-II acts, "the wholly overt intention which lies at the core of . . . [K-I acts] . . . may, *without any breach of rules or conventions*, be frustrated" (p. 613, italics Strawson's). What is common

to the two kinds of illocutionary act is that the speaker's intention is "wholly overt," that is, intended to be recognized by the audience; what is different is that in one case the intention is to produce a certain audience response, in the other, to "further a certain [conventional] practice" (p. 612).

Strawson concludes with the caution, "it would certainly be wrong to suppose that all cases fall clearly and neatly into one or another of these two classes . . . [for example a] speaker whose job it is to do so may offer information, instructions, or even advice, and yet be overtly indifferent as to whether or not his information is accepted, his instructions followed, or his advice taken" (p. 614).

II. A Problem about the Univocity of K-I Categories

Despite some ambiguity in the passage just quoted, it is clear that Strawson intends the K-I/K-II distinction to apply not to act tokens but to illocutionary acts kinds, for example, to kinds designated by various performative verbs such as "inform," "instruct," "advise," "entreat," and so forth. Consider then those explicit performative K-I tokens about which he says that the "conventional meaning" "exhausts the illocutionary force." Are these tokens conventional in the sense that their having the force they do is "constituted by convention?" Are there conventions that make them into acts, say, of advising, warning, entreating, raising objections, and so forth? If so, a problem arises about the univocity of these various K-I act categories. A class of speech acts grouped together and named according to the particular audience response intended by the speaker can not be, as such, a class that an act token gets into by convention. That a speaker has a given intention cannot be a mere matter of convention. There might of course be a convention always to *treat* certain kinds of actions, for certain purposes, *as though* they embodied certain intentions—to "count them as" embodying these intentions, that is, as legally or morally or socially equivalent to actions actually embodying these intentions—but this would not make them *into* embodiments of intentions.

Conversely, it is not reasonable to suppose that having a certain intention in speaking might "count as" performing a certain conventional act. What "counts as" performing a convention-constituted act has to be something relatively arbitrary, something for which another thing might have been conventionally substituted. One's intentions in speaking cannot be supposed to play that sort of pawnlike role. Nor should we be confused by the fact that having a certain kind of intention may be something that has social consequences. Intending to embarrass, intend-

ing to deceive, intending to help, intending to kill—all these have social consequences that tie in with rules of ethics, rules of etiquette, the law, and so forth. This does not mean that these intentions "count as" anything *in accordance with conventions.* The intention to kill may be said to make the act of killing "count" as a more serious crime, punishable perhaps by death. But we really should speak more clearly. Killing intentionally is considered to *be* a serious crime. This is not a matter of convention but of conviction. Intentional killing is in some places punishable by death. This is not a matter of convention but of law. Cultures may of course differ in what they consider to be a crime, in what they consider to be polite, in what they codify into law, and so forth. That does not make these matters "conventional." Not all cultural variation results from differences in conventions.

To avoid this difficulty about the univocity of K-I acts, we might try denying that the use of an explicit performative turns a K-I act into an act "constituted by convention." Perhaps explicit K-I acts are just natural acts of expressing one's intentions that happen to be performed in a conventional manner—as one can perform the natural act of holding one's fork in a conventional manner, say, tines up, in the right hand, with the thumb on top. This would be consonant with Strawson's caution that he is considering in his essay only "normal and serious" uses of language (p. 599), which might mean here, that we are to consider explicit performatives only when backed by the intentions these conventionally express. Then one might argue that by the use of such performatives, nothing has been accomplished that could not in principle have been accomplished in a world without conventions. It is merely that something natural has been done in a conventional *way.* It is not the speaking of certain words, then, but merely the expressing of a certain audience-directed intention that makes an utterance of, say, "I entreat you . . ." into an entreaty, and so forth.

Still, this cannot be the solution, because in fact it is perfectly possible for a person to request, entreat, order, or demand a thing that she nonetheless expects the hearer will fail to accomplish, intending only to distract the hearer, or to trick the hearer into failure, or into starting into the designated action. Nor can we patch our theory by requiring for a K-I illocutionary act only that S intend H to think that S intends H to act or believe. Strawson himself gave us the contrary example: "A speaker . . . may . . . be overtly indifferent as to whether or not his information is accepted, his instructions followed, or his advice taken."

Faced with this sort of difficulty, some authors (Schiffer 1972, Bach and Harnish 1979, Recanati 1987) have proposed another epicycle: the K-I act requires only that S intends that H recognize S's intention to "provide H with reason to believe" that S intends H to act or believe.

The difficulty of understanding this claim, and the fear of provoking yet more epicycles, discourages attack. Still, a less baroque solution seems preferable. I will propose that K-I acts are defined quite straightforwardly by their *purposes*, and that conventional acts often have purposes *as such*. For this reason, conventional acts fall into K-I categories directly. To explain this, I will first explain what conventions are. Then I will talk about purposes and how conventions acquire them. This will reveal how a conventional illocutionary act can have its own purpose, additional to the purpose of the speaker. Last I will discuss the conventionality and purposes of K-II illocutionary acts.

III. CONVENTIONS

It is the conventionality of *acts* and *activities* and *patterns of activity* that will concern us—often I will just say "acts." In the sense that we need to examine first, "conventional" acts are "reproduced" items.[2] Conventional act tokens are modeled on prior act tokens, previously performed, typically, by other people. More formally, the concrete form—I am going to say "shape"—of the natural act embodying a conventional act token is determined according to the shape of certain historically prior natural acts such that, had the shape of these prior acts been different along certain dimensions, the token would have differed accordingly. This may be because the act is directly copied or imitated. Alternatively, the process of reproduction may be indirect, as when one person instructs or trains another to act in accordance with a convention. Second, when they have functions, as they often do, conventional acts, activities, and patterns of activity are characterized by a certain arbitrariness in relation to function. Thus patterns of skill, though they may be handed down by copying and instruction, are not *as such* conventional patterns. The shape of a conventional act or pattern is not dictated by function alone. A reproduced act or pattern that has a function is conventional only if it might have differed or been replaced by differently shaped acts or patterns which, assuming similar proliferation in the culture, would then have served the same function. This does not give us a sharp boundary for the conventional. A borderline case might be, for example, certain "conventional" techniques handed down in different schools of violin playing. These techniques are not totally interchangeable. They have subtly different musical effects. But the conventions of each school taken in toto accomplish pretty much the same.

A conventional act token is such in part because it has been reproduced. That is, some aspect of its shape or pattern or place in a pattern has been reproduced. It is conventional then under a description

or label—one that designates this shape, pattern, or place. Tokens of wearing black to a funeral may be conventional under that description, as may tokens of shaking hands with the right hand. But "wearing black to a funeral" and "shaking hands with the right hand" are not names of act *types* that are, *as such*, conventional. Tokens falling under these types are not conventional *per se*, but only when done *as* following convention, that is, when reproduced rather than accidentally instantiated. Thus, *It is conventional to wear black to a funeral* and *Susan wore black to a funeral*, when conjoined, do not necessarily imply *Susan performed a conventional act*. Similarly, there is nothing to prevent the same shape from being used in more than one convention. Raising one's hand is conventional in order to vote. It is also conventional in order to request to speak. Which if either of these conventions is instanced when a particular hand is raised depends upon which if any previous instances of hand raisings are the causes and models for this one, instances used for voting, or instances used for requesting to speak.

Some conventional patterns (that means, being very careful, some patterns that get conventionally reproduced or tokened) are very complex. The conventional pattern that is reconstructed when a group of children plays *ring a ring a roses* is rather complex. More complex are the conventional patterns that are reproduced when parliamentary procedure is followed during a meeting, or when one plays chess with a conventional board and pieces. These patterns are not only complex but "relational." It is not absolute shapes (forms) that are reproduced but relationships between shapes. Such patterns are most easily described by giving rules for their construction, often rules involving conditionals. These are rules that have to be followed insofar (and only insofar) as one's purpose is to follow the particular convention. Many of the patterns of activity that define within a given society the institutions of marriage, property holding and transfer, use and transfer of conventional powers, and so forth are complex, relational conventional patterns. Some may also be written into law or other sanctioned regulations. Others are *only* written into law or other regulations. They are never or almost never merely reproduced from previous examples of the same pattern. Then they are not conventional in the sense I am now discussing (but see §VI below).

Conventional patterns are often reinforced with sanctions of one kind or another. This has no bearing on their conventionality. Some cultures frown on every failure to conform to convention. But it is neither the threat of these frowns nor the degree of conformity to a convention that makes it into a convention. A substantial literature to the contrary, conventions are not, *as such*, either things that everybody in some group follows, or things that everybody in some group thinks

you are supposed to follow. Think, for example, of wearing white for tennis, which in many circles is conventional even though nobody cares whether you do or you don't. And think about moves in chess. After any given move in chess one could always quit and start playing dolls with the pieces. If that is not allowed, it is rules of etiquette or tournament rules, not chess rules, that prohibit it. The rules of chess don't tell you that you can't quit, but only what would constitute going on.

Nor should we suppose that conventions are instantiated only by people knowingly following them. Witness the conventions for correct social distance when conversing. These distances vary from culture to culture, and are unconsciously reproduced by being learned as a skill. If you are at the wrong social distance, the one to whom you are speaking will move, so that to avoid slow circling about as you talk, you learn to stay at the conventional distance. Similarly, a person, even everyone, might unconsciously learn to conform to the convention of driving on a given side of the road solely as a skill—as a means of avoiding oncoming traffic.

One particularly interesting kind of conventional act token deserves a name of its own. This kind is an optional piece of a conventional pattern, the shape of which piece puts constraints on the shape of ensuing pieces. That is, if the conventional pattern is to continue to unfold, the rest must be conformed to this piece, so as to bear the right relation to it. Thus a move on a conventional chess board and a conventional Protestant marriage ceremony each constrain what can follow while according with relevant conventions. Such acts are interesting because convention does not say when to perform them, yet they effect changes in the situation that must subsequently be taken into account if events are to unfold under the covering convention. They are "free" acts under the convention that have predictable effects or that put constraints on effects under the convention. Thus they put constraints on *actual* effects insofar as the convention is actually followed. We can call such act tokens "conventional *move* tokens" and speak of them as having "conventional outcomes."

Contrary to the flavor of recent discussions, probably we should explicitly note that the situation with conventional moves is *not* this: that having instanced a certain shape under certain (difficult-to-pin-down) conditions automatically "counts as" x-ing, irrevocably, inexorably, no matter how much you kick and scream. *Simply as such*, making a conventional move is merely putting in place a piece of a reproduced pattern which others (or oneself) may or may not then be motivated to complete. The pattern allows or requires a decision to be made at the location of the conventional move. In most cases participants will not be interested in following through to the conventional outcome of an

apparent move if they think it was not made intentionally. But, especially in cases where abiding by the convention happens to have sanctions attached, and especially where there might be reason for a person sometimes to be dishonest about whether a move was intended, then, as Strawson put it, "the play is strict" and either the convention or some law or regulation may override the need for a consonant intention behind a conventional shape introduced at a decision location. In such circumstances one may also expect that the law or regulation is quite strict about the exact shapes to be used for the moves. Sloppy reproductions will not be allowed.

Some labels group natural acts together by "shape" (e.g., "wearing black," "wearing black to a funeral"). Others group conventional acts together by conventional role ("wearing traditional attire," "wearing funeral attire to a funeral"). Different shapes occurring in different conventions, in different traditions, are discerned as holding corresponding places in their respective patterns, hence they are classed together. "Getting married," "giving a (conventional) greeting," and "observing table manners" are such labels.[3] Each of these role-described conventional acts or patterns can take any of numerous "shapes." There is a certain ambiguity in some of these abstract labels. For example, does one who wears black to a funeral without knowing of the convention "wear funeral attire"? We might say, it depends on whether you read that opaquely or transparently. I will say that a role-described act that is done *following* convention is "role-constituted." Thus role-constituted acts are acts that could not be performed were there not covering conventions.

To perform a natural act, x, in a conventional manner involves performing a role-constituted act under the description "doing x conventionally." For example, dressing in a conventional manner is a role-constituted act which takes different shapes in different cultures. More important for our purposes, a "conventional move" (read opaquely) is a role-constituted act classed under a description of the move's conventional outcome. For example, making a bid, getting married, and performing a naming ceremony are each, as such, role-constituted moves. Notice that they are indeed classed according to their conventional outcomes.

Apparently Austin thought that names for K-I acts such as "warning," "entreaty," "order," "objection," and so forth, designate conventional moves, that is, acts classified by conventional outcome. Strawson suggested that these labels classify primarily by speaker intention. My suggestion will be that they classify by purpose. Classification by intention or purpose are *other* ways to classify acts more abstractly than by "shape." For example, quite differently shaped activities constitute

"hunting mice" as a hawk does it, as a cat does it, and as I once did it thumbing through the yellow pages in preparation for a mouse-loving daughter's Christmas. But I am getting ahead of my story.

IV. Speaking as Making Conventional Moves

It is not, of course, a matter of convention that a speaker has communicated his intention. Nor is it, in general, a matter of following convention that a hearer should respond as a speaker intends her to. But a hearer does follow convention when she does what a speaker explicitly *says* to do, or believes what a speaker explicitly *says* is true. In each such case the hearer completes the reproduction of a conventional pattern of movement from speaker words into hearer reactions. Correlatively, in each of these cases the speaker makes a conventional *move* having a conventional outcome. He lays down the beginning of a conventional pattern in a way that constrains what can follow *in accord with the convention*. To see that this is so it is important to keep in mind (1) that to follow a convention is not mandatory *as such*, hence that no sanctions need constrain the hearer to respond in a conventional way and (2) that following conventions is not always following conscious rules. The speaker's production of the expression and the hearer's cooperative response to it constitute a reproduced pattern whose form is arbitrary relative to its function. That is all that is needed for convention. Contrast the conventional syntactic and tonal patterns that embody tellings to and tellings that with conventional exclamations ("Hurrah!" "Ouch!") which are merely conventional *means of expression*, calling conventionally for no particular determinate response from the hearer.

In the case of conventional directive uses of language, the pattern that is conventionally reproduced begins with an intention or desire of S's that H should act in a certain way. It is completed when H has acted that way as a result of guidance, in accord with conventional rules for guidance, from conventional signs made by S. That the pattern is not completed until H has acted as directed is clear, for new instances of the pattern would not be initiated by Ss were it not that Hs sometimes complete such patterns. The first part of the pattern is conventional, is reproduced, only because both parts are sometimes reproduced. Thus when you ask or tell me to do something in a conventional way, using some appropriate shape from some public language to do so, it is *conventional* for me to comply: this outcome is the completion of a conventional pattern. The full recipe for the convention tells what H has to do upon hearing such and such words.

Similarly, when S tells H that something is the case in a conventional

way, it is conventional for H to believe it. That the pattern is not completed until H has been guided into belief in accordance with the conventional rules is clear because new instances of the pattern would not continue to be initiated by Ss were it not that Hs sometimes believe what they are told. Had earlier Hs responded in accordance with different patterns of interpretation and belief this would have affected the behavior of Ss with the result that H too would have learned to exhibit different patterns. These patterns of belief formation do not result from voluntarily following a rule, any more than standing at the right social distance is a result of voluntarily following a rule. Whether or not I believe what I hear is not under voluntary control. But it results from a process of reproduction which in turn has resulted from learning. I believe as I do in part because others who speak the same language have followed similar patterns in moving from what they hear to what they believe. I come to believe what I hear as conforming to a convention.[4]

Suppose that Strawson is right that for S to convey certain intentions as to H's response can be a way (if not, I shall soon argue, the only way) of performing a K-I act. It will then naturally come about that use of an explicit K-I performative has the accomplishment of the designated K-I act as a conventional outcome. How? S's explicitly saying that S is performing a certain K-I act has as its conventional outcome that H believe S is performing it. Suppose now—the worst case—that my (forthcoming) claim proves correct that K-I acts can also be performed by the tokening of conventional moves with corresponding purposes, these corresponding to their conventional outcomes. In the absence of a *conventional* device for performing the designated K-I act, having made the conventional response of believing that S is indeed performing this act, H must conclude that S's *intention* accords with the act. Insofar as Hs are sometimes obliging, then, a repeated pattern will emerge which begins with speaker intentions about hearer responses, moves through the use of explicit K-I performatives, and ends with hearers fulfilling these speaker intentions. Any such repeated pattern will soon be not just repeated, each speaker and hearer pair inventing it anew, but *reproduced.* Speakers will imitate, intentionally initiating the full pattern *as such,* and hearers will imitate, following through directly with the new pattern of response. Like a dead metaphor, this use of explicit performative expressions will soon have become fully conventionalized.

Speaking consists in large part of making conventional moves. Hence, just as certain forms intentionally having been gone through entails that you are married, or have been christened, or that the meeting is adjourned, so it seems reasonable that certain verbal forms intentionally having been gone through might entail that you have been informed, or told that, or told to, or asked whether, and so forth. Yet this only

exacerbates the difficulty concerning the univocity of K-I categories (§II). How does the fact that a certain conventional move has been made get in the same category as the fact that a speaker has a certain intention? I will now try to resolve this tension.

V. K-I Acts Are Defined by Their Cooperative Proper Functions

Concerning those cases of informing, warning, and so forth that are performed despite the speaker's overt indifference about the hearer's response, Strawson suggests, "in some cases, [the speaker] may be seen as the mouthpiece, merely, of another agency to which may be attributed at least general intentions of the kind that can scarcely be attributed, in the particular case, to him" (p. 614). That is, I take it, there are analogical uses of "informs," "instructs," "advises," and so forth. Similarly, we say that dogs and cats "ask to go out," that the difference between dogs and cats is that "dogs request things while cats demand them," there are interesting studies ostensibly about animals' "greetings to conspecifics," and so forth. Assuming that animals do not indulge in embedded Gricean intentions, on Strawson's account of K-I acts these descriptions must also be analogical. I will now argue for an account perhaps simpler than Strawson's, on which all of these descriptions are literal. K-I acts are grouped under their appropriate labels by, in a suitably broad sense, their *purposes*—more precisely, their "cooperative proper functions."

I can offer here only the quickest review, without any defense, of the notion "proper function—just enough to give the flavor.[5] Items have proper functions as belonging to families of items reproduced one from another, where the continued reproducing depends or has depended on some function these items serve. The biological functions of body organs and the functions of mechanisms that produce tropistic behaviors are prime examples of proper functions. The functions of behaviors learned by trial and error are also examples, as are the functions of customs and of words and syntactic forms. An item also has a proper function if it is the product of a prior device designed to vary or adapt its productions depending on circumstance so as to perform certain functions in those circumstances. These adapted productions then have "derived proper functions." Using a worn example, the mechanisms in worker honey bees that produce bee dances are supposed to vary their dance-producing activities depending upon where nectar is located so that the dances can guide fellow bees to it. The different dances that result have different derived proper functions: each is supposed to send watching bees off in a different direction. I have argued that behaviors produced in a normal

way by the behavior-producing mechanisms in humans and other higher animals also have derived proper functions, though derived in a far more complex way, and that these functions coincide with what we would usually identify as the purposes of these behaviors or of the individuals exhibiting them. Human intentions, understood as goal representations harbored within, have as derived proper functions to help effect their own fulfillments.[6] And human artifacts have as proper functions the purposes for which they were designed.

Now consider the syntactic forms that embody indicative, imperative, and interrogative moods in the various natural languages.[7] These are reproduced from one speaker to another; children copy them from adults. These forms continue to be differentially reproduced *because they are serving differentiated functions*. And they serve differentiated functions because hearers respond to them differentially. What stabilizes these functions?

The evolutionary mechanism at work here is parallel to that which tailors the species-specific song of a bird and the built-in response of its conspecifics to fit one another, or tailors the nipple of the mother and the mouth of her infant to fit one another, but with learning standing in for natural selection. Speakers (collectively) learn how to speak and hearers learn how to respond in ways that serve purposes for both, each leaning on the settled dispositions of the other. This kind of co-tailoring requires there to be functions served at least *some of the time* by cooperation *some of the time* between the paired cooperating devices—(just) enough of the time to keep them tuned to one another. So there must be purposes that are sometimes served for hearers as well as speakers, served at least often enough, by hearers' responding in the right way to speakers' utterances of the various language forms. For example, often enough there are rewards to motivate hearers who satisfy imperatives. Indeed, simply pleasing the speaker is usually enough reward. And speakers often enough speak the truth, so that there are often rewards for hearers who believe indicatives. A proper function of the imperative mood is to induce the action designated, and a proper function of the indicative mood is to induce belief in the proposition expressed.[8]

Similarly, a proper function of the *explicit* K-I performatives, taken not just type by type but as embodying a certain common reproduced *form* of expression ("I [performative verb] you (that)(to) . . ."), is to produce their associated hearer responses. In the case both of the grammatical moods and of the explicit K-I performatives, the conventional outcome of the speech act employing the expression accords with a proper function of the expression. (Caution: I do not mean to extrapolate from these examples that every conventional move has a proper function. Many conventional patterns or parts of patterns may be

imitated blindly, not due to any particular function they are performing. Functional convention blurs into mere habit and the pointlessly convention-bound on one side and into pageantry on the other.)

Thus it is that the dog asking to go out at the door, the person gesturing in a nonconventional manner for you to open the door, the person who says "Open the door," and the person who says "I demand that you open the door" are behaving, *as such*, in ways that have a "purpose in common" in a univocal, not merely an analogical, sense. These behaviors have a proper function in common: to get you to open the door. In each of these cases the proper function of the act is, more specifically, a "cooperative proper function." If fulfilled in the normal way[9] it will be fulfilled via a cooperating response—one having as one of its proper functions the completion of the initiating act's proper function *as such*. Note the close analogy here to the reciprocal structure of Gricean intentions.

The proposal I offer then is that K-I acts are defined by their cooperative proper functions. Because the various grammatical moods have cooperative proper functions, their use *in and of itself* is enough to constitute a broad kind of speech act—at least, say, a telling that or a telling to or an asking whether. More specific K-I speech acts are then differentiated according to additional or more fine grained *speaker* (rather than expression) purposes—more exact mechanisms by which the speaker intends or expects to procure the intended response—just as Strawson said.[10] Or, in the case of the explicit performatives, they are differentiated by naming themselves. Thus they become "self verifying." *Qua* instances of the original informative conventional pattern from which they were derived (§IV above) and which they also exemplify (they still are ultimately reproductions of it) their more recent conventional purposes automatically accord with what they *say* is the purpose of the saying.

A perhaps surprising result of this analysis is that the person who says "Open the door" may be acting in a way that has *conflicting* purposes or proper functions. Suppose that she is joking or acting in a skit, or that she misunderstands the public-language function of the words she uses, or that she wants only that you trigger a booby trap placed over the door. If she doesn't actually intend you to open the door, then her saying "Open the door" has two opposing proper functions at once. The first is derived from the history of the language forms she reproduces (the imperative mood and, independently, the words she arranges into this mood). This is the proper function of the *expression* she uses. The second is derived from the speaker's intention in speaking, which in turn is derived from the functions of the cognitive-conative mechanisms in the speaker that produced the intention. (In the sorts of cases that account

for the survival and proliferation of the English imperative mood, of course, these two kinds of purposes do not conflict.)

In the case of insincere uses (the booby trap case) the proper function derived from the speaker's intention is not a *cooperative* proper function, so it does not affect the question what sort of K-I act is being performed. But there are also cases where the speech act does have conflicting *cooperative* functions. For example, is jokingly asking you to leave *really* asking you to leave? Perhaps it is really asking you to leave but not seriously—as I might really slap you in the face in a skit but not seriously. Is unintentionally asking you to leave (suppose I don't understand the words I use) *really* asking you to leave? Or consider these cases: the armed robber smiles and says "I *entreat* you to hand over your money"; Anytus threatens Socrates, "I *advise* you to be careful"; the mountain climber boasts, "I *admit* that it was terribly hard going there toward the last"; Mom orders "I am *asking* you for the last time whether you are going to take out the garbage!". The cooperative proper functions of these expressions do not match the cooperative intentions of the speakers. Has the designated act been performed? I think you can say what you like, so long as you don't mislead in the context. Certainly these are not paradigm cases of asking, entreaty, and so forth.[11]

VI. K-II Acts

Not all conventional moves made in speaking are conventional moves in the sense I defined. Some are moves in patterns that are not reproduced from prior instances but dictated by law or other explicit regulation. The pattern of moves required to make a foreign born person into a U.S. citizen, including the necessary taking of oaths, is an example of such a pattern. Also, many acts are of intermediate status. The patterns in which they are embedded are mainly copied, but they or portions of them are also written into codes or laws. Marriage ceremonies, including the act of signing certain documents, are an example of this. There is no sharp line, then, between moves that are conventional in the sense I earlier defined, and moves that are conventional because they fall under explicit regulation. In speaking of moves at or close to the explicitly regulated end of the spectrum I will speak of "regulated conventions," of "regulated moves," and of "regulated outcomes." The regulated outcome of a move may also have a "proper function," in a sense that falls quite strictly under the definition given in (Millikan 1984). This will be derived from the intentions of the person or group responsible for defining the move and its outcome—those responsible for initiating the regulations. Thus, "in some cases, [the speaker] may be seen as the

mouthpiece, merely, of another agency . . ." (Strawson, p. 614). (Once again, however, we should not hastily conclude that behind the conventional outcome of every regulated move there *necessarily* lies a clear purpose.)

Conventional and regulated moves are classed, as such, by their conventional outcomes. K-I illocutionary verbs classify by purposes that accord with the conventional outcomes of the moves made when these expressions are used performatively. At the opposite end of a continuum are performative verbs and other descriptions which apparently classify by conventional outcome alone. These appear to designate conventional moves as such: Strawson's K-II illocutionary acts. These are moves whose outcomes, for a number of good reasons, could not reasonably be intended by speakers in the absence of conventions to determine them. Also, these outcomes may routinely fail to be strongly intended by speakers.

First, paradigm K-II acts (think of marrying a couple or formally granting someone a degree) have outcomes that involve the coordination of many persons, many or some of whom may not be present, in behaviors forming a complex interwoven pattern, difficult even to specify, let alone amenable to being communicated by improvisation. I can improvise with a gesture a request that you open the door, but not that you turn the oven to 350 degrees Fahrenheit at 5 P.M., scrub six medium-sized potatoes, grease them, and put them on the top rack inside—nor that you should behave as one who is married and get treated by the law and by others that way.

Second, all or many of the outcome behaviors of K-II acts may be heavily sanctioned but only *as* falling under the convention, so that a speaker expects follow-through accordingly. Because one cannot seriously intend what one has no hope of achieving, no reasonable person could intend such an outcome apart from the organizing force of convention.

It is generally true too that the shape of a K-II move includes not just some words spoken but also the position of the speaker and the context of the speaking. You can't make the conventional move of bidding two no trump if it's not bridge or if it's not your turn to play, nor adjourn the meeting if you are not in a meeting or not chair of it. Such requirements were labeled "felicity conditions" by Austin, but lacking them is in fact lacking part of the move's very shape. What is reproduced or regulated as part of a pattern is not words but words-in-a-context. In these cases, if motivation for following through to the traditional or regulated outcome is observance of the convention (perhaps under sanctions), of course the speaker cannot hope to effect this outcome out of context merely by conveying his intentions to effect it. Thus it is that the K-II act can be

performed only conventionally. (On the other hand, it may be considered, on occasion, that the very shape of a move is, just, the conveying of the right intentions by the right person at the right time. For example, at the right time in an informal bridge game one can pass with an understandable gesture, and I once witnessed a marriage ceremony performed by a severely handicapped minister who administered the vows and blessings without words. But in both cases, the conventional setting is/was essential.)

Lastly, a K-II act speaker is likely merely to expect, rather than strongly to intend, much of the conventional outcome of his K-II act—as a chess player expects, rather than strongly intending, that his opponent's future moves will be constrained by his own move in accordance with the rules. Indeed, the K-I speaker may have no personal interest whatever in the outcome of his move, which he performs in line, primarily, with custom or duty. The minister may merely be doing what he is asked to do in performing the marriage ceremony; the provost is obliged formally to grant the degrees that the trustees have formally approved.

But there are also many speech acts that fall between Strawson's K-I and K-II extremes. The chair says "the meeting is adjourned." His intention is to cause the members of the meeting to stop introducing motions and debating them. If nobody pays any attention, debate goes on, and three more motions are passed, his intentions will surely be frustrated. Equally clearly, his act is intended to "further a certain [conventional] practice." It is intended to play the conventional role of adjourning a meeting under sanctions of law or custom. And there is a sense in which the chair's *saying* that the meeting is adjourned "cannot fail to do so" (Strawson, p. 612). No matter what the members go on to do, "when the play is strict" there is a sense in which "the meeting has been adjourned" once the chair has spoken—just as after the minister pronounces a pair man and wife they are married, even if they don't act married, and even if everyone else, including those responsible for upholding the law, refuses to treat them as married. Similarly too, after Mom says "take out the garbage," Johnny is *under instructions to take out the garbage*, whether or not he does so. But Mom surely intends him to take it out too. There is a wide strip of middle ground then between paradigm K-I and paradigm K-II illocutionary acts.

RUTH GARRETT MILLIKAN

UNIVERSITY OF CONNECTICUT
UNIVERSITY OF MICHIGAN
FEBRUARY 1994

NOTES

1. For a good discussion of this issue, see also Recanati 1987.

2. For a more formal discussion of "reproduction" as that term is meant here, see Millikan 1984, chapter 1.

3. Something like castling in chess is a little different. For although pieces of any shape can be used for chess, indeed, chess can be played even without a board (for example, games can be played by post card), games of chess all fall in the *same* tradition. The game of chess is an extremely abstract pattern, not a concrete one—one that is sometimes reproduced in highly imaginative ways. (Wilfrid Sellars once suggested using Cadillacs and Volkswagens, etc., and moving them from one Texas county to another.)

4. Note the disagreement with Strawson here, who holds that "the wholly overt intention which lies at the core of . . . [K-I acts]. . . may, *without any breach of rules or conventions*, be frustrated" (p. 613, italics Strawson's).

5. The notion "proper function" is defined in Millikan 1984, chapters 1 and 2. It is further explicated and applied in Millikan 1993, for example, chapters 1, 2, and 11, and in Millikan 1994.

6. See, especially, Millikan 1984, chapter 6, and Millikan 1993, chapter 8, section 6.

7. For more details, see Millikan 1984, Introduction and chapters 1–4.

8. See Millikan 1984, chapter 3. It is important that these proper functions are not derived by averaging over speaker intentions.

9. If fulfilled, that is, in accordance with a "Normal explanation." See Millikan 1984, chapters 1 and 2.

10. Sperber and Wilson have questioned whether, as a general rule, speech acts "have to be communicated and identified as such in order to be performed" (1986, 244). They suggest that, for example, predicting, asserting, hypothesizing, suggesting, claiming, denying, entreating, demanding, warning and threatening do not (245). If this is right, then some of the differentia defining K-I acts that fall under the basic categories of tellings to, tellings that, and askings whether may not correspond to purposes of these acts, or they may correspond to purposes that need not be cooperative. For example, perhaps I can successfully warn you by making you alert to a danger without your grasping that as being the point of my remarks.

11. On the other hand, there would seem also to be clear cases in which the cooperative proper function of an expression is *overridden* by a speaker intention which turns it not to a conflicting use but to a cooperative *derivative* or *parasitical* use. For example, saying sarcastically that it is thrilling is not at all telling you that it is thrilling. Perhaps this results because sarcasm itself is a conventional device, riding on and at the same time overriding the normal proper function of its vehicle.

BIBLIOGRAPHY

Bach, K. and R. M. Harnish. 1979. *Linguistic Communication and Speech Acts*. Cambridge, Mass.: MIT Press.

Grice, H.P. 1967. "Meaning." *Philosophical Review* 66 (3):377–88. Reprinted in Rosenberg and Travis, 1971, pp. 436–43.

Millikan, R. G. 1984. *Language, Thought, and Other Biological Categories.* Cambridge, Mass.: Bradford Books, MIT Press.

————. 1993. *White Queen Psychology and Other Essays for Alice.* Cambridge, Mass.: Bradford Books, MIT Press.

————. 1994. "A Bet with Peacocke." In *Philosophy of Psychology: Debates on Psychological Explanation,* C. Macdonald and G. Macdonald, eds. Oxford: Oxford University Press.

————. 1998. "Language Conventions Made Simple." *Journal of Philosophy* 95, no. 4 (April): 1–20.

Recanati, F. 1987. *Meaning and Force: The Pragmatics of Performative Utterances.* Cambridge, UK: Cambridge University Press.

Rosenberg, J., and C. Travis, eds. 1971. *Readings in the Philosophy of Language.* Englewood Cliffs, N.J.: Prentice-Hall.

Schiffer, S. 1972. *Meaning.* Oxford: Clarendon.

Searle, J. 1969. *Speech Acts: An Essay in the Philosophy of Language.* Cambridge: Cambridge University Press.

————. 1989. "How Performatives Work." *Linguistics and Philosophy* 12:535–58.

Sperber, D., and D. Wilson. 1986. *Relevance: Communication and Cognition.* Cambridge, Mass.: Harvard University Press.

Strawson, P. F. 1964. "Intention and Convention in Speech Acts." *Philosophical Review* 73 (4):439–60. Reprinted in Rosenberg and Travis, 1971, pp. 599–614.

Warnock, G. J. 1973. "Some Types of Performative Utterance." In *Essays on J. L. Austin,* G. J. Warnock, ed. Oxford: Clarendon, pp. 69–89.

REPLY TO RUTH MILLIKAN

The topic of Professor Millikan's paper is my discussion, in "Intention and Convention in Speech Acts," of the notion of an illocutionary act, introduced by J. L. Austin in his lectures *How To Do Things with Words*. Austin declared unequivocally that every illocutionary act is a conventional act, an act done as conforming to a convention. I disputed this, drawing a sharp distinction between two kinds of illocutionary acts. On the one hand, there are acts of which the purpose is to further a conventional or rule-regulated procedure by the use of a conventionally prescribed form of words (examples from the law, games, etc.). These are Professor Millikan's K-II acts and are indeed essentially conventional. On the other hand, there are very many acts, such as warning, entreating, raising an objection in a discussion (Millikan's K-I acts), in which it is not as conforming to a convention of any kind that the particular illocutionary act in question is performed.

A qualification to this last remark about my view of K-I-type acts is called for. For I remarked that, and explained why, such an act can always be performed by the use of the explicit performative formula (e.g., 'I warn you that . . .', 'I entreat you to . . .'etc.) and is thus linguistically conventionalized right up to the point at which illocutionary force is 'exhausted' by conventional linguistic meaning. Whether I intended at the time to say that the use of any such formula constituted the illocutionary act itself a wholly and essentially conventional act or merely to say that in such a case a linguistically conventional means of *performing* the act was employed, is a point that was initially unclear to Professor Millikan and perhaps also, at the time, to myself. So much she has remarked to me in correspondence. More of this below, where I resolve the uncertainty.

Professor Millikan casts doubt on the sharpness of the distinction which I drew. She argues, as she puts it, "for a strong continuum, with many cases falling in the centre." She convinces me that I should indeed

modify my original position, if not quite in the way she describes. Thus she says, surely correctly, that a speaker's use of the indicative, imperative, and interrogative forms is a conventional means of performing the *very* broadly conceived illocutionary acts of, respectively, 'saying that . . .', 'telling to . . .' and 'asking whether . . .'; and that the conventions in question would never have become established as such if it were not for the fact that the hearer's response of, respectively, belief, compliance, or (relevant) answer is sufficiently regularly forthcoming. She says, further, that the hearer, in so responding, completes the reproduction of a conventional pattern of movement from speaker words to hearer reaction; and, indeed, that the hearer follows convention in so responding.

Now, at this point, I think it is necessary to turn back to Austin's original introduction of the notion of an illocutionary act and, in particular, to the sharp distinction he draws between the illocutionary and perlocutionary acts. (It might indeed be better to speak of these not as distinct acts, but rather as distinct aspects or features of a single act. But I shall ignore this refinement and continue to follow Austin's terminology here.) Austin holds that the illocutionary act is brought off, successfully performed if and only if audience-*uptake* is secured; i.e., the sole condition of the successful performance of the illocutionary act is that the hearer should *recognize* the illocutionary force of the utterance, i.e., should recognize how the utterance was meant or intended to be *taken*. Now any normal audience (i.e., an audience which understands the speaker's language) cannot fail to appreciate the force of the indicative and imperative moods as conventional means of respectively saying (asserting) that . . . or telling to . . . and therefore cannot fail to recognize the minimal illocutionary force of utterances framed in these moods. Hence it is reasonable to say that the minimal illocutionary acts of saying (asserting) that . . . and telling to . . . are fully conventional acts. For no more is required for their successful performance than a grasp of the relevant linguistic conventions, conventional meanings, of a language common to speaker and audience. And it can equally plausibly be held that the same goes for those more than minimal illocutionary acts which are performed by the use of the explicit performative form. If I say 'I apologize', 'I warn you that . . .', 'I promise', 'I advise you to . . .', then I am understood by any hearer with a grasp of the language as having given him an apology, a warning, a promise, advice—whatever his response may be. So, in these cases too, the illocutionary act can properly be described as a fully conventional act, an act done in accordance with a convention. For, remember, the only condition of the successful performance of the illocutionary act is the securing

of audience-uptake. Thus I resolve the previously mentioned uncertainty.

In Austin's view the case is quite different with the perlocutionary act; and in my own view the case is also quite different with those illocutionary acts of which the force is not made explicit by linguistic convention, e.g., by the use of the explicit performative. On the first issue, that of perlocutions, I am in substantial, if mildly qualified, agreement with Austin. On the second, I am totally at variance with him. The issues are quite separate and I will treat them separately.

In Austin's view the question of what perlocutionary act I performed in speaking is just a matter of what *effect* is thereby brought about, of what the *outcome* was, of how the hearer in fact *reacted* to my utterance; and this, he says, is not a matter of convention at all. There is certainly truth in this. If I say something with the illocutionary force of a warning, intending it to be taken as a caution against running a certain risk, you may, even while understanding it as such, act in precisely the way you are cautioned against, viewing the fact as an incentive to display your courage or as something that adds a spice of excitement to the undertaking; and this you may do even if I use the explicit performative formula, thus performing the illocutionary act in a fully conventional form. You may, on the other hand, 'heed' the warning, as we say, and refrain from so acting. In either case it is entirely up to you. There seems to be no element of convention in either perlocutionary outcome. It may be argued that the same is true of responses to ordinary utterances in the conventional indicative or imperative forms; that whether the outcome is belief or disbelief, compliance or noncompliance, is not a matter of convention at all.

But here one may feel some sympathy with Professor Millikan. She points out that these forms would not have acquired the *conventional* force or character they have unless they sufficiently regularly fulfilled the *function* of securing, respectively, belief and compliance. The conventions in question, of using these forms, have, as she puts it, a 'cooperative' proper function; and she concludes that when the responses of belief or compliance are forthcoming, the audience is indeed 'conforming to a convention'. She would perhaps, though I am not sure of this, take a similar view of perlocutionary outcomes, i.e., audience responses, in some of the cases in which a more than minimal illocutionary act is performed by the use of the conventional form for performing it, i.e., the explicit performative formula such as 'I warn you . . .', 'I promise', 'I advise you to . . .', 'I apologize'. That is, she would perhaps say that those who, respectively, avoid the mentioned hazard, form a confident expectation of the fulfillment of the promise, follow the advice or accept

the apology, are acting in conformity with a convention. For here again the words in their conventional first-person use have a function which it is difficult to believe they could acquire and retain without at least fairly often eliciting the appropriate response; so when they do, it may not seem wholly inappropriate to describe the response also as conventional. But the case does not seem to me clear. In some cases it is clear enough: it is a matter of social convention to accept an explicit apology, as it is to comply with a polite request; it is a matter of military discipline to obey an explicit order. But it does not seem to me that a hearer's response to a wholly explicit warning ('I warn you that . . .'), understood as such by the hearer, whether the response takes the form of risk-avoiding or of risk-running behavior, can be naturally or happily described as a matter of either following or breaching a convention. Again, when I hear and understand as such a statement couched in the indicative form, it does not seem to me that I breach any convention in withholding belief or that I follow convention in believing what is said—even though I accept Professor Millikan's point that the form would not have acquired and retained its conventional force had its use not often enough resulted in audience belief. So though I have qualified my agreement with Austin's view concerning perlocutionary effects, my qualification is itself highly qualified. Some sympathy with Professor Millikan's view on the matter falls far short of wholehearted agreement.

Now, finally, to the matter of those illocutionary acts of which the force is *not* made *explicit* by any convention such as the use of the explicit performative form. Austin maintains that these also are conventional acts, acts done as conforming to a convention. (Indeed he holds this to be true of *all* illocutionary acts without exception.) On this point I am, as I said above, in total disagreement with Austin; and I suspect that Professor Millikan's view is here not far from my own. It is conceded that the use of the indicative form, when understood, makes it a matter of convention that the minimal illocutionary act of saying that . . . , or asserting, has been performed. But where is the additional convention that, in the absence of, e.g., an explicit performative formula, endows the act with the additional illocutionary character of a warning, or of an objection in discussion, when it is both meant and understood as such? Three factors combine to confer on the act of utterance the illocutionary character of a warning, or of an objection: they are (1) the surrounding situation (in the case of an objection, the context of discussion); (2) the speaker's intention (whence Austin's point that illocutionary force *could* always be made explicit by the use of the performative formula); and (3) the possession by the audience of sufficient intelligence to appreciate (1) and (2) and thus to bring about the securing of uptake. But none of these

is, or could be, a matter of convention, any more than the effect of the utterance on the hearer (the perlocutionary outcome) is. And here I rest my case against Austin's extravagant contention that every illocutionary act is a conventional act; and I do not think that Professor Millikan disagrees with me on this.

In this reply I have concentrated on what seem to me the major issues raised by Professor Millikan's paper. This means that I have neglected some of the refined and subtle points she has made and examples she has given which do indeed point to the existence, though not, I think, to any great extent, of a grey central area. It may appear to some readers that both her and my contributions have a contrived intricacy which is out of place. But we are concerned, as Austin put it, with "the total speech act in the total situation"; and that is not a simple matter.

P.F.S.

2

Susan Haack

BETWEEN THE SCYLLA OF SCIENTISM AND THE CHARYBDIS OF APRIORISM*

"Analytic philosophy has become increasingly dominated by the idea that science, and only science, describes the world as it is in itself," Putnam writes in the Preface to *Renewing Philosophy*; however, he continues, "there are important figures within analytic philosophy who combat this scientism: one has only to mention Peter Strawson"[1]

Sir Peter himself, in an illuminating essay contrasting his style of analytic philosophy with Quine's much more science-oriented approach, modestly refrains from any claims about their respective merits, describing the choice between them as "perhaps a matter of individual temperament."[2] Still, here and, more explicitly, elsewhere,[3] he makes it clear enough that Putnam's observation about him is not far wide of the mark; he is not only by temperament unsympathetic to scientism, but also keenly aware of the difficulties and limitations of a conception of philosophy which is too closely, or inappropriately, science-oriented. Strawson's sympathies lie, rather, with a conception of philosophy as focused primarily on descriptive analysis of "interrelations and independences of . . . pervasive concepts and concept-types" of "the common, as distinct from the scientific, understanding."[4]

As my title suggests, I shall be urging the merits of an intermediate position which repudiates the scientism towards which Quine sometimes steers too closely, while also declining the apriorism to which Strawson seems drawn. I might describe it (stressing the contrast with Quine) as being scientific but not scientistic, or (stressing the contrast with Strawson) as being analytical but not purely a priori, and as looking to commonsense conceptual connections in a potentially critical rather than purely descriptive spirit.

I hasten to add that the intermediate position I shall be articulating has nothing in common with the recently fashionable idea that philosophy is not a form of inquiry at all, that it is more akin to literature than to science, and should be "edifying" or "hermeneutic" rather than systematic, analytical, truth-oriented. This fashionable radicalism is doubtless motivated in part by dissatisfaction with the scientism of some contemporary analytic philosophy; but though I share that dissatisfaction, as Strawson does, I am wholly out of sympathy with this response to it, as Strawson is.[5]

In "Two Conceptions of Philosophy" Strawson writes, with studied neutrality, of Quine's "scientific commitment": a phrase nicely designed to indicate that Quine thinks it appropriate and important to ally philosophy closely with science, while avoiding the need to specify the nature or degree of intimacy Quine intends that alliance to have.[6] Strawson quotes Quine: "Philosophy, or what appeals to me under that head, is continuous with science," and comments, "'continuous with', not 'identical with'."[7] This shrewd comment prompts the thought that, on closer examination, Quine's "scientific commitment" appears to combine several, not altogether harmonious, elements. I begin by distinguishing three of these.

The first is that philosophy is a form of inquiry which differs, not in kind, but only in degree of abstraction and generality, from scientific inquiry; in particular, that philosophical inquiry doesn't seek a peculiarly philosophical kind of truth, and doesn't require a peculiarly philosophical method. Philosophical inquiry is to be conducted in something like the way natural-scientific inquiry is conducted, and is to aspire to something like the same standards of rigor and precision as the natural sciences do. It will be convenient to refer to these ideas, henceforth, by means of the label, "the continuity theme."[8]

The second element in Quine's "scientific commitment" is much more radical. Many times Quine suggests that this or that philosophical question should be turned over to the sciences to resolve: epistemology "falls into place as a chapter of empirical psychology," for example; the part of the problem of induction that makes clear sense is to be tackled by appeal to the theory of evolution; the logic of temporal discourse is to be settled by reference to the theory of relativity.[9] Sometimes he goes further, suggesting that questions which cannot be resolved within the sciences are not genuine questions: the question, for example, of the reality of the external world, or of the epistemic status of science itself.[10] It will be convenient to refer to these, henceforth, as "the scientistic themes;" and to distinguish the former, less radical, from the latter, more

radical, version by means of the labels, "reformist scientism" and "revolutionary scientism."

The difference between the continuity theme and the scientistic themes is, of course, precisely the difference at which Strawson's observation, "'continuous with', not 'identical with'," hints. And, as that observation reveals, the continuity theme is not only different from, but actually incompatible with, the scientistic themes. Philosophy cannot be both continuous with, and at the same time assimilated to, or displaced by, science. How could Quine have failed to notice this? Perhaps because he uses the term "science" ambiguously, sometimes narrowly, referring to the natural sciences specifically, but sometimes broadly, referring to empirical knowledge generally. This ambiguity creates the temptation to run together the continuity theme, that philosophy is part of our empirical knowledge, continuous with the natural sciences, with the reformist scientistic theme, that philosophy is part of the natural sciences. And then the sheer implausibility of the claim that traditional philosophical problems can be handed over to the sciences to resolve (to what branch of science does it fall to tell us why successful prediction is indicative of the truth of a theory? why are inductions involving predicates like "grue" incorrect? etc., etc.) creates the temptation to shift to a revolutionary scientism which denies the legitimacy of problems that the natural sciences can't resolve.[11]

The third element in Quine's "scientific commitment" I shall call "the extensionalist theme." This phrase is intended to allude to Quine's rejection of meanings, of synonymy, of the analytic, his repudiation of modal logic, his refusal to posit properties or propositions or possible worlds, his unease with the subjunctive and the counterfactual, and his reservations about the propositional attitudes.[12]

His extensionalist theme significantly affects how Quine's continuity theme has to be interpreted. His continuity theme involves the denial that philosophy is a peculiar kind of inquiry, seeking a peculiar kind of truth; the extensionalist theme suggests that Quine acknowledges, in effect, only one kind of inquiry, only one kind of truth—the empirical. Quine's continuity theme involves the idea that philosophical inquiry should aspire to the same standards of precision and rigor as scientific inquiry. The extensionalist theme reveals that Quine's conception of those standards is more than austere; on the face of it, at least, it is markedly revisionary. For Quine's standards of rigor and precision—of intelligibility?[13]—seem more demanding than could be justified simply by reference to the sciences as they are actually practiced. That, no doubt, is part of the explanation of Quine's hopes that a strictly behaviorist approach will suffice in the human sciences; and of his hopes

that dispositional, subjunctive, and counterfactual talk can be extension-
ally paraphrased away—or, if it can't, that such locutions can be shown
not, after all, to be needed by science. And that, in turn, is part of the
explanation of Quine's unease about just where to draw the boundaries
of science, and his evident relief when he can focus on physics.[14]

Quine's "scientific commitment," then, is ambivalent, to put it
mildly; conflicted, to put it more bluntly. His extensionalism imposes an
austere, and apparently revisionary, interpretation on the rigor and
precision to which, according to the continuity theme, philosophy
should aspire; his scientistic leanings transmute the continuity theme
into a kind of scientific imperialism in which, at best, philosophical
inquiry is turned over to the sciences, or, at worst, philosophical inquiry
is abandoned altogether in favor of scientific inquiry.

Strawson's discussion of Quine's conception of philosophy focuses on
matters of ontology. He chafes against the restrictiveness of Quine's
approach; in particular, against the restriction that only those entities be
posited which are, as he neatly puts it, "Q-certifiable," i.e., such that
decently extensional criteria of identity can be given for things of that
kind. Strawson prefers a more liberal condition: an admissible entity
must, simply, be identifiable as the thing it is—whether or not there is a
common criterion of identity for all things of that kind; and he does not
require that the conditions of such identification eschew the intensional.
This comports with his preference for allowing not only those entities
required by science, but also those required by other modes of discourse
(he mentions, *inter alia*, art history and literary history), and by our
everyday, commonsense talk of things and persons and—here, he
thinks, Q-certifiability will surely have to be sacrificed—their properties
and mental states.[15]

The conception of philosophy which Strawson favors, like the
Quinean conception with which he contrasts it, is a composite of several
elements. One theme, already noted above, is that philosophy should
concern itself, not exclusively with the concepts and categories of
science, but also with those of other disciplines, and, most centrally, with
"the structure of our common thinking." I shall call this "the theme of
extra-scientific scope." Another is that the central task of philosophy
is analysis of conceptual structures and interconnections—"the
conceptual-analysis theme." A third is that this task is to be conducted in
a spirit that is descriptive rather than critical. Strawson sometimes refers
to this as a form of naturalism, but it will be less confusing (in view of
Quine's different use, or rather, uses, of this term) to call it "the
descriptivist theme."[16]

If my argument has been correct, Quine's continuity theme is
independent of his extensionalism[17]—and incompatible with his scien-

tism. The three Strawsonian themes—extrascientific scope, conceptual analysis, descriptivism—are not in tension, but they are independent of each other. So the possibility is open of divorcing the continuity theme from the other Quinean themes, and divorcing the theme of extrascientific scope from the other Strawsonian themes—and of marrying them in an intermediate conception. That is, in effect, what I propose.

My approach may be summarized in four themes. First: philosophy is obliged to tackle questions which are not reasonably construed as falling within the scope of the sciences (this is much like Strawson's theme of extrascientific scope). However, second: philosophical inquiry is in important ways like scientific inquiry (this is much like Quine's continuity theme). Third: philosophical inquiry is neither purely conceptual nor purely empirical in character, but combines the two. Fourth: the analysis of commonsense concepts and conceptual connections is an important task of philosophy, but should be undertaken in a spirit which is, not purely descriptive, but potentially critical.

I begin with the first, and most Strawsonian, of my themes. Among the questions which legitimately fall to philosophy and which could not reasonably be expected to be answered by the sciences, are *meta*scientific questions, such as whether, and if so why, a theory's making successful predictions is an indication that it is true; which predicates are inductively projectable, and why those are and others are not; whether, and if so why, the sciences have a special epistemic status. Then there are what might be called "bridge questions," such as whether the ontologies of physical theory and of commonsense physical objects, or of neurophysiological theory and of commonsense mental states, are genuinely rivals, and, if so, how one should choose between them. Then there are questions which are empirical in character, but of such scope and generality as to qualify rather as philosophical than as scientific, such as whether perception involves a direct relation to external objects, or is rather a matter of inference from directly-experienced sense-data. And then there are, as Strawson reminds us, metaquestions about historical, literary, etc., theorizing; and questions of aesthetics, ethics, and so forth.

What about the questions to which Strawson gives pride of place, questions about the concepts of "our common understanding," and the interconnections among them? If I have given them a less central position, thus far, than Strawson does, it is in part because I see them as ubiquitous—as cropping up, sooner or later, whenever one tackles any of the various kinds of extrascientific question listed earlier.[18]

Now I turn to the second, and more Quinean, of my themes: that philosophy is continuous with science. Of course, the interpretation I intend to give this is a modest one which steers clear of the scientistic

transmutations to which Quine is disposed. Philosophy is a kind of inquiry, a kind of truth-seeking. It uses the method of science, in the broad, vague sense in which not only scientists, but also historians, detectives, and the rest of us, use "the method of science": that is to say, it involves making conjectures, developing them, testing them, judging the likelihood that they are true. The breadth and vagueness of this characterization is crucial; for there is no "scientific method" in the narrower, sharper sense in which that term has sometimes been understood: no set of rules which can be followed mechanically and which are guaranteed to produce true, or even probably true, results, and no method which is peculiar to the sciences, unavailable to inquirers in other fields.

Philosophical inquiry is also like inquiry in the sciences in aspiring to as much precision and rigor as possible. The guardedness of this observation is crucial too; rigor and precision, though of course desirable, are not always either feasible or overriding considerations. In the early, fumbling-around phases of inquiry, whether scientific, mathematical, or philosophical, analogical or metaphorical or just plain vague articulation is the best one can do—and, in that fumbling-around phase, may be better than a premature precision which might inadvertently cut off paths worth exploring. More importantly, philosophical inquiry is obliged to aspire, not only to rigor and precision, but also to depth and breadth; and, obviously enough, these desiderata are often in tension. This tension is certainly not absent from scientific inquiry; in contemporary psychology, for example, the aspiration to measurable, mathematical rigor often seems to be given too much weight, the aspiration to find deep and significant truths about what makes people tick, too little. But the tension between rigor and precision, on the one hand, and depth and breadth, on the other, could be described without much exaggeration as *the* occupational hazard of philosophy; for the scope of philosophical inquiry is peculiarly resistant to any artificial limitation. James's observation, that no system of philosophy can hope to be accepted unless it satisfies both "the passion for simplification" and "the passion for distinguishing," is apropos.[19]

Precision and rigor are not altogether easy to define. Extensionality is a very considerable virtue in that vein; for the extensional parts of our language, those that translate into a logical notation the semantics of which are well-specified, are those of which we have the best understanding. Once again, though, the interpretation I intend to give this observation is a modest one which steers clear of the dogmatic extensionalism to which Quine is disposed. In striving to rigor and precision, I should say, one properly seeks, where possible, extensional ways of construing thusfar recalcitrant notions; which is, however, not to say that, unless and

until such re-construals are forthcoming, one properly eschews such notions altogether.

I have been, thus far, deliberately evasive about whether I sympathize, as Strawson has recently written that he does, with the thesis of the *autonomy* of philosophy.[20] But now I can begin to explain why my reply would have to be, "yes and no." One reason is that I see philosophy as like science in its goal and, in the sense explained earlier, in its method, but as different from science in its scope. Another is that I allow the possibility that results from the sciences may have a contributory relevance to some philosophical issues (e.g., about the objects of perception), while denying that such results could be sufficient, by themselves, to resolve them.[21]

A further reason arises at the interface of my second theme and my third, which I shall call "the theme of conceptual/empirical intertwining." Here, I steer between Quine and Strawson, seeing philosophical inquiry as combining the empirical and the conceptual; as I think scientific inquiry does, although, no doubt, in different proportions.

I have already hinted at two of the sources of empirical elements in philosophical inquiry. First, where philosophy is focused on metascientific questions, experiential evidence may bear upon it at one further remove, one more level of indirection, from its bearing on scientific theorizing. Second, because philosophical inquiry is sometimes obliged to answer questions which, though of such abstraction and generality as to fall outside the scope of the sciences, are manifestly synthetic in character, it will sometimes require, not carefully controlled and designed scientific observation, but close attention to features of ordinary, everyday experience so ubiquitous that they generally go unnoticed. Interestingly enough, one finds a gesture in the direction of something like this point when Strawson remarks that, unlike more science-oriented philosophers, he is content to live his intellectual life "in the . . . atmosphere of the more mundane—of what, in another tradition, has been called 'expérience vécue'."[22]

There is also a third source, not yet touched upon: an admixture of the empirical within the conceptual structures and interconnections which Strawson sees as the chief focus of philosophical attention. Some concepts exhibit a good deal of internal complexity; and sometimes this internal complexity depends on empirical presuppositions. I adapt Putnam's term, "law-cluster concept,"[23] for concepts which presuppose natural laws holding together the bunch of characteristics which they represent as conjoined. (I think natural-kind concepts are like this.) This is one way, but not the only way, in which empirical presuppositions are built into conceptual structure. Another kind of case is exemplified by our conception of the evidence of the senses, which, as I have argued

elsewhere, has built into it the presupposition that our senses are a source of information about things and events around us.[24] Even the apparently least multidimensional concepts—the ones on which the hoariest examples of analytic truth rely—sometimes unexpectedly reveal hidden empirical depths, as Quinton reminds us when he notes the problem that the possibility of surrogacy has created for the definition of "mother of x."[25] This intertwining of the empirical and the conceptual lies behind the phenomenon of open texture: as our knowledge grows, some of our concepts get more determinate, and others suffer a kind of fragmentation.

In the introduction to *Individuals*, Strawson writes that there is a core of concepts and categories which "has no history."[26] Both there and, more recently, in *Skepticism and Naturalism*, he acknowledges that, while some concepts are, in essentials, common to all times and cultures, and have endured with little change or accretion, others are less stable, have undergone larger changes, more significant growth.[27] The concepts on which *Individuals* focused—of a physical object, of a person—are, doubtless, among the stablest. Nevertheless, even these, I believe, have shifted and grown in meaning over time. That is why I think metaphysical analysis should be, not as purely descriptive as Strawson suggests, but open to the possibility that even the stablest concepts and categories may stand in need of refinement, of stripping of indefensible accretions, and even of correction of implicit empirical presuppositions. This is my fourth theme, the theme, as I shall call it, of "critical commonsensism."

In case it is not obvious, let me point explicitly to the connection between this theme, and my reference, earlier, to what I called "bridge questions," questions about the relation of the concepts and categories of the common understanding to the sometimes apparently competing concepts and categories of science.

To relieve the abstractness of the discussion thus far, it may be appropriate to look a little more closely at a kind of bridge question which has, in different ways, exercised both Strawson and Quine: the question of the relation of commonsense ascriptions of mental states to the categories and concepts of the sciences of cognition.

Of late, some unambiguously scientistic philosophers, claiming that beliefs have no place in the best current science, have repudiated "folk psychology" and denied outright that there are such things as beliefs.[28] Quine has not gone quite so far. But he has long seemed ambivalent, uneasy: to eschew beliefs altogether seems to threaten the viability of history, of the human sciences—and of epistemology; but the prospect for a straightforward reduction to states of the brain is dim, and belief-ascriptions appear to be irremediably intensional.

Strawson is not sympathetic to the aspiration "to purify the theory of knowledge of all intensional notions."[29] Since the celebrated third chapter of *Individuals*, he has stressed that our concept of a person is of a "unitary being irreducibly and essentially . . . characterizable as one which satisfies both psychological, or mentalistic, and material, or physicalistic, predicates." And he is unimpressed by those who, "apparently with pejorative intent," refer to our mentalistic explanations of behavior as "folk psychology"—the kinds of explanations given, as he wryly puts it, "by such simple folk as Shakespeare, Tolstoy, Proust, and Henry James."[30] (And, one might add, by such simple folk, and subtle psychologists, as William James and Alexander Bain.)

The physical and the psychological stories we can tell about a person, Strawson suggests, are "stories told from two different points of view"; puzzlement arises, he continues, when we "attempt a unified story where none is to be had."[31] And of late, it seems, Quine's ambivalence has crystallized into a somewhat similar attitude. In *The Pursuit of Truth* Quine writes unambiguously that he regards the intentional as both irreducible and indispensable, and, though not so unambiguously, that we should not seek a theoretical unification of the physical and the psychological stories, but only, "separately alongside," "alternative coverage."[32]

I am entirely in sympathy with Strawson's briskly dismissive attitude to those who would simply repudiate mental states as unscientific "folk psychology." At the same time, I feel the force of Quine's worries about the physical realization of beliefs, and about the apparently nonextensional character of belief-ascriptions. But—this, naturally, I confess with some trepidation—the point on which, it seems, Quine has of late come to agree with Strawson, that there is no unified story to be had, does not sit altogether easily with me. (The unease is due, in part, to some ambiguity in "unified," a point to which I shall return.)

The concept of belief is, I think, among those concepts which are, in essentials, common to all times and cultures; but it needs articulation, refinement, and accommodation to our best scientific theorizing. My articulation would begin with a distinction of two senses of "belief": to refer to a belief-*state, someone's believing something*, and to refer to a belief-*content, a proposition, what someone believes* (henceforth, for short, "S-belief " versus "C-belief ").

Belief states, S-beliefs, involve what Price called "multi-form dispositions,"[33] i.e., (no doubt extremely complex) interconnected congeries of dispositions to verbal and to nonverbal behavior: to assert, or to assent to, such-and-such sentences and sentence fragments,[34] and to engage in this or that behavior in relation to the things, events, etc., that

those sentences, etc., are about. My S-belief that the ice is thick enough to bear my weight, for example, would involve, *inter alia*, a disposition to assert, or assent to, sentences such as "The ice is thick enough to bear my weight," and a disposition, if I need to get to the other side of the lake, to set out to walk across. Assent is sincere if accompanied by appropriate nonverbal dispositions.[35]

This articulation of what is involved in an S-belief, sketchy as it is, suggests some underpinnings for Reid's comments about skepticism. Though a philosopher may exhibit the kinds of *verbal* behavior characteristic of the S-belief that the evidence of the senses is never to be trusted, no one could long conduct his life in a way that exhibited the kinds of *nonverbal* behavior characteristic of this S-belief. Reid puts it more poignantly: "This indeed has always been the fate of the few that have professed *scepticism*, that when they have done what they can to discredit their senses, they find themselves, after all, under a necessity of trusting to them I never heard that any sceptic run his head against a post . . . because he did not believe his eyes."[36]

This articulation also suggests why one would expect that the same S-belief would be differently realized in different persons. The complex of dispositions involved in my believing that p will include my being disposed to assent to, or to assert, certain English sentences, and my being disposed to act in certain ways in the circumstances in which I find myself; that involved in Ivan's believing the same thing may include his being disposed to assent to, or to assert, certain Russian sentences, and his being disposed to act in certain rather different ways in the different circumstances in which he finds himself. This articulation also enables one to side-step the awkward question, how states of the brain could have semantic properties, by making it clear that it is not sentences, but dispositions to assent to sentences, that are in the head. And it even suggests an accommodation with some recent research in the brain sciences. Unlike Paul Churchland, who professes to believe that, since the mechanisms posited in connectionist neurophysiology are non-propositional in structure, we should conclude that there are no such things as beliefs, I take such work to contribute to our understanding of how a person identifies and recognizes, among other things, the linguistic expressions dispositions to assent to which constitute one strand of the multiform disposition of an S-belief.

Our beliefs are about things and events in the world; my believing that the ice is thick enough to bear my weight could hardly contribute to the explanation of my behavior unless it referred to the ice on the lake, the ice across which I walk. But how can the requirement that my C-belief be about the ice on Lake So-and-So to be accommodated?—after

all, I may have no idea what lake this is. This might be achieved by construing a C-belief as about some ordinary object, but about that object under a certain description; as Burdick proposes,[37] as of an ordered pair of an object and a predicate, the latter representing the appropriate "mode of presentation"—in the present case, as of <the ice on Lake So-and-So, "the ice on the lake by which I am standing">. On this reconstrual nothing irredeemably intensional remains; but the role of the mode of presentation, the mentioned predicate, in the explication, suggests an explanation of why belief-ascriptions might *appear* to involve nonextensional objects.[38]

Has this been a "unified story?" Yes and no. Yes: human beings are physical objects in a physical environment, physical organisms capable of reasoning and intentional action. No: it is not to be expected that explanation of a person's intentional behavior will reduce to a purely neurophysiological story. Unlike reflex reactions or any structure-determined "behavior," intentional behavior is mediated by signs. The best way I can find to express it is this: the story can be unified in the sense in which one can unify a contour map and a road map of the same terrain. (Perhaps it is the influence of the Positivists' thoroughly reductionist conception of "unified science" that is responsible for our losing sight of this modest but important sense of "unified.")

The hope is to have illustrated how, as the theme of continuity suggests, philosophical analysis may find some accommodation of commonsense concepts with scientific theory, and, as the theme of critical commonsensism suggests, refine and sharpen our preanalytic concepts.

I chose the phrase "critical commonsensism" not only for its intrinsic appropriateness, but also for its historical resonance. It derives from Peirce (who uses it in reference to his attempted synthesis of elements of Reid's and Kant's responses to Hume).[39] My intention, in using the phrase, is not only to suggest the historical antecedents of my fourth theme, but also to acknowledge that the conception of the tasks of philosophy that I have been articulating here is, in all essentials, Peirce's.

That Peirce aspired to a reformed, "scientific," philosophy is quite well known; what is not so well known is how very far from the scientism of much contemporary philosophy his conception is of what such a reformed, scientific philosophy would be. It would, first of all, be undertaken with "the scientific attitude," by which Peirce means: from a pure, disinterested desire to find out how things are. And it would use "the scientific method," by which Peirce means: the method of experience and reasoning, abductive, deductive, and inductive. None of this

implies, as reformist scientism supposes, that philosophical questions can be turned over to the sciences to resolve, let alone, as revolutionary scientism supposes, that philosophical questions are misconceived; and, indeed, Peirce explicitly denies such scientistic claims. It does imply that philosophical inquiry depends, in part, on experience; and, indeed, Peirce explicitly argues that one of the distinctive features of philosophical inquiry is that it depends, not, like the natural sciences, on experimentally contrived and controlled observation, but on features of our everyday experience so commonplace that they generally go unnoticed—hence his interest in phenomenology, or, as he calls it, "phaneroscopy." The Pragmatic Maxim, according to which the meaning of a concept is given by (an open-ended list of subjunctive conditionals representing) the experiential consequences of its applying, is quite well known; what is not so well known is its connection with Peirce's thesis that meaning grows, concepts become more determinate, as our knowledge grows. And part of what Peirce means by describing his philosophy as "critical commonsensism" is that, although—eschewing the counterfeit, paper doubts of the Cartesian method—it takes the natural, instinctive beliefs of commonsense as starting-point, it does not accept them uncritically; for their apparent indubitability, he observes, is proportional to their vagueness, and so they stand in need of further determination, of reformulation, of critical scrutiny.[40]

If my four themes are reminiscent of Peirce, Strawson's suggestion that one's conception of philosophy is a matter of individual temperament is reminiscent of James's discussion of the tough- and the tenderminded.[41] Strawson says, "perhaps a matter of individual temperament," and, as his qualification hints, the issue is not a straightforward one. The suggestion is true if interpreted simply as alluding to certain facts about the division of intellectual labor. Some, doubtless, are better suited by taste and temperament for work in philosophy of science, others for work in ethics, say, or philosophy of literature. Some, doubtless, are better suited by taste and temperament for broad-brush speculative theorizing, others for finely-detailed analytic or logical articulation. And this is all to the good; philosophical inquiry is surely advanced by these kinds of diversity.

Beyond this point, however, the suggestion seems too bland; as, indeed, is revealed by Strawson's criticisms of Quine's extensionalism and of his scientistic leanings. The difference between Strawson's approach to philosophy and Quine's is not simply a matter of Quine's favoring philosophy of science and Strawson the traditional questions of metaphysics, nor simply a matter of Quine's preferring the precise but restricted techniques of extensional logic and Strawson the broader, subtler, but vaguer, resources of natural language analysis. Beyond that,

there are issues, not of taste or temperament, but of substance. It is those that have been my concern here.

SUSAN HAACK

DEPARTMENT OF PHILOSOPHY
UNIVERSITY OF MIAMI
MARCH 1994

NOTES

* I wish to thank Hilary Putnam for allowing me to adapt a phrase of his for the title of this paper, Mark Migotti and Sidney Ratner for helpful comments on a draft, and Howard Burdick for helpful conversations.

1. Putnam, H., *Renewing Philosophy* (Cambridge, Mass.: Harvard University Press, 1993).

2. Strawson, P. F., "Two Conceptions of Philosophy," in Barrett, R. and Gibson, R., eds., *Perspectives on Quine* (Oxford: Blackwell,1990), 310–18 (the quotation is from p. 318). See also *Skepticism and Naturalism: Some Varieties*, (New York: Columbia University Press, 1985), p. viii.

3. See *Skepticism and Naturalism: Some Varieties*, pp. 2, 73, and "The Incoherence of Empiricism," *Proceedings of the Aristotelian Society*, Supplement, 66 (1992): 139–43.

4. Strawson, "Two Conceptions of Philosophy," pp. 312–13. See also *Analysis and Metaphysics* (Oxford: Oxford University Press, 1992), especially chapters 1 and 2.

5. Strawson, "Two Conceptions of Philosophy," p. 312. My arguments against the revolutionary response are developed in some detail in "Vulgar Pragmatism: an Unedifying Prospect," chapter 9 of *Evidence and Inquiry: Towards Reconstruction in Epistemology* (Oxford: Blackwell, 1993).

6. "Two Conceptions of Philosophy," p. 310. On p. 140 of "The Incoherence of Empiricism" he writes, more bluntly, of Quine's "anti-intensionalist scientism."

7. Strawson, "Two Conceptions of Philosophy," p. 310.

8. See, for example, Quine, W.V., *Word and Object* (Cambridge: MIT Press, 1960), p. 22.

9. See, for example, "Natural Kinds," in *Ontological Relativity and Other Essays* (New York: Columbia University Press, 1969), p. 29, and *The Roots of Reference* (La Salle, Ill.: Open Court, 1973), pp. 19–20, on evolution and induction; *Word and Object*, section 36, on temporal logic.

10. See, for example, "Five Milestones of Empiricism," in *Theories and Things* (Cambridge, Mass. and London: Belknap Press of Harvard University Press, 1981), p. 72, and "Things and Their Place in Theories," also in *Theories and Things*, p. 22.

11. See "Naturalism Disambiguated," chapter 6 of *Evidence and Inquiry*, for detailed articulation of this diagnosis.

12. The extensionalist theme is ubiquitous in Quine's philosophy; but see, for example, chapter VI, "Flight from Intension," of *Word and Object*.

13. "Formulability within the framework of the predicate calculus is not a sufficient condition of full intelligibility, but to me it is pretty nearly a necessary one"—Quine, *The Pursuit of Truth* (Cambridge, Mass. and London: Harvard University Press, 1990), p. 72.

14. See, for example: *Word and Object*, section 46, where Quine offers an extensional analysis of dispositional statements, and "Natural Kinds," where he suggests that such statements are eliminable from completed science; "Burdick's Attitudes," *Synthese* 52 (1982): 231, where Quine remarks of the propositional attitudes that "[l]ike the modalities they are a thorn in the flesh, but they are not a thorn easily withdrawn"; "Reply to Putnam," in Hahn, L. and Schilpp, P.A., eds., *The Philosophy of W.V. Quine* (La Salle, Ill.: Open Court, 1986), pp. 430–31, for what I have described as "his evident relief when he can focus on physics."

15. On properties, see "Two Conceptions of Philosophy," pp. 311ff.; on the mental, "The Incoherence of Empiricism," pp. 140ff.

16. All three themes are articulated, in various ways, in "Two Conceptions of Philosophy," *Skepticism and Naturalism*, and *Analysis and Metaphysics*.

The reason the term "naturalism" is potentially misleading in this context is, of course, that Quine uses it of his approach to epistemology, an approach which is, albeit ambivalently, scientistic. "Descriptivist" also has the advantage of recalling Strawson's defense of "descriptive metaphysics" both in *Individuals* (London: Methuen, 1959) and, more recently, in *Skepticism and Naturalism: Some Varieties*.

17. "[E]xtensionality is no part of my conception of science as such," Quine writes in *The Pursuit of Truth*, p. 72.

18. Strawson's discussion in *Analysis and Metaphysics*, pp. 10ff., and, especially, p. 21, suggests something akin to this thought.

19. James, W., "The Sentiment of Rationality," in *The Will to Believe and Other Essays in Popular Philosophy* (1897) (New York: Dover, 1956), pp. 66–67.

20. "The Incoherence of Empiricism," p. 139.

21. Cf. *Evidence and Inquiry*, chapter 5, section V, and chapter 6, sections II and III.

22. Strawson, "Two Conceptions of Philosophy," p. 318; cf. *Skepticism and Naturalism*, p. 52.

23. Putnam, H., "The Analytic and the Synthetic," in Feigel, H. and Maxwell, G., eds., *Minnesota Studies in the Philosophy of Science*, III (Minneapolis, Minn.: University of Minnesota Press, 1962), p. 376.

24. *Evidence and Inquiry*, chapter 5. Cf. Strawson, *Analysis and Metaphysics*, pp. 60–61.

25. Quinton, A. M., "Doing Without Meaning," in Barrett and Gibson, *Perspectives on Quine*, pp. 302–3.

26. Strawson, *Individuals*, p. 10.

27. Strawson, *Skepticism and Naturalism*, pp. 14ff.

28. Churchland, P. M., *A Neurocomputational Perspective: The Nature of Mind and the Structure of Science* (Cambridge, Mass. and London: Bradford Books, MIT Press, 1989); Stich, S. P., *From Folk Psychology to Cognitive Science* (Cambridge, Mass. and London: Bradford Books, MIT Press, 1983).

29. "The Incoherence of Empiricism," p. 143.

30. The quotations come from *Skepticism and Naturalism*, pp. 54, 56, 61.

31. *Skepticism and Naturalism*, p. 62; but recall his characterization, quoted above, of our concept of a person as of a "unitary" being.

32. I say, "not so unambiguously," because Quine writes at one point that "there is good reason not to try to weave [intentional discourse] into our scientific theory of the world to make a more comprehensive system," but then, on the next page, that "[t]here is scope for science on the intensional side too"

(*The Pursuit of Truth*, pp. 71–72; the context makes clear that the difference between "intentional" and "intensional" will not explain the apparent shift.)

I note that the relevant sections of *The Pursuit of Truth* are significantly changed in the revised, 1992, edition, where Quine describes intentional talk as "complementing natural science in [its] incommensurable way" (p. 73), and seems to despair altogether of the salvageability of propositional attitudes *de re* (pp. 70–71). But I shall not pursue these complications here.

33. Price, H. H., *Belief*, Allen and Unwin, London, 1969, pp. 267ff.

34. Or other nonnatural signs.

35. Cf. Strawson, *Analysis and Metaphysics*, p. 80.

36. Reid, Thomas, *Essays on the Intellectual Powers of Man*, chapter II, *Works*, eds. Wright, G. N., and Tegg, Thomas (London, 1842), pp. 28–29. A little earlier in the same chapter (p. 22), Reid observes that a true skeptic would be considered a lunatic, and that it would be inappropriate "to reason gravely with such a person."
See also Strawson, *Skepticism and Naturalism*, pp. 11–12, 33, 39.

37. Burdick, H., "A Logical Form for the Propositional Attitudes," *Synthese*, 52 (1982): 185–230.

38. See chapter 8 of *Evidence and Inquiry* for further relevant discussion.

39. Peirce, C. S., *Collected Papers*, eds. Hartshorne, C., Weiss, P., and Burks, A. (Cambridge, Mass: Harvard University Press, 1931–58), 5.505, c. 1905.

40. See, for example, Peirce, C. S., *Collected Papers*, 6.1–5, 1898, and 1.126–29, c. 1905 (on the need for the scientific attitude and the scientific method in philosophy); 1.241, 1902 (on philosophy's reliance on "observations such as come within the range of every man's waking experience," as "*coenoscopic*"); 5.14–40, 1903 (on the Pragmatic Maxim); 2.302, c. 1895 (on the growth of meaning); 5.439–42, 1905, and 5.497ff, c. 1905 (on the need to criticize and refine commonsense beliefs). Peirce's repudiation of scientism is so delightful that I quote it: "to make experiments to ascertain, for example, whether there be any uniformity in nature or no, would vie with adding a teaspoonful of saccharine to the ocean in order to sweeten it," 5.522, c. 1905.

Scholars may also enjoy Peirce's comment on what we are these days urged to dismiss as "folk psychology": "There is not the smallest reason for supposing that natural psychology is at all accurately true; on the contrary, it probably involves great errors. At the same time, its authority must be allowed to be very high indeed in regard to all features which are of importance in the conduct of life; for, on the whole, man has prospered under such beliefs," 7.441, c. 1893; and by his anticipation of some themes of connectionism in a remarkable passage of "Psychognosy" at 7.370, 1902.

It may also be worth mentioning that Quine reviewed volumes II, III, and IV of Peirce's *Collected Papers* in *Isis*, 19, 1933, pp. 220–29 and 22, 1934, pp. 285–97 and 551–53.

41. James, W., *Pragmatism* (1907), eds. Burkhardt, F., and Bowers, F., (Cambridge, Mass. and London: Harvard University Press, 1975), p. 13. (I note by the by that, although James's suggestion that a pragmatist philosopher will typically combine elements of both temperaments has some historical plausibility, it seems that different pragmatist philosophers have done so in virtue of different combinations of elements.)

I also note a smidgen of pragmatism in Strawson's account of the way the concept of agency contributes to other concepts, e.g., of location (*Analysis and Metaphysics*, p. 78).

REPLY TO SUSAN HAACK

I read Susan Haack's paper with great pleasure and with the sympathy natural to anyone generally inclined to try to find a middle way between opposed positions. Indeed, though I am myself cast as the representative of one of the two in question (Charybdis) and Quine as the representative of the other (Scylla), I do not find it very easy to locate large issues on which I am in serious disagreement with Professor Haack. With her Scylla-directed views I concur entirely: philosophical and natural-scientific enquiry should certainly share common standards of general rationality and aim at as much rigor and precision as possible; at the same time philosophical enquiry should not be constrained by an exclusive veneration for natural science or by a Puritanical aversion to intensions.

When she turns to consider my own favored conception of philosophy, Professor Haack finds, just as she does with Quine's, one central ground of agreement and two grounds for dissent or, at least, for qualification. Thus she shares with me the rejection of the view that 'philosophy of science is philosophy enough', holding that the scope of philosophical enquiry extends beyond the concepts and categories of science. But she denies that the task of philosophy is purely that of conceptual analysis, the elucidation of conceptual structures and interconnections, urging instead that philosophical enquiry is neither purely conceptual nor purely empirical, but combines both characters; and, finally, she argues that the analytical enterprise should be conducted in a spirit which is not purely descriptive, but potentially critical. Clearly the two points are connected: the results of empirical investigations may call for conceptual adjustments or revision.

I am not in the least disposed to quarrel with this last observation. As the historical modification of the conception of physical space sufficiently shows, it would be folly to do so. Neither do I wish to dispute the view that certain ideas which have, or have had, some currency are

inherently incoherent, confused, or empty: e.g., those of fate or of the simple, immaterial, imperishable soul-substance or spirit. If their elimination is what the exercise of the critical spirit accomplishes, *vivat!*

Such instances as these, however, are not Professor Haack's main concern. When I consider those that she actually adduces, I remain unconvinced of the combined conceptual-empirical character of philosophical enquiry. Thus she says that our conception of the evidence of our senses has built into it "the presupposition that our senses are a source of information about things and events around us"; which in turn carries with it acceptance of the belief in "the reality of the external world." Now, propositions such as that the physical world exists and that our senses are a source of information about it are certainly, as Professor Haack says, of a degree of abstractness and generality that qualifies them as philosophical; and it is absolutely reasonable to call them, as she does, "presuppositions" of our common conceptual practice, of our ordinary thought. What I jib at is calling them, at the same time, "empirical," a description which, in *this* context, clashes badly with "presuppositions." Far better here to follow Wittgenstein in *On Certainty*, where (to select a few from among a plethora of phrases and images) he assigns such propositions to our "frame of reference," to "the scaffolding of our thoughts," or to "the substratum" of all our empirical enquiring and asserting, the "background" against which we distinguish between the true and the false. So though, as he remarks, they have "the form of empirical propositions," they are not really such nor, of course, are they logically or analytically guaranteed, One might even teasingly suggest that he regards them, in effect, as what Kant would call *synthetic a priori* propositions. Wittgenstein of course does not, and would not, call them that; he even, at one point, disputes their right to be called "propositions" at all, though elsewhere he readily enough uses that designation for them; and if that term is to be used, it would be madness to deny it the qualification "philosophical."

This is not the only region in which Professor Haack finds support for the view that philosophical enquiry does, and should, combine the empirical with the conceptual, the a posteriori with the a priori. She refers to "concepts which presuppose natural laws holding together the bunch of characteristics which they represent as conjoined." The explaining of such conjunctions by the discovery of such laws, when it can be done, is a matter of empirical enquiry by natural scientists; and the results, like much else, may be of interest to the philosopher, as to others; but it hardly seems to be one of his professional concerns. The case is different, as already remarked, when empirical discovery and natural scientific and technological advance call for conceptual revision, adjust-

ment, or even decision. Banal examples are those of the concept of 'fish', revised to exclude the mammalian whale, and the concept 'mother of', requiring adjustment to cope with the fact that the bearer of a child may not be identical with the supplier of the fertilized ovum. Recent discussions of the concept of personal identity point to further and more philosophically interesting possibilities of this kind. More immediately pertinent, however, is the vogue for what are called metaphysical necessities and described as necessary identities established a posteriori: water = H_2O. I should regard this as yet another conceptual decision or revision, reasonably enough adopted in the light of empirical discovery. Thus, to use an older terminology, is real essence absorbed into nominal essence.

As an example of "questions which are empirical in character, but of such scope and generality as to qualify rather as philosophical than scientific," Professor Haack instances the question "whether perception involves a direct relation to external objects, or is rather a matter of inference from directly experienced sense-data." The issue, or group of issues, alluded to by this not wholly perspicuous form of words, has been continuously, one might almost say obsessively, discussed, especially by British philosophers, throughout the present century. Its, or their, resolution demands nothing more, and nothing less, than a careful and sensitive attention to, and use of, our language. Professor Haack's own discussion of the matter in her book *Evidence and Inquiry* is a good example of the sort of treatment required. I see no reason to suppose that further empirical discoveries, however interesting in themselves, could have any significant bearing on the substantial philosophical question(s) at issue.

Professor Haack explicitly mentions another aspect of the Charybdean stance which is exposed, in her view, to criticism. This is what she calls, with justice, my descriptivism. Philosophical analysis, she says, should be undertaken in a spirit which is not purely descriptive, but potentially critical; it should "be open to the possibility that even the stablest concepts and categories may be in need of refinement, of stripping of indefensible accretions and even of correction of implicit empirical presuppositions." I think that whatever concessions are called for on this score I have already made in remarking that empirical discoveries and scientific advance may call for conceptual adjustment or revision. But there is one terminological point on which I wish mildly to take issue with Susan Haack. I do not, and cannot, quarrel with her use of the term "descriptivism," sufficiently vindicated by my own use of the related adjective. But I also characterized my general position as a form of "naturalism"; and she suggests that this characterization might be confusing. So it would have been, had I not been at pains to distinguish

sharply between the Scyllan variety of scientistic or "hard" or "reductive" naturalism and my own variety of what I called "soft" or "liberal," and might have called "human," naturalism; and equally at pains to illustrate the distinction over a number of philosophically contentious areas. More is conceptually (and irreproachably) *natural* to our human, thinking species than finds a place in natural science; as both Hume and Wittgenstein, for all their differences, acknowledged or, rather, proclaimed.

Professor Haack turns finally to a question concerning which she finds that Quine and I come, at least of late, surprisingly close together: the question of "the relation of commonsense ascription of mental states to the categories and concepts of the sciences of cognition." That there is here no unified story to be had is a point on which her two target philosophers seem lately to agree; but she confesses that it leaves her with some uneasiness. Of course she agrees that there is no prospect of "folk-psychological" explanations of intentional behavior being replaced by a purely neurophysiological story or of the terms of the former being reduced to the terms of the latter. Yet she hopes, more modestly, for some "accommodation" of the two.

It is obvious that an agent's current beliefs, among other things, enter essentially into the explanation of his intentional actions. Professor Haack is surely right in maintaining that any theoretical approach in this area should begin by distinguishing between the *content* of a belief (the proposition believed) and the *state* of believing it; and it is hard to doubt that any such state has at least some physical (neurophysiological) realization. So far, so good. But of a "unified story" we are offered no hint beyond an engaging little analogy from maps.

Let us settle, for the time being, for "accommodation." This is a blessedly diplomatic word. It allows for mutual recognition, respect, a treaty, even some trade. We may, and perhaps must, be finally content with this.

 P.F.S.

3

E. M. Adams

ON THE POSSIBILITY OF A
UNIFIED WORLD VIEW

In *Skepticism and Naturalism* (1985), Peter Strawson contends that we are by nature committed to two perspectives: the scientific-objective (which I shall call simply the "scientific") standpoint and the human-perceptual-moral (which I shall call the "humanistic") standpoint. Each perspective generates its own conceptual system and view of reality. Hence the philosophical problems about the moral qualities of human actions and the scientific account of human behavior, the commonsense phenomenal and the scientific views of physical objects, mental states and acts and bodily states and processes, and the matter of meaning (which Strawson conceives in terms of intentional entities) and the scientific view of existence. The philosophical problems cited, he contends, are generated by the assumption that in all these cases one of the standpoints gives us the true view of reality and the other an illusion. Thus skepticism about one or the other of the two views of reality or reduction of one to the other. The reductive naturalist insists that the scientific view is correct and that the humanistic view of things is reducible to, or explainable in terms of, the scientific view. The idealist, although not mentioned by Strawson, claims the reverse.

Strawson rejects the assumption that only one of the two views is correct. So he rejects the usual kind of philosophical skepticism about either perspective. Foremost in his mind is rejection of the reductive naturalist effort to reduce the humanistic language grounded in the human-perceptual-moral perspective to that grounded in the scientific standpoint or to explain it in a way that leaves the scientific view as the only claimant to objective truth. He says that we cannot have a reason for holding either the scientific or the humanistic view as exclusively correct, for in order to do so we would have to have "a standpoint we could

occupy which was superior to either . . . [and] there is no such stand-point" (p. 53). We have no choice, he says, but to accept both perspectives. Our commitment to each is simply a fact of nature; and, therefore, it is not a matter open to question or to justification. He contends that the appearance of contradiction between the two accounts of reality disappears as soon as we are prepared to recognize "a certain ultimate relativity in our conception of the real" (p. 44). Each perspective, he contends, has its own standard of the real. We simply have to live with this ultimate relativism and give up the search for an integrated culture and a unified world view.

In other words, Strawson avoids the usual kind of skepticism about one or the other of the two perspectival views only by accepting a kind of skepticism about both; or what amounts to the same thing, he introduces skepticism about, or rejects outright, the belief that a unified world view is possible.

NATURAL BELIEFS

Strawson introduces his discussion of skepticism and naturalism with an examination of classical skepticism about the existence of bodies. He accepts Hume's position that nature has not left such an important matter to our "uncertain reasonings and speculations," but has antecedently implanted in the human mind an unavoidable belief in an external world and the existence of bodies in particular. Thus Strawson holds, along with Hume and Wittgenstein, that there are parts of our belief system that are not products of, and are not subject to, our knowledge-yielding and critical powers. They are, he says, *natural* beliefs.

Strawson distinguishes between two kinds of naturalism: liberal naturalism as defined by the thesis that our basic stances or beliefs are by nature; and reductive naturalism, which holds that the scientific view of reality is exclusively correct and that the humanistic view has to be reduced to or explained in terms of it. He accepts naturalism in the first sense, but rejects reductive naturalism, as we previously observed.

I have no quarrel with the claim that some beliefs are natural. But what does this mean? We think of such things as earthquakes and tornados as natural, for they have natural causes. In the biological realm, we may encounter a two-headed turtle. Such a monstrosity is by nature in one sense—it has natural causes; but it is unnatural in another sense—it is not by the specie nature of the animal even if it is by its "individualized" nature (the form the individual's genetic constitution takes under the conditions of its existence). Natural beliefs, I suggest, are not by nature in the first sense, but by *our nature*. They are beliefs that a

human being has if one develops according to human nature to the point that one is a functioning knower-agent. If a human being lives but fails to become a knower-agent, something will have gone wrong. But even if something goes awry so that a human being never becomes a functioning knower-agent, he or she is the kind of being who by nature ought to mature into a knower-agent.

This way of thinking is humanistic. Human beings are conceived as knower-agents who have a subjective and normative structure tied in with an existential and factual constitution. This involves having an organized dynamic "inner" realm or dimension, a multilayered complex of semantic states and acts (experiences, memories, fantasies, thoughts, desires, intentions, aspirations) in which all manner of things, possibilities, and even impossibilities are or may be *present to* one (as distinct from existentially *present with* one) and thus in what we may call one's "semantic" environment. There is an inherent normative structure to this complex of subjective states and acts with respect to which the whole complex may be said to be well ordered and well functioning, yielding knowledge and justified decisions, or deranged and malfunctioning, yielding illusions, false beliefs, and wrong or bad decisions. All of these semantic states and acts are presumed to have a bodily dimension, but the inherent normative structure of the subjective domain seems to be causally active in eliminating inconsistencies and generating normatively required subjective states and acts. The bodily dimension of these subjective states and acts seems to be in tow to the causal dynamics of the "inner" arena where the semantic environment and normative requirements are largely the determining factors, not the bodily states and events and their connections in the existential environment. An agent's overt acts are not only produced by the causal dynamics of the inner realm; they have their identity and unity in terms of their own intentional structure and they must be placed in the context of the agent's total subjective complex in order to be fully understood. This is what we mean by freedom in human thought and action. It is the categorial structure by virtue of which human experience, thought, and action are subject to rational appraisal. When subjective states and acts are taken to be in tow to bodily states and events and their causal interactions in the physical realm, we think that the person is not a free agent and that his or her thoughts and actions are not proper subject matter for rational appraisals.

If we are, by our nature, knower-agents and if we have to have certain framework beliefs in order to be functioning knower-agents, then we may say that we are endowed with those beliefs by our nature and that they are natural beliefs in this sense. We do not, for instance, depend on an

empirical discovery for our belief in an objective world; the belief is part of the framework that makes empirical discoveries possible. In going to a lecture at an appointed time, one believes that there is a lecture hall (or at least a lecture place) and that there are other people who will be there at the same time. These beliefs presuppose that there is an objective world. One may discover empirically that there are no other people at the lecture hall or even that there is no lecture hall. But one could not discover empirically that there is no objective world. We cannot reject this belief and go on with ordinary activities, for we cannot function as knower-agents without it. It is necessary for marking the distinction between veridical and nonveridical experiences and between true and false beliefs. And we could not act in response to our perceived environment without the belief in an objective world, for overt actions presuppose the belief. Infants who move their heads to keep passing objects in their view or reach for them with their hands already have the belief in an objective world in some rudimentary form.

Neither are we dependent on an empirical inventory to discover that people have natural beliefs. We know that one could not be a knower-agent without having beliefs of this kind. Even the realization that one's experiences and beliefs did not hang together in a way that confirmed any of them would not lead one to conclude that there was no objective world; rather one would conclude, insofar as one still had reasoning powers, that one had lost one's mind. In other words, belief that there is an objective world is a presupposition of perceptions and beliefs about, and actions in response to, ordinary things and events. With the development and exercise of our natural knowledge-yielding and agency powers, we find ourselves with such beliefs.

Such natural beliefs are also known as a priori beliefs. Calling them "natural beliefs" or "beliefs by nature" may be more acceptable to certain kinds of empiricists who abhor the idea of the a priori. The beliefs are framework beliefs that make possible, and are presupposed by, ordinary experiential takings, beliefs, and actions.

CRITICISM OF NATURAL BELIEFS

Strawson seems to think that, like other natural events such as earthquakes and tornados, natural beliefs are not subject to justification or condemnation. Certain beliefs with natural causes (e.g., some of the beliefs of the delirious or the insane) may not be rational, that is, they may not be grounded in or responsive to reasons. We do not argue with people who have beliefs of this kind; neither do we hold people like this

responsible for their actions based on such beliefs. But we do appraise their beliefs as false (or just possibly true).

Strawson does not deny that natural beliefs are true. In fact, he seems to assume that they must be true. Regardless of how much two natural beliefs or sets of natural beliefs (e.g., humanistic and scientific beliefs about human behavior) may appear to be contradictory, he holds that they are not really inconsistent, for we have to accept both views as true. But if a turtle can be endowed by its "individualized" nature with two heads, or a human being can be endowed with a male body and a female psyche or vice versa, perhaps a human being can be endowed by one's "individualized" nature with false basic beliefs. This may be what happens to some human beings whom we regard as congenitally deranged so that they cannot become functioning knower-agents. It must be only successful knower-agents who are endowed by their nature with true basic beliefs.

We are warranted, I suggest, in concluding that natural basic beliefs are true only if they make possible a successful knower-agent, for the truth of the basic beliefs is the best explanation of the fact that they make possible a successful knower-agent. In like manner, and for the same kind of reason, we may conclude that basic beliefs with natural causes are false if they do not make possible a successful knower-agent. Therefore, it seems that, even though natural basic beliefs may not be accepted or rejected for reasons, they may be critically assessed as true or false for reasons. So even if we can neither accept nor reject a natural belief, we can rationally accept or reject the belief that a given natural belief is true.

There is, of course, a problem about what our natural basic beliefs are. We operate with them as knower-agents but may never articulate and analyze them. Philosophers attempt to do this. In trying to give a correct formulation and analysis of our natural or a priori basic beliefs and commitments, those presupposed by our ordinary beliefs and undertakings as knower-agents, philosophers may make mistakes. If so, they encounter peculiar logical problems; they sooner or later find themselves making philosophical claims that are inconsistent with the presuppositions of ordinary thought and action. This, I suggest, is one way of generating philosophical skepticism.

Hume himself made the classic case for skepticism about belief in independent, external physical objects. Indeed, he went further. He claimed that we cannot give any meaning to talk about physical objects other than in terms of sense impressions. This is a form of reduction: Physical objects, according to Hume, cannot be conceived as anything other than clusters of actual and possible sense impressions so that the

meaning of physical-object sentences must be explicable in terms of sense-impression sentences. Hume seems to hold that the "natural" belief in external, independent physical objects is unavoidable but an illusion nonetheless—one without any real content, for we cannot so much as form a genuine idea of such objects. Yet he maintains that when we leave our "philosophical closets" we all go on with our natural illusion.

Hume's skepticism about, or philosophical rejection of, the truth of the natural belief in the existence of physical objects as such was generated by his philosophical theory about sensory experience. He tried to explain how sense experiences have objects by analogy with physical impressions of one thing on another—for example, footprints on a beach. But having conceived a sense experience of an object as an impression of it, he had a problem about how we could ever know that there was an external cause of the sense impression or that the sense impression resembled the alleged cause. Having physicalized the semantic dimension of sense experience, Hume came to reject the view that sense impressions are intentionalistic. They are not representations, he maintained, but original existences without any representative quality.[1] He held that the expression "sense impression *of* red," for example, does not mean that the sense impression is intentionalistic and that a patch of red is its semantic content or object. Rather he contends that the "of" is appositional. The expression, according to him, means the same as "the sense impression, red." Thus, rather than a sense experience with the intentionalistic content red, he recognizes a new existent, the sense impression, red. In this way, he generates the impenetrable sense-impression curtain that denies us not only epistemic but even semantic access to a realm of external, independent physical objects. So he concludes not only that we cannot have knowledge of such objects but that we cannot so much as form a legitimate idea of them. Our apparent idea of such an object cannot be what it appears to be; it is really about a cluster of present and possible sense impressions. More precisely, as later phenomenalists put it, sentences that appear to be about such objects turn out, under philosophical analysis, to be translatable into sentences about present and possible sense impressions.

The fact that the Humean sense-impression theory puts in jeopardy the truth and even the content of the natural belief in physical objects makes his sense-impression theory suspect. It is now widely recognized that the sense-impression theory was a mistake. The absurdity of the phenomenalism to which the theory gives rise invalidates it. The error, I suggest, lies in the attempt to "naturalize" sense experience—the attempt to account for sense experience of objects solely in terms of the scientific conceptual system that has been cleansed of all humanistic

concepts. In fact, a strong case can be made that philosophical skepticism about many areas of discourse results from error in attempts at philosophical clarification and analysis of our natural (or a priori) beliefs presupposed by our truth-claims.

We may conclude, then, that we have natural (or a priori) beliefs as knower-agents, beliefs that we cannot do without and still function as knower-agents. But philosophers do try to articulate and clarify them and to give reasons for and against their being true. Hume, as we just observed, gave philosophical reasons for believing that our natural belief in physical objects is an illusion, even though he recognized that the reasons could not dislodge the natural belief in real-life situations. But he did not have to conclude that the natural belief was an illusion; it would have been a wiser move for him to have concluded that his philosophical theory of sense experience was in error because it brought him to an absurd conclusion. This would have led him to reexamine his account of sense experience.

BELIEF IN A UNIFIED WORLD VIEW

We may wonder whether Strawson's skepticism about, or rejection of the possibility of, a unified world view is itself grounded in some philosophical error. Belief in a unified world seems to have just as good a claim to be a natural and unavoidable belief as the belief in physical objects or the humanistic view of human behavior. The felt logical tension between the scientific and the humanistic world views is itself testimony to the natural belief in a unified world. Although Strawson claims that the felt logical tensions are not real, there is a long history of humanistically purified scientific descriptive/explanatory language crowding out rational appraisal language. We have, for the most part, given up looking for the justification of congenital deformities, disease epidemics, earthquakes, tornados, and the like. The application of the two teams of concepts to the same subject matter appears to involve us in contradictions in our presuppositions about it. Would Strawson tell us that there is no reason to abandon the humanistic way of thinking about such matters because of the success of the scientific way of thinking about them? If the apparent logical conflict between these two ways of thinking about natural events is real, why is there not a problem when both teams of concepts are applied to human behavior? In each case, I suggest, the application of the two teams of concepts generates contradictions in that they presuppose contradictory views about the categorial structure of the subject matter. The humanistic way of thinking about something presupposes that it has an inherent intentional, normative, and teleological

structure; the scientific way of thinking about it presupposes that it has a purely factual and nonteleological causal structure.

What is of greater significance is that our descriptive/explanatory conceptual system has presuppositions not only about the categorial structure of the specific subject matter to which it is applied but about the categorial structure of the world. A descriptive/explanatory account of something places it in the world not only in terms of empirical concepts and laws; the account, by its categorial presuppositions, places the phenomenon in the world categorially, that is, it locates the phenomenon in a categorial world view. Humanistic and scientific descriptive/explanatory accounts of even different subject matters seem to present contradictory categorial pictures of the world. This is what has driven so many modern naturalists to conclude that humanistic language has no descriptive/explanatory use in our intellectual quest, not even in our effort to understand human beings and their behavior. But rational appraisals of human behavior, not just descriptive/explanatory accounts, have categorial presuppositions about human beings and their behavior and thus implications for a categorial world view.

Furthermore, a unified world view seems to be required for a unified self; and a unified self seems to be required for making both rational knowledge-claims and rational decisions. Self and world are correlative concepts. Knowledge-claims and rational decisions are acts of a self unified under a transcending center that expresses itself as *I*. As long as one is of two or more minds about something one cannot authentically say "I think that it is *F*, not *G*," or with regard to a proposal for action, say "I will do *X*." If one superficially thinks that *X* is *F* but has deep contrary assumptions, these assumptions or commitments are likely to generate doubts about or even dislodge the belief that *X* is *F*. Only a thought that one's whole belief system supports or is consistent with is authentically one's own. In like manner, only a decision that one's whole complex belief/precept/volitional system supports or is reconciled to is authentically one's own. As long as one's world, the world as it is present to one, is chaotic or ununified with regard to facts and values, one's factual beliefs and value commitments cannot be unified. We achieve a unified self that makes possible authentic knowledge-claims and rational decisions only in concert with achieving a unified world view. Disturb one's unified world view and you disturb one's unified self. We cannot be at peace with felt contradictions in our belief system. Total fact and value chaos would reduce the self to mush, for without focus on an ordered world there is no unity in the self, no I. So we seem to be endowed by our nature with a belief in a unified world. Any philosophical theory that forces us to reject the possibility of a unified world view casts doubt on itself.

The most likely place for error in Strawson's position is in his account of the scientific and the humanistic perspectives. He characterizes one standpoint as objective, yielding an account of how objects are in space and time, and the other standpoint as yielding an account of things in terms of our personal and reactive attitudes. This is, I suggest, a prejudicial account, drawing on cultural ways already devised for solving the problem Strawson holds is insolvable. It is an attempt to achieve an integrated culture and a unified world view by taking the scientific world view as objectively true and the humanistic world view as subjective but uneliminable nonetheless. Although Strawson professes to embrace both perspectives as equals, he seems to share the cultural prejudice built into his characterization of the problem.

It is a thesis of this paper that it is an error to take the modern scientific perspective to be a natural standpoint on a par with the humanistic perspective on human beings and their behavior. There is, however, a common objective standpoint that seems to be natural to the human mind, but it may not be a priori in the sense that makes it immune to rational reconstruction. According to this standpoint, we take whatever is present to us in critically approved experience or thought to obtain in the world. And certainly it is not obvious that only sensory experience and thought grounded in it are worthy of critical approval in a way that warrants taking their contents to obtain in an objective world order.

Human beings are, by their nature, engaged in two distinguishable enterprises. We are concerned with defining, organizing, directing, and living our lives from within as individuals, institutions, and societies; and we seek to understand ourselves and the world in a way that would provide us with the knowledge, wisdom, and inner strength for this enterprise. This is the humanistic approach. Of course in living our lives and running our institutions and societies, we have to use our physical environment to meet our materialistic needs and we seek to understand things in a way that will enable us to do so more effectively. In our common natural standpoint, this concern is an integral but subsidiary part of our humanistic concern with living our lives and making our institutions work. Our effort to understand our physical environment is cast from within the humanistic perspective and draws on our total categorial and experiential involvement with the world. This approach was dominant throughout most of human history.

Although it is arguable whether, or at least to what extent, the humanistic categories are applicable to subject matters in general, we cannot escape thinking about human beings and their activities in humanistic terms. It is clear that the humanistic view of human beings and their behavior is a natural, unavoidable view in Hume's sense.

Certainly the scientific view of human beings and their behavior is not a natural, unavoidable view. Indeed, it is not a natural and unavoidable view of any subject matter; it is a product of modern Western civilization.

In the early modern period, there was a historical shift in our dominant culture-generating stance toward the world. In classical Western civilization, humanistic interests and concerns that focused on who we are and what we ought to become and ought to do were dominant and humanistic ways of thought defined our intellectual view of ourselves and the world. In the early modern period, materialistic interests, those that can be satisfied by manipulation and control of the material conditions of our existence, became increasingly more prominent and our culture-generating stance was redefined by the desire to master the material conditions of our existence and to impose our will on the world. With this development, we sought the kind of knowledge that would give us manipulatory power over things. The quest for knowledge and understanding became divorced from the humanistic approach that drew on all our modes of experience and thought. The modern scientific approach is the result of this process. Its epistemic base is restricted to refined and critically assessed sensory observation. Its descriptive/explanatory conceptual system has been purified of all humanistic concepts, especially the categories of value, normativity, meaning, and teleological causality.

I can only conclude that the naturalistic world view generated by the modern scientific standpoint is not a natural belief system in Hume's sense. It is a distinctively modern Western cultural product. Unlike the humanistic perspective toward at least human beings, their behavior, and cultural and social phenomena, which is genuinely by nature and unavoidable, the scientific view of at least human beings, their behavior, and cultural and social phenomena is at risk and stands in need of justification. While the extension of the humanistic conceptual system to nonhuman subject matter is arguable and needs justification, the scientific picture of even the physical world is arguable and needs defense because human beings and their cultural and social phenomena are deeply enmeshed in the physical realm.

The physical realm, it would seem, must be understood in a way that does not leave the human phenomenon, indeed the whole biological and psychological realm, an ontological dangler. We must understand the sub-biological world in a way that makes the existence of the biological, psychological, and personal realms intelligible. It is arguable whether this can be achieved on a purely physicalistic view. This is the problem that drives people to embrace either a physicalistic view of biological, psychological, and personal phenomena or a humanistic world view. Our

intellectual quest cannot be satisfied without a unified world view in which we can place all that we must acknowledge to be real.

TOWARD A UNIFIED WORLD VIEW

Let us review where we are. Accepting the humanistic and the scientific views of reality as equally natural, unavoidable belief systems, Strawson concludes that no unified world view is possible. I have contended that the humanistic perspective, properly conceived, is a natural perspective toward, and yields natural a priori beliefs about, human beings and their behavior. People seem to have viewed all things from this perspective throughout most of human history. And we may yet have to expand these beliefs into a humanistic world view, but if so, it will not be simply the expression of a natural, unavoidable standpoint. Such a world view, if justified, would be a priori in that it could not be denied without doing violence to, or rendering unintelligible, the natural and a priori humanistic view of human beings and their behavior.

I agree with Hume that the belief in objects existing in space and time independently of sensory perception is a natural (and a priori) belief, but I have argued against Strawson's expansion of this natural belief into the scientific view of reality. This expanded view may be a priori and philosophically justified, if it is logically tied to the natural and a priori part of our belief system so that it cannot be rejected without contradicting or rendering unintelligible truths that are both natural and a priori; but, like the expanded humanistic view, it is not the simple expression of a natural standpoint.

There is a common natural objective view, or so I have claimed, but it is not limited to the natural belief in physical objects. It includes the entire human perspective. Truth-claims in whatever area of experience or discourse are taken to be objectively true or false, whether about physical objects and factual states of affairs, the subjective or "inner" dimension of people and their behavior, the meaning and logical dimensions of speech-acts, texts, and symbols, or normative requirements and values. And at least human subject matter is taken to involve categorial structures of factuality, normativity, subjectivity (or intentionality), and teleological causality. Any narrowing of this natural objective perspective, just as the expansion of the humanistic view of human phenomena or the natural view of physical objects into a world view, is a matter of philosophical theory.

With the rise of the modern scientific perspective, which began with its focus on the physical realm, the humanistic dimension of the broader natural objective view has been progressively subjectivized and relativ-

ized in order to reconcile it with the scientific view, thus leaving the scientific view with the only claim to objectivity. Although Strawson claims that the humanistic view of human beings and their behavior cannot be dislodged, I am not sure that he regards them as objectively true (Hume, for instance, held that even the natural belief in physical objects was an illusion); he applies the term "objective" to only the scientific view.

We may conclude, if I am on the right track, that the dilemmas with which Strawson is concerned in *Skepticism and Naturalism* are not between two natural unavoidable standpoints, but between a natural humanistic standpoint about human phenomena (and perhaps an expanded humanistic world view) and a modern cultural world view (the scientific view of reality) that purports to be inclusive.

Even though the scientific perspective is not a natural and unavoidable standpoint in Strawson's sense, it looms large in our modern culture and it is widely recognized as epistemically superior to the humanistic perspective. The scientific world view dominates our modern intellectual life. Its conflict with the humanistic view of human beings and the world has defined the agenda of Western philosophy ever since the seventeenth century. Indeed, the prestige of modern science is so great that many think that even the restricted humanistic view of human and cultural subject matter must yield to the scientific view, if we are to achieve a unified world view at all. Some claim that we have no alternative but to conclude that the humanistic belief system is either reducible to or explainable in terms of the scientific world view. Some even claim that in time we will be able to replace "folk psychology" with a respectable scientific psychology. No one to my knowledge has proposed that we eliminate value language, but many hold that it is interpretable or explainable in a way that leaves the value-free scientific world view undisturbed.

No area of the culture is the equal of modern science in achieving what we may call "internal" objectivity—that is, objectivity with respect to the truth-claims made within the scientific methodology and conceptual system in contrast with the objectivity of scientific methodology and the scientific conceptual system. Science has developed a remarkably successful methodology. Scientific truth-claims have to be testable by competent scientists, without regard to ethnic, class, political, religious, or sexual identity. When scientists put forth a finding or a theory, they invite scientists everywhere to prove them wrong. Only ideas that have survived this challenge acquire the status of scientific truth. Even then they remain provisional, always open to new challenges. Furthermore, all of our technological/industrial enterprises depend on the truth of scientific claims; and the success of these enterprises bears witness to the

objectivity of science. Only mathematics can claim anything comparable, but pure mathematics is widely regarded as uninformative about the world.

Certainly the humanistic disciplines and modes of thought cannot claim anything comparable. It is difficult to get several people within the same culture to agree on a simple matter of what a given person or group did or said in a concrete situation or what a specified text or symbol means. The difficulty is compounded with regard to value judgments about people and cultural objects, for agreement here requires agreement at the level of factual comprehension. The manifest difficulty in reaching agreement on such matters is a powerful argument for the subjectivity of humanistic beliefs and judgments. Couple this with the fact that science, having eliminated value and meaning concepts from its descriptive/explanatory language, has had such success in reaching agreements and in providing the knowledge base for technology and industry, there is little wonder that subjectivistic and relativistic theories of humanistic truth-claims abound.

Yet there is a case (a strong case, I believe) for the over all objectivity of the humanistic perspective and for its superiority over the scientific standpoint. Here I can only sketch with bold strokes what such a case would be.[2]

I readily admit that it is practically impossible for us to achieve in the humanistic perspective the same level of rational agreement that is standard in science. But there are explanations for this lack of agreement that do not compromise the claim to objectivity—the claim that the belief is true of what it is about.

Consider our moral judgments about human acts. One's moral judgment about an act is, of course, dependent on what one takes the act to be. One has to have a correct perception of or belief about an act in order to judge it correctly. A correct description of the act has to be in terms of the intention that gives it its identity and unity. In order to understand the intention, we have to place it in the context of the agent's relevant complex of beliefs, attitudes, value judgments, plans, and other intentions. This is one reason why aliens, strangers, and enemies so often misread what a person says or does.

There is another problem with understanding behavior. Most acts admit of multiple correct descriptions. An act that may be correctly described as giving the patient a medication may also be described as killing the patient; an act that may be described as going to the airport may also be described as skipping bail; and so forth. We have to get the appropriate correct description of an act in order to make the correct moral appraisal of it.

Perhaps most of our "moral disagreements" are not really moral

disagreements about the same act but judgments about different acts. Once we have agreement about what someone did and why he or she did it, moral agreement is easier and more common than we usually acknowledge.

Overt acts, speech acts, experiences, beliefs, attitudes, thoughts and the like have their identity and unity in terms of an inherent structure of meaning. They are identified and individuated in terms of their form and content. Their content is, shall we say, semantically, not existentially, in them; and their form is logical, or we might say grammatical. This is the domain of subjectivity, the "inner" realm of people and their behavior. It is inaccessible to purely sensory observation; we know it through self-knowledge, reflection, and perceptual understanding.[3] Those who believe that our knowledge-yielding and data-gathering powers are restricted to scientifically purified sensory observation deny the reality of this dimension of human beings and their cultural productions.

Of course understanding what someone does, like understanding what someone says, is a humanistic task. Clearly we do understand what people say or write; and much of the time we get it right. Dialogue and interaction will confirm or disconfirm our understanding better than spectator observation. Much the same is true with our understanding of the behavior of others. Perceptual understanding of expressions and behavior seems to be a basic power of the human mind. It is one of the earliest epistemic powers human infants develop.

The point of all of this is that humanistic discourse about human beings and their behavior is many layered and very complex. Error or difference at one point will give rise to error or difference at other points. Nonetheless, there is a subject matter to which we are accountable and often we reach confirming agreements with one another about the subject matter when we take proper care to do so.

But what about our value experiences and judgments? Are they our reactions to comprehended situations, revealing something about ourselves but not truths about the subject matter? Or is there a normative structure and value dimension to the subject matter with respect to which our value experiences and judgments are true or false? The answer to these questions turn on the nature of our value experiences and judgments.

It is my view that value experiences, the whole array of our nonindifferent or emotive experiences, are intentionalistic; they are inherent structures of meaning that have their identity and unity in terms of an inexistential content and logical form. We identify a feeling, for instance, in terms of what is felt. If one should say simple "I feel," we would ask,

"What do you feel?" The reply might be "I feel bad" or "I feel that I am not well," meaning that the speaker feels that his or her body is not functioning the way it ought to function. The speaker could express the feeling, as distinct from reporting it, by saying "I am not well." The logical form of the experience, like the logical form of a thought, is shown by the logical form of the sentence that is an appropriate expression of it. The feeling in question has the form of a perception; it is expressible by a value judgment and the value experience is veridical and the judgment is true just in case the factual condition of the speaker's body is not the way it ought to be. This, of course, presupposes that there is an inherent normative structure of the body—the way in which one's body by its nature ought to be and ought to function.

Being hungry is, I suggest, a perception of a bodily lack and the need for food. The experience can be reported by saying "I feel weak and want something to eat" and expressed by saying "I am weak; let's get dinner." The simple desire for food is awareness of the body's requirement for food; the form of the awareness is shown by the form of the imperative sentence that expresses it. Although we do not speak of an imperative as true or false, we do speak of its being valid or invalid according to whether there are conditions in which it is grounded so that the conditional "If these conditions are the case, then that enjoined in the imperative ought to obtain" would be true.[4]

Of course we do not perceive only the normative conditions and requirements of our bodies; we experience the lacks and requirements of ourselves as persons. To be lonely is, I suggest, to perceive a social lack and the need for companionship. To be anxious about something is to feel that it may not turn out well; to suffer from general anxiety is to feel that either oneself or the world cannot be trusted to work well. To be depressed is to feel that nothing matters. To feel good physically is to feel that one's body is in good condition and functioning well; to be happy is to experience the healthy condition and well-functioning of one's self as a person. And of course we have similar experiences of the normative conditions and requirements of whatever group or social entity with which we identify.

Furthermore, we have emotive experiences of other people and the environment in general. These experiences also meet the conditions of being perceptual. The beauty of a flower, a landscape, a sunset, or whatever is the semantic content of our aesthetic experience of it; and we may be warranted in taking it to obtain in the existential object. We resist such a realist position because, according to our modern view of the causal structure of the world, beauty and the so-called secondary qualities on which it depends make no causal difference. But if we

acknowledged a teleological causal structure (one in which normative requiredness is a causal factor), then physical beauty and secondary qualities might be involved in the causal processes of nature.

The point of this all-too-brief discussion is that, with the proper framework of thought and approach, greater agreement could be reached in the humanistic study of subject matter than we now achieve with our modern skepticism and subjectivism.

But what is more important, if I am right about the epistemic character of self-knowledge, reflection, perceptual understanding, and emotive experience, the humanistic perspective is more broadly based in the total range of our knowledge-yielding experiences and offers a wider epistemic window on the world than the scientific perspective with its dependence on sensory observation and thought grounded therein. Furthermore, where the scientific perspective is governed by our interest in power to impose our will on the world, the humanistic perspective supports the enterprise of defining, directing, and empowering ourselves, our institutions, and our societies from within. In other words, although science achieves a greater internal objectivity for its truth-claims, the humanistic perspective, with all things considered, is more objective than the scientific perspective, for it is based in a wider range of epistemic powers and governed by a broader spectrum of human interests.

One more thing. The modern scientific world view, I suggest, is not only inconsistent with the humanistic world view; it is self-inconsistent; it cannot be consistently thought through. In the naturalistic world science defines for us, there could be no science, for even human behavior, including scientific inquiry, would have to be brought under the descriptive/explanatory conceptual system of modern science. This would place the behavior of the scientist in doing science in the categorial world-picture presupposed by empirical science, thus rendering scientific activity improper subject matter for rational and epistemic appraisal and rejecting it as knowledge-yielding.

CONCLUSION

We may conclude, then, that belief in a unified world is a natural belief in Strawson's sense, but that neither the humanistic nor the scientific world view is a natural belief system. Each is generated from a more limited natural perspective: the humanistic from the natural perspective toward human phenomena and the scientific from the natural perspective toward independent objects of sensory perception under the influence of cultural interests in mastering our physical environment. Furthermore,

we may conclude that of the two expanded perspectives and their respective world views, the humanistic perspective and its world view, with all things considered, is superior to the scientific perspective and its world view. It follows that the scientific perspective has to be interpreted as a limited approach to the factual constitution of the physical world that provides a fruitful knowledge-base for technology and industry in the service of our materialistic interests, but that it is inadequate to provide a valid or even consistent world view. The humanistic perspective, however, is capable of providing us with a unified world view.[5]

E. M. ADAMS

DEPARTMENT OF PHILOSOPHY
UNIVERSITY OF NORTH CAROLINA AT CHAPEL HILL
JANUARY 1993

NOTES

1. David Hume, *A Treatise of Human Nature* (Everyman's Library: New York: E.P. Dutton and Company, 1911), II, pp. 127–28.

2. For a fuller presentation of my case for the objectivity and superiority of the humanistic perspective, see my *The Metaphysics of Self and World: Toward a Humanistic Philosophy* (Philadelphia: Temple University Press, 1991).

3. For a fuller discussion of this topic, see ibid., pp. 128–78.

4. For a detailed account of my views on emotive experiences and value judgments, see my *Philosophy and the Modern Mind* (Chapel Hill: University of North Carolina Press, 1960), pp. 77–138; and my *Metaphysics of Self and World*, pp. 39–42, 136–43, 148–57.

5. For a fuller discussion, see my *Metaphysics of Self and World*, pp. 279–308.

REPLY TO E. M. ADAMS

I think that the differences between Professor Adams's views and my own, though there are some, are not as great as he supposes. I accept, and shall use, his own terminology of the contrast between the 'humanistic' and the 'scientific' perspectives or standpoints.

To begin with, we need some distinctions. In the first chapter of *Skepticism and Naturalism*, in which I discuss some traditional forms of skepticism, specifically about the mind-independent existence of physical objects, no use is made of the above contrast of perspectives; no reference at all is made to what we are here to understand by the 'scientific' perspective. I agree with Professor Adams (and with Wittgenstein) that the existence of the external world is a presupposition of all our human thinking and acting. I am happy to go along with him in agreeing that it is something we accept a priori; it is certainly not, as Wittgenstein also pointed out, an empirical proposition, though it has the form of one. I agree also with Hume (and with Professor Adams) that it is a belief that we are naturally and inescapably committed to. There is much justice in Professor Adams's critique of those of Hume's views which lead him to a skeptical conclusion in the matter; but I think that Professor Adams errs in representing Hume as a crypto-phenomenalist (as the Professor explicitly does). For though Hume, given his theory of ideas, must hold that we can have no *clear* conception of body as something distinct in its existence from sense-impressions, it is equally evident that the belief to which he holds us to be naturally committed is precisely the belief in that of which he holds we can have no clear conception. Hume could be counted as a phenomenalist only if he offered the phenomenalist thesis as an 'analysis' or, perhaps, a 'rational reconstruction' of the content of our natural belief; but of course he does no such thing. The very idea is anachronistic.

So now to the cases where the contrast between the two perspectives does come into question. But here again we must distinguish. In

particular, we must distinguish between my treatment of the mental and the physical in the third chapter of my book and my treatment, in the second and fourth, of the questions concerning sensible qualities, moral attributions, and such putative abstract objects as properties and intensions generally. In the case of the mental and the physical there is, on my part, no appeal to the 'relativizing move' which Professor Adams finds distressing because he sees it as threatening a 'unified world view'. The discussion centers, rather, on the thesis of the identity of every mental event with some physical (physiological) event; and that thesis is decisively rejected. The justification for including the discussion at all in a treatment of the two 'perspectives', scientific and humanistic respectively, is that there is a certain affinity or kinship between the identity-thesis and the scientism which is, to quote myself, "dismissive of whatever cannot be exhaustively described and accounted for in the terms of physical science" and which, in its extreme form, may extend to embrace the doctrine of 'eliminative materialism'. Any such excess I of course reject absolutely, as does also the most distinguished advocate of the identity thesis, namely Davidson. No appeal to the relativizing move is in question. What we are left with is, on the one hand, the actual normal practice of explaining human *behavior* in terms of the agent's desires, perceptions, beliefs, and decisions and, on the other hand, the theoretical possibility of a causal explanation of gross *bodily movement* in purely physical and physiological terms. Of course these are, in a sense, complementary, since intentional action involves bodily movement. But they are in no sense competitors. Neither is a threat to the other. Striving to understand and explain intentional human action is one thing; seeking the physical causal antecedents of physical movements of tongues, arms, and legs is another. Both are legitimate and noncompeting forms of enquiry. So, once again, there is no need for, and no question of, the relativizing move.

There remain the matters of sensible qualities, moral attributions, and intensions as abstract objects. In the first two cases I explicitly embraced the relativizing move. In the last I expressed, and feel, more doubt as to whether such a move could be regarded as providing a satisfactory solution; and, insofar as it does not, I show my hand by rejecting the side of reductive naturalism and opting exclusively for normative rationality and all that it entails.

So we are left with the questions of sensible qualities and ethics (or value-judgments in general). Here indeed I do explicitly commit myself to the view that, by relativizing our "reallys" to the humanistic and scientific perspectives respectively, we can, and should, remove the apparent contradiction between the assertion, on the one hand, and the

denial, on the other, that secondary quality predicates can be and often are objectively true of observable physical objects and that moral predicates can be and often are objectively true of human actions. This is the doctrine that Professor Adams finds deplorable in itself and destructive of the possibility of achieving unified world view.

But Professor Adams does not report my presentation of my views quite accurately. Thus he reports me as contending that we are "by nature committed" to both of the two perspectives, that "we have no choice but to accept both" for "our commitment to each is a fact of nature," that I accept that both views of reality are "equally natural, unavoidable belief systems." He even suggests that I "attempt to achieve a unified world view by taking the scientific world view as objectively true and the humanistic world view as subjective but ineliminable."

I wish to say that the attribution of the above-quoted views to me is in every case false. While it is true that I regard us, as members of the human species, as naturally and unavoidably committed to the humanistic standpoint or perspective, it is not true that I regard us, or have represented us, as equally naturally and unavoidably committed to the scientific perspective. On the contrary, as an even moderately careful reading of my text would show, I am at pains to stress it is only temporarily and rarely, save, possibly in the case of certain exceptional individuals, that some of us are able to embrace the scientific perspective, to the temporary exclusion of the humanistic. Thus I say that "it is possible for us sometimes to achieve a kind of detachment" from the latter or, again, that "we can, by an intellectual effort, occupy at times, and for a time," the former.

The scale of naturalness, then, comes down heavily on the humanistic side; and this is a point on which Professor Adams also insists, though he fails to acknowledge that he is here in agreement with me. But why then, he may ask, do I make the relativizing move at all, claiming, it seems, equal validity for the seemingly contradictory deliverances of both standpoints? The answer is really very simple. It is that there is really no question of being forced to *abandon* either perspective for the sake of the other. To think so should be as absurd as supposing that somebody engaged in establishing the validity of a mathematical proof (from, say, the logico-mathematical perspective) was incapable of appreciating, at the same time, its elegance (from, say, the aesthetic perspective). The parallel is not quite just; for it may, in many cases, be difficult to occupy both humanistic and scientific standpoints *simultaneously*. But this does not mean that the deliverances of either one or the other have to be regarded as in principle somehow suspect or not fully objective.

There are sometimes good reasons, practical as well as theoretical, for viewing human behavior, and human reactions to it, in a light which

involves the suspension of moral assessment (judgment), in the interests of understanding its, and their, aetiology and, perhaps, of control (or self-command). There are, doubtless, always good theoretical reasons for investigating the physico-physiological mechanisms involved in the generation of a subject's visual experience, reported by the subject himself as of seeing an object as colored in a certain way. There is no reason to deny that the results of such enquiries may be objectively true, though of themselves they leave no room for attributing moral qualities to actions or colors to objects. Yet at the same time these results do not impugn the validity of the relevant moral or color judgments. Indeed the philosopher could impartially and reasonably describe the scientifically minded investigator as engaged in the task of explaining why the agent behaved as badly as he truly did or why the subject saw the object as being of the color it truly was.

Professor Adams is really a little unfair to the scientific perspective. True, he acknowledges that scientific investigations generally set, and attain, higher epistemic standards than mundane human enquiries into ordinary human concerns; and that the possibility of reaching rational agreement in the former is higher than it is in the latter. But he denigrates the motivation of the scientific enterprise, representing it as essentially undertaken as a means of gaining control over nature in order to manipulate it in a way designed to satisfy our materialistically directed desires. Surely this is quite untrue. Most scientists, I think, are moved mainly by the wholly admirable wish to discover the truth about their subject; or if a less disinterested motive clouds the purity of their endeavor, it is most probably that "last infirmity of noble minds," the desire for personal reputation or, as the poet more concisely says, for "fame."

In sum, my way of resolving apparent contradictions between the deliverances of the two perspectives is not to denigrate either, still less to express skepticism about both. It is, rather, while fully acknowledging and endorsing our natural and rational commitment to the humanistic perspective, to recognize also, and to respect, our relatively recently acquired ability to occupy sometimes, for entirely legitimate purposes, an opposed standpoint from which we may gain a quite different kind of insight into the working of the world's, and our own, nature. Of course I am at one with Professor Adams in rejecting the reductive naturalism which would honor these latter insights exclusively, at the expense, and to the detriment, of the humanistic standpoint.

Finally, it seems to me that my position does nothing to damage a 'unified world view', insofar as such a conception makes sense. On the contrary, it enriches the humanistic perspective by recognizing and applauding a type of exercise of rationality responsible for some of the

most considerable intellectual achievements of our species. Professor Adams seems at moments to pine for a different way of 're-unifying' our world view, a way which would involve some kind of categorial revolution in our scientific understanding of the physical world—perhaps a 're-enchanting' of nature. But this thought leaves me blank, as does his reference to "a transcending center that expresses itself as I."

P. F. S.

4

Panayot Butchvarov

THE RELATIVITY OF *REALLY*S

I

In *Skepticism and Naturalism*[1] Sir Peter Strawson argues that some seemingly irreconcilable philosophical theories can be reconciled if seen as relative to different "standpoints," to different standards of "the real," and thus that the *really*s typically occurring in them are themselves relative (p. 45). His explanation of how this is possible seems to be that "truth in philosophy, though not to be despaired of, is so complex and many-sided, so multi-faced, that any individual philosopher's work, if it is to have any unity and coherence, must at best emphasize some aspects of the truth, to the neglect of others which may strike another philosopher with greater force" (p. viii). There is much to be said in favor of this remark, but it seems to me insufficient as an explanation of the thesis of the relativity of *really*s. Let us, however, consider what Strawson says about some actual topics he thinks illustrate that thesis.

One familiar topic (discussed by Strawson also in *Freedom and Resentment*[2] and to some extent in *Analysis and Metaphysics*[3]) is the objectivity of moral properties. Viewed from one standpoint, "the standpoint that we naturally occupy as social beings . . . human actions and human beings appear as the bearers of objective moral properties" (*Skepticism and Naturalism*, p. 35). But viewed purely objectively, naturalistically, scientifically, they obviously do not. (Especially in *Freedom and Resentment*, Strawson seems unsure that the latter standpoint can really be adopted by anyone.) Well, which is the correct standpoint? From which do we see how people *really* are? Strawson's answer is that the views appear contradictory because of the false assumption that there is "some metaphysically absolute standpoint from which we can judge between the two standpoint . . ." (*Skepticism and Naturalism*, p. 38).

Another topic Strawson uses to illustrate his relativity thesis is the question whether physical objects really possess such properties as colors-as-seen and shapes-as-felt. Common sense says, yes, the scientific realist says, no. Do they contradict one another? They do not. There is "a certain ultimate relativity in our conception of the real . . . Relative to the human perceptual standpoint, commonplace physical objects really are bearers . . . of phenomenal visual and tactile properties. Relative to the standpoint of physical science (which is also a human standpoint) they really have no properties but those recognized, or to be recognized, in physical theory" (*Skepticism and Naturalism*, p. 44). Elsewhere, in "Perception and its Objects,"[4] coming in my view closer to the mark, Strawson argues that the question of whether common sense and scientific realism contradict each other "is one of identity." "Can we coherently identify the phenomenally propertied, immediately perceptible things which common sense supposes to occupy physical space with the configurations of unobservable ultimate particulars by which an unqualified scientific realism purports to replace them?" (p. 108). The contradiction or incoherence is avoided if we recognize "the relativity of our 'really's" (p. 110).

A third example is the relationship between mental and brain states. There is the identity theory, according to which each mental state is identical with a brain state (toward the end of his discussion Strawson recognizes that the motivation behind the theory is the tacit acceptance of eliminative materialism), and there is also the dualist (not necessarily Cartesian) theory, that rejects any such identity. Again, the diagnosis of the disagreement is that there is a failure to recognize a difference of standpoints. One standpoint is that of the diarist or biographer. The other is that of the physical scientist. No choice should be made between them, no attempt to achieve "a unified theory where none is to be had" (*Skepticism and Naturalism*, pp. 61–62).

Now, obviously, my intention in this paper is not to discuss in detail any of these three topics, or those I shall mention in Section II. It is to try to understand Strawson's relativity thesis.

What does he mean by a standpoint from which x's are really F (or from which there really are F's) and a standpoint from which x's are not really F (or from which there really are no F's)? The obvious first possibility is that we have two mutually contradictory views, but this is exactly what the relativity thesis denies.

A second possibility is that there is no contradiction because the word *really* is equivocal, it is used in different senses in the apparently contradictory assertions. I find no support for this interpretation in *Skepticism and Naturalism*, but there is such support in *Analysis and*

Metaphysics. In the latter work, we find Strawson saying, with regard to the second topic, that

> the phrase 'things as they really are' is used with different senses, or different criteria of application, in the two propositions. In the sense in which it is used in the first proposition, all ascription to things of qualities peculiar to a given sensory mode—as colour, felt texture, etc.—is excluded from the description of things as they really are; the standard of reality is physical theory. In the more ordinary sense in which the phrase is used in the second proposition, such ascription is not excluded Provided that we distinguish the two uses of 'real' or 'reality', we can grant to each standpoint, each standard, its own validity. (p. 66)

This passage is difficult to judge since it employs, without the needed distinctions, the notions of a sense, a criterion of application, a standard of reality, uses of *real*. Only the first notion clearly supports a diagnosis of equivocation. If that were the right diagnosis, then Strawson's relativity thesis would be of little interest—nothing substantive rests on a mere equivocation—and at any rate would seem obviously false: surely the word *real* is not equivocal in the cases under consideration. It is not like the word *bank*. As to *uses* of *real*, equivocation would be the obvious diagnosis only if we crassly identify the meaning or sense of an expression with its use, something I doubt the premier living British philosopher would do. (The general thesis of his ground-breaking article "On Referring"[5] was to distinguish them.) Even Wittgenstein, to whom we owe the slogan, was not at all fully committed to it. Indeed, in chapter 4 of *Skepticism and Naturalism* Strawson is explicit about this. As to criteria of application, we are at best left with another controversial Wittgensteinean notion. If we mean what Wittgenstein called a "defining criterion," then presumably we are back to the uninteresting diagnosis of ordinary equivocation. If we mean what has been called a nondefining criterion, then we are left with one of the most obscure philosophical notions of recent invention. The remaining notion on our list, that of a standard of reality, is of course too close to the relativity thesis to be of much help in understanding it.

In many places Strawson has defended the Kantian view that "experience is permeated with concepts" (*Analysis and Metaphysics*, e.g., pp. 85, 64), that (speaking of Wittgenstein's remarks on aspect-seeing) "Beside Wittgenstein's metaphor of the 'echo of the thought in sight' we might put others: the visual experience is *irradiated* by, or *infused* with, the concept; or it becomes *soaked with the concept*" ("Imagination and Perception," in *Freedom and Resentment*, p. 57). This is why "[Kant] would agree that it would be impossible to give accurate, plain reports of our perceptual experience which did not incorporate those beliefs [in the continued and distinct existence of

bodies]. The beliefs form an essential part of the conceptual framework which has to be employed to give a candid and veridical description of the perceptual experience" (p. 50). The "picture of a *concept-free* access to facts, to reality" is "confused and ultimately self-contradictory." "[Y]ou can have no cognitive contact with, hence no knowledge of, Reality which does not involve forming a belief, making a judgment, deploying concepts" (*Analysis and Metaphysics*, p. 86). One can question this, of course, depending on how seriously one takes the word "cognitive." Presumably the acquisition of one's first concepts is grounded in experiences that did not involve concepts. Perhaps this is why Strawson qualifies his claim that thought, experience, and language are inseparable from each other by saying that this is so at any *developed level* (*Skepticism and Naturalism*, p. 92). Unlike Strawson, I do not think that this is essentially a psychological issue that we may ignore.

Nevertheless, perhaps now we have the answer to our question about what Strawson means by his relativity thesis. It is not a matter of ordinary contradiction, or simple equivocation, or employment of different mysterious criteria of reality. It is a matter of a clash, but not contradiction, between different conceptual schemes (or different parts of one and the same general conceptual scheme). There is a clash because the schemes are about one and the same subject matter, e.g., the objects of perception (*Analysis and Metaphysics*, pp. 66–67). But there is no contradiction because the concepts (or at least some of them) employed in one scheme are different from those employed in the other, and we cannot separate the concepts from the subject matter and judge independently which concepts are faithful to the subject matter. The latter is permeated by the former. To question this "might be an invitation to step outside the conceptual scheme which we actually have—and then to justify it from some extraneous point of vantage. But there is nowhere to step; there is no such extraneous point of vantage" (*Analysis and Metaphysics*, p. 64).

So far, so good. But the next question we must ask, of course, is, What does Strawson mean by "concept"? If he meant what many others have meant, e.g., a word or a use of a word, then we can just express our disappointment and refer to what we have already said about these notions when employed in an explanation of the relativity thesis. But, at least in *Skepticism and Naturalism*, Strawson means none of these. In chapter 4 of that book, he argues (though he also expresses some lack of confidence) against "a purely naturalistic account, a naturalistic reduction, one might say, *of the matter of meaning*—and all that goes with it" (p. 78), having in mind mainly the Wittgensteinean view that meaning is correct use, the standard of correctness being social agreement. He asks, "does this account do justice to our experience? to our experience, for

example, of recognizing particular things as of a certain general character or kind?" (p. 78), including the recognition of linguistic expressions themselves (p. 84)? His answer is negative. What is involved in recognition is the seeing of a particular as falling under a concept, or attribute, or property, or kind, or type, or in general under what philosophers have called universals (p. 69). What is characteristic of all these is that they are abstract, not natural, objects, that they are not in nature, that they are not locatable in space or datable in time (p. 70).

There is here, surprisingly, a Fregean conflation of the notion of a concept with the notion of a property or attribute. We appealed to the notion of a concept in order to understand the notion of a conceptual scheme, and we appealed to the latter in order to understand the relativity thesis. Now let us agree that properties and attributes are nonnatural objects, that they are not in space or in time. But surely conceptual schemes are datable and also locatable in (at least in the sense of being attributable to) the persons who employ them. How exactly does a concept, understood as an abstract object, enter our conceptual scheme, and especially how does it "permeate" our perceptual experience? A comparison with H. H. Price's *Thinking and Experience*[6] may help here. Price begins the book with a judicious, neutral discussion of what he calls "the philosophy of universals" and "the philosophy of resemblances." Then he proceeds to the topics mentioned in the title of his book, and describes a concept as "[f]undamentally a recognitional capacity" (p. 355), the ability to see something as the same again. That he thought there was an intimate connection between concepts, so understood, and universals or resemblances is obvious. But it is equally obvious that he thought of concepts as being essentially characteristics (e.g., capacities) of human beings, and of universals or resemblances as being in or between the objects to which the concepts are applied.

But suppose that Price had actually adopted what he called (in chapter 1 of his book) the moderate, Aristotelian version of the philosophy of universals, according to which universals exist only *in rebus.* (Officially, he maintained neutrality on the issue.) Then universals could be said to permeate our experience, and recognition to be simply the "seeing" of the universal in the particular, the seeing of the particular as such-and-such. Then the difference between him and Strawson would be minor. In favor of his use of the word "concept" Price might have simply appealed to the idiom of describing people as possessing or lacking a given concept. But Strawson might have defended *his* use by pointing out that while of course it is people who have or lack the capacity to see a given universal in a particular, it is the presence of the universal that is meant when we describe experience as permeated with concepts, while our seeing or failing to see the universal is a matter of import only to

empirical psychology. And Strawson might have gone on to say that his account explains what it is to have a recognitional capacity, while Price's, because of its neutrality with respect to the philosophy of universals, does not. He might also have pointed out that his view of the relationship of concepts to experience fits better the traditional notion that experiences (as contrasted perhaps with their objects as these are "in themselves") are essentially qualitative in nature. It is interesting that in *The Bounds of Sense* Strawson seems to adopt, in passing, a view very much like Price's. He writes: "we can surely acknowledge that we can form no conception of experience, of empirical knowledge, which does not allow of our becoming aware in experience of particular items which we are able to recognize or classify as instances of general kinds or characteristics. We must have the capacities for such recognitions and classifications, i.e., we must have general concept. . . ."[7] But capacities do not permeate experience. Their manifestations do. Does this amount merely to the truism that any object of experience, at least qua experienced, must have attributes and be experienced through those attributes, or is there something much deeper involved?

II

There are other questions to ask. I spoke of a clash between conceptual schemes, though a clash that does not constitute a contradiction. And I suggested that there is a clash between the conceptual schemes because they have the same subject matter. But in some of the examples that Strawson gives, it is not clear that this condition is satisfied, and in others he denies that a clash is possible.

He seems to place most weight on the clash between the phenomenal and the scientific pictures of the objects of perception. In a clear sense, they are about the same objects. But is it obvious that these objects are seen, perceived differently? I suggest that it is not. The scientist does not *perceive* objects as lacking phenomenal properties. At most, he only *thinks* of them as such in his professional moments. The properties he does then ascribe to them do not permeate his or anyone else's experience. They may be said to permeate some of his thought, but that is a different matter. When he says (if he is foolish enough to take a stand on this philosophical issue) that material objects do not really have phenomenal properties, he is not speaking from a different and conflicting standpoint, in Strawson's sense. Rather, he is using *really* in what may be called its theoretical sense, the sense in which he might say, for example, that there really are no truly rigid rods, a sense quite irrelevant to Strawson's relativity thesis. (There is yet another, different but no less

irrelevant use of *really*, namely what may be called its fictional use, as in "None of Shakespeare's characters is really flawless.") Indeed, in "Perception and its Objects," Strawson writes: "Without the [alleged] illusion of perceiving objects as bearers of sensible qualities, we should not have the illusion of perceiving them as space-occupiers at all; and without that we should have no concept of space and no power to pursue our researches into the nature of its occupants. Science is not only the offspring of common sense; it remains its dependant" (p. 112). The point is especially obvious when we recall that scientific claims must rest, at least to a degree and in however chaotic a way, on the perceived phenomenal characteristics of *observed* objects such as instruments and of course natural objects and events. The standpoint of what Wilfrid Sellars called "the scientific image" presupposes that of what he called the "manifest image," and without the latter would either be incomprehensible or remain, as perhaps it does, mere science fiction, in neither case constituting a standpoint to be contrasted with that of common sense, from which we can view (understand) the world.

I am inclined to make similar remarks regarding the mind-body dualism issue. I doubt that eliminative materialists (I shall ignore the identity-theorists, who seem to me just to misuse the word *identity*) fail to perceive at least themselves, and almost certainly also others, as having irreducibly mental states. Their position, as represented for example by Paul Churchland in *Matter and Consciousness,*[8] seems to be little more than a preoccupying interest in recent neurophysiological developments (or even in computer technology—another current interest among academics) and the fervent hope that somehow, some day, perhaps centuries from now, somebody will prove them right. The motivation, it seems to me, is again purely theoretical, like that of the physicist though less praiseworthy, and has nothing to do with the adoption of what Strawson calls a standpoint. The materialist too has her headaches and merely speculates about the state of neurophysiology in the distant future. (But in Section III I shall qualify this.)

Curiously, the cases that support Strawson's relativity thesis are precisely those to which he hesitates to apply it, because he hesitates to allow that in fact it is possible to view the subject matter in those cases from different standpoints. I mentioned earlier the clash between the standpoint from which human beings are seen as possessing objective moral properties and the standpoint from which they are viewed as mere organisms. In *Freedom and Resentment* he seems to allow only for occasional detachment from, and internal modifications in, what he calls "the general structure or web of human attitudes and feelings" (p. 23), but not for an external appraisal and abandonment of it, as might seem to some to be called for by the thesis of determinism. But this is very

questionable, and at any rate I do not see how it is to be decided by philosophers. It is, of course, explicitly denied by many philosophers and scientists. Indeed, like Thomas Nagel, I too am inclined to deny it.[9] Seeing persons as mere things and thus avoiding the moral standpoint seems not only possible but, unfortunately, not uncommon.

Strawson explicitly declines to apply his relativity thesis to skepticism regarding the existence of bodies and regarding induction. His prime example is Hume. He distinguishes between "Hume the sceptic and Hume the naturalist," the former being the Hume who denies that either the senses or reason can provide us with justification of our belief in bodies, or of our acceptance of induction as valid, the latter being the Hume who proclaims that it is vain to ask whether there is body, nature not having left it up to us to seriously raise this question, and who also cheerfully proposes definitions of causation. According to Strawson, while in the moral case it is at least theoretically possible to view human behavior purely naturalistically, it is not even theoretically possible to view the world of bodies as nonexistent and induction as invalid (*Skepticism and Naturalism*, pp. 39–40 et passim.) Again like Nagel, I disagree. But my reasons are somewhat different.

Both moral skepticism and skepticism regarding the external world and the validity of induction are philosophical positions that, as Nagel points out, are generated by fairly ordinary experiences. The relativity of moral beliefs across cultures, the all too frequent and sometimes almost total surprises the future confronts us with, the occurrence of dreams and hallucinations, all naturally *suggest* the extreme skeptical positions. But, of course, skepticism is a philosophical position, defended with arguments and regularly attacked with arguments. The evaluation of these arguments, not the avowal of agreement or disagreement with the skeptic, is the proper business of philosophy.[10] I doubt that Strawson would disagree with what I have just said. But this is not the issue. The issue is whether the skeptic's conclusions can be internalized, whether they can constitute standpoints from which to view people, the "world," and the future. (I shall continue to use the word *skepticism* for what is really a stronger position: the denial of the reality of what the skeptic questions; there is no readily available word for the latter position.) I have expressed the opinion (only a scientist can go beyond mere opinion on such matters) that the standpoint of moral skepticism can be internalized. But I believe Humean skepticism about the existence of bodies and the reasonableness of induction also can be internalized and thus constitute a standpoint from which to view the "world."[11]

Indeed, Hume (like Descartes, in the *Meditations*) somewhat theatrically described the temporary effects of his skeptical reasonings on him. Could they be more than temporary? I don't see why not. One may

regard the objects of one's perceptions as neither continuous nor distinct, or cease to have any expectations about the future. What is true is that such a person would be so abnormal that we would regard him as insane and probably as in need of being protected from himself. But this is hardly philosophically important. It is hardly more important than the fact that people who seem to lack any moral sensitivity are often called moral idiots. Their state is unfortunate but hardly a philosophically significant fact. And we do not win arguments by name-calling.

So both the standpoint of moral skepticism and that of skepticism about the existence of bodies and the reasonableness of induction are humanly possible, indeed almost certainly exist, and contrary to what Strawson implies at least about the latter, they too would generate a relativity of *really*s, if we grant the general possibility of such relativity. From the standpoint of moral skepticism, there really are no moral qualities. From the standpoint of skepticism with regard to the senses, there really are no bodies. From the standpoint of skepticism about induction, past experience provides us with really no reason to expect anything about the future. It is just that these standpoints are seldom internalized. But sometimes they are, and indeed do clash with the opposite standpoints. With respect to them we do not have the comfort, as we do with respect to scientific realism, of regarding the use of *really* as merely theoretical, in the sense I have explained. If I am right, so far only the "standpoint" of the eliminative materialist *with respect to* herself is impossible (but see the qualifications below), while that of the scientific realist is not a standpoint in Strawson's sense at all.

III

But do we have a relativity of standpoints even in the cases of the moral skeptic and the skeptic about the existence of bodies and the reasonableness of induction? To be sure, we do have a genuine difference in attitude toward the world. But are the different attitudes equally acceptable? I mean, of course, acceptable from the standpoint of reason, not socially or psychologically or politically acceptable. The relativity thesis requires us to say, yes. I shall take the case of skepticism about the existence of bodies as my example, because of Strawson's ambivalence about that of moral skepticism. There are arguments both for and against such skepticism. Strawson holds that the existence of bodies and the reasonableness of induction belong to our basic conceptual framework, to question the legitimacy of which would be unintelligible. But surely Hume's questions are not unintelligible. If, as Strawson correctly points out, Hume misunderstood the relation between perception and its

objects, the skeptic could easily appeal instead to Descartes's dream-argument, which does not presuppose representationalism even though Descartes was a representationalist. Is that argument unintelligible? Hume claimed that the conclusions of such skeptical arguments are unbelievable, vain. Strawson agrees, and for this reason rejects them. He writes: "Skeptical doubts are not to be met by argument. They are simply to be neglected . . . because they are *idle*; powerless against the force of nature, of our naturally implanted dispositions to belief" (*Skepticism and Naturalism*, p. 13). I have given reasons for thinking that skepticism is neither unbelievable nor vain. But what matters is the obvious question, even if it were, so what? As Moore said, "the direct object of Ethics is knowledge, and not practice."[12] If this is true of ethics, surely it is true of epistemology.

But, clearly, we have not done justice to Strawson's relativity thesis. Let us recall that he speaks of the relativity of *really*s and that at least at one place he says that there is "a certain ultimate relativity in our conception of the real" (*Skepticism and Naturalism*, p. 44). The relativity thesis is the thesis that the concept of reality is relative. Now, quite apart from the examples we have canvassed, it should be clear that the concept of reality need not be relative just to standpoints; it could be relative to persons. Let us ask what might be meant by such relativity.

Consider an ordinary concept, such as that of the (phenomenal) color blue or that of the (phenomenal) shape square. To say that the concept of the color blue is relative presumably would be to say either that the word *blue* is equivocal or that the appearance of blue color to people is relative to their circumstances and visual capacities. I shall ignore the latter alternative. This leaves us with the first. Well, what would it mean to say that the word *blue* is equivocal? Accepting Strawson's realism regarding properties, presumably the answer is that in some cases, for some people, it stands for a property other than that (those) for which it stands in other cases, for other people.

Now, can we say that the concept of reality is relative in this sense? No, but now for reasons deeper than those that led us to reject the supposition of equivocation earlier in this paper. Rather, its relativity is due to the fact that, though a genuine concept, with applications to things, it stands for no property of things. (This resembles and in fact is related to, but is not the same as, Kant's familiar argument that existence is not a real predicate[13]). But how does the relativity of the concept follow? Not from the fact (if it is a fact) that it is applied to different situations by different people or different cultures, but from the fact that since it stands for no property, indeed, for *nothing* in the world, there is no objective constraint on our application of it, as there is in the case of the concepts of blue and square. Our application of it is a matter of habit,

of a way (form?) of life, not of recognition of an objective fact. But would not agreement in judgments with other people act as such a constraint? No, because we must presuppose the concept of reality in judging that any such agreement is real.

To describe the concept of reality in this way is indeed to divorce it from any connection with properties or attributes, but still the description retains what I take to be the spirit of Strawson's use of the concept of reality, indeed of his use of the very concept of a concept. To employ a metaphor that is not at all unfamiliar, we may say that a concept is a way of seeing what it is applied to, though we should understand "seeing" here broadly, as we do, e.g., when we speak of seeing the solution of a mathematical problem. Sometimes a way of seeing is grounded in and legitimized by the presence in the subject matter of a certain property. But sometimes it is not. And the concept of reality is an example of seeing of the latter kind. (The closely related concept of identity, as I shall suggest shortly, is another example.) There can be no question of grounding or genuinely legitimizing its use. But it is a genuine way of seeing things and, at least in principle, there can be variation in such ways of seeing that would justify the label of relativity.

Let us again take as an example the skeptic about the existence of bodies. She simply sees the objects of perception as fragmentary, disjointed, in a perpetual flux. She denies the reality of bodies, which she correctly assumes are supposed to have exactly the opposite characteristics. (She may still have the concept of reality, because she may contrast how she sees the objects of perception with how she sees mathematical objects—she may be a Platonist!) Could she, on the other hand, happily apply the concept of reality to the disjointed items she perceives and thus accept the way Berkeley professed to see them? Yes, but only on the supposition that they are also perceivable by other minds, presumably God. Otherwise the tie of the concept of reality with the concept of identity would be severed. This is why one's natural response to Berkeley's claim that to be is to be perceived is that it involves a gross abuse of the concept of reality (being), too gross to be excused as merely expressing a way of seeing things. Seeing things as Berkeleyan ideas of sensation is possible, but the description of these ideas as real objects is unintelligible, unless we import the hardly less unintelligible supposition of their public perceivability. The concept of reality may stand for nothing in the world, and may be equally legitimately applied in very different situations, but from this it does not follow that it is totally wanton—it is a *concept* after all.

What makes a concept of reality a concept of *reality*? Here the connection with the concept of identity, of which I have already hinted, becomes crucial. (And I don't have in mind Quine's slogan "No entity

without identity," which Strawson critically discusses in his important paper bearing that title.[14]) I have in mind the fairly obvious fact that we see objects as real when we see them as having a certain identity in the sense of being identical with indefinitely many "other" objects. This fact is familiar though difficult to state without offending philosophers' logical sensibilities. Some simple examples would make it, however, clear. We see a visible object as real perhaps because we see it as identical with a certain tangible object. We see a man, who, unexpectedly, is found in our private office as real (rather than hallucinatory) perhaps because we recognize him as, see him as identical with, the man next door.

This is not the place to elaborate on this point. I have done so elsewhere.[15] I shall conclude by observing that it is even more evident that the concept of identity corresponds to nothing (e.g., to no relation) in the world. Whether x is identical with y depends on how we see them, not on our detecting a relation of identity between them. This is why philosophical disputes about certain alleged kinds of identity (bodies' identity through time, personal identity, qualitative identity between particulars) are hardly resolvable by argument. At best we may hope to resolve them by showing the weakness of the arguments for the position we oppose and by appealing to analogies that the opponent may be willing to accept. Appeals to "intuitions" are merely pretentious avowals of our confidence that we are right.

Perhaps the best example of this common philosophical predicament is the science fiction of brain transplantation, and the interminable wrangles among philosophers writing about it. If this is not an example of what we may call the relativity of identity, I don't know what would be one. But the relativity of identity immediately engenders the sort of relativity of reality to which I have devoted this section. Whether the person whose brain was transplanted still exists is a matter of whether we see him and the recipient of the brain as the same person.

How does this suggestion affect some of the topics to which Strawson applies the relativity thesis? I have hinted that the eliminative materialist cannot seriously believe that she does not have a headache when she does have one. But she also is not one likely to have reflected on the concept of reality. Can her view be rationalized with the help of what I have been suggesting in this section? Wittgenstein said that in his private-language argument he was not asserting that a sensation is nothing but only that neither is it something. I shall ignore his further explanation that in the language-game a nothing would serve as well as a something, because I think one can offer an explanation deeper than one that has to do with language. What is this explanation? The reader would guess of course that it is to be found in Wittgenstein's claim that a sensation, understood as a private object, is not reidentifiable. Though he did not draw this

conclusion explicitly, we can immediately say that it follows that a sensation, so understood, is not something real. It is not literally nothing, of course, since after all it was the subject of the question whether *it* was reidentifiable; we knew which item the question was concerned with. But, like Meinong, perhaps Wittgenstein was aware that there is no simple dichotomy between something and nothing. Even to raise the question of the reality or nonreality of something we must at least think of that something. In view of his article "Is Existence Never a Predicate?," included in *Freedom and Resentment*, and the revisions he made in the earlier article "On Referring," I hope Strawson would not be totally unsympathetic to this suggestion.

Now a reasoning like this may substantiate even an intelligent eliminative materialism, at least with respect to qualia. But the extent to which it may do so would depend very much on how we see our sensations. I shall limit myself here to illustrating my point. A person has a headache when going to bed, awakes in the middle of the night with a qualitatively similar headache, and arises in the morning again with a similar headache. She can see the three as distinct but ephemeral events and for this reason may refuse to ascribe to them genuine reality. But she could also see them as one and the same headache, unfelt for long periods of time but nevertheless *there*. In other words, she may apply the concept of identity to them or deny it. If she does apply it, I suggest, she would be much more inclined to view the headache as a real event of some duration. Which would be the right thing for her to do? There is no answer, I suggest, since there is no fact of the matter that could ground either decision. She may be swayed by her physician's report, but even if the physician has found a persistent physiological disturbance that accompanies the headache(s), this would in no way compel either the patient or the physician to treat the episodes as three experiences of one headache. It would at most motivate a conceptual decision to apply the concept of identity and thus of reality; it would not justify it. Hence the relativity of reality, grounded in the relativity of identity.

To be sure, I am speaking only of the basic, noninferential cases. After the initial applications of the two concepts, which surely precede the acquisition of language (after all, as Strawson observes, words themselves have to be recognized, seen as the same again, if they are to be learned), a (presumably intersubjective) conceptual structure is built up, or joined in, that guides our conceptual decisions about reality and identity. It is only then that it would make sense to speak of *criteria* and of *paradigms* of reality and identity. But when faced with the sorts of philosophical conundrums that Strawson attempts to resolve with *his* relativity thesis, we may be led to recognize the ultimate relativity of even those criteria and paradigms.

I do not wish what I have said in the last few paragraphs to be taken as an interpretation of Wittgenstein or of eliminative materialism. And it certainly is not meant to be attributed to Strawson. But I believe it connects closely enough with all three to provide the respective views, those I have mentioned, with a somewhat different rationale. Nor has my purpose in this paper as a whole been to criticize Strawson. It has been to raise certain questions, chiefly, What does he mean by a concept?, especially by the concept of reality, with the hope of eliciting an answer that goes beyond what he has written. If I succeed in this, the paper would have served the only purpose it did, or should have been expected to, have.

PANAYOT BUTCHVAROV
DEPARTMENT OF PHILOSOPHY
UNIVERSITY OF IOWA
OCTOBER 1994

NOTES

1. P. F. Strawson, *Skepticism and Naturalism* (New York: Columbia University Press, 1985).
2. P. F. Strawson, *Freedom and Resentment and Other Essays* (London: Methuen & Co., 1974).
3. P. F. Strawson, *Analysis and Metaphysics* (Oxford: Oxford University Press, 1992).
4. P. F. Strawson, "Perception and its Objects," in Jonathon Dancy, *Perceptual Knowledge* (Oxford: Oxford University Press, 1988). The article originally appeared in G. M. McDonald, ed., *Perception and Identity: Essays Presented to A. J. Ayer* (London: Macmillan, 1979).
5. P. F. Strawson, "On Referring," originally published in *Mind* 59 (1950): 320–44, reprinted with revisions in Antony Flew, ed., *Essays in Conceptual Analysis* (London: Macmillan, 1956).
6. H. H. Price, *Thinking and Experience* (London: Hutchinson's University Library, 1953).
7. P. F. Strawson, *The Bounds of Sense* (London: Methuen, 1966), 47–48.
8. Paul Churchland, *Matter and Consciousness,* revised edition (Cambridge and London: MIT Press, 1988).
9. Thomas Nagel, *The View from Nowhere* (Oxford: Oxford University Press, 1986), 124ff.
10. See J. J. Valberg, *The Puzzle of Experience* (Oxford: Clarendon Press, 1992), chapter 8: "Ignoring the Problematic Reasoning: Strawson on Hume and Wittgenstein."
11. Consider the case of a person who constantly checks the door to make sure it is locked. For reports of such cases and of many others that exemplify

what she calls "skepticism gone wild," see Judith L. Rapoport, "The Biology of Obsessions and Compulsions," *Scientific American* 260, no. 3 (March 1989): 82–89, and *The Boy Who Couldn't Stop Washing: The Experience and Treatment of Obsessive-Compulsive Disorder* (New York: Dutton, 1989).

12. G. E. Moore, *Principia Ethica* (Cambridge: Cambridge University Press, 1971, originally published in 1903), p. 20.

13. The argument is not as clear as it may seem, and it may be said that Kant merely meant that existence is not a monadic property, and held the phenomenalist view that it is a relational property, that of entering in appropriate relations with other actual or possible experiences. For example, see *Critique of Pure Reason*, A225/B272–A226/B273. For an illuminating discussion of this aspect of Kant's philosophy, see Hans Seigfried, "Kant's 'Spanish Bank Account': *Realität and Wirklichkeit*," in Moltke S. Gram, ed., *Interpreting Kant* (Iowa City: University of Iowa Press, 1982). I am indebted to Professor Günter Zöller for bringing this to my attention.

14. P. F. Strawson, "No Entity without Identity," in H. D. Lewis, ed., *Contemporary British Philosophy*, Fourth Series (London: Allen and Unwin, 1976).

15. Most recently, in "The Untruth and the Truth of Skepticism," in *Proceedings and Addresses of the American Philosophical Association* 67, no. 4 (January 1994). See also my *Skepticism and the External World* (New York: Oxford University Press, 1998).

REPLY TO PANAYOT BUTCHVAROV

In his lively and interesting paper Professor Butchvarov touches on a wide range of issues, but, as his title indicates, his primary concern is with the suggestion I made in *Skepticism and Naturalism: Some Varieties* that, in certain cases, two apparently contradictory views about the same subject matter can be reconciled, can both be allowed validity, provided we are prepared to *relativize* our conception of the *realities* of the case to each of the respective standpoints from which the apparently conflicting views are advanced.

As I remarked in my reply to Professor Adams, we must begin with some distinctions. There are just two types of case in which I explicitly embrace the relativizing move referred to above. These are, first, the case of moral reactions and attributions to human behavior and, second, that of the attribution of phenomenal sensible qualities to observable physical objects. Professor Butchvarov gives, as what he calls "a third example," the relationship between mental and brain states, suggesting, it seems, that I represent disagreement between those who accept and those who reject the thesis of identity of mental with brain states as another instance of failure to recognize the possibility of embracing the relativizing move in this case also. Of course I do no such thing. On the contrary I simply reject the identity thesis. I do indeed accord equal validity to both the ordinary human practice of seeking to understand and explain human behavior in predominantly mentalistic terms and the legitimate scientific search for a causal explanation of the details of bodily movement in purely physicalist terms. But these are in no sense competitors and no appeal to the relativizing move is called for.

The issue of traditional skepticism about the material world is equally irrelevant, since I do not invoke the relativizing move in this connection either. I cannot think of anyone to whom such a move could have any appeal except those philosophers—at best a vanishing breed—who contrive, in their philosophical moods, to be strict phenom-

enalists. Hume was not among them. On the remaining issue discussed in the book, 'the matter of meaning', I do indeed show how the relativizing move *could* be invoked in this case, but express the dubiety I feel about its reconciling power here.

There remain the matters of sensible qualities and moral attributions and reactions. Professor Butchvarov appears to find my position unclear or elusive, particularly as regards my employment of the word *really*. But, speaking unequivocally, as I do throughout, it really is not. The position is this. Most of us, for all of the time, and some of us, for most of the time, are humanly committed, in speech and thought, to the nonreductive naturalist spirit, and it is in this spirit that, without any *arrière pensée* we express our moral reactions, frame our moral judgments and characterize observable physical objects as variously colored, textured, or shaped. *Really*, if it figures at all in such utterances, figures unequivocally. But it is possible, at least for some, and at least sometimes, to understand matters differently, and in the spirit of this understanding to view the just-mentioned judgments and characterizations as simply the result of the projection of subjective reactions—either sense-experiential or affective-emotional—on to the objects and behavior which elicit them: in each case both the reactions themselves and the items on which they are projected are real indeed; but that, on this view, is all. Two important points should be made about each of the variants of this position. First, as theoretical views about their respective subject matters, neither is eccentric. There is plenty of evidence, from both the past and the present of philosophy, that informed and thoughtful people have held and do hold one or the other or both. But, second, it is comparatively rarely and in rather special circumstances that either view is clearly and fully reflected in actual human practices and attitudes: in the moral case, the circumstances are of the kind I mentioned in my book; in the case of sensible qualities, the circumstances are perhaps those of the researcher, trained in the physics and physiology of perception, at work in his laboratory. But this is no reason to question the full and unequivocal force of the *really*s that may figure in the expression of the views in question, whether merely affirmed by reflective philosophers (and scientists) or also imbuing and affecting our practical attitudes. What is inescapable, as I have said, is the relativity of these *real*s or *really*s to the respective standpoints of the two varieties of naturalism that I was at pains to distinguish.

I doubt if this will satisfy Professor Butchvarov. But it is the best I can do. Or perhaps I can do better by turning finally to the questions which, at the end of his paper, he says it has been his chief purpose to raise, viz. what do I mean by a concept? and especially by the concept of reality

First as to *concept:* where I have carelessly written as if there were no difference between concept and property (or universal), I was clearly in error. Someone may have the concept (e.g., know what generosity or courage is) without having the property (being generous or courageous); equally someone may have the property (e.g., be diabetic or tubercular) without having the concept (knowing what diabetes or tuberculosis is). The concept is, roughly speaking, the idea or thought of the general thing, the property, the property is the general thing itself.

Reality, really, and *real* are more complex. They are best understood by contrast. There is the range of contrasts which particularly appealed to Austin: a real (as opposed to a decoy) duck; real (as opposed to artificial) silk; real (as opposed to paste) diamonds. In all these cases there is an actual concrete item or items; but it or they fail to satisfy the conditions for the unqualified application of the relevant predicate; they are not truly (really) duck, silk or diamond. More to the present purpose is another range of contrasts: where *real* is opposed to *fictitious* or *mythical* or *delusive* or *illusory* or *imaginary* or, simply, *nonexistent.* The Austinian items which are not really (in reality) what they appear to be do not fall foul of any of these more significant contrasts. They exist all right, are real things or items. So what does Professor Butchvarov make of the more significant contrasts?

Well, he insists, first, on a strong connection between the concept of reality (existence?) and that of identity. No one would quarrel with that; but it is not quite clear how Professor Butchvarov understands the connection. The idea seems to be that to be satisfied of the reality of a putative item, x, we must be satisfied that, for some y, x is identical with y. But the force of this requirement is unclear. Would the simple availability of alternative descriptions of the putative item suffice? Butchvarov's examples seem to suggest that at least where concrete particulars are concerned, something stronger is needed: reidentifiability over time or over sensory modalities. But, again, this is not clear: he himself remarks that even to raise the question of the reality or unreality of something, we must at least be able to think of (identify?) *it* (the something); which suggests that a minimal condition of reality (existence, occurrence) is more easily satisfied.

Do these discussions advance understanding of the *reallys* whose relativization is in question? Not, I think, very much. The important contrasts, with *fiction, illusion, nonexistence,* still stand. The reductive naturalist insists that all there really is in the disputed cases consists of certain physical, behavioral and reactive features which do not include either naively understood visual and tactile qualities of physical objects or specifically moral qualities of human actions; the nonreductive naturalist, on the other hand, persists in asserting that such qualities

really do characterize their putative bearers. What I have been contending is that we are now humanly capable of appreciating the force and legitimacy of both viewpoints and even—though rarely, if ever, at the same time—of occupying both. So the point, ultimately, is a point about ourselves. And there is nothing wrong with that. 'The proper study of mankind is man'. It is at least a large part, if not the whole, of the proper study of philosophers.

P.F.S.

5

Richard W. Behling

TWO KINDS OF LOGIC?

A. N. Whitehead has maintained that it is more important that a statement be interesting than that it be true. This interesting dictum, though false, is important, for it puts us readers in the proper frame of mind when we read and evaluate Sir Peter Strawson's extended statement—his essay—"Two Kinds of Logic."[1] We shall have trouble in reporting that Strawson's remarks, contained therein, are true, well-taken, or correct—to write perfunctorily—but his expressed position is of great interest, especially to those who were both edified and entertained by Strawson's lively attack upon Lord Russell's "Theory of Singular Descriptions," proffered some four decades ago.[2] Indeed, we shall have occasion to return to the exchanges between Russell and Strawson of that time, but, first, let us try to get clear on the nature of the newborn kind of logic of which Strawson writes.

Quite expectedly, Strawson's second kind of logic is distinguished from the hoary, formal, deductive logic which dates from Aristotle through Peano and Frege, through Russell and Whitehead and, lately, through the mathematically minded philosophers, Gödel, Post, Hilbert, Ackermann, Leblanc, and other such luminaries. But Strawson's new logic is not contra-distinguished from the deductive instrument, replete with its "entailment rules." Strawson's new logic is not the inductive variety of the scientifically minded or the abductive variety of the elder pragmatists; rather, it is a logic of ordinary language (or of ordinary-language usage), replete with its characteristic "referring rules." This new logic—the "referring rules" one—is said by Strawson to "supplement" the received one—the "entailment rules" kind—so as to form a more adequate logical system. Indeed, a logic which displays only entailment rules cannot tell the complete logical story. Something must needs be lacking from that tale told by Aristotle and his distinguished students! But, *what* is lacking? What is inadequate in the formal,

deductive logic, in the "entailment rules" that formal logicians hold in such high esteem?

Well, Sir Peter's argument, as I reckon it, might be stated thus. The subject matter of formal logic is intimately connected with (some) natural language (say, English, French, Dutch, etc.). More to the point, Logic is necessarily concerned with truths and falsehoods, and it sets highest priority on the necessary transmissions of Truth from premises to conclusion in the arguments it sanctions. Since, then, the *meanings* of the premises and conclusion that go into the making of a given argument, (to be analyzed) must needs be gleaned (so as to provide fodder upon which a given logic system might be used), rules to be used for the attainment of those meanings must be presented, adopted, and codified so that the System of Logic at hand might do its intended job.

But, hold! Do we not remember that it is not the bare string of words that is either true or false, but the *use* of such a string on this or that historical occasion, at this or that spatio-temporal locale? Perhaps we should recall the problems that Lord Russell encountered when he dared to imagine that the entire meaning of a statement could be exacted through the use of the entailment rules of deductive logic alone. When Russell took the *analysandum*, "The present king of France is wise,"[3] so as to illustrate the workings of his own vaunted theory of definite descriptions, he thereby showed its deficiency. Or so Strawson argued.

Strawson maintained then, and he maintains now, that it is unmeaning to speak of the truth-value of such an *analysandum*. There have been times (spatio-temporal locales) where and when the use of the word-string, "The present king of France is wise," whether parsed in accordance with Russell's theory of descriptions or understood straightforwardly (in that vulgar sort of way), is simply true; at other times, its use, the assertion, would have been false. Then, again, our reigning king at the time of our presentation may be deemed wise by some, and not up to it by others. What shall be said then? Or, most importantly, what if our putative assertion, "The present king of France . . . ," is made just now, in 1998, when there is no reigning monarch in France? Wouldn't it be correct simply to note that our putative assertion (in this final case) is not an assertion at all, that the use of our word-string has no truth-value, that we fail to express anything either true or false in our unhappy circumstance of utterance, that we presuppose something that might have made our use of the given word-string happy (that is, either a true usage or a false one)?

Such is Strawson's criticism—or, at least, a portion of his criticism—of Lord Russell's so-called "theory of (singular) descriptions." And let there be no doubt that Lord Russell felt himself under attack;

Russell bemoaned the fact that Strawson had fixed upon Russell's own "King of France" word-string, ignoring the less vulnerable, "The author of *Waverley* was Scotch."[4] This latter word-string is, indeed, either true or false—namely, true—quite independently of its occasion of use[5] and, if I might now come to say it, if Strawson had read the whole of my writings, he would have seen clearly that he has nothing to teach any of us, for his "insights" about Usage and Truth were already made by me in earlier writings. Or so came Russell's vitriolic reply to Sir Peter.

Now, the philosophical hour is late, and for the purposes of this essay—and, one would hope, for *any* purpose—a "winner" in this dispute need not be determined. Although, in truth, were I to be assured that the defendant Russell would not "take the stand to speak in his own defense" (as he did in his essay, "Mr. Strawson on Referring"), I should like to gainsay Strawson's criticisms from *one* (important, I believe) perspective. And so I shall. And so the present essay continues!

Let us return, just now, to the distinction that is defended in earnest by Strawson: the distinction, that is, between *formal* logic (with its attendant "entailment rules") and *ordinary-language* logic (with its attendant "referring rules"). We recall that, according to Strawson, the truth-conditions relevant to the *use* of a declarative word-string are given, not only by the ol'-time entailment rules (as Russell and other mathematically minded logicians would have us believe), but by the newfangled referring rules of our supplement to deductive logic. And let us return, too, to the perspective of the subject matter of Logic (or a portion thereof) which I attributed to Strawson in the third paragraph of this essay. We maintained there that, according to Strawson, the subject matter of Logic (of whatever ilk) is inextricably tied up with the goings-on in a natural language; logic must needs concern itself with what is true or false; and, thus, since it is the *use* of a declarative sentence that is either true or false, Logic must concern itself with declarative sentences as used, on this or that historical occasion. Again, and because of this truism, entailment rules of deductive logic are to be supplemented by the referring rules of the ordinary-language logician. It is only when the one logic supplements the other that "the complete logical picture" emerges.

Well, how are we "mathematically minded logicians" to reply? What are we to say to all of this?

Before we get too far along in our response, we might do well to ask of our plaintiff, Strawson, just one more thing. An illustration of how the hybrid Logic might work (in the context of the proffering of an actual argument and in the evaluation thereof) would be nice. And it is just here where (in some small measure) Strawson comes up short. He allows us to guess as to how our supplemented logic would work, but in fairness

to Strawson we should concede that he has given us a sufficient number of cues (or clues) so that even we who are rather unimaginative might come up with an example.

Let me take as a first example an item that first appeared in a recently published logic primer. Its author writes:

> There are some arguments that are valid because of their non-logical content. For example, consider the following valid argument:
>
> (1) John McEnroe is a professional tennis player.
> ∴(2) John McEnroe is a professional athlete.
> The principal logical form of this valid argument is the invalid form
> (1) A
> ∴(2) B
>
> But the argument is valid nevertheless, because of its non-logical content.[6]

Now, we suspect that Strawson—not to mention most of the others of us—would have some serious reservations about the position here taken. From the Strawsonian perspective, and given our tool of the hybrid logic, we must view, say, this "McEnroe" argument from the perspective of an historical occasion of its use. Were I to use it just now, I would use the name "John McEnroe" to refer to that gentleman who is of short fuse and gifted backhand, that man in his thirties who, yesterday, provided color commentary for women's tennis matches at Wimbledon, the one who made small-talk with Dick Enberg, etc. And I would use the terms "professional tennis player" and "professional athlete" in just that way that 99.99 percent of us would customarily use it in this year, 1998. (By the way, I am not wholly confident that McEnroe continues to play professional tennis at the time of this writing. And Strawson, in his evaluation of the above-presented argument, might well make some moment of whether or not McEnroe still participates on the professional tour.)

But, just as Strawson would have reservations about the correctness of our author's position, I think that he would be somewhat sympathetic with it as well. One must understand that the "referring rules" which Strawson champions are, admittedly, somewhat "inexact," their implementation being a somewhat "fluid" affair.[7] So, although Strawson would not have it that the "McEnroe" argument (used, just now, by me) is valid *because* of its nonlogical content, he might well maintain that it is a valid enthymemically-used one (which has suppressed the true usage of the declarative sentence, "All tennis players are athletes") because of *both* its formal structure *and* its historical content. But we must be careful. When Mr. McEnroe—the Mr. McEnroe to whom I have recently referred, that is—dies, the "McEnroe" argument (again, evaluated from

the perspective of Strawson's hybrid logic) might well warrant further examination. If nothing else, there might come a time, for example, when athletes worthy of that sublime name would not stoop to playing tennis, a game worthy only of sissies! And one begins to wonder: as humans become more "macho" (relegating noncontact sports such as tennis to sissies, to nonsportsmen[!]), does the use of the "McEnroe" argument move from the realm of the valid to that of the invalid (upon a possible, later *usage*)?

Now, one might imagine that Strawson has a rather terse answer for the question lately asked: "Yes!" And one imagines that he could give this answer without blushing, for were we not the ones who maintained that a "true statement (or word-string)" must remain true for all time, when, in fact, the self-same word-string can be used to make both a true and a false assertion? Why ought we not say that an argument might be used to assert a valid connection between its premises and conclusion today and used tomorrow to express an invalid argument?

This question—whether it be endorsed by Strawson himself or raised only somewhat rhetorically by me—deserves an answer. And I should like to suggest that a fitting prologue to that response is a passage from J. L. Austin:

> Philosophers often seem to think that they can just 'assign' any meaning whatever to any word; and so no doubt, in an absolutely trivial sense, they can (For example, some meanings that have been assigned to 'know' and 'certain' have made it seem outrageous that we should use these terms as we actually do; but what this shows is that the meanings assigned to these terms by some philosophers are wrong.)[8]

It is important that we philosophers should understand well the folly of Humpty-Dumpty's view, namely, that words (and their usages) are our slaves, not contrariwise. Words are not obsequious; they cannot be played with, or stretched, with impunity. I may say that I am satiated just before I die of starvation; and I may identify the television set in my living room with the subject matter of Logic, but one remains innocent of that discipline while watching my television set, be it turned on or off!

We simply cannot play fast-and-free with such terms as "logic," "valid," "rule," and "entailment." These terms (like many others in that cluster used predominantly in the subject matter of [what has come to be called] Analytical Philosophy) have a now, long-distinguished history of usage. They may be stretched, but their discursive tensile strength is not as strong as a G. E. Moore or a P. F. Strawson might think. When we read that Moore understood the subject-matter of Logic to include "formal logic, general questions about the nature of truth, about grounds, evidence, proof; and perhaps . . . also . . . all the questions which now

go under the head of the philosophy of language,"[9] we begin to wonder, not about Logic, but about Moore! And, in this regard, let us return to Strawson's view—his incorrect view, as I should have it—of the nature of, the subject matter of, Logic.

First, it must be acknowledged that the subject matter of formal logic once was inextricably connected with concerns of ordinary discourses. Without "ordinary," natural-language argumentation, Aristotle's syllogistic would not have been invented, if for no other reason than that it would have served no (practical) purpose. And, without the syllogistic, there would have been no formal logic (at least, not as we know it today). Historically, and until the beginning of the present century, ordinary-language discourse did have a most intimate association with Logic, that is, with the logic of Aristotle (as extended by the medievalists). Logic had a strong affiliation both with the True and with the False, just as Geometry—"geo-metry"—once had a strong affiliation with the Earth and with the measurement thereof. But linguistic epochs, once strong, are revised so that new word-use histories come into focus. And they calcify.

It is interesting that, early on in his essay, "Two Kinds of Logic," Strawson remarks, "it is with ordinary discourse that I am [here] concerned."[10] One is struck by the candor of that pronouncement, and one is thankful for Strawson's forthrightness, but I think that it is safe to say that Logic, as understood today, has long since enjoyed a divorce from ordinary language. And if Strawson's feet are in the muddy turf of ordinary discourse, perhaps we should simply suggest that Logic, now conceived, is no longer *gründlich* in that way, and that it is no longer acceptable to criticize a logician for having one or both of his feet out of the muck of natural-language usage. But, *that* is precisely the kind of assault that Strawson launches against the mathematically minded philosopher. "Excuse me, Sir; you have but one foot in the muck!" "Madam, pardon me, but you seem to fly well above the slop!" These motifs seem to supply both the criticism of the Logician *and* the springboard for a new, hybrid kind of logic-system. Let me explain.

Strawson and many of his *belles-lettres* colleagues seem to have it that there exists an intimate, and necessary, connection between Logic and Truth (Falsehood); further, since truths (and falsehoods) are, to put it preliminarily, the fruits of declarative sentences, Logic must needs be concerned with (a) natural language (and its grammatical strings). And, further, since it is not *just* the acceptable declarations of a natural language which concern the logician, but their *uses* (in socio-historical contexts), the Logician must need be concerned with uses—"utter-

ances"—of declarative sentences—unique truth-value bearers—by those who employ the language at hand.

But, clearly, this view is muddled. First, even if we accept the dubious idea that there exists an intimate (necessary) connection between the subject matter of logic and natural-language usage, it by no means follows that Logic is necessarily concerned with that which is true/false! D. S. Clarke, Jr., and others, have written cogently of logical systems which reflect usages of imperative sentences (commands), coupled or not with sentences used indicatively. Consider:

(1) If you (Jones) want to succeed, study hard!
 I (Jones) want to succeed. Thus, I must study hard.
(2) Take this letter and post it! Thus, post this letter!

Clearly, in (1), its first premise is not the sort of item that can be true or false, but the inference of which it is a part is (one is tempted to say) valid; and it seems that (2) is clearly valid, although it is composed exclusively of constituents that cannot be either true or false.

More importantly, and excluding imperative (and like esoteric) logics, we can see how Logic (in general) need not lean against natural-language usage, and, certainly, not against truth-values. Indeed, let us consider how the mathematician (and the mathematically minded logician) uses (the adjective) "true."

First, he or she does *not* use that term to characterize axioms, "givens," or starting points.[11] We can all recall how in Plane Geometry class we were asked to try to prove such-and-so, given this-and-that. We may have been asked to demonstrate that, if a pair of parallel line-segments were cut by a transversal, a specific pair of its alternate interior angles is equal in degrees. If a picture of the goings on were produced, it would have been quaint (at best) or silly (at worse) for someone to object, "But *those* line-segments aren't really parallel. See? As I now extend them (*properly, using straight-edge*), they intersect!" "So what?" we should be given to ask! Our (mathematical) inquiry has to do with what follows from the given or, to be verbose, it has to do with what follows from the given, if true. And mathematicians, by nature, tend *not* to be verbose!

When "true" and "false" are used in logico-mathematical circles, that usage is deviant from ordinary-language usage. For logicians/mathematicians, the word "satisfies" wears the pants, and notions of the true and of the false are derivative. Consider:

(1) We might say that the function, "*x* is wise," is satisfied by (the substituend) "Strawson." Thus, Strawson is wise; if one insists, it is true that Strawson is wise.

(2) "$x = x + 1$" cannot be satisfied. Instances of this function are neither axioms nor theorems of standard number theory. (Whence the appeal to The True, The False?)

One should not assume that ". . . is true" and ". . . is false" have univocal function in both ordinary- and logico-mathematical usage. The "ordinary" user of these appellatives is fixed (usually) upon stating how, whereas his own remarks accurately reflect reality, the utterances of his fellow do not accurately describe reality. In logic, in mathematics, in chess, there is no "reality" (no extra-systemic realm) to be described, either poorly or well. (No chess-master or novice has ever wondered, "How is it, this marriage between the Red King and the Red Queen?" Rather, the "entire meaning" of each of these entities is given wholly in terms of how each moves on the checkerboard.)

Occasionally, in pursuing a logic text, one bumps into such a passage as this:

> All . . . proofs rest upon four basic laws (axioms, postulates, conventions):
> 1. The Law of Identity. In a fixed context, the truth value of a proposition cannot change. If p is true in a setting, then it is true throughout that setting; and if it is false there, then it is false throughout. . . .[12]

"Truth value?" "Fixed context?" "Proposition?" "If p is true?" (I would have thought that 'p' is simply a symbol which functions ideally in well-defined ways in systems in which it plays a part.) Consider how (the symbol) 'p' actually functions in logistics.

It appears, or might appear, in the context of an axiom, "$(p \lor p) \supset p$." Given a rule of substitution, the same axiom might be expressed: "$((p \lor q) \lor (p \lor q)) \supset (p \lor q)$." Or, given a law of substitution which would allow for the replacement of strings of the form $p \lor p$ by p, and conversely, our originally written axiom might now be expressed as (the theorem) $p \supset p$, (the theorem) $(p \lor p) \supset (p \lor p)$, etc. All that is required of (the symbol) "p" is that, in all of its occurrences, it appears as a token of the same type. The semantic mumble-jumble regarding truth and propositions and settings are very much beside the point here; indeed, these notions, in the context of a logistic, are unintelligible! Of course, the "variables"—the "p's," "q's," "r's," etc.—of a logistic might be given interpretations (in a corresponding informal logic), but the system itself exists independent of any interpretation.

Such considerations as these are important when we seek to consider and to evaluate such things as Russell's theory of (singular) descriptions, Strawson's attack upon that "theory," and Strawson's promulgation of the ordinary-language logic. First, to begin at the beginning, we must recall what it was that Russell tried to accomplish in his analysis of

definite and indefinite descriptions. We must remember what meaning he gave to each.

In his "On Denoting," Bertrand Russell was concerned—explicitly concerned—with the shortcoming of the ontologies of both Frege and Meinong *vis-à-vis* the reference of singular, definite descriptions. Informal (interpreted) systems of logic featured particles of the forms, "a so-and-so" and "the so-and-so," and it was necessary to provide to those entities analogues in formal systems which might allow for reasonable, nonartificial understandings. As a proposal, Russell offered a *paraphrasis* for descriptions, definite or indefinite. The proposed paraphrasis for definite descriptions provided for (what might be called) the truth-conditions (or meaning) for interpreted schemata of the type, "The so-and-so exists" or "The so-and-so is such-and-such." The statement of this "paradigm," whether given strictly and formally (in the *Principia*, where Russell himself would have us look for it) or informally, by way of illustration (in "On Denoting"), details a way in which (the particle) "the ϕ" might be understood, whether formally or informally. And, although Russell did make mention of the necessity of considering the truth-values of those independent parts of the informal paraphrasis given to (the form) "The so-and-so is such-and-such," his concern with "truth" was wholly foreign to his ordinary-language critics.

Russell writes:

> (I)f I say 'the author of *Waverley* was a man', that is not a statement of the form 'x was a man', and does not have 'the author of *Waverley*' as its [logical] subject We may put, in place of 'the author of *Waverley* was a man', the following: 'One and only one entity wrote *Waverley*, and that one was a man'.
> . . . The proposition 'Scott was the author of *Waverley*'. . . becomes 'One and only one entity wrote *Waverley*, and Scott was identical with that one'; or, reverting to the wholly explicit form: 'It is not always false of x that x wrote *Waverley*, that it is always true of y that if y wrote *Waverley*, y is identical with x, and Scott is identical with x'.[13]

And we students of Russell glean from this paraphrasis the notion that "The so-and-so is such-and-such" is true (to use that term) just in case the function "x is uniquely so-and-so and x is a such-and-such" is sometimes true, that is (using obvious abbreviations), that the function: "x is a ϕ, and given anything that is ϕ, it is x, and x is Ψ" is satisfiable, that is, that $(\exists x)\,(\phi_x \cdot (y)\,(\phi_y \supset x = y) \cdot \Psi_x)$.

We should heed, too, what Russell means (if only by implication) by the term "proposition." Anticipating Quine's position on Meanings, Russell uses "proposition" to designate a sensible ("physical") object, namely, a grammatical concatenation of words, typically presented on the printed page. "Meanings" find a place amongst the constituents of

declarative sentences only in grammatically proper names that denote uniquely, that is, amongst the so-called "logically proper names" (and that meaning is, then, that [unique] *designatum*). When it comes to the putative meanings that Russell assigns to definite and indefinite descriptions, David Kaplan states matters best:

> In the case in question the new expression to be introduced is the definite or indefinite description operator. But what meaning is given to it, or even to the full description? None! For the central thesis of Russell's theory is that this phrase has no meaning in isolation.[14]

Indeed! Kaplan is instructive here on two points. First, the concern of Russell (in his treatment of "the so-and-so") relates to the definite description *operator*, namely, the "$(\imath x)$" in its several symbolic contexts; thus, Russell's concern–his proper and only concern–related to the matter of how the definite description operator is to be interpreted from the logistic in which it found its place. His concern, that is, had to do exclusively with the use of "$(\imath x)$" at both the formal (logistical) and informal (interpreted) levels of logical discourse.

Secondly, Kaplan uses a bit of hyperbole so as to make us understand—not that the definite description has *no* meaning in Russell's view—but that "$(\imath x)$" has contextual meaning only, given in its now-familiar definition-in-use. (To suggest that descriptions have no meaning in Russell's system is only to note that they are "unsaturated" [in Frege's sense].) The general point, then, is that, since definite descriptions have no meaning in isolation, there is nothing for Russell to be correct or incorrect about in his proposed definition-in-use; if his definition is helpful to us (at the formal and informal levels of analysis), we are free to adopt his view; if not, we are free to discard it.

Well, with all of this behind us, let us turn to the tasks at hand. Let us make explicit the (mistaken) way in which Strawson views the Russellian logistic, and, secondly, let us see how it is that Strawson's view of "a new logic" (replete with its "referring rules," used to supplement the "rules of inference" of the received system) is a chimera. First thing first.

I noted earlier that Strawson, being concerned with ordinary discourse, tends to evaluate the logical stance of Russell (and, one presumes, the stances of others) partly on the basis of the adequacy of Russell's treatment of this "ordinary" discourse. And there is the problem! Russell, as I have lately suggested, is not concerned with the "slop" of ordinary speech—not at all. If G. E. Moore uses (the word) "some" to designate a few things—You know!, say, three or four or more things—that is Moore's business, and at the level of ordinary discourse we must not disregard what the astute Moore has to say! But the logician

is not checked, "grounded," by ordinary usages of familiar terms. For him, "some" is conveniently used so as to designate at least one entity, so that in his logistic it will be possible to define with ease such notions as "at most three," "exactly four," "at least two," etc. The sloppy (vague) use of "some"—quite important for some ordinary-language ends—is eschewed by the logician so as to attain precision, a *desideratum* of logistics. Russell does not *fail* to capture formally the nuances of ordinary-language usages; he does not *fail*, for he does not *try*! The high-jumper who knocks off a cross-bar while taking off his warm-up jacket does not fail at the height at which the bar has been set!

It seems that the *belles-lettres* philosophers—even those who, like Strawson, have a superior understanding of the formal work done by the mathematically-minded philosopher—tend to view the formal logician, or feign to view him, as a kind of latter-day Procrustes, that is, as one who does discursive dirt to some commonly used words by stretching or contracting them on beds (forms) of canonical notations until their very life-blood has all but been extracted! But, again, this understanding is perverse, and I cannot help but draw upon ill-advised criticism of Wittgenstein's early writing so as to illustrate my belief.

One Wittgensteinian critic writes:

> Wittgenstein never gave an example of anything that he recognized as an elementary proposition because he thought that the elementary propositions of a language would be recognized only after a complicated analysis had been carried out.[15]

Nonsense! If Wittgenstein was perturbed by those who asked him to illustrate the meaning of "elementary proposition," he would have been upset by anyone at any time who might have dared to expect an illustration or two. The *Tractatus* is a kind of rudimentary logistic; as such, its aims have naught to do with ordinary-language illustration. No amount of analysis will exact an extrasystemic meaning for a term like "atomic fact," for these "facts" are not to be confused with, say, the concrete facts noted by the court reporter or historian. For Wittgenstein, the term "elementary proposition" has contextual meaning only, and its use—wholly foreign to what is familiar to us–is analogous to, say, the way in which Whitehead uses (the non-English term) "prehension" in his expositions.

Indeed, it is important to understand how the goals of Wittgenstein's *Tractatus* differ from those in his *Investigations*. These differences are most germane here. When I remarked earlier that precision is desirable in mathematical language, my observation may strike some as mere platitude . . . and, in one way, it is! But we should not think that the goal

of *all* language-use is precision. In truth, in many ordinary circum-
stances, in using the vernacular, we want an instrument which allows for
vagaries. Husbands who arrive home in the wee hours, being asked
"Where?" questions by their wives, do not strive for mathematical
precision in their responses! When we say that the traffic was heavy or
that the waiting room was crowded, we do not speak precisely, but, then,
we have not that desire! And, again, when I report that some students
came to my office, I fully mean to be vague. I don't know their exact
number. I didn't count them!

The poet knows well the role of effective vagaries, and the mature
user of a natural language knows how to exploit ambiguities. When
Alexander Hamilton mused on the ideal qualities of his wife-to-be, he
said, "As to religion, a moderate stock will satisfy me; she must believe
in God and hate a saint." Delightful! We get the point! And our
understanding doesn't rest upon whether (the indefinite description) "a
saint" is understood "in the singular" or "in the plural"!

Remarkably, Professor Strawson (*contra.* the illustrations of language
use just presented) would have us believe that logicians are concerned
with (explaining) the meaning of a statement-making sentence, . . .
(saying) under what conditions someone who used it would be making a
true[or false] statement"[16] And, of course, he is quick to remind us
that his use of (the statement-making sentence) "My cat is dead" will
differ from King's use, Smith's use, etc. With a flourish of trumpets,
then, Strawson gainsays the majority of formal logicians who supposedly
claim that ". . . formal logic is an adequate instrument for the dissection
of ordinary speech."[17]

We scarcely know how to reply! First, I rather doubt that any logician
within whose breast a sense of the sublime lurks would be given to the
view that the notations of formal logic can capture adequately the
nuances of ordinary speech; on the contrary, logicians seem to make a
show as to how their usages of, say, ". . . and . . ." and ". . . but . . ."
resist precise differentiation. Further, although we could not deny that
sentences which contain egocentric particulars are used by various
speakers and writers (etc.) to mean various things, we must deny that
that fact is relevant to the adequacy of a given logic (logistic, logical
system); the lexicographer, the linguist, and, perhaps, the grammarian
are—all of them—concerned with specifying the conditions under
which a given usage of a word-string is to be counted as true, but the
logician need not offer an opinion; logic need not concern itself with that
which is true and that which is false. Insofar as it does, it departs from its
proper role in furthering knowledge.

Since the term "formal logic" is redundant, we are well-advised to

deny the possibility of a "logic of ordinary language," of a special kind of rule. Let us adopt the Wittgensteinian dictum—"Look and see!"—so that we might understand why.

When we look to see how ordinary language is actually used, we are able to understand the folly of trying to tame, to understand, that usage by subjecting it to "rules" of any kind. Allow me to illustrate this point, if only briefly, and with but a couple of examples.

I once watched a soccer match, broadcast on television, with a mathematician friend. During the course of events, a player fell to the turf, and there he remained, motionless, for about ten minutes. He was removed from the field on a stretcher, and he failed to respond to stimulants. Needless to say, everyone was concerned with his well-being, so the television announcer sent his assistant to the locker room so as to bring back a report on the player. Some twenty minutes later, the runner returned with the following message: "The doctors tell me that Cowlor may, or may not, return to the game."

Everyone, or nearly everyone, was relieved, of course, because the message (however one might try to restate it) was clear. But, my pedantic friend seemed still a bit on edge; "Well, of course there's a possibility of his return *or* a possibility that he'll not return," he began, "but what we want to know is: will he be all right?"

To take Strawson's own example—"My cat is dead."—it is not at all clear how anyone's clarification of the meaning of the use of this word-string could possibly help the logician in his scholarly pursuits. What Strawson might mean by his use of this string is that Strawson's cat is dead, but *meanings* (propositions) are not what the logician is after. What is at hand is the word-string, "My cat is dead," and it is that (physical) object with which the logician must concern himself. A *meaning* does not have a form; meanings, therefore, are not of concern to the logician. (It was Austin, I think, who had it that a person must have something on his platter before he can mess around with it.) As for "referring rules" that might be used so as to "transcribe" Strawson's use of "My cat is dead" to (say, the inscription) "Strawson's cat is dead," what would be the nature of that rule? Whence its origin? How can we affirm this rule (for this specific case?) rather than another. Jones, who has been assigned by Interpol to follow Strawson for the past fifty years, reports that Strawson never has used that statement-making sentence! Its use, from the mouth of the seemingly patriotic Strawson, means, "The Queen is dead, and I have succeeded in killing her!" (For the whole of her life, my maternal grandmother called me "Donnie," the name of my brother. She got his name right: she called *him* "Donnie," too! Does the use of a Strawsonian "rule" come into play here? How could it?)

CONCLUSION

Some years ago, *New Yorker* magazine published a cartoon which depicted a beleaguered, middle-aged husband who was seated most uncomfortably on his living room couch. His wife hovered over him, and she was to get in the "last word" in their heated debate; "And what *you* must understand," said she, "is that my argument has nothing to *do* with logic!" Rule following, as I should like to put it, has little to do with ordinary discourses; there are occasional "tips of the hat" to the canons of informal logics, but referring *rules*—Could there be anything quite so austere in our street-talk?—are not only not used by us, they are unknown to us!

And, we should note, too, that even if there were acknowledged, accepted rules that could be used so as to "precisify" the vagaries of ordinary word usages, the employment of those rules would tend to damn the use of the instrument of formal logic; inference rules would have little hope in a system that contained referring rules. Consider:

If any canon be sacred in formal logic, it would be that if the conclusion of an argument and one of its premises are tokens of the same type, then that argument is valid.[18] Thus, on any account of logic, the argument, "Today is Monday. Thus, today is Monday.", must needs be deemed valid. But, of course, if referring rules are used, the egocentric terms used in the distinct instances of "Today is Monday" must (or might) be made clear. And, of course, if the premise of the argument at hand were used during the duration of the 58th and 59th seconds of the 23rd hour of July 25, 1994 (a Monday) and its conclusion were used during the next two seconds' duration, the argument, faithfully rewritten so as to take usages into account, would have a true premise use and a false conclusion use, the hallmark of an invalid argument (on the Truth-value interpretation of Validity); in any event, the conclusion of the "rightly understood argument" would not be deducible from its premise, so, again, our verdict would be that the simple argument at hand is (at least sometimes?) invalid.

Or what if the Earth were destroyed. Would we have it that (the word-string) "Today is Monday" is unmeaning in any of its possible uses, and, hence, that the argument, "Today is Monday. Thus, today is Monday.", is neither valid nor invalid, but—What?—silly?[19]

Professor Strawson rightly reasons that if logic and truth be intimately related, the logician must needs concern himself with usages of statement-making sentences (given in ordinary discourse), for it is there where, generally speaking, truths and falsehoods are to be found. But I have endeavored to show that there is no intimate connection between

the domain of the logician and the Truth or the Falsehood. Logic and Language have long-since divorced, and logic has become a formal discipline . . . just as Geometry, once intimately connected with the measurement of the Earth, has become divorced from its mundane beginnings to become a formal discipline.

There are those, of course, who will want to hold tightly to what they believe to be a significant contribution made by Sir Peter in the realm of logic. One writes:

> We may state the main thesis of the Theory of Descriptions thus: If 'the F' is a definite description and '. . . is G' is a monadic predicate phrase, then the proposition expressed by an utterance of 'the F is G' is logically equivalent to the proposition expressed by an utterance expressed by an utterance of 'there is one and only one F, and everything that is F is G'.[20]

Mercy! That may be Leon Russell's paraphrasis of "the so-and-so," but it ain't—It could not be!—Lord Russell's doctrine. There can be no place in Logic for *utterances* (usages) or for *propositions* ("things that are expressed by").

Those of us who have even a passing interest in (what has come to be called) pragmatics are indebted to Sir Peter Strawson, for it is he who is to be credited with its discovery. But logic is logic, and pragmatics is pragmatics, and ne'er the twain shall meet!

RICHARD W. BEHLING

DEPARTMENT OF PHILOSOPHY AND RELIGIOUS STUDIES
UNIVERSITY OF WISCONSIN—EAU CLAIRE
AUGUST 1994

NOTES

1. P. F. Strawson, *Introduction to Logical Theory* (London: Metheun & Co., Ltd., 1967), 211–32.

2. P. F. Strawson, "On Referring," reprinted in A. P. Martinich, ed., *The Philosophy of Language* (New York: Oxford University Press, 1985), 220–35.

3. Bertrand Russell, *An Introduction to Mathematical Philosophy* (London: George Allen and Unwin, Ltd., 1919), reprinted in Martinich, op. cit., 217ff.

4. In his "Mr. Strawson On Referring," Russell would have us believe that Strawson had to pick and choose from amongst Russell's own examples so as to show the supposed weakness of Russell's stance. In truth, no matter which of Russell's examples he might have selected, Strawson's criticism might have been the same. In his criticisms, Strawson was (to paraphrase the Cole Porter lyric) always true to Russell in his fashion, always true to Russell in his way.

5. Well, Russell would have us believe that this word-string is true independently of its occasion of usage, but, of course, it would be unmeaning (on straightforward interpretations) at any time before the writing of *Waverley*.

6. Kathleen Wu, *Discovering Formal Logic* (Guilford, Conn.: Dushkin Publishing Group, 1994), 47.

7. *Introduction to Logical Theory*, 230.

8. J. L. Austin, *Sense and Sensibilia* (New York: Oxford University Press, 1964), 62–63.

9. P. F. Strawson, *Analysis and Metaphysics* (London: Oxford University Press, 1992), 31.

10. *Introduction to Logical Theory*, 212.

11. We must "cross our fingers" here. Certainly, Euclid selected his axioms and postulates because of their true—their obviously true—content. I write here of the contemporary mathematician and logician.

12. James Hall, *Logic Problems for Drill and Review* (Lanham, Md.: University Press of America, 1991), 1.

13. "On Denoting," reprinted in R. M. Harnish, ed., *Basic Topics in the Philosophy of Language* (Englewood Cliffs, N.J.: Prentice Hall, Inc., 1994), 168–69.

14. David Kaplan, "What is Russell's Theory of Descriptions?", reprinted in D. F. Pears, ed., *Bertrand Russell: A Collection of Critical Essays* (Garden City, N.Y.: Doubleday and Company, Inc., 1972), 233-34.

15. Robert J. Ackermann, *Wittgenstein's City* (Amherst: University of Massachusetts Press, 1988), 86.

16. *Introduction to Logical Theory*, 211.

17. Ibid., 216.

18. Actually, the only kind of argument (-form) that logicians would universally deem as valid would be one wherein the last-stated premise (-form) is typographically identical with the conclusion; in that case, the statement of the argument (-form) itself would constitute a proof of that item. An argument of the form, "$p, q \vdash p$" need not be deemed valid for, on a Deducibility definition of "validity," the first premise may not admit of being "reproducible" from the set of premises in accordance with given rules, laws, etc.

19. One is here reminded of the Positivists' nightmare in their trying to decide upon whether or not (the argument) "2 + 2 = 4. Thus, 2 + 2 = 4, or stealing is wrong," is valid. Some, like Strawson, took the natural language "dress" of this inference far too seriously and decided that this argument is neither valid nor invalid, but meaningless!

20. Stephen Neale, *Descriptions* (Cambridge, Mass.: M.I.T. Press, 1990), 6.

REPLY TO RICHARD BEHLING

F rege observed that it falls to logic to discern the laws of truth; that the word 'true' indicates the aim of logic as does 'beautiful' that of aesthetics and 'good' that of ethics.

This is not Professor Behling's view. There is, he says, no intimate connection between the domain of the logician and truth or falsehood. Logic, he holds, is a purely formal discipline; in the expression 'formal logic' the word 'formal' is redundant. The discipline is concerned solely with the question of which word-strings or symbol-strings (physical objects) are validly deducible in the system from which others. Consequently 'logic need not concern itself with that which is true and that which is false'; and the logician can dismiss as beside the point, or even, in the context of a logistic, as 'unintelligible', what Professor Behling calls the 'semantic mumble-jumble regarding truth and propositions and settings'. For example, the logician must hold that any argument in which the premise is typographically identical with the conclusion is valid. The fact that such an argument might on a given occasion—because of variation in the reference of indexical expressions or in the sense of predicate-expressions—have a true premise and a false conclusion has nothing to do with the case!

Well, this is one view of the matter; and anyone who holds it with such admirable consistency as Professor Behling is free to make just such cheerful fun as he does of the notion that 'referring rules', or any other pragmatic-semantic 'mumble-jumble', has any relevance to logic. But it is worth pointing out that not all respectable logicians have taken quite such an austere view of their subject; and that the relevance of logic to rational discourse in general would come into question if this were the only view to take. I do not deny that the term 'formal logic' can, perhaps should, be understood in precisely the strict sense which Professor Behling defends. But there is surely a case for understanding the *unqualified* term 'logic' in a more liberal fashion, preserving its link with

semantic, and therefore also with pragmatic, considerations. So all of us do in practice and many in quite refined theory.

Incidentally Professor Behling does me too much honor in crediting me with the discovery of 'what (has come to be called) pragmatics'; and, given that most of us have mastered the correct use of indexical expressions, it must be an exaggeration on his part to say that referring rules are unknown to us in our street-talk.

P.F.S

6

John McDowell

REFERRING TO ONESELF

I

In an influential passage in *The Blue Book*,[1] Wittgenstein distinguishes "two different cases in the use of the word 'I' (or 'my')," which he calls "the use as object" and "the use as subject." We have the use as object in, for instance, "My arm is broken," "I have grown six inches," "I have a bump on my forehead"; we have the use as subject in, for instance, "I see such-and-such," "I think it will rain," "I have a toothache." Wittgenstein explains the distinction like this:

> One can point to the difference between these two categories by saying: The cases of the first category involve the recognition of a particular person, and there is in these cases the possibility of an error, or as I should rather put it: The possibility of an error has been provided for It is possible that, say in an accident, I should feel a pain in my arm, see a broken arm at my side, and think it is mine, when really it is my neighbour's. And I could, looking into a mirror, mistake a bump on his forehead for one on mine. On the other hand, there is no question of recognizing a person when I say I have toothache. To ask "are you sure that it's *you* who have pains?" would be nonsensical And now this way of stating our idea suggests itself: that it is as impossible that in making the statement "I have a toothache" I should have mistaken another person for myself, as it is to moan with pain by mistake, having mistaken someone else for me.

And he suggests a conclusion: "To say, 'I have pain' is no more a statement *about* a particular person than moaning is." That is, "I," at any rate in the use as subject, does not serve to refer to a particular person. It is not the case that the role of an utterance of "I," in helping to determine the significance of an utterance of a form of words like "I have toothache," is to indicate that of which the rest of the

utterance is predicated—what the rest of the utterance has to be true *of*, if what one says in making the utterance is to be true.

II

In "The First Person,"[2] G.E.M. Anscombe explicitly argues that "I" is not a referring expression (p. 61):

> Getting hold of the wrong object *is* excluded, and that makes us think that getting hold of the right object is guaranteed. But the reason is that there is no getting hold of an object at all. With names, or denoting expressions (in Russell's sense) there are two things to grasp: the kind of use, and what to apply them to from time to time. With "I" there is only the use.

"I"-statements have, as it were, the look of predications, with "I" in subject position. And there is indeed a subject of predication, a target of reference, in the offing: in the case of my "I"-statements, the person John McDowell.[3] If I make an "I"-statement, it is true just in case its apparently predicative material is true of the person John McDowell; and in that specification of a truth-condition, we have a proper predication, with an authentic singular term denoting the item of which the predication is made (see p. 60). But according to Anscombe, it would be wrong to suppose that my "I"-statement is another way of predicating that material of that same item. "I" said by me is not another way for me to refer to that item.

Anscombe does not invoke the passage from Wittgenstein or exploit the distinction between the use as subject and the use as object. Her thesis seems to be quite general: an utterance of "I" does not refer, no matter what apparently predicative material it is concatenated with—"have a broken arm" no less than "have a toothache." Wittgenstein's suggestion, in contrast, seems to leave it open to us to suppose that at least in the use as object "I" is a referring expression. Still, Anscombe's point that "getting hold of the wrong object is excluded" is surely a descendant of Wittgenstein's point that no provision is made for a certain possibility of error.[4]

Her treatment of "I" centers on its role in giving expression to "unmediated conceptions (knowledge or belief, true or false) of states, motions, etc." (p. 62), where the truth or falsity of the "I"-statements turns on whether the states, motions, etc. can be truly predicated of (in my case) the person John McDowell. The significance of "unmediated" comes out clearly in her exploitation of an anecdote from William James (pp. 64–65). A person nicknamed "Baldy" had fallen out of a carriage; he had the idea that someone had fallen out of the carriage; and, on being

told that Baldy had, said "Did Baldy fall out? Poor Baldy!" This indicates a "lapse of self-consciousness," which Anscombe locates in the fact that Baldy's "thought of the happening, falling out of the carriage, was one for which he looked for a subject" (p. 65). An unmediated conception of the falling, in the relevant sense, would have been one for which that was not so. (Compare Wittgenstein's "there is no question of recognizing a person.")

This connects in an obvious way with the fact that "getting hold of the wrong object is excluded." Getting hold of the wrong object would be going wrong in looking for a subject of which to predicate the content of a conception. If there is no looking for a subject, there is no going wrong in looking for a subject.

We need also to deal with the use as object. There Wittgenstein's point, in the present terms, is that the conceptions expressed are not unmediated: looking for a subject is not excluded. I have a conception of, say, having a broken arm, and in Wittgenstein's accident case I need to look for a person of whom the state that my conception is a conception of could be truly predicated. (In another case I might not need to look for a subject for the predication; but even so, I know which person it is whose arm is broken in the sort of way in which one knows when one came to know by looking for a subject for predication.) But Anscombe's position is that here too, when I say "I have a broken arm," I am not predicating the state, having a broken arm, of a person to whom I refer by my use of "I." And that seems the right line for her to take.

What do I convey by saying "I have a broken arm," rather than, say, "John McDowell has a broken arm," which would be unproblematically a reference concatenated with a predication?[5] Presumably the point of using the first-person form is to effect a certain association between my mediated conception of the state, having a broken arm, and the unmediated conceptions to which I could give expression in what we can think of as the central uses of "I." By saying "I have a broken arm," I indicate that the person whose possession or not of a broken arm is to determine the truth or falsity of my statement is the one whose states, motions, etc. would determine the truth or falsity of statements I might make in which the first-person form would give expression to unmediated conceptions of those states, motions, etc. But if we must suppose that in the case of these potential other statements, where the conceptions are unmediated, the person in question would not be determined by being referred to, surely we had better suppose that in the associated uses too.

Anscombe says: "The expression 'self-consciousness' can be respectably explained as 'consciousness that such-and-such holds of oneself'" (p. 51). Here "oneself" is the "indirect reflexive," which is intelligible only

in terms of the first person. The only explanation of the *oratio obliqua* form, "consciousness that such-and-such holds of oneself," is in terms of an *oratio recta* form containing an expression of the first person: consciousness whose content is given by "Such-and-such holds of me." (See pp. 46–47.) Now this account of self-consciousness is indifferent to whether the conception expressed in a replacement for "such-and-such" is mediated or unmediated. But Baldy's lapse of self-consciousness, in Anscombe's account, lies in his lack of unmediated conceptions of states, motions, etc. of the person Baldy (p. 65). That is surely right; and that is why expressions of unmediated conceptions are the central uses of "I," even though self-consciousness (in the sense of Anscombe's general account) is exemplified also in uses of "I" that express mediated conceptions. If there are no unmediated conceptions, as perhaps in some states of dissociation, then first-person talk and thought lapses altogether. But if first-person talk and thought is available at all, then it—that very thing, and hence self-consciousness—can extend to mediated conceptions (the use as object) as well.

III

Anscombe's thinking here starts with an insight. It is indeed fundamental to an understanding of first-person forms that their central use is in expressing unmediated conceptions. But we can acknowledge that, and nevertheless refuse to accept that "I" is not a referring expression. We can block the inference by giving proper weight to this remark of P. F. Strawson's, which formulates the beginning of wisdom on these questions: "'I' can be used without criteria of subject-identity and yet refer to a subject because, even in such a use, the links with those criteria are not in practice severed."[6]

What Strawson describes as a use of "I" without criteria of subject-identity is what Anscombe describes in terms of unmediatedness, the absence of any need to look for a subject. I do not look for a subject for the unmediated conceptions that I express in some of my "I"-statements (the central ones). Strawson's point is that that is no reason not to suppose that by "I" I refer to the person (in my case John McDowell) whose having the content of those conceptions truly predicable of him or not determines the truth or falsity of the statements (to put the matter in Anscombe's terms).[7]

As the possibility of putting it like that indicates, Anscombe does not simply reject the claim that the links with criteria of subject-identity are not severed. For her too, my "I"-statements are semantically connected

to a particular human being: something that can be referred to in a way that is governed by criteria of identity. Where Anscombe diverges from Strawson is that she thinks this semantical connection cannot be a matter of reference. My "I"-statements are indeed true or false according to how it is with a particular human being, a potential target for reference that would be governed by criteria of identity; but not, according to her, because the utterances of "I" that figure in what looks like subject position in those statements refer to that human being.

Anscombe thinks that if one did take one's utterances or thoughts of "I" to be cases of referring, and tried to respect the facts about the use of "I," then the only thing one could find (or invent) for one's "I" to refer to would be a Cartesian Ego: "*if* 'I' is a referring expression, then Descartes was right about what the referent is" (p. 58). She argues for this by imagining herself in a condition of sensory deprivation, telling herself "I won't let this happen again!"

> If the object meant by "I" is . . . this human being, then in these circumstances it won't be present to my senses; and how else can it be 'present to' me? But have I lost what I mean by "I?". . . I have not lost my 'self-consciousness'; nor can what I mean by "I" be an object no longer present to me Nothing but a Cartesian Ego will serve.

We can consider this as an extreme case of unmediatedness, where there is not even a possibility of finding (as a result of looking for) a human being who could be said to have the intention expressed in "I can't let this happen again!" In less extreme cases, finding a subject of which to predicate the content of one's unmediated conceptions is not an outright impossibility; it is just that if one did that, one would not be respecting the fact that the conceptions are unmediated, and the resulting judgments and statements would not be first-personal.

Anscombe's thought here seems to be something on these lines: if "I" were a referring expression, its character as such would need to be entirely securable from within its central uses. The unmediatedness of those uses then precludes crediting "I" with a referent that is subject to the criteria of identity for human beings, since no such criteria are appealed to in those uses.

For another application of that thought, consider the succession of "I"-statements that would give expression to a stream of consciousness (self-consciousness). If "I" refers, how is it that in the course of such a succession no question arises about whether there has been an unnoticed substitution of a new referent for the old?[8] Now suppose one takes it that the resources for responding to such questions must come from within the stream of consciousness itself. In that case one might be tempted to think the answer must be that the continuing referent of "I" is especially

easy to keep track of: there is nothing to its persisting as one and the same thing, over and above the experienced continuity within the stream.[9]

This temptation is precisely what leads to the illusion of the Cartesian Ego, according to Strawson's reading of Kant's diagnosis in his section on the Paralogisms of Pure Reason. It is this line of thought to which Strawson responds, on Kant's behalf, with the remark that the links to criteria of subject-identity are not severed, even in thought and talk where there is no appeal to those criteria. Continuing "I"-thinking involves no keeping track of a persisting referent; but it is nevertheless rightly understood as involving continuing reference, to something whose sameness over time involves satisfaction of those criteria—a particular person. "I" can refer, without being governed by criteria of identity, to something for which there are criteria of identity, because understanding "I" requires understanding that the first person is also a third person, an element in the objective world.[10]

This claim also fits the extreme case of unmediatedness that Anscombe tries to exploit. I can think "I won't let this happen again!" in sensory deprivation only against a background understanding, which I cannot suspend on pain of suspending my ability to think first-personally altogether, that the first person is also a third person. It is that third person—who is present to me, in these circumstances, only as the subject of my thinkings, intentions, and so forth—that I mean by "I," even in this condition. Certainly some of the usual materials for bringing that background understanding to bear—for identifying the relevant third person third-personally—are not currently at my disposal. But that does not show that my "I," in these circumstances, cannot refer to the person who, on Anscombe's own account, has those thoughts and forms those intentions. It would show that only on the assumption that a referring role for "I" would need to be fully accountable for within my stream of consciousness. And in the light of the point Strawson finds in Kant, that assumption, which drives Anscombe's argument, looks profoundly Cartesian.

Of course Anscombe is not tempted to postulate Cartesian Egos to be the referents of our uses of "I." On the contrary, she uses the fact that that would be hopeless in order to argue, by *modus tollens*, that "I" is not a referring expression. But we can see something Cartesian in the thought that underlies the conditional premise of her *modus tollens*: the thought that if "I" is a referring expression, its character as such must be able to be wholly provided for from within its use in the articulation of unmediated conceptions. The ultimate Cartesian error is not the postulation of the Ego, but rather an idea to this effect, which underlies the postulation of the Ego: the semantical character of the judgments that

articulate a stream of consciousness is self-contained, able to be completely provided for within the stream. Certainly Anscombe does not embrace that idea in the unqualified form in which I have stated it: she allows, indeed insists, that the truth or falsity of my "I"-judgments turns on whether their content can be truly predicated of a certain third person, a certain particular element in the objective world. But she thinks avoidance of the Ego requires us to hold that "I" does not refer. Ironically enough, given that anti-Cartesian motivation, this reflects a vestigial form of the Cartesian idea that a stream of consciousness is semantically self-sufficient: she does not let her denial that the judgments in question are semantically self-contained extend to the question whether their logical form is that of reference and predication.

I have already quoted something she says about Baldy's lapse of self-consciousness: it lay in the fact that "his thought of the happening, falling out of the carriage, was one for which he looked for a subject" In a continuation that I omitted, Anscombe implicitly equates that with saying that "his grasp of it" was "one which required a subject" (p. 65). This equation encapsulates her thought that the unmediated conceptions that the central cases of first-person talk express must be "subjectless." To give proper weight to Strawson's point is to see that the equation is a mistake. We must indeed insist that the conceptions exclude looking for a subject, if we are to keep our hold on what is special about the first person. But even so, we can suppose that the conceptions require to be predicated of a subject: the particular person each of us refers to by "I." Of course one does not single out that subject, as if from other candidates, to be what one predicates the content of the conceptions of; but it would be a mistake to think reference must always be a matter of singling out in that sense.[11]

IV

Strawson credits the essential point to Kant, but I think this may be generous to Kant. We should not underestimate Strawson's own creativity in what he offers as a reading of Kant. (I do not mean to dispute that his thought is deeply Kantian in spirit.)

As Strawson concedes, Kant "barely alludes" to the fact that we have empirical criteria of identity for persons. Strawson manages to cite only one passage, where Kant says: "Its [the soul's] persistence during life is, of course, evident *per se*, since the thinking being (as man) is itself likewise an object of the outer senses."[12]

And it is not just that a topic that is central to the point Strawson finds in the section on the Paralogisms is scarcely mentioned there. That

one remark certainly displays Kant as splendidly immune to a familiar Cartesian temptation, the temptation to suppose that what does one's thinking is something other than a certain human being.[13] And the main business of the section is certainly to uncover, at the foundation of rational psychology, a misconstrual of the functioning of "I," in the "I think" that must be able "to accompany all my representations" (B131): "The unity of consciousness, which underlies the categories, is here mistaken for an intuition of the subject as object, and the category of substance is then applied to it" (B421). But Kant can diagnose the misconstrual of that extraordinary use of "I" without needing to take any view about its ordinary uses. Specifically, the diagnosis does not require him to claim that the human being that does one's thinking is the referent of one's ordinary uses of "I."

What Kant's purpose requires him to say about "I" is just that in the "I think" that can accompany all my representations, it does not give expression to "an intuition of the subject as object." This "I," the "I" that expresses "the unity of consciousness," does not refer; the rational psychologists' misunderstanding is precisely to suppose that it refers, and invent a referent for it. Empirical uses of "I," in contrast to that transcendental use, figure in the section on the Paralogisms only for Kant to stress that they are out of bounds for rational psychology. He has no need to offer a doctrine about how they are to be understood. The remark about "the thinking being (as man)" is not made in the context of offering any such doctrine: the thinking being (as man) is not introduced as the referent of its own empirical uses of "I." Anscombe too, of course, has the minimally anti-Cartesian view that the thinking being (as man) is an object of outer sense. As far as I can see, everything Kant says is compatible with her view that it is not by way of reference that one's empirical uses of "I" relate to the human being one is.[14] And in that case Stawson's reading takes a decisive step beyond what is actually in Kant.

V

The Kantian context in which that insight of Strawson's figures threatens, indeed, to have a positively damaging effect on our understanding of an indispensable thought, which Strawson expresses, in *Individuals*, like this (p. 102): "a necessary condition of states of consciousness being ascribed at all is that they should be ascribed to the very same things as certain corporeal characteristics, a certain physical situation &c."

Strawson's avowedly Kantian treatment of self-reference focuses on that unity of a series of experiences that we can capture by saying that its members "collectively build up or yield, though not all of them contrib-

ute to, a picture of a unified objective world through which the experiences themselves collectively constitute a single, subjective, experiential route, one among other possible subjective routes through the same objective world."[15] He (in effect) seeks to preserve the thought I cited from *Individuals* by insisting that this conception—the conception of "a temporally extended *point of view* on the world" (ibid.)—does not contain a sufficient condition for the possibility of self-consciousness. To approach a sufficient condition, we need to make it explicit that the temporally extended point of view is an aspect of the career of an embodied subject of experience—a human being, in the only case we are familiar with. But about the conception of a temporally extended point of view on the world, abstracted from the full conditions for the possibility of self-consciousness, Strawson claims on Kant's behalf that, since that conception provides for the distinction between how things are and how things are experienced as being, it can be recognized to contain "the basic condition for that possibility" (p. 108). And it is easy to read this as suggesting that the conception does, as it were, almost all the work: that in order to build up an adequate (if skeletal) understanding of self-consciousness, we need only put the conception back into the context from which it is abstracted, stipulating (in accordance with the remark from *Individuals*) that the experiences that make up a stream of consciousness are to be attributed to a bodily thing.

I think any such suggestion would be seriously wrong. In order to bring out why, I shall adapt and extend a thought experiment of Anscombe's.

Anscombe envisages (p. 49)

a society in which everyone is labeled with two names. One appears on their backs and at the tops of their chests, and these names, which their bearers cannot see, are various: "*B*" to "*Z*", let us say. The other, "*A*", is stamped on the inside of their wrists, and is the same for everyone. In making reports on people's actions everyone uses the names on their chests or backs if he can see these names or is used to seeing them. Everyone also learns to respond to utterance of the name on his own chest and back in the sort of way and circumstances in which we tend to respond to utterance of our own names. Reports on one's own actions, which are given straight off from observation, are made using the name on the wrist. Such reports are made, not on the basis of observation alone, but also on that of inference and testimony or other information. *B*, for example, derives conclusions expressed by sentences with "*A*" as subject, from other people's statements using "*B*" as subject.

What I want to exploit from this description is the point that "reports on one's own actions" are made primarily on the basis of observation. (The other modes of informational access that Anscombe mentions can be thought of as substitutes for observation.) In a central case of a

"report on one's own actions," B (say) observes the clenching of a fist (say) with an inscribed "A" visible on the inside of the wrist to which it is attached, and says "A is clenching his fist." This kind of report can be mistaken in that the fist actually belongs to a body other than the one whose chest-and-back label is "B." (Perhaps the report could have been truly made; but only by coincidence, if B's fist was being clenched also.) Such a report gives expression to an observationally acquired conception of a bodily movement, and the observation includes finding a subject of which to predicate the movement. Getting hold of the wrong object is not excluded. In short, the conceptions expressed in these reports are not unmediated. And that is enough to justify saying that, at least so far, the practice does not provide for expressions of self-consciousness: "A" does not function like "I."[16]

In Anscombe's scenario, the bodily thing whose movements one can correctly report using "A" is singled out by the fact that its back and chest are inaccessible to one's vision (ignoring mirrors). The detail depends on the fact that she wants it to be especially clear that the various terms in play function as names: their bearers are actually labelled with them. But that is inessential for my purposes. In a variation on Anscombe's case, we can leave out the labels, but preserve the role of the point of view from which one sees. So "A is clenching his fist" is said, as before, when one observes a fist clenching, and, now, when one can tell by observation that the fist belongs to the body at the front of whose head is the point from which the observed scene is seen. (As before, one can short-cut observation by relying on testimony, inference, and perhaps just guesswork.) The effect is to turn "A" into an indexical expression rather than a label, and, to that extent, to bring it closer to "I." But the conceptions expressed are still not unmediated, so we have still not made provision for self-consciousness.

The "A"-language was introduced only in connection with "reports of actions." One obvious addition would be reports on the posture, relation to other objects, and so forth of the singled out bodily thing. (We could hardly countenance "A is clenching his fist" while refusing to make sense of "A's fist is clenched.") Nothing essential is altered so long as these reports too are made primarily on the basis of observation. All the reports we are envisaging so far are, we might say, third-personal, just because they are fundamentally observational; it makes no difference that one of the potential referents for third-personal talk is singled out in that special way.[17]

Can the "A"-language be extended to psychological predications? We are already contemplating reports made on the basis of observation (which we have tacitly limited to visual observation). So far we have restricted the topics of observation to the bodily movements, postures,

and so forth of the speakers themselves and others of their kind, but that is surely inessential; we can imagine that the language provides for observational reports on other aspects of the passing show. Now let us enrich the range of predications with "*A*" in subject position like this: when a speaker is in a position to make an observational report of some state of affairs, that very position equally entitles the speaker to produce a statement of a new kind, in which the report of the state of affairs is prefaced by "*A* sees that"

This is radically unlike the predications with "*A*" in subject position that we have so far had in view, in that the basis on which these reports are made does not include identifying an object of which to predicate the rest of the statement. There is no such thing as making sure it is *A* who sees that such-and-such is the case, as one might need to make sure it is *A* who is clenching his fist. These new "*A*"-statements give expression to conceptions that are unmediated.

Does that mean we have brought self-consciousness into the picture? Surely not. These statements attribute seeing that such-and-such is the case to a bodily thing whose movements, posture, and so forth are still reported only on the basis of observation and surrogates for observation. If it was right to conclude that the original "*A*"-language did not provide for one to think of the things whose "actions" one reported as oneself (indirect reflexive), how can we have brought self-consciousness into the picture by allowing for describing that thing as something that sees as well as "acts"?

We can increase the psychological resources of the "*A*"-language. One obvious addition is a notion of appearance. When one says "*A* sees that P" on the usual sort of observational basis, and it turns out not to be the case that P, let it be correct to say "It seemed to *A* that P." (This presupposes a capacity for a certain sort of memory.) The present-tensed form, "It seems to *A* that P," will be suitable instead of "*A* sees that P" in circumstances in which there is some palpable risk that the latter statement may need to be withdrawn; but we can count it true whenever one has the usual sort of observational entitlement to the less cautious form.

And must we limit the reportable contents of streams of consciousness to perceptual experiences? Statements of the form "It seems to *A* that . . . ," like statements of the form "*A* sees that . . . ," are made without any need to make sure it is *A* who enjoys the experience. Negation yields "It is not the case that it seems to *A* that . . . ," and that cannot import a new obligation to make sure that it is *A* of whom the statement is true. Now suppose a speaker of our expanding language suffers complete sensory deprivation. If what we are describing is a mode of intelligible speech, it must give expression to a possible mode of

thought. So why not suppose this speaker can *think* (say to itself) something to the effect of "*A* has no experience at all"—so that the otherwise empty stream of consciousness nevertheless contains occurrent thoughts?

When we introduced "*A* sees that . . . ," we already made room for the thought that "*A*" refers to something like a subject of experience, not something with only corporeal properties. With this last move, we might wonder if we have made room for an "*A*"-speaking philosopher who, impressed by the continuing possibility of "*A*"-thinking in sensory deprivation, or perhaps by the susceptibility to hyperbolical doubt of all bodily predications with "*A*" in subject position, argues like this: "Even in sensory deprivation or while entertaining hyperbolical doubt, *A* can be certain of *A*'s existence: *A* thinks, therefore *A* is. This shows that what "*A*" really refers to is not a bodily thing at all, but a thing that thinks—that is, enjoys a mental life. If, as normal sensory experience suggests, there is a body through whose eyes *A* sees, and so forth, that body is something to which *A* has a special relation; it is not what *A* is." And perhaps another philosopher might diagnose this as a paralogism of pure reason, a result of mistaking the purely formal "*A* thinks" that can accompany all *A*'s representations for a genuine reference to a substantial object.

We have, apparently at least, given the "*A*"-language materials for constructing something like the notion of a temporally extended point of view on the world, including the distinction between how things are and how things are experienced as being, which Strawson singles out as the most fundamental necessary condition for the possibility of self-consciousness. With the last development, we have even given the appearance of making room for an analogue to the illusion of rational psychology and its diagnosis. And the diagnosis might continue by insisting that although one does not appeal to criteria of identity when one predicates experiences with "*A*" in subject position, nevertheless the links to such criteria are not severed, and the target of these references is a bodily thing; so we seem to have the unity of consciousness in the required context, as an aspect of the career of a bodily thing.

But surely "*A*" still does not give expression to self-consciousness. In a characteristically Cartesian fashion, our quasi-Cartesian "*A*"-speaking philosopher focuses on the fact that the not purely psychological aspects of what he conceives as "*A*'s biography" can be obliterated, for its subject, by sensory deprivation, or thought away in hyperbolical doubt; he concludes that the real subject of the biography is something whose properties are exclusively psychological. In this case, the composite biography out of which the quasi-Cartesian pure subject is distilled was attributed to a subject whose "actions" are accessible to everyone only

by observation (or substitutes for observation). That still seems to ensure that no one can think of this item as himself (indirect reflexive). How could a fantasy of shedding its bodily aspects turn a way of being that is not that of a self into a case of self-consciousness?

VI

Clearly the trouble lies in the way "reports on one's own actions" functioned in the original "A"-language; what I have been exploiting is the fact that nothing in the enrichments has made any difference to that. What an "A"-speaker is entitled to describe as "A's doings" is just a singled-out collection of what observably happens. It is true that these particular happenings are movements on the part of a body that is the point of acquisition of the sensory basis on which the speaker speaks. But they are known about only observationally (and by way of substitutes for observation), not through intention; and that means that, for all their intimate connection to the speaker's point of view on the world, they cannot be conceived as one's doing things. These reports are not reports on actions, one's own or anyone's, except in the sense in which one might report the action of water on a stone.

The behavior of the singled out bodily thing, not known through intention, is not a case of anyone's exercising agency. Trying to imagine oneself in the "A"-practice, one might be tempted to picture those merely observable happenings as the result, in the impersonal objective world, of something else that really is one's doing. I act, in some inner sphere, and thereby somehow bring about those observable motions on the part of the bodily thing that audibly calls itself "A." But nothing in the "A"-language provides for this conception of the inner I who is a genuine agent, manipulating the bodily thing called "A" like a puppeteer. And in any case, if we separate the real agent like this from the bodily thing through whose motions the agent makes its mark in objective reality, we surely prevent ourselves from making real sense of agency.

This must go for the speech behavior of the singled out bodily thing as much as any other. If that range of activity is likewise accessible to all parties only through observation and substitutes for it, what we have described is a repertoire of activity that is not undertaken, gone in for, by anyone. It would make no difference if we enriched the repertoire with "reports on actions" that are exercises of the repertoire itself, so long as the sole basis for these "reports on actions" was observation and substitutes for it.

If I try to imagine myself looking at the world through the eyes of a participant in the "A"-practice, I find no one with whom I can identify

myself, no one for me to be. I hear utterances that are intelligible in their way, with "*A*" in subject position, coming from the mouth of the singled out bodily thing. But, not knowing these utterances through intention, I cannot find myself speaking in them; I can conceive them at best as results of my agency, not cases of it. In the fantasy of an inner I, which utterances get made is under my control, and some of them give expression to the content of experience that I undergo, through *A*'s sense organs. But they attribute that experience not to me but to *A*, a bodily thing that I have to distinguish from myself, since it is not what acts when I act, but at best an instrument whereby my agency makes its mark in outer reality.

At least the final stage in my expansion of Anscombe's thought experiment now comes into doubt. If the "*A*"-practice is, from the start, a repertoire for things that are not agents, and so not a language anyone could speak, in a sense in which speaking is an exercise of agency, then we cannot assume that an elaboration of the practice yields a way of giving expression to a mode of thought. This undermines the pretext on which I introduced the quasi-Cartesian "*A*"-speaking philosopher. But the thought experiment, however shaky, can still serve my purpose, which is to point to the basic importance of agency for making self-consciousness intelligible.

A potential for reflectiveness belongs to thought as such; "I" encapsulates that potential into a way individual things can be presented in the contents of thinkings. It would be wrong to put this by saying that oneself (indirect reflexive) is presented to one, in any bit of "I"-thinking, as the thinker, as well as the object, of this bit of thinking. Of course thinking can be immersed in its ground-level concerns, so that the potential for reflectiveness is merely latent; and this goes for "I"-thinking too (consider "That rhinoceros is about to charge at me"). What we can say is this: if a thought presents an object as oneself, it presents the object in such a way that no further information is required, besides what is already there in the mode of presentation, to warrant the reflective judgment that the object of this reference is the maker of it.

We can understand how something can figure in that way in thought if we can understand how something can figure in that way in speech. It might seem that "*A*" presents its referent in just that way: that the mode of presentation associated with "*A*" itself contains enough to warrant the judgment—whose materials, then, would have to be all at least implicit in the mode of presentation—that the referent is also the maker of the reference. But that misses the point I have been insisting on, that in exercises of the "*A*"-practice there is no speaker, and so no maker of references. If we allow ourselves the fantasy of the inner puppeteer, we have a maker of references in view, at least in the sense of someone who

sees to it that references get made; but now the referent is not the maker—the author or originator—of the reference. Contrast how it would have been if reports on one's actions using "A" had been introduced as expressions of intention. Then we could indeed have said that the warrant, and materials, for the reflective judgment that the object of this reference is its maker are implicit in the mode of presentation associated with "A." But in that case "A" would have been, from the start, a first-person form, a mere variant on "I." The materials for the reflective judgment are indeed implicit already in the very idea of an ascription of action that is an expression of the intention being actualized.

When we try to think ourselves into the "A"-practice, a certain singled out bodily thing appears at best as an instrument for the will of a self that can only dubiously find a place in our imaginings, a self that recedes inward to the point of vanishing. With bodily agency in the picture, that bodily thing becomes something one can identify as oneself; now there is something plainly present in the world for oneself to be. And it is not clear that we can understand the specific agency exercised in referring—the idea of which is implicit in the potentially reflective mode of presentation under which one is presented as oneself (indirect reflexive)—except by beginning with referring as an element in speaking, a particular mode of physical intervention in the world on the part of the bodily agent that one can identify as oneself. Surely this cannot be less fundamental, in our understanding of self-consciousness, than providing for a distinction between how things are and how things are experienced as being.

Strawson's reading of Kant is revelatory when the question is how self-reference can be reference at all, but it is less helpful towards understanding how self-reference works, what the mode of presentation expressed by someone's use of "I" is. Perhaps I can put the point like this. When it comes to understanding how self-reference works, we are better served by the division in P-predicates and M-predicates, as in *Individuals*, than by the Kantian abstraction of a temporally extended point of view on the world from the career of an embodied subject. P-predications include, from the start, ascriptions of intentionally under-taken bodily movements.[18] In that context, one's being a bodily agent cannot take on the look of an afterthought, a mere frame for something that could sensibly be supposed to be more fundamental to self-consciousness.

JOHN McDOWELL

DEPARTMENT OF PHILOSOPHY
UNIVERSITY OF PITTSBURGH
SEPTEMBER 1994

NOTES

1. Ludwig Wittgenstein, *The Blue and Brown Books* (Oxford: Basil Blackwell, 1958), pp. 66–67.

2. In Samuel Guttenplan, ed., *Mind and Language* (Oxford: Clarendon Press, 1975), pp. 45–65.

3. Anscombe says that a person is "a living human body" (p. 61). She means to be talking about something that is not "still there when someone is dead." But I do not see how the words "living human body" can be intelligibly construed otherwise than by taking "living" to attribute a property that a human body can lose, *scilicet* without going out of existence. When there is no longer life in it, my body *will* probably "still be there" for a while. (It may not be, but only if the life is snuffed out by the body's, say, being blown to smithereens.) What will not "still be there" is the human being I am—not a human body, though certainly a bodily thing.

4. I am isolating one strand in Anscombe's complex case for her conclusion; I prescind, for instance, from her claim that Frege's notion of sense cannot be made to fit a construal of "I," uttered by a particular person, as a referring expression. I believe Frege had a better view of that question; and he does not hesitate to speak of the "particular and primitive" mode of presentation under which one can figure only in one's own thoughts (pp. 25–26 of "The Thought: a Logical Inquiry," translated by A. M. and Marcelle Quinton, in P. F. Strawson, ed., *Philosophical Logic* [Oxford: Oxford University Press, 1967], pp. 17–38).

5. Perhaps I have forgotten my name in the accident. But then we can ask why I say "I . . ." rather than, say, "The person in this bed . . . ," or whatever other (non-first-personal) designation is at my disposal.

6. *The Bounds of Sense* (London: Methuen, 1966), p. 165.

7. I follow Strawson in assuming that the criteria of subject-identity are (at least for the subjects we know about) criteria for the identity of human beings; that is, animals of a certain kind. In this connection, Strawson wrote (in 1966): "The topic of personal identity has been well discussed in recent philosophy. I shall take the matter as understood." (*The Bounds of Sense*, p. 164). This remark looks dated now, but those were better days.

8. See Anscombe, pp. 57–58.

9. If one is tempted by this answer, one ought still to worry about unnoticed substitutions when one picks up one's "I"-thinking after intervals of sleep.

10. Compare Anscombe's explanation of why "no problem of the continuity or reidentification of 'the I' can arise" (p. 62).

11. Strawson himself encouraged a step in this direction when he suggested (*Individuals* [London: Methuen, 1959], p. 100) that one singles the right item out, as from other candidates, at least for others. For a protest, see Gareth Evans, *The Varieties of Reference* (Oxford: Clarendon Press, 1982), p. 208.

12. *Critique of Pure Reason*, translated by Norman Kemp Smith (London: Macmillan, 1929), B415; cited (in a slightly modified form) by Strawson at p. 164 of *The Bounds of Sense*.

13. Contrast the topic of the reflections that include the Cartesian *cogito*, which is not the human being, René Descartes. See Anscombe's perceptive discussion of this, pp. 45–46.

14. It would be wrong to suppose that "the human being one is" already rules out Anscombe's position. She holds, as she must, that "I am E. A.," said by her, "is not an identity proposition;" see pp. 60–61.

15. *The Bounds of Sense*, p. 104.

16. This vitiates the use to which Anscombe puts the case. She wants the trouble with "*A*," as a candidate for a way of giving expression to self-consciousness, to be just that it is a referring expression. Thus she suggests that people who treat "I" as a referring expression either represent "I" as "in principle no different from . . . 'A'" or, seeing the difference between "I" and "*A*," "are led to rave in consequence" (p. 60). But the difference between "*A*" and "I" is already sufficiently in place when we register that the conceptions expressed in the "*A*"-language are not unmediated; we do not need to say as well that one refers and the other does not. (Anscombe's mistake, which Strawson's insight allows us to expose, is exactly not to see that we can endorse the first of these claims and reject the second. But at this point I mean to have left Anscombe's mistake behind; I am exploiting her thought experiment for my own purposes.)

17. "Third-personal" is not completely felicitous, just because there is nothing in the language that answers to the contrasting description "first-personal."

18. See *Individuals*, pp. 111–12.

REPLY TO JOHN MCDOWELL

That the first personal pronoun "I," in the mouth or mind, speech or thought, of some human being must refer to that very same human being (unless he or she is simply acting as the *mouthpiece* of some other individual) sounds like the veriest truism. A philosophical innocent might wonder how anyone with ordinary linguistic competence could possibly question or deny it. To the less innocent it will come as no surprise that more than one philosopher can find reason for doing so. Thus Wittgenstein points out that when a subject reports on his current state of mind or consciousness, on what he currently sees, thinks, or feels, there is no possibility of his making a mistaken reference in his use of the first personal pronoun. He apparently concludes that where there is no question of getting the reference wrong, there is no question of getting it right either; i.e., that in such cases of what Miss Anscombe calls "unmediated" self-consciousness, there is no reference to a subject at all. The content of consciousness is *expressed*; but it is not ascribed to, or predicated of, any subject. The use of "I" is here nonreferential.

Miss Anscombe, as McDowell remarks, extends this conception beyond Wittgenstein's chosen cases of unmediated self-consciousness to others, equally unmediated; for there seems no more need to make sure of getting the subject right in such judgments as "I have fallen over" or "I am lying down" than there is in the type of case cited by Wittgenstein. Appeal to the ordinary criteria of personal identity seems equally irrelevant in all these cases. But, she goes on, if these criteria are irrelevant to the use of "I," and if we are still determined to find a subject, then, as she puts it, "nothing less than a Cartesian Ego will serve"; and thence she argues, by *modus tollens*, to the conclusion that "I" is not used to refer at all.

Here we find a qualified point of contact with Kant. Of course Kant, in the Paralogisms, is not directly concerned with the use of "I" in

framing empirical statements. He is concerned with the "I think," which is the sole text of rational psychology, the "I" that can accompany all my representations, that expresses the "unity of consciousness" or "consciousness in general" or the "transcendental unity of apperception" and, as such, has a purely nondenotative significance; yet, because of its simplicity and constancy, is erroneously taken by the rational psychologist to refer, once again, to a simple, immaterial identical substance, a Cartesian ego.[1] Of course Kant does not draw Miss Anscombe's conclusion regarding empirical uses of "I," of which he has little to say; but, as McDowell points out, nothing he does say is incompatible with Miss Anscombe's view that it is not by way of reference that one's central empirical uses of "I" relate to the human being one is.

McDowell applauds me for correcting this omission or incompleteness in Kant's account of self-consciousness; as I do by remarking that the unmediatedness of central uses of "I," which Anscombe insists on and McDowell endorses—the fact that in these uses there is no appeal to criteria of personal subject-identity—does not mean that the link with those criteria are in practice severed. On the contrary the very understanding of "I" requires the understanding of it as referring to a subject which is also a corporeal being among others in an objective world, namely, a human being. So the inference from "unmediated" to "nonreferential" is disallowed.

Nevertheless, McDowell holds, I am seriously misled by the Kantian context of the discussion of self-consciousness. I suggest that the Kantian conception of the unity of consciousness, which I construe as the unity of a series of experiences which collectively yield a picture of a unified objective world through which the experiences themselves collectively constitute a single subjective experiential route, by providing for the distinction between subjective experience and the objective world experienced, contains in itself the fundamental ground of the possibility of self-consciousness, of the self-ascription of experiences. Although I concede that this falls short of the full conditions of this possibility, which require indeed that the subject of experience should be, and be conceived as being, itself, a corporeal object, I nevertheless leave the impression, McDowell says, that the conception of "a temporally extended point of view on the objective world," by providing for "the distinction between how things are and how they are experienced as being," does nearly all the work and only needs *supplementing* with the

conception of the subject as a bodily thing. And this, says McDowell, is seriously wrong.

To explain why, McDowell adapts and extends a thought experiment of Anscombe's; and succeeds, in the process, of brilliantly and cogently demonstrating the inadequacy of the conception he criticizes. At the heart, and explicitly at the conclusion, of this demonstration is the thought that it is in the case of intentional action, including speech behavior—the case of intentionally undertaken bodily movements— that self-consciousness in the full sense, awareness of oneself, one's human self, (as acting), is most clearly and fully intelligible. McDowell's route to this thought is intricate, imaginative, and compelling.

Yet I think it is not quite the whole story. Could we have "I" at all without "you" and "they"? Could we have "ago" without "agis" and "agunt"? Could we have personal self-consciousness without consciousness of other persons? The fact that we are social beings, or, at least beings aware of others of the same type as ourselves, is arguably no less central to self-consciousness than the fact that we are intention-actualizing agents. In a way I anticipated this thought earlier on when I remarked that the very understanding of "I" requires the understanding of it as a subject which is also a corporeal being *among others* in an objective world; and, having written more expansively on the point in *Individuals*, I will not enlarge on it now.

I think it is worth pausing a while for a little further exploration of a notion allied to that which McDowell criticizes so effectively, the notion, namely, of a center of consciousness tracing a subjective route through an objective world consciously conceived as such and including, therefore, consciousness of the possibility of other such routes through that world. Such a notion, in blatantly abstracting from the full conditions of personal self-consciousness, is, as Dr. Cassam has argued,[2] dubiously coherent. But if it is (or were) intelligible at all, then it does (or would) provide for the thought of a distinction between *this* and *other possible* experiential routes through the world, *this* and *other possible* series of such experiences, and thus for a faint analogue of self-consciousness—an analogue, indeed, not far removed from what appears to be Kant's own conception of empirical self-consciousness. But the point is, at best, more relevant to a discussion of Kant than it is to the real subject of McDowell's essay and my response.

And now, finally, I must come clean. If our central topic is the question, whether or not the human user of the first personal pronoun "I" thereby always makes a reference, and indeed a reference to himself, then most of the preceding more or less subtle and complex argument,

though interesting and revealing in itself, is strictly beside the point. What I wrote in the first sentence of this reply stands firm with the mere substitution of "is" for "sounds like." The fact that, in what McDowell calls central cases of the uses of "I," there is no need to invoke criteria of personal identity, no need to ensure that you are getting the reference right, has nothing at all to do with the case. It is simply an error to separate, as Miss Anscombe implicitly does, the semantics of the use of "I" sentences from the question of whether the use of "I" is referential, and the question of what reference it makes. What McDowell generously describes as the "beginning of wisdom" on this question is also its end; though it would be better to replace the lofty word "wisdom" with something more modest like "plain sense" (except that they often come in philosophy to much the same thing). Seriously to question whether, in any standard use of "I" a person is referring to himself or herself is as futile as seriously to question whether in any standard use of "now" as a temporal adverb a person is referring to a (more or less extended) present.

To say that the foregoing discussion is quite irrelevant to what appears to be the central question at issue (the question of reference) is not to say that it is pointless. It all bears, and bears most interestingly, on the question of self-consciousness. The fact that, in central cases, "I" is correctly used without any thought of appeal to criteria of personal identity is certainly worthy of remark; and the fact, which impressed Wittgenstein, that this is so conspicuously true when "I" is used to report current states of the user's consciousness, is, as we should all agree, the deep and deceptive source of the Cartesian illusion, since it encourages the thought that the reference must be to some immaterial item.

The immunity of any person's use of "I" from the risk of mistaken reference is of course not a peculiarity of what McDowell calls its "central" uses. It is perfectly general and applies just as surely in such cases as the Prince Regent's claim, "I was at the battle of Waterloo" or the remark of some vainglorious but deluded or mendacious person who says "I first discovered the proof of Fermat's last theorem." That such remarks are false, since the predicate is not true of the subject, has no bearing on the matter. For the immunity in question is quite generally guaranteed by the role of the pronoun in ordinary practice; or, more bluntly, by its meaning.

My final concern has been simply to emphasize the simple, indeed platitudinous, point underlying the truth, on which McDowell and I agree, that the case concerning reference to oneself is no different when

one says, truly or falsely, "I am in pain" or "I see such-and-such" or "I am NN." To think otherwise is simply confusion.

P.F.S.

NOTES

1. See Strawson, "Kant's Paralogisms: Self-Consciousness and the 'Outside Observer'," in *Theorie der Subjektivität* (Frankfurt: Suhrkamp, 1987).
2. See Cassam, "Transcendental Self-Consciousness," in *The Philosophy of P.F. Strawson* (New Delhi: Indian Council of Philosophical Research. 1995).

7

Simon Blackburn

RELATIVIZATION AND TRUTH

I

The task of writing something about Sir Peter Strawson's work is easy in one way, but difficult to the point of impossibility in a much more important way. Easy because Strawson's work touches virtually every central topic of philosophy, so that a commentator is spoiled for choice. But difficult because the quality of his writings makes elucidation unnecessary and seems to doom in advance any attempt to match the breadth and depth of his thought. In this brief and inadequate response to the challenge I merely hope to sketch some thoughts inspired by one of the most celebrated, and perhaps puzzling, of the positions characteristically occupied in his later work, and particularly visible in the lectures collected as *Scepticism and Naturalism*.

In these lectures Strawson discusses a number of places where different views of the world appear to come into conflict. Cases include the area visited in the famous lecture 'Freedom and Resentment', where a view of ourselves as natural beings whose doings are mere happenings in the unfolding course of nature appears to conflict with our personal and moral practices and attitudes. They include too the conflict between a scientific 'colorless' view of the world and our commonsense view of it as containing the colored, secondary-qualitied objects of ordinary perception; the conflict between thinking of persons purely as *loci* of neurophysiological events, and thinking of them as subjects of conscious states; and the conflict between a view which takes Quine or Wittgenstein to have drained the world of rules or universals, contrasted with the view which we take of ourselves as following rules, noticing aspects of things and contemplating their abstract features. In each case the conflict that threatens pits an objective, detached, 'naturalistic' view, which

insists that the first class of descriptions tells us truly all that there is, against a richer, more humanistic position which insists that the second type of view is not only natural to us, but legitimate in its turn. Philosophers who maintain that only the first kind of view is permissible Strawson calls 'reductive naturalists', and he says that it would be "stretching the word a little, but not perhaps too much, to represent them also as varieties of *scepticism*," although he agrees that this need not be the *mot juste*.[1] Still, it is at least arguably in place because, typically, the reductive naturalist will regard the alternative, rich, view as offering only error and illusion. Strawson's own project however is to oppose reductive naturalism with a liberal or catholic, non-reductive variety "which recognizes the human inescapability and metaphysical acceptability of those various types of conception of reality which are challenged or put in doubt by reductive or traditionally sceptical arguments." It is because the rich human view is inescapable to us that a theory respecting it deserves calling a kind of naturalism: it acknowledges and insists upon the propriety of something that is natural to human beings, part of human nature.

Although Strawson here speaks of recognizing the metaphysical acceptability of the richer views, it is not entirely clear what this can mean for he also sounds a distinctly cautionary note about the enterprise of showing that the rich views are not only natural, but more than that, legitimate. He says, for example, that:

> The non-reductive naturalist's point is that there can only be a *lack* where there is a *need*. Questions of justification arise in plenty *within* the general framework of attitudes in question; but the existence of the general framework itself neither calls for nor permits an external rational justification (sic). (To put the point in Wittgenstein's idiom: This language-game, though its form may change with time or be subject to local variation, is one we cannot help playing; not one we choose.)[2]

In the light of such comments it would not be right to say that the liberal or catholic naturalist seeks to *establish* the 'metaphysical acceptability' of the rich conceptions. For the framework they form is simply not up for establishing. It cannot be established to be acceptable or otherwise. It simply exists, a given: a point which must be taken for granted in all our reasonings. Associating himself with Hume, or Wittgenstein at this point Strawson is also making common cause with Quine and those influenced by him who believe that traditional, justificatory, epistemology is substantially misconceived. However, the liberal naturalist is not presented as entirely indifferent to normative questions. Even if there is no enterprise of *establishing* the acceptability of a framework, Strawson still describes him as *recognizing* this acceptability. But what exactly can this mean?

Hume nicely illustrates the lurking ambiguity. According to Hume, unlike Wittgenstein and Quine, our common sense scheme of 'visuo-tactile continuants' is certainly natural and necessary, but also certainly erroneous. It involves us, he believes, in the vulgar error of supposing that the very same things that are continuous and independent of us are also discontinuous and dependent upon us.[3] Since however we cannot abandon the scheme 'carelessness and inattention alone afford us any remedy'. My point is not that Hume is right in diagnosing the ordinary scheme as inconsistent. I am only indicating the space he opens up for two different senses in which the basic structure of our natural beliefs are recognized as acceptable. In one sense, that suggested by the above passage from Strawson, they are fitted to stand any purported trial at the bar of reason, because there is really no such trial, since reason has no jurisdiction in the case.[4] In the other sense, however, there is such a trial, and the elements on trial spectacularly fail it; in spite of this we have no option but to accept them back into our thought. In the case of the external world, Hume only illustrates the second combination, whereas Wittgenstein, Quine, and, I take it, Strawson are more attracted to the first. The Humean combination, at this point, is a melancholy or distressed acceptance; the liberal option is a relaxed, carefree acceptance.

The Humean distress only afflicts us in the study, and it is easy to suggest that there is therefore something bogus about it ('just try in a real case to doubt . . .'). But after all it is in the study that we reflect and do philosophy. The distress is not, it seems to me, bogus, since in the study the demand that we do not accept incoherent systems of belief is as necessary, natural and inevitable as the demand that we trust our senses, or regard each other as moral agents, or as beings speaking determinate languages. The norms of reason are not here set wholesale against the norms of nature, but are themselves natural to us, part of our natural, and naturally self-conscious, truth-seeking propensities.

Recognizing the acceptability of divergent points of view, then, can be done in a melancholy way, that recognizes that acceptability is bought by carelessness and inattention, or in a frank and unembarrassed way, supposing that acceptability is recognized because the schemes in question survive all the trials they are properly required to stand, in the study or out of it. And there will be different degrees of embarrassment and melancholy, depending with what flying colors the schemes pass any trials they stand, or with what fearlessness they walk away from any such proposed trials. So it is certainly to the point to ask anyone whether the spirit in which he promotes the acceptability of various of our commit-ments is of the distressed or the relaxed variety. The theme I want to explore is whether Strawson would claim to be offering the second, although the materials on offer end up giving us only the first.

There is a further point to notice about the kind of position that Hume illustrates, and indeed that was shared by many writers in the century following Descartes. His problem is one of holding together views that seem to be inconsistent, or at least in some kind of opposition or tension. This was also Locke's problem, and the one that Berkeley solved only by idealism. Unlike Locke, but quite like Berkeley, Hume believes that the holding operation cannot really be carried out. So his skepticism at this point is not the pale, Cartesian variety that laments the bare possibility of things not being as we take them to be. It is the more brutal doctrine that things cannot possibly be as we take them to be; the commonsense scheme involves out-and-out inconsistency. It is only because of this that we need carelessness and inattention. The case is quite different, for example, from that of inductive reasoning or that of ethics. In these cases reason cannot enforce our practices, and leaves a gap to be filled by nature and custom. With induction we can cross our fingers, and may be right. With ethics we are in the domain of attitude and emotion, and deploy them naturally and effectively to further our cooperative needs. Reason, conceived purely as a faculty for aligning belief with truth, is silent about these facets of our nature, neither speaking for nor against them. There is nothing standing in the way of relaxed recognition of acceptability here, nothing about which to be melancholy, unless we lament the way in which rationality has been cut down to size. But for Hume it is quite otherwise in the case of the external world, and his very divergent attitudes to the cases of the external world and ethics, or the external world and induction, should at least remind us of the danger of a blanket assimilation of the one to the other. It may well be, for instance, that Strawson's commendation of the reactive attitudes is entirely appropriate, immune from any counterattack from reason or objectivity, precisely because we are here in the realm of attitude, emotion, and reaction. But this leaves it open that in the other cases we are not.

A final remark may be in order about the Humean attitude. As I said, Hume's problem is one of an inconsistency that he detects in our commonsense scheme of thought. It is not a problem that arises from giving undue privilege to one particular point of view: an 'absolute conception' or scientific world view, or view that sees only primary qualities of things. This may mean, indeed, that Hume at this point is not an example of the philosophical structure that interests Strawson, and which does arise from pitting one, supposedly privileged view, against another. But Hume still bears witness to what may happen in Strawson's structure, namely that we arrive at incoherence or inconsistency, and then simply have to put up with it, getting only melancholy or distressed acceptability. And we should notice in passing that not only out-and-out

inconsistency can generate melancholy. Other problems of fitting together the one scene with the other may trouble us just as badly, remembering that the skeptical threat arises whenever the rich view is not at all legitimate by standards which are at least as natural to us as it is itself. One desideratum or ideal which sets its own normative inquiry is what we should at least be able to see how the rich view is as much as *possible*, given the conception of the world offered in the austere view, and difficulty over this will be prominent both in the case of secondary qualities, and in that of intentionality.

II

We should notice that each putative conflict could be resolved by what I shall call straight compatibilism, borrowing the term from the position often presented in discussion of free will. The straight compatibilist suggests that what is seen from the second, rich standpoint is in fact nothing incompatible with the facts as determined by the first, austere standpoint. Or, there is no difficulty about seeing how the rich point of view arises, given the facts as determined by the austere view. Rather, it is the objects or facts of the austere view apprehended in a particular way, but not in any way that is mysterious or illegitimate. Straight compatibilisms would include (obviously) views such as those of Locke or Hume on free will, which find nothing uncomfortable in holding a person responsible for acts that manifest a bad character, regardless of his or her responsibility for that character. They also include the Lockean theory that colors are possessed by objects, being just powers to affect our senses, varieties of identity theory or functionalist theories explaining attributions of consciousness, and perhaps dispositional or teleological approaches to intentionality. But as these examples suggest, the natural strategy for straight compatibilism is close to simply giving victory to the reductive naturalist. For compatibilisms play, as it were, on a field that he has laid out. They are strategies that attempt to show that the apparently threatened (or threatening) rich commitments in fact meet any standards that the scientific or reductive philosophy sets.

It is not altogether easy to draw the boundaries of such straight approaches. But it is at least initially clear that Strawson's approach to the problems is very different. He recommends a relativizing move, arguing that once we relativize our conception of the real to different standpoints, the appearance of incompatibility disappears.[5] And because it disappears the view of the reductive naturalist, that we live our human lives in a fairly permanent state of illusion, disappears with it, for that was motivated entirely by the belief that the two views are in some kind

of conflict. To illustrate the strategy in the case of free will, the idea is to accept that while from the scientific point of view a person is a neurophysiological complex whose trajectory through space is either entirely determined or, perhaps, partially but helplessly random, we can also and without incompatibility say that the same person is responsible for their actions and accountable to others for their misdeeds. Or, while we can say that from the scientific point of view the objects in space have no colors or feels or odors, we can also say that from the commonsense point of view they have all these features. The points of view are distinct, but not incompatible, although Strawson does admit that they are in some sense 'opposed'.[6] It will be useful to reflect on this opposition a little further.

A standpoint seems to oppose another most directly if the description of what is seen from the one contradicts the description of what is seen from the other. If from the standpoint of the *Times* people are poor only because they are lazy, and from the standpoint of the *Guardian* people are sometimes poor in spite of being industrious, then the two papers contradict one another, and at most one of them is right. The relativization Strawson is suggesting cannot be like this, for it is designed to remove incompatibility, not to reaffirm it. So how do the two points of view relate?

One suggested model might be the standpoint of fact against that of fiction. It may be that no Englishmen were present at a certain Berlin conference in the nineteen-thirties, but there is no conflict if my spy-thriller places my English hero there (the conventions are quite subtle: if there were no buses, but only trams in Berlin in the thirties but I have my hero escape by bus, I may expect to receive letters of correction). However, fiction is hardly the model that Strawson must have us follow, since liberal or catholic naturalism is precisely designed to remove the shadow that one point of view is embroiling us in fiction.

A more promising model is suggested by this kind of case: from the normal human standpoint (literally standing erect) the desert is silent; from a different one (ear to the ground) the sand whispers. Here there is nothing wrong with either saying that the desert is silent, or that it whispers, and the incompatibility is indeed resolved by introducing the two standpoints. In my first example, we seemed forced to choose between the *Times* and the *Guardian* and each protagonist will want us to do so. The *Times* intends a claim that excludes viewing the matter as the *Guardian* does; the desert traveler commenting on the silence need intend no claim that excludes what happens when he puts his ear to the ground. We might signal the difference by calling the newspapers' points of view exclusionary in intent, and the traveler's conciliatory in intent.

An unwise traveler might intend an exclusionary claim, believing that

precisely because the desert is silent, there is no standpoint from which to hear noises it makes. He may refuse to credit those who put their ears to the ground, or suppose that they are victims of illusion; he may want to claim that there is no sound to be heard from anywhere or by anybody. He is in a sense a victim of *hubris*, believing that what is heard from his own erect position throws its authority further than in fact it does. Here we have a closer analogy to the situations described by Strawson, and the reductive naturalist may stand charged with similarly overextending the authority of the austere point of view.

In more complex cases it may not be obvious whether claims are exclusionary or conciliatory in intent. Indeed, misunderstandings on this issue are exactly what drives the teacher's exasperation with 'freshman relativism', when claims the teacher intends in the exclusionary sense ('abortion is really wrong, not just in my opinion') are blandly read by the freshman as conciliatory ('that's true from your point of view, but not from mine'). To take a more interesting example, an historian, telling the story of the Civil War from the standpoint of social history, may make claims about its causes that seem to conflict with claims made by one who concentrates upon the personalities of the major figures. It may not be obvious whether the intention of the former story is exclusionary, dismissing 'explanations' of events in terms of personality, or whether it is conciliatory, allowing such explanations but (for example) seeing personality itself as the vehicle for the social forces whose operations the story charts. Here, there may be cases and cases.

Unification may be easier in some cases, or seem easier in some lights, than in others. Naturally, it is easiest of all if the descriptions offered from the different standpoints are not even superficially incompatible, before any question of relativization. Thus at one point Strawson reflects upon the various kinds of identity theory that are regularly offered by way of a straight solution to the problem of relating the neurophysiological and mental aspects of a human being. He rightly, I think, displays little enthusiasm for attempts to identify events related in 'the personal story, the biographer's or diarist's story' to those related in a physiological story, confined to displaying causal routes through the physical organism.[7] There is just the one organism, that both thinks and exhibits patterns of neural activity, but the one event, coming from one story, is not the other that comes from a different one.

At this point it should occur to us that if this is all that needs to be said, then there is also no need to talk of relativization. We can simply concatenate the two stories, and regard each as true from any point of view whatsoever. The biographical facts are what they are, and so are the neurophysiological facts. Similarly although conciliatory versions of the desert case may start with simple relativization we would expect them

rapidly to move beyond it: the participants can agree on the (absolute) truth that the desert appears silent listened to in one way, and noisy listened to in another way.

Perhaps the most vociferous proponent of a kind of relativizing move in recent philosophy has been Hilary Putnam. Putnam concentrates upon examples of apparently direct contradiction between claims made within one scheme, and those made within another. His advice is not so much that we 'relativize' the claims to their respective schemes, but that we see various of the terms involved as *used* entirely differently, so that the apparent contradiction disappears. Thus in one of his frequent examples a classical count might yield three objects in a room, and a mereological count may yield seven; the classicist may say that there is no red and white object there, but the mereologist will say that there is. My reaction to this is to subject it to a dilemma: either the classical and the mereological stories are genuinely incompatible, or they are not. If they are, then they are contraries, and we must allow that at most one of them is true; if they are not, because the terms involved have different uses, we can have them both. Neither way do we have a relativization that has us putting on and taking off the alternative pair of spectacles, and seeing truth only one way at any time, but different ways at different times.[8]

Problems seem only to arise if there is an exclusivity claim that in some sense the events related in the one story exhaust what is going on, and crowd out the events alleged in the other. The problem this poses for Strawson, then, is that concentrating upon relativization threatens to leave an unstable position. *If* the relativization leaves us conciliatory claims, then each can be regarded as true absolutely; *if* on the other hand each standpoint gives rise to exclusionary claims, their joint acceptability remains problematic.

It is time to drop the pretense that having an exclusionary or conciliatory intention is entirely an optional extra, attributable to some historians or philosophers but not to others. For it is we ourselves who can successively occupy the different standpoints, and what troubles us is surely that we do not know *which* of these senses to employ. In the Civil War example, I may read both histories, and be inclined to accept each account of events, yet be troubled by their relation. I would like a univocal answer to the question of how much the personality of the King contributed to events, and may not be satisfied with the relativization that, told from one standpoint it was not much, but from another it was crucial. I want to *unify* the accounts, and remain dissatisfied until either I can do so, or I can learn to jettison one or the other.

Here too we might usefully reflect that the metaphor of a standpoint or point of view suggests exactly the possibility of such unification, for

(as Strawson more than anyone else this century has made clear) our spatio-temporal scheme is precisely a structure for unifying what is experienced from one point with what is experienced from another, in terms of the history of stable spatially located objects amongst which the observer is situated at specific places and times.

In the desert case I said that the travelers could agree that the desert is noisy listened to in one way, and silent listened to in another. But we should concede there is no imperative to unify the two accounts in another way, by deciding which is the better or the uniquely *right* way to listen. It is here incorrect to think of the one world, of sound or silence. It is in the first instance because they correctly see that this point applies to secondary quality perception, but also believe that it extends to all perception, that philosophers such as Bayle or Berkeley threaten the single, objective and perceptible world. But in one respect their case is even stronger than this alone suggests. We could by decision or convention or on pragmatic grounds select one kind of procedure as the 'right' one, by privileging certain conditions of perception or kinds of perceiver. In the desert case we might, if it were useful, accept a convention that whether something is silent is judged by erect listening, and in the case of colors many people suggest that we accept certain kinds perceiver and conditions of perception by this means. But if we know that this is how the standards are set, we will not be able to see rightness as a matter of correct representation of one world. A dog, for instance smelling or hearing differently, is not a party to the conventions and cannot be judged wrong by we who deploy them. But this does not mean that the dog is wrong about smells or sounds (on the contrary, it is usual to think that dogs are better at sounds and smells than we are). We want to see our relation to the perceptible world in terms of truth, or correct representation, and at this stage, and for these qualities, the selection of just one standpoint by convention as the right one is not adapted to secure such a thought.

To counter Bayle and Berkeley we need a conception of the one world variously perceived: we can see these philosophers as setting unification as a challenge, and one that was not effectively taken up until Kant. So the question arises whether unity is 'set us as a task' in the philosophical cases Strawson instances just as much as in this more familiar case. If so, then the relativization that he proposes will not itself be a final solution to the problems that beset us. For we will insist on worrying at the putative opposition, and in particular at the question of exclusionary force and its propriety or otherwise, and at what we lose by way of understanding one world if we insist on conciliation.

Each of the reductive naturalist and the straight compatibilist will want to insist that this is indeed how it stands. The reductive naturalist,

of course, depends entirely upon the drive towards unity. His claim, it must be remembered, is not that there is a story to be told in austere terms, for everyone acknowledges that much. His distinctive claim is that in some sense or other, this story and others that can be united with it, give us *all that there is.* Anything that cannot in one way or another be unified with it is therefore to be dismissed as illusory. It was this exclusivity that seemed at first sight just like the *hubris* of the desert traveler who dismisses the reports gained by stooping. But now that we have sensitized ourselves to the aspiration for unity we must recognize the comparison as unjust. Of course, straight compatibilism similarly acknowledges the imperative towards unity, but pleads that it can be met in full.

From this point of view the space opens up for the kind of project that Strawson seems to dismiss in the passage quoted above, of raising certain questions of legitimacy. For while it may be taken for granted that we do and will occupy the richer point of view, and while we may know in advance that the upshot of our mediations must be that there is no good reason for finding it illegitimate, still, while we cannot see our way to maintaining a unity between it and the austere picture, normative questions will remain troubling. It will be as if we skipped to the end of the story and know that the butler did it, but are in the middle of the plot where we cannot see how it is possible for him to have done so. And we will be afflicted with Humean melancholy if, having finished the book, we are still in the same position. We should, then, put alongside Strawson's liberal naturalist, and the austere Quinean naturalist, a third character, to whom I myself feel sympathy: the *anxious* naturalist, who fears that the end of the book will leave only melancholy.

III

Why should there be cause for anxiety? Here the cases that Strawson considers differ somewhat, as indeed he himself admits. In the case of freedom and resentment the traditional reason would be that the richer story is actually incoherent. It attempts, it is said, to tell a story of free choice that represents the agent neither as totally determined, nor as subject to random fits and starts. Unhappily, according both to incompatibilists and to compatibilists these exhaust the coherent alternatives. Hence there is no coherent rich story. It should be noticed that since this is the nerve of the problem, then as with Hume's problem with the external world, it is not quite right to see the difficulty as arising from a peculiarly austere conception of events, nor from a specifically naturalistic one. The dilemma of determined or random, is presented as afflicting

any event of which we can conceive, not just events in some austere or specifically natural sphere. It would afflict ghostly homunculi inside the head, for instance. For this reason, the free-will problem is not at first sight dependent upon exclusionary claims on behalf of some privileged class of events or facts.

The situation now is that the rich point of view seems forced to stand trial at the bar of reason. It is charged with inconsistency, just as Hume charges the scheme of visuo-tactile continuants with inconsistency, and if we have to accept it notwithstanding then it must be in the melancholy spirit of carelessness and inattention, not in the relaxed pluralistic spirit suggested by Wittgenstein or Quine. This is why we are motivated to seek straight compatibilism. So the common approach is to deny that the rich story of commonsense attributions of control and responsibility *does* attempt to tell of events that escape the dilemma. The personal, moral, reactive descriptions and stances that make up the rich story do not tell of such mysteries; they tell only of subjects of flesh and blood and events that unfold in their determined (or random) courses; but in particular they tell of agents whose characters are revealed in their thoughts and actions, and sometimes merit praise and sometimes blame. This is straight compatibilism. The moves are then familiar enough: the incompatibilist highlights the subject's lack of responsibility for his own character—the elements of luck involved in our ending up with the temperaments we have—and maintains that it would be unjust to hold someone responsible for the outcome of something over which they have no control. The compatibilist in turn points out that we do and must constantly hold attitudes to people because of just such factors: hating someone for having a cursed character is no less natural and justifiable than loving them for having the gift of beauty. And the incompatibilist replies that while this may be true for some affections, we should not in our moralizing similarly connive at injustice, and it remains unjust to blame someone for drowning if we cannot blame them for being under water. The compatibilist seeks to deflect the analogy by describing actions and choices where we could have done otherwise; the incompatibilist replies that this is always at bottom a matter of seeing what we actually do under different circumstances, and leaves us no better off than, for example, Jesus would be if having blasted the fig tree in Bethany for not bearing figs in winter, he justified his anger by claiming that the fig tree could have borne figs, as witnessed by the fact that it sometimes does, in the summer.[9]

Philosophers find different places to rest on this well-worn path. But it seems as though we have no option but to travel it, or take some other means for escaping the charge of incoherence, perhaps by maintaining that actions, unlike other events, are not the kind of thing to which the

original dilemma applies. Actually, more than this would need to be defended for libertarianism to work. We would need not only that actions are not themselves the sort of things to which the dilemma applies, but that they do not supervene upon states of affairs and events to which the dilemma applies. But that is very hard to maintain. What we cannot do, it seems to me, is embrace without melancholy a relativization, supposing that from one point of view the rich story is incoherent, but that this is just one point of view, and to be neutralized by remembering that within its own terms it works well. The reason is that the first point of view represents not a particular, perhaps austere and naturalistic, standpoint, but something more like the standpoint of reason. The dilemma presents itself as inescapable, except, of course, to the careless or the inattentive. It is exclusionary in intent because, it seems, the only way to evade it is openly to embrace an acknowledged illogicality, and, as I have already said, the standards that make us uncomfortable doing that are at least as natural, in the study, as either of the views in question. For this reason, any pluralism we rest with here would have to be of the melancholy kind.

If I am right that the free-will problem does not centrally arise from a clash between an austere naturalistic standpoint, and another rich one, why does the different diagnosis suggested by Nagel and Strawson seem attractive? I think only because one aspect of the problem that does indeed contrast different standpoints is the phenomenology of choice. We can contrast taking up a 'third person' point of view, that of the spectator contemplating and perhaps predicting the actions of people, including themselves, in some future state, with the perspective of the deliberator, actively deciding what to do. We might then suppose that this second perspective discloses to us a kind of fact—a free choice, real control, responsibility—that is invisible in the first view, and further- more that since this second perspective is inevitable, for we must live our lives as deliberators, we have here a way of posing the problem as one of a putative clash between two inevitable standpoints.[10]

I take it that such an approach bears some relation to Kant's notoriously obscure doctrine of freedom, although he himself denies that phenomenology ever discloses whether we acted freely. In this, at least, he is surely right. First of all, nothing genuinely disclosed in the perspective of a deliberator is incoherent: he cannot perceive his own choice-making as neither determined nor random, if it must be one or the other. And secondly, there should be no motive to believe the contrary, for in fact nothing about the aetiology of our own choice- making is represented from within the perspective of deliberation. When we deliberate we focus upon aspects of the situation, not upon our own

minds, and not, usually, upon our own desires and interests, even if these determine which aspects of the situation are salient to us. Nothing about the causes of our own choice-making is visible, but that is not because we are looking where causes would be and finding nothing, but because we are looking elsewhere.

I should like to pause here and draw a comparison that I find illuminating with the fourth of Strawson's concerns, which is the reality of determinate intentionality. Here it is the determinacy of meaning which seems intuitive and inevitable to us, in the deliberative mode (which only means, as we think, and thereby rely on our words). Familiarly this is supposed to clash with the clear-eyed spectator's vision of indeterminacies everywhere; Quine, Kripke, and arguably Wittgenstein have in different ways emphasized the possibility of a multiplicity of interpretations of what we are really doing, which rules we are really following, or which universals we have really latched onto. Here too it is natural to oppose the determinacy of meaning that is inevitable to us from within the standpoint of thinking, with the skeptical or even eliminativist thoughts that seem justified from the objective or external standpoint of the spectator of our deliberations. And, again, there is a temptation to interpret the standpoint of deliberation as one in which determinate meaning is actually disclosed, and which therefore enriches the bleak landscape seen from the external point of view. The comparison with the free-will problem suggests that this route is closed, for it may be that we think our meanings determinate only as we think our actions uncaused, not because these things are disclosed to us, but because while we think and deliberate we are not looking at the places where indeterminacy, or causation, would be visible.

I believe that any idea that determinacy, or freedom, is a phenomenological given is blocked by this point. Yet there is a deep unease in each area. It is natural to think that my own freedom, in the sense of some kind of open possibility of going either way, is a presupposition of deliberation, and it is equally natural to think that my own determinate understanding is in a similar way a presupposition of all thought. I cannot deliberate, this thought goes, if at the same time I am aware that in reality all except one option is closed, and I cannot rationally compute a function or apply a concept if at the same time aware that in reality there is no determinate function or concept with which I am operating. It is not just that I am not looking at the place where causation would be found, or indeterminacy would be visible, but that I must practice as if *were* I to direct attention to these areas, nothing damaging would be found. In the one case there would be no determinism (or randomness) making deliberation futile, and in the other there would be no indeter-

minacy making thought futile. If it is indeed the case that we are bound to practice as if freedom and determinacy of meaning are each real, then melancholy threatens us again. For in the absence of a straight compatibilism, it will sound as if we are condemned to practice as if things were so that cannot be so; that deliberation itself depends upon a fiction or illusion.

IV

In the case of intentionality I believe we can achieve a better appreciation of the cause of anxiety if we put matters in terms of supervenience.[11] This is not because supervenience solves things, but because it illustrates what is needed to solve them. So we think in terms of a base totality of physical facts concerning a person. In this totality we include a total choreography of the movements of all the things that there are in space, and we can include the dispositions of the person and other members of the person's community. We can add causal linkages between events and states of affairs. In other words, we include anything nonintentional that we like. But now, it is alleged, it turns out that reference or meaning is undetermined by the base totality. To use the familiar example:

(A) The base totality of facts does not determine whether (1) 'rabbits' refers to rabbits, or (2) 'rabbits' refers to stages of rabbits, or any other proxy we care to construct. That is, each of (1) and (2) are compatible with the same base totality.

The second claim of austere, reductive, and eventually skeptical naturalism may be put:

(B) there is nothing else to make true either (1) or (2).

And the conclusion follows that there is nothing making either of these claims true, so that they are neither of them true. Here philosophers as different as Quine, Putnam, and Strawson may all be attracted to a kind of relativization. Quine tells us that we may accept (1) by 'acquiescing' in our home language. For Putnam, objects and signs are each 'internal to the schemes of description' of users, and this somehow alleviates the difficulty.[12] Strawson himself wisely remarks that relativization is less palatable in this kind of case than in the others he treats, and I would like to suggest why.[13] For the Quine-Putnam approach requires that there is such a thing as a determinate home language, or determinate scheme of description, relative to which (1) is true. But (A) and (B) together tell us that there can be no such thing. Calling the problem indeterminacy of

translation or interpretation disguises this. Determinately meaning rabbits by 'rabbits' myself, I can notice indeterminacy of translation, but then (resignedly, as it were) decide to translate you by the 'identity' transformation or homophonic manual.[14] The problem with this bland solution is that the abyss opened up engulfs my own standpoint as well: I cannot acquiesce in a home language if there can be no such thing. But, since a language is the medium with which we determinately understand each other, this is what (A) and (B) together threaten. Of course, I can say the words occurring in the statement of (1), but according to (A) and (B) there will be nothing making it false that this is an assertion of (2). So it is simply not true that relative to a translation manual or home language, we can assert (1) as opposed to (2). This is not a success we can achieve, or a standpoint we can occupy (this is an example of the second kind of incoherence I identified in the first section, where it is not that we have apparent inconsistency which may be resolved by relativization, but where one point of view seems to make the other one impossible).

It would be congenial to Strawson's liberalism to deny (B), accepting a further relatively self-standing layer of facts determining the truth of intentional claims. One possible layer would be facts about perception: surely one element making it true that a person determinately thinks in terms of rabbits is that they see the scene in front of them as containing rabbits. But if there is no straight compatibilist solution elsewhere, I do not think there can be one here. If indeterminacy is indeed a problem, it is certainly not one met by simple introduction of perception. To know how someone perceives the world is already to attribute determinate intentionality; in describing him as seeing the scene in front of him as containing a rabbit we have already, by Quine's standards, 'switched muses' just as surely as if we simply described what he believes and thinks. Of course, I do not doubt our right to do this, but doing it is not itself solving the problem of how it is a possible thing to do.

The advantage of putting these matters in terms of supervenience is that it highlights the need to relate any putative, further facts displayed by the rich view, to those recognized by the austere, illiberal naturalist. It is not, once again, that mention of supervenience solves anything. It only reminds us of a responsibility, and one, it seems to me, that in each area the liberal naturalist must discharge before anxiety is dispelled, and any relaxed pluralism claim to have been earned. I have argued this often enough in the moral case. But the same structures threaten in all these areas. This is why the problem of rule-following, for example, cannot be rectified simply by enlarging our ontologies, including a layer of determinate rules or universals, or even a primitive notion of acquaintance with them. Unless this layer stands in some determinate relationship with the

events of the extensional world, we still face indeterminacy claims, and to rule them out we need that the facts conceived in terms of universals supervene upon those acknowledged in the austere view.

My own straight compatibilism therefore denies (A); I believe that determinate reference and meaning supervene upon a determinate physical reality: all we have ever been offered to the contrary are small-scale illustrations of rectifiable problems of interpretation, as if someone were to argue that the correct solutions to crossword puzzles are always indeterminate, citing as argument the difficulty of solving for sure the first clue.

A very relaxed pluralist, deaf to the threat of anxiety and the strains of Humean melancholy, might refuse the responsibility of discussing supervenience. After all, showing how the rich facts arise in a world of austere facts is confessing that in one important sense the austere facts determine what there is. God had only to fix the physical facts through time, and he had fixed everything. I suppose that at a deep level I do believe this. Like Sellars, I suppose that although it is a perennial problem of philosophy to relate the rich 'manifest' image to the scientific image, it is only a problem because science tells us not just what there is in one version of the world, but in the world. What Strawson has tried to do is exactly what needs to be done: to dispel the fear that the rest is as Berkeley put it, but a 'false, imaginary, glare'. The aim must be to rejoice without anxiety in what we, with our scientifically constituted natures, make of the world, and how splendid it is that we manage to do so.

SIMON BLACKBURN

DEPARTMENT OF PHILOSOPHY
UNIVERSITY OF NORTH CAROLINA
MAY 1995

NOTES

1. P. 68. All quotations from Strawson are from his *Scepticism and Naturalism* unless otherwise indicated.
2. P. 41.
3. The central discussion is of course Bk I, Pt IV Sec. 2 of the *Treatise*.
4. See also, for example Strawson's reply to Ayer and Bennett, in *Philosophical Subjects*, ed. Zak van Straaten (Oxford: Oxford University Press, 1980), p. 265: 'Our proneness to reactive attitudes is a natural fact, woven into the fabric of our lives, given with the fact of human society as we know it, neither calling for nor permitting general 'rational' justification'.
5. See esp. pp. 45–50.

6. P. 65.

7. P. 63. My own mistrust of identity is explained in 'Losing Your Mind: Physics, Identity and Folk Burglar Prevention' in Essays in *Quasi-Realism* (New York: Oxford University Press, 1993).

8. See my 'Enchanting Views' in *Reading Putnam*, eds. Peter Clark and Bob Hale (Oxford: Blackwell, 1994). Putnam perversely misreads the argument in his reply, saying falsely that I suppose him to believe genuinely inconsistent propositions to be true (p. 244). This was never in question: the point of the charge is that since he escapes from believing this by distinguishing different uses, there is no obstacle to concatenating the descriptions, and maintaining the unity of truth, which, at this point, was his criterion for the dreaded 'metaphysical realism'. In effect I do say that if his position is to be interesting, he needs that the views are opposed or inconsistent, but I did not conclude the *modus ponens*. His own combination of views, namely that "the ordinary notion of 'meaning' was simply not invented for this kind of case", whereas apparently the ordinary notion of use was, since we can see unambiguously that words are used differently in the two different descriptions, is scarcely reassuring.

9. Matthew 21, 19–20.

10. In 'Has Kant Refuted Parfit', in *Reading Parfit*, ed. Jonathan Dancy (Oxford; Malden, Mass.: Blackwell, 1997), I reflect on the similar problem of whether within the deliberative stance a necessary determinacy of personal identity is postulated, when from the third person or objective standpoint it is illusory.

11. In what follows I echo the presentation of the problem I gave in 'Enchanting Views'.

12. *Reason, Truth, and History* (Cambridge: Cambridge University Press, 1981), p. 52.

13. Pp. 92–94.

14. It is mildly scandalous that philosophers continue to talk as if problems here affected only translation and interpretation, when in fact as soon as Quine brought the issues back to the 'home language' neither word is at all in place. We are talking of determinacy of understanding.

REPLY TO SIMON BLACKBURN

Professor Blackburn discusses attempts I have made, in *Skepticism and Naturalism* and other writings, to resolve apparent conflicts in certain philosophical areas. Such tensions arise, I have suggested, when two types of naturalism confront each other: on the one hand, an 'austere' or 'reductive' naturalism, which allows reality to nothing which is not ultimately reducible to or explicable in terms of the natural sciences; on the other, a 'liberal' or 'humanistic' naturalism which provides for a richer conception of the real, making room, for example, for morality and moral responsibility, for sensible qualities as genuinely characterizing physical things, for determinate meanings, meaning-rules, and universals—all as we ordinarily conceive of them. My general suggestion was that, whenever the two types of conception appear to be in conflict, the apparent conflict should be resolved not by rejecting either, but by relativizing our conception of the real to their respective standpoints.

Blackburn develops some well-reasoned doubts about the satisfactoriness of this maneuver. He does not initially tackle any of the relevant issues head on. Instead, he begins by deriving a quite general moral from Hume's diagnosis of the causal origins of our natural belief in the existence of 'body', i.e., of the existence of physical objects independently of our perceptions. While Hume recognizes the belief as one to which we are naturally and inescapably committed, his diagnosis of its causal origin represents it as logically incoherent, indeed self-contradictory. It is only by carelessness and inattention to the norms of reason that we (or those of us who are made conscious of the dilemma) are able to accept and live with the situation—a state of affairs which Blackburn describes as one of 'distressed' or 'embarrassed' or 'melancholy' acceptance of it. The question Blackburn raises is whether my 'relativizing move' in the areas of conflict between austere and humanistic naturalism can amount to anything more than a comparable acquies-

cence in what can only be regarded, from a rational point of view, as a markedly inferior second-best.

It is perhaps worth remarking that the choice of Hume's treatment of the belief in the existence of body as a model for the treatment of the dilemmas actually in question cannot be regarded as a wholly happy one; for Hume's account of how we come to hold that belief, his account of its causal origins, is purely fanciful; it is, at best, a consequence of his dogmatic and unargued premises—if it is even that. It is clear enough that Blackburn himself has no faith in it, and could scarcely hold the views he does acknowledge if he had.

Nevertheless the general moral holds good. If there is a clear and genuine conflict between what the norms of reason exclusively sanction and certain kinds of belief to which we are naturally, even inescapably, committed, then, since, by hypothesis, we cannot abandon the latter, the only resource available to us is that of anxious and melancholy acceptance, i.e., of a depressed acquiescence in our own irrationality. There is, of course, the possibility of disputing, in relevant cases, the antecedent of this conditional; for perhaps the appearance of conflict is sometimes itself illusory, no more than appearance, and the deliverances of austere naturalism are quite reconcilable with our humanistic beliefs and practices—when the latter are appropriately interpreted and understood. This is the general form of what Blackburn calls the 'compatibilist' solution.

There is at least one area in which Blackburn and I are agreed that no particular effort of interpretation is required in order to show an absence of conflict. The 'biographical' story about a human being which includes accounts of his mental life as a subject of conscious states is in no way in conflict with the largely neurophysiological story which traces causal routes through the physical organism. Widely different as the interest of each may be from that of the other, both stories are acceptable side by side. Each may be strictly true. By the same token, as Blackburn points out, there is no call here for a relativizing move. Neither, since not even an appearance of conflict is involved, is there any need to reach for a 'compatibilist' solution.

There remain the issues of morality, meaning, and sensible qualities. Regarding the first of these, Blackburn concentrates on the familiar stark alternative—all action is either random or ultimately determined—which is held to threaten the notion of moral responsibility; and he argues, correctly in my view, that the libertarian attempt to discover, and establish the reality of, a kind of freedom which escapes the dilemma and thereby grounds the threatened notion of responsibility, is an attempt that can never succeed. Hence, the argument goes,

committed as we naturally are to the whole range of moral reactions and judgments, we are committed either to a logically indefensible belief in a 'libertarian' freedom or to the moral incoherence of conniving at the injustice of blaming agents for actions for which they are not ultimately responsible. In either case, acquiescent acceptance of this situation can only be at best of the distressed or melancholy kind.

It is worth remarking that one of the two 'depressed' alternatives here offered rests on an appeal to a notion—that of the morally just—belonging to the class of notions the entire membership of which would be brought into question if the situation were really as bleak as Blackburn here represents it. Happily it is not. It is quite true, indeed tautological, that an agent can be justly blamed for an action only when he can be held morally responsible for it; and it is true that he is responsible for so acting only if he acted freely. But it is quite false that these requirements of justice can only be met by the satisfaction of some condition of *ultimate* responsibility which can no more be coherently stated than can the libertarian's conception of free will. Human beings, or the more judicious among them, are really quite skilled in determining whether, and to what degree, the conditions of moral responsibility are satisfied. It would be tedious to rehearse them, since this has been done again and again. So we can relax: the whole issue between determinists and libertarians is an irrelevance; and the fact that it has been so long and earnestly debated is but one more illustration of the tendency of philosophers to raise a dust and then complain they cannot see. So do I emerge as a straight compatibilist? If so, *ainsi soit-il*.

I must add that nothing I have said above detracts from the contention, advanced in *Skepticism and Naturalism*, that it is theoretically, and sometimes practically, possible for us to achieve a certain kind of detachment in our attitude to human behavior, viewing it in a purely naturalistic or 'objective' light and aiming at a kind of understanding which has no place for moral judgment. Insights arrived at in this way, though difficult to attain, will have their own validity. It is not that they conflict with moral assessments. The two operate in different spheres.

Now to meaning and reference. I am as unmoved by arguments for indeterminacy as Blackburn is—and must be. He must be, because the whole structure of his own argument rests on the demand for rationality, or consistency in thought; and thought itself requires the determinacy which those other arguments seem to threaten. But, given his frank avowal of what 'at a deep level' he believes, Blackburn faces a difficulty here. What he believes at this level is that once the facts about physical objects and events through time are fixed, everything is fixed; that the 'austere' or physical facts determine what there is; and obviously these

facts themselves include no facts about determinate meanings or intentions in general. His solution is to appeal to the concept of supervenience. Proclaiming himself, in the matter of meaning, a straight compatibilist, he believes that determinate reference and meaning *supervene* upon a determinate physical reality. In the absence of an answer to the question, 'How?', we might be tempted to complain that this is to explain the obscure by the more obscure. But leave that for the moment. The point is that reconciliation with the deep-level belief is to be secured by the thesis that the facts about determinacies of meaning and reference, though not themselves included in the austere physical facts, are somehow determined by the latter, are fixed once all of the latter are fixed.

As in all invocations of supervenience, the question of what kind of determination this is, what kind of necessity is involved whereby the items of the austerer range determine or necessitate those of the richer, remains unanswered and perhaps unanswerable. My own preference is simply, without invoking this uncertain prop, to acknowledge the existence of those abstract intensional items, determinate meanings, etc., which thought requires and which consequently have a secure place in our conceptual scheme. Of course this is not to deny their relation to the physical facts. It is only to question the need for an obscure account of that relation, an account motivated by 'deep-level', i.e. metaphysical, beliefs.

But where, finally, do Blackburn and I respectively stand? I think, as regards Blackburn, the clue lies in his concluding sentences. Although "science tells us not just what there is in one version of the world, but in the world," yet we may legitimately, he thinks, "aim to rejoice without anxiety in what we, with our scientifically constituted natures, make of the world and how splendid it is that we manage to do so." The key phrase here is 'our scientifically constituted natures'. We human beings, part of nature, with our variously, but scientifically, constituted natures, respond to our selves and the other variously, but scientifically, constituted parts of nature, in ways which are determined, or fixed, by those natures themselves, i.e., by the physical phenomena with which science directly deals; and our response takes the forms with which we have been concerned, the forms, for example, of finding human behavior endowed with moral properties, of operating in thought and speech with determinate concepts or meanings, and, we may add, of attributing sensible qualities, naively understood, to physical objects. Is this, then, a species of projectivism? Yes, but, it is implied, one we can embrace 'without anxiety' because what we thus 'make' of the world of science is determined (thus legitimated?) by that world itself. So the features of the

problematic areas may be held to acquire a kind of derived, or secondary, reality. Hence, perhaps, Blackburn's own characterization of his position in these areas as 'quasi-realism'.

What of my own position? What, in particular, of the 'relativizing move', the suggestion that, in appropriate cases, we relativize our *reallys* to the austere and liberal naturalist standpoints respectively and thus avoid the appearance of contradiction between the stories they respectively deliver? Insofar as my views are of a generally compatibilist character, as they appear to be, it seems that the relativizing move is redundant: all that is necessary is to deny the 'exclusionary' character of the contrasting stories in each case; so that the relativization of 'really' seems both gratuitous and misleading.

Yet I would defend it, as idiomatically and psychologically appropriate. What is essential is to recall the rubric that implicitly governs each occurrence of the relevant *really*: i.e., 'From the natural-scientific standpoint' or 'from the humanistic standpoint'. The point is that the respective standpoints are, in a perfectly straightforward sense, *opposed* to each other, even where their deliverances are not genuinely in contradiction with each other. They are opposed to each other in the sense that it is rarely, if ever, psychologically possible to occupy both at the same time; and then only if one who achieves this feat is conscious of his divided attitude. So it is natural, in what is the normal undivided state, to take it that the view from one's current standpoint, whichever it is, is the only correct view of how things really are in the area in question. And herein lies my general justification of the relativizing move—even if, from the overarching philosophical point of view, it is not strictly indispensable.

Finally, a word about my suggestion that Blackburn's position is metaphysically motivated. I do not use the word 'metaphysics' pejoratively here—or, I hope, anywhere; though I do not think I share Blackburn's metaphysics. But it is worth recalling here the views of one philosopher about whose work Blackburn has most brilliantly written and most eloquently spoken. I refer to Collingwood who had his own idiosyncratic view of the task of the metaphysician. That task was, according to him, to discover and record the 'absolute presuppositions' of the science of a given period of human history, past or present; where 'science' is to be understood, not in the modern sense of 'natural science', but in the older and correct sense of 'a body of systematic or orderly thinking about a determinate subject-matter'. I do not think that Blackburn shares Collingwood's historian's view of the nature of metaphysics; but I do think that what Blackburn acknowledges as his own 'deep-level' belief is easily recognized as having the character of an

absolute presupposition of much of the philosophical thinking of his, and my, contemporaries.

P.F.S.

8

Tadeusz Szubka

STRAWSON AND ANTIREALISM

It is commonly assumed that the debate between realism and antirealism can be pursued within at least three branches of philosophical inquiry: metaphysics, epistemology, and semantics or philosophy of language. As a result of this it is supposed that there are three varieties of realism and antirealism: metaphysical (or ontological), epistemological, and semantic. The relations between these varieties are unclear and disputable, but it is to some extent clear and hardly contentious what these realisms and antirealisms claim. To put it very roughly, metaphysical realism holds (and metaphysical antirealism denies) that there is the external reality independent—in its existence and structure—from us as knowing subjects. Epistemological realism claims (and epistemological antirealism rejects) that we are able to get knowledge about such external independent reality. And finally, semantic realism holds that the meanings of our sentences or statements are determined by truth conditions that may transcend all possible evidence. This idea is put in doubt by semantic antirealism that insists that the meanings of our statements can be given only in terms of their assertability conditions, recognizable and manifestable in the public use of language.

Strawson is generally perceived as a philosopher who has taken the side of realism in all these three debates; it seems also that this opinion is well supported by his writings. However there are some presuppositions and facets of his philosophy that make the antirealist perspective more congenial to his views than it might appear at first sight. In the present essay I would like to identify and elucidate a few such facets, suggesting in this way that it is—at least to some degree—as much suitable or justifiable to describe Strawson as a kind of antirealist, as to describe him as a kind of realist. Thus what follows is not a completely neutral and impartial account of Strawson's views relevant to the realism debate. But as Strawson himself says in the preface to his *Skepticism and Naturalism*

truth in philosophy, though not to be despaired of, is so complex and many-sided, so multi-faced, that any individual philosopher's work, if it is to have any unity and coherence, must at best emphasize some aspects of the truth, to the neglect of others which may strike another philosopher with greater force.[1]

Nevertheless this lack of neutrality has some rationale: I think that antirealist aspects of Strawson's views are rather unduly neglected and bringing them to the fore may significantly deepen our understanding of his overall philosophical position.

I

Let us begin with Strawson's contribution to the debate between semantic realism and antirealism. I shall first present Strawson's criticism of semantic antirealism and the rebuttal of that criticism by Crispin Wright, and subsequently try to argue why Strawson should, after all, find a nonrevisionary semantic antirealism more congenial to his philosophy than a full-blooded semantic realism.

Strawson believes that there is something paradoxical about the way in which the doctrine of semantic antirealism has been formulated. The doctrine has its roots in the intuitionistic account of mathematical discourse, which holds, among other things, that to know the meaning of a mathematical statement is to know how to prove it. The advocates of antirealism are convinced that there are good reasons for generalizing this account on all discourse concerning the natural world. Obviously, in the course of this procedure the notion of provability will have to be replaced by its more general counterpart, so that the central claim of semantic antirealism may eventually take the following form: to know the meaning of a statement or declarative sentence is to know the conditions of its verification or warranted assertability. But are there really good reasons for this generalization? Strawson is inclined to say 'no,' since he finds *a striking contrast* between the subject matter and content of mathematics, where it is quite proper to speak of mathematical realm as being constructed by mathematicians, and the subject matter of natural science, geography, history, and ordinary discourse, where we always deal with "a realm of facts waiting to be explored, some parts of which might, indeed would, remain undisclosed or be irrecoverably lost sight of."[2] Given that, the meanings of the sentences in the latter areas should be understood not in terms of warranted assertability but rather in terms of their truth conditions, understood as the conditions of the world which may be unrecognizable by us, i.e., verification transcendent.

Furthermore, and this is another general charge against semantic antirealism made by Strawson, it is not at all clear where the lines of the disagreement between realists and antirealists should be drawn. The antirealist does not object to the idea of understanding the meaning of declarative sentences in terms of truth conditions if these sentences are conclusively verified, but strongly opposes application of the same idea to the meanings of the sentences that are in fact or in principle unverifiable. We must make this distinction, the antirealist claims, if we are to avoid the implausible consequence that the meanings of a certain class of sentences are given by their recognition transcendent truth conditions. The consequence is implausible since we are then at a loss how meanings of such a class of sentences can be learned and their grasp manifested in the public use of language. But this antirealist challenge is rather vague—we are not told what falls within the range of recognition-ally transcendent truth conditions, whose and what kinds of capacities or cognitive powers they transcend, how to construe the talk that some sentences are 'in fact or in principle' unverifiable and especially what 'in principle' really means here. This evident lack of clarity at such important points leads Strawson to rather unfavorable assessment of the way in which the whole debate between semantic realism and antireal-ism has developed: "My own impression is not that we are in the presence of a single clear-cut issue, but rather that we are in a confused area in which several well-worn philosophical problems are jostling each other as well as a number of new, and perhaps gratuitous, perplexities."[3]

However besides these two general complaints, Strawson tries to show on particular examples that the elucidation of meaning along the antirealist lines does not work. These are examples of sentences ascribing sensations to others ('John is in pain') and sentences about the past ('Lord Anglesey had his leg shot off at Wellington's side' and 'Charles Stuart walked bareheaded to his place of execution').

It seems obvious that the sentence 'John is in pain' in the mouth of anyone else than John himself has verification transcendent truth conditions. Thus, according to the antirealist, analysis of its meaning cannot proceed in terms of its truth conditions, or its truth conditions have to be conceived in such a way as to make them recognizable. Strawson considers three possibilities here:

(1) The sentence has no *truth conditions*, but it can be rightly uttered in certain publicly detectable circumstances, and knowing its meaning amounts to knowledge of those circumstances.

(2) The sentence has truth conditions, but they are, for everyone except John, simply the disjunction of the above mentioned circumstances; that is to say, these conditions are publicly observable aspects of

TADEUSZ SZUBKA

John's behavior. Knowing the meaning of the sentence is reduced to knowledge of such truth conditions.

(3) The sentence has truth conditions, but they have nothing to do with its meaning; so one can grasp its meaning without having any idea of what those truth conditions are.

Strawson finds all these possibilities deeply unsatisfactory. The third leads to the unacceptable consequence that one can know the meaning of the sentence in question without knowing what she or he is asserting by uttering it. The second is an expression of behaviorist or physicalist reductionism concerning the ascription of mental predicates, the reductionism which seems hardly defensible. The first possibility, although the least unattractive, does not provide us with any account of what the speaker is actually doing while uttering such a sentence without truth conditions at all. It appears then, concludes Strawson, that there are strong reasons to uphold the realist account of the meaning of 'John is in pain'—the meaning are simply its truth conditions, in most cases verification transcendent. These reasons are, on the one hand, the defects of all three antirealist proposals and, on the other hand, agreement of the realist account with our general picture of the world. Strawson writes:

It *is* part of what it is now fashionable to call our general *theory* of the world that we regard other people as subject to roughly the same range of sensations as we are painfully or joyously or indifferently aware of in ourselves; and it is in no way contrary to reason to regard ourselves—as in any case we cannot help doing—as justified in certain circumstances in ascribing to John a particular state of feeling which we cannot in the nature of the case experience ourselves, and his being in which is therefore, if such is the standard invoked, necessarily verification-transcendent. The seas of argument may wash for ever around these rocks of truth; but the rocks are not worn away.[4]

Similar problems arise when one attempts to give an account of the meanings of statements about the past along the antirealist lines, as for example 'Lord Anglesey had his leg shot off at Wellington's side' or 'Charles Stuart walked bareheaded to his place of execution.' Here the antirealist also faces a choice between three alternatives: (1) such sentences have no truth conditions at all; (2) their truth conditions are nothing else but evidence in their favor; or (3) the sentences in question have truth conditions but they are totally irrelevant to meaning. Moreover, if one follows the standard antirealist route of absorbing truth conditions into evidence or replacing them by assertability conditions, she or he would have to admit that statements about the past radically change their meanings as the evidence in their favor takes a different form. For instance, one would have to admit that the sentence 'Charles

Stuart walked bareheaded to his place of execution' uttered by a witness of the execution a few days later has a different meaning from the same sentence asserted by us now on the basis of the historical evidence. This is a rather unwelcome consequence, since we are strongly inclined to say that on both these occasions the sentence with the same meaning was uttered, and this inclination is supported by the fact that one cannot locate any ambiguity in the sentence—neither in its constituents nor in its construction—which might explain this alleged difference in meaning.

Strawson believes that the above considerations taken together suggest the following conclusion:

> The conception of verification-transcendent truth conditions—at least in one or another of the relatively stringent senses of 'verification-transcendent' which [. . .] anti-realist seems to favor—this conception and its link with that of meaning, is an essential part of a general view of the world which is in no way contrary to reason and to which we are in any case inescapably committed.[5]

In short, semantic realism is arguably a much better and more natural option than semantic antirealism that faces a lot of difficulties.

Crispin Wright has tried to respond in detail to Strawson's criticism of semantic antirealism.[6] To begin with, Wright thinks that the general charge of a lack of clarity does not weaken the antirealist challenge at all. Perhaps it is the case that we cannot, even in a broad outline, determine the class of sentences whose meanings, both for realist and antirealists, may be regarded as given in terms of (conclusively verifiable) truth conditions. As a result, it is quite plausible that any attempt to draw a clear and fixed line of disagreement between realists and antirealists will meet insurmountable difficulties, at least at the present stage of the debate. But this does not worry the antirealist at all. For to put in doubt the realist account of meaning in terms of truth conditions, she or he needs only a few unproblematic cases of statements whose truth conditions are obviously verification transcendent; and such cases abounds: unrestrictedly general hypotheses, many types of subjunctive conditionals, statements about the remote past and future, statements about others' mental states, etc.

Wright responded with three critical comments to Strawson's claim that the antirealist is unable to give a satisfactory analysis of the sentence 'John is in pain.' First, in assessing the antirealist proposals about the meaning of this sentence, Strawson seems to make a tacit realist assumption that the only adequate account of asserting or uttering a sentence by a speaker proceeds in terms of necessary and sufficient conditions for truth of that sentence (that is, in terms of its truth conditions). This explains, for example, why Strawson says with such

confidence that if we suppose the sentence 'John is in pain' has no truth conditions, or its truth conditions have nothing to do with its meaning, we would not know what is being asserted by uttering it. According to Wright correctness of the assumption is crucial for the prospects of a successful antirealist account of (declarative) sentence meaning but Strawson, unfortunately, did not produce any argument for that assumption.

Secondly, three antirealist options envisaged by Strawson do not exhaust all possibilities of how the sentence about John's pain may be analyzed in accordance with the antirealist strategy. The possibility (4) has been overlooked, with the following distinctive features: it differs from (1) in admitting that 'John is in pain' has truth conditions (they amount to the fact that John is in pain); and from (2) in denying the feasibility of reductive analysis of those truth conditions in terms of publicly accessible behavior or physical states; and from (3) in holding that grasping the meaning of 'John is in pain' involves possession of a conception of what it is for the truth conditions of that statement to obtain. Moreover, (4) differs sharply from the realist account of truth conditions, since it insists that to possess a conception of the truth conditions of 'John is in pain' is to know publicly accessible circumstances that warrant the assertion of this sentence. In other words, 'grasping the truth conditions' is "constituted by possession of a complex discriminatory skill exercised in response to public circumstances."[7]

Third, in defending a realist analysis of the sentence about John's pain, Strawson seems to assume that antirealist alternatives are bound to be radically revisionary of our 'general theory of the world' and linguistic practice. But perhaps, contrary to Strawson, the antirealist does not revise them; perhaps she or he seeks their new illuminating interpretation. Thus the strong conviction that others have the same range of sensations as we do—although they are not directly accessible—may be taken as an expression of the fact that the ascriptions of various mental states to others are essentially *defeasible*, that is to say, that they are not immune from revision and can always be, at least in principle, overturned. Therefore, concludes Wright, the 'rocks of truth' referred to by Strawson, "are not worn away not because they are the erosion-proof base of the true, realist, philosophy of mind, but because they are platitudinous reflections of features of our mental language—and are thus above the water-line."[8]

What in turn is Wright's reply to Strawson's remarks about the incredibility of antirealist analysis of historical statements? Of course, as in the case of sentences about sensations of others, Strawson does not take into account the possibility (4) which is immune from his objections and perfectly available for the antirealist. But even if the antirealist

accepts the option (1) or (3) it is not clear at all whether she or he would have to admit that any *change* in the evidence warranting the assertion of a sentence is a change in the sentence's meaning. Wright makes this point by considering the occasional sentence 'Strawson once visited the University of Warwick.' The constituents and the structure of this sentence are clearly unambiguous but its truth conditions, or conditions of warranted assertability, change—they are a function of the temporal context. But if such changes do not introduce any ambiguity into the sentence, then why should it be otherwise in the case of sentences about the past, considered earlier by Strawson? Perhaps it is even so, continues Wright, "that grasping the meaning of past tense sentences precisely involves grasping how their conditions of warranted assertion shift as one's own temporal location shifts."[9] If this is not a fully satisfactory answer to Strawson's charge that variations in assertability conditions make the sentences about the past radically ambiguous, then it is certainly the first step towards avoiding this unpalatable consequence.

Nevertheless if someone is still not convinced by the above replies and still thinks that the examples of the difficulties pervading semantic antirealism chosen by Strawson show that this is not a viable philosophical position, she or he has no right to take it as decisive vindication of semantic realism. Perhaps there is no satisfactory general account of sentence meaning. In those circumstances the refutation of antirealism can be accomplished only by meeting the antirealist challenge directly. As Wright says: "The essential challenge is to explain how man might manifest in his use of sentences of a certain sort that it was governed by a verification-transcendent conception of their truth-conditions."[10] It is important to notice that the antirealist does not question the very idea of verification transcendent truth conditions but rather the view that they somehow *govern* our use of the relevant sentences, or to put it more precisely, that the assessment of all particular uses of the sentences is made in the light of our conception of their truth conditions.

Strawson seems to accept just this view. Although at one point he writes as if the crucial problem in the debate between realist and antirealist were whether a speaker's responses to the recognizable situations relevant to asserting or denying a given sentence are *governed* by a conception of potentially verification transcendent truth conditions, a few lines later he tends to suggest that this kind of dependence indeed takes place:

It is enough for the truth-theorist that the grasp of the sense of a sentence can be displayed in response to *recognizable* conditions—of various sorts: there are those which conclusively establish the truth or falsity of the sentence; there are those which (given our general theory of the world) constitute

evidence, more or less good, for or against the truth of the sentence; there are even those which point to the unavoidable absence of evidence of either way. The appropriate response varies, of course, from case to case, in the last case being of the form, 'We shall never know whether p or not.'[11]

One can put the main point of this passage as follows: a competent user of a language has the adequate understanding of their sentences, that is, she or he knows under what conditions they are true, and this enables her or him to assess and respond to various sorts of detectable circumstances warranting or justifying assertion of those sentences.

The antirealist picture of the relation between assertability conditions and truth conditions, proposed by Wright, puts the things other way round. The proper account of this relation can be given by elaborating on the possibility (4) suggested above, according to which grasping truth conditions is *constituted* by a 'a complex discriminatory skill exercised in response to public circumstances,' that is in response to assertability conditions.[12] Of course, it is easy to see the mechanism of this constitution in the case of conclusively verifiable sentences, since their assertability conditions simply *are* truth conditions. But how does it work in the case of a far broader class of sentences that do not admit conclusive verification? Here our grasp of truth conditions cannot be exhausted by our knowledge of assertability conditions. What more is thus needed? That the latter conditions are taken to be *defeasible*—replies Wright's antirealist. So, if we consider some circumstances as justifying the assertion of a given nonconclusively verifiable sentence, we must acknowledge that new evidence may be provided that overturns this assertion. Furthermore, to some extent we have an idea of what kind of evidence this could be. For instance, if John groans we may be justified in asserting that he is in pain; but we are at the same time aware that these assertability conditions may be defeated by the evidence that he pretended to be in pain in order to gain our attention. In this sense the antirealist (at least the antirealist of a modest kind who does not eliminate the idea of truth conditions altogether) can admit that our knowledge of truth conditions is generated out of our own grasp of assertability conditions, but not reducible to it.

Contrary to Strawson's own pronouncements, it seems to me that in view of its perfect consonance with various claims he makes in the philosophy of language and epistemology the antirealist account of the relation between assertability conditions and truth conditions should be more suitable to his philosophy. I shall try to show this by considering the truth conditions of the simplest atomic sentence *Fa*, which ascribes some property or other universal feature to a particular individual. Such a sentence is a result of what is, for Strawson, the most fundamental

operation of thought and speech: the operation of picking out some individual item and characterizing it in a general way. Grammatically such a sentence consists of two components: subject-expression and predicate-expression. My argument depends crucially on the assumption that any constraint concerning the use of a component of an atomic sentence has bearing upon the account of the truth conditions of the sentence. I believe this assumption is quite plausible and does not require separate defense.

The expression playing the role of the subject in an atomic sentence is a definite singular term (a name or a definite description). This expression purports to pick out, or stand for, or refer to a particular item; or even better, it is a speaker of language who by using that expression purports to pick out or refer to that particular item. The necessary condition of a successful reference is, according to Strawson, possession by the speaker of some identifying knowledge about that item. That is to say, in order for an atomic sentence to be meaningful for the speaker, she or he has to know how to recognize the object the sentence is about. This recognition can take either a form of identification of the object through its most distinctive features, or a form of its demonstrative identification, where the latter is conceived by Strawson as the speaker's ability to "pick out by sight or hearing or touch, or [. . .] otherwise sensibly discriminate, the particular being referred to, knowing that it is that particular."[13] If one considers various chains of identificatory relations, one can quite easily see that demonstrative identification is here absolutely fundamental and does not depend on the other form of identification. However, the most important point for my argument is that we cannot sensibly talk about or refer to objects without having any idea how to identify or discriminate them, from which it does seem to follow that such unidentifiable or recognitionally transcendent objects cannot be part of the truth conditions giving meaning to an atomic sentence.

A similar, although not identical, constraint holds in the case of predicate-expression, that is, the expression specifying a general property or some other universal feature, accompanied very often by a copulative device (usually a form of the verb 'to be'). The expression in question is a general term and it introduces a general concept or universal. Strawson thinks that in order to grasp the sense of a general name one has to grasp *individual* essence of a *general* thing, i.e., a universal, that this name introduces. To grasp an individual essence means in this case to be able to discriminate the given concept or universal from other concepts or universals and to recognize its particular exemplifications or instances. One should notice that this constraint does not entail the implausible requirement that the grasp of a general

concept is impossible without the existence of its instances and their actual recognition. The really indispensable requirement concerning our grasp of the universal or general concept is, according to Strawson, "that one should know that there logically *could* be an instance of it and to know in principle how you would tell that you had encountered such an instance."[14] But this requirement is again enough to justify the conclusion that an unidentifiable or recognitionally transcendent universal (i.e., property, relation, or kind) cannot be part of the truth conditions giving meaning to an atomic sentence.

However one may argue that these two constraints concerning subject- and predicate-expressions do not guarantee that the truth conditions of an atomic sentence have to be recognizable and cannot significantly transcend its assertability-conditions. The argument for this claim may be as follows. The truth-conditions of an atomic sentence are not a mere combination of an individual and universal specified respectively by the subject- and predicate-expression; it is rather the fact that the individual *possesses* or *exemplifies* the universal in question. It is very often so that we know how to identify an individual referred to by a singular term and we have the full identificatory grasp of the property or relation ascribed to that individual, but we do not know whether that individual really has that property or relation. Take for example my statement 'John Smith is left-handed' and suppose it is about a person whom I know only from correspondence. Although I may be able to identify him in one way or another and know what does it mean to be left-handed, the sentence can still have verification transcendent truth conditions, quite distinct from its recognizable assertability conditions.

Nevertheless it seems to me that this transcendence is not very radical, and not only for the reason that these truth conditions are transcendent for me and obviously not for anyone who, for example, work with John Smith. They are also not totally or radically transcendent for me, since I know what behavior of John Smith might exhibit his left-handedness; when put in his presence I would easily recognize that. And this holds irrespective of the peculiarity of the selected example. It is quite likely that the same holds for any atomic sentence, and results from my identificatory knowledge of an individual being the object of reference as well as my grasp of the general concept specified by the predicate-expression. In other words, if I know how to identify an individual, I know—at least very vaguely—what kind of object it is, and if I understand the general concept, I have an idea to what kinds of objects it can be sensibly ascribed. The two constraints on the use of singular terms and general names seem to ensure that the way in which an individual referred to exemplifies or possess a given universal cannot be recogni-

tionally transcendent. Hence there cannot be a radical gap between assertability conditions and truth conditions, and there is no obstacle to constructing the latter out of the former. Thus the crucial condition of the (modest) antirealism is met, and I do not see any reason why Strawson should not be counted as such an antirealist.

II

Now, let us deal briefly with Strawson's views pertinent to metaphysical and epistemological debate between realism and antirealism.

It seems pretty clear from Strawson's writings that he is firmly committed to metaphysical realism. He conceives the aim of philosophy as a systematic attempt to elucidate the most general structure of our conceptual scheme, the framework and mutual connections of concepts in terms of which we think *about* the world existing independently of our knowledge of it, that is, the objective reality. While pursuing this aim we should resist the temptation to do two things which—according to Strawson—lead to confusions and illusions: (i) to step outside the entire structure of our conceptual scheme and then attempt a criticism or justification of it from such an exterior point of view; (ii) to find particularly secure or privileged part of that structure or framework and reduce other parts to it. Both these requirements are apparently reasonable, but they impede any attempt to justify epistemological realism without which metaphysical realism becomes a highly dubious and unsupported doctrine. This can be clearly seen in Strawson's account of perception.

Strawson begins it with a 'strict' or phenomenological description of our sensible experience, that is, a description which is true and faithful to the experiences we actually enjoy, and which does not entail the truth of perceptual judgments based on these experiences. Contrary to A. J. Ayer, Strawson insists that these conditions are not met by a description in terms of various sensible patches and patterns, without mentioning at all the concepts of objective objects employed in perceptual judgments. He holds that these concepts of realistically conceived objects permeate our mature sensible experience and must figure in any veridical characterization of that experience. This means that although it is to some extent correct to speak about a general, realist view of the world presupposed by these concepts, or better, by our perceptual judgments in which they are employed, it is totally inappropriate to take this view as a *theory* with respect to sensible experience, where the content of that experience is the *evidence* supporting the theory. It is inappropriate

because it is not possible to describe this 'evidence' without the acceptance of the 'theory' it supposedly supports. Thus, Strawson holds, the description in question justifies the conclusion

> that mature sensible experience (in general) presents itself as, in Kantian phrase, an *immediate* consciousness of the existence of things outside us. (*Immediate*, of course, does not mean *infallible*.) Hence, the common realist conception of the world does not have the character of a 'theory' in relation to the 'data of sense'.[15]

A further elaboration of this conclusion—the elaboration which to some extent goes beyond the strict or phenomenological description—yields a view that we are naturally committed to direct realism, according to which we immediately perceive real, enduring physical objects in space and time, objects having various properties and causing our perceptions of them.

But why, one may wonder, we should accept this natural commitment to direct realism? Perhaps it is only a piece of unsupported common sense which needs to be abandoned or modified in the light of critical scientific knowledge. If we want to defend the claim that the above description is not merely an account of perception as it *appears to us*, but also an account that reveals to us the real nature of perception, we have to be able to respond to this challenge and show that direct realism survives critical examination.

Strawson tries to meet this challenge by displaying the difficulties inherent in one scientific alternative to the natural direct realism. On this alternative view there are indeed objective things that occupy outer space but some of their perceptible properties, e.g. color, are subjective. Hence the things-in-themselves are in certain respects different from the things as they look to us in ordinary perception. But can we, Strawson asks, coherently draw a distinction between subjective perceptible properties and the objective ones? He responds that, contrary to what may appear at first sight, this is rather impossible. If we admit that, for instance, the color of a thing is a subjective property, we must consequently say the same about such a supposedly objective property as the perceptible shape of that thing. This is so because the perceptible shape is nothing else than a visible boundary of a colored object. The advocate of scientific realism may of course reply that in the case of shape, and some other qualities, there is a full *resemblance* between our subjective representation and objective reality, but Strawson does not find this reply convincing. As he argues:

> It makes no sense to speak of a phenomenal property as *resembling* a non-phenomenal, abstract property such as physical shape is conceived to be by scientific realism. The property of looking square or round can no more

resemble the property, so conceived, of being physically square or round than the property of looking intelligent or looking ill can resemble the property of being intelligent or being ill. If it seems to make sense to speak of a resemblance between phenomenal properties and physical properties, so conceived, it is only because we give ourselves pictures—phenomenal pictures—of the latter. The resemblance is with the picture, not the pictured.[16]

So it seems that only the following option is open to the so-called scientific realist: to maintain, in Kantian fashion, that behind the world of ordinary experience there is the real world of things as they are in themselves. However the scientific realist is not happy to go so far as Kant, namely to locate the things-in-themselves beyond the realm of what is knowable and to deny any similarity between the perceived and the real world. The scientific realist holds that science is after all able to tell us what kinds of things and properties are really in the world. Moreover these two worlds coincide as far as space and positions occupied by objects are concerned. But the serious difficulty of this view is to give a satisfactory account of the procedure enabling us to abstract the idea of a spatial system and the concept of a position in space from all phenomenal or perceptual associations.

Strawson suggests that the best way out of the conflict between commonsense and scientific realism is to recognize a certain relativity in our perception of the world. We very often say, for instance, that a given thing looks red in this peculiar light and maintain that it is green in normal daylight, as well as acknowledging that when appropriately magnified it appears to be blue and yellow (i.e., its surface really consists of blue and yellow dots). These ascriptions are not inconsistent, since they have been made in different circumstances and from different standpoints. In the same vein we may say that scientific realism does not conflict with ordinary direct realism—it is simply a result of a very radical shift to a viewpoint from which the only qualities or properties ascribed to objective things are those that figure in scientific theories. To use another example, it seems that the picture of the world suggested by scientific realism does not conflict with the conception of objective things as possessing visual or tactile properties in the same sense in which the statement that blood is in fact almost colorless does not conflict with the statement that it is bright red.

This 'relativizing move,' as Strawson calls it elsewhere,[17] reconciles scientific and commonsense realism by introducing some relativity in our conception of the real properties of external or physical objects:

Relative to the human perceptual standpoint the grosser physical objects are visuo-tactile continuants (and within that standpoint the phenomenal properties they posses are relative to particular perceptual viewpoints, taken

as standard). Relative to the scientific standpoint, they have no properties but those which figure in the physical theories of science.[18]

Strawson notes that the above account of perception, as well as the suggested reconciliation of commonsense and scientific realism will not satisfy the absolute-minded. But I suspect it is unlikely that this account will satisfy even an ordinary epistemological realist without absolutist yearnings. Here are the reasons for my doubts.

To begin with, it is important to note that by applying the terms 'standpoint' and 'point of view' to commonsense and scientific realism, Strawson uses them in somewhat stretched or analogical sense. In their primary and literal meaning they apply to spatial and temporal positions occupied by us while we perceive and judge various things. In most such cases it is easy to explain why we arrive at conflicting perceptual judgments about the same objects from different positions. This is due to the distance involved (a mountain certainly looks different from a short and a long distance), perspectival distortion (a small thing within the reach of my hand looks bigger than a thing of a considerable size located over one hundred yards away from me), and the like. These explanations are obviously of no use for the apparent conflict between commonsense and scientific realism, understood as the general philosophical conceptions. Here the conflict must be accounted for by discrepant philosophical preferences concerning the aims to be achieved, concepts to be applied, and the like. And this very easily gives rise to the view that the truth about the world is in itself relative: it essentially depends not only upon the way the world is but also upon the kinds of concepts being employed, discriminatory standards being applied, and even upon our interests.

If Strawsonian 'relativizing move' really entails relativity of truth, his view might, paradoxically, turn into a form of transcendental idealism,[19] to the effect that we are able to establish various perspectival truths about the world but we will never reach just *the* truth about the world, and in consequence we will never get to know the world as it is in itself. I doubt, however, that Strawson would welcome this conclusion. He might reply that his 'relativizing move' does not entail all-embracing relativity of truth, since after all those 'moves' are being made inside a very general framework of concepts indispensable to any meaningful thought about the world. In other words, there are "*necessary* features of any conception of experience which we can make intelligible to ourselves, and hence the concepts of these features will be, in just this sense, necessary concepts, non-contingent elements of our conceptual structure."[20]

But this reply may still be unsatisfactory to the epistemological realist who wants to have some grounds for saying that we are able to get

knowledge about the world as it is in itself. Of course, this requirement should not be construed as a request to do something which is clearly impossible, namely to provide us with some grounds for saying that we may get to know what the world is like independently from any cognitive procedures, indeed in abstraction from any knowledge of it. What the epistemological realist has in mind here is, to put it very crudely, whether our knowledge conforms to objects in the external world, or whether the objects have to conform to the general structure of our knowledge. In particular, the epistemological realist expects to give us some reasons for the claim that our contribution to perception, however important, is not a contribution to its content.

Strawson is reluctant, or even implicitly refuses, to provide us with such reasons. He thinks that any attempt of this kind would inevitably distort the picture of the relation between perception or experience, concept and judgment. The main distortion would consist in the suggestion that we enjoy certain experiences that subsequently give rise to a concept, that in turn is employed in various judgements. Contrary to that suggestion, experience, concept and judgment are merged. Strawson elaborates this idea as follows:

> It is not, by itself, even enough to say, as Kant did, that concepts of the real are nothing at all to a potential user of them except in so far as they relate directly or indirectly to a possible experience of the real. More especially, as he also realized, those concepts which enter into our basic or least theoretical beliefs, into our fundamental judgments, are just those concepts which enter most intimately and immediately into our common experience of the world. They are what—special training apart—we *experience* the world *as* exemplifying, what we *see* things and situations *as* cases of. Correlatively, experience is awareness of the world as exemplifying *them*.[21]

Putting aside the issue of judgment, one may say that at the bottom of Strawson's view on this matter is his strong conviction that perceptual content is permeated or soaked all the way through by concepts. That is to say, in normal mature perceptual experience one cannot distinguish a level of nonconceptual perceptual content on the basis of which we form concepts or are prompted to apply the concepts that we already possess. Strawson may adduce for his conviction familiar and widely accepted reasons:[22] that nonconceptual perceptual content is another name for a long-discredited myth of the given, that such an account of perception undermines the possibility of justificatory or rational connections between our perceptions and judgments, and that the very idea of a nonconceptual content is simply an expression of a confused attempt to get outside our conceptual scheme. I am not going to assess the cogency of these reasons here, but only want to emphasize that without this idea, irrespective of its vulnerability to criticism, Strawson's epistemological

realism is highly problematic. Or to put it in a more straightforward and provocative way: Strawson's supposed direct realism concerning perception, unsupported by any attempt to distinguish between our human contribution and a contribution of the world to the content of perceptual experience, tends to slide into a form of epistemological antirealism or at least a disguised skepticism concerning the main line of the realism debate in epistemology.[23]

TADEUSZ SZUBKA

DEPARTMENT OF PHILOSOPHY
CATHOLIC UNIVERSITY OF LUBLIN, POLAND
THE UNIVERSITY OF QUEENSLAND, AUSTRALIA
JUNE 1996

NOTES

1. *Skepticism and Naturalism: Some Varieties* (New York: Columbia University Press, 1985), p. viii.
2. P. F. Strawson, "Scruton and Wright on Anti-Realism *Etc.*," *Proceedings of the Aristotelian Society* 77 (1976–77): 17–18.
3. Ibid., p. 17.
4. Ibid., p. 19.
5. Ibid., p. 20–21.
6. "Strawson on Anti-Realism," *Synthese* 40 (1979): 283–99; reprinted in Wright's collection *Realism, Meaning and Truth* (Oxford: Blackwell, [1987] 1993), pp. 70–84 (all page references are to the reprinted version).
7. Ibid., p. 76.
8. Ibid., p. 77. Wright in his essay makes no attempt to reply to Strawson's general complaint that semantic antirealism seems to be improper generalizations of intuitionistic philosophy of mathematics onto other areas. But the above considerations suggest what his reply could be: if antirealism has no far-reaching revisionary consequences for our theory of the world and language, then it does not necessarily entail that the subject matter of natural science, geography, history, and ordinary discourse is constructed or created in the course of our investigations. In short, the antirealist is not bound to deny the striking contrast mentioned by Strawson.
 A direct reply to Strawson's complaint can be found in Dummett's writings. Dummett points out that the striking contrast between the subject matter of mathematics and the subject matters of other disciplines arises only if one accepts certain questionable philosophical assumptions, and that the metaphysical questions of existence of those domains are not crucial for the realism debate as envisaged by him. See M. Dummett, *Truth and Other Enigmas* (London: Duckworth, 1978), pp. xxiv–xxix.
9. "Strawson on Anti-Realism," p. 78.
10. Ibid., p. 82.

11. "Scruton and Wright on Anti-Realism *Etc.*," pp. 16–17.

12. Strawson seems to miss this claim about dependence and constitution involved in the option (4) when he wonders why it should be taken as a species of antirealism. See his review of Wright's *Realism, Meaning and Truth, Mind* 96 (1987): 417.

13. *Individuals: An Essay in Descriptive Metaphysics* (London: Methuen, 1959), p. 18.

14. P. F. Strawson, "Individuals," in G. Fløistad, ed., *Philosophical Problems Today*, vol. 1 (Dordrecht: Kluwer, 1994), p. 32.

15. "Perception and Its Objects," in G. F. Macdonald, ed., *Perception and Identity: Essays Presented to A. J. Ayer with His Replies to Them* (London: Macmillan, 1979), p. 47.

16. Ibid., p. 54.

17. *Skepticism and Naturalism: Some Varieties*, p. 50.

18. *Perception and Its Objects*, p. 58.

19. As pointed out by J. D. Kenyon in his review of *Skepticism and Naturalism, Philosophical Investigations* 12 (1989): 248.

20. P. F. Strawson, *Analysis and Metaphysics: An Introduction to Philosophy* (Oxford: Oxford University Press, 1992), p. 26.

21. P. F. Strawson, *Subject and Predicate in Logic and Grammar* (London: Methuen, 1974), p. 14.

22. See for example J. McDowell, ed., *Mind and World* (Cambridge, Mass.: Harvard University Press, 1994), and H. Putnam, ed., "Sense, Nonsense, and the Senses: An Inquiry into the Powers of the Human Mind," *Journal of Philosophy* 91 (1994): 445–517. The positive views on perception put forward in these works are in certain respects remarkably similar to the main line taken on this matter by Strawson.

23. For helpful comments on an earlier draft of this essay and stylistic improvements I am indebted to John Heil, Zofia Kolbuszewska, Leemon McHenry, and Paul F. Snowdon.

REPLY TO TADEUSZ SZUBKA

Dr. Szubka begins by mentioning an assumption which he does not explicitly endorse, viz. That the debate between realism and antirealism comes in three distinct varieties: metaphysical, epistemological, and semantic. He remarks that I myself am commonly seen as standing, throughout, on the realist side of the debate; but suggests that this perception is in fact one-sided and that, in view of what he discerns as antirealist aspects of my work, I should be seen, rather, as straddling the divide.

Perhaps I may remark, initially, that although such a posture is in general by no means uncongenial to me, in fact, in this matter, I share the common perception, regarding myself as firmly on the realist side of the question.

But now to detail. Dr. Szubka considers first the semantic approach. The issue here turns on the relation between the meaning of any declarative sentence and its truth conditions. The realist is held to maintain that the relation is that of identity, the antirealist to accept this, at best, only in a highly qualified form. Discussion of the issue has in practice turned on the question of what *understanding* such a sentence, or grasp of its meaning, consists in; and this, in its turn, on what it is to *manifest* such understanding.

Dr. Szubka gives a lucid and fair account of the debate as conducted between Crispin Wright and myself. The details are mostly there and I will not repeat them. Let me concentrate instead on the 'modest' form of antirealism for which Wright finally settles. It is modest in that it does not involve the outright denial that grasp of meaning is grasp of truth conditions, but instead offers an account, in terms of the conditions of warranted assertibility, of what this grasp consists in. It consists, on this view, in knowing what publicly accessible circumstances would warrant the assertion (and, presumably, what such circumstance would warrant the denial) of the sentence in question. In Wright's own words, "grasping

the truth conditions" is "constituted by possession of a complex discriminatory skill exercised in response to public circumstances."

Now of course the realist need not deny that understanding a declarative sentence of a given type generally involves, indeed in some cases must involve, the possession of skills of this sort. He will only insist that possession of such a skill, as manifested in response to publicly accessible conditions, cannot be the whole story; that the story must include, crucially, a knowledge of truth conditions *simpliciter*. And in the cautious antirealist's concession that assertibility conditions must always be taken to be *defeasible* I think we find an implicit acknowledgment of this.

This is by no means the end of the story. There are many statements which we can understand but for which there is no prospect of our obtaining any grounds either for asserting or for denying them. The assertibility conditions of such statements (or of their negations) are quite as publicly inaccessible to us as are their simple truth conditions. So, for the antirealist who does not dispute our understanding of them, the question arises of how we are to manifest our grasp of their assertibility conditions. We manifest it, according to Wright, in our recognition of the nontranscendent truth that such conditions do not obtain. But to be able to do this we must at least know what it *would be* for them to obtain—something not obviously easier to know that what it *would be* for the relevant particular statement to be simply true; which is all that the semantic realist requires of one who understands it.

To return from Wright to Dr. Szubka. The latter claims to detect an antirealist element in my treatment of that class of subject-predicate statements in which a particular object or individual is identifyingly referred to and characterized or classified in some general way. He echoes my own contentions that in order to understand such a statement one must have some identificatory knowledge of the individual referred to and be able in principle to recognize instances of the general characterization conveyed by the predicate; and is tempted to infer that these two constraints ensure that the way in which an individual referred to exemplifies such a general characterization cannot be recognitionally transcendent. Hence he concludes, in apparent agreement with Wright, that "there cannot be a radical gap between assertibility conditions and truth conditions, and there is no obstacle to constructing the latter out of the former"; thus meeting the crucial condition of modest antirealism.

Dr. Szubka makes things slightly easier for himself by attending mainly to the case in which identificatory knowledge of the individual concerned consists in the ability to identify that individual *perceptually*; but I take it that he would not wish to limit the scope and interest of his

conclusion in such a way. So I shall test it by recourse to an example which is not thus limited.

Consider the following sentence (which might be encountered in a work of historical fiction): 'Caesar, saying "alea jacta est," scratched his ear and smiled grimly'. It is certain that we (or most of us) understand the sentence: we know who is meant by 'Caesar' and we could perfectly well recognize any man's manifestation of the complex general property conveyed by the predicate. We may also reasonably take it to be the case that no good grounds will ever come to light for regarding the proposition it expresses as true (or false). In other words there do not exist any publicly accessible assertibility conditions for us to respond to. On the other hand, we can perfectly well envisage what it would be for such conditions to be available to us: in, say, the existence of an accurate translation of a surviving memoir by a reputable contemporary witness. In the best case, the translation would include *the very sentence* our grasp of the meaning of which is in question. Is it not then preposterous to maintain that our grasp of the meaning of that sentence is constituted by our appreciation that the availability of such grounds as here hypothesized would, if they were indeed available, give us assertibility conditions for the sentence in question? Or, as Szubka expresses it at one point, that our knowledge of the statement's truth conditions is *generated* or *constructed* out of such appreciation? I know not how to make the implausibility of this position any more evident; so will simply repeat the semantic realist contention that we understand the statement because we know well enough, and *modulo* vagueness, what it would have been for it to be true.

To deal more succinctly with this class of subject-predicate sentences or statements to which Dr. Szubka directs our attention. I agree entirely with him that a necessary condition of our fully understanding any such statement is that we should both have identificatory knowledge of the individual item referred to by its subject-expression and be able in principle to recognize exemplifications of the general property signified by its predicate. Where I differ from him is in holding that—provided the sentence makes sense, i.e., involves no category mismatch—this necessary condition is also *sufficient* for knowing the truth condition of the statement, i.e. for fully understanding it.

Dr. Szubka turns next from the issue of semantic realism to a cloudier and arguably more significant area, undertaking "to deal briefly with Strawson's views pertinent to the metaphysical and epistemological debate between realism and antirealism." The link between these two aspects of the question is, in one direction, obvious; for, clearly, the epistemological claim that we are able to achieve knowledge of a reality independent, in its existence and structure, of ourselves as knowing

subjects requires, logically, the existence of such a reality—which is the substance of the metaphysical claim. This latter claim in turn, Szubka remarks, would seem wholly unsupported, indeed empty, unless the epistemological claim could be shown to be well-founded. He goes on to observe that the real issue here is whether our knowledge conforms to objects in reality (as, he implies, epistemological, and hence metaphysical, realism demands) or whether those putative objects have to conform to the general structure of our knowledge.

This observation evidently evokes the contributions to philosophy of its greatest modern practitioner: if we embrace the second of these two alternatives, are we not committed to a transcendental variety of antirealism? But here we must tread carefully; for Kant himself explicitly espoused the second alternative, and yet proclaimed himself a realist of a kind (an empirical realist) about the spatio-temporal world studied in natural science. On one interpretation of his views he *appears* indeed to combine this species of realism with another and more questionable variety according to which reality *as it is in itself,* (supersensible or noumenal reality) remains and must remain in principle forever beyond the reach of human knowledge. This appearance, however, must be deceptive; for the 'two realisms' are uncombinable. If we cling to the reality of the natural world, the doctrine of the noumenal reality, of things as they are in themselves, can at best be given a weak interpretation which empties it, so to speak, of any substance. If, on the other hand, we cling to the reality of the supersensible, empirical realism suffers, and the world of things in space is reduced, at best, to the status of a merely subjective appearance.[1]

What, then, of Dr. Szubka's crucial issue: whether our knowledge conforms to objects in reality or whether those objects have to conform to the general structure of our knowledge? But this is a false dilemma. For us to have knowledge of objects in reality we must have and employ concepts and we must enjoy sensible experience. (In Kant's terms, our intuition is sensible and our intellect discursive.) These truths are, if you like, truths characterizing 'the general structure of our knowledge'. Granted that the spatio-temporal objects of natural science and common experience are indeed 'objects in reality' (as only an out-and-out idealist, certainly not Kant, would deny), then it follows, as I have argued amply elsewhere[2] that our awareness of objects as spatio-temporal is a necessary condition of our making empirical judgments and hence of possessing any empirical knowledge of the natural world. Kant indeed expressed this point misleadingly enough by saying that space and time were, merely, *our* forms of sensible intuition. But unless we are prepared to embrace the out-and-out (Berkeleyan) idealism which Kant himself emphatically repudiates, there is no occasion for us to be misled.

It may seem that, in conducting the discussion so far at a markedly general level, I have unfairly neglected that substantial part of Dr. Szubka's paper which he devotes to consideration of my views on perception. Physical objects, and the natural world in general, conceived solely in the terms belonging to the physical sciences, may seem so very different from those same objects (that same world) conceived in the terms belonging to ordinary human perceptual experience that conflict seems to be generated between those who are disposed to deny and those who affirm or are content to take it for granted that the sensible qualities normally attributed to such objects do really and objectively characterize them. The suggestion of mine to which Dr. Szubka refers was that the conflict is more apparent than real and that both views are acceptable, when qualified by recognition of their contexts, the relative 'points of view' from which they are respectively held. But this seems to Szubka to amount to the admission that we can never attain to more than 'perspectival'truths about the word', relativized to our own cognitive capacities, and thus that we can never have knowledge of the world as it really is, 'as it is in itself': an anitrealist, if not transcendental idealist, conclusion.

Here again, however, I must repeat the substance of a point made ealier when I accused Dr. Szubka of posing a false dilemma. He acknowledges that if the epistemological realist, in demanding assurance that we can attain knowledge of the world *as it is in itself,* is demanding "grounds for saying that we may get to know what the world is like independently from any cognitive procedures, indeed in abstraction from any knowledge of it," then his demand is absurd. So no reasonable realism can be thus understood. But, if not thus understood, then a reasonable realism must accept whatever conditions are imposed by the fundamental insight that sensibility and understanding (the capacities for conceptual thought and sensible experience) are the joint and mutually complementary sources of all human knowledge of the spatio-temporal world in which we live. What those conditions are it is one of the tasks of philosophy, though not of philosophers alone, to work out. I see no reason to think that they exclude acceptance of my modest proposals concerning perception.

Fundamentally, and perhaps unfairly, I fancy I detect in Dr. Szubka, as in Kant himself (with his gesture towards 'intellectual intuition'), a kind of yearning, which both would acknowledge to be humanly unful-fillable, for a species of insight into reality 'as it is in itself' which transcends our cognitive schemes and capacities altogether. But the fulfillment of the unfulfillable, the satisfaction of the unsatisfiable, cannot be a necessary condition of the rational acceptance of epistemo-logical and metaphysical realism. Realism, reasonably understood, is the

unarticulated metaphysics of the common man, as it is of the common natural scientist as well; and, in a suitably refined form, it is also the metaphysics of the reasonable metaphysician.

P.F.S.

NOTES

1. See Strawson, 'The Problem of Realism and the A Priori', in *Kant and Contemporary Epistemology*, ed. Parrini (Dordrecht: Kluwer Academic Publishers, 1994).

2. Ibid; and 'Kant's New Foundations of Metaphysics', in *Metaphysik nach Kant*, ed. Henrich and Horstman (Stuttgart: Klett-Cotta, 1988).

9

David Frederick Haight

REFERENCE AND REALITY

I

At one time Wittgenstein said rather cryptically, "Logic must take care of itself."[1] Though it is not altogether clear from his earlier writings what he considered to be included within the precise domain of logic, it might be said that what he meant by this remark is that the formation and transformation rules of a logical calculus would be sufficient to determine the truth-functional relations between or amongst statement-making sentences, or propositions. To illustrate this interpretation, let us take just one example from ordinary discourse. We might tentatively translate (a) "Ms. Smith is a spinster," and (b) "Ms. Smith is an old maid," into the first-order function calculus accordingly:

(a') (Fa)
(b') (Fa)

Supposedly, such translations disclose the "logical form" of the sentences so as to make subsequent logical manipulations, i.e., inference, possible. There are two problems here which immediately arise in connection with these two translations. (1) Why should not (b) rather read, (b'') (*G*a) where the predicate variable is *different* from that in (a')? (2) And why should it not further read, (b''') (*Gb*)—where the subject-variable is *different* from that in (a')? That is to ask, what grounds have we for translating ". . . is a spinster," and ". . . is an old maid" into (a') and (b') as referring to the *same* predicate? And what further grounds have we for construing "Ms. Smith" in (a) and (b) as referring to the *same* person? Why should not (a) and (b) be translated into (a') and (b''), or, for that matter, into (a') and (b''')?

The negative answer to these questions is this: it is not on the basis of

the formation and transformation rules of the calculus *alone* which determines how (a) and (b) are to be symbolized. All that the formation rules provide for are the conditions for the well-formedness of the formulae—what patterns of variables and constants do and do not go together, not what individual *values* of these variables belong together. And all that the transformation rules govern are the inference-patterns of the formulae *once* the formulae have been formed. Consequently, neither set of rules regulates the translation from ordinary discourse into a language-system with respect to the items which appear as values of those variables. Some *further* sets of rules are necessary to allow the translation of, e.g., (a) and (b) into (a') and (b'). The first set of requisite rules consists of the synonymy-conditions of the natural language, English, in which the two predicates, ". . . is a spinster," and ". . . is an old maid" occur. The second set involves reference-rules for the use of the singular term, "Ms. Smith."

Given the satisfaction of these two conditions, the "logical form," so to speak, of the two original statements is revealed in (a') and (b'), and the logical maneuvers of deduction can then occur in virtue of this canonical notation. It can then be claimed that each of these statements entails the other, just as any statement entails itself, or just as any proposition expressed by any two synonymous expressions entails itself.

This consideration of what constitutes the rules necessary for the logical manipulation of sentences in ordinary discourse necessarily involves, among other things, the discussion of the conditions of reference. What is in question is what these conditions are and what terms in logic or language carry the referential burden. Strawson and Quine, for examples, are ostensibly in basic agreement as to the conditions for reference, but they disagree as to what terms have the referential task. They both agree that the conditions of reference are contextual; i.e., that whether or not a term is used successfully to refer depends upon the context of the utterance of the sentence in which the term is used.[2]

Though the two thinkers indicate basic agreement over the claim that reference is context-bound, there is nonetheless a significant suggestion of disagreement signaled by Quine's use of the word, "ambiguous."[3] Strawson will insist that the "ambiguity" by both men is *not* a dangerous or misleading ambiguity which must be eradicated, whereas Quine does. Compare and contrast the following quotations. (Prior to the first, Strawson has been discussing the theory that the meaning of a term is the object to which the term is applied, and now he states how this mistaken theory of meaning can lead one [he has Russell in mind] to believe that terms must be "ambiguous" because they can be applied to more than one thing.)

We have detected . . . the belief, underlying the Theory of Definite Descriptions, that a genuine logical subject, a true referring expression, can have a meaning only if there exists an object to which it applies. "The King of France," which failed to satisfy this condition, was degraded from the status of referring expression. Now why is this belief so firmly held? The answer seems to be that the meaning of any genuine referring expression is taken to be *identical with the object to which it applies.* . . . This simple and only too natural equation is fatal to the claims of phrases like "a man" as referring expressions. For while there are plenty of men, there is plainly no single object which is the meaning of the phrase. And yet the phrase is not one we should ordinarily call ambiguous. It has the same meaning in immense numbers of sentences. So the conclusion seems to follow that it is not a referring expression.[4]

Strawson's point can be made with respect to singular terms, as well. They, also, are not "ambiguous" precisely because their meaning is not any one object, or a multiplicity of objects. In fact, some singular terms, like indexicals, for example, are not *names* at all, which could therefore be said to ambiguously name a number of "I's," a number of "nows," a number of "heres," etc.

But Quine merrily persists in using the word "ambiguity" in a manner so as to indicate the possible need for the elimination of such ambiguous words as singular terms.[5] Then he makes his intentions concerning this ambiguity explicit: "We shall see, indeed, that the whole category of singular terms is theoretically superfluous, and that there are logical advantages in thinking of it as theoretically cleared away."[6]

It must be emphatically suggested that because of each thinker's attitude toward the terms which are ordinarily used to refer, like those quoted by both Strawson and Quine above, there is a corresponding difference of attitude toward the agreed-upon conditions of reference—and this divergence of attitude toward the *referential rules* makes for a significant difference in their respective *ontologies.*

The disagreement is this: for Strawson, "Ms. Smith" is a legitimate referential expression; for Quine, it is not—rather, the terms in the ordinary language reading of $[(\exists x)\ (y)\ (Fy\equiv y=x)\ .\ Gx]$ carry the referential burden. Strawson gravitates closer to an ontological foundation for the ordinary use of singular terms in the contextual conditions of reference, while Quine levitates toward a context-free calculus in which logical quantifiers carry not just the referential, but the ontological, burden. This brief statement of agreement and divergence must now be carefully exposed and evaluated.

It is agreed upon by both men that the referential conditions must somehow be met if statement-making sentences are to have a truth-value.[7] The general conditions for reference can be stated as follows. If statements are going to be logically deducible from one another, certain

terms in them must not only be used to refer, they must be used to refer to the *same* things, whether those things are real or unreal. Furthermore, this sameness of reference can only occur in places and times that are in some relevant sense *approximate* to each other. Consider the following statements:

 A. Genêt is a thief.
 B. Genêt is a crook.

The first can be said to entail the second, granted the partial synonymy of "thief" and "crook," if, for instance, it has not occurred that (A) has been uttered on March 1, 1905, and (B) on March 1, 1945, during which time the man in question has reformed. A true assertion would entail a false assertion if this conversion has in fact occurred, and this would disallow a valid entailment. Here the proximity of time is essential. Also, the first can be said to entail the second if it is the case that the Genêt referred to in (B) is the same French playwright referred to in (A). If the Genêt of both statements were not the same person, then (B) would be false, and (A) true, in which case there would be another invalid entailment. Here the emphasis is upon the sameness of referent.[8]

Granted that these referential conditions must hold if statements are going to be capable of mutual entailment, it does not immediately follow that any particular linguistic or logical terms are necessary for the referring job. Here the conflict begins between Strawson and Quine. The issue which divides the two thinkers over the theory of reference, summarily speaking, has to do with the allegedly possible elimination of singular terms in natural languages. Quine argues that such an elimination is possible, and Strawson argues that it is not. To be sure, it is not as if Quine were attempting to eliminate reference to things altogether, although part of the move toward elimination is to allow statements to be more *context*-free; rather, he is claiming that the terms in the quantified assertions, into which the statements containing singular terms are paraphrased, have the old referential task. By translation into canonical form Quine purports to retain referential expressions while adding a new criterion for ontological commitment—the quantifiers of symbolic logic. Then whatever is claimed to be referred to by the use of quantifiers also belongs to the ontology of the user of that quantifier. To be is to be the value of a bound variable.

But the Strawsonian objection to this Quinian program is this: variables in themselves *do not refer*—they simply do *not* perform the job of referring by unique identification to particulars *unless*—and this is the crucial rider—it is already assumed that the referring identification

has been completed and that therefore the closed formula in question has a truth-value! This is precisely Strawson's point: in order for the closed formula to be truth-functional, the conditions of reference must have *already* been met, and *this* formula in itself does *not* perform such a referring function. Hence, the Quinian (and Russellian) translation procedures for eliminating definite descriptions, names, and other referring expressions presupposes that references have already been successfully executed with the use of some other terms than those in the logical paraphrase.

I propose now to show, first, that Strawson argues effectively against this Quinian program, and second, that this divergence has significant ontological implications.

II

Consider the following Quinian paraphrase involving the existential quantifier:

(1) Pluto is a planet.
(1′) $(\exists x)[(y) (Fy \equiv y=x) . Gx]$

From (1) Quine obtains (1′) by paraphrase, which, when read in a certain way, eliminates the proper name "Pluto." There is supposedly no elimination of *reference* to the planet named Pluto; the referring job is just transferred to the existential quantifier.

The question is: How are we to read (1′)? There are two general ways:

(1″) There is something which Pluto-izes, and with which anything which Pluto-izes is identical, and which is a planet.
(1‴) For something, it is true to say that it and only it Pluto-izes and that it is a planet.

On both readings, the words, "There is something," and, "For something," respectively, are supposed to carry the referential burden, on Quine's translation. But there is a major difficulty with this which can be expressed in two ways. Strawson explains this difficulty by claiming that the existentially bound variable does not in the slightest refer, but rather presupposes that the thing about which these existential assertions are made has already been referred to, or demonstratively identified, and this identification could only come through the referring uses of those very terms, i.e., singular terms, which Quine wishes eliminated. Strawson's objection seems to be well-taken. Suppose someone says, "There is something which is white and cool and tastes sweet." In one

tone of voice, viz., "*There* is something . . . ," the person might be said to be referring to a given something; but look at what he would be referring to—the *place* where it, whatever it is, might be found. He is by no means referring to the thing itself. Rather, some *further* reference must be made to distinguish and identify the thing itself from other possible white, cool, and sweet things in the vicinity. So in this emphatic reading, in an ordinary situation, reference to the thing is not made, but presupposed. In another tone of voice, one might say, inquisitively, "There is *something* around here which" In this case, the word "something" is not used to refer to anything specifically, or anything definitely; rather, it is used to call attention to an *indefinite* something or other, which, under a general description expressed in the predicate, is sought, but which when found is demonstratively referred to by a singular term, like, "*This* is the source of that sweet aroma," or "*That* ice cream is superb," etc. Now, if the two readings, (1″) and (1‴), are the only two possible readings, and furthermore, if these readings have only two primary emphatic renderings, viz., the definite use of "there" and the indefinite use of "something," then it has been shown that Quine's translation of formula (1) into (1′) does *not* eliminate the use of singular terms so much as presuppose it. I would suggest that this is in fact the case, and, furthermore, that the two subsequent emphatic readings of the existential quantifier in ordinary discourse are exhaustive of the *general* modes of using the words, "*There* is something," or "For *something.* . . ." But, in order to make this case more secure and not just defy the reader to present a new reading, I shall present a second consideration of that existential quantifier in which it will be shown that "something" is *by no means a referring expression at all.*

Consider the following two statements:

(2) The ball broke the window.
(2′) Something broke the window.

The two grammatical subjects operate quite differently; in (2) there is a reference to a definite object, but in (2′) there is at most, rather, an implicit call to inspect and determine what that something is which caused the crash and the broken glass. The point is this: "something" is not a *name*, or a description, etc., but is rather the *place-marker* for a name, a definite description, or some other referring expression. The word "something," as it is used in readings (1″), (1‴), and (2′), is not a referring expression and therefore cannot be used to refer to anything, which is what Quine would ostensibly want the word to do—with the help of the word "there" and the added predicative descriptions, of course. But this use of "something" is illegitimate because, like "being,"

"thing," "object," etc., the word acts as a general *substitute* for some item which can be named or referred to; it itself cannot be used to refer. Quine talks as if the place-markers (his own term)[9] for singular terms take referential precedence over the substitution instances of those place-markers. For example, he says, "Pronouns are the basic media of reference; nouns might better have been named propronouns."[10] (Propronouns, indeed.) There is something seriously wrong here insofar as an order of referential precedence has been reversed, and thus it appears that Quine has mistaken place-markers for referring expressions as a shady kind of referential expression themselves, perhaps the only legitimate ones. It is rather like mistaking the reservation sign on a restaurant table for the name of the people who have reserved it, or like mistaking the blank space on a check as a mysterious kind of reference to the person whose signature should fill the blank. And surely these are odd mistakes to make.

What these criticisms of Quine's alleged elimination procedure amount to is the establishment of a legitimate dilemma. Either Quine must admit that Strawson's singular terms are essential for referring, or *else* he must denigrate entirely the need for *any* referring expressions at all. His introduction of the existential operator as a referential device is a proposal which attempts to escape the horns of this dilemma in the following way: the operator purportedly both performs the referential task and simultaneously avoids the ambiguities of the contextual conditions in that the assertion of an existential claim makes explicit whether or not the ambiguous conditions have been satisfied. But this proposed escape from the dilemma fails precisely because the operator involved does *not* refer. Furthermore, it does not guarantee that the conditions have been satisfied; rather, it presupposes that they have. Therefore, Quine either has to admit the existence of some other terms which can do the referring job or be content just to perform logical maneuvers by ignoring the questions of reference-success altogether. This dilemma, I would suggest, seems unavoidable if Strawson's arguments and my additions are conclusive. Quine simply cannot have his referential operator and deny it, too.

The diagnosis for this Quinian elimination attempt is in part the following. What has happened in Quine (and in Russell's "On Denoting," as well) is that a very peculiar kind of referential expression was sought—an expression which could both *guarantee* that the conditions of its referring use were met and yet *ignore* those very conditions for the purposes of logical maneuvers in a calculus. Existential assertions (and Russell's assertions involving "logically proper names") *seem* to meet both these requirements in that they must be either true or false (a

necessity for logical inference), and in that they appear to avoid the possible ambiguities of the contextual situations by eliminating any possible terms which might *fail* to refer.[11] This translation procedure fails because it purports to have referring expressions which cannot in fact be used to refer, but rather presuppose some that can.

III

The differences between Quine and Russell on this matter of reference, however, are as significant as their ostensible agreement over the elimination of some or all singular referring expressions, for they indicate totally divergent ontological motivations. Russell's theory of denoting was directed toward the total elimination of singular terms which did not have a guaranteed referent in order to arrive at ontological atoms, standing in an immediate relation to the logically proper names which would remain after the elimination of pseudo-names, pseudo-definite descriptions, etc. Consequently, Russell's program consisted in trying to bring successful reference right into the canonical notation and make reference wholly independent of contextual considerations lying outside the notation. There would be no context-dependence whatsoever. One could ostensibly see by the notation whether or not a reference to extralogical items had been successfully made. This motivation, however, is not shared by Quine. Rather, his motivation in making reference partly manifest in canonical notation—recall that it is partly dependent upon context—is to eliminate truth-gaps in logic in order to have a "smoother logical theory."[12] His program, therefore, is not atomistic, though it amounts to a denigration of context-dependence for successful reference. With these similarities and differences noted between Russell's and Quine's programs of the elimination of singular terms, we begin to see the relevance of the theory of reference to ontology.

The implications which Russell drew from his theory of denoting were clearly ontological. He thought that if any genuine referring expressions could be found, they could serve as the names of the ultimate "simples" which the world must have in order for there to be meaningful employment of other referring expressions. For example, Russell maintained that if there are in fact any logically proper names, i.e., referring expressions which *cannot* fail to have referents, then there would be automatic success in finding something in the extralinguistic world to which these expressions necessarily referred.[13] Here, indeed, would be a *bona fide* ontological referent, that is, something that would actually exist and *have* to exist because the logically proper name itself exists.

Russell thought that he had found examples of such names in the words, "this" and "that," because, it seemed to him, that these expressions, whenever they were used, could not fail to refer to something immediately known.[14] Terms like "this," "now," "I," etc., cannot but have referents; so it would seem that an ontologist would have immediate access to extralinguistic entities simply by determining what the referents are of these logically proper referring expressions.

This Russellian quest for logically proper referring expressions takes explicit form in "On Denoting," wherein subject-predicate statements containing definite descriptions *which fail to refer* are translated into explicitly existential statements in which the once subject term—the definite description—now appears as a kind of predicate. By appropriate paraphrase it seems as if what were once merely "grammatical" subjects without referents could be translated into statements where these referentless terms appeared as predicates which do not name or refer to referents. The subsequent paraphrase hence displayed the correct logical form of any such statements involving terms without referents. In a word, "grammatical form" was shown to be a sometimes misleading presentation of "logical form." This search for a "logical subject," as opposed to a purely "grammatical" one, then, became the quest for the logically proper name, that elusive referring expression which had to have a referent and which therefore offered the ontologist something like a guaranteed metaphysical "simple." It was thought that whatever could be logically named, existed ontologically.

Quine's motivation for eliminating singular terms, however, was more logical than ontological. Unlike Russell, he sought not to arrive at logical atoms so much as to eliminate singular terms for the purpose of providing a means for eradicating truth-gaps in a logical calculus which would otherwise disallow the consistent application of the Law of Excluded Middle. With his technique of paraphrase, he could claim that *every* statement in the calculus had to be true or false, thereby allowing logical maneuvers which would be otherwise postponed by the lack of truth-values. In this program, however, the effect is nonetheless similar to that of Russell's in that the contextual requirements for reference become rather scornfully ignored. Quine makes this contempt quite explicit when he says, "Whether a word purports to name one and only one object is a question of language, and is not contingent on facts of existence."[15]

The assumption crucial to both Quine's program of paraphrase and Russell's quest for logical subjects seems to be this: names, indexicals, and definite descriptions all refer to whatever they are names of, indexes of, and descriptions of, *if* they are *legitimate* names, indexicals, etc. This

assumption was strenuously questioned by Strawson in "On Referring" and in *Introduction to Logical Theory* where he claimed that these sorts of expressions do not refer—rather, *people* refer to things by means of them.[16] The crucial divergence between Russell and Quine, on the one hand, and Strawson, on the other, can then be epitomized as the disagreement over whether or not singular *terms* refer. Fundamental to the understanding of this significant conflict is the Strawsonian insistence that referring is an activity of persons, not words—that singular terms do not refer but rather are *used* by people to refer. Hence, it is correct to say that, for Strawson, the *meaning* of the singular term, in a sense, is the *use* of that term, not the referent of it.[17]

This is the foundation for Strawson's disdain for the word, "ambiguity," when it is claimed by Russell and Quine that both singular and general terms are "ambiguous" because they refer to more than one thing. According to Strawson, these terms do not refer ambiguously, because they do not in themselves refer *at all*. In this talk of ambiguities, Russell and Quine presume that the meaning of the terms is not their use but their referents. Consequently, when they cannot find the relevant referents, they call the terms either ambiguous or deceptive. How else could Russell claim, with respect to general terms, "A phrase may denote ambiguously; e.g., 'a man' denotes not many men, but an ambiguous man"?[18] (An ambiguous man, indeed.) And how else could Quine claim, with respect to singular terms, "The singular term 'Jones' is ambiguous in that it might be used in different contexts to name any of various persons,"?[19] (An ambiguous name?)

Terms which are used to refer are not ambiguous referring terms because, in themselves, they do not refer, and thus they do not refer ambiguously. Rather, they are *used* to refer and if there is any ambiguity or vagueness involved, it is the fault of the persons using the terms or the situations in which the terms are used, not the terms themselves. Words are blameless, but people are not. The corollary to this Strawsonian analysis of referring, as opposed to the Russell-Quine theory, is that a successful reference does not depend upon the term used but upon the context and conditions of its use. If Russell and Quine were correct in assuming that terms in themselves refer, then something like an ultimate metaphysical atom would appear by the mere mention of its logically proper name (Russell), or else all singular terms should be eliminated that leave possible truth-gaps in a logical calculus (Quine). Both types of paraphrase are predicated on a questionable assumption, viz., that terms refer, rather than people. It remains to be seen whether this Strawsonian qualm can be rebutted or mitigated.

IV

It might be objected that Strawson has failed to distinguish two *prima facie* separate senses of "use" in his claim that a word does not refer, but rather that it is used by people to refer. These two senses of "use" can be characterized in the following way. The first sense of "use" would be that sense in which "use" is synonymous with "linguistic function." We could say, "The use, or linguistic function, of a name, indexical, definite description, etc., is to refer." In this first use of "use," it would be correct to say that, "The meaning, or use, or linguistic function, of these terms is to refer," and nothing would have been said about the *actual* use of the terms by people. The actual use of the terms would involve a second sense of "use" in which singular terms are now actually used by people in making a claim or in referring to something. In the actual use of the meaningful, in the sense of linguistically functional, term, the actual use is added, and this actual use is the utterance of a particular person in a particular situation. This use, then, of the term would be the actual referring use, as opposed to the potential referring use. Such a use is over and above the meaning or function of the term. This distinction between the two senses of "use" is that between the notion of "use" as function—the potentiality of a term—and the notion of "use" as actual utterance—the actuality of use. It is roughly the difference between Russell and Quine's sense of "denotation," which is an activity of *words*, and Strawson's sense of "referring," which is an activity of *people*. This *prima facie* distinction is obviously one of the lingering ambiguities lying behind the claim that the meaning of a term is its use. In the case of purportedly referring expressions, it seems as if there are at least two senses of "use"—the preceding. Furthermore, it seems as if perhaps Strawson has not properly distinguished between them.

Two responses must be made to this accusation against Strawson. One, Strawson himself makes this very distinction. Two, he by no means draws the conclusions from this distinction that Russell and Quine do. Strawson is manifestly aware of this ambiguity behind the "meaning is use" doctrine, but his explanation of the first sense of "use" is emphatically different from that of Russell and Quine. What they might call part of the linguistic function of a singular term is its denotation, whereas Strawson calls this aspect of a word simply its function. And Strawson analyzes the notion of "function" in such a way that it cannot mean "denotation" in the sense that Russell and Quine use the term.[20]

Strawson distinguishes between two senses of "use"—"use" in the sense of rules for the employment of words, etc. (in the footnote of the

above reference), and "use" in the sense of people's activity, or utterance (in the quotation preceding the footnote). The former has to do with *sentences*, or expressions which have meaning, but which are not in fact used. They are functional, but they are not in actual operation; theirs is a status of being operational, but they are not yet *in* operation. The second sense has to do with *statements*, or expressions which are sentences used to make a claim; they *are* in fact in operation. For example, consider Strawson's selected series of words, "The king of France is wise." As a sentence, it is meaningful, i.e., functional, but the subject term does not refer to any specific king of France. The phrase, "king of France," does not even purport to refer to any *particular* king of France. It merely has the potentiality for use as a reference to a specific king. As a statement, however, the above sentence comes to have a truth-value depending upon whether there is a king of France and whether or not he is wise.[21] It is not, therefore, true to say that Strawson fails to make a clear distinction between "use," or meaning, as a function of sentences and "use," or meaning, as an activity of people.[22]

Second response. But what is in dispute at this point between Russell and Quine, on the one hand, and Strawson, on the other, is the correct analysis of the first sense of "use." Each side seems to want to accuse the other of assimilating the first sense to the second, or the reverse, respectively.[23] Contrast Russell and Strawson.

Russell:

> So far as I can discover from the context, what (Strawson) objects to is the belief that there are words which are only significant because there is something that they mean, and if there were not this something, they would be empty noises, not words. For my part, I think that there must be such words if language is to have any relation to fact.[24]

Strawson:

> The source of Russell's mistake was that he thought that referring or mentioning, if it occurred at all, must be meaning . . . he confused expressions with their use in a particular context; and so confused meaning with mentioning, with referring.[25]

The disagreement is obvious. For Russell, if there is to be meaning at all, some terms must *in fact* "denote." For Strawson, if there is to be meaning, some terms must be *capable* of being used to "refer." What must be made explicit is Strawson's own analysis of what it means for an expression in a locution to be "capable" of referring, as opposed to actually doing so. Strawson says:

> Consider another case of an expression which has a uniquely referring use, viz., the expression "I"; and consider the sentence, "I am hot." Countless

people may use this same sentence; but it is logically impossible for two different people to make *the same use* of this sentence: or, if this is preferred, to use it to express the same proposition. The expression "I" may correctly be used by (and only by) any one of innumerable people to refer to himself. To say this is to say something about the expression "I": it is, in a sense, to give it meaning. This is the sort of thing that can be said about *expressions*. But it makes no sense to say of the *expression* "I" that it refers to a particular person. This is the sort of thing that can be said only of a particular use of the expression.[26]

According to this passage, to give the meaning, in the first sense, of "I," is to say how it *can* be used by different individuals. It is not to say to what person or persons it *actually* does refer. For the word to have meaning, it is necessary that it be capable of being used for referential purposes. So Strawson can say:

Meaning (in at least one important sense) is a function of the sentence or expression; mentioning and referring and truth or falsity, are functions of the use of the sentence or expression. To give the meaning of an expression (in the sense in which I am using the word) is to give *general directions* for its use in making true or false assertions.[27]

It is clear, therefore, that Strawson *does* make the distinction between the first and second senses of "use" and explains the former in terms of the latter—at least in the case of referring. In other words, for Strawson, the function of a term is to be understood in terms of its actual use, not vice versa. For Russell and Quine, the reverse seems to be the case: that a term be used to denote, i.e., be purposed to denote, is to be explained by its actually denoting in itself. But we have seen that terms like "I" do not in themselves denote. "I" is not a logically proper name, as Russell thought, nor is it an ambiguously denoting singular term as Quine believed.

Thus, it seems that against Russell it can be reiterated that extra-linguistic things do not wear their logically proper names on their faces for all to immediately recognize. Hence, the metaphysical slogan that "Whatever can be (logically speaking) properly named, exists, ontologically," appears to be useless in the ontological enterprise. Its truth depends upon the credibility of the thesis that names, indexicals, etc., in themselves refer, and this, due to Strawson's analysis of these terms, appears quite questionable. Against Quine, it can be repeated that singular terms in themselves do not refer ambiguously because they do not refer at all. His program of paraphrase gains plausibility because of his thesis that singular terms ambiguously refer and hence should be eliminated in favor of a smooth, logical calculus in which all ambiguities and truth-gaps are expunged. Such a program seems to garner its

plausibility from its thesis that singular terms ambiguously (with a sneer) refer. But because of Strawson's analysis of referring, this thesis, too, seems quite questionable.

DAVID FREDERICK HAIGHT

DEPARTMENT OF PHILOSOPHY
PLYMOUTH STATE COLLEGE OF THE
UNIVERSITY SYSTEM OF NEW HAMPSHIRE
FEBRUARY 1996

NOTES

1. Ludwig Wittgenstein, *Notebooks 1914-1916* (Oxford: Basil Blackwell, 1961), pp. 2e, 11e. Cp. L. Wittgenstein, *Tractatus Logico-Philosophicus* (London: Routledge and Kegan Paul, 1961), 5.473.
2. P. F. Strawson, *Introduction to Logical Theory* (London: Methuen and Co. Ltd., 1952), p. 213. (Emphasis his)
3. W.V.O. Quine, *Methods of Logic* (New York: Holt, Rinehart and Winston, 1950), p. xi.
4. Strawson, op. cit., p. 188. (Emphasis his)
5. Quine, op. cit., p. 203.
6. Ibid., p. 211.
7. Cf. Quine, *Methods of Logic*, p. xi, and Strawson, *Introduction to Logical Theory*, p. 4.
8. Cf. *Introduction to Logical Theory*, pp. 29, 214, 216f., and *Methods of Logic*, pp. 203, 216.
9. Quine, op. cit., p. 225.
10. Quine, *From a Logical Point of View* (Cambridge: Harvard University Press, 1961), p. 13.
11. Cf. Quine, *Methods of Logic*, p. 220, and B. Russell, "On Denoting," reprinted in *Logic and Knowledge*, ed. by R. C. Marsh (London: George Allen and Unwin Ltd., 1956), p. 47. For more of our reservations, see our book, *The Scandal of Reason* (Lanham, Md.: University Press of America, 1998).
12. Quine, *Methods of Logic*, pp. 218, 219.
13. Russell, "The Philosophy of Logical Atomism," in *Logic and Knowledge*, p. 201.
14. Ibid.
15. Quine, *Methods of Logic*, p. 205.
16. P. F. Strawson, "On Referring," reprinted in *Essays in Conceptual Analysis*, ed. A. Flew (London: Macmillan and Company Limited, 1963) pp. 29, 31.
17. Strawson, "On Referring," op. cit., pp. 27, 28.
18. Russell, "On Denoting," op. cit., p. 41.
19. Quine, *Methods of Logic*, p. 203.
20. Strawson, "On Referring," op. cit., pp. 27, 28.
21. Ibid., p. 27–29.

22. Cf. p. 30 for more examples of the differences between sentences and statements.

23. Cf. Russell, "Mr. Strawson on Referring," in *Contemporary Readings in Logical Theory*, ed. by Copi and Gould (New York: The Macmillan Company, 1967), p. 129; and Strawson, "On Referring," op. cit., p. 31.

24. Russell, op. cit., p. 129.

25. Strawson, "On Referring," op. cit., p. 31.

26. Ibid., p. 29, 30. (Emphasis his)

27. Ibid., p. 30. (Emphasis his)

REPLY TO DAVID F. HAIGHT

In 'Reference and Reality' Professor Haight shows such sympathetic understanding of my views on the subject he discusses, and such deep agreement with them, that I can have no significant criticisms of his paper. There are, however, some additions I can make; and, perhaps more important, one clarifying point about the great divide that appears to separate, and does indeed separate, myself from both Quine and Russell.

This last clarifying point concerns our respective directions of interest. Neither Quine nor Russell is in the least interested in the question that concerned me and that concerns, or should concern, all theorists of general linguistics, viz. the question of how language actually works in communication between those who speak or write and those they address. Russell and Quine are so far removed from concern with this question that if their views were seen as attempts to answer it, then, as Professor Haight amply demonstrates, those views would look like travesties of the facts. Russell and Quine have less earth-bound aims. They have higher theoretical game in their sights. I am not presumptuous enough to try to specify exactly what, though it is clear that both logic and, at a remove, ontology would figure in the specification.

Now for some additions to Professor Haight's observations. One difficulty with the project of replacing those singular terms which are ordinary proper names with general terms in predicative position vis à vis a bound variable is that of specifying a predicate uniquely satisfied by the individual whose name, say 'N', is to be eliminated. Recourse to the form 'N-izes' is little more than a confession of failure: virtually acknowledged as such by Quine's later resource of replacing it with '=N', a predicate undoubtedly, but hardly a general term, since the name obstinately reappears within it, and reference (or intended reference) by singular term remains uneliminated. The point is implicitly made by Professor Haight, when he remarks that any 'logical paraphrase' of the

kind in question presupposes the achievement of singular reference by some other means.

Of course, it may justly be remarked that, since the paraphrase begins with the existential quantifier (with or without a preceding negation sign), the risk of reference-failure bringing with it a failure of truth-value (a 'truth-value gap') has indeed been eliminated. And so it has. But the identity of the truth-value bearer (what used to be known as the proposition expressed) remains as context-dependent as ever; for no proper name is immune from being multiply borne. Names, in this respect, can be appropriately classified with overtly indexical expressions like 'this' and 'I', although, in contrast with these last, the variable applications of names are not governed by rules of meaning, but by customs or conventions of a different kind.

Insofar as our discourse concerns *particular* events or objects or situations in the natural world, this last point, as Professor Haight also implicitly remarks, can be generalized. That is to say, the identity of truth-value bearers in such discourse is always contextually dependent: whatever the tense of the verb may be, the content of *what is said* depends on the time and place and, in general, the circumstances of utterance.

Of course these considerations will be only of lesser interest to philosophers like, at times, both Russell and Quine, whose main concerns are the general truths of mathematics and natural science. But philosophers of natural language must take account of them.

P.F.S.

10

Joseph S. Wu

P.F. STRAWSON'S
CRITICISM OF FORMAL LOGIC

I. INTRODUCTION

As a student and scholar from the Far East, upon getting his doctoral degree in Western philosophy, the author of this essay published a paper in 1968 with the title "Contemporary Western Philosophy from an Eastern Viewpoint."[1] As he pointed out in that paper, there has been a common trend underlying the major currents of Western philosophy. This common trend is the spirit of *searching for clarity and certainty.* This search for clarity and certainty "was initiated in Greek thought, sharpened by the schoolmen of the middle ages, developed rapidly with modern philosophy, and has been reaching its climax in the analytic philosophy of the contemporary world."[2] Analytic philosophy, as its major currents tell us, can be roughly identified as "the philosophy of logical analysis," and "the philosophy of ordinary language." Logical analysis started with Frege and Russell and was developed rapidly in the works of Rudolph Carnap and A. J. Ayer, while the philosophy of ordinary language was initiated by G.E. Moore and Ludwig Wittgenstein and was developed by contemporary British philosophers such as J. L. Austin, Gilbert Ryle, and P. F. Strawson.

Strawson's *Introduction to Logical Theory*[3] is not only a landmark treatise in logical theory, but also an important criticism of the tradition of formal logic, from Aristotle to Bertrand Russell, Alonzo Church, and W. V. Quine. This article is an attempt to expose Strawson's critique of formal logic. Being limited by space, selective emphasis is inevitable. After his exposition, this author will express his own idea of logic and his viewpoint of ordinary language.

2. The Supremacy of Logical Analysis

Searching for clarity and certainty has been the supreme goal of the philosophers of Western Civilization. It has been well known that for Descartes the criteria of truth consist in clarity and distinctness. Probably due to the disappointments in their search for clarity and certainty in ordinary languages, many philosophers turned to the clarity and certainty provided by deductive systems of mathematics. Rationalists like Descartes and Leibniz were much concerned with the establishment of axiomatic systems and the principles of deductive operation. Nevertheless traditional rationalists still believed that a deductive system established by a philosopher or mathematician was not separable from the structure of reality. So, for them, metaphysics was still the foundation of philosophy and logical analysis was only the technical and methodological aspect. But for contemporary logical analysts, metaphysics, which has been considered the obstacle blocking the way to clarity and certainty, has to be eliminated from the working schedule of a philosopher. So, for the logical positivists as well as the professional formal logicians, the proper task of philosophy is nothing more than logical analysis.

History of modern formal logic can be traced all the way back to Leibniz, but the real pioneering works were Boolean algebra and the axiomatic method after the development of non-Euclidean geometry in the nineteenth century. The appearance of *Principia Mathematica* (1910–1913) by Bertrand Russell and Alfred N. Whitehead has established the firm foundation of contemporary formal logic. Ludwig Wittgenstein, being a student of Russell, in his *Tractatus Logico-Philosophicus* published ten years later still echoed the supreme goal of clarity of the philosophic enterprise of Western Civilization. Thus he remarked:[4]

> The object of philosophy is the logical clarification of thought.
> A philosophical work consists essentially of elucidation.
> The result of philosophy is not a number of "philosophical propositions," but to make propositions clear.
> Philosophy should make clear and delimit sharply the thoughts which otherwise are, as it were, opaque and blurred.

In fact, Wittgenstein was not satisfied with the clarity of formal logic. So, in his later years, he developed a strong sensitivity in ordinary language. Together with the philosophic legacy of G. E. Moore, Wittgenstein has opened up a new page in Anglo-American philosophy. This is the movement of the critique of ordinary language. Followers include prominent scholars such as H. L. A. Hart, J. L. Austin, and Gilbert Ryle.

These scholars, however, are more interested in piecemeal analysis and casual critiques. A very important exception from these scholars is P. F. Strawson, the author of an elaborate and systematic work in logical theory.

3. STRAWSON'S CRITICISM OF FORMAL LOGIC

The entire book can be considered an elaborate criticism of formal logic. But in this essay we are going to discuss only one major critique. This critique aims at the very nature of formal logic. According to Strawson, formal logic is established on entailment rules, a set of rules governing the formal relations among statements. "To say that S_1 entails S_2 is to say that it would be inconsistent to make S_1 and deny S_2."[5] An example is the statement "B is a younger son" entails "B has a brother."[6] Formal logicians can easily arrive at a general formula that "x is a younger son" entails "x has a brother." The operation of entailment rules, as formal logicians believe, is a matter of logic rather than a matter of factuality. But as Strawson points out "A statement made in the words 'The author of *Paradise Lost* is a younger son' does not entail a statement made in the words 'John Milton has a brother'; for though the predicates are applied to the same person, it is a matter of fact, and not of logic, that the person who wrote *Paradise Lost* is John Milton."[7] Formal logicians "have commonly neglected such facts as that one and the same expression may be used on different occasions to refer to different individuals, that the time at which a sentence is uttered may make a difference to the truth or falsity of what is said."[8]

Entailment-rules, as Strawson points out, must be supplemented by rules of another kind. These are called "referring rules." "Referring rules take account of what entailment-rules abstract from, viz., the time and place of the utterance and the identity of the utterer."[9] The most important matter is, "a referring rule lays down a *contextual requirement* for the correct employment of an expression."[10] Formal logicians are usually concerned with how the statement forms hang together and ignore the referring elements in the context of ordinary speech.[11] The formal logicians only aim at an exact and highly systematic logic comparable with mathematics. But they fail to work out an exact and systematic logic of expressions of everyday speech; for these expressions are too dynamic to be mechanized by exact rules.

It was about thirty years ago, when this author was a teacher of formal logic, he encountered an interesting problem. It was the problem of existential import in a universal proposition. In the statement form

"All S is P," modern formal logicians interpreted it as "For anything x, if x is S, it is P." The existence of S is never assumed. But, when we go back to the logic of Aristotle, the statement form "All S is P" presupposes the existence of S. Now the question is, which logic is correct? The logic of Aristotle or contemporary formal logicians? P. F. Strawson would probably say "neither." The most important matter is to supplement the statement form "All S is P" with referring rules. There must be a reference to the tone, the mood, or implied attitudes of the speaker. If the statement is uttered as a "categorical" statement, (e.g., All cats are animals.) S is presumed to exist. However, if it is uttered as a "hypothetical" statement (e.g., All trespassers are to be prosecuted), S is not presumed to exist. The author of this essay is in complete agreement with Sir Peter Strawson that formal logic has to be supplemented by referring rules in order to become a more efficient method of inquiry.

4. THE LOGIC OF ORDINARY LANGUAGE

After his criticism of formal logic, Strawson made friendly and sincere suggestions for another kind of logic, the logic of ordinary language. "Side by side with the study of formal logic, and overlapping it, we have another study: the study of the logical features of ordinary speech."[12] In fact, a major part of his *Logical Theory* is concerned with the interrelation between these two types of logic.[13] Now, the question is: how do we establish this kind of new logic?

A student of traditional logic is probably immediately reminded of logical rules. There were rules governing the validity of syllogisms and they were usually expressed in terms of fallacies: fallacy of four terms, fallacy of undistributed middle term, illicit major, illicit minor, among others. Do we expect to see rules of ordinary language comparable to the rules of syllogisms? To the disappointment of many philosophy students, the logic of ordinary language is not founded on clear and distinct rules. P.F. Strawson explains this point very well:[14]

> In speaking of entailment-rules we make use of the distinction between analytic and synthetic (or contingent) statements. In speaking of type-rules we make use of the distinction between the literal and the figurative use of language. But we must not imagine these distinctions to be very sharp ones, any more than we must imagine our linguistic rules to be very rigid
> This fluidity in our rules, and this imprecision in the distinctions they involve, are things we must be aware of if we aim at a realistic study of the logic of ordinary speech.

If the logic of ordinary language is not built upon clearly defined rules, what is its foundation? To the understanding of the author of this essay,

the foundation of the logic of ordinary language consists in a sharp awareness of the diversified ways of the uses of ordinary language. Oxford philosophers contributed to philosophical analysis by occasional observations of our linguistic habits and problems rising from them. Gilbert Ryle's "Systematically Misleading Expressions"[15] and "Categories"[16] are important examples of this kind of contribution, yet Ryle did not claim to establish any logical rules. In fact, the philosophers of ordinary language are not aiming for building a system of rules, but aiming for a liberation from the self-enclosed system and rigid rules of formal logic. Once we realize this point, we are on our way to the logic of ordinary language.

5. LOGIC AND ITS PERENNIAL PROBLEM

In ordinary language, the term "logic" does not have one single meaning that all logicians or philosophers would agree upon. Its meaning is primarily contextually determined. But, logic as an intellectual discipline can be defined within its historical context. As the author of this essay sees it, no matter how logic is defined, it is a method of inquiry, inquiring into the truth and falsity of our beliefs, inquiring into the validity or invalidity of our arguments, and inquiring into the meaningfulness (or meaninglessness) of the problems that we encounter. Even though the inquiring process employs rules which are general or formalistic, the inquiring process itself does not take place in an experiential vacuum. In other words, the process of inquiry requires the interaction between logical formality and the experiential data, or, put in plain words, the interaction between ideas and facts. Now the most important problem in logical theory is to understand properly the relation between the logical forms and the logical subject matter (experiential data). Putting this in plain language, our important task is to understand the relation between the rational and the empirical, or simply between form and matter.

Formal logicians are inclined to think that logical forms are a priori, being independent from the world of experience. But one of the founders of contemporary formal logic, Alfred North Whitehead, sharply pointed out that mathematical concepts were abstracted from nature, or the world of experience.[17] As the author of this essay observes, the relation between logical forms and the world of experience is a *genetic and functional* one. It is genetic in the sense that forms are the intellectual products growing out of the world of experience. It is functional in the sense that they perform the function of directing, regulating, refining, modifying, and even reconstructing our experience. Since our world of

experience is subject to change all the time, new forms may emerge accordingly.

With an adequate understanding of the relation between logical forms and logical subject matter (experiential data), we are on our way to the improvement of our logical method. We may delete obsolete forms and increase necessary and useful ones. We can check the validity or efficiency of existing forms by bringing them back to experiential contexts. By doing this, a formal logical system will no longer be rigidly oriented or self-enclosed, and formal logic itself will become a more powerful method of inquiry in our intellectual pursuit as well as our practical life.

6. CONCLUSION

As a scholar from the Orient, I have been fascinated by the intellectual elegance of mathematical logic in the Russell-Whitehead tradition. But, just like Kant's encountering of Hume, I was awakened from the intoxicating slumber of formal logic by the sincere and insightful warnings of P. F. Strawson. So, throughout my essay, I did not have any negative comment on his theory. I did not make any negative comment not because of personal pedagogic piety, but because we share similar viewpoints in logic. Strawson seems to use logic of ordinary language to balance the formalistic extreme of modern formal logic, and I appeal to a philosophy of experience in order to deliver myself from the formalistic trap. In our criticism of formal logic, we seem to agree with each other without dispute.

Nevertheless, in the conclusion of this essay, I venture to express myself as someone who does not approve of the position of an "ordinary language" philosopher. First of all, "ordinary language" philosophers very often based their language observations on only one language, namely English. This means that their philosophical foundation was built upon a very narrow site. Certainly this kind of linguistic awareness can be transferred to the context of a different language. I have used Gilbert Ryle's "category mistake" to clarify some misinterpretations of a Confucian classic and was evaluated highly by my fellow scholars in Asian studies.[18] But, to me, ordinary language analysis is merely one of the philosophical techniques. It can hardly replace the traditional goal of philosophy. Secondly, the term "ordinary" in the phrase "ordinary language" is highly misleading. It may be ordinary to one person and becomes extraordinary to another. Perhaps the inventor of the term made up this usage as a contrast to the artificial symbols of mathematical logic, but when the "ordinary" is subject to the hands or thinking of a

philosopher, it will lose its "ordinary" nature. What is the fate of the future of our philosophy? Will it be in the hands of "ordinary people" who speak "ordinary language"? Or, will it be in the hands of a few who take the "extraordinary" for the "ordinary"? Answers to these questions will be totally beyond the clarity and certainty of our formal logic, and will probably remain forever in the realm of uncertainty and obscurity.

JOSEPH S. WU

DEPARTMENT OF PHILOSOPHY
CALIFORNIA STATE UNIVERSITY, SACRAMENTO
JUNE 1995

NOTES

1. Joseph S. Wu, "Contemporary Western Philosophy from an Eastern Viewpoint," *International Philosophical Quarterly* 8 (December, 1968): 491–97.
2. Ibid., 491.
3. P.F. Strawson, *Introduction to Logical Theory* (London: Methuen & Co., Ltd.; New York: John Wiley & Sons, Inc., 1952).
4. Ludwig Wittgenstein, *Tractatus Logico-Philosophicus* (London: Routledge and Kegan Paul; New York: Humanities Press, 1955), p. 77.
5. Strawson, pp. 19–20.
6. Ibid., p. 26.
7. Ibid., p. 28.
8. Ibid., p. 29.
9. Ibid., p. 213.
10. Ibid.
11. Ibid., p. 214.
12. Ibid., p. 281.
13. Ibid.
14. Ibid., pp. 230–31.
15. Gilbert Ryle, "Systematically Misleading Expressions," *Proceedings of the Aristotelian Society* 32 (1931–32): 139–70.
16. Gilbert Ryle, "Categories," *Proceedings of the Aristotelian Society* 38 (1937-38): 189–206.
17. Alfred N. Whitehead, *Science and the Modern World* (New York: Macmillan Publishing Co., 1925), chapter 2.
18. See my article "A Critique of the Maoist Critique of Confucius: A Clarification of 'Ke Chi Fu Li'" in my *Clarification and Enlightenment* (Washington, D.C.: University Press of America, 1978). A Chinese version of this paper was published simultaneously in Taiwan.

REPLY TO JOSEPH S. WU

Professor Wu's paper has important points of contact with Professor Haight's. Both place needed emphasis on the fact that what is actually said or written when a declarative sentence is actually uttered or written on a particular occasion—in other words, the content, the very identity of what is to be evaluated for truth or falsity—will normally depend on the time, place, and other circumstances of utterance. Professor Wu suggests, as I have done in the past, that, in order to do justice to this context-dependence of the truth-evaluable, we should supplement the rules which determine the character of standard formal logic as we have it with another class of rules ('referring rules') which have an equal claim to a place in a more realistic and comprehensive logic.

That there are such linguistic rules, governing the use of indexical expressions, the tenses of verbs, personal pronouns, and the definite article, and that they are of central importance to the use and understanding of language, I have no doubt at all. But, with one or two exceptions (the rules governing the use of 'I' and, possibly, 'you'), any attempt at a truly comprehensive and accurate statement of those rules would have a vagueness and openness which, while being no bar to the ready understanding of the use of the relevant expressions in practice, are utterly uncharacteristic of the rules governing the employment of what Ryle wittily, though mischievously, called 'the carefully wired marionettes of formal logic'. Think of the vast variety of ways in which we may quite correctly and intelligibly use the pronouns, 'this' or 'that', and the corresponding variety of items, abstract or concrete—scenes, situations, theories, projects, near or remote in space and time, or not spatial or temporal at all—to which we may refer, directly or indirectly, by their use. In every case context or setting of utterance bears the burden of success. But the ways in which it does so cannot be simply, or at all, reduced to precisely stateable rules. So there is really no case for

regarding the norms of reference as on a par with those of formal logic or for thinking that the latter could simply be supplemented with the former to yield a richer and more comprehensive system of logic.

Formal logic can and must, as Wittgenstein said, look after itself. It is not, as some have thought, and some perhaps still think, the one unique skeleton key which will unlock for us all the mysteries of semantic structure, hence the structure of thought and hence, perhaps, of reality itself. But in its modern form it has become a powerful and indispensable tool for use in the investigation of these structures.

Professor Wu, who emphasizes the negative aspect of the above thoughts about formal logic, is equally skeptical of exclusive philosophical reliance on the study of the 'ordinary use' of language; and justly so. Here again we have a powerful resource, one we ignore or denigrate at our peril. But as philosophers we rightly aim at a grasp of general features of structure, of conceptual connections and dependencies, which (if I may quote myself) "do not display themselves on the surface of language, but lie submerged." We have to think down to them.

The extent of my substantial agreement with Professor Wu will be clear from what I have written above.

P.F.S.

11

Andrew G. Black

NATURALISM AND CARTESIAN SKEPTICISM

Contemporary philosophers have not been kind to skepticism. A doctrine (rather a family of doctrines) with a long and unexceptionable pedigree, it has come to be widely regarded not as false—a failing surely shared by very many respectable philosophical positions—but as useless, meaningless, incoherent, pointless. In short, skepticism is, and presumably always has been, a waste of time. I take it that P. F. Strawson captures this attitude when he writes, in *Skepticism and Naturalism*, that the right attitude toward skepticism is not to attempt to meet it with arguments, but rather "to pass it by."[1] I believe that this attitude is wrong, that the skeptical challenge should not be passed by. I will not try to show that in this paper, but shall content myself with something less ambitious. I shall consider one general kind of argument for refusing the skeptical challenge, an argument based on the view that Strawson calls Naturalism, and will show why I think that its strategy is misguided. In *Analysis and Metaphysics*, Strawson writes "a radical and all-pervasive (i.e. philosophical) scepticism is at worst senseless, at best idle,"[2] and in very rough, the argument is this: with respect to some significant propositions that I believe, there are no circumstances under which I would hold them to be false, thus it is idle to doubt them (and if, as Strawson interprets Wittgenstein, idle implies senseless, then it is senseless to doubt them.)[3]

Descartes is notorious for having entertained the kind of philosophical skepticism Strawson finds idle. My contention in this paper is that, given Descartes's concerns and the context of his reflection on skeptical considerations, his doubts were not at all idle. The moral will be that while a radical, all-pervasive skepticism touted for its own sake and unanchored by broader considerations, whether philosophical, scientific, or practical, may be idle (perhaps any such philosophical view would be)

in the context of the search for a certain standard in scientific knowledge, a skeptical stance makes very good sense.

It is not uncommon for a philosopher to try to find haven from skeptical demons in basic commonsense beliefs.[4] In a curious reversal, Descartes, finding himself beset by commonsense beliefs, called up a skeptical demon to rid himself of such unwelcome thoughts. The justification for the reversal is well enough known. Descartes's goal was to establish a body of scientific belief (*scientia*) that avoided the crucial failing of prior science—its proneness to revision and rejection.[5] Descartes sought a basis for science that was permanent. Only thus could continuous scientific advance be guaranteed. Recognizing that the basis for his beliefs had never been seriously scrutinized, he wanted a way of suspending them, of permitting himself only those that satisfied a set standard—the standard of absolute certainty.

Descartes's *First Meditation* reflections on the basis of his knowledge have given rise to a certain mythical character in philosophy—the Cartesian skeptic. We can identify this character as being the person who goes step by step with Descartes right up as far as the end of the *First Meditation*, but no further. The Cartesian skeptic sees Descartes as offering a certain challenge, and claims that the challenge has not been, and perhaps cannot be met. (Descartes, of course, thought that he had met it.)

The Cartesian skeptic, although to some degree a mythical beast, is nonetheless a significant player in the history of philosophy. Cartesian skepticism has come to be seen as the paradigm member of the family of skeptical positions. Responses to the Cartesian skeptic take many forms, but they can be significantly divided into two different categories. On the one hand there are those who claim, pace the Cartesian skeptic, that Descartes's challenge can be met—Descartes himself was one of these, and, famously, G. E. Moore.[6] On the other, there are those who, for principled reasons, refuse the challenge. Hume, Carnap, Wittgenstein, Quine have been counted on this hand, and Strawson himself finds precedent for his attitude to skepticism in the writings of some of these figures.[7] For the historically minded, there is something comforting about the second kind of response. It is a response to Descartes himself, and not to a mythical beast—Descartes without the *Second* through *Sixth Meditations*—since the real Descartes really can be seen as posing a challenge and it is this challenge that is refused.

First of all, we need to identify the challenge, and this is not quite so

straightforward as might be thought. Descartes announces that the strategy of the *Meditations* must be followed if we wish "to establish anything firm and enduring in the sciences (*in scientiis.*)"[8] There is a famous sentence at the beginning of the *Second Meditation* in which Descartes states the challenge in its broadest way: "Archimedes used to demand just one firm and immovable point in order to shift the entire earth; so I too can hope for great things if I manage to find just one thing, however slight, that is certain and unshakeable."[9] This echoes a suggestive passage from the *First Meditation*: "Reason now leads me to think that I should hold back my assent from opinions which are not completely certain and indubitable just as carefully as I do from those which are patently false. So for the purpose of rejecting all my opinions, it will be enough if I find in each of them at least some reason for doubt."[10] This broad statement of the skeptical strategy, along with its Archimedean goal, remains rather unhelpfully vague. I propose that we can formulate the challenge in outline in terms of the following question:

The Question: for a given belief of mine *b*, is it possible that I should have the basis for believing *b* that I actually have and yet that *b* be false?

Descartes's skeptical strategy amounts to the offering of the following challenge:

The Challenge: find a belief for which the answer to The Question is "no."

It would be fruitful to reflect on the goal first of all, since surely the question embodied in Descartes's challenge gets its relevance, if at all, with respect to his goal. The Latin phrase is "quid . . . firmum et mansurum . . . in scientiis stabilire" and in the now standard English edition, John Cottingham translates this as "to establish anything in the sciences that is *stable and likely to last*."[11] This translation, like all good translations, singles out one significant feature of the import of the original. Cottingham finds in Descartes (surely rightly) a pragmatic drive behind his metaphysics, and his formulation of Descartes's goal highlights the sensible, the sober, the scientific. There is a textbook myth about Descartes the super-rationalist armchair metaphysician. This is not the Descartes of Cottingham's translation. The Descartes he gives us is the scientist, the pragmatist.

When properly heeded, this version is instructive and valuable not least in redressing a certain imbalance in the way Descartes has traditionally been understood. But it seems to me inevitable that something is left out, and to this extent Cottingham's Descartes must be misleading (since any translator's must be). Some of the ways in which it

is misleading are pertinent to the discussion of Descartes's challenge and whether it should be taken up—pertinent because one principled way to refuse the challenge is to refuse the goal, to claim that there is no point in it.

One is entitled to find in that phrase "firmum et mansurum" a standard much more stringent than mere stability and likelihood of lasting. Genuine permanence is a prerequisite of *scientia* for a seventeenth century thinker. While it is right to play up the very close relationship between *scientia* and the modern "sciences" (Descartes does use the plural, after all) it must be emphasized with care. A distinguishing feature of the search for *scientia* is the unity of the project—ultimately there is only one true science, toward which "the sciences" (*scientiis*) are aiming, and *scientia* is intended to embody absolute, objective, and, most significantly, secure truth, a body of knowledge that, once established, will not be overthrown.[12]

The point of this is that while the goal of Cottingham's Descartes seems legitimate enough, even noble, it is natural enough to ask whether the question embodied in Descartes' challenge is at all relevant to the goal. While no one could object to the ambition of providing something likely to last in science, a common way of refusing the skeptical challenge is to point out that absolute certainty of the kind for which Descartes's question seems to be asking—a body of unrevisable doctrine—is neither necessary nor practical for the business of science, or for any other business for that matter. Thus, if the question is relevant, there must be more to Descartes's goal than merely establishing something stable and likely to last in the sciences, there must be something calling for the kind of absolute certainty sought in the question. Surely, the point is that if a proposition can be found for which the answer to The Question is "no" then, I will never have any occasion to surrender my belief in it. I will have shown that it is epistemically stable. This is the character Descartes requires for his Archimedean point, the secure platform from which to establish science.

Let us return to Descartes's question then, since, as I have suggested, it is not as straightforward as it seems. For any given belief of mine *b*, is it possible that I should have the basis for believing *b* that I have and yet *b* be false? I want to make some observations about the notion of possibility at work. Descartes reflects, in the *Third Meditation*, that some of the doubts he has raised in the *First Meditation* are slight and "so to speak metaphysical." There are some opinions that he is psychologically committed to, his belief is "as it were bound over to them as a result of long occupation and the law of custom."[14] We might say that concerning these beliefs he is psychologically certain of their truth. Nevertheless, he

is able to articulate a possibility, a metaphysical (maybe logical) possibility, according to which those beliefs may be false. Part of the task of the *Meditations* is to upgrade the psychologically certain to the metaphysically certain, to the status of being such that no metaphysical possibility of falsehood can be articulated compatibly with the holding of the belief. Let us call such certainty "strict" certainty to contrast it with psychological certainty.

Descartes's own response to the challenge is notorious.[15] He raises his question for his belief in his own existence. He came by that belief just by thinking about it. Is it possible that he should think that he exists and yet it be false? No matter how he came by this belief, it is impossible to articulate a consistent scenario in which he believes it and it is false. So he can find a belief such that the answer to his question is "no." He has met the challenge.

It is necessary also to reflect on the notion of basis in The Question, and, since I claim that this is Descartes's question, to see what notion of basis we find in Descartes. Here is what he says:

> For the purpose of rejecting my opinions, it will suffice if I find in each of them at least some reason for doubt. And to do this, I will not need to run through them all individually, which would be an endless task. Once the foundations of a building are undermined, anything built on them collapses of its own accord; so I will go straight for the basic principles on which all my previous beliefs rested.[16]

What kinds of things are the "basic principles?" The Latin word is *principia* and the primary meaning of this is "sources."[17] If we think of the first of the three skeptical arguments Descartes presents in *Meditation I*, it seems his idea is to undermine our faith in the suitability of a certain source of belief for generating the foundations of *scientia*.

> Whatever I have up till now accepted as most true I have acquired either from or through the senses. But from time to time I have found that the senses deceive, and it is prudent never to trust completely those who have deceived us even once.[18]

The employment of my senses is a significant way in which I have acquired beliefs and it is worth asking whether it is true of *any* beliefs that came to me from that source that they could be false. Descartes's first thoughts are that indeed any of them from that source could be. I know what it is to be mistaken in a sense-based belief, so here is a genuine possibility that excludes all my sense-based beliefs from passing the challenge. His second thoughts are more cautious. I can articulate a possibility according to which my sense-based beliefs about some categories of things, the remote, very small or otherwise hard to perceive, may be false; but concerning the medium-sized, near-up, easy to perceive

things, if my beliefs about these have genuinely come through the senses it's hard to see any way in which they could be mistaken.

I think Descartes is willing to concede, for the sake of argument, that for some beliefs that I come by through the senses I cannot articulate a possible scenario in which I come by them in that way and yet they are false. This may strike some as surprising. Isn't the dream argument supposed to present just such a scenario? I do not believe so. The possibility that I'm dreaming that I'm by the fire while I'm actually naked in bed is not compatible with my coming to believe that I'm by the fire through seeing and feeling that I am. Descartes knows this. The dream possibility raises a different kind of problem. Descartes wants to assert (at least provisionally) "for any belief I come by by dreaming it, I can think of a way in which I could have that dream and it be false." So no belief acquired by dreaming is going to meet the challenge. But "there are never any sure signs by means of which being awake can be distinguished from being asleep."[19] So I can't tell, with respect to any sense-based belief, whether it is a sense-based belief rather than a dream one.

It should be observed that treating 'basis' in our question as 'source' has some justification. We can, I think, give a complete and satisfactory account of Descartes's procedure in the *Meditations* in this way. But we can formulate the question in any number of different ways. Take that feature that you think confers warrant on beliefs and substitute it for basis. If you think beliefs are warranted (if at all) by their foundation in subjective experience, you can ask: for any belief *b*, is it possible that *b* has the foundation in subjective experience that it has and yet that *b* is false? Alternatively, if it is role in a coherent system of belief that confers warrant, it may be asked: for any belief *b*, is it possible that *b* plays the conceptual or epistemic role it does and yet that *b* is false?

Now, I am claiming that the question can be formulated, or understood, in all these ways, but not that there is any sense or use in asking it. I am not claiming the day already. It has been suggested, for example, that Descartes's question would only make sense (or would only have any use) if subjective experience foundationalism were true, and we come to see that The Question is pointless by seeing that our basic beliefs are not grounded in subjective experience but have a different epistemic role.[20] The point I want to establish here is that my formulation of Descartes's question should be read flexibly.

So how do things stand with respect to The Challenge? For some sense-based beliefs, the answer to Descartes' question may be "no;" but the problem of meeting The Challenge is not to establish that there are some beliefs for which the answer to the question is "no," but to find them, identify them. The difficulty in the case of sense-based beliefs is

discriminating them from dream-based beliefs. The point is perhaps more clearly made with respect to the later objects of doubt, mathematical truths, for example. Here, I take the basis of my beliefs to be a clear and distinct perception of them, but there is a problem that Descartes summarizes most succinctly in the *Discourse on Method*: "I decided that I could lay it down as a general rule that the things we conceive very clearly and very distinctly are all true; only there is some difficulty in recognizing which are the things we distinctly conceive."[21] Once again, Descartes may be willing to admit, for the sake of argument, that if I hold some belief on the basis of a clear and distinct perception of it, then there is no compatible possibility of its being false. But I cannot tell, with respect to any given belief whether I am clearly and distinctly perceiving it or whether it might have been put there by God or some other powerful being, a source that would be compatible with its falsehood.[22]

In summary, Descartes starts out with a certain goal, the goal of *scientia*, an ultimate unified body of theory about what exists and its nature. He seeks for this body of theory a permanence, a stability that all prior science has lacked, and thus he poses the challenge, speaking generally, that in order to attain the goal it is necessary to find beliefs that are strictly (and not just psychologically) certain. That challenge embodies the question "is it possible that belief *b* has the basis it has and is yet false?" because if the answer is "yes" then that is the criterion of the failure of *b* to be strictly certain. Up as far as the "Cogito," every belief has failed the challenge. In many cases it is not because the answer is "yes," but because it is impossible to determine the answer.

NATURALISM

Descartes's challenge might be refused in a number of different ways. I have suggested some already. One might refuse the goal, and indeed claim that there is no worthwhile goal requiring complete and strict certainty. One might feel that the challenge is irrelevant to the goal. One might feel that the challenge only makes sense interpreted in a certain way, and that that interpretation is pointless, irrelevant to the goal, or whatever. Thus, as I have said, someone might argue: "if what we claimed as our knowledge were grounded in our subjective experience, it would be worthwhile asking whether that subjective experience could be as it is and our beliefs be false. But since our knowledge isn't so grounded, no such question is relevant."

The position I want to take up now is a position something like that last one. It is articulated by Strawson in *Skepticism and Naturalism*, but has its roots in a theory of concepts developed in *Individuals* and *The*

Bounds of Sense and summarized lucidly and succinctly in *Analysis and Metaphysics*.[23] In *Skepticism and Naturalism*, Strawson writes: "At its most general, the skeptical point concerning the external world seems to be that subjective experience could be just the way it is without its being the case that physical or material things existed" (SN 5). Here, the belief in question is the belief in the existence of an external world. So a skeptic about the external world, for Strawson, is someone who, when faced with Descartes's question, interprets it as a question about subjective experience, and claims that, concerning the belief in the external world, it is possible that subjective experience be the way it is and yet there be no external world.

This view of philosophical skepticism is perhaps the standard textbook view, and it comes to us primarily from Kant who, having noted the "scandal" of philosophy's failure to prove the existence of an external world, diagnosed the problem in an excessively polarized conception of the relationship between experience and its objects.[24] Of course, even if we grant subjective experience as the basis in the skeptic's challenge, the most general form of the skeptical point would be that our subjective experience could be just as it is and yet *all* of our beliefs be false. That is one reading of the state of things at the end of the *First Meditation*. I have read Descartes rather differently, not in terms of subjective experience but in terms of the way we come by our beliefs. If I can find a belief that I know to have come from a maximally reliable process, then it passes the challenge. Really, though, this difference is not significant for Strawson's position, and I don't want to make too much hang on that way of reading Descartes. I find it suggestive and helpful with understanding some thorny passages in the *Meditations*, but I can only reiterate that it should be treated as one legitimate way of reading him among perhaps many. External world beliefs are the principal class of beliefs that are called into doubt in the *First Meditation*, and Descartes's grounds for doubting them are that he cannot tell when his sensory-type experience is genuinely sense-based. However, the final skeptical move of the *First Meditation*, the introduction of the evil deceiver, generates a more radical doubt.

Nevertheless, I think we can stay in line with Strawson's reading of skepticism if we call the skeptic that individual for whom the answer to Descartes's question is never "no." Strawson thinks that the right "way with skepticism" is not to "meet the challenge," as he says, "but to pass it by." He reminds us that there is nothing new about this way "since it is at least as old as Hume; and the most powerful latter-day exponent of a closely related view is Wittgenstein. I shall call it," he says, "the way of naturalism" (SN 10).

So what is naturalism, in Strawson's hands, and how does it purport

to pass the skeptical challenge by? He starts with the following favorable quotation of a famous passage in Hume: "Whoever has taken pains to refute the cavils of this total scepticism has really disputed without an antagonist, and endeavour'd by arguments to establish a faculty, which nature has antecedently implanted in the mind, and render'd unavoidable."[25] The central idea, well enough known in Hume, is that there is an important class of beliefs, central to our thinking, with respect to which it is pointless, idle, to ask whether there might be some possibility of their falsehood. We are naturally, psychologically committed to believing them. Strawson finds a similar, though as he says more complex, idea in Wittgenstein's notes *On Certainty*.[26] "Like Hume," Strawson writes, "Wittgenstein distinguishes between those matters—those propositions—which are up for question and decision in the light of reason and experience and those which are not, which are, as he puts it, 'exempt from doubt'" (SN 14).

He concludes:

> To attempt to confront the professional skeptical doubt with arguments in support of these beliefs, with rational justifications, is simply to show a total misunderstanding of the role they actually play in our belief-systems. The correct way with the professional skeptical doubt is not to attempt to rebut it with argument, but to point out that it is idle, unreal, a pretense; and then the rebutting arguments will appear equally as idle. (SN 19)

Let's bring this view into line with Descartes's challenge. The claim is that there is an important class of beliefs, the most fundamental to our belief-system with respect to which it is pointless to ask whether it is possible that they should have the basis they do and yet be false. This is obvious when we understand what their basis is. It is not subjective experience or source or anything like that. In an important sense they do not have a basis, although one could equally well say that their basis is the fundamental role they play in our conceptual scheme.

Why is it pointless to ask the question? Put simply, it is because any possibilities we might be able to articulate would be idle, they could not bring us to surrender these beliefs. Let's distinguish between serious and idle possibilities. We will say that a possibility is serious (it is s-possible) with respect to a given belief *b* if and only if consideration of that possibility could change the believer's degree of conviction in *b*. A possibility is idle (i-possible) with respect to a belief if and only if it is possible but not s-possible. With respect to the fundamental beliefs in question it is only ever i-possible and never s-possible that they should play the role they do for us and yet be false, because contemplation of no possibilities could change anyone's degree of conviction in them.

Strawson does not merely endorse the views he finds in Hume and Wittgenstein, but has his own reasons for thinking that naturalism is

"the right way with skepticism." These are found throughout a career-long campaign in defense of a roughly Kantian conceptual theory. Rejecting what he sees as a pernicious reductivism about concepts that is locked in an unholy alliance with epistemological foundationalism, Strawson argues instead for a view according to which our concepts are given their content by a web of interconnections.[27] What is distinctive about his view, among the many contemporaries who share the same basic outlook, is his proposal that certain of our concepts are nonreductively basic. What this basicness amounts to can be summed up like this: one concept is more basic than another if one cannot employ the latter properly without being able to employ the former. There is a certain set of concepts which are absolutely basic in the sense that it would be impossible for us to employ our conceptual scheme at all without being able to employ these: and they include space, time, individual, etc. In *Skepticism and Naturalism*, Strawson extends this idea to incorporate basic beliefs. These are beliefs such that we would not be able to employ our conceptual apparatus without them. These are the fundamental beliefs of the naturalist and for Strawson they include belief in the existence of bodies, in induction, in the existence of the past, to name three significant examples.

Let us call beliefs that are basic in this way Strawson-fundamental. Strawson's strategy with respect to Descartes's challenge is thus to say that there are no s-possibilities with respect to Strawson-fundamental beliefs. To change my degree of conviction in a Strawson-fundamental belief would be to lose my grip on my entire conceptual scheme. Thus, to entertain a possibility of falsehood about Strawson-fundamental beliefs "amounts to the rejection of the whole conceptual scheme within which alone such doubts make sense" (I 35). Such possibilities cannot simultaneously be s-possible and meaningful. Thus, if they are meaningfully articulated, they can only be idle.

NATURALISM AND SKEPTICISM

The time has come to evaluate the naturalist "way with skepticism." As I indicated at the beginning, with the help of a quotation from *Analysis and Metaphysics*, Strawson's claim is that philosophical skepticism is at best idle, at worst senseless. He thinks of the philosophical skeptic as the person who holds that Descartes's challenge should be taken up and that the answer to Descartes's question is never "no." The worst-case assessment, skepticism's being senseless, arises, as Strawson thinks it does for Wittgenstein, if the idleness of a question implies its senselessness. On this view, because the possibilities the skeptic may want to raise

with respect to our fundamental beliefs are i-possibilities, they are really senseless. Then, of course, if they are genuinely senseless, they are not really possibilities at all. The only true possibilities are s-possibilities. So that with respect to our fundamental beliefs, Descartes's question is not at all idle; it admits of a significant answer of "no." I take it that each of the philosophers concerned thinks it is a significant fact that there are no s-possibilities with respect to our fundamental beliefs.

But anyway, I think that Strawson is uneasy with the proposal that i-possibilities are senseless. The real force of his position is that there is no discernible point to raising philosophical doubts where we can be certain that no change in belief would ever issue, whether there is sense in those doubts or not. Even if one's goal is *scientia* such doubts could not advance the cause.

To begin to see what I find misguided in this, I want to reflect first on Strawson's appeal to Hume and Wittgenstein as comrades in arms against the skeptic. Strawson's position differs significantly from that of each of these philosophers. Hume's attitude to skepticism is notoriously ambivalent and has been the source of great controversy. In contrast with his well-known antiskeptical barbs (the most famous of which is quoted above), many have stressed the strong skeptical residue in Hume. Michael Williams has, I think rightly, described Hume's attitude to human knowledge as "pessimistic."[28] It is primarily in the closing pair of paragraphs of Book I, Part IV, section ii of the *Treatise* that the evidence for this pessimism is detected.[29] Hume admits that he is "inclin'd to repose no faith at all in [his] senses," and that he "cannot conceive how such trivial qualities of the fancy . . . can ever lead to any solid and rational system." The object of Hume's residual doubt is clearly *systematic* knowledge. It is the concept of a "system" and the inability of any such to account for our belief in an external world that comes repeatedly under attack in these closing sentences. "Carelessness and inattention alone can afford us any remedy." So how are we to treat Hume's attitude about external world skepticism? It is obvious that in one sense he does not doubt the existence of external things. This is the sense in which we find that Descartes too does not doubt them—what I have called "psychological" doubt. But he does share Descartes's "metaphysical doubt," and unlike Descartes he sees no remedy. Systematic knowledge, secure and certain knowledge as required by the goal of *scientia*, are impossible, because mere psychological certainty is too prone to revision. Hume regards the certainties he has established as "a leaky weather-beaten vessel." His "memory of past errors and perplexities makes [him] diffident for the future" (THN I IV vii, 264).

Hume, then, while sharing Strawson's conviction that some beliefs are not susceptible of real doubt—we cannot genuinely suspend belief

with respect to them—remains skeptical of the security of these beliefs. Thus, in the context of the search for enduring and systematic knowledge, he remains in the position of the Cartesian skeptic. Wittgenstein, too, while insisting that some fundamental beliefs are not up for question, concedes that even these may be revisable. In developing an extended analogy in which the water of a river may be thought of as propositions up for question in the light of experience and the bank is constituted by those propositions that are not open to doubt, he tells us that the relation between these propositions may alter over time, that the bank may become fluid and the waters become hardened.[30] For Wittgenstein too, an enduring system of stable knowledge is an impossible goal.

Strawson parts company from Hume and Wittgenstein in an important way here. Unlike them, Strawson holds that our fundamental beliefs are secure, in the sense that we could never come to revise our opinion about them, to hold them to be false. That is in part what it is for a belief to be Strawson-fundamental. This is an important point in the evaluation of Strawson's attitude toward skepticism. One could certainly follow the line of thought that the enduring and unrevisable character Descartes seeks for his beliefs is irrelevant to genuine knowledge. I think this is a common attitude and seems to characterize Wittgenstein's position, though surely not Hume's. But it is not Strawson's position. His critique of skepticism is not premised on the incoherence or irrelevance of Cartesian certainty.

I should say that it seems to me to be absolutely right that if a belief is Strawson-fundamental there isn't any point in doubting it, where that means trying to put one's self into the psychological condition of suspension of belief. But we should remind ourselves of The Challenge. The Challenge is not The Question. With respect to Descartes's question we may admit that it is idle or senseless concerning Strawson-fundamental beliefs, but The Challenge is to identify those beliefs. Surely it is a serious question, a question with a point, whether what are put forward as fundamental beliefs in Strawson's sense are thus fundamental. He has spent a career defending the view that they are.

I want to tighten up this point a little. I am going to introduce a new character, a close relative (I think probably an identical twin) of the Cartesian skeptic, the Serious Skeptic. The Serious Skeptic reformulates Descartes's question thus: for any belief of mine b, is it s-possible that I should have the basis for believing b that I do and yet that b be false? The Serious Skeptic, being a good Cartesian, admits that there are all sorts of beliefs with respect to which the answer is "no." Recall that I suggested that Descartes was happy with the idea that the answer is "no" for some sense-based beliefs. The Serious Skeptic accepts that if a belief is Strawson-fundamental then the answer is "no."

But now the Serious Skeptic turns his attention to Descartes's challenge. Find one of these beliefs for which the answer is "no," and the Serious Skeptic says "it can't be done." Now, I am not endorsing the view that it can't be done. What I am proposing is that the Serious Skeptic is a serious skeptic. This is a serious position, not "senseless or at best idle." There is, I am claiming, some content to the idea that the beliefs we take to be Strawson-fundamental are not so, that we could get by without them. It is a labor of significance to try to show that they are Strawson-fundamental. If the belief in body is Strawson-fundamental, then it is idle to raise the possibility that all matter is an illusion, if that means to try to suspend belief in body. But Descartes's challenge is not to dismiss the possibility, but rather to show that the belief is of the right kind. For Descartes, this means not showing that the belief is psychologically certain, which would be redundant, but showing that it is strictly certain.

My intention was to show that what Strawson calls the naturalist way with skepticism is misguided. Let me try to summarize why I think this is so. Hume, recognizing that certain fundamental beliefs are "implanted in the mind" by nature and are thus "render'd unavoidable" for us, nevertheless remained skeptical about the possibility of a stable system of knowledge. For Strawson, our fundamental beliefs carry their stability with them. However, if they are to play the basic systematic role that Descartes seeks for them , and that Hume despairs of, it is necessary to show that they have this stable quality by showing that they are strictly certain. This is the challenge the skeptic offers, and it is not an idle challenge. Even given Strawson's modestly nonfoundationalist commitments, progress in knowledge is only going to be guaranteed by knowing which parts of the system are secure and which are up for revision.

Philosophical Skepticism is given its meaning by the context in which it arises. Portrayed as an abstract and unanchored philosophical puzzle, it is certain to be idle, but then so is any other philosophical theory. In the context of early modern thought about science, skepticism poses a genuine challenge to the possibility of providing secure and unshakeable foundations—the "something firm and enduring" that Descartes seeks in the *Meditations*. Indeed, modern skepticism, thought of in this way, is thoroughly in vogue, so much so that it is almost unquestioned background context for much of contemporary epistemology. Between the influential work of Quine and Kuhn alone,[31] the immunity of any scientific belief, however central, to revision has been thoroughly discredited. Interestingly, Strawson is an almost solitary figure among major contemporary philosophers in defending the stability of our most fundamental beliefs. That his rich and complex defense is so far removed from his cursory dismissal of skepticism shows that he does not draw, as

I am inclined to, the close connection between modern skepticism and the search for stability and permanence in scientific knowledge. Without this context, skepticism is indeed empty and pointless, but given the background of scientific ideology in the modern era it is a major challenge that Strawson has struggled hard (albeit unwittingly) to overcome.

ANDREW G. BLACK
DEPARTMENT OF PHILOSOPHY
SOUTHERN ILLINOIS UNIVERSITY AT CARBONDALE
JANUARY 1996

NOTES

1. P. F. Strawson, *Skepticism and Naturalism: Some Varieties* (London: Methuen, 1985) p. 10. Henceforth cited as SN.
2. P. F. Strawson, *Analysis and Metaphysics* (Oxford: Oxford University Press, 1992) p. 96. Henceforth cited as AM.
3. SN 14–18.
4. G. E. Moore is most renowned among recent philosophers for this approach to skepticism, exhibited notably in "A Defense of Common Sense" and "Proof of an External World" in *Philosophical Papers* (London: Unwin, 1959).
5. Descartes laments at length the inadequacy of the science he learnt at school in parts I and II of the *Discourse on Method*. References to Descartes's writings will be to J. Cottingham, R. Stoothoff and D. Murdoch, eds. *The Philosophical Writings of Descartes*, 2 vols. (Cambridge: Cambridge University Press, 1984), henceforth referred to as CSM. The goal of stability in scientific knowledge is not exclusively a modern one. In the *Almagest*, Ptolemy asserts that the proper mark of a science is to be "concerned with things which are always what they are and therefore [to be] able to be always what it is" (R. C. Taliaferro, trans. [Chicago: Britannica, 1939]). Descartes would have regarded it as particularly ironic that he wrote at a time when the entire doctrine of the *Almagest* was in the course of being overthrown.
6. See note 4.
7. David Hume, *A Treatise of Human Nature*, Sir A. Selby-Bigge and P.H. Nidditch, eds. (Oxford: Clarendon, 1978), notably Book I, Part IV (henceforth cited as THN); Rudolf Carnap, *Pseudoproblems in Philosophy* (London: 1979); Ludwig Wittgenstein, *On Certainty*, G. E. M. Anscombe and G. H. von Wright, eds. (Oxford: Blackwell, 1969); W.V. Quine, *Word and Object* (Cambridge, Mass.: MIT Press, 1961), "Epistemology Naturalized" in *Ontological Relativity and Other Essays* (New York: Columbia University Press, 1969).
8. CSM II 12.
9. CSM II 16.
10. CSM II 12.

11. CSM II 12.

12. For thorough discussions of Descartes' concept of science see Daniel Garber, *Descartes' Metaphysical Physics* (Chicago: University of Chicago Press, 1992) and Stephen Gaukroger, *Descartes: An Intellectual Biography* (Oxford: Oxford University Press, 1995).

13. CSM II 25.

14. CSM II 15.

15. CSM II 16–17.

16. CSM II 12.

17. This understanding of Descartes's use of "*principia*" is also found in Barry Stroud, *The Significance of Philosophical Skepticism* (Oxford: Oxford University Press, 1985).

18. CSM II 12.

19. CSM II 13.

20. This is the view of Marie McGinn, *Sense and Certainty* (Oxford: Blackwell, 1989) and of Michael Williams, *Unnatural Doubts* (Oxford: Blackwell, 1991).

21. CSM I 127.

22. The interpretation of Descartes' various presentations of this criterion for truth is not an easy matter. This passage from the *Discourse* does not sit well with its counterpart in the *Meditations*, where the clarity and distinctness of a perception does not seem to be open to doubt, but rather whether clear and distinct perceptions are all true does seem to be. I do not believe this interpretative difficulty defeats my illustration here.

23. P. F. Strawson, *Individuals* (London: Methuen, 1959) henceforth I; *The Bounds of Sense* (London: Methuen, 1966).

24. Immanuel Kant, *Critique of Pure Reason*, N. Kemp-Smith, trans. and ed. (New York: St. Martin's, 1965). The "scandal" passage is found in type B edition Preface (Bxl) and Kant's rejection of skepticism is found in the A edition in the "Fourth Paralogism" (A366–380) and in the B edition in the "Refutation of Idealism" (B274–279).

25. THN I IV I, p.183.

26. Ludwig Wittgenstein, *On Certainty*, G. E. M. Anscombe and G. H. von Wright, eds. (Oxford: Blackwell, 1969).

27. My feeling is that by far the clearest exposition of this is given in *Analysis and Metaphysics*, chapter 2.

28. Williams, *Unnatural Doubts*, p. 2.

29. THN I IV ii 217–18.

30. *On Certainty*, p. 15.

31. W.V. Quine "Two Dogmas of Empiricism" in *From a Logical Point of View* (Cambridge, Mass.: Harvard, 1953); Thomas Kuhn, *The Structure of Scientific Revolutions* (Chicago: University of Chicago Press, 1962).

REPLY TO ANDREW BLACK

In his extremely interesting paper Professor Black finds my way with philosophical skepticism misguided. His central point of reference is Descartes. But he refers also to modern philosophers of science; and to those two very different thinkers, Hume and Wittgenstein, whom I claimed (misguidedly again, he thinks) as allies.

I had declared that insofar as it calls into question the existence of body (the 'external world'), the reality of the past of our practice of inductive belief-formation, philosophical skepticism is idle and neither calls for nor requires refutation by rational argument. It is idle because these beliefs and this practice are matters to which we are naturally and inescapably committed in a way which no reasoning, however plausible or sophisticated, has any power to displace. (Here the appeal is to Hume.) It is perhaps even worse than idle since what our skeptic seeks to represent as propositions up for question or open to doubt are really no such things, but rather constitute part of the framework ('scaffolding') within which all thinking, questioning, reasoning, or argument have their life. (Here to Wittgenstein.)

What in this does Professor Black find misguided? Let us begin with the doubts he expresses about my appeals to Hume and to Wittgenstein. Professor Black rightly emphasizes that Hume's skepticism is at least as strong and genuine as what I have chosen to call his naturalism. Indeed it is. Hume is surely right in holding that reason can never take us from his own chosen epistemological premises to a firmly grounded belief in the existence of body. If we were truly and firmly convinced that all coherent thought must rest exclusively on those same premises, then 'carelessness and inattention' alone would indeed be our only resource. But, as Hume also remarks, nature has taken care that we are not in thrall to any such conviction; that, rather, the existence of body is "a point which we must take for granted in all our reasonings."

In the case of Wittgenstein Professor Black refers to the famous bank

and river analogy used by Wittgenstein to illustrate his contrast between what is unquestionable and what is open to question, and draws attention to Wittgenstein's observation that some matters which at one time appeared to have the former status may later lose it. Part of the bank may be, in his image 'washed away'. But we must follow Wittgenstein further in his image and acknowledge, as he does, a distinction between parts that may be washed away and parts that are "subject to no alteration or only an imperceptible one." Thus the geocentric view of the Universe or the Euclidean conception of physical space may equally have appeared, at one time or another, as unquestionable elements in the foundations of thought; and both have lost that status. But both were particular conceptions, however secure they once seemed, and are alike incomparable with that acceptance of physical reality which both they and their successors presupposed, and which we must indeed take for granted in all our reasonings.

I think, then, that Professor Black errs in seeking to detach these two authorities from my side and enlist them in support of his own case. But perhaps there is misunderstanding here. Perhaps, after all, his case is not really a rival of my own. So let us turn back from these eighteenth- and twentieth-century figures to the (modern) *fons et origo*, Descartes. "Given Descartes's concerns," Black writes, "and the context of his reflection on skeptical considerations, his doubts were not at all idle"; and he continues: "in the context of a search for a certain standard in scientific knowledge, a skeptical stance makes very good sense."

There are two points to make about this 'context' and these 'concerns'. First, it appears that the final end and aim of Descartes's enquiry was a unified system of scientific knowledge which would be firm and enduring, possessing a permanence and stability which previous scientific theories had lacked. Such is the 'standard in scientific knowledge' which Descartes is said to have been searching to achieve. But this is not the whole story about Descartes's concerns. For, second, Professor Black remarks, Descartes holds that, in order even to begin the search, it is necessary to find some belief—the Archimedean point—which is not merely psychologically or humanly inescapable, but is *strictly* certain, *strictly* impossible to doubt. We know, of course, where Descartes located this Archimedean point; and it would not be to the purpose, in the present context, to pursue familiar arguments about this point itself and the dubious structure of argument which Descartes rests upon it.

More to the immediate purpose is the first of the above two points about Descartes's concerns. It is in this connection that Professor Black refers to modern philosophers of science, mentioning specifically Quine and Kuhn, by whose work, he says, "the immunity of any scientific

belief, however central, to revision has been thoroughly discredited." He might also have referred to Sir Karl Popper, who earlier and yet more emphatically emphasized the openness to revision of all scientific theory. But his is a point which my naturalist and I would have no difficulty in conceding. The notion of a final, absolutely secure, unified, and unshakeable system of natural science is at best a merely 'regulative' idea, as Kant might express it, an ideal towards which scientific enquiry may strive without hope or expectation of attaining it. If this is all that the serious skeptic contends, then he may plausibly be granted the victory; though the victory may seem somewhat empty insofar as he may now equally plausibly be said to have 'disputed without an antagonist'.

Again, this is not the end of the story. We must refer again to the other of Descartes's concerns, shared by Professor Black's 'serious skeptic'. The few matters such as the existence of the physical world which, following Wittgenstein, I declared to be fundamental to all thought and enquiry, are clearly not themselves members of the class of scientific theories. Yet it is of these too that Black's 'serious skeptic' demands to be shown that they are 'strictly certain'; but here again I can only echo my post-Cartesian authorities, especially Wittgenstein; and perhaps recommend a re-reading of *On Certainty*. Such matters are, strictly, beyond or before serious doubt or question; and when Professor Black finds 'some content' in the idea that the beliefs we take to be in this way fundamental are not so and that 'we could get by without them', one wonders who 'we' could be.

So, finally, I find *myself* in some doubt—doubt as to what Professor Black's target really is. I have distinguished two strands in his thought. There is, on the one hand, the skeptic who questions the possibility of achieving final certainty and stability in the domain of natural science; and, on the other, the skeptic who professes there is room for doubt about, say, the existence of body. Both types exist or have existed. With the former we lack reason to dispute; but it is the latter who has most exercised, and, it appears, still exercises, philosophers.

Since any form of exercise may promote health or give pleasure, it would, after all, be incorrect, as well as impolite, to call it pointless. It is only if the exercise is thought to be more than just that—an exercise—that the dyslogistic term becomes appropriate.

P.F.S.

12

David Pears

STRAWSON ON FREEDOM AND RESENTMENT

Peter Strawson's 1962 lecture to the British Academy, 'Freedom and Resentment', made an original and important contribution to a perennially controversial topic, personal responsibility for one's actions. When is an agent accountable for what he has done? The natural answer is "When he freely originated his action," but the attempt to draw a firm line around the concept of accountable origination has always proved difficult. Considerations of value as well as factual considerations are embedded in the concept and give it a baffling structure. Strawson broadened the inquiry by including in it not only the legal and quasi-legal treatment of offenders but also the whole range of our natural reactions to each other's behavior in daily life. However, it is not easy to identify the exact impact of his innovation on earlier discussions partly because of the complexity of the issues and partly because of the subtlety of his argument.

I will start with a preliminary analysis of the complexity of the disputed territory on which Strawson took a stand in his lecture. Everyone will agree that human agents originate many, if not most, of their own actions. We are all convinced of the truth of Aristotle's remark, "The originating cause (arché) of actions is a man,"[1] whatever it means. This is not quite so bold as it looks, because our interest is in the accountable origination of actions and we can at least begin to draw a line around this concept, excluding certain cases which clearly lie outside its extension. True, we cannot complete the line and we have to make do with a specification of the phenomenal base of the concept which takes the form of an open-ended negative disjunction: "He was not acting under duress, or hypnosis, or a compulsive neurosis . . . etc." However, we know something about the principle which guides the choice of the disjuncts: the performance of the action must be sufficiently independent

for it to be fair to treat the agent as its accountable originator. This is convincing but hardly precise.

Here, then, is one complication: the concept of the *accountable origination of actions* rests on an incompletely specified phenomenal base and so the range of its applicability may be modified by future discoveries. It is a hostage to fortune and the risks that it runs are not easy to assess, because the principle governing the structure of the phenomenal base is too imprecise for certainty about the hypothetical vicissitudes of the concept in every newly discovered contingency.

Another, equally familiar complication needs to be mentioned. There are two very different ways in which we may be led to reduce the concept's range of applicability. First, a specific new condition may be discovered to be connected in an intelligible way with a specific loss of independence, and even with the agent's inability to have acted in any other way. Second, without any such discovery, the total set of conditions immediately preceding any action, whatever they may be, may be taken to produce a universal loss of independence. That, at any rate, is what the Hard Determinist claims.

If determinism is so different from the specific conditions which would normally be taken to deprive an agent of his independence as an originator of actions, it may be the wrong kind of thing to appear on the list on which they appear.[2] That is something for which I shall argue later. The point that I want to register now is that my reason for keeping determinism off the list will differ from the Soft Determinist's usual reason for keeping it off. His typical strategy is to allow that, from a logical point of view, determinism is a suitable candidate for inclusion but then to exclude it by an argument from the evident structure of our conceptual scheme, reinforced by pragmatic considerations. I am going to argue for the more radical thesis that it is not even a suitable candidate from a logical point of view.

So much for the complexity of the territory on which Strawson took his stand. His first move is to draw attention to a conspicuous deficiency in the typical Soft Determinist's response to Hard Determinism. This response consists of two points, both of them important, but it omits a third, equally important point. First, the Soft Determinist observes that in daily life when we withhold the concept of accountable origination, our reason for withholding it is never the total set of conditions immediately preceding the action, regardless of its composition. What influences us is always the presence of one of the specific counterconditions whose absence constitutes the phenomenal base of the concept. Second, he offers an explanation of the constitution of this phenomenal base: the conditions whose absence is required are those that would

make the agent impervious to moral pressure. This is a pragmatic criterion which looks to the outcome: if, for example, he was acting under extreme duress, no amount of moral pressure would have inhibited the action. The third feature of the typical Soft Determinist's response is what he does *not* say: he says nothing about the feelings and attitudes that surround the concept of *accountable origination* and so he gives an incomplete account of the difference between being injured by another person and being bitten by a dog or a mosquito or a machine.

What are the consequences of this deficiency? That will depend on the view taken about what would make it good. The Hard Determinist will say that what has been omitted is only guilt—guilt as it is attributed and guilt as it is felt. But guilt, he will maintain, is incompatible with determinism, and so the deficiency cannot be made good. Strawson's suggestion ranges more widely and is less pessimistic: according to him, what has been omitted is the larger system of reactive feelings and attitudes which drive all our dealings with one another. Resentment for harm done and gratitude for benefit received are the prime examples, but there are also vicarious analogues, like moral indignation, and self-directed examples, like the sense of obligation or the feeling of guilt (which now figures as only one element in an extensive system of reactions).[3]

That sets the stage for the development of Strawson's argument. But before I take it any further, it is worth observing how much he has broadened the position usually adopted by the Soft Determinist. He has expanded the narrow focus on moral and legal liability to take in cases in which there has been no wrongdoing and the concept of *accountable origination* is the pivot of ordinary, undramatic interactions between people in their daily lives, their friendships, and their loves. In this wider area he demonstrates that the concept rests on much the same phenomenal base, and he argues that we treat human beings as persons only so long as we are prepared to allow that they accountably originate their own actions.

The question that I want to pursue is about the impact made by this move of Strawson's on the traditional controversy between Hard and Soft Determinists. Can he, from his new standpoint, really argue the Hard Determinist out of his pessimism about the continued applicability of the concept of *accountable origination*? There is also another, deeper question underlying this one: How are the two ways of treating an agent, "as a person" and what Strawson calls "objectively," related to the underlying facts? He argues, in the Kantian tradition, for a double-aspect theory—we can see an agent objectively, as a cog, or we can see him personally, as an accountable originator. These two points of view are set

up to accommodate two different patterns of feelings and behavior towards him and we need an explanation of the objective differences on which they are based.[4]

However, Strawson's next move is to advance on the Hard Determinist with a proposal. Now that the usual shallow pragmatism of soft determinism has been supplemented with a full account of our feelings and attitudes to one another as persons, will he not abandon his pessimism about the compatibility of the concept of accountable origination with determinism?

But why should he do that? His response is more likely to be that Strawson has changed the controversy only by raising the stakes. He has thrown in the whole system of our reactive feelings and attitudes, but that system faces the phenomena with much the same list of defeasibilities as the concept of *accountable origination* with which it is associated. So it will be drawn into the same conflict with determinism and the outcome will be the same: whatever the action, no other was possible and therefore the verdict of accountable origination must always be withheld and our reactive feelings and attitudes should always be inhibited. Or so the Hard Determinist will argue.

However, Strawson's invitation was not quite what it seemed to be. He was not trying to tip the scales in favor of the retention of the concept of *accountable origination* in spite of the acceptance of determinism. The offer that he was making to the Hard Determinist was meant to be one that he literally could not refuse. For his point was that our whole system of reactive feelings and attitudes is an ineradicable part of our lives. As Hume said about "belief in the existence of body", "Nature has not left this to his [sc. the sceptic's] choice, and has doubtless esteem'd it an affair of too great importance to be trusted to our reasonings and speculations."[5]

We may well wonder how much weight this kind of naturalism can be expected to bear. There is also a special complication in the case of the concept of *accountable origination*. This is a concept with a list of counterconditions constructed on a principle which we can more or less understand and extend to new circumstances. It is therefore possible for the Hard Determinist to retort that the incompatibility on which he harps is itself the result of a conceptual structure imposed on us by nature. The concept of *accountable origination*, he may say, is like a rocket programmed to avoid certain obstacles—the counter conditions—but in one terminal situation—the acceptance of determinism—to destroy itself. I am not endorsing this view of the matter but only pointing out that it needs to be forestalled by anyone who makes Strawson's appeal to naturalism in this controversy.

I will now try to show why the strategic situation has to be assessed in

this way. That will put me in a better position to examine the traditional confrontation between Hard and Soft Determinists and, in particular, Kantian solutions to it.

When Hume relies on the naturalness of a habit of thought, like belief in physical objects or in causation, the point that he is making is always that the belief is nonrational rather than irrational. However, he allows that a concept which is in general nonrationally applied may have a complex structure—for example, the structure encoded in his "rules for judging cause and effect"—and that this structure will make the concept applicable in some cases but not in others. So though the general basis of the concept is, according to him, nonrational, it would be irrational to apply it to a particular case to which its structure showed it to be inapplicable. Presumably, he would take the same view of its general inapplicability if, improbably, the phenomena, properly understood, never exhibited the structure which the concept required us to find in them. The belief that that was the situation would be inconsistent with belief in causation.

Now, according to Hume, our belief in causation is not generally inconsistent with any of our other beliefs. Our natural tendency to think in causal terms merely fills a vacuum, because it would not be irrational not to do so. If the content of a naturally generated belief did include something inconsistent with the content of some other belief that we held, Hume would not be so reassured by its natural origin. For example, he expresses doubts on this score when he is discussing belief in personal identity, but not when he is discussing belief in causation. Whether he is right or wrong about these two cases, his general position is certainly correct: if a naturally generated belief does prove to be inconsistent with another belief which we are not going to give up, we cannot simply acquiesce in the predicament in which nature has put us.

This indicates something important about the strategic situation on the field of the controversy about determinism. Strawson offers the hard Determinist an option which he then tells him that he cannot refuse, the maintenance of our system of reactive feelings and attitudes. But if this option involves the belief that the system is justifiable, and if that belief really is inconsistent with determinism, anyone who accepts determinism will find himself in a predicament in which he cannot acquiesce.[6] He cannot remain passive while he is being saddled with an inconsistency and so this way of dissolving the problem will not work. Naturalism has its limits.

But does the option offered by Strawson involve the belief that the system of reactive feelings and attitudes is justifiable? And is that belief really inconsistent with belief in determinism?

I shall not spend time on the first of these two questions, because,

predictably, the second one will emerge as the more contentious one. Evidently, if maintenance of the system were inconsistent with determinism, that would not be a straightforward case of direct inconsistency between factual beliefs. For what is being maintained is not a factual belief but a practice and the feelings associated with it, and it is only when we add belief in their justifiability that we find any inconsistency with determinism. Strawson maintains that the unavoidability of this system makes the question of its justifiability an issue of no practical importance,[7] but that would not make it any less agonizing, and might even make it more agonizing.

Is belief in the justifiability of the system of reactive feelings and attitudes, including the practice of holding agents responsible for many of their actions, in fact inconsistent with belief in determinism? The case for an affirmative answer is familiar. The Hard Determinist points at the total set of the immediate antecedents of any action and claims that it made that action, with all the details of its performance, unavoidable. According to him, the career of every human agent develops with an inevitability which is just as rigid as, and only less perspicuous than the career of a comet. He, therefore, concludes that all imputations of responsibility are unfair.

The case for the opposite verdict is equally familiar and when Strawson offered the Hard Determinist the option which he took to be unrefusable, he was operating with the usual fall-back position behind him. For he could exploit the difference between pointing at the total set of the immediate antecedents of an action, whatever its composition, and identifying a specific condition which made it inevitable in a way that we can understand.[8] So the next question is whether the importance that is usually attached to this difference can be explained and defended.

But first, more needs to be said about the contrast between treating an agent "as a person" and treating him "objectively." There are two doubts that might be felt about Strawson's way of drawing this distinction, one fairly trivial and the other more weighty.

Suppose that someone is provoked and hits out in a blind rage and we do not hold him accountable for his violence. Are we refusing, for the duration of the episode, to treat him as a person? According to Strawson we are, but it would seem more natural to say that treating him as a person is treating him *in general* as the accountable originator of his own actions but that part of this personal treatment is exculpating him on this occasion because the line of production of this particular action was skewed by a recognized countercondition. A spectator who refused to treat him as a person would be one who took the view that he seldom or never accountably originated an action.

However, that is an unimportant issue. What is more important is Strawson's application of the term "objective" to the treatment of an agent who is exculpated either in this kind of episode or in the longer term. If this meant no more than treating him as a mere object, without whatever enhancements would make him a person, it would be questionable but possibly acceptable. However, the vague implication, that personal treatment is nonobjective, easily leads to an exaggeration of the opposition of the two points of view and suggests that accountable origination does not rest on a factual basis as firmly as nonaccountable origination rests on the presence of some countercondition. We do not need to accept a Kantian ontology to find such an asymmetry attractive. For our everyday applications of the concept of responsibility rely on the assumption that the facts allow it unless it is proved otherwise. However, the open-ended character of our specification of the factual basis of responsibility does not exclude a deeper symmetry and a much stronger argument would be needed to persuade us to abandon the assumption that both nonaccountable and accountable origination rest on factual bases, though, of course, we have to concede that the support given by the facts is always mediated by value judgments.[9]

Strawson mentions with approval Thomas Nagel's version of the ideas that underlie the denial of symmetry at this point.[10] Nagel believes, as I do, that the denial leads to an intellectual *impasse*, but unlike me, he regards it as the inevitable consequence of reflecting on human agency. So he accepts Kant's formulation of the problem, but not his, or Strawson's, or anyone else's, solution. He sums up the situation, as he sees it, in these words:

> I believe that in a sense the problem has no solution, because something in the idea of agency is incompatible with actions being events, or people being things. But as the external determinants of what someone has done are gradually exposed, in their effect on consequences, character, and choice itself, it becomes gradually clear that actions are events and people things. Eventually nothing remains which can be ascribed to the responsible self, and we are left with nothing but a portion of the larger sequence of events, which can be deplored or celebrated, but not blamed or praised.[11]

If the two pictures that are opposed to one another in the first sentence of this passage are contrasted in the way that Kant contrasts them—one of them noumenally, and the other phenomenally, based—we do not have an intelligible explanation of the accountable origination of actions. The agent's will, to borrow H. A. Prichard's telling phrase,[12] is supposed to "butt in" on the natural order of events from some safe haven, but whence could it operate? And where would it find reasons for its interventions?

This way of thinking about agency is so desperate that it is hard to see how anyone could acquiesce in it. Various explanations have been suggested,[13] but they need not detain us. The remainder of this paper will be concerned with the question, whether Strawson's Humean double-aspect theory can be reinforced in a way that might really convince the Hard Determinist that he is mistaken.

The Soft Determinist argues that determinism should not be in-cluded among the counterconditions of responsibility. The more radical claim that I made earlier was that it is not the sort of thing that can even be considered for inclusion on that list. If this disqualification of its candidature can be justified, it may give us a better understanding of the differences between a structural feature of the world, which is what determinism would be, and a material countercondition of responsibili-ty, like duress. When the Libertarian saw determinism claiming a total monopoly of our world, he ought to have asked himself whether its pervasiveness did not, perhaps, undermine its claim to inclusion on the list before starting on his hopeless quest for a transcendent fulcrum for his will or for interstices in the otherwise rigid lattice of causation.

We may start with a naturalistic treatment of determinism's problem-atic claim to be included among the counterconditions of responsibili-ty. Assuming that it is true, how could we test it for inclusion?

Now there is a great variety of counterconditions. Some make their impact at the moment of action, while others reach far back into the agent's history. They do not all turn on the impossibility of his acting in any other way than the way in which he did act. The trouble with the psychopath is that, as a child, he was emotionally incapable of internaliz-ing the code by which he was to be judged as an adult, and, therefore, could not be expected to conform to it. So too, in a case where education is faulty, we cannot expect law-abiding behavior from gypsy children in Rome trained from the start as pickpockets. However, we may be allowed to concentrate on cases in which the exculpating condition is the agent's inability to have acted in any other way. For it is such losses of the Freedom of Indifference that the Hard Determinist seeks to spread across the board.

If someone jumps from a low window when his hotel is on fire, he acts with all the freedom that he could wish for, given that the fire would not allow him to sleep on in safety. Indeed, many philosophers have argued that in this kind of case, even if the agent could not have done anything else, his action is a paradigmatic exemplification of freedom—specifi-cally, of the freedom of spontaneity. He had no hesitation or nagging doubts and what he did was a perfect expression of his own nature insofar as the situation engaged it.[14]

However, in this example there is no opposition to self-preservation,

and, in any case, nothing that could be debited to the agent's account. The accountability of the origination of the action would become a pressing issue only if there were the possibility of a better course of action, and then usually only if it involved someone else—e.g., an infant crying for help in the next room. We then want to know if panic in a fire is an irresistible force which removes responsibility for leaving the infant to die.

Sometimes the answer is obvious. When it is not, we test the condition for irresistibility in other cases and often with other agents. The tests always require an opposing motive in the other pan of the scales and an egotistical one is usually taken to give the most convincing results—e.g., the agent has a valuable painting in the next room. The immediate outcome of such tests is purely factual. What is not purely factual is our reaction to the statistics, which is to draw the line between obligation and supererogation at a certain level. This line is institutional and it requires a value judgment, but one made in the light of the facts.

There are two reasons why determinism cannot be tested in this way for inclusion among the counterconditions of responsibility. First, it is at present no more than a formal conjecture. We point inarticulately at the total set of antecedent conditions of an action and we guess that if they recurred in every detail, the action would be repeated. Now we may put aside the question whether determinism is true, because we are concerned only with the question whether, if it is true, it ought to be included among the counterconditions of responsibility. But how could that be tested? We are not yet in a position to analyze the total set of the antecedent conditions of any action and so we lack the criterion for their recurrence which would be needed for the test.

The Hard Determinist may reply that this is only a temporary impediment. He can imagine an increase in our knowledge which would put us in a position to analyze the total set of antecedent conditions of every action so that we would have the requisite criteria for their recurrence. But it is not clear that this really is imaginable. The exact sciences rely on abstraction and on the relative isolation of the processes to which they are applied, while a human agent acts in a concrete predicament with an extensive sensitivity, derived from the past, to all its features.

However, even if the Hard Determinist is allowed his picture, there would still be no possibility of testing determinism for inclusion among the counterconditions of responsibility. For when we had established the recurrence of the same total set of antecedent conditions, we could not pit an opposing motive against it without producing a new totality. This is evidently an insuperable impediment to testing determinism for inclusion in the way that other conditions are tested.

"Of course," the Hard Determinist will reply, "the pervasive, structural character of determinism makes it impossible to test it for inclusion in the way in which we test specific, material conditions for inclusion. That is very obvious. But it is equally obvious that it also makes it unnecessary to test it. Its claim to be numbered among the counterconditions of responsibility does not rest on any empirical investigation, because it is an a priori deduction which merely relies on the concept of impossibility. If determinism were true, antecedent circumstances outside the agent's control would have made it impossible for him to do anything other than what he actually did. What more need I say?"

But there is more to be said. Possibility, like probability, is often relativized to selected circumstances, and it may well be that the possibility required for accountable origination is relativized to the absence of all the counterconditions which have been tested in the way already described. At the very least, the Hard Determinist has to demonstrate that this is not so. It is not enough for him to argue a priori from the general concept of impossibility, because an impossibility founded on the general structure of the world may well be irrelevant to responsibility. He, of course, assumes that it is a trump card more powerful than any empirically testable specific condition that his opponent can put down. But the assumption can be questioned and, with it, his undiscriminating a priori argument.

Naturally, he will turn the question against his opponent and demand a justification of *his* assumption that any candidate for inclusion on the list of counterconditions must be testable. This may make it look as if the next, and last, stage in this controversy can only be a tedious dispute about the incidence of the onus of proof. But fortunately, that is not the direction that the discussion has to take.

Instead, there are two moves that the Soft Determinist can make. First, he can broaden the inquiry in a new way. He can point out that tests of the counterconditions of responsibility have much in common with a manufacturer's test of his product before he guarantees it against malfunction or breakage. The manufacturer will not have any precise criteria of "fair wear and tear," but he can specify types of maltreatment which void his liability to replace the product. This list, like the list of counter-conditions of responsibility, will be based on tests and a superimposed value judgment—in this case a judgment of the cost of making the product foolproof. Now it would obviously be absurd for the manufacturer to deny liability for all malfunctions and breakdowns on the ground that each of them must have had a total sufficient condition, whatever its composition might be. So why would it be any less absurd for the Hard Determinist to deny any agent's responsibility for his misdeeds on the same ground?

This is an awkward question, which the Hard Determinist will try to dodge. But can he succeed? Certainly, there are big differences between the two cases. Procreation and education are not like manufacture; education is not, or ought not to be, at all like manipulation; and in one case it is the product, the mature agent, who is accountable, while in the other case the account is sent to the producer. However, these differences do not affect the formal similarity between the methods of composing the two lists of counterconditions. It is this similarity that gives the question its point, and it looks as if the Hard Determinist has to find an answer to it.

Or can he parry it by showing that the similarity is superficial? His argument would have to be that the human will is unique and that the only hope—a necessarily frustrated hope—of reconciling its freedom and responsibility with determinism would lie in a deep investigation of its special nature and operations. This is the line that Libertarians have always followed in their sector of the controversy with Hard Determinists. Now the differences between agent's responsibility and manufacturer's liability certainly create an atmosphere in which it is easy to think that one can see the possibility of finding a way of escaping Hard Determinism through some unique feature of human nature. But any escape from a world in the grip of determinism would be likely to take the will into another world in which it would be in an even worse position.

However, the controversy might never reach this point if the Hard Determinist could be forced to face the comparison between his thesis and the absurd suggestion that, if determinism were true, manufacturers could deny liability for all malfunctions and breakdowns on the ground that each of them must have had a total sufficient condition, whatever its composition might have been. The comparison deflects the controversy from a deep investigation of human nature to a broad investigation of the social context. Far from being a weakness, it is this move that gives the comparison of the two absurdities its power. Because the issue is not the moral responsibility of the slipshod manufacturer, there is no temptation to conduct a deep investigation at that point, and at the other point, the product, it would obviously be inappropriate.

The Soft Determinist's second move would be to point out that in fact there is no dispute about the onus of proof. His opponent has undertaken to show that determinism is incompatible with the freedom required for responsibility, but he has failed to make his point. His undiscriminating a priori argument from the general concept of impossibility is not a trump card which sweeps up all the specific possibilities of acting otherwise which have been established by empirical tests. On the contrary, it leaves us free to discriminate different impossibilities based

not on a single structural feature of the world but on various material features. These material features are tested in the way already described and inclusion on the list of counterconditions of responsibility is then decided by a value judgment made in the light of the statistics.

If the controversy were left at this point, much would remain obscure. We need to know how a genuine belief in determinism, if we could acquire it, would alter our lives. We also need to understand why a general impossibility, based on a structural feature of the world is not the trump card that the Hard Determinist takes it to be. The two points are connected by a Kantian line of thought, but, of course, not by the line that he followed in his solution to the problem of free will.

Consider, first, the effect of a genuine belief in determinism. Obviously, it would alter our lives, but not necessarily in the way described by the Hard Determinist. We could keep our old way of thinking about agent's responsibility and manufacturer's liability, but we would probably feel that a shadow had darkened our affairs. It would be as if the whole piece had been transposed into a minor key without any change in the relations between the individual notes.

The more important question is whether this is how we *ought* to adjust ourselves to a belief in determinism. Strawson argues that we need not face this question, because we could not possibly make the more radical adjustment demanded by the Hard Determinist.[15] I have faced it and adduced two further arguments for resisting the Hard Determinist's attempt to stampede us out of our present system. Determinism is not the sort of feature that can be tested for inclusion on the list of counterconditions of responsibility, and the undiscriminating a priori argument from the general concept of impossibility lacks cogency. But perhaps the best way to understand why structural features are inappropriate candidates for inclusion on the list is to look at the consequences of including them.

The first consequence is the obliteration of the empirically established lines between agent's responsibility and exculpation, and between manufacturer's liability and the voiding of it. This is the obliteration described by Nagel: "Eventually nothing remains which can be ascribed to the responsible self, and we are left with nothing but the larger sequence of events, which can be deplored or celebrated but not blamed or praised."[16] Perhaps, rather than speaking of the obliteration of the two lines, we should say that we may keep them if we like but may not use them.

The second consequence is the Libertarian's conviction that there are only two ways of securing the freedom required for responsibility. One is to have recourse to another world. But this is so obviously hopeless that he is more likely to try to fit freedom into whatever interstices can be

found for it in the general structure of this world. This strategy is based on the assumption that structural features are eligible for inclusion on the list of counterconditions of responsibility, and the disagreement with the Hard Determinist is then only about the rigidity of the structure. But how would relaxing the structure help? If the best available laws were only probabilistic, would that really make room for our wills to operate with the freedom required for responsibility? The very idea is absurd, but not because the exercise of free will requires predictability, as some Soft Determinists have argued,[17] but for another, more general reason: if the freedom of the will is directly proportional to its detachment not only from everything that precedes its exercise, but also from everything that follows its exercise, then it is a useless gift.

Our first reaction to the consequences of accepting the Hard Determinist's basic assumption, that structural features of the world are suitable candidates for inclusion on the list of counterconditions of responsibility, is likely to be pessimism about the Libertarian's prospects. But a much more radical conclusion can be drawn from them. They are really absurdities which follow from, and show what is wrong with, the Hard Determinist's basic assumption. The lines between agent's responsibility and exculpation and between manufacturer's liability and the voiding of it are both drawn within the world. Their correct location can be questioned and we have agreed ways of settling such questions. The obliteration of the lines is not forced on us by the hypothesis of determinism. On the contrary, it is only a consequence of the Hard Determinist's assumption that the "transcendental" structure of a totality can be mobilized against an empirically founded distinction within it.

The Soft Determinists' defense of their position has often been found unconvincing. This is partly because their focus is too narrow—a fault which Strawson corrects when he extends the field of the traditional controversy to include the whole range of our reactive feelings and attitudes. However, that still leaves another fault in their defense uncorrected: it relies on the current list of counterconditions of responsibility without inquiring how it was formed and without taking determinism's claim to be included on the list seriously enough to investigate its basis and demonstrate its inadequacy. If the analogy with manufacturer's liability achieves nothing else, it may at least make us look at the origins of the two systems, without which they are both equally unintelligible.

DAVID PEARS

OXFORD UNIVERSITY
UNIVERSITY OF CALIFORNIA AT LOS ANGELES
MARCH 1995

NOTES

1. Aristotle: *Nihomachean Ethics*, 1112 B 31–32.

2. Strawson, like most writers on this subject, stresses the importance of the difference between determinism and specific conditions incompatible with independent agency. See his *Analysis and Metaphysics* (Oxford: Oxford University Press, 1992), p. 132.

3. See Strawson: *Analysis and Metaphysics*, pp. 137–38, where he connects our reactive feelings and attitudes with the sense of freedom, and both with the sense of self.

4. In Kant's theory the two aspects have metaphysically disparate bases, but Strawson's theory is Humean.

5. Hume: *Treatise of Human Nature*, ed. P. H. Nidditch (Oxford: Clarendon Press, 1989), p. 187. The parallelism is endorsed by Strawson in his *Scepticism and Naturalism; Some Varieties* (London: Methuen, 1983).

6. See S. Wolf: 'The Importance of Free Will', *Mind* 90, no. 359 (July 1981): 392–93.

7. See Strawson, *Freedom and Resentment*, section 4.

8. See n. 3 above.

9. See below, p. 9.

10. Strawson: *Scepticism and Naturalism: Some Varieties*, p. 32, referring to Thomas Nagel: 'Moral Luck' in *Mortal Questions* (Cambridge: Cambridge University Press, 1979).

11. Nagel: *Mortal Questions*, p. 37.

12. See H. A. Prichard, *Moral Obligation* (Oxford: Oxford University Press, 1949), p. 193.

13. See J. Bennet: 'Accountability', in *Philosophical Subjects, Essays Presented to P. F. Strawson*, ed. Z. Van Straaten (Oxford: Clarendon Press, 1980), pp. 25–28, and Bernard Williams, 'Morality and the Emotions', in *Problems of the Self* (Cambridge: Cambridge University Press, 197, p. 225.

14. See Hume: *Enquiry Concerning Human Understanding*, ch. VIII.

15. See Strawson: *Freedom and Resentment*, section 4.

16. See above, p. 7.

17. E.g., A. J. Ayer: *Freedom and Necessity* in *Philosophical Essays* (London: Macmillan, 1954).

REPLY TO DAVID PEARS

In his subtle and perceptive paper Professor Pears discusses once more the old question, whether a belief in determinism is incompatible with ascribing responsibility for their actions to human agents. He refers first to the customary list of conditions any one of which is generally accepted as sufficient to exclude any such ascription in any particular case in which that condition obtains; but points out, in effect, that anyone (any compatibilist or 'soft determinist') who represented the disjunction of those conditions as a necessary condition of excluding any ascription of responsibility would be begging the question against the view that the truth of determinism would be a completely general sufficient condition for denying responsibility. How, indeed, can anyone be held responsible for anything he does if the entire sequence of preceding states of affairs makes it unavoidable that he does what he does, makes any other action strictly impossible? One pragmatically inspired response favored by some soft determinists is to the effect that it is socially justifiable to admit as responsibility-exempting only those determining conditions (e.g., duress or physical or neurotic compulsion) which are such that moral or social pressures would have made no difference to the outcome.

Pears rightly dismisses this reply as inadequate. Not only is it intellectually unsatisfactory. It has the further deficiency of omitting all mention of the entire range of attitudes and feelings which in fact govern all our relations with one another and our reactions to human behavior in general, whether that of others or of ourselves. These, in 'Freedom and Resentment', I called 'reactive attitudes' and held that they entailed the ascription or acknowledgment of responsibility in all cases except those in which they were inhibited by one or another of the generally recognized inhibiting conditions.

I further maintained that this network or system of attitudes and feelings is so deeply rooted in our human natures that no merely theoretical conviction of the truth of determinism could possibly dis-

place or even disturb it. Pears rightly describes this position as a kind of naturalism comparable with Hume's acknowledgment of our natural and nonrational commitment to belief in physical objects or in causation.

As it appears, however, Pears does not find this position satisfactory as it stands—any more than that of the pragmatically inspired soft determinist. The parallel with Hume's acknowledgment of our natural belief in the existence of body is imperfect, for in that case there is no equally naturally entrenched conflicting belief; whereas we are naturally prone to hold that the absolute impossibility of agents' ever acting otherwise than they do act, which would follow from the truth of determinism, would indeed be incompatible with holding them responsible for what they do.

Not that Pears hands the victory to the other side: neither to Hard Determinists who hold that determinism is true and that therefore responsibility is an illusion, nor to the Libertarians who think that this conclusion would follow from the truth of determinism, but seek to safeguard freedom either by locating its source extraphenomenally, like Kant, or by some other equally unpromising manoeuvre.

The approach favored by Pears is quite different. First, he points out that, however it may be in other areas of our knowledge, there is, in the relevant area, i.e., that of intentional human action, no possibility of empirically establishing, or even testing, either the truth of determinism or its qualifications for being included in the list of responsibility-defeating conditions. Then second, waiving the matter of empirical tests, he argues that it is mistaken *in principle* to invoke an absolutely general structural feature of the world, such as determinism posits, as a candidate for inclusion in that list.

He supports this contention, decisive if sound, with a pleasing, but admittedly imperfect, analogy. Its point, however, can be detached from its limitations, and considered independently on its merits. And the point seems to be that the distinction between those cases in which responsibility is ascribable and those in which it is not is, in practice and in origin, a real distinction, drawn *within* the world, on an empirical foundation, and cannot be simply abolished or obliterated by appeal to what is represented as an absolutely general structural feature of the world as a whole.

Now what is my response to this refined structure of argument? It is mixed: a mixture of agreement and quite substantial qualification. I agree that we should consider seriously the origin—the fount and origin—of the distinction we draw in practice between cases where responsibility is ascribed and cases where it is not. But I think Pears gives insufficient weight—indeed, towards the end of his paper, no explicit

weight at all—to just those features of the fount and origin which I was at pains to emphasize in my characterization of reactive attitudes in 'Freedom and Resentment'. There I spoke of our natural responses, personally or vicariously felt, to certain states of mind we discern as manifested by agents in their actions—notably their good or ill will or indifference towards ourselves or others. Circumstances which exclude manifestation of such states, so manifested, do not evoke the responses in question (e.g., gratitude or approbation, resentment or indignation)—and such circumstances are precisely the generally recognized defeating conditions of responsibility.

Now, let us turn briefly from defeating conditions to what we would normally regard as the generally necessary conditions of someone's acting, as we say, freely or voluntarily, and hence being responsible for what he does. They seem to include the following: the agent knows what he is doing, is aware of what at least seemed to him other possibilities of action and chooses to do what he does in the light of his belief about the facts and of his attitudes, principles, and preferences. (Note, parenthetically, that the notion of choice makes no sense here unless it at least seems to the agent as if other possibilities of action are open to him.) The satisfaction of what we normally regard as these positive conditions of responsibility carries with it at least the possibility, though by no means always the actuality, of the agent's behavior manifesting one or another of those states of mind which typically evoke in an observer (or patient) of his action the reactive attitudes I spoke of.

But now, what if we came to believe that a multitude of influences in the agent's past ranging through his history indefinitely backwards, made the agent just what he currently is, fashioned his principles, his tastes, and his currently seeing both situation and his apparent alternate courses of action just as he in fact sees them—in short, all the immediate antecedents of his action? What difference would it make? or should it make?

The answer is: none. It is entirely irrelevant. The belief, in its fully generalized form, is by no means unreasonable, although, as Pears points out, it is untestable; but any imagined result of any imagined test would be equally irrelevant.

Of course, if we held the belief in its fully generalized form we *could* say that no one is *ultimately* responsible for his or her actions, thereby doing a sort of justice to one apparently ineliminable natural-philosophical conviction. But *ultimate* responsibility in this sense is neither here nor there. We have the empirically founded distinctions with which in practice we worked; and once we are fully clear about the real nature of those foundations, foundations in phenomena which we

are quite good at discriminating, we see equally clearly that no such general doctrine as determinism, in any of its forms, would possibly disturb them.

So, it will be seen I agree with the conclusion reached by Professor Pears; but hope to have made its foundations more secure by referring again to the phenomenology of the moral life.

P.F.S.

13

Robert Boyd

STRAWSON ON INDUCTION

While Peter F. Strawson is best known for his work with ordinary language and descriptive metaphysics, he provides an important contribution to the study of inductive reasoning.[1] His contribution is the foundation for this brief paper. In the first section, I outline part of Strawson's contribution. Although he has much to say about the so-called justifications for induction,[2] my focus is upon his construction and evaluation of arguments which are inductive.[3] As with most intellectual contributions, shortcomings exist. Professor Strawson opens the Pandora Box, but he only offers road signs for the analysis of inductive reasoning. In the second section of this paper, I provide a method of examining inductive reasoning that is consistent with Strawson's emphasis on ordinary language and his comments on induction.

I

In practice we frequently draw conclusions that are not entailed by their premises. Strawson provides three brief illustrations:

a) He's been traveling for twenty-four hours, so he'll be very tired.
b) The kettle's been on the fire for the last ten minutes, so it should be boiling by now.
c) There's a hard frost this morning: you'll be cold without a coat.[4]

Since we do use inductive reasoning in ordinary language, Strawson maintains that our logical theory should reflect this practice. Thus, "side by side with the study of formal logic, and overlapping it, we have another study: the study of the logical features of ordinary speech."[5] Strawson hints at this notion with his closing comment in "On Referring."[6] He claims that "neither Aristotelian nor Russellian rules

give the exact logic of any expression of ordinary language; for ordinary language has no exact logic."[7]

Ordinary language has its own logic: the logic of induction. When examining the reasoning of ordinary dialogue "we shall not find . . . that character of elegance and system which belongs to the constructions of formal logic."[8] Rather the logic of ordinary language is characterized by a fluidity and imprecision of rules. Furthermore, the rules of this logic should develop from our practice of using language.[9] Unlike the logic of entailment, inductive reasoning requires *degrees* of support.[10] Whereas a deductive argument is either valid or invalid, and cannot be more valid or less invalid, the relative strength of an inductive argument lies between strong and weak. Furthermore the argument could be stronger or weaker.

The evaluation of inductive reasoning is not based on standards appropriate for deductive reasoning, but upon standards appropriate for induction. For example:

> The evidence for a generalization to the effect that all As are Bs is good (1) in proportion as our observations of instances of As which are B are numerous, and (2) in proportion as the variety of conditions in which the instances are found is wide.[11]

Three additional aspects of Strawson's contribution to the construction and evaluation of inductive reasoning are found in the following passage.

> Our assessment of evidence is an activity undertaken not primarily for its own sake, but for the sake of practical decision and action. Our use of words for grading evidence will in part reflect the degree of caution demanded by the action proposed. Evidence which the general public finds conclusive may not satisfy the judge.[12]

First, pragmatic reasons direct the analysis process. The evaluation of reasoning found in ordinary language should be motivated by practical reasons. Furthermore, the analysis uses ordinary language; the evaluation should be presented in ordinary language. Finally, the context of the argument must be taken into account as part of the evaluation. An argument in ordinary language is context dependent.

II

In this section I present a method of examining arguments in ordinary language that is consistent with Strawson's contribution and illustrate its application. As suggested by Strawson, the criteria and examination

process is embedded in our normal use of language. To say that induction is embedded in our ordinary use of language is a controversial claim and is a justification of induction from the standpoint of ordinary language philosophy: if you can show something in ordinary language you have justified its practice.

However, if we accept the claim that our logical theory should be broad enough to encompass the reasoning reflected in ordinary discourse without forcing this reasoning into compliance with formal standards, then by what standards do we evaluate it? Consider the following line of reasoning.

Senator X was afraid of Bork's conservatism. Senator Y, as was Senator Z, was also afraid of Bork's conservatism. We might conclude that the reason Bork was not confirmed to a Supreme Court position was that most liberal senators were afraid of his conservatism. (Senators X, Y, and Z were all liberals.)

Two immediate questions arise; each reflecting specific criteria. How many liberal senators were there? Do Senators X, Y, and Z represent different factions within the set of liberal senators? These questions illustrate the criteria suggested by Strawson in the above quote: 1) **sample size** and 2) **sample diversity**. When the former is violated, we have a Hasty Generalization; when the latter, a Biased Statistic.

The following line of reasoning suggests a third criterion.

"Smoking by pregnant women may result in fetal injuries, premature birth, and low birth weight." (Surgeon General's warning on a pack of cigarettes.) Susan is a 95-year-old smoker. Probably, her next child will be born premature.

While the issue of sample size is pertinent, the key to this passage is that it appears to ignore all the relevant facts. At issue is the criterion of **total evidence**. When this criterion is violated, as in the above reasoning, the fallacy of Incomplete Evidence occurs.

A third argument suggests still another criterion.

In 1974 there was an oil shortage that resulted in higher prices for gasoline, long lines at gas stations, and short tempers. In 1990 there was another oil shortage that resulted in higher prices and gas lines. I guess there were probably some short tempers.

In order to evaluate this reasoning, we would reflect on the **relevance of analogy** by focusing upon relevant similarities and relevant dissimilarities. If the passage violates this standard, then we have a False Analogy.

Finally,

Mr. Heller, now at VISA International, was a governor of the
Federal Reserve Board from 1986 until earlier this year, claimed
"the mere existence of a marketstabilizing agency helps to avoid
panic in emergencies." Therefore, we need a marketstabilizing
agency. (*Wall Street Journal*, October 27, 1989)

In this **appeal to authority**, we must be concerned with the expertise of
the cited authority and whether other experts in the field view Mr.
Heller's position as plausible. If either issue is violated, we have a
Fallacious Appeal to Authority.

In addition to identifying six general criteria, by looking at examples
of reasoning in ordinary speech, we can identify five[13] different types of
enumerative induction. The last two passages respectively represent
arguments from analogy and **appeals to authority**. Three more types of
enumeration are identifiable by examining the movement within ordi-
nary reasoning. In the above argument concerning Bork's confirmation,
the evidence deals with particular senators and the conclusion concerns
most liberal senators. It moves from particular to general. This is an
inductive generalization. However, the movement within the argument
concerning Susan's next child is the reverse. The evidence involves a
generalization from which a claim about a particular individual is made.
This line of reasoning is a **statistical syllogism**. Other enumerative
arguments involve evidence concerning particulars and conclude with a
claim about another particular; these are **simple enumerations**.[14]

This report in the *Texas Monthly* claims that the following cities
are exciting places to live: Austin, Texas; Dallas, Texas; Fort
Worth, Texas; Houston, Texas. While the magazine failed to
mention it, I am sure that we can conclude that Boyd, Texas is
also an exciting place to live.

The analysis of enumerative induction assumes that each type of
enumerative argument has its own criteria by which we evaluate it. The
following chart shows the criteria to be satisfied for each form of
inductive reasoning.

Simple Enumeration	Inductive Generalization	Argument from Analogy	Statistical Syllogism	Appeal to Authority
1) Total Evidence	1) Sample Size	1) Relevance of Analogy	1) Total Evidence	1) Expertise
2) Sample Diversity	2) Sample Diversity		2) Sample Size	2) Consensus

Furthermore, a five step process provides structure for presenting the
evaluation. This evaluation is best accomplished as a dialogue.[15] The
dialogue is a discussion concerning the likelihood of whether the

criterion is satisfied. The criteria provide a structure, and the dialogue provides the randomlike nature. The first step consists of putting the argument into standard form. This requires a careful examination and interpretation of the passage. Once the argument is in this form, we can determine the type of enumeration. This is step two. The third step involves a discussion/dialogue of the argument in terms of the specific criteria for that argument type. This discussion leads to insights concerning the argument that previously escaped our attention. Furthermore, this third step leads us to raise numerous questions concerning the argument and its reasonableness. These questions often highlight assumptions made within the argument and provide a stimulus for further research. If we determine at step three that a particular criterion is violated, then at step four we name the corresponding fallacy. (A fallacy results only when a standard or criterion of correct reasoning is violated.) The fifth step in this process is a general discussion of the strength of the argument. At this stage we decide whether the argument is strong, moderate, or weak and provide a justification for this decision. If an argument is fallacious, step four, then the argument is weak. (However, not all weak arguments are fallacious.) I provide two examples of such an analysis.

<div align="center">EXAMPLE I</div>

Board members need policies, training activities, guidelines to ensure that if and when sexual harassment occurs, school officials are prepared to deal with it Furthermore, if a sexual harassment case reaches the courts, the grievance and rectifying procedures provide some legal protection, proving that your board made a goodfaith effort to prevent sexual harassment among employees. You also might find your efforts make it possible to prevent it.[16]

Step 1

If sexual harassment policies are in place, then school boards will know how to respond when sexual harassment occurs. If a sexual harassment case reaches the courts and a policy is in place, there is legal protection given those school, assuming the policy is applied in good faith. Possibly the mere presences of a sexual harassment policy will prevent sexual harassment from occurring.

∴All school boards need a sexual harassment policy.

Step 2

Inductive Generalization

Step 3

Sample diversity: The diversification of this argument is excellent. Notice that the first premise deals with present tense sexual harassment; the second deals with past tense cases; the third premise points to future cases of sexual harassment.

Sample size: While there are only three premises, it seems that the sample size is more than adequate. There is a "qualitative" factor present in the evidence. Each premise, by itself, has adequate quality to support the conclusion. (Sample size typically is satisfied quantitatively, but here it is satisfied qualitatively.)

Step 4

No fallacies

Step 5

The conclusion is extremely strong in terms of "all schools." However, given the subject of the argument a weaker claim seems inappropriate. Because of the diversity in the evidence and the qualitative nature of that evidence, the argument is strong.

Example II

CONDOMS NOT WHAT SCHOOLS NEED. The American people have lost their minds. I'm referring to passing out condoms in our public schools to our children to help combat AIDS. Did it ever occur to anyone to have a class teaching our young people that it is morally wrong to have sex outside of marriage and that there are guidelines in the word of God for people to follow? Those guidelines have been around for about 2,000 years, and no one has ever been able to improve upon them![17]

(Although the author of this argument did not clearly set forth her argument, the line of reasoning can be seen by asking two basic

questions. First, what claim is being made? [Condoms are not needed in our public schools.] Secondly, what evidence is used to support that position? [Biblical view of sex and the assumed use of condoms.])

Step 1

> According to the Bible sex outside of marriage is wrong.
> The purpose of condoms is for sexual activities.
> ∴We should not be passing out condoms in our public schools.

Step 2

> Appeal to Authority

Step 3

> **Expertise**: Is the Bible considered an expert or authority in moral issues? Yes, even those who disagree with the Bible would acknowledge that it is an authority (at least for Westerners).
> **Consensus**: Is there a consensus among experts that the position advocated by the Bible is correct? Notice the audience to which the argument is presented—the general public. In today's society, those recognized as authorities by the general public would not agree. This is illustrated by the fact that today, in light of AIDS, 'safe sex' is promoted more frequently than abstinence. Therefore, the criterion is violated.[18]

Step 4

> Fallacious appeal to authority

Step 5

> Argument is weak because it is fallacious.

This example illustrates an interesting feature of arguments in ordinary discourse. If we reconsidered this argument, changing only the audience, the assessment also might change. Instead of being presented in a public newspaper, let's assume that the argument was presented in a church bulletin of a conservative orthodox Christian church. With this new audience, we would now have a new group of experts. Those viewed as experts in such issues, by the new audience, might be in agreement with the position advocated by the Bible. Thus the criterion of consensus would not necessarily be violated. Furthermore, if this audience maintains a strong view of Biblical authority, then it might be claimed that the

argument is strong. This illustrates the importance of taking the audience into account when evaluating an argument; as Strawson claimed, the grading of evidence must reflect the situation.[19]

Peter F. Strawson provides a valuable contribution to the study of induction by offering road signs concerning the direction of study. While the logic of ordinary language is inexact, it is not without its own standards. Analysis of inductive reasoning is possible without forcing such arguments into formal language or requiring them to satisfy deductive standards.

ROBERT BOYD

DEPARTMENT OF LETTERS
FRESNO CITY COLLEGE
JUNE 1996

NOTES

1. Strawson, *Introduction to Logical Theory* (New York: Wiley & Sons, 1952): chapter 9 and "On Justifying Induction," *Philosophical Studies* 9 (January-February 1958): 20–21.

2. Strawson's solution to the historical problem of induction is not without its critics. William Gustason, *Reason from Evidence: Inductive Logic* (New York: Macmillan College Publishing Company, 1994): 192.–97. D. P. Chattopadhyaya, *Induction, Probability, and Skepticism* (Albany: State University of New York Press, 1991): 21–22. Jerrold J. Katz, *The Problem of Induction and Its Solution* (Chicago: University of Chicago Press, 1962): 45f. K. W. Rankin, "Linguistic Analysis and the Justification of Induction," *Philosophical Quarterly* 5 (1955): 322. Wesley C. Salmon, "Should We Attempt to Justify Induction?" *Philosophical Studies* 14 (June 1963): 51–56. E. J. Lowe, "What is the 'Problem of Induction'?" *Philosophy* 62 (July 1987): 325–40.

3. George Schlesinger says "the measure of his (Strawson's) influence may be gauged from the fact that nowadays when someone is said to be engaged in investigating the problem of induction he is as a rule automatically assumed to be engaged not in trying to justify induction but in trying to describe in detail the rules of induction." (200) While Schlesinger tackles the issue of rules, his focus is with probability. "Strawson On Induction," *Philosophia (Israel)* 10 (December 1981): 199–208. Strawson's response to Schlesinger is found on pages 321–22 of the same issue. Also see G. L. Pandit, "Inductive Relations," *Indian Philosophical Quarterly* 10 (January 1983): 183–91 and Gary Atkinson, "Rationality and Induction," *Southwestern Journal of Philosophy* 4 (Spring 1973): 93–100.

4. *Introduction to Logical Theory*, 235.

5. Ibid., 231. Similarly Strawson connects his entailment-rules and referring-rules (Ibid., 213). Seeking connections is a dominant theme of Strawson's logic and metaphysics. See his *Analysis and Metaphysics: An Introduction to Philosophy* (New York: Oxford University Press, 1992).

6. "On Referring," *Mind* 59 (1950): 320–44.

7. Strawson, "On Referring," *Mind* (1950), reprinted in *Meaning and Truth: Essential Readings in Modern Semantics*, ed. Jay Garfield and Murray Kiteley (New York: Paragon House, 1991): 108–29. An interesting note, when Bertrand Russell wrote his heated response to Strawson's paper, one of the few points Russell agreed with was this claim by Strawson. (Russell's response is also reprinted in *Meaning and Truth: Essential Readings in Modern Semantics*, 134f.)

8. *Introduction to Logical Theory*, 232.

9. Ibid., 230.

10. Ibid., 237.

11. Ibid., 246. While we frequently think of induction as involving conclusions that are generalizations, Strawson believes there are other kinds of induction. We might presume that standards or criteria other than sample size or sample diversity, as presented in this passage, exist for these other kinds of induction.

12. Ibid., 248.

13. A sixth type of enumeration is Appeal to Testimony. Its criteria are credibility of source and consistency with known facts.

14. Arguments that appear to move from generalization to generalization are also considered simple enumerations.

15. Robert Boyd, *Critical Reasoning: The Fixation of Belief* (Bessemer, Ala.: Colonial Press, 1992): 106–44. For application to writing essays, see *Writing with Logic in Mind* (Fort Worth: Harcourt Brace College Publishers, 1994), "Teaching Writing with Logic," *College Teaching* 43 (Spring 1995), and "Inductive Reasoning and Rhetoric" (unpublished paper, 1996).

16. Decker, "Can Schools Eliminate Sexual Harassment?," *Education Digest* (January 1989).

17. *Fort Worth Star Telegram* (October 18, 1990).

18. Recently I discussed this argument with a group of graduate students. They claimed that 'consensus' is not violated since the issue in the argument is teens and sex. While many educators, counselors, psychologists, clergy, medical personnel, and ethicists are currently (1996) advocating abstinence for teens for health and psychological reasons, it is a matter of historical study whether that message was advocated in 1990. It has also been suggested that the main point of the editorial was not about condoms, rather it was a call to reexamine our moral standards. Because of the use of bold upper case letters, I believe the primary conclusion does concern condoms, although a secondary conclusion might address moral standards.

19. "A particular statement is identified, not only by reference to the words used, but also by reference to the circumstances in which they are used, and, sometimes, to the identity of the person using them." *Introduction to Logical Theory* 4. Also see his discussion of referring-rules (213f).

REPLY TO ROBERT BOYD

Hume, generally, though contentiously, regarded as a skeptic about causation and, less contentiously, about the justification of inductive reasoning, nevertheless recognizes 'rules for judging of causes and effects'. Professor Boyd proceeds, as Hume does not, to a fuller and more detailed study of the canons of ordinary nondeductive reasoning in those cases where the concern is not arriving at general theoretical, but at particular, even practical conclusions—reasoning, in short, such as people customarily employ in ordinary circumstances.

Professor Boyd's procedure is to consider a number of such arguments, most of them quite weak, and by examining their weaknesses or, in one case, strengths, to elicit the criteria which arguments of different nondeductive types should satisfy, if good, and the ways in which they may fall short, when poor. I have no criticisms of this procedure or of the morals which Boyd draws from following it. I would only demur, mildly, at his use of the word 'logic' in this connection, since the term does so strongly point towards the possibility of formalization, which, *pace* Carnap, is really alien here. However my protest has to be a mild one, since in ordinary parlance it is perfectly possible unmisleadingly to criticize or applaud such arguments by saying, e.g., 'That's illogical' or 'That's quite logical'.

P.F.S.

14

Hilary Putnam
STRAWSON AND SKEPTICISM*

Peter Strawson is one of the great philosophers of the century. If I have long been an admirer of his work, it is because of the exemplary way in which, time and time again, he has advanced the state of philosophical discussion and opened new avenues for us to explore. He has done this in area after area (while always keeping in mind the interrelatedness of philosophical issues). I particularly value the fact that he opened the way to a reception of Kant's philosophy by analytic philosophers. In this essay, however, I explore a tension I find between Strawson's Kantian and his Humean sympathies.[1]

STRAWSON'S HUMEAN TENDENCY

In *Skepticism and Naturalism: Some Varieties*, Peter Strawson takes a rather hard Humean line. Belief in the external world, or the uniformity of nature, is a matter of natural inclination, not received conviction, and we could not be brought to give such beliefs up by any reasons. Moreover, the skeptic's doubts and the various philosophical attempts to answer the skeptic are alike pointless; beliefs that are not based on reasoning can neither be undermined nor defended by it.

Strawson's tendency to appeal to Hume is *not* a recent development. It is worth recalling a short debate between Strawson and Wesley Salmon as long ago as 1957–58. In *Introduction to Logical Theory* (1952), Strawson had denied that induction can be given a general justification. At the same time, he had written (p. 249) "to call a belief reasonable or unreasonable is to apply inductive standards," saying further (p. 257) that "to ask whether it is reasonable to place reliance on inductive procedures is like asking whether it is reasonable to proportion the degree of one's convictions to the strength of the evidence. Doing this is

what 'reasonable' means in such a context." Criticizing all this in an article published in 1957,[2] Salmon wrote, "If the foregoing theory [that induction cannot be given a general justification] is correct, empirical knowledge is, at bottom, a matter of convention. We choose, quite arbitrarily it would seem, some basic canons of induction; there is no possibility of justifying the choice." And he went on to say,[3] "The attempt to vindicate inductive methods by showing that they lead to reasonable belief is a failure. . . . If we regard beliefs as reasonable simply because they are arrived at inductively, we still have the problem of showing that reasonable beliefs are valuable. This is the problem of induction stated in new words. . . . It sounds very much as if the whole argument [that reasonable beliefs are, by definition, beliefs which are inductively supported] has the function of transferring to the word 'inductive' all of the honorific connotations of the word 'reasonable', quite apart from whether induction is good for anything. The resulting justification of induction amounts to this: If you use inductive procedures you can call yourself 'reasonable'—*and isn't that nice!*"

Strawson, of course, could not let this go by unanswered. And two issues later in the same journal,[4] he retorted,

> [Salmon] says that if [the view that induction cannot be given a general justification] is correct, then it must also be true that inductive beliefs are *conventional*; that empirical knowledge is, at bottom, a matter of *convention*; that it is a matter of our arbitrary *choice*, that we recognize the basic canons of induction which we do recognize.
>
> I find it mysterious that Mr. Salmon should think this. For he refers more than once, in the course of his paper, to Hume. Hume, I suppose did not think that induction could be given a general justification. He did not, on this account, think that inductive beliefs were *conventional*, he pointed out that they were *natural*. He did not think that our 'basic canons' were arbitrarily *chosen*; he saw that this was a matter in which, at the fundamental level of belief-formation, we had *no choice at all*. He would, no doubt, have agreed that or acceptance of the 'basic canons' was not forced upon us by 'cognitive considerations' (by Reason); for it is forced upon us by nature.
>
> If it is said that there is a problem of induction, and that Hume posed it, it must be added that he solved it.

Puzzlingly, in *Individuals*, written about the same time (published in 1959), Strawson claims (p. 35) that Kantian insights are effective in exposing certain confusions involved in skeptical arguments. "[the skeptic's] doubts are unreal, not simply because they are logically irresoluble doubts, but because they amount to the rejection of the whole conceptual scheme within which alone such doubts make sense."

This asserts that apart from the conceptual scheme which the skeptic rejects, the skeptic's doubts do not so much as make sense. It follows, at the very least, that the skeptic is in the following position: if her

argument is correct, then her argument makes no sense! (That would seem to be a *reductio* if I ever saw one!)

But in his later (1985) *Skepticism and Naturalism: Some Varieties* he returns to the themes of his short reply to Salmon. In particular, he argues again that the basic categories of our conceptual system are not chosen for reasons *because they are not chosen at all*; and suggests that to so much as ask for reasons for them is accordingly a mistake.

HUME AND THE PROBLEM OF INDUCTION

If it is said that there is a problem of induction, and that Hume posed it, it must be added that he solved it.

To begin with, the idea that Hume 'solved' the problem of induction is decidedly problematical. My disagreement with this claim is not based on the textual point that Hume does not speak of 'canons' of induction. But in fact it is not clear that there *are* 'canons,' in the sense in which Salmon's quarrel with Strawson concerned the issue of whether the (supposed) canons of induction can be justified.

The canons of induction Salmon writes about are supposed to describe a method by which the totality of our empirical knowledge (all of our knowledge that has predictive import) could in principle[5] have been arrived at starting with nothing but observation (and, of course, deductive logic). *Salmon* believes (to this day) that there are canons of induction in this sense because he follows Reichenbach in supposing that the so-called 'straight rule of induction,' namely *posit that the limit of the relative frequency will be close to the so-far-observed relative frequency*, is such a (in fact the only) canon.

Unfortunately for this view, all such 'rules of induction,' if unrestricted, lead immediately to inconsistencies. One example of such an inconsistency is Goodman's famous 'grue' example.[6] A commonsense response to this difficulty might well be to say that we do not project the Goodmanian 'regularity.' 'All emeralds are grue' because to do so would require us to predict that emeralds will *change color* at the stroke of midnight on December 31, 1999, and we have no reason to expect such a change. To the expected Goodmanian response, 'So what? To project the regularity we do project, namely 'All emeralds are green', requires us to predict that emeralds will *change gruller* at the stroke of midnight on December 31, 1999, and what reason do we have to expect *that* change?', we might answer that gruller changes are mere 'Cambridge changes,'[7] while color changes are what we consider 'real changes.'

Can we save Reichenbach's 'straight rule of induction,' or any

alternative such rule or system of rules, by requiring that the predicates we project be such that something can remain S and remain P (where 'All S's are P's' is the induction we wish to make) without undergoing a 'real change'? No, because many predicates we wish to project would be excluded by such a criterion. (Something cannot remain a mammal for any length of time, for example, without undergoing a variety of 'real changes,' including *aging*.) "But those are *normal* changes, whereas the kind of change that would be involved if all emeralds *were* 'grue'—namely, that every emerald in the world would change color from green to blue simultaneously at midnight, December 31, 1999—would be decidedly abnormal." But now we are appealing to a fund of background knowledge, not to some supposed 'canon of induction' by which all of that background knowledge was allegedly obtained!

Goodman's own solution is to seek canons of induction which are restricted to what he calls 'projectible' predicates. Projectibility depends, for Goodman, simply on how often a predicate has been projected in the past (the technical criterion is quite complicated, but this is the basic idea). Yet new predicates, with no history of prior projection, are frequently introduced by physical theories and immediately thereafter used in 'inductions,' Moreover, I remain unconvinced that (even if we accepted Goodman's criteria for projectability) we *could* state any set of 'canons' by which it would have been possible to arrive at the knowledge we do have. (Goodman's own canons presuppose a vast amount of knowledge about the history of prior projections, much of which it is not at all clear we actually have.) In sum, as long as no one has ever succeeded in exhibiting the supposed 'canons of induction' on which our inductive practices are thought to depend, the problem of their 'justification' must remain utterly unclear. If we can't even *state* canons of induction, then the problem *can't* be that we accept them 'without choice,' or that they represent 'natural beliefs.'

It is often supposed by philosophers that wherever there is a practice that can be correct or incorrect, there must be a set of 'rules' or 'standards' that could be explicitly stated. Otherwise, it is thought, 'anything goes,' But this is quite groundless. There are right and wrong ways of using a screwdriver, but there are not explicitly stateable rules or standards for screwdriver use. Moreover, even where our practices do have rules, it is rare indeed that those rules are as precise as computer algorithms. Usually what we have is the sort of 'rules' Kant had in mind when he observed[8] that there cannot be such a thing as a *rule for good judgment*, because if there were *we would need good judgment to apply the rule*. Thus there is nothing contradictory in saying that we have practices—indeed, an innumerable number of practices—which could be described as procedures of 'inductive inference,' in the sense that they

lead from observed phenomena, while denying that those practices are governed by 'canons of induction' of the kind that Reichenbach (and Carnap) sought with their ventures in 'inductive logic.'

In an older sense of the term, there are some 'canons of induction'; Mill's methods are an example. But those methods apply only to situations of a special kind; in fact, they are rules for eliminating the factors which are not causally responsible for the phenomenon by carefully controlling all of the potentially relevant factors. Thus, they apply to what Reichenbach would have called 'advanced knowledge'; they are not methods by which all of our knowledge could have been arrived at to begin with.

What Strawson shares with some of his critics (not only Wesley Salmon, but also Michael Williams[9]) is a tendency to assume that the skeptical demand to 'justify the canons of induction' represents a coherent problem, that is to assume that it is clear just *what* we are unable to do, or unable to justify by giving reasons. But it is in fact far from clear.

I said that the idea that Hume 'solved' the problem of induction is decidedly problematical. Not only did he not discuss the 'problem of justifying induction' that Salmon and Strawson debated, but his discussion of the problem he did discuss, the problem as to whether Reason can tell us anything about what will happen in the future, depends on premises which, I shall argue, Strawson should be the last philosopher in the world to accept.

HUME'S 'LOOSE AND SEPARATE' EXISTENCES

Hume did claim that Reason is powerless to tell us what will happen in the future. Strawson's reply to Salmon asserts, as we have mentioned, that "If it is said that there is a problem of induction, and that Hume posed it, it must be added that he solved it." The double qualification in this sentence may well reflect an awareness that there is something problematic about talk of 'a problem of induction', but the qualification does not save Strawson's claim. I shall now argue that, contrary to Strawson, if it is said that there is a problem of induction, and that Hume posed it, then it must be added that he posed it in a seriously confused way.

The problem, quite simply, is that Hume's argument depends on other views of Hume's which are utterly untenable. What Hume claims (this is the central 'lemma,' so to speak, in Hume's demonstration that Reason is powerless to tell us what will happen in the future), is that *events at different times are completely logically independent in the sense*

*that what happens at one time has no logical or conceptual connection
with what happens at any other time.* In Hume's own terminology, the
'existences' at different times are 'loose and separate'. And this view
(which, I shall argue, is itself untenable) is defended by Hume with the
aid of the following further views: (1) Reason, when pushed to its limits
('in the study', i.e., in the context of careful philosophical reflection, in
which our natural belief in the existence of enduring and unobserved
objects is temporarily suspended) inevitably leads to the demonstra-
tion—that is to the *valid* demonstration—that the very notion of an
enduring physical object as something which is capable of existing
unperceived is incoherent. On this much, Hume agrees completely with
Berkeley. What can coherently be thought to exist is only 'ideas and
impressions', and these do not logically or conceptually depend on the
existence of material bodies or an objective causal order (indeed, as just
said, the notion of 'material bodies' that we think we have is incoherent).
(2) Any sequence whatsoever of ideas and impressions represents a
possible future course of the world, i.e., it could be the case (regardless of
what has existed in the present and past) that all that will exist in the
future is that sequence of ideas and impressions occurring in that order.

Hume needs these premises, because it would be enormously implau-
sible to contend that any sequence of events whatsoever is logically
possible, if the 'events' in question are described in our normal concep-
tual scheme—that is, in terms of kinds of material objects acting on and
being acted upon by one another in familiar sorts of ways. (This is a
point that Strawson himself is extremely aware of when he wears his
Kantian hat. After all, he did write that "[the skeptic's] doubts are
unreal, not simply because they are logically irresoluble doubts, but
because they amount to the rejection of the whole conceptual scheme
within which alone such doubts make sense." What puzzles me is that he
seems to forget all that when he puts on his Humean hat.) A material
object, say a cat or a rock or a table, is something that has certain
familiar causal powers. To be sure, we cannot determine what those
causal powers are simply by conceptual analysis; our ideas of them are
subject to revision. But the idea that something might be a cat while
having none of the familiar causal properties of cats has, as it stands no
intelligible sense. (I say, 'as it stands' because it can happen that we tell a
story which provides a context in which it makes sense to say that
something is a cat but isn't, say, visible—but then the story makes sense
of the statement by explaining how something or other interferes with
the seeing of the cat, that is, the story introduces additional causal
elements.) Yet the supposition that the world might, from now on,
consist of 'events' in a random order—at one moment there is a cat
chasing a mouse, the next instant the cat is twelve feet tall and singing

'Yankee Doodle,' the next instant there is a purple tidal wave sweeping over a field of flowers with heads like Charlie Chaplin . . .—implies that, from now on, *there will be no significant regularities at all*, and, *a fortiori*, no cats, mice, waves, or flowers!

Incidentally, it is not only Strawson who overlooks the relevance of this point to Hume's argument. Reichenbach himself has brilliantly argued that all our empirical claims have predictive import.[10] Yet when he writes about induction he simply assumes that we begin the enterprise of empirical inquiry in the following situation: we have accumulated knowledge—observational knowledge—that certain things have happened in the past, but no knowledge about the future, and our problem is to make justifiable 'posits' as to what will happen in the future. But the position Reichenbach imagines in his writing on induction, namely that we have *no knowledge whatsoever about the future and have to justify our very first "posit"* is totally incoherent. (Under ordinary circumstances, we would not be willing to say "I know there is a chair here" if we weren't also willing to say "If I go forward and touch it, I will feel a chair"; observational knowledge and predictive knowledge are not independent—"loose and separate"—in the way Reichenbach's discussion of induction presupposes.)

Of course, this criticism does not apply—or at least, does not apply at first blush—to Hume himself. Hume, as I said, is not talking about such events as a cat chasing a mouse. He is talking about sequences of *ideas and impressions*, that is sense data considered as immaterial objects of which we are directly aware. But—as Kant very well saw—this does not rescue Hume's argument. For even if we assume that we know what we are talking about when we talk of *immaterial* "ideas and impressions"—a very big "if" indeed![11]—the notion of a *future* is inextricably connected with the notions of space, time, and causality. This is not just a fact about Newton's physics, or Einstein's, but about our ordinary conceptual scheme as well. Imagine, thus (assuming the existence of Humean or Berkeleyan immaterial "ideas and impressions," for the sake of argument), that there is a more or less instantaneous) world-state, call it "A," consisting of a sense impression as of a cat chasing a mouse, a world-state, call it B, consisting of a sense impression as of a twelve-foot cat singing "Yankee Doodle," and a world-state, call it "C," consisting of a sense impression as of a purple tidal wave sweeping over a field of flowers with heads like Charlie Chaplin. What sense does it have to say that these are *states of one and the same world*, let alone to speak of them as temporally ordered, if there are no causal connections of any kind between them?[12] Hume's argument depends upon our thinking of the concepts experiences A and B [think of experiences at different times here] lie in one and the same phenomenal world and "A is

earlier than B" as themselves *presuppositionless*. But they certainly are not.

Of course, "Hume was right" if all we imagine Hume to have been arguing is that we do not have deductive certainty concerning what will happen in the future; but no philosopher—no ancient, medieval, or modern philosopher—ever imagined that we did. Hume was not out to refute a straw man. Hume wanted to show something truly surprising, namely that knowing the nature of a current existent (when our notion of that nature is not allowed to be inflated by our tendency to subjectively project various ideas—the idea of causality, or the idea of enduring matter, for example—onto what is given) tells us nothing about what is likely to happen in the future. This amounts to claiming that the nature of the current existent, as it is in itself, is "loose and separate" from all dispositions, causal connections, etc. And that is an incoherent idea.

WHY DO I GO INTO ALL OF THIS?

The debate with Salmon was a long time ago, and Strawson's part in that debate was only two pages in length. It would hardly be worth discussing if Strawson had not returned to something like the earlier position in *Skepticism and Naturalism: Some Varieties*. There, he argues that it is a mistake to even raise the question of justifying such beliefs as our belief in "the uniformity of nature" and our belief in the existence of "the external world" (so the skeptic and the philosopher who tries to "answer" the skeptic are alike victims of some sort of confusion). The reason, according to Strawson, is, as before, that these are *natural* beliefs; we do not hold them for *reasons*; if we did, then we would have had to be able at some time to seriously consider *not* having them. But we have no *choice* here. And where we have no choice, it is "idle" or "vain" to speak of reasons for and against. (It is clear from such statements that Strawson thinks that the question of the *truth* of skepticism does not genuinely arise, but it is not clear what this is supposed to mean. It is not clear whether the supposed fact that the question is "idle" implies that it *does not make sense*, or whether Strawson is conceding that it makes sense.) Michael Williams has also (very legitimately) questioned this last step, asking whether Strawson's point is supposed to be a logical one or only a psychological one;[13] however my problem begins earlier. The very idea that there is a problem of showing that it is not an illusion that nature is "uniform," that is, that it is governed by causal laws and things exhibiting a variety of causal dispositions, assumes that we can make coherent sense of a world in which there are events and a time order but

no causal laws or types of objects with determinate causal powers and dispositions. But this is just the Humean idea that the world might consist of a series of "loose and separate" events all over again!

Additional Remarks on "The Uniformity of Nature"

To say that there is no genuine problem of "the uniformity of nature"—and that is what I am saying—is not to deny that we can coherently imagine that *many* of the regularities we depend on in science or in daily life will someday break down. But suppose we imagine a bizarre science fiction future—imagine, say, that one morning we wake up and find that, although there is a strange uniform illumination permitting us to see one another, there is no sun in the sky. (So the famous induction to the conclusion "the sun will rise tomorrow" will break down.) Imagine also, if you like, that any of the events that one reads about in "fantasy" novels takes place—wizards cast spells success-fully, horses speak, etc., etc., etc. Still, the very fact that we imagine that we can identify ourselves, see other people and many familiar sorts of objects and identify and re-identify them—not to mention performing such familiar acts as putting on one's clothes, eating a meal, walking down the street—means that we have conceived of a world where a great many familiar regularities (indeed, most of the ones that matter to the daily life of human beings through the centuries) continue to hold.

Moreover, if the problem is that particular regularities on which we rely can be conceived of as breaking down, *that* problem arises even if we suppose that at a fundamental level nature is much as contemporary science conceives it to be. Is the problem that "the sun might not rise tomorrow"? Well, it could conceivably go nova. Or a space-time singu-larity could capture Terra, and take it far away from our sun. In-deed—although this would take an alteration in our current physical theory—it could be that space-time has an end "in the future direction," that for some time t, there are no events at all after t, and not even such a thing as "time after t." But a space time which is finite in both the past and future directions is still not one in which "the uniformity of nature" fails. I don't deny that the conceivability of such scenarios can be and has been used to generate skeptical difficulties. But these are *particular* scenarios, particular future "possibilities" (as the skeptic terms them), which we are unable to rule out *deductively*. What to make of that is a question which has often been discussed, and we shall discuss it again shortly. But the difficulty is *not* that there is *one* overriding "possibility," namely that "nature might not be uniform," such that if we could only

rule *that one* out, then our inductive house would be in order. (Indeed, the uselessness of any supposed "principle of the uniformity of nature" from the point of view of providing a support for the particular inductive inferences we make has often been pointed out.)[14] Strawson's picture in *Skepticism and Naturalism: Some Varieties* is a familiar one, in which there are, as it were, certain "presuppositions of empirical knowledge" a lá Bertrand Russell—the uniformity of nature, the existence of the external world, etc.—and what we have to discuss is whether or not *these* can justified by means of reasons or whether, instead, they are "natural beliefs." But that is not a picture we should accept, nor (in view of his insightful remark in *Individuals* that "[the skeptic's] doubts are unreal, not simply because they are logically irresoluble doubts, but because they amount to the rejection of the whole conceptual scheme within which alone such doubts make sense") is it a picture Strawson himself should accept.

THE "EXTERNAL WORLD"

What of that other old chestnut, the "existence of the external world"? Here too it is extremely questionable whether there is a coherent alternative, that is, whether it is coherent to think that there is something which would properly be described as discovering that the existence of "external objects" is illusory. Of course, for eighteenth-century philosophers it seemed to make perfect sense. Sense impressions were conceived of by rationalists and empiricists alike as immaterial; it was the coherence of the idea of *matter* that was thought (by certain empiricists) to be problematic. But today, not only do Berkeley's and Hume's difficulties with the conceivability of "unperceived matter" seem wrongheaded,[15] but in addition the very idea of "sense data"[16] (Hume's "impressions and ideas"), thought of as immaterial particulars which alone we directly observe, has been repeatedly attacked by some of the best philosophical minds of the century. Without attempting to review a vast literature (and without attempting to deal with all of the confusions and unwarranted assumptions that hover around the notion of "experience" in the philosophical literature like a swarm of hornets) let me make just three points here.

First of all, the very idea that experiencing something is being related to an immaterial particular or universal[17] ignores an obvious possibility (sometimes called the "adverbial" view of perception), namely the possibility that experiencing something is being in a certain state or condition, in short, *having a certain sort of predicate apply to one*, and not being in a mysterious relation R to a mysterious sort of entity.[18] The

adverbial view has the advantage of being nicely neutral on a number of contested metaphysical issues.[19] Although, when I was young, one still found some philosophers who thought that the relational analysis of experience (i.e., the analysis that says that having a particular experience is being in a relation R—a relation of "directly experiencing"—to an immaterial something [a something which is not itself a state of the experiencer, although it may be dependent on his mind for its existence]) was *obviously* correct, indeed, thought that it was not an "analysis" at all, but just a report of the plain facts of (sufficiently sophisticated!) introspection, today I know of no philosopher who thinks this. Today, I believe, all philosophers of perception recognize that all of these "accounts" are compatible with the "subjective quality" of experience itself. Indeed, at one point in the *Investigations*,[20] Wittgenstein seems to suggest that such accounts mistake what is just a new way of talking for the discovery of a novel feature of reality.

Secondly, the idea that the experiencing subject could herself be just a "collection of ideas and impressions" (this is Hume's account of the self) is enormously problematic. Not only did Hume himself, famously, see deep difficulties with his own account, but the fact is that we learn what perception is (as Strawson himself has more than once pointed out) in the course of talking about transactions between persons and a material world which they sometimes perceive rightly and sometimes wrongly. Indeed, in the *Metaphysical Foundation of Natural Science*, Kant suggests that even our idea of *color* involves notions of body, of surfaces of bodies, and of laws ["rules"] relating our perceptions to what goes on with the surfaces of bodies. The idea of taking away all the bodies (including the body of the experiencer) and leaving the experiences makes no more sense than the idea of taking away the Cheshire cat and leaving the grin.

Thirdly, our whole experience of persons, including ourselves, is as *embodied* beings. The Berkeleyan notion of a "spirit," is, as the etymology suggests,[21] a survival of a time when the human mind was thought to consist of *wind*. Why should we grant that this is an intelligible notion?

If we take these points into account, then the natural upshot may well be a view of perception like the one that Strawson adopted in *Individuals*. The main elements of such a view are the following: (1) We understand persons as having special properties (Strawson's "P-predicates"), including experiential properties (as in the "adverbial view"), properties which figure in explanations of, in particular, the *reasons* for our attitudes and doings. (2) Because the analysis of conduct from the point of view of its intentional meaning and its justification or lack of justification in terms of reasons is a different enterprise from the enterprises of physics and chemistry, the explanations we give using "P-

predicates" employ a different sense of "because" than do physical (or chemical, etc.) explanations of our bodily motions, and because the "becauses" are different, there is not, in principle, any *conflict* between the physical and the psychological perspectives on our behavior. (3) We need not be driven to a metaphysical dualism by the fact that P-predicates aren't reducible to physical (chemical, electro-chemical, etc.) predicates in any sense of "reducible" we presently possess. (4) Being a possessor of P-predicates is not the same thing as being an immaterial "spirit" or "soul" in a mysterious relation to a body.

But isn't it the case that from such a view claims that "nothing exists except spirits and their ideas [experiences]" (this was Berkeley's claim), and "nothing exists except ideas and impressions" (this was Hume's view, at least "in the study") rest on a misunderstanding of the necessary preconditions for ascribing predicates at all? If our conception of what an experience *is* indeed derives from our mastery of ordinary talk of *persons' experiencing particular objects, properties of objects, interactions between objects, etc.*, then such ideas as the idea that persons might *be* experiences (or immaterial "spirits" plus experiences) do not make sense, except in the loose way in which a myth or a fairy tale makes sense.

I have expressed surprise at the fact that Strawson does not see his Humean tendencies and his Kantian tendencies as in any way in conflict. In *Skepticism and Naturalism: Some Varieties* he reconciles them in the following way: Kantian arguments show us how our concepts hang together, but do not speak to the skeptic's challenge to justify our conceptual scheme as a whole; Strawson's Humean contention that the question of justification cannot even be raised, because reasons are not and cannot be in question here, appears to speak to that challenge. But, the contention employs the wrong "cannot." Strawson's contention speaks to the issue of pointlessness given the way we are "hard-wired," not to the issue of intelligibility. Surely, the skeptic's challenge to justify "the uniformity of nature" and "the existence of the external world" presupposes that these can be *coherently* doubted. And that is just what the Kantian arguments call into question. How our concepts hang together has everything to do with whether there *is* an intelligible skeptical challenge.

But *Are* the Skeptical Scenarios 'Rationally Meaningful?'

In *Skepticism and Naturalism: Some Varieties*, Strawson does briefly discuss the issue of the intelligibility of the skeptical challenge, or, rather, he briefly discusses *Stroud's* discussion of that issue.[22] The challenge to

the intelligibility of the skeptical challenge that Strawson considers is Carnap's,[23] and Stroud, in Strawson's summary, finds that "Carnap does not altogether miss the point [of the skeptical challenge], but seeks to smother or extinguish it by what Stroud finds an equally unacceptable verificationist dogmatism. It is all very well, Stroud says, to declare the philosophical question to be meaningless; but it does [not] seem to be meaningless; the skeptical challenge, the skeptical question, *seem* to be intelligible. We should at least need more argument to be convinced that they were not."[24] And Strawson adds (loc. cit.): "Many philosophers would agree with Stroud, as against Carnap, on this point; and would indeed go further and contend . . . that the skeptical challenge is perfectly intelligible, perfectly meaningful" Strawson then proceeds to discuss the prospects for answering the skeptical challenge by rational argument . . . leaving unchallenged the view of "many philosophers" that "the skeptical challenge is perfectly intelligible, rationally meaningful!" (Contrast Strawson's own statement in *Individuals* that we quoted earlier, that the skeptic's doubts "are unreal, not simply because they are logically irresoluble doubts, but because they amount to the rejection of the whole conceptual scheme within which alone such doubts make sense"!)

Stroud (and, if he indeed agrees with him on this point, Strawson) is, of course, right that the way to meet the skeptical challenge *isn't* to resort to "verificationist dogmatism." But, as I have been explaining, there are grounds for doubting whether the traditional skeptical scenarios in connection with "the existence of the external world" really are meaningful, and none of the ones I have rehearsed turns upon a prior commitment to a philosophical theory (such as verificationism) that is supposed to yield a general method for assessing the meaningfulness of an arbitrary statement.

<div align="right">HILARY PUTNAM</div>

DEPARTMENT OF PHILOSOPHY
HARVARD UNIVERSITY
MARCH 1997

NOTES

* I owe even more than usual thanks to Jim Conant, to whom I am immensely grateful for his penetrating criticism of previous drafts and for many marvelous discussions in the process.

1. My draft of this paper has, in the course of time, grown into something much too long for this volume! What I have extracted for this occasion is a part of what I hope will eventually be a monograph on Skepticism, centering on Strawson.

2. Wesley C. Salmon, "Should We Attempt to Justify Induction?", *Philosophical Studies* 8, no. 3 (April 1957). The above quotation is from p. 39. Salmon himself believes that it is possible to give a deductive "vindication" of induction, that is, a proof that induction must lead to successful prediction if any method does. For a refutation of this claim see my "Reichenbach and the Limits of Vindication," reprinted in *Words and Life* (Cambridge, Mass.: Harvard University Press, 1994).

3. loc. cit., p. 42.

4. P. F. Strawson, "On Justifying Induction," *Philosophical Studies* 9, nos. 1-2 (January-February 1958). The above quotation is from pp. 20–21.

5. Salmon accepts Reichenbach's conception of the task of philosophy as "rational reconstruction." The sort of reconstruction he has in mind is illustrated by Reichenbach's *Experience and Prediction* (Chicago: University of Chicago Press, 1938).

6. In *Fact, Fiction and Forecast* (Cambridge, Mass.: Harvard University Press, 1979, 1983), Goodman gives a celebrated argument to show that not all predicates are equally projectible. The argument depends on his definition of the strange predicate "grue." Goodman defines something as grue if it is either observed before a certain date and green or observed after that date and blue.

7. The term "Cambridge change" was introduced by Peter Geach, *God and the Soul* (1969). He defined a Cambridge change ("since it keeps occurring in Cambridge philosophers of the great days, like Russell and McTaggart," as follows: "The thing called 'x' has changed if we have 'F(x) at time t' true and 'F(x) at time t₁' false, for some interpretations of 'F', 't' and 't₁'." He observed, "But this account is intuitively quite unsatisfactory. By this account, Socrates would change by coming to be shorter than Thaetatus . . . the changes I have mentioned, we want to protest, are not 'real' changes." (op. cit., pp. 71–72).

8. *Critique of Judgment*, 169. In Kant's language, an apriori standard of *good* judgment can only be "subjective," or, better put, transcendental logic cannot play the role of supplying "mother wit." Ct. Julie Floyd, "Heautanomy: Kant on Reflective Judgment and Systematicity," forthcoming in Herman Parret (Hrsg./ed.) *Kant's Ästetik* (Berlin/New York: Walter de Gruyter Verlag, 2 vols.).

9. Michael Williams, *Unnatural Doubts* (Oxford: Blackwell, 1991).

10. See H. Reichenbach, "Are Phenomenal Reports Absolutely Certain?," *Philosophical Review* 61, no. 2 (April 1952), pp. 147–59, and Reichenbach and the Myth of the Given," in my *Words and Life*.

11. For a criticism of sense datum ontology and epistemology see my "The Dewey Lectures 1994: Sense, Nonsense and the Senses; An Inquiry into the Powers of the Human Mind," *Journal of Philosophy* 91, no. 2 (Sept. 1994).

12. Even if one tries to reconstruct time-order phenomenalistically, as Carnap did in *Der Logische Aufbau der Welt*, by defining A to be earlier than B (in a solipsistic version of the world) if a memory of A coincides with B, we are committed to there being a lot more in the world than an *arbitrary* sequence of sense impressions if there is to be time-order. For one thing, there have to be all those *memories*; and—although Carnap chooses to ignore this—a *lot* has to be in place before it makes sense to speak of an experience as a "memory."

13. In *Unnatural Doubts*, pp. 13-15.

14. For an especially clear discussion, see Ernest Nagel, *The Structure of Science*, pp. 317-18.

15. Cf. the discussion of Berkeley's difficulties with the notion in "Language and Philosophy," reprinted in my *Philosophical Papers*, vol. 2, *Mind, Language and Reality* (Cambridge: Cambridge University Press, 1975), particularly pp. 15-16.

16. Many terms have been used in the course of four hundred years of 'modern' epistemology.

17. At one time, Russell thought sense data were universals.

18. In logical notation: "Helen experiences (or seems to herself to be experiencing) the presence of a blue sofa" trivially has the logical form P(Helen), but we do not have to agree with sense datum theorists that the P has the "analysis": $P(x) = (Ey)(xRy$ & y is a blue sofa sense datum). Note that an adverbialist need not, as is often claimed by critics, analyze *all* the aspects of an experience as further properties P', P'', . . . of the subject: if I see a chair with certain features, the various qualifications of my experience can be analyzed as *properties of a property of me*, not as simply further properties of me. I believe that, in fact, all the "formal" objections to the adverbial analysis are easy to meet.

19. These issues include the tenability of traditional mind-brain reductionism (Reichenbach thought that having a certain sort of experience is being in a particular brain-state; Sellars opposed this sort of reductionism on the ground that it was being in a kind of state which is *sui generis*); the question of functionalism (applied to experiences, this is the philosophical theory that having a certain sort of experience is being—or one's brain being—in a particular *computational state*; I proposed this view in a series of papers starting in 1960, but I reject it now, for reasons given in my *Representation and Reality* [Cambridge, Mass.: MIT Press, 1988]); and also the question whether we should think of the "qualitative identity" which (it is claimed) sometimes obtains between "veridical" and "nonveridical" perceptions as due to the presence of something which is literally "numerically identical."

20. *Philosophical Investigations*, section 400.

21. Not only in Indo-European languages: the Hebrew word for "spirit," *ruach*, originally means "wind"!

22. The article Strawson discusses is Barry Stroud's "The Significance of Skepticism," in P. Bierri, R. P. Horstmann, and L. Kruger, eds., *Transcendental Arguments and Science* (Dordrecht: Reidel, 1979).

23. R. Carnap, "Empiricism, Semantics and Ontology," *Revue Internationale de Philosophie* (1950), vol. 11. Reprinted in L. Linsky, ed., *Semantics and the Philosophy of Language* (Champaign: University of Illinois Press, 1952).

24. *Skepticism and Naturalism: Some Varieties* (New York: Columbia University Press, 1985), p. 7.

REPLY TO HILARY PUTNAM

Reading a paper by Hilary Putnam has always been a source of pleasure and admiration. So it is, for me, in the present case; and not only of admiration, but also, in large measure, of agreement. Not, as we shall see, total agreement; though the difference, in the end, is small.

Putnam proposes to explore a tension he finds between my Kantian and my Humean sympathies, and shows his own sympathies to be very much more in tune with the former than with the latter. Since, to revert to my own case, the former are in fact very much stronger than the latter, it is pertinent to ask: What is at issue? And here it is relevant to record some points of agreement and of relatively minor disagreement between Putnam and myself.

(1) First we agree that the practice of inductive reasoning, which takes many forms, is not something that either can be given, or stands in need of, justification by argument–whether it be to demonstrate the acceptability of certain 'canons' or to demonstrate the truth of some general proposition about 'the uniformity of nature' or the existence of causal regularities.

(2) Second, we equally agree that there is no question of justifying by argument our 'belief' in the existence of 'the external world' or, as Hume expresses it, of 'body'.

(3) Putnam maintains that the truth of (1) and (2) rests on the fact that skeptical doubt on either matter is meaningless or incoherent or unintelligible. And the reason he gives is that to call either into question is, in effect, to call into question, or to reject, the entire conceptual scheme within which alone the raising of *particular* doubts makes sense. Since, for this reason, the skeptical challenge is unintelligible, the invocation of Humean 'nature' is, he seems to say, gratuitous, unnecessary and, indeed, mistaken. (Note: Putnam quotes my passing remark [in reply to Salmon]: "If it is said that there is a problem of induction, and that Hume posed it, it should be added that he solved it." Putnam seems

to take it that I think that there is such a problem and that Hume solved it. But this is to ignore the context of the remark and its irony. I think no such thing. It is Salmon who thinks that there is such a problem and that it is or ought to be soluble. I take Hume rightly to have dismissed the idea of such a problem altogether.)

(4) Now, with one reservation, which I shall come to in due course, I share the views attributed to Putnam above; and here he and I both seem to find ourselves in good company, indeed the best—viz. with the Wittgenstein of *On Certainty*. Wittgenstein's terminology is different. He speaks not of our 'conceptual scheme', but, in a variety of metaphors of a world-picture which constitutes the 'scaffolding' of our thoughts, the 'substratum' of all my inquiring and asserting, the 'foundations' which underlie all questions and all thinking, which is 'exempt from doubt', and 'beyond being justified and unjustified'. Clearly there can be no significant questioning of what 'underlies all questions'. Yet it is not quite certain that Humean naturalism is altogether excluded. Wittgenstein follows the phrase 'beyond being justified or unjustified' with the telling expression 'as it were something *animal*'. Something "we must take for granted in all our reasoning" (Hume) is clearly not exposed to *rational* doubt. But Nature, it may be, allows us no option but to take it for granted in all our reasonings. So the doctrine of the incoherence of skeptical doubt is not clearly incompatible with Humean naturalism. Why should not "the inherited background against which I distinguish between true and false" (Wittgenstein) be itself the outcome of a natural evolutionary process?

Before coming to my final reservation, I should like to register some further points of mostly unqualified agreement with Putnam. Points (5), (6), and (7) below are internally connected; (8) is relatively independent of them.

(5) I entirely agree with Putnam in rejecting the whole Humean caboodle of impressions and ideas as all that 'can coherently be thought to exist', along with the wild consequence that anything might conceivably come of anything. (Direct Kantian studies apart, I do this most explicitly in the article, 'Causation and Explanation', which originally appeared in *Essays on Davidson: Actions and Events* [1985].)

(6) Hume speaks of causally related events as 'distinct existences' and implies that there can never be any logical or conceptual connection or link between items so related; they are, necessarily, logically, or conceptually independent of each other. This is a doctrine still held by many, and I have heard it invoked as an objection to a philosophical account of perception which qualifies as a 'causal theory'. It is a doctrine to be handled with care. In one sense it is perfectly true that natural occur-

rences and natural objects which are 'distinct existences' cannot be logically connected. They are items of altogether the wrong type or category for that. But the concepts or descriptions under which they fall, the propositions recording their occurrence or existence, may indeed be logically (conceptually) connected. The risks of confusion here are easily illustrated, as can be shown by reference to cases remote from the theory of perception. Thus somebody makes a remark about the assassination of Julius Caesar, saying, perhaps, it took place in Rome on the Ides of March in B.C. 44. This speech episode is one thing, a distinct existence from another, the assassination itself; but it would be equally absurd either to deny the latter a place in the causal ancestry of the former or to deny that the *fact* (or *truth*) that the speaker made *that* reference logically implies the *fact* (or *truth*) that the event in question occurred. As in the theory of reference, so in the theory of perception. Just as an intended and successful reference to any past event would be both causally and logically impossible without the occurrence of that event, so, and similarly, my catching sight of your gesture of greeting is a distinct existence from the latter and causally dependent on it, while, at the same time, the fact that the former is correctly so described logically implies that the latter occurred.

(7) Putnam refers to the once commonly held view that any particular perceptual or quasi-perceptual experience involves its subject being directly aware of some immaterial item (sense-datum or such) which is not itself a state of the experiencer; and that this is so, whether or not an actual material object is perceived. He rightly repudiates this picture of a transitive awareness-relation between the subject and such an immaterial entity in favor of what some have called, unhappily, I think, an 'adverbial', and might better be called an 'adjectival', view of what is true of the subjective state of the experiencer, whether or not there be an actual material object which the subject perceives. Of course, if there is such an object, then the predicative phrase which truly and fully characterizes the experiencer's subjective state will include a reference to that object and a transitive verb ('sees' or 'catches sight of') governing the noun or noun-phrase carrying that reference; and all this without prejudice to the point made at (6) above, viz. that the perceiver's experience is a distinct existence from the object perceived, and causally dependent on it, while their descriptions are logically linked.

(8) Now for a matter relatively independent of points (5) to (7) above. Putnam rightly remarks that there is not, in principle, any *conflict* between the physical and the psychological perspectives on our behavior. The explanations of human conduct which we give in terms of intentional meaning simply belong to a different enterprise from the explanations of our bodily motions which can be given in physical or chemical or

electro-chemical terms. This seems to me exactly right. But Putnam glosses this by saying that the explanations given in the former enterprise employ a different sense of 'because' from that which belongs to explanations given in the latter. And this duplication of senses seems to me unnecessary. Explanation is explanation in whatever sphere it may be: 'because' has the constant role of introducing the explanans for a given explanandum, and this is all the sense it needs, whether we are explaining why a particular chess-situation is perilous for White, why Brutus played the role he did in Caesar's assassination, why such-and-such a purported proof is invalid, why a certain piece of matter moved in the direction and with the velocity it did, or even why one course of action would be morally preferable to another. These are different theatres, calling in each for different gifts of understanding on the part of those who undertake the task of explanation, and involving different criteria of success; but the move from one to another does not have to involve a shift in senses of 'because'. But the point is a minor one, while the substantial issue is major.

I come now, finally and tentatively, to what may be the one substantial difference between Putnam and myself. It concerns 'that old chestnut, the "existence of the external world."' Putnam's announced position is that the skeptical challenge on the matter is unintelligible, that it makes no sense; that skeptical doubt on it cannot be coherently entertained. The position is a strong one. Not only is it easy to dismiss various bad arguments that have historically been advanced to supply some foothold for the doubt—usually in order to invite arguments to resolve it. Such dismissals are well enough in their way. But there is much stronger ground, associated, as we have seen, with Wittgenstein (though not with him alone), to the effect that what is at issue here is not really one belief among others that we might form, and hence come to question, but something that is part of the framework or background of all argument, all thought, all asserting or questioning. It is internal to the structure of all thinking, so that the attempt to question it, which is tantamount to an attempt to reject our conceptual scheme in its entirety, leaves us without the resources for any coherent thought at all.

Well, that is strong indeed. But perhaps a thought too strong. The skeptic's defending counsel will represent his client in a chastened light: not as one who poses a real problem, calling for resolution by rational argument, but as one who simply calls attention to a logical possibility, while conceding that it has no practical, or theoretical, consequences of any moment; viz. that the course of a thinking subject's conscious experience, considered in its 'inner' or subjective aspect, could logically be just as it is without there being any physical objects at all.

Of course, the actuality of such a state of affairs, if it were actual,

would not matter to such a subject in the least. There would be no reason for him to suppose things to be anything other than as he assumed, i.e., that he was living, perhaps, a rich and satisfying social life in a fascinatingly varied physical environment. The 'scaffolding' of 'framework' of *his* thinking and inquiring would be just such as Wittgenstein speaks of. His general conceptual scheme would be ours.

Even this modest defense, not of the importance (for it has none), but of the mere minimal intelligibility of the skeptic's position is liable to be greeted with negative responses, ranging from derision, or a pitying shake of the head, to outrage (or even rage). But such responses, I think, are symptomatic of a disorder that affects much, though by no means all of philosophical thinking today; and that is an inclination to minimize or reduce or even, in extreme cases, to deny the reality of what I shall unashamedly refer to as inner or subjective experience. This inclination has, I think, a variety of sources that I shall not try to detail. In the shadow of this tendency it is well to remember that none of our greatest predecessors in the modern period was subject to it; not Descartes, not Locke, not Hume, not Kant; and neither, I am sure, is Putnam.

P.F.S.

15

Paul F. Snowdon

STRAWSON ON THE CONCEPT OF PERCEPTION

I. PREAMBLE; STRAWSON AS TUTOR

Part of Strawson's life as a philosopher has consisted in the relatively private activity of teaching, and I wish, as a rather inadequate tribute to him in that role, to record a few impressions of him as a tutor, impressions formed when I was an undergraduate at University College, Oxford, towards the end of Strawson's period as a Fellow there.

An Oxford tutorial usually lasted an hour. It began with the student reading aloud an essay he or she had written in the course of a week, based on a list of readings and a question given by the tutor. Tutorials with Strawson were described as, and certainly felt like, 'interviews with God'. To reach his room one had to ascend (a flight of stairs), leaving one, especially if in a hurry because the essay had only just been completed, rather breathless and nervous. Strawson sat, at the far end of the room, on a wooden chair by a desk, to the left of a fireplace, and we, the students, sat on a sofa or armchair. Strawson exuded an air of calm, authority, complete intellectual confidence, and alertness. As the essay was read, Strawson would occasionally interrupt to correct an error, or to request a clarification, and he would make a few notes.

In responding to the essay, Strawson did four things. He would, first, make a number of criticisms. In my experience he focussed on *significant* difficulties, that is difficulties which were important for the case being argued in the essay. It is, as any tutor knows, easy to find something wrong with students' essays; it is not easy, indeed Strawson's abilities in this respect, reflect his outstanding speed of understanding and also his mastery of the structure of philosophical debates, to seize on flaws which

really matter. Second, he encouraged us to develop our own ideas, by pointing out how they could have been taken in other directions, pushed through more rigorously, and linked in other ways. Third, he would reveal an approach of his own to the problem, which always seemed (to me) deeply considered, original and persuasive. Fourth, in the course of discussion and in response to objections, he would manifestly *think* before our eyes, a thinking which issued in pellucid, ingenious, honest, and abstract responses. In these four ways Strawson encouraged us to be intensely self-critical, to be constructive, but also to think through our ideas as thoroughly as possible, all of which left me, as it must have anyone, with an overwhelming sense of the power of intense, abstract, reflection to solve problems which initially strike one as insuperable. Strawson's tutorials have represented to me ideal examples of that form of teaching (and it has always been my goal, as a tutor, to get as close as possible to that ideal).

I wish to mention two other marks of Strawson's effectiveness as a tutor. The first is the very large number of pupils of his who became philosophers. This is true of at least four other undergraduate students present at University College during my time. I feel that we were attracted to such a life, at least, in part, because Strawson palpably embodied and displayed its value in a very pure form. The second is the extent to which pupils of Strawson dominated the Henry Wilde Prize, a prize offered for the best performance at philosophy in Finals. The prize was set up in 1965, and between then and 1969 (after which no undergraduate pupil of his took finals) students from University College won it twice, and twice were runners up.[1]

There can have been no better introduction to, or training in, philosophy than to have had Strawson as a tutor.

2. STRAWSON ON PERCEPTION

An outstanding feature of Strawson's writings is the very broad range of topics with which they deal. Perception is one topic about which he has written, and he has explored many aspects of it. There are two recurring, and, it seems to me, very important themes in his writings about perception that I wish to highlight. The first is the thought that the proper description of normal human perceptual experience (or, as one might also put it, of appearances) requires the employment of objective physical (and, what Strawson might call, personal) concepts. Thus, there

is no alternative, and hence no better way, to report a standard appearance than as, say, its looking to one as if there is a deck chair in a garden occupied by a bearded man.[2] Much of what Strawson has written about perception can be thought of as an attempt to explain, and to draw philosophical consequences from, this insight. The second recurring theme is that the concept of perception is a causal concept. Here is one of his expressions of this idea. "The idea of the presence of the thing as accounting for, or being responsible for, our perceptual awareness of it is implicit in the pre-theoretical scheme from the very start."[3] Strawson accepts that it is a conceptual truth that if a subject perceives an object then that object is producing an effect in the subject. It is some aspects of his elucidation of this idea in his famous and still widely read (and cited) article 'Causation in Perception' that I wish to consider here. In that article Strawson makes a very important contribution to the task of developing a causal analysis of the concept of perception. I am not in as much sympathy with this idea as Strawson is, but I acknowledge that the debate about its merits is far from over. The crucial task is, of course, to bring this debate to a reasonable conclusion. In this paper, though, I wish to be less ambitious. I want merely to review some aspects of Strawson's development of the causal approach, not because the acceptability of the causal approach depends in any way on their acceptability, but simply because they are of considerable intrinsic interest.

Strawson's purpose in the paper in question is to support a causal analysis of the concept of perception, to provide what he calls a 'rationale', or explanation, for the concept's having that structure, and then to decide how best to add to the appropriate causal condition to make the analysis more complete. Here he has a negative purpose, to show that Grice's proposal to mention *ways* is mistaken, and to suggest, more positively, alternative extra conditions.[4] In this paper I shall not discuss Strawson's criticisms of Grice. Instead I wish to consider, in section 3, his own positive arguments for the causal theory, in section 4, the rationale he advances for it, and, in sections 5 and 6, his own suggested positive additions. The upshot of these discussions is rather negative, but I hope to advance, in section 7, some more positive, if speculative, points of my own.

It is necessary to introduce the terminology that Strawson employs; he talks of an 'M-experience', meaning an experience as of an M; an 'M-perception', meaning a perception actually of an M; 'M-perception belief'—the belief that one is having an M-perception; and the M-facts—the fact that there is an M. ('M' stands for 'material array'.)

3. The Arguments for the Causal Analysis

Strawson formulates a slightly restricted version of the causal analysis of the concept of perception in these words; "it is a logically necessary condition of the M-experience being the M-perception it seems to be, that the obtaining of the appropriate M-facts should be a causally, or non-logically, necessary condition of the occurrence of the M-experience."[5]

Before discussing (rather briefly) whether this claim is supported by Strawson, there is an objection to it which I wish to express. The formula that we are being asked to accept is rather elaborate and artificial, and so we need to ask; what, exactly, does it mean to say that "the M-experience is the M-perception it seems to be"? The most straightforward way to take these words is this: an M-experience is the M-perception it seems to be if it is (or gives) a perception of a situation which is actually M. Thus, if it looks to me as if there is a red apple then this experience is the M-perception it seems to be if I am actually seeing a red apple. However, if this is what is meant then there seems to be a counter example along the following lines. It looks to S as if there is a red apple; S can see a red apple; however, the apple is in a special light which makes any surface look red. This appears to be an example where the M-experience is the M-perception it seems to be, but where there is no causal dependence of the appearance of red on the presence of red.

I wish, though, to leave this criticism aside and ask whether Strawson supports the rather weaker, but clearer, causal claim as expressed in the quotation in the previous section. In his article Strawson supports such a conclusion at two places.[6] The first argument derives from Grice, and Strawson describes it this way; "it is logically possible that the M-perception-experience should have been produced by unusual methods—e.g. cortical stimulation, suggestion, an arrangement of mirrors and objects—methods which could have been used to produce the M-experience even if there had been no appropriate M-facts. He concludes . . . that the M-experience should be causally dependent on those M-facts [for it to be an M-perception]."

The conclusion that Strawson reports Grice as drawing, and which he is, following Grice, urging us to endorse, hardly seems to follow from the evidence. The agreed datum is that if an M-experience is produced in a way which could have occurred without the M-facts obtaining, in, for example, the ways specified, then it is not an M-perception. So, there is something about examples of this sort which rules them out as cases of perception (of the relevant M-array). What, however, is that feature? We are precisely trying to determine what that feature is, and no reason has

been given for believing that it is the lack of causal dependence, rather than the lack of some other sort of involvement of the M-facts in the M-experience which is present when it is an M-perception. The pro-causalist argument certainly, therefore, needs supplementing. It might be supplemented by arguing that there is no conceivable mode of involvement other than causal dependence. Such a claim, however, seems incorrect. Thus, we might say that for an M-experience to be an M-perception the M-experience's obtaining must consist in the presence of a relation between the subject and the M-facts. Such a relation could not obtain without the M-facts, so if the M-experience were produced in such a way that the M-facts are irrelevant to its obtaining then in that case the obtaining of the M-experience cannot consist in such a relation, and so it could not be an M-perception. This suggestion relies on the possibility that M-experiences might sometimes consist of relations to M-facts, whereas at other times, it has to be agreed, they do not. Nothing so far has been said to rule this (disjunctive) possibility out. I conclude that this first argument lapses because it presents nothing to rule out an alternative account.

In the later course of his discussion, Strawson imagines someone objecting that the causal analysis builds in more than the naive, 'innocent', concept of perception contains. He replies, and this is his second remark in favor of the causal claim, by pointing out that when Macbeth hallucinates a dagger, adding a dagger before his eyes would not make what was going on into a case of seeing a dagger. This is, of course, true, but all that follows is that having an M-experience when there is a matching M-fact is not in itself sufficient for there being an M-perception. The point of the discussion, however, is to specify in an informative way what extra is required. The example in no way indicates what that extra is. It is clear that if the criticism of the Gricean argument applies then the Macbeth example does not support the causal theory.

The causal theory, then, remains as a contender, but these arguments give it very little support.

4. The Rationale for (or Explanation of) the Causal Condition

When analyzing concepts, philosophers are normally content to try to demonstrate that certain entailments obtain. The arguments considered in the previous section were attempts to establish a causal entailment, but, I suggested, did not do so. Strawson, however, continues his argument by suggesting what he calls a 'rationale' for the causal

entailment (see pp. 70–71). It seems that for 'rationale' we could substitute 'explanation'. In looking for a rationale in this case, Strawson is engaging in the sort of explanatory activity which he has, for a long time, suggested philosophers should engage in. Thus, in his early article 'Construction and Analysis' Strawson suggests that as well as analyzing concepts, philosophers should do more. "For fully to understand our conceptual equipment, it is not enough to know . . . how it works. We want to know also *why* it works as it does."[7] In Part One of *Individuals* Strawson was clearly guided by this conception. I wish to consider the idea in general, as well as its application to perception.

Now, there are two questions which suggest themselves on encountering the present application of the idea (before even considering the details of the explanation offered). (1) Do we *need* a rationale? Aspects of this question are; should acceptance of the causal claim depend on the provision of an explanation? Is there anything initially puzzling about the claimed entailment (such that an explanation is needed to remove that puzzlement)? The answer to question (1), I suggest, is that we do not *need* a rationale. It seems obvious that providing a rationale for the supposed truth, that C entails D will amount, at least, to showing that C entails E and E entails D. If so, we cannot carry on providing rationales for each acknowledged entailment. But, furthermore, there are, it seems, many acknowledged entailments of a causal character, for which we do not need a rationale. For example, S dried M entails that S caused M to become drier, but there is no rationale for this causal entailment which appeals to an intermediary entailment. It seems unlikely, then, that we can say that we *need* a rationale.

The second initial question raises a more skeptical note; (2) *Can* we provide a rationale (or explanation) for an entailment? One possible reason for skepticism here is this; it might be argued that when we explain a fact we specify another fact, such that the first fact would not have obtained if the second fact had not obtained. But explanations in this sense cannot be provided for necessary truths, which cannot fail to obtain in any circumstances.

There are, however, at least two reasons for being unhappy with the conclusion of this argument. The first is that the notion of explaining necessities seems to figure in a description of the very method of conceptual analysis. How are conceptual analyses arrived at and justified? Let us suppose that we are trying to provide an analysis of C. The process seems, at least usually, to be this. We provide a description D, where, in response, it is our intuition that (not C). On this basis we regard (if D then not C) as true, and, furthermore, as a necessary truth. The aim is then to specify a more general proposition of the form; (if C

then E), specifying what is involved in C's obtaining, (viz., E), such that this truth *explains* the less general proposition which was revealed, in some sense, by intuition. We say that the less general truth is true *because* the more general claim specifies what is involved in C. Now, it might be that this characterization of conceptual analysis (or at least of some conceptual analysis) as a form of inference to the best explanation is mistaken, but it provides such a natural and appealing description of the method, that it should not readily be abandoned. It is, of course, a description that requires the legitimacy of the notion of explaining necessities.

The second reason for not being skeptical of the idea is that it is, anyway, an intuitively plausible one. Thus there are, for example, certain sequences of numbers generated by a formula which exhibit a pattern, where the pattern can be explained, as we would say, by a feature of the formula. Both the explained facts and the explaining facts are necessary.

Wanting, for these reasons, to resist the skeptical conclusion we can locate a mistaken assumption in the skeptical argument. It rests on an overly limited characterization of explanation; explanations simply need not cite contingent facts. We do not need to provide a better, more comprehensive, characterization of explanation, to be justified in rejecting that assumption.

The upshot, then, is that rationales for (or explanations of) necessities are perfectly legitimate, and there is, therefore, nothing in principle wrong with Strawson's project, characterized as explaining necessities. However, it is reasonable to be a little cautious; it is not entirely clear when something can count as a rationale (or explanation) of a necessity of conceptual analysis. There is a very important distinction here that needs to be observed. It is one thing to attempt to explain why the concept of perception has a certain structure. It is quite another to explain why we have the concept of perception, a concept with that structure. In carrying out the latter task we can, of course, appeal to contingent facts. The fact being explained is itself, presumably, contingent. There is, then, nothing problematic about explanations of concept possession, even if we do not know what the explanation is. We have, though, far less grasp on when an explanation for a fact revealed by conceptual analysis is appropriate or what it would look like. A difficulty is the following. If we reflect on the cases where explaining necessities is appropriate, it seems to be where we derive from something laid down a logical consequence of a general sort. Now, suppose that we hold that it is a conceptual truth that P entails Q, that is, that gives a partial analysis of P. To fit the model of necessity explanation onto this case we would need to think that Q was derived from P via some other necessary

feature required by P. Then, the difficulty is that this other feature is presumably the proper, or basic, conceptual analysis of P, relegating Q to a derived entailment, but not really itself the analysis of the concept. This argument supports, I think, genuine puzzlement about the idea of explaining truths of conceptual analysis. I think that this worry, to which I shall return, has simply to remain as the details of the rationale are considered.

Is the specific rationale that Strawson offers sound? The culmination of Strawson's rationale is presented in the following passage.

> The rationale lies in the conjunction of the two facts; (1) that if an M-experience occurs for which the dependence-condition does not hold, and if the subject of the experience believes in the appropriate M-facts, then he will normally be mistaken in that belief; and (2) that if he takes the M-experience to be the M-perception it seems to be, then he necessarily has that belief. So we would say in such a case that he is wrong in taking the M-experience to be the M-perception it seems to be even if, by a fluke, he happens to be right in his belief in the appropriate M-facts. The concept of perception is too closely linked to that of knowledge for us to tolerate the idea of someone's being in this way merely flukishly right in taking his M-experiences to be the M-*perception* that it seems to be.[8]

The idea in this passage might be stated in a very crude way thus: perceiving an object is, in its nature, a way to get knowledge about the object. But to gain knowledge one must not be merely flukishly right in the opinions one forms. So, it must be a requirement on perceiving that there is an appropriate causal dependence (or link). It seems to me that the two central ideas in this crude version of the suggestion are both intuitively plausible. Perceiving has to do with knowledge; *and*, being flukishly right is *not* gaining knowledge. However, despite the intuitive plausibility of these insights, it remains quite unclear, in my opinion, that they provide (or provide the core of) a rationale for the causal requirement. I want to make *three* comments on the passage and proposal.

(A) A first, and very minor comment, can focus on Strawson's emphasis on what, in the quoted passage, he calls fact (1). This is the fact that *normally* when an M-experience does not causally *depend* on the appropriate M-facts, then the appropriate M-facts will not obtain. Now, as things are, it should be agreed that this is true. However, it seems to me that (1) is only contingently true. It might have been that even normally when the causal dependence requirement is not satisfied, the appropriate M-facts did obtain. This means, I suspect, that (1) is *not* really the core of the rationale, because a rationale for a necessity must itself be necessary. We might put the criticism in the form of a question: would the proper rationale not have obtained if the world had not made

(1) true? Surely a rationale, if there is one, would not have lapsed in such circumstances. This doubt should encourage a reformulation of the rationale, which will involve stressing something which Strawson did emphasize in a slightly earlier passage. The crucial point in the rationale is this: when the subject follows the character of the experience and believes in the appropriate M-facts, then it will be an accident or fluke that the subject is right unless there is causal dependence of the right kind. I am not saying that this claim is correct, but that it, and not (1), corresponds to what should figure centrally in Strawson's rationale.

(B) It is, I have agreed, very plausible to think that there is a necessary link between perception and knowledge, but it is very hard to state the link in a general way. Thus, it is not a necessary truth that if S sees M then S can gain knowledge of M. There are at least three obvious difficulties. (1) S may not realize that S is seeing M, but think mistakenly that he or she is, say, hallucinating. (2) In some visual encounters M is not seen, as we say, in enough detail to provide much, if any, information to the percipient. (3) In some visual encounters, M may be seen in a deceptive way. Further, (1), (2), and (3) can all occur together. I shall, therefore, not try to formulate a defensible principle. Evidence of a necessary link, though, comes from our treating it as totally unproblematic that someone's knowledge that P can be explained by saying that they saw that P. Evidence also comes from the way that sensing has always traditionally been taken to be a route to knowledge. If there is a necessary (but hard to formulate) link here, does it provide an explanation for the causal theory?

A significant problem for thinking, with Strawson, that it does, is that there are alternative, and certainly not ruled out, conceptions of the relation between perception and knowledge which would ground a necessary link but without the desired explanatory significance for the causal analysis of perception. One can say that perception being what it is (and involving what it involves) and knowledge being what it is (and involving what it does) there is a link between them. The link does not itself *explain* what perception involves, but is, rather, itself to be explained by what the two states, as it were independently, require. On this conception, the link is what is explained, rather than what explains the structure of our perceptual concepts. Another alternative, though, is that the link between perception and knowledge explains the content of the concept of knowledge. Thus the idea might be that our fundamental understanding of knowledge is as what is yielded by perception in certain circumstances. It must be conceded that these remarks do not constitute a refutation of Strawson's rationale; they amount, rather, to the claim that there is no good reason to agree to Strawson's rationale.

One response to this criticism would be to change the understanding of the rationale; it may be best to treat it as an extra argument supporting the causal theory rather than as an explanation of its truth. This understanding of it simply requires that the causal theory can be derived from reflection on the link between perception and knowledge.

(C) Suppose we accept this modified understanding of 'rationale', does it get us to the causal requirement? The obvious formulation of the rationale would be then: (i) If S perceives M then S is able to gain some knowledge of M (cet par). (ii) If an experience can give knowledge then it cannot be a *fluke* (or accident) that what it indicates, obtains. (iii) If the fact caused the experience then it would not be a fluke. Now each of (i) to (iii) has something to be said for it. But, as it stands, the rationale is flawed; the three claims do not imply the causal requirement, since (iii) leaves it open that there may be *other* ways to avoid flukishness.

Indeed, not only *may* there be such ways, there are other ways. The first I shall mention (one which is regularly cited in this debate) would not be regarded as a plausible candidate for inclusion as a condition in the analysis of the concept of perception, but it remains a candidate as far as the present rationale is concerned. Thus, it is not a fluke or an accident that many flowers, flower more or less simultaneously, but there is not causal connection between the flowerings. The nonaccidentality of the co-occurrence is (roughly) a matter of systematic *joint* causation. The rationale would be satisfied by a concept requiring merely this type of link between M-experiences and M-fact, or by a concept requiring either a direct causal or a joint-causal link.

The second way to secure nonaccidentality of link between the character of the M-experience and M-facts (in a perceptual case) is, I think, of greater interest and plausibility, but I shall merely sketch it here. If there is to be a genuine alternative to the causal theory, there must be a way to specify a noncausal relation in which objects can stand to experiences when those experiences amount to perceptions of those objects. I talked, in section 3, without much explanation, of a constitution relation. Clearly, a crucial task for opponents of the causal theory is to specify this relation in a fuller way. However, assuming that it can be done, it is a small extension to suggest that cases in which someone can see (and thereby know) how things are, are cases where the visible facts are constituents of the experience. My point is that the obtaining in such cases of this relation would make the relation between experience and the facts a 'non-flukey' one. If this is right there is a gap in Strawson's derivation.

I conclude, then, that the rationale does not explain, or carry us to, the causal requirement.

5. The Exclusion of Capricious Wills

Strawson's purpose in the rest of the paper I am focussing on, is to locate extra conditions for perceiving (or seeing) beyond those already given. Part of the purpose is negative, to argue that Grice's suggestion that we should introduce reference to certain *ways* that the causing occurs, is seriously mistaken. That contention I shall leave aside here. Rather I shall consider and criticize the two positive claims that Strawson advances. My purpose is not simply to suggest that the claims are incorrect, but to try to draw some more general conclusions, to develop an alternative perspective on the issue in question.

Strawson accepts (as should everyone) that the Mad Scientist could deliberately give a subject a veridical hallucination. In such a case there is causal dependence of the M-experiences on the M-facts, without there being an M-perception. Strawson's response is this: "We can rule the case out by declaring that causal dependence which runs through the will of a capricious intervener is not to count. Notice the qualification 'capricious'. It does not seem to be the fact that causal dependence runs through the will which makes it necessary (if it is necessary to rule the case out); but rather the fact that the will is a capricious will."[9]

I wish to raise two doubts. (a) Is it convincingly established that we want to rule out, and to let in, what this proposal rules out, and, by implication, lets in? (b) Suppose we take the answer to (a) to be "yes," is the insertion into the analysis of the clues which Strawson suggests the right way to generate the correct extension?

As to (a) I want to make three remarks. When a suggested sufficient condition for the application of a concept is rejected, and hence extra conditions are to be looked for, this can be motivated in two ways, of which the present example is one. Thus, suppose the analysis suggested is;

$$C \leftrightarrow B$$

One way to reject this is to offer a case described as 'B&D' which elicits the judgment '~C'. Having no reason to renounce the elicited judgment we have in the description 'B&D' a guide to what is necessary to include in our analysis—namely something excluding, in some way, D. However, another way is this; one just has the conviction that there can be cases where B but not C; and a rough amplification of an example. If this is the ground for rejecting the analysis, there is little to indicate what extra condition to suggest. Now it seems to me that the example here is more akin to the second case than the first. We simply agree that a scientist can, as we might say, using our variables, generate ~C, despite B being

true. There is nothing much in the description of the example to indicate what *makes* it a case of (not C), that is simply built in to the description of the possibility we accept. There is, therefore, no real reason to stress capriciousness in the analysis; that was not a stressed feature in the original description; it did not, indeed, figure.

This much will be conceded, but it may be replied that when capriciousness was stressed intuitions were revealed as, in some way, sensitive to it, and therefore it qualifies as a relevant factor. But, I want to suggest, the claims of capriciousness to qualify as a relevant feature are rather flimsy. In the first place, 'capricious' is surely a vague notion; it comes in degrees—highly capricious, fairly capricious. What, then, exactly is a capricious will? In the second place, is it *really clear* that the Mad Scientist cannot quite noncapriciously give veridical hallucinations? It is striking, I think, how distant this description is from any cases which in the normal course of events someone who has the concept of perception engages with? Where does our confidence that we are giving the right verdict come from? A similar observation applies to the so-called noncapricious case. How can we have any *confidence* that produced in this way it is a case of perception? It seems to me quite natural to be at least *skeptical* of our responses. For myself, when such cases are described I think that the correct response is: 'Well, that's an interesting case, but I simply do not know what to say'. This is a plea for the acknowledgment of ignorance. It might be asked: under what circumstances is the acknowledgment of ignorance warranted? I am not suggesting a rule which lays down when we do not know. Being very unlike cases we encounter is neither necessary nor sufficient for a description's not properly eliciting a verdict. The point is, rather, that where a described example is quite unlike standard ones, we should wonder, of the intuitions they elicit, whether we have any reason to be confident about their trustworthiness, and be prepared, where the credentials of the intuitions are not manifest, to be skeptical of their veracity.

This is my answer to question (a). What of (b)? We need to distinguish between a claim that a certain condition is a necessary condition for the correct application of a concept, and the claim that it should figure explicitly in the analysis. The goal of analysis is to find what we might call explanatorily salient and general conditions, from which, of course, more specific conditions may follow. Could the exclusion of causation-through-the-capricious-will be a basic and explanatory salient condition to be included in our analysis? We seem to reach a point which has an analogy with certain arguments in the philosophy of language. We need to ask how we, each of us, realized that capricious-will-causation was an

excluded possibility. Clearly, it is not a condition we were introduced to, instructed about. It seems, then, that we must count recognition of it as flowing from whatever more general instruction or explanation we received. But this seems to mean that it cannot be a condition that figures as an independent clause in analysis. So, even if we accept the validity of Strawson's verdicts about the imagined cases, the analysis should not accommodate it in the way he suggests.

The general moral of the discussion of the first question is that we should encourage an attitude of skepticism about intuitions about cases which are very alien to the normal. The moral of the discussion of the second question is, if sound, that the content of an analysis needs to integrate with our answer as to how the concept possessor might acquire the mastery of the conditions, given the kind of instruction available. Conceptual analysis should not be done in isolation from an understanding of how concepts are acquired. (There is more on this in section 7.)

6. RANGE AND OBSTRUCTION

Strawson's second positive suggestion is conveyed in the following quotation:

> The naive concept of perception—unaided perception, that is—includes that of a perspective or 'view', from a certain point of view determined by the position and orientation of the appropriate organs of sense, on contemporary or near-contemporary states of the world. From this flows all sorts of tautologies . . . in which the causal and the logical are inseparably intertwined, and in which there figure essentially the concepts of (i) *range* and (ii) *masking* or *obstruction*. Thus, as regards range, we have the tautology that, however large the visible thing, if removed far enough away, it will be out of sight. (p. 79)

Strawson's idea is that these tautologies are internal to the concept, or concepts, in question and he thinks that they will filter out cases where the basic causal requirement is fulfilled but which are not cases of perception. This suggestion is certainly plausible, and has struck many people as on the right tracks. But, it is also true that, although Strawson introduces it as a supplementary clause in a causal analysis, it does not have to be embedded in that theoretical context. The conditions are not specified as modifications or modes of a causal relation. The suggestion is, then, a free-standing proposal.

I shall argue that Strawson's very interesting proposal faces two difficulties.[10] The first concerns the use to which Strawson wishes to put it. Strawson's idea seems to be that application of the tautologies will exclude those cases where there is an M-experience which is causally

dependent on an M-fact but which are not cases of M-perception. Now, they may certainly exclude some, but it hardly seems that they can exclude all. Here is one such example. A sound is present around S who, ex hypothesi, does not hear it (because, perhaps, of some fault in the ears), but the sound so vibrates S's head that an hallucination is produced which matches the sound. Clearly, the sound is not masked, nor is it out of range, but it is not heard.

The second criticism is more important. It is obvious that there are tautologies to do with, for example, sight and distance. If an object is too far away to be seen then it cannot be seen. But tautologies of this sort cannot be employed to give verdicts in particular cases, for what needs to be known is whether the object *is* too far away or not. The tautology does not tell us that. It seems, then, that the tautologies, if they are to be usable, must have the following form (or something like it); if an object is 150 meters away then it cannot be seen. The obvious problem is that the tautologies are supposed to be conceptual truths, which is to say, they are supposed to be a priori. Are such conditionals known a priori?

It is highly implausible, it seems to me, to think that such conditionals are known a priori. One way to argue this is to take an example, for instance a standard post box, and to ask people, who evidently have the concept of vision, just how far away can it be and still be seen. People might begin by feeling confident that they know, but certain questions would, I think, disturb this confidence. Is the distance affected by the character of the objects surrounding the box? How far away can it be seen if it is on its own and suspended in the sky? Is the distance affected by the sort of illumination? Or by the conditions of the air? I think that it will emerge that we simply do not know the answer to such questions a priori. We understand 'seeing' and 'perceiving' without knowing the truth of such conditionals.

There is, also, a very plausible picture of how we gain such knowledge. We decide, of an object the location of which we know, whether we can see it. Thus, we move away from a post box until we can see it no more. Or we get someone to shine a light on it and consider whether this enables us to see it. These little experiments ground our knowledge. According to this conception of the method, our judgments, and our understanding of those judgments, as to whether we see the object, is prior to our knowledge of such conditionals. Such conditionals form, rather, part of a low grade empirical theory of seeing, which records our knowledge of the conditions and features which influence visibility. A less low grade understanding is then attained by the emergence of a theoretical conception which itself unifies and explains the truth of such conditionals. In this higher level theoretical account the link between object and perceiver is, of course, taken to be a causal one.[11]

Strawson's suggestion, then, seems to me to mislocate the position of such conditionals in the structure of our understanding of perceptual concepts.

7. An Alternative Proposal

The conclusions of this paper have so far been rather negative. In this final section I shall try to be more positive, although it will be speculative and not tightly argued.

Considerable effort has been devoted to analyzing the concept of perception, and since the publication of Grice's article, the dominant assumption has been that a causal analysis is correct. The disagreement has mainly concerned how to add to the causal requirement to make the analysis more nearly sufficient. Strawson's article, to which I am responding, is one of the most important in the tradition discussing that issue, a tradition of which it can be said that it has reached no resolution. Indeed, it is hard to escape the impression that the search for a more sufficient analysis within this framework has lead philosophers to import, into their analyses, notions which seem remarkably sophisticated for inclusion in the analysis of such a primitive concept. It cannot be said, though, that this is, or that there is, very strong evidence that this tradition needs replacing.

I wish to sketch what seems to me to be a promising alternative approach, an approach which is at least *worthy* of further investigation.[12] One element in this approach is to impose a restriction of focus on the role of conceptual analysis. One conception of conceptual analysis is, roughly, that it is the provision of a priori determinable necessary truths about an element or feature. According to this conception, however, there is no reason to limit the concepts or notions which figure in the analysis to ones possessed by everyone who possesses the concept being analyzed. To justify that restriction we need a more limited notion of conceptual analysis. According to that, analysis aims to articulate the essential components involved in possession of the concept in question. But the idea of the essential components involved in possession of the concept surely should relate in some way to an account of the acquisition of the concept. The essential components must either be acquired at the same time, or be the concepts on the basis of which the concept is constructed. The proposal, then, is that we should think of our analysis as aiming to recreate (or to make sense of) the conceptual route whereby the concept is acquired.

Now, treating such a concept as that of seeing from this perspective, is merely part of approaching the whole structure of our mental concepts

from the perspective. There is, then, the quite general question: how do we acquire our mental concepts? How do they relate to the other concepts which are, perhaps, more basic, and in the context of which we gain mastery of our psychological vocabulary. The point of introducing this general question here is not as a prelude to answering it, but, rather, to relate the analysis of our perceptual concepts to a general distinction which at least *seems* evident when we survey our psychological concepts as a whole. It seems that some psychological concepts pick out, or are *of* phenomena to which we can attend, phenomena which can attract our attention, elements which stand out amongst a range of other features. Examples would be pains, and itches. Many psychological concepts are, however, not concepts of phenomena of this sort. One obvious example is the concept of belief. We cannot attend to a belief. Another example is consciousness. Consciousness is not an item, amongst others, to which we can attend. Our perceptual concepts are also, surely, concepts of this latter sort. When we are seeing objects, we can attend to the objects, but we cannot attend to our seeing of them, as an item amongst others currently available to us. If, though, they are not concepts of features to which we can attend, we need an explanation as to how we can 'latch onto' the phenomenon in question. At this juncture an obvious hypothesis (though not the only hypothesis) is that such concepts are functional concepts. They latch onto features *as* features which perform a role.

Now, standard functionalism in the philosophy of mind attempts to develop this hypothesis. It does so, though, in an over rigid manner, which we have no reason to accept. An alternative, and it seems to me quite plausible, functionalist model for some psychological concepts is to specify the function, or functions, using other psychological notions, which we can assume are more primitive or basic. (We might call this hypothesis 'psycho-functionalism' if that name did not already have another use.) An account, of course, remains to be given of these basic concepts. It is also plausible to suppose that our concepts form a hierarchy; once we have latched onto certain functionally distinguished features, we can use them to latch onto others. Thus, and very roughly, 'being conscious' is, it might be suggested, fixed on as a general internal condition without which we are unable to perceive our environment or to think.

If the concept of seeing is such a functional concept (somewhere in the hierarchy) then there will be what can be called functional truisms about seeing, roughly of the following form: 'if S sees O the S is capable of G-ing'.

I want to suggest one such truism. It will be expressed imprecisely, but the suggestion is that it is moving in the right direction to capture a

fundamental functional aspect to the concept of perception. As well as being imprecise, I cannot here tackle the problems with the proposals which will strike anyone. The suggestion is this. If we consider a normal case of seeing an object then it seems that in virtue of standing in that relation to that object we, normal humans, are able to think about it in a distinctive way. The characteristic way to express the thinking would be by using a demonstrative. Thus we might say; 'What is *that*?' We might think; '*That* is a flower'. In its simplest form, then, the idea is that it is a functional truism about seeing that if S sees M then S thereby stands in a relation to M which enables S to think about M in a distinctive, demonstrative way. It is quite natural, it seems to me, to look to this idea to explain the frequently repeated thought that in perception items are *presented* to us, or that it *acquaints* us with objects. It is appealing, too, for the following reasons. First, if someone genuinely thinks that he or she can see M, then they must be prepared to agree that amongst the array of possible demonstrative judgments they could, there and then, make, there will be a true one expressible in the words '*That* is M'. If they failed to acknowledge that as a consequence of what they thought, then they do not understand seeing. Second, it fits, I think, the manifest epistemology of seeing. When we are trying to decide what, if anything, we can see, we do not fix on an agreed result and wonder about its cause, rather we are wondering about the status of the very first thing (if thing it be) that we reach when our attention moves outward. The fundamental question posed by perception is: 'What, if anything, is *that*?'. To answer that is to decide what we are seeing. Now, there is one misunderstanding about this proposal to guard against; it is not that seeing M requires the subject to actually think of M, but rather that, to stand in that relation is to fulfill the subject-world condition which, given the satisfaction of various other conditions in S, would bring it about that S thought in this style about M.

This proposal obviously faces problems. It also faces the following question. Suppose that it is agreed that there is a functional truism along the suggested lines, is it not implausible to think that it is the only one? Is it not plausible to think that there is a functional truism to do with the role of perception in the generation of knowledge? In response, all that I can say is this is indeed plausible, but its investigation and integration with the other truism, if that can be defended, remain tasks for the future.

What, finally, of the causal requirement on this approach? That, I think, should be viewed, not as an a priori condition, but, rather, as a truth revealed by empirical investigation of the real nature of the relation which enables us to relate to the world in accordance with the functions

310 PAUL F. SNOWDON

built into the concept of perception. To use a term of Strawson's, our concept of perception is very 'innocent' indeed.[13]

PAUL F. SNOWDON

EXETER COLLEGE, OXFORD
APRIL 1997

NOTES

1. See the *Minutes of the Henry Wilde Prize*, started in 1965.
2. One exposition of this idea is in P. F. Strawson, 'Perception and its Objects' in (ed.) G. F. Macdonald, *Perception and Identity* (London: Macmillan, 1979), pp. 41–60. Page references are to the reprinting in (ed.) J. Dancy, *Perceptual Knowledge* (Oxford: Oxford University Press, 1988).
3. Strawson, 'Perception and its Objects', p. 103.
4. For Grice's proposal see H. P. Grice, 'The Causal Theory of Perception' in *Proceedings of the Aristotelian Society,* suppl. vol. 35 (London, 1961), pp. 121–51. It is reprinted in an abbreviated form in Dancy, 1988.
5. P. F. Strawson, 'Causation in Perception' in *Freedom and Resentment* (London: Methuen, 1974), pp. 66–84.
6. I have elsewhere analyzed these arguments in detail, and shall deal with them briefly here. See P.F. Snowdon 'Perception, Vision and Causation' in Dancy, 1988, pp. 192–208, and 'The Objects of Perceptual Experience', *Proceedings of the Aristotelian Society,* suppl. vol. 64 (London, 1991), pp. 121-50.
7. See P.F. Strawson, 'Construction and Analysis' p. 107, in (ed.) G. Ryle *The Revolution in Philosophy* (London: Macmillan, 1956).
8. See Strawson 'Causation in Perception', p. 71.
9. See Strawson 'Causation in Perception', p. 74.
10. The criticisms which I shall make here overlap with those which Christopher Peacocke made in *Holistic Explanation* (Oxford: Clarendon Press, 1979), pp. 95–99. He brings out very well the problems which Strawson's suggestion faces, although he does so with an eye for his own preferred account.
11. These two criticisms are not the only ones. A further problem, not unlike the one which Strawson himself raises for Grice's theory, is this. If we imagine all the tautologies articulated and set down we would end up with a list of conditionals of the form; if a T object is D meters away then it is not visible, if a T* object is D* meters away then it is not visible, . . . if a T** sound is D** loud then it is not audible, etc. The question then would be; what unifies and grounds all these tautologies? They simply cannot have the status of independent conditions constitutive of the concept.
12. The present sketch is related to some ideas contained in 'The Objects of Perception', especially sec. VI. However, some elements are added, and I here attempt to relate the approach to a more general program in the philosophy of mind.
13. An earlier version of this paper was read to two groups in Oxford, and I wish to thank Professor Strawson and Professor Dummett for various comments, to which I have not adequately responded, and also Bill Brewer, David Charles, Bill Child, Fiona Ellis, Roland Stout and Helen Steward. I also benefitted while thinking about Strawson's paper from reading Matthew Souteriou's 1996 London M.Phil thesis.

REPLY TO PAUL SNOWDON

Paul Snowdon begins his paper with some extremely generous remarks about my role as an Oxford tutor. There may well be some exaggeration on his part when he speaks of my merits as a teacher; but there is certainly none on mine when I speak of his qualities in the complementary role of a pupil. When he read his very first essay to me, I at once formed the conviction, borne out by the event, that here was a man who could not fail to gain the highest honors available to an undergraduate student of the subject. Already manifest were the clarity and care, the balance and judiciousness which characterize all his work, together with a kind of majestic comprehensiveness which is rare at any age and in any context.

Perception, I remember, was the subject of that first essay; as it is of the present one. In this last, Snowdon undertakes a critical examination of the thesis that it is integral to the ordinary concept of perception that, when a subject perceives an external object, the object is causally responsible for the subject's perceptual experience. Snowdon concentrates mainly on the case of sight, of visual perception, as is common enough in discussion of the subject; and I shall follow him in this. So limited, the thesis in question is that it is a conceptual truth that when a subject S sees an external object O, O is causally responsible for S's visual experience.

Snowdon's discussion seems to me a model of a philosophical critique. Each successive point is made with maximum clarity and none is made to bear more weight than it can. His attitude to the doctrine at issue cannot be said to be one of final acceptance or of final rejection. It is one of reserve. He begins, in effect, by considering a popular argument, formulated by Grice and thought by him to establish the doctrine. If a subject has an experience which seems to him to be that of seeing an object O, but which was in fact produced in a way which could have occurred without the presence of O, then the subject does not in fact

perceive (see) O. The conclusion is thought to follow that such an experience is in fact a perception of an object O only if the experience is causally dependent on the presence of O. Snowdon agrees that *some* relation between the subject's experience and the presence of O must indeed obtain if the subject does genuinely perceive O; but, he adds, no conclusive argument has yet been produced to show that the required relation must be the canvassed one of causal dependence.

Recasting its form somewhat, Snowdon next considers a supposed rationale for, or explanation of, the truth of the causal theory. He acknowledges a necessary, though not tight, link between the concept of perception and that of knowledge. When a subject perceives an object, he generally thereby acquires some knowledge about what it is he perceives. Now it was characteristic of the examples produced by Grice in his original argument, referred to above, that there was in fact just such an object as the subject took himself to be seeing just where the subject took himself to be seeing it; so the belief that the subject, on the basis of his experience, formed about what was before him was true. But since that object played no part in the generation of the subject's belief, that belief was only flukishly or accidentally true: it could not count as knowledge. Equally obviously, the subject could not be allowed to have perceived the object he took himself to be perceiving.

So, the argument concludes, for a subject genuinely to perceive, and hence gain knowledge of, an object, that very object must be causally responsible for the subject's perceptual experience; where this causal relation obtains, the possibility of flukishly or accidentally correct belief is removed.

As before, Snowdon has an answer to this argument; and the answer is parallel in form to its predecessor. Certainly the fulfilment of the causal requirement (i.e., that the object perceived should be causally responsible for the subject's perceptual experience) is one way to avoid flukishness. But no argument has been produced to show it is the only way. There may be other ways. One possibility formally open, though hardly, in the present context, a plausible candidate, is that of systematic joint causation of the object's presence on the one hand and the subject's experience on the other—the will of a benevolent deity, say, fulfilling, à la Malebranche, the role of common cause. Or perhaps, no more plausibly and dispensing altogether with the notion of cause, the metaphysically ultimate prevalence of a principle of preestablished harmony.

Snowdon does not waste time by lingering on such fantasies. He concedes that "if there is to be a genuine alternative to the causal theory, there must be a way to specify a non-causal relation in which objects can stand to experiences when those experiences amount to perceptions of

those objects." He proceeds to sketch another possible way "of greater interest and plausibility" of securing a nonaccidental link between perceptual experience and external facts. Such a link would hold if, in his words, "cases in which one can see (and thereby know) how things are, are cases in which the visible facts are *constituents* of the experience." This would, he seems to imply, obviate the need for a causal relation. Snowdon does not develop this suggestion here; but it obviously deserves further consideration, and I shall shortly return to it.

So far, then, Snowdon has argued merely that the existence of the proposed causal link has not been decisively shown to be a necessary condition of perception. He has not claimed to have shown the theory of its necessity to be false; nor does he at any point make this claim. What he does in the next two sections (5) and (6) of his paper is to examine certain attempts to supplement the doctrine of causal dependence as a *necessary* condition of perception in such a way as to yield a *sufficient* condition. I think his comments on, and criticisms of, these attempts are sound and shall not examine them further.

The next step for me, then, is to examine Snowdon's suggestion of a 'plausible' alternative to a causal account of the relation that must hold between external objects and experiences "when those experiences amount to perceptions of those objects." It is not quite clear to me how Snowdon conceives of this alternative relation. He seems to suggest that when a subject, for example, sees an object, the visible object is somehow partly *constitutive* of the experience. Again it is not quite obvious how to understand this. But the plainest gloss on it is the following. If a subject S sees an object O, then S's experience is accurately described in the words 'S sees O'. But the truth that S sees O logically requires the existence and presence of O. It would be logically impossible for *that* experience to occur without the presence of O. So the relation between experience and object is certainly non-accidental: it is logical. So no causal relation is required.

There is a temptation here to take a further step. Not only is a causal relation not required. It is actually excluded. For logically connected items *cannot* be causally connected. So the causal theory is refuted.

Snowdon does not take this step. Indeed it would be to take a step, or several steps, too far. Of course it is true that logically connected items cannot be causally connected; for they are of quite the wrong type. Only distinct natural items ('distinct existences') can be *causally* connected; only things capable of truth or falsity (propositions or propositional contents, the contents of assertions, hypotheses, descriptions, etc.) can be *logically* connected. The fact that the truth of a *description* of one item logically requires the truth of the existence of another has no force at all

to show that the items in question are not distinct natural existences, capable of being causally linked. The idea that these natural items *themselves* could be logically linked is nonsense, a category howler.

One can, indeed must, go further. Only someone temporarily blinded by philosophy could dream of denying that when a subject S sees an external object O, the visual experience enjoyed by the subject S is one thing or occurrence in nature and the object seen is another and distinct thing in nature. Now Snowdon has already conceded that in order for an experience to amount to a genuine perception of an object (and hence a way of gaining knowledge of it) there must be such a relation between object and experience as to rule out the case of a subject's being merely flukishly or accidentally right in taking it that there is just the object before him that he takes himself to be perceiving. Since Snowdon's suggestion of an alternative to the relation of causal dependence turns out to be a nonstarter, the causal remains the only plausible candidate.

Not only plausible. Really inevitable. In the concluding section of his paper Snowdon makes some interesting and promising suggestions for another, 'functional', approach to the concept of perception. In his final paragraph he implies that on this approach there would be scope for, perhaps even need for, "empirical investigation of the real nature of the relation which enables us to relate to the world in accordance with the functions built into the concept of perception." Indeed there is scope for such investigation, and it has been vigorously and successfully prosecuted. What it reveals, what is *empirically* discovered in its course, is precisely the physical and physiological mechanisms by means of which external objects are causally linked to perceptual experience of them. What is not an empirical discovery at all, but a conceptual truth presupposed by these investigations, is the general requirement of the causal dependence of genuine perceptual experience on its objects. The 'real', i.e. detailed, nature of that relation is certainly a matter for empirical investigation. Its real *general* nature is not.

P.F.S.

16

Arindam Chakrabarti
EXPERIENCE, CONCEPT-POSSESSION, AND KNOWLEDGE OF A LANGUAGE

As for the followers of the Nyāya school, predicative perceptions constitute their life-breath If it is asked "What is that real referent of words (with which these predicative perceptions are verbalized)?", the answer would be "Those same objects which are manifested in pre-predicative awareness." Do universals etc. also figure as objects in pre-predicative awareness? Surely, they do. That is what we shall say.
> —Jayanta Bhatta (*Nyayamanjari*, ch. 2, pp. 133–45)

In experience one takes in, for instance sees, that things are thus and so.
> —John McDowell (*Mind and World*, p. 26)

Can someone possess the concept of a flower without knowing the word "flower" or any word for flower in any language? Can someone see or notice a flower without having or applying any concept whatsoever?

I shall try to defend an affirmative answer to the first question and a negative answer to the second. I shall also try to excavate a link between these two answers. Most of our garden-variety perceptions are loaded with concepts picked up at the time of language learning. But once we recognize that prelinguistic possession of concepts must be possible it becomes easier to admit that preconceptual perception is a mere myth.

Between two suspect notions, viz. nonlinguistic grasp of a concept and nonconceptual experience of particular objects, the latter—the source of the Myth of the Given—surely deserves a decent burial and for the sake of that, this paper tries to argue, the former merits a cautious resurrection. Knowledge of the sense of a word requires knowledge of that word and knowledge of at least that fragment of the particular

language which determines its use. An unverbalized (but verbalizable) predicative perception of a as F does not seem to require perceiving a as falling under the extension of a kind-*word* of any particular language. It is the fear of meeting such a steep requirement which has often made philosophers expel concepts from the contents of nonverbal perceptions, and suspect even simple predicative perceptions as experience adulterated with verbal hence nonnatural thought. Once we make room for possession and application of concepts which need not be grasped *merely* as senses of words, we can frankly admit the role of such concepts even in our most primitive noticings of our surroundings. Mythologizing about inexpressible pre-predicative immaculate perception of pure particulars can then be clearly recognized to be otiose. Recognition of the purely perceptual character of concept-enriched experience, thus, makes us ready to embrace the sort of direct realism about ordinary propertied particulars that Professor Strawson has defended with his characteristic vigor and rigor.

In the age-old epistemological schism between passive perceptual cognition through the senses and spontaneous rumination, belief-formation, and communication through language, *concepts* were always thought to belong to the language-faction. It is more realistic, in both the technical and colloquial senses of 'realistic', I suggest, to affiliate concepts—at least some basic concepts—with the perception-faction. The indescribable aroma of a new blend of coffee which we smell quite obviously as of a definite kind and intensity is not perceived as a bare particular stripped of all recognizable features. The aroma may be nameless but it is not therefore featureless. We could not be groping for a word for that *sort* of smell unless we already fitted that particular whiff to an olfactory sort or concept. The smelling goes wordless not because it is concept-free but because no word has yet been found to match the *concept* with which the smell was smelled.

"In experience one finds oneself saddled with content. One's conceptual capacities have already been brought into play, in the content's being available to one, before one has any choice in the matter" (*Mind and World*, lec. 1, p. 10). Years before John McDowell said this, Strawson had written "the ordinary human commitment to a conceptual scheme of a realist character is . . . something given with the given" (Strawson 1979, p. 47). Strawson also gave a Kantian sort of explanation why this is so. In order that fleeting and subjective events like our sensations could be taken as caused by and pointing towards objective and enduring bodies, we need to possess and apply *concepts* of distinguishable and reidentifiable objects. Thus our actual intake of perceptual experience is said to be "soaked with or animated by, or infused with . . . the thought of other past or possible perceptions of the same object" (Strawson 1974,

p. 57). But this concept-saturated character of all experience is often taken as evidence for the fact that our language permeates our perceptions, that our experience is as much caused by convention-guided speech as it is by the world knocking at the door of our senses. To take, once again, Strawson's convincing example, "I hear the clock strike twelve. Could I hear *this* without grasp of the concept of a clock and of the number-system? And whence does this grasp derive? . . . Perception, our perception, is *powered and driven by the word*" (1993). Now, this may be true of the rather sophisticated "hearing" which is involved in the above example, but to insist that any *seeing* (or hearing or touching or tasting or smelling) is seeing plus implicit employment of speech is but one small step away from the idealistic thesis that the world that predicative perception opens up to us is constructed by us through some kind of a linguistic social contract.

To put the matter in the form of a typical philosophical puzzle: Each of the following three propositions seems to be initially plausible.

1. No adult perception is imagination-free or nonconceptual.
2. Concepts (roughly equated with Fregean senses) are nothing but ways or rules of using words.
3. Some adult perceptions (e.g., of an unfamiliar smell) are causally and contextually nonlinguistic.

Yet these three could not be true together. If no perception is possible without concepts and no concepts are possible without some actual or implicit use of language, then no perception should be free from linguistic loading, i.e., proposition 3 must be false. Making a distinction between belief-independent perception and judgment based on perception, Evans would perhaps drop the first claim. He openly pleads for nonconceptual content of perceptions. In Ancient and Mediaeval Indian Philosophy, standard Nyāya would also reject 1 by putting forward the distinction between prejudgmental indeterminate perception and determinate predicative perception. We should not forget that even indeterminate perception was postulated as the prior acquaintance with a property like *F*ness which would take up the role of the qualifier in the determinate cognition ⌜*a* is *F*⌝. But even the content of determinate perception they would emphasize, including the particular to be characterized, the qualifying property and their characterizing tie, is wholly perceptual. Determinate perception is not perception partly generated by words. Bhartṛhari solves the puzzle by rejecting 3: Nothing counts as a cognition of an object, according to him, unless it is a distinguishing illumination of it, and nothing but a linguistic grid can enable us to illuminate and distinguish. Matilal, while discussing this view of Bhartṛhari quotes Sellars in rather vehement support: "all awareness of sort, resemblance,

facts etc.—in short, all awareness of abstract entities—indeed all awareness even of particulars—is a linguistic affair."

Amending the traditional Nyāya position in lines suggested (but not fully developed) by Matilal, and developing Strawson's picture of perceiving itself as involving demarcating, classifying, recognizing, and identifying, I suggest that we solve the puzzle by rejecting 2.[1] Let us stop regarding some basic empirical concepts as mere meanings of bits of speech and acknowledge their anchorage in direct sense-experience. All animals, says Aristotle, "have an innate discriminative capacity called perception." And when a lion has many memories of individual oxen, it has a concept of an ox although it is not going to be able to give reasons for calling something an ox or ascribe possession of this concept to itself. But as Sorabji has wondered, even we humans do not give further reasons for all our concept-applications (Sorabji 1993, p. 35). Our command over the concept of *pain*, for instance, must be as independent of language-use and as experiential as a beast's multiple-memory command over the concept of pain. With due respect to Wittgenstein's "public language argument," ability to use the word "pain" in the right circumstances is no essential ingredient or manifestation of that command.

The path to such a language-independent account of concept possession, unfortunately, is rather thorny. It bristles with powerful objections and often gets lost in thickets of confusion. I shall have space to consider only one powerful objection. But before that let me clear up some of the confusions.

Suppose in early childhood my father pointed to a cow and told me, "That is called a cow." At that learning moment I did have to see the cow and also understand what he said in an accepting manner. It was a case of knowledge from testimony assisted by perception. Does that mean that now in my mature experience of the world whenever I see and claim to see an animal as a cow I am only telling an ungrateful half-truth if I say that I know it was a cow because I simply perceived that it was a cow? Should I rather say, each time, that I knew it was a cow on the basis of what I saw and what my father told me? If the latter answer were more accurate, then all predicative perception which could be reported by using words (common nouns, proper names, or verbs) that one originally needed to learn would indeed be awarenesses jointly produced by words and the senses. And insofar as arbitrary human semantic conventions would substantially contribute to their content, no predicative perception would ever reveal the world as it really is. It is to reject this covertly antirealistic construal of all judgmental perception that the adjective "nonlinguistic" (*avyapadeśyam*) was added to the general definition of perception in the *Nyāyasūtra* 1.1.4. Vātsyāyana's commentary on this

tricky word unambiguously shows that he was not regarding it as applicable only to the allegedly preconceptual indeterminate variety of perception, but was taking it to cover fully predicative perceptions like hearing a sound as a dog's bark as well. Of course one could not *say* what one saw or heard before learning some language or other. But the content of what one sees or hears after learning the word does not necessarily differ from that of the time when one had not learnt the word (*tadarthavijñānam tādṛgeva bhavati*). Jayanta goes even further. Even if training in a language does enable us to see differences and similarities which go unnoticed by speechless brutes or babies, the resulting concept-applicative perception is not knowledge of the word any more than seeing of a book lit up by a candle is seeing of the candle. Like the candle, the word or its memory is at best an aid to the senses. We see with help of rods and cones in the retina, do we therefore see rods and cones? Even Vacaspati, who restricts the application of the epithet "nonlinguistic" only to the so-called unverbalizable pre-predicative perceptions clearly recognizes that the feature that is meant by the remembered generic word is also first independently perceived by the senses, that the word remains neutral and uninterfering as far as the content of the experience is concerned.

The crucial argument that Jayanta gives for the thesis that mastery over the use of the word "cow" cannot be presupposed by our perceptual ascription of cowness to a particular object is that such a mastery itself presupposes a prior grasp of the concept of a cow or a capacity to recognize cowness when faced by it. Even when the first instructor tells the novice: 'Such animals are called cows', she must be assuming that the novice has already seen the ostensively identified body as a sample of the bovine ilk but just does not know the name of the ilk. If the learner has not done so and asks 'Which animals?' it would be a joke empty of all information for the teacher to answer back 'Just the ones which are called cows'. To give, as the nominalist Buddhist does with his exclusion-theory of concept-invention, a primarily linguistic account of universals is to commit two fallacies. First, there would be reciprocal dependence which is one form of circularity: The limiter of qualificandness and the predicated property being identical, to use a bit of neo-Nyāya jargon, the language learner's newly acquired information will take the form: *"red" stands for whatever it is that "red" stands for*, which is no information at all (indeed Nyāya would regard such tautologies as senseless somewhat in the fashion of the *Tractatus*). Secondly, if, on subsequent occasions, to see a surface as red were to actively invoke one's knowledge of the meaning of the word "red" then every word would in effect mean itself because the complex object of the dispositional understanding or occur-rent recall of the meaning of the word would include the word itself as

the chief qualifier of the complex. This would make every word self-allusive which is intolerable.

Both of these fears, of course, could be considered baseless. The guidance given to the first learner can remain linguistic without going round in a circle repeating the word to be taught. The instructor can just use synonyms or explanatory phrases to teach the use and hence the meaning of the word. But this rejoinder does not satisfy a realist who has independent reasons to find an extralinguistic home for at least some basic universals. To use the picturesque phrase of McDowell, we don't want to reduce our conceptually enriched picture of the world to a "frictionless spinning in the void" of a large circle of intertranslatable words none of which makes any direct contact with the world we speechlessly encounter. Of course, Bhartṛhari or Quine would say that to be speechless is to be worldless. Accordingly, Bhartṛhari would make a virtue out of the second fallacy. He welcomes the consequence that every word would stand for itself because on his theory the form or "own universal" of the word itself is its primary meaning. Couple this with his doctrine that the real word is the word-type or some internalized version of it, and you get the result that a word primarily means itself. Since neither his view of reality as evolving out of some eternal Speech-essence nor his view of Language as an indivisible inner and innate endowment common to all sentient beings is recognizable as common sense, we have excellent Strawsonian reasons to set aside such rejoinders to Jayanta's arguments as revisionary and esoteric.

Jayanta's circularity objection against a uniformly linguistic account of concept-possession struck me as uncannily similar to Dummett's complaint against modest theories of meaning:

> We are being told that an understanding of the word "sheep" consists in a knowledge of the proposition expressed by a certain sentence, that a knowledge of this proposition requires grasp of the concept of a sheep, and that a grasp of that concept by a speaker of the language in question will consist in his understanding of the word "sheep". Since no more paradigmatic case of a circular explanation could be devised, we may conclude that the conception of a modest theory of meaning is a phantasm. (Dummett 1991, pp. 112–13)

Unfortunately, in spite of his insistence on the full-bloodedness of our account of knowledge of a language, Dummett would suspect any language-independent (what Peacock calls "pure"?) theory of concepts of the worst kind of mistake which he calls the code conception of meaning and which he has attacked and made fun of *ad nauseum*. So the first powerful charge against my suggestion that some concepts must be at our disposal before we can begin to learn any language would be this: Once we make it possible to grasp a bit of sense or think a bit of thought

antecedently to our command over the bit of speech-pattern which would eventually capture or express that sense, there is no escape from the psychologistic associationist picture of concepts as coming before our consciousness before they put on the dispensable clothing of words. It is well-known how Dummett finds this popular mentalist picture guilty of a category mistake, a vicious regress, and a skeptical invitation to the damaging idea of a private asocial mastery of a language. But as recent development in pure theories of thought have demonstrated, and as the concluding remarks of McDowell's recent book bring out, to make room for a basic prelinguistic ability to see actual shared and distinguishing features of objects and therefore to credit humans along with some other retentive action-planning animals with the power to have world-directed thoughts prior to and independently of language is not necessarily to embrace a code conception of language. Apart from Dummett's own nagging doubts about what he labels the cardinal tenet of Analytical Philosophy, viz. the explanatory priority of language over thought, I can just hint at a new way of cashing out the opposite priority. Why don't we forget this confusing equation of concepts as possessable by individual thinkers with Fregean senses which are not possessed but apprehended anyway! Instead let us take the more daring step of going back to Frege's own use of the word "concept" and start talking about properties without cognizing which it is impossible to recognize any particular or situation at all. What I am proposing is a Fregean realism about properties without Frege's Platonist baggage that properties could only be thought but never perceived. Strawson, who recognizes that it is more natural to report that one saw a gait or heard a tune than gloss it as having perceived particular instances of these universals, still has a hard time believing that we could literally see universals (Strawson 1995, p. 412). If we can give a sophisticated account of sensing universals as inhering in spatio-temporal exemplifiers—and such an account already exists in Nyāya—then we need not be afraid of slipping into any mentalism about concepts.

If we underplay his earlier animus against the demand of full-bloodedness, then John McDowell's recent vigorous defense of the idea of concepts perceptually thrust upon us by the external world can help us strengthen this claim that we do not need to invent or impose universals as mere meanings of words. In order to fit words, concepts need not have a wordy origin. A common external world can be the mother of both perceived properties and meanings of common nouns and adjectives. There could be a deep connection between *senses* as the avenues through which the world impinges on our consciousness and *sense* as that which is grasped when a word is understood. (See Kant's remarks on *sinn* and *sinnes* in section 28 "On Imagination" of his *Anthropology*.) Surely we

need a trained mind to be receptive to such sighted rather than blind intuitions. But there is no reason to think that what is received by such a "second nature" is tampered-with data. Concepts do open up the possibility of *error*, for they make *truth* possible. The mythical blind or raw intuitions which were supposed to be preconceptually received would not have given us any truer picture of reality. They would have given us no picture at all.

This restoration of the full prestige of genuine perception to verbalizable but not word-generated experience saddled with concepts I take to be welcome fall-out from Strawson's open rejection of the two-step theory of perception in his last book *Analysis and Metaphysics* (Strawson 1992, pp. 62–63). After this it is easier to offer a right-minded affirmative reply to the question: Would we have experienced the world as containing white snow and green grass, mothers sitting and dogs running fast if we did not have words like "snow," "grass," "mothers," and "running"? In order to say a long-overdue "yes" to this, I'm afraid, we have to make room for concepts which are not due to words but nevertheless lie ready to be put into words.

ARINDAM CHAKRABARTI

DEPARTMENT OF PHILOSOPHY
UNIVERSITY OF DELHI
UNIVERSITY OF HAWAII AT MANOA
MAY 1996

NOTES

1. I have given a number of strong reasons why, I think, the idea of pre-predicative perception should be fully dropped and proposition 1 above should be fully embraced by Nyāya philosophers. See my "Against Immaculate Perception," forthcoming in *Philosophy East and West.*

REFERENCES

Dummett, Michael. 1991. *The Logical Basis of Metaphysics.* Cambridge, Mass.: Harvard University Press.
McDowell, John. 1994. *Mind and World.* Cambridge, Mass.: Harvard University Press.
Matilal, Bimal Krishna. 1986. *Perception: An Essay on Classical Indian Theories of Knowledge.* Clarendon Press: Oxford.
Sorabji, Richard. 1993. *Animals, Minds, and Human Morals.* London: Duckworth.

Strawson, P. F. 1974. *Freedom and Resentment and Other Essays.* London: Methuen.

———. 1979. "Perception and its Objects." In *Perception and Identity,* ed. G. F. MacDonald. Ithaca: Cornell University Press.

———. 1992. *Analysis and Metaphysics.* Oxford: Oxford University Press.

———. 1993. "Knowing from Words." In *Knowing from Words,* ed. A. Chakrabarti and B. K. Matilal. The Netherlands: Kluwer.

———. 1995. "Reply to Chakrabarti." In *The Philosophy of P. F. Strawson,* ed. P. K. Sen and R. R. Verma. New Delhi: Indian Council of Philosophical Research.

REPLY TO ARINDAM CHAKRABARTI

With the central contention of Arindam Chakrabarti's paper I am in total and unqualified agreement. It seems to me obvious, as I think it does to him and to some of his Nyāya predecessors like Jayanta, that it would be impossible for us to learn the most elementary general terms of our vocabulary unless we had already grasped corresponding (or nearly corresponding) concepts—or, better perhaps, unless the grasp of such concepts had been, as it were, already forced upon us in the course of perceptual experience of our common world. It is simply preposterous to suppose that *all* concepts are language-dependent or linguistically generated. Indeed I would have supposed that view to be a merely modern heresy had not Professor Chakrabarti produced evidence from classical Indian philosophy—referring especially to Bhartrhari—that the view in question had much older origins in that ancient and sophisticated tradition.

Chakrabarti argues skillfully, in ways I will not repeat, in support of his own view and against that of his opponents. I do not think he would dissent if, as I shall, I extend his thesis beyond the range of cases he explicitly considers. He concentrates on the fundamental situation of ordinary perceptual experience, where, as Kant might put it, intuition and concept, sensibility and understanding, are most basically and indissolubly united. But I think the central thesis holds at a more sophisticated level than this. I shall suggest, for example, that it holds at the level of sensitivity to (sometimes quite refined) discriminations of aspects of human character and behavior; and even that it holds at the level of advancing physical science. We are surely able to discern and recognize, in our fellow-beings, the traits we learn to characterize with the words 'bright' or 'dim', 'cold' or 'warm', without being *first* taught these figurative extensions of those terms. The grasp of the concept precedes, and is a necessary condition of, those extensions.

Similarly in the case of natural science: where the word 'wave' was

used in a fresh, and initially metaphorical, way to express an antecedently formed conception of the propagation of light. (I can cite here the authority of Quine in his excellent article 'Postscript on Metaphor' from *Theories and Things*.) There is even some evidence that the term 'molecule' was not even devised until someone had formed the idea of gases as composed of tiny moving bodies—hence what is now known as the molecular theory of gases.

Of course, in all these latter cases, both the scientific and the personal, the existence of language *in general* is presupposed—by our search among, or recourse to, already existing linguistic resources for an appropriate form of expression; but it is the prior grasp of the concept that prompts the exploitation of this resource. And, again of course, these remarks call for the qualification that, at least in some cases, the initially and nonlinguistically formed concept may acquire a firmer shape or definition in the light of linguistic development. But the main point remains that the capacity of conceptual thinking underlies the whole process of linguistic development, indeed the very existence of language.

This brings me to a further point: a point about concepts, on the one hand, and properties (or universals generally), on the other. Though I do not suggest that he confuses these, they are not quite clearly distinguished by Chakrabarti. But they should be. As I have written elsewhere in this volume, it would certainly be a mistake to identify concept and universal (or property). They are clearly distinct. In the case of most primitive and basic concepts and in the case of many sophisticated ones as well, to possess a concept, or at least to have a full grasp of it, is at least to have a certain recognitional capacity, though it is normally more as well; e.g., to know something of its relation to other concepts, its place in a system of concepts. To possess a property is no such thing (unless, of course, it is precisely the property of possessing a concept). Thus someone may possess the *concepts* of courage or generosity (understand what courage and generosity are and recognize their manifestations in others) without possessing the *properties* of courage or generosity (without being courageous or generous himself). Equally someone may have a certain property (e.g., being schizophrenic or diabetic) without any grasp of the relevant concept. Indeed inanimate or abstract things may possess properties (being a *wooden* artifact or a *prime* number), while it would be absurd to ascribe to them the possession of any concepts at all. All things, of whatever category, have properties; only conscious beings, and perhaps societies, can be said to have concepts.

Now we come to a question which appears to be a matter of controversy—even of disagreement or, as I shall suggest, apparent

disagreement, between Chakrabarti and Nyāya on the one hand and myself on the other. This is the question of whether there can be direct perceptual acquaintance with properties or universals; whether we can, for example, literally *see* universals. Anyone who holds, as I do, that universals are essentially abstract entities—not, therefore, in space and time, though their instances may be—must necessarily answer this question negatively; Nyāya and Chakrabarti answer it affirmatively. I think, however, that if we attend carefully enough to all the rather subtle distinctions which bear on the question, we will see that this apparently sharp opposition of views becomes much less sharp—or even disappears completely.

Let us begin with some examples: 'Happiness shone in her eyes'; 'His hatred was visible in his whole countenance and demeanor'; 'He loved to gaze on the brilliant blue of her eyes and the crimson of her lips'. Here, surely, it might be said on the Nyāya side of the question, the universals happiness, hatred, blue and crimson are visible objects of direct perception. But let us look a little more closely: it is *her* happiness, *his* hatred, *the* blue of *her* eyes, *the* crimson of *her* lips that are literally visible, the objects of direct sensible perception. And these are *particular* objects, certainly in space and time and directly perceived. They belong to the category of what I long ago called 'particularized qualities' and might perhaps better be called 'property instances'—and they certainly belong to our ontology of perceptible objects. But none of them is the universal itself. Her happiness is short-lived; the blue of her eyes dims. But the universal is not short-lived, does not grow dim. You can taste the salinity of the sea-water in a glass; but the universal does not taste salty. Or again, you see a trio of friends or a quartet of players and see them as being three or four in number. Is this seeing the number 3 or the number 4 itself?

It may well seem that these examples are unfair. But I am not really concerned with making debating points. Rather I am concerned to show how little really divides us. For I am perfectly ready to concede that we can *see* courage or ambition in action, can *witness* unselfishness or, sadly enough, brutality, can *taste* sweetness or *feel* smoothness. I am more than happy to agree with Chakrabarti that we can *perceive* universals or properties *as inhering in substantial spatio-temporal exemplifiers*. But this is to say no more than that, for example, we see the particular action *as* courageous, we feel the particular surface *as* smooth. No more, but also no less. For—and this is perhaps where our fundamental agreement most clearly shows itself—we couldn't rightly be said to perceive the particular item at all except *as* in this way exemplifying one or another universal. Perception is concept-saturated throughout; and every concept is the concept of a universal. But we can also *think* about the

universal itself in abstraction from any particular exemplifiers, as we do when engaged in pure mathematics or in abstract philosophical thought; and it is certainly more than plausible to maintain that when we are engaged in these activities we find the use of language, or of symbolic representation in general, for the most part indispensable. Such thinking might reasonably be called pure conceptual thinking; and, although, as I emphasized earlier, it would be a mistake to identify concepts with the universals of which they are concepts, the relations between concepts are exactly reflected in the relations between the universals of which they are concepts—a fact which may, at least in part, account for that identification of universals with their concepts which I was at pains to refute.

Something must be said in conclusion about a general moral to be drawn from Professor Chakrabarti's paper. Besides being a contribution, on the right side, to an ongoing debate, his paper demonstrates vividly how one and the same philosophical issue can be a matter of contention in philosophical centers entirely distinct from each other, widely separated in time and space, and belonging to quite disparate cultures. And this in its turn provides a compelling argument for two things: first, for the genuine universality of some major philosophical problems; and, second, for the desirability of further comparative study of the respects in which the two philosophical traditions in question may illustrate this universality—a study for which Professor Chakrabarti shows himself supremely well qualified.

<div align="right">P.F.S.</div>

17

Wenceslao J. Gonzalez

P. F. STRAWSON'S
MODERATE EMPIRICISM:
The Philosophical Basis of His
Approach in the Theory of
Knowledge

B ritish philosophy in this century has in P. F. Strawson an outstand-
ing figure, whose contributions to different fields of philosophy have
been highly influential. One of the realms where this influence has been
greatest is in the theory of knowledge. This subject is, in his conception,
interconnected with the main parts of the systematic philosophy, form-
ing a unified enquiry.[1] Thus, his position in this area has a direct
relevance for his view of philosophy as a whole. However, the philosoph-
ical basis of his approach in the theory of knowledge is not sufficiently
clear, because he exhibits a tendency towards eclecticism. This phenom-
enon, which is recognizable in many ways, includes aspects such as the
attempt to find common grounds for the authors that he considers to
have more influence upon him: Aristotle, Hume, Kant, and
Wittgenstein.[2] In fact, his overall approach is a striking blend of
Wittgensteinian perspectives (in fields such as philosophy of language
and philosophy of mind) and Kantian views (in areas such as theory of
knowledge and metaphysics), which raises the question of a possible
inconsistency in his philosophical thought, in general, and in his theory
of knowledge, in particular.

Before this problem of consistency is discussed, it seems necessary to
clarify his approach in the theory of knowledge and its repercussions on
the main characteristics of his final conclusions. Strawson is generally
considered among the empiricists.[3] But, what kind of empiricism is
defended by an author who belongs to the analytic tradition and is
working very frequently on Kant's thought?[4] In other words, is his

empiricism a modern one, although he publishes in the twentieth century, or is it a new version of empiricism which avoids the classical problems of empiricism? Arriving at answers to these questions makes it particularly important that a general theoretical framework of this theory of knowledge be first presented. This should deal with the tension between modern and contemporary views. After this theoretical setting has been laid, it can be possible to compare and contrast his empiricism with the "classical" British tradition of empiricism and most recent versions of this conception.

I. THE GENERAL THEORETICAL FRAMEWORK: MODERN OR CONTEMPORARY?

To begin with, two aspects should be taken into account in order to clarify the modern or contemporary character of his general theoretical framework in the theory of knowledge. On the one hand, as analytic philosopher under the influence (among others) of the late L. Wittgenstein,[5] Strawson is without doubt a *contemporary* philosopher. But, on the other hand, as a philosopher who reconstructs I. Kant's *Critique of Pure Reason* in a way sympathetic to empiricist philosophers,[6] Strawson could be understood as a *modern* philosopher, even though his writings span the second half of the present century. Moreover, he seeks for similarities between contemporary philosophers and modern ones, including cases such as Wittgenstein and Hume,[7] who are generally considered as quite different in their perspectives.

If we accept that the *turning point* from modern thought to contemporary philosophy is Frege, then we have a criterion to locate Strawson in one side or another of the philosophical frontier. There are serious reasons to put that author in the very beginning of contemporary philosophy, as M. Dummett has pointed out frequently. Moreover, he considers that the place of Frege in the history of philosophy is equivalent in importance to the philosophical revolution initiated by R. Descartes.[8] According to this interpretation, both authors have offered new starting points for philosophical reflection. Descartes starts modern thought by giving primacy to the *theory of knowledge* (which he understands from individual consciousness): he made the theory of knowledge the foundation of philosophy; whereas Frege initiates contemporary thought by focusing on the *analysis of meaning* as the first aim in every philosophical inquiry (which he links to a logical perspective). This comparison could be complemented by a second element: neither Descartes nor Frege reaches the radical consequences of their revolu-

tion—in the field of knowledge or in the realm of language— because the most characteristic features appear later on, with Kant's critique of knowledge and Wittgenstein's critique of language.[9]

Even though the parallel between Frege and Descartes may seem to be pushed too far, since characteristic contemporary branches of philosophy (such as philosophy of mind) were not included in Frege's approach,[10] it seems clear that, in several instances, the *theory of meaning* has the character of a *philosophia prima* in contemporary thought.[11] This is, at least, the case in three philosophical tendencies which receive Frege's influence: Husserl's phenomenology, Carnap's logical positivism, and Wittgenstein's analytic philosophy (both in *Tractatus logico-philosophicus* and in *Philosophische Untersuchungen*, where he often quoted Frege and, frequently, with approval).[12] And Strawson discusses Frege's analytic approach when he deals with the problem of meaning and truth[13] as well as in the philosophical aspects related to the subject-and-predicate structure.[14] Although his final conclusions are usually different from Frege's, there is no doubt that, in these areas—philosophy of language, philosophy of logic, logic, and so on—the contemporary character of Strawson's approach is beyond question.[15]

Furthermore, the notion itself of "philosophy" is deeply embedded in the idea of *analysis of language*. In fact, one of his main contributions to this tradition of thought is his attempt to clarify and specify what "analysis" of language is and what kinds of "philosophical analysis" there are.[16] More recently, Strawson has chosen the word *elucidation* rather than *analysis* to characterize his philosophical model, because *analysis* suggests the idea of dismantling a whole into its parts, the transit from the complex to the simple.[17] For him, the notion of analysis understood in terms of something moving always towards the direction of greater simplicity should be abandoned. He thinks that concepts—and language—form an elaborate network, a system of connected items, such that the function of each item (i.e., each concept) is to be understood only by grasping its connections with the others, establishing its place in the system. The philosophical task consists in elucidating those concepts and their interconnection in the system, mainly in the linguistic system.

However, it could be argued that the theory of knowledge is a singular case and has specific elements, which make it different from other parts of philosophy. This argument is not only based on the mere fact that Frege (as well as other analytic philosophers)[18] was not interested in the theory of knowledge,[19] but also could be supported by the kind of empiricist approach that, de facto, Strawson adopts on human knowl-

edge. Thus, his acceptance of an empiricist stance could be seen as a clear indication of being a *modern* philosopher and can suggest that his theory of knowledge is different from his work in other philosophical fields. Several reasons can back up this assumption. First of all, he always highlights the importance and contents of the theory of knowledge, which is the most characteristic subject matter of modern philosophy. But this can not be the main reason, because it is rather obvious that other contemporary philosophers have also paid special attention to the theory of knowledge (such as G. E. Moore or B. Russell). Secondly, he shows a constant *interest* in Kant's thought, which is once again very noticeable in recent years, as well as in the British modern or "classical" empiricists (J. Locke, G. Berkeley, and D. Hume), whose *links* with Kant are emphasized.[20] Nevertheless, this is not sufficient to categorize Strawson as a modern philosopher, because historical affinities do not involve *eo ipso* a theoretical dependence. Thirdly, in the approach in and in the type of *conclusions* of his theory of knowledge, Strawson exhibits direct influence from Kantian views and a tendency to accept empiricist claims.

This third reason seems to be more plausible, because it seems rather obvious that Strawson is Kantian in many respects regarding human knowledge, especially in his *approach* to the conditions for having a conceptual structure. This is the case in his main book on the theory of knowledge, *The Bounds of Sense*, as he explicitly recognizes: "I found myself frequently enquiring into the conditions that make possible certain kinds of knowledge and experience which we in fact have."[21] This perspective is clearly reminiscent of Kant's investigation into the conditions of the possibility of experience in general, which—in his case—leads to conclusions compatible with some elements characteristic of modern thought (i.e., sensory experience, perception, imagination, . . .). In fact, he accepts Kantian elements, mainly those which belong to what he calls "Kant's empirical realism."[22] These components connect with a central claim in Strawson's theory of knowledge: that space and time provide the uniquely necessary media for the realization of the possibility of numerically distinguishable individual objects falling under one and the same concept.[23] Generally, his final position includes statements of this type: what is a necessary condition of any empirical judgment is not in itself a product of any such judgment. Usually, these final claims of his analysis of knowledge are an expression of a Kantian version of a *moderate empiricism*, whose main characteristics will be clarified later on here.

It should be emphasized, before this kind of empiricism is examined, that Strawson himself thinks that his approach is a combination of both a moderate empiricism and a moderate rationalism.[24] And the interpre-

tation of his theory of knowledge as modern, instead of contemporary, seems to be strengthened by this acknowledgment. But, in order to answer the question on his general theoretical framework, this claim of his should not be taken literally, because "empiricism" as well as "rationalism" could be understood in very different ways. In fact, Strawson understands "rationalism" as that position which supports the defense of the "intensional notions,"[25] a discussion which belongs almost entirely to contemporary philosophy.[26] To mention here the acceptance of a moderate rationalism appears to be only a way to stress the nonreductive character of his empiricism. Thus, what he really wants to express is his willingness to avoid radical or extreme positions, mainly in the empiricist camp.

Although Strawson recognizes that he has not developed a "system," like the great modern thinkers (Descartes, Spinoza, and Kant),[27] the different parts of his philosophy point to a common direction. His theory of knowledge does not have an independent status: it is connected to other philosophical subjects, such as the theory of meaning—his philosophy of language—couched within the general idea of philosophy as a conceptual activity: "concepts of the real can mean nothing to the user of them except insofar as they relate, directly or indirectly, to possible experience of the real."[28] Language and experience are interdependent, both related to our conceptual scheme. This overall perspective, where philosophy is one unified enquiry, is a *contemporary* one: the emphasis is on human language, in general, and the problems of meaning, in particular, as the central issues for philosophy. These topics (i.e., sense, reference, use, . . .) are characteristic of analytic philosophy and constitute a clear contribution to contemporary thought.[29] In fact, from G. Frege onwards, they are among the features which make contemporary philosophy different from modern philosophy.[30] The main difference with Frege lies in Strawson's deliberate attempt to reconstruct empirical knowledge (especially, the Kantian theory of knowledge) using notions taken primarily from language (i.e., sense and conceptual structure), because he links the bounds of sense—its significance—with the conceptual scheme which underlies the use of ordinary language.

2. STRAWSON'S EMPIRICISM AS POST-KANTIAN

Already the contemporary character of Strawson's empiricist approach has been established. A crucial feature of his perspective is its *post-Kantian* character.[31] This is not a mere chronological trait, based in a pure temporal ascription; on the contrary, it is a constitutive element of his whole theory of knowledge.[32] In effect, among the main characteris-

tics of his philosophy is his constant interest in the Kantian theory of knowledge. In fact, he develops a perspective which is frequently sympathetic to Kant's positions. This occurs not only in his main contribution to this realm, *The Bounds of Sense*, but also in his essays on metaphysics, *Individuals* and *Analysis and Metaphysics*,[33] as well as in aspects of his philosophy of language. It is clear that important elements of what he calls "the metaphysics of experience" of the *Critique of Pure Reason*[34] (such as space and time, objectivity and unity, permanence and causality) have a direct echo in Strawson's conceptual scheme. That Kantian influence also affects his philosophical use of imagination,[35] especially in his construction of a different world (only with sounds) in *Individuals*.[36] Moreover, there is also an important coincidence with Kant in the philosophical *method*, above all in metaphysics, insofar as both are dealing with the "conceptual structure which is presupposed in all empirical inquiries."[37]

Simultaneously, following the main trend in British philosophy to date, Strawson elaborates a position in theory of knowledge which is in line with central tenets of empiricism (such as the role of experience regarding the significance of language or the interpretation of the universals and their relations with abstraction[38]). In this regard, he seems to combine two different components: on the one side, he assumes a Kantian position, the transcendental argument,[39] which is antinaturalistic in its specific elements,[40] (particularly as philosophical method); and, on the other side, Strawson adopts an empiricist perspective of human knowledge, which involves a kind of naturalistic approach (the assumption that human knowledge is "naturally" well oriented as it stands), and is related to his "linguistic naturalism."[41] Thus, the problem of consistency appears once again: is his theory of knowledge, in some way, a mixture of very different perspectives on the starting point and the characteristics of human knowledge?

Peter Strawson holds emphatically that "Kant's *Copernican Revolution* can plausibly be seen as having substantially prevailed in the philosophical tradition to which I belong."[42] However, it does not mean that transcendental idealism has achieved a full acceptance among British philosophers during the twentieth century, because it is patent that only few aspects of that philosophical orientation are alive or flourishing among British thinkers. De facto, the prevailing aspects in those thinkers who have taught and published in English are frequently far from the idealist tendency of Kant's transcendental deduction. This is the case in the author of *The Bounds of Sense*, who assumes many aspects of Kant's theory of knowledge regarding sense perception (the "metaphysics of experience"), while disregarding the metaphysics of transcendental idealism of the *Critique of Pure Reason*. For him, the

ambivalence is clear: the book contains "great insights and great mystification."[43]

Hence, there are two different sides in his approach. The *positive* side supposes that the *Critique of Pure Reason* has important achievements. The main contribution is, for Strawson, that Kant carries out the program of "determining the fundamental general structure of any conception of experience such as we can make intelligible to ourselves."[44] He considers that the part of the *Critique* which is most interesting and original consists of "the investigation of that limiting framework of ideas and principles the use and application of which are essential to empirical knowledge, and which are implicit in any coherent conception of experience which we can form."[45] But, according to the *negative* side, Kant goes too far with this program about human knowledge, because Strawson maintains that the essence of this "Copernican revolution" (the theory of mind making nature) is not acceptable. Thus, he rejects that the very possibility of knowledge of necessary traits of experience can be seen, like in Kant, as dependent upon a transcendental subjectivism.[46] This is a substantial obstacle for his sympathetic understanding of the *Critique,* because he does not support the doctrines of transcendental idealism and the associated picture of the receiving and ordering apparatus of the mind producing nature as we know it, outside the unknowable reality of things as they are in themselves.[47] He insists on seeing as unacceptable the conception of a "transcendent metaphysics" which is concerned with a realm of objects inaccessible to experience.[48]

Within Strawson's theory of knowledge, this negative side has special weight: he considers that Kant's Copernican theory was not well founded. For Strawson, that attempt at explaining the status of synthetic a priori propositions (a key point for a reformed metaphysics compatible with scientific knowledge) fails because "Kant nowhere gives an even moderately satisfactory theoretical account of the dichotomy between analytic and synthetic a priori propositions; nor can any be gleaned from his casually scattered examples."[49] He emphasizes the existence of important deficiencies in the position on human knowledge in the *Critique*:

> all Kant's treatment of objectivity is managed under a considerable limita-
> tion, almost, it might be said, a handicap. He nowhere depends upon, or
> even refers to, the factor on which Wittgenstein, for example, insists so
> strongly: the *social* character of our concepts, the links between thought and
> speech, speech and communication, communication and social
> communities.[50]

These important discrepancies do not impede Strawson's acknowl-edgment of Kant's relevant contributions to the new foundations for metaphysics and to the study of human knowledge. Strawson argues that

Kant gives us two out of three assumptions which allow us to comprehend that we have the functions of judgment (the logical forms and therefore, presumably, just the pure concepts) and the spatio-temporal forms of intuition that we in fact do have.[51] The assumptions are, first, that we are creatures whose intellect is discursive and, second, that our intuition is sensible. These components are admitted and proclaimed by Kant. But his theory of knowledge rejects Strawson's third assumption (which is particularly important in his conceptual scheme): that objects and ourselves are, as they are in themselves, spatio-temporal things. This difference is crucial, because in Kant there is a defense of the ideality of space and time, which is a decisive element in the doctrine of transcendental idealism.[52]

In spite of this difference, Strawson stresses the direction towards "empirical realism" of Kant's transcendentalism. He offers an explanation of the Kantian view that human sensibility includes spatial and temporal forms of intuition: "the objects, including ourselves, *are* spatio-temporal objects, are *in* space and time—where by 'objects' is meant not *just* 'objects of possible knowledge' (though that is also meant) but objects, and ourselves, as they really are or are in themselves."[53] Furthermore, Strawson considers that, in judgment, we employ and apply

> general concepts to the objects of sensible intuition; the very notion of the generality of a concept implies the possibility of numerically distinguishable individual objects falling under one and the same concept; and, once granted that objects are themselves spatio-temporal, then space and time provide the uniquely necessary media for the realization of this possibility in sensible intuition of objects.[54]

Establishing this interpretation of Kant's theory of knowledge in his recent papers, which reinforces its empirical side (i.e., that spatio-temporal intuition of objects is a uniquely fundamental and necessary condition of any empirical knowledge of objects), Strawson here follows the lines which were already in *The Bounds of Sense*. In this book the essential issue is the *principle of significance*: the need for empirical application for the concepts. According to that principle,

> there can be no legitimate, or even meaningful, employment of ideas or concepts which does not relate them to empirical or experiential conditions of their application. If we wish to use a concept in a certain way, but are unable to specify the kind of experience-situation to which the concept, used in that way, would apply, then we are not really envisaging any legitimate use of that concept at all. In so using it, we shall not merely be saying what we do not know; we shall not really know what we are saying.[55]

Reinterpreting Kant's theory of knowledge in an empiricist way leads to a double phenomenon: on the one hand, Kant's theory could be used

to show the deficiencies of the British modern empiricists (the limitations of the "classical" empiricism); and, on the other hand, it leads to a post-Kantian version of the empiricism itself (an approach which avoids the idealist stance), which is what Strawson does de facto. For him, the central doctrine of empiricism is just that without experience of the real, we should not be able to form true beliefs about it. He asseverates that this is the truth on which Kant emphasized decisively: "the very concepts in terms of which we form our primitive or fundamental or least theoretical beliefs get their sense for us precisely as concepts which we should judge to apply in possible experience situations."[56] Furthermore, Strawson holds that Kant freed this principle from the errors of classical or atomistic empiricism.[57]

In this regard, insofar as Kant builds a positive metaphysics of experience, he departs sharply from the main claims of classical empiricism. In effect,

> the central problem of classical empiricism was set by the assumption that experience really offers us nothing but separate and fleeting sense-impressions, images and feelings; and the problem was to show how, on this exiguous basis, we could supply a rational justification of our ordinary picture of the world as containing continuously and independently existing and interacting material things and persons.[58]

Even though Strawson recognizes that Kant avoids these limitations and confusions of classical or atomistic empiricism, nevertheless the direct criticism appears: Kant "encased his correct understanding of the principle in a doctrine—that of transcendental idealism—which violated it; but even if so, it may still be possible to detach what is valid in his interpretation from the casing which surrounds it; whereas the confusions and limitations of classical empiricism are inherent in it."[59] Thus, there is in Strawson a recognition of a post-Kantian empiricism: there are valid elements in Kant's theory of knowledge which avoid the inadequate version of empiricism and, at the same time, this genuine empirical content can be protected from the transcendental idealism.

3. THE REJECTION OF RADICAL EMPIRICISMS

There is in Strawson a natural tendency to avoid radical claims in philosophy in general, and in the theory of knowledge in particular. For him, it is clear that "extreme positions are rarely right."[60] This attitude has many consequences in his gentle way of doing philosophy, where he always seeks the positive aspects of the views which he rejects. However, the list of empiricisms that he rejects is not short: (1) the British empiricism of the Baroque period (J. Locke, G. Berkeley, and D. Hume);

(2) B. Russell's logical atomism; (3) R. Carnap's neopositivism; (4) A. J. Ayer's logical positivism; and (5) W. V. Quine's epistemological naturalism.[61] All of them are for him, in one way or another, the expression of a *reductive* way of understanding what philosophy is and, therefore, what is the genuine content of the theory of knowledge.[62]

Following this negative path of examining what he rejects, it is possible to be closer to what he really stands for. The focus is still in the initial question: what kind of empiricism is defended by an author who belongs to the analytic tradition and works very frequently on Kant's thought? The reply cannot be straightforward, because there are several possible kinds of empiricisms; some of them are in sharp contrast with Strawson's positions, whereas others seem sympathetic to his proposals in the theory of knowledge. In this section, the emphasis is on the disagreements, while in the next one he focuses on the similarities. The former attends to the "reductive" approaches, whereas the latter deals with the empirical doctrines which are "nonreductive."

Chronologically and thematically, the first empiricism is the British modern thought of Locke, Berkeley, and Hume. Among them, Strawson usually stresses the importance of the last one, but he does so following two different lines: on the one hand, he considers that David Hume was really interested in our conceptual scheme (the "descriptive" aim of philosophy); but, on the other hand, Strawson also thinks that Hume tends to change this conceptual structure (the "revisionary" motive of philosophy).[63] This ambivalent interpretation of Hume is based on the idea that

> there is an unresolved tension in Hume's position (a tension which may be found reminiscent in some ways of the tension between Kant's empirical realism and his transcendental idealism). One might speak of two Humes: Hume the skeptic and Hume the naturalist; where Hume's naturalism . . . appears as something like a refuge from his skepticism.[64]

According to Strawson, the Humean program seeks to exhibit the structural connections among concepts and accepts the need of a philosophical analysis to get the *ultimate* or *simple* elements of the conceptual scheme. In this reductive approach, the *atoms* of analysis are fleeting items of experience which Hume called *impressions*, whose (supposed) copies in imagination and in memory were simple *ideas*. Strawson considers that program (and that tradition) dead or, at least, moribund, in its extreme form; whereas a more *moderate* version is still alive, because some problematic concepts can be reduced to some others which are felt to be more perspicuous.[65] Thus, the extreme form is rejected (i.e., the complete reduction of complex concepts to the absolutely simple), whereas the moderate version is accepted (i.e., some

problematic concepts are explained in terms of some others which are more basic). Therefore, the Humean search for simple ideas is no longer acceptable within the theory of knowledge which assumes our conceptual structure, the conceptual scheme of ordinary language.

Regarding the British "classical" empiricism (and contemporary empiricisms insofar as they are an updated version of the modern reductive analysis of knowledge), Strawson makes his criticism explicit.[66] (i) There is no question of justifying the general structure of ideas on the narrow basis of the notion of a "temporally ordered sequence of subjective states." That general scheme of ideas in itself, understood as the general framework of our thought, is the basic thing. (ii) An explanation of the ontogenesis of the framework of concepts can be attempted or given in psycho-physiological terms; but the very terms of the explanation belong to, or presuppose, that framework. (iii) It would be very hard to find a single philosopher nowadays who retains any confidence in the original program of definitional reduction. The difficulties of reduction seem nowadays insuperable, and the concepts of *material objects* are themselves indispensable to a veridical description of the very sense experiences in terms of which they were to be defined.[67]

A contemporary empiricism, from the chronological point of view, is Russell's logical atomism. But, for Strawson, it seems a *modern* empiricism, insofar as Russell is seen as a continuation of the British classical empiricists. From *On Referring* to *Analysis and Metaphysics*, there are comments linking logical atomism to classical empiricism, which are usually followed by a criticism. In that paper the connection is with Locke,[68] whereas in the book the association is with Hume. This one is directly related to our topic here, because for Strawson the Humean reductive program, which looks for "simple ideas," is analogous to the logical atomism (with its "atoms") to which Lord Russell adhered towards the end of the first quarter of the twentieth century.[69] As an alternative to that logical empiricist approach, there is a connective model of concepts—instead of simple or ultimate ideas—in addition to praise of "Immanuel Kant who made the most serious and determined effort to establish a certain minimal conceptual structure as necessary."[70]

Another kind of reductive analysis, understood also both in a cognitive and a logical way, is in the logical positivism of the Vienna Circle (which, after internal and external criticisms, become a logical empiricism, i.e., a conception without "verification," the "received view" in its final version). The theory of knowledge which embedded the scientific approach developed by R. Carnap (and, in Britain, by A. J. Ayer)[71] was, in effect, a radical version of empiricism (properly called "neopositivism," because knowledge and meaning were merged in a way

unknown by the positivism of the last century). The method followed by Carnap in philosophical clarification was the construction of a formal system, in which the concepts forming the subject matter of the system were introduced by means of axioms and definitions. Besides the system there were extrasystematic remarks; they had to relate the concepts of the system to concepts which we use already in an unsystematic way. This method of "rational reconstruction," based in formal logic, is quite different from Strawson's descriptive method, which seeks to describe the actual conduct of actual words.[72] Thus, there is a clear contrast regarding the conceptual scheme of ordinary language, because the connectionist model of Strawson seeks to make explicit the real content of the language that we used, whereas the Carnapian reductive model tries to replace it by a precise "perfect language" (a logical one).

Carnap's verificationism, the type of empirical investigation which he follows, has no echo in Strawson's post-Kantian empiricism. In this case, the Wittgensteinian influence on him is noticeable, because his philosophical aim is to describe the real use of language and the type of experience which ordinary language exhibits. It seems clear that the ordinary use of language does not suggest a verification of statements, either in a phenomenalistic way or in physicalistic terms. In addition, there is a drastic difference in how they conceive the relations between meaning and truth. For a verificationist of the Vienna Circle, meaning and truth are understood in empirical terms, and the relation is that there is a "verification"—an empirical truth—which guarantees the meaning of the statement (a requirement which metaphysics was not able to fulfill and become more than false, i.e. meaningless). Thus, only the empirically based statements have sense.

But in a Wittgensteinian perspective, meaning matters more than truth, and meaning is given by the rules of use, not by a concrete empirical truth. Following this path, it is possible to get almost the opposite view to the verificationists, because meaning—the use of statements in the appropriate circumstances—is what allows us to have truth. De facto, for Strawson meaning has more weight than truth.[73] Moreover, he puts the key point in the use of language (i.e., in the pragmatic factor, instead of in the semantical dimension, which was the focus of logical positivism). Therefore, for him, far from considering a statement meaningful because it has been verified, truth depends finally on the rules of language and the communication-intention of the speaker,[74] because the "reference, direct or indirect, to belief-expression is inseparable from the analysis of saying something true (or false)."[75]

Besides the stress on human speech for understanding human language (including topics such as meaning and truth), in Strawson's philosophy there is no elbow room for *Protokollsätze*, a foundationalist

grounding for all empirical knowledge. In effect, he neither selects one class of propositions as the foundation-class of propositions, nor thinks that it would be necessary to look for such a class.[76] This criticism also affects A. J. Ayer, insofar as the author of *Language, Truth and Logic* supports the observational statements as "foundations" for guaranteeing the truth (understood in verificationistic terms). That neopositivist program is at odds with Strawson's moderate proposals on empirical knowledge, even though Putnam considers him *too* empiricist on notions like "sense" and "conceptual truth."[77] In any case, there is a marked contrast, in most respects, between his theory of knowledge and those conceptions of Carnap and of Ayer.

Nonetheless this criticism of the logical positivists, Strawson himself recognizes that Ayer adopted different versions of empiricism in his long career. This recognition of varieties of empiricism arises from a triple characterization made by Strawson: (a) the general structure of our thought is to be regarded as a kind of *theory* which is elaborated on the basis of the sequence of subjective states; (b) the general structure of our beliefs is thought of, not as a theory that calls for a reasoned justification, but rather as a way of thinking to which we are naturally committed; and (c) all the notions which constitute the general structure of our thought apart from the elements accepted as basic are what used to be called 'logical constructions' out of those basic elements. Ayer was originally an adherent of the third, a line sympathetic to Carnap, but later preferred a theory in which the first is mingled with the second (which is Hume's variety of empirical approach).[78]

Comparing Strawson's post-Kantian empiricism—a conception which accepts important criticisms from Kant of classical empiricists—with the empiricisms in the theories of knowledge of neopositivists (and logical empiricists, such as Carnap or Ayer), it is clear his approach is more *Kantian* than these authors. It seems more patent if we accept a criterion suggested by Putnam, because he has emphasized that the point where Kantianism differs from empiricism is not in attributing to us any mysterious faculty

> which could give us direct access to things in themselves, but in upgrading *reflection on the presuppositions of knowledge* to the status of a fundamental source of knowledge. Carnap and Reichenbach also favored reflection on (scientific) knowledge, of course; that is what philosophy *is* in their conceptions, but the notion of *presupposition* of knowledge disappeared from their thought, to be replaced by the notion of linguistic convention.[79]

Strawson deals in effect with the problem of the presuppositions of knowledge and thinks, in addition, that Kant established "the lower limits of sense."[80]

Quine is probably the author whose theory of knowledge is most

often criticized by Strawson and, generally, in a straightforward way. He represents a strong version of naturalism, a narrow-minded approach to human experience: "the thoroughgoing anti-intensionalist, the determined reductive naturalist."[81] In effect, regarding the relations between the limits of our language and the limits of our world, Strawson judges that "Quine can be represented as an extreme case of this restrictiveness: as one disposed to limit what exists to what is comprehensible by one particular kind of *human understanding*, the kind that yields physical and biological theory."[82] This strict naturalism, clearly oriented towards a scientifically minded human knowledge, relies completely on the ephemeral sensory stimulation.[83] Therefore, there is no doubt, as Strawson himself has pointed out, that they maintain two different conceptions of philosophy.[84]

Taking into account Strawson's rejection of radical forms of empiricism (mainly the skeptical version of Hume's reductive analysis of knowledge and the restrictive neopositivist primacy of some empirical statements), it seems clear that he is ready to affirm that the empiricism which he retains "is not of a markedly classical or positivist variety."[85] On the one hand, he does not want to be considered a modern thinker—someone closer to the classical British empiricists; but, on the other hand, he is also unwilling to be identified with some contemporary philosophies built on empiricist bases. In addition, there is a general idea that he expresses in many ways: there exists a conceptual scheme or a basic structure of beliefs to which we are inescapably committed, which includes the belief in the existence of physical objects and the practice of inductive belief-formation, the "natural metaphysics."[86] What kind of empiricism could be supportive of a natural metaphysics?

His starting point shares a common ground with other empiricisms: there is certainty in some sense perceptions. In effect, for Strawson, although it is not implied that sense perception always yields true judgements, "it is certainly a feature of our ordinary scheme of thought that sense perception is taken to yield judgements which are generally or usually true."[87] His notion of "sense perception" includes the causal dependence of the experience enjoyed in sense perception on features of the objective spatio-temporal world. The possibility of certainty regarding empirical knowledge suggests the cognitive basis for that "natural metaphysics," the kind of ontological naturalism which he is able to endorse: "we are not logically compelled to draw from these facts the conclusion that things, as they really are, are different from things as they appear to us under normal conditions of perception."[88]

Between some empiricisms—especially, the strong versions—and Strawson there is a clear difference regarding objectivity, because for him "our sensible experience is permeated . . . by concepts of the objec-

tive world, the world spread out in space and time, how things are in which determines the truth or falsity of our judgements."[89] Nevertheless, he does not have a genuine realist approach and so does not dissolve some characteristic claims of the empiricism, either conceived in classical terms or in more recent varieties (which affect B. Russell or A. J. Ayer). Thus, although Strawson criticizes these positions, he often accepts elements of the views which he explicitly rejects. This happens in the cases of J. Locke,[90] B. Russell,[91] or A. J. Ayer.[92] But this *eclectic* tendency is not strong enough to be incoherent: Strawson is not a real follower of "Lockian realism,"[93] of Russell's conception based on sense data, or of Ayer's phenomenalism or his later "sophisticated form of realism."[94]

Despite his tendency towards eclecticism, there is a "genuine" Strawsonian position on knowledge, a *moderate empiricism*.[95] This perspective shares, to some extent, the characteristics of a critical realism.[96] (1) Fallibilism is a feature of perceptual knowledge: "*every* source of primary data, (or prima facie evidence), is fallible, its deliverances liable to correction in the light of reflection and/or subsequent experience."[97] (2) The sphere of human knowledge can go beyond immediate experience: "it would be perverse to deny that we have access, through observation and testimony, to data which demand explanation of the kind which we call 'historical' or 'social'."[98] (3) Empirical knowledge, either in natural sciences or in human and social sciences, cannot exclude nonobservational concepts: an explanation (or an understanding) of persons requires concepts such as "intentional human action" (there is not a purely physical "behavior").[99] (4) Human knowledge needs intensional concepts: "any attempt to purify the theory of knowledge of all intensional notions is doomed to failure."[100] These aspects reveal that Strawson's rejection of radical empiricism is compatible with a defense of a moderate empiricism.

4. The Nonreductive Empiricisms

What Strawson's empiricism cannot accept is a reductive approach, especially if it is understood as a unique one, i.e., a view which excludes any other kind of perspective. His position accepts the compatibility between scientific views and ordinary perspectives. To some extent, it is a conception sympathetic to another version of contemporary empiricism: G. E. Moore's doctrine of *common sense*.[101] Both share, in effect, an interest in the analysis of ordinary language and a type of approach which incorporates a defense of a "common sense" theory of knowledge. But Strawson has done it in a way that exhibits the Kantian influence on

his thought as well as the Wittgensteinian contribution (in his last period). Moreover, his rejection of the reductive empiricism moves him to defend a nonreductive conception.

Among the better known contemporary approaches based on an empiricist theory of knowledge, Moore's thought is the closest to Strawson. The way in which the latter has gotten this proximity to the former is based not only on the acceptance of the philosophical value of ordinary language, but also on several elements of the theory of knowledge: (i) rejection of the extreme version of empiricism: the skeptical one;[102] (ii) approval of Kantian "empirical realism"; (iii) criticism of the atomistic versions of empiricism; (iv) questioning of foundations of knowledge according to a special group of favored propositions; and (v) adoption of a naturalism that includes intentional notions and establishes differences between the predicates of characteristics of mind and of the properties of the body.[103]

For this moderate empiricism, human knowledge is, in principle, naturally well oriented.[104] This is the result of the empiricist reconstruction of Kant's "metaphysics of experience" and the re-elaboration of the Wittgensteinian way of thinking about ordinary language. At the same time, it makes it possible for Strawson to have some relevant affinities with G. E. Moore, especially in relation to his conception of common sense.[105] This attuneness is particularly clear in his latest book *Analysis and Metaphysics*.[106] The recent similarities are neither completely new nor inconsistent with previous claims. In fact, they are consistent with his "doctrinal naturalism," which accepts the philosophical consequences of the description of ordinary language.[107] In effect, to accept that this language is (naturally) adequate for philosophical purposes (i.e., it is correct as it stands) includes, in principle, the acceptance of the perspective of common sense.[108]

When Strawson deals with the philosophy of common sense, he maintains that, among the most important kinds of things there are, two of them are material or physical objects and acts or states of consciousness. He also mentions the fact that "at least the first of these kinds of things are in space and both of these kinds of things are in time."[109] But there is a difference between Moore and Strawson: where the former speaks of the most general kinds of things that exist in the universe, the latter speaks of "the most general concepts or concepts-types which form part of a scheme or structure of ideas or concepts which we employ in *thinking and talking* about things in the universe."[110] Thus, Strawson emphasizes his own philosophical procedure: it talks about our *conceptual structure*, the structure of our thought about the world, rather than, as it were, directly about the world. It seems to me that, regarding the general philosophical focus (which includes the crucial role of descrip-

tion as philosophical method and common sense in theory of knowledge), Strawson is closer to Moore than to Aristotle and Kant,[111] whom he mentions as the "descriptive metaphysicians" in *Individuals*.[112]

Still Strawson does not endorse Moore's defense of common sense completely. This aspect is in keeping with the Kantian influence upon the author of *The Bounds of Sense*. In effect, there is a critical factor in his view of human knowledge: "simple dogmatism settles nothing in philosophy."[113] Moreover, Strawson does not embrace the validity of Moore's proof of an external world against the skeptical thesis that it cannot be known with certainty that material objects exist. In fact, in his book *Skepticism and Naturalism*, he holds that "if Moore, in making the claims he made, was simply relying on his own experience being just the way it was, he was missing the skeptical point altogether; and if he was not, then, since he issues his knowledge claims without any further argument, all he has done is simply to issue a dogmatic denial of the skeptical thesis."[114]

Certainly Strawson's approach is not sympathetic to skepticism, but his perspective gives some elbow room to skepticism insofar as he encourages us towards criticism and cautions us against credulity.[115] In his conception, the main interest should be in the most general concepts or categories, in terms of which we organize our thought about—and our experience of—the world. Moreover, those concepts must have application to the world of our experience for it to be possible to have objectively true judgments. Even though this is under Kantian influence, which includes criticism regarding human knowledge, it is de facto linked to a moderate empiricism about perception: "though not *every* accepted belief or purported piece of information can be checked or tested against the evidence of our eyes and ears, some can be so tested and many should be. We cannot coherently question everything at once; a radical and all-pervasive skepticism is senseless; but one of the things we learn from experience is that selective skepticism is wise."[116]

Again, this combination of a Kantian method (antinaturalist) with empiricist contents (naturalist) leads us towards a *new common sense* perspective, because a central claim in Strawson's theory of knowledge is his emphasis on the need of being quite faithful to the actual character of our ordinary experience. It demands that, at any instant in the ongoing stream of "episodes of sensible affection", our perceptual experience involves the deployment of concepts of objects of the desired sort. Thus, our representational states at each moment are thoroughly permeated by such concepts.

> The truth that perceptual experience *at any given moment* is to be thus characterized is precisely what is necessary and sufficient to link the actual current perception or representational state to other, not actually current,

past, or possible future representational state Concepts of enduring objects with causal powers have precisely this nature: any actual current perception, or representation, of something as falling under such a concept is essentially linked to other nonactual, noncurrent perceptions of the same kind.[117]

Therefore, some empiricist theses (mainly Humean) are rejected by Strawson, because nonpresent perceptions are in a sense represented in, or alive in, the present perception of the subject of experiences.

In line with this common sense perspective, Strawson maintains that our successive states of conscious perceptual experience are such that they cannot, in principle, be accurately characterized without employing concepts of enduring objects with causal powers. This is, for him, a necessary condition of knowledge arising from perceptual experience. Furthermore, he accepts, from the results of studies in physiological psychology, "that our *conscious* perceptual experience is causally dependent on neuro-physiological processes of immense complexity, processes of which we are *not* conscious at all while we are enjoying the conscious experience that depends upon them."[118] Thus, his views on experience are compatible with developments in empirical (and physiological) psychology, because these particular occurrences and processes in the brain and nervous system are themselves occasioned by impingements on the external organs, and, at the same time, his conception is incompatible with a Kantian imaginary subject of transcendental psychology.

"New common sense" theory of knowledge and "nonreductive naturalism" on human knowledge are two ways to refer to Strawson's empiricist approach. Both coincide in the validity of the basic scheme of concepts where questioning or justifying beliefs can take place (i.e., there is a realm for serious operations of reason).[119] At the same time, those labels are far from a "scientism" that supports "a dismissive attitude to whatever cannot be exhaustively described and accounted for in the terms of physical science; an attitude which, in its extreme form, amounts, in the present context, to a refusal to recognize the existence of subjective or conscious experience altogether."[120] This is, as he points out, the kind of naturalism of some professors, such as J. J. C. Smart and D. M. Armstrong.

"Naturalism" is also a term which Strawson uses for the position which he invokes.[121] However, Quine's theory of knowledge, especially since "Two Dogmas of Empiricism,"[122] has long been considered the genuine "naturalist" program, though some new naturalisms have now emerged.[123] According to A. Rosenberg, that paper "made philosophical space for naturalism as a viable alternative to positivism and ordinary language philosophy";[124] whereas Strawson—as we have seen in the

previous pages—criticizes neopositivism and the naturalized epistemology, defending the analysis of ordinary language. The difference is once more in the content of term used. In this regard, "naturalism" in a Quinean form produces a reductive scientific version, as Rosenberg has pointed out: "once the distinction between the analytic and the synthetic is surrendered, the demarcation between scientific theory and philosophical analysis is extirpated. Philosophy neither needs to nor can defend itself as merely the logical clarification of thought. It need no longer fear to tread the same standards as very abstract scientific theory. For that is the only thing philosophy can be for those who accepted "Two Dogmas [of Empiricism]." But "naturalism" has come to label that movement in philosophy which is willing to adopt Quine's arguments against empiricism, but not to go the whole way with Quine towards eliminativism about modality and meaning."[125]

That is the case of Strawson, who builds his naturalism against Quine's eliminativism about modality and meaning.[126] In addition, his views are different from Quine's "verbal behavior" as well as distinct from the "identity thesis" which derives from his naturalism in the case of the mind-body problem. The gap between the two kinds of naturalism is clear: the non-reductive variety recognizes the human inescapability and metaphysical acceptability of those various types of conception of reality which are challenged by reductive arguments.[127] This happens in the important notion of the *subject of experiences*, who is characterized by Strawson as "a being both conscious and corporeal."[128] The distance from reductive naturalism of the scientific sort is then obvious and it becomes bigger insofar as Strawson has no inconvenience in making a mixture of *doctrinal naturalism* with a *methodological antinaturalism*. For his doctrine is naturalist on topics as basic as language, where he accepts the Wittgensteinian correctness of ordinary language and the contents of the descriptive task as the main ingredients of Philosophy; but he also admits the antinaturalistic enterprise, because he subscribes to its adequacy for philosophical purposes. In effect, he has no inconvenience in using the imagination (for example, creating the world of sounds, in chapter 2 of *Individuals*) for the philosophical aim of clarifying how our real world is.

Finally, there is a clear answer to the questions which I brought up at the beginning: Strawson is not incoherent in his theory of knowledge when, using a contemporary approach (a Wittgensteinian idea of language), he adopts a new kind of empiricism (a post-Kantian version[129]) compatible with a nonreductive naturalism. Dealing with language and experience, he does not mix very different conceptions about the starting point and features of human knowledge. On the one hand, what he accepts of Kant's approach is his "empirical realism" according to the

principle of significance. Thus, the reconstruction of *Critique of Pure Reason* in *The Bounds of Sense* as well as in recent papers is consistent with Strawson's rejection of idealism and his clear tendency towards a moderate empiricism. On the other hand, he maintains that Kant freed the central principle of empiricism from the errors of classical or atomistic empiricism.[130] In other words, the concept user is made aware of reality in experience, but that experience is not simply a convenient link with the world.[131]

But Strawson manifests a tendency towards eclecticism insofar as he accepts a dependence on Kant's transcendentalism and, at the same time, he defends a perspective linked to common sense. In many cases, his claims on human knowledge may be better understood under the influence of Wittgenstein's philosophy. In this regard, Strawson's rejection of the subjectivism of classical empiricism (Locke, Berkeley, and Hume) could be interpreted as a direct consequence of Wittgenstein's criticism of the egocentric focus (i.e., the primacy of one's own case regarding human knowledge).[132] Both emphasize the intersubjective factors (mainly, the use of language) within a descriptive attitude in philosophy. However, they offer somewhat different arguments: Strawson likes to follow Kantian lines on human knowledge (on concepts, judgments, and experiences), understood in an empiricist way and seeking objectivity in the contents, whereas Wittgenstein adopts a more pragmatic view and insists on the problem of certainty according to an intersubjective emphasis on the uses of propositions. Thus, the final picture is different, because Strawson's perspective—but not Wittgenstein's—is a post-Kantian empiricism; in fact, it includes a Kantian perspective on human knowledge compatible with the plausibility of common sense.

The philosophical basis of his theory of knowledge is an updated and sophisticated version of empiricism (a post-Kantian and nonreductionist one), a new step in the long British tradition of empiricism. His approach, focusing on language and experience, avoids many of the "classical" problems of empiricism. But, it seems to me that improvements need to be made in order to achieve his aim of clarifying the conceptual structure of the ordinary subject of experiences. I will point out here only two of them: (a) the need to incorporate, in a more explicit form, the historical aspects of the human being as individual and as a member of the society; and (b) the importance of a better understanding of the notion of "concept," to be able to reach the goal of the objectivity of knowledge.

Both problems have clear roots in Strawson. In the first case, neither the British tradition of empiricism nor Wittgenstein have paid real

attention to the human *historicity,* i.e., to the fact that the human being has a historical character and it is also involved in a society which is historical as well. Human activity has, in effect, a dynamic aspect, besides its static component, both in individual actions and in social actions.[133] The conceptual scheme of persons—the subjects of experience—includes the important range of concepts regarding history, time, and change. Moreover, the human reality and the social world are intelligible in historical terms; and the historical aspects in human knowledge are now widely recognized in science.[134] Strawson accepts that "the human world-picture is of course subject to change."[135] But, on the one hand, he rejects completely the category of "process";[136] and, on the other hand, he sees the acceptance of the historical aspects as a submission to a "historicist" conception (in the sense of R. G. Collingwood).[137] However, insofar as he seeks the real human world-picture, he cannot omit the historical aspects: the human nature which he emphasizes does not go without the historical dimension.

Concerning the second case, the notion of "concept," even though Strawson has made steps in the right direction in order to look for more objectivity in knowledge than other empiricists, the final aim is not completely achieved. The reason is that he does not guarantee the *objectivity* of the concept itself. In effect, his notion of "concept" highlights his tendency towards a kind of eclecticism. If, on the one hand, he seems to accept the position of the realism of common sense; on the other hand, his preference goes to the Kantian view that there are general concepts which are exemplified in a variety of particular cases.[138] Furthermore, he rejects the notion of "concept" as genuine *resemblance* between the subjective representation and the objective reality; and he also disregards the idea of "perceptual representation" as such.[139] Thus, he does not accept the existence of representations as mediators between the subject who knows and what is known; therefore, he assumes a direct perception. For him, the "concept" is something which accompanies what is "given,"[140] without a specific content and without configuring the extramental reality. He thinks that a general concept could be exemplified in a great number of different concrete instances. The concepts are principles of collection and also "principles of distinction";[141] but, in his approach, they do not carry out a genuine intellectual possession of the reality. It is, finally, a notion compatible with a *conceptualism* of an empiricist character.[142]

Beyond this conceptualism, there is a realist approach where the *concept* itself could be objective. It differs from the conceptualist style which connects the concepts as "constructions" with spatial and temporal experience of bodies and persons, because this notion does not

guarantee the objectivity of the *content* of the concept. For a realist, in that conceptualist view, the concept itself cannot have a genuine intellectual possession of the reality. What exists in the concept and what exists in reality could be the same, but it is possessed in a different way: the intellectually concept can contain what physically exists in the world. Then the concept appears as a mental representation insofar as it intervenes in a psychological act, but the concept itself does not depend on that act. Objectivity of the concept does not require it to be a Platonic entity; but it does require it to be accessible to thinkers in general. In my judgment, this objectivity in the content of concepts is needed in Strawson's theory of knowledge in order to avoid the criticisms that he has not overcome some central problems of empiricism. His post-Kantian approach, embedded with Wittgensteinian suggestions, constitutes a more realistic perspective to human knowledge than a vast majority of empiricists.

WENCESLAO J. GONZALEZ

CENTER FOR PHILOSOPHY OF SCIENCE,
UNIVERSITY OF PITTSBURGH
UNIVERSITY OF LA CORUÑA, SPAIN
MAY 1997

NOTES

1. "The general theory of being (ontology), the general theory of knowledge (epistemology), and the general theory of the proposition, of what is true or false (logic) are but three aspects of one unified enquiry," P. F. Strawson, *Analysis and Metaphysics* (Oxford: Oxford University Press, 1992), p. 35.
2. Cf. P. F. Strawson, "My Philosophy," in P. K. Sen and R. R. Verma (eds.), *The Philosophy of P. F. Strawson* (New Delhi: Indian Council of Philosophical Research, 1995), p. 18. As is well known, he considers two authors very different in their approaches, Aristotle and Kant, as "descriptive metaphysicians" and, therefore, in connection with the "descriptive metaphysics" that he proposes, cf. Strawson, *Individuals: An Essay in Descriptive Metaphysics* (London: Methuen, 1959), p. 9.
3. H. Putnam stresses this point. Moreover, he considers that Strawson is too empiricist, cf. Putnam, "Logical Positivism, the Kantian Tradition, and the Bounds of Sense," in Sen and Verma, *The Philosophy of P. F. Strawson*, pp. 145–60; especially, p. 146.
4. In addition to what has been published in the books, in recent years he has focused on Kant in several papers: Strawson, "Kant's Paralogisms: Self-Consciousness and the 'Outside Observer'," in K. Cramer, H. F. Fulda, H. Horstmann, and U. Pothast (eds.), *Theorie der Subjetivität* (Frankfurt:

Suhrkamp, 1987), pp. 203–19; Strawson, "Kant's New Foundations of Meta-physics," in D. Henrich and R. P. Horstmann (eds.), *Metaphysik nach Kant?* (Stuttgart: Klett-Cotta, 1988), pp. 155–63; Strawson, "Sensibility, Understand-ing, and the Doctrine of Synthesis," in E. Förster (ed.), *Kant's Transcendental Deductions* (Stanford: Stanford University Press, 1989), pp. 69–77; and Straw-son, "The Problem of Realism and the A Priori," in P. Parrini (ed.), *Kant and Contemporary Epistemology* (Dordrecht: Kluwer, 1994), pp. 167–73.

5. Strawson explicitly recognizes a general or nonspecific influence of Wittgenstein upon him: "I sometimes feel my own work to be in one way, though certainly not in another, quite Wittgensteinian in spirit," Strawson, "My Philosophy," in Sen and Verma, *The Philosophy of P. F. Strawson*, p. 18. Nevertheless, there are important topics, such as "truth," where the positions between them are very close, cf. W. J. Gonzalez, "The Notion of 'Truth' in Wittgenstein's Philosophy of Mathematics," in P. Weingartner and G. Schurz (eds.), *Logic, Philosophy of Science and Epistemology* (Vienna: Hölder-Pichler-Tempsky, 1987), pp. 419–23.

6. Cf. Strawson, *The Bounds of Sense: An Essay on Kant's Critique of Pure Reason* (London: Methuen, 1966), p. 16.

7. Cf. Strawson, *Skepticism and Naturalism: Some Varieties* (New York: Columbia University Press, 1985), pp. 14–21. In fact, Strawson asks how close Wittgenstein is to Hume (cf. p. 17); at the same time, there is an explicit recognition of differences between them (cf. p. 14). David Hume is in the short list of great philosophers who Strawson acknowledges as having influences on his work, cf. "My Philosophy," p. 18.

8. For Dummett, Frege "achieved a revolution as overwhelming as that of Descartes," M. Dummett, *Frege: Philosophy of Language*, 2nd ed. (Cambridge, Mass.: Harvard University Press, 1981), pp. 665–66.

9. Cf. W. J. Gonzalez, *La Teoría de la Referencia. Strawson y la Filosofía Analítica* (Salamanca-Murcia: Ediciones Universidad de Salamanca and Publicaciones Universidad de Murcia, 1986), p. 25. On Frege and his historical context, cf. C. Wright (ed.), *Frege: Tradition and Influence* (Oxford: Blackwell, 1984) and M. Dummett, *Frege and Other Philosophers* (London: Duckworth, 1991).

10. It seems rather obvious that the analytic tradition has developed a variety of new problems, most of them related—in one way or another—to L. Wittgenstein.

11. This phenomenon of the primacy of the theory of meaning (or, in general, the philosophy of language) with foundational features, similar to some extent to those of Aristotle's ontology and Kant's theory of knowledge, has also been pointed out by nonanalytic philosophers, cf. K. O. Apel, "The Transcenden-tal Conception of Language-Communication and the Idea of a First Philoso-phy," in H. Parret (ed.), *History of Linguistic Thought and Contemporary Linguistics* (Berlin: W. De Gruyter, 1976), pp. 32–61; especially, pp. 33–34 and 49–57.

12. Regarding the first case, Dummett maintains that "the first philosopher fully to adopt Frege's perspective was Wittgenstein: the difference between him and Russell is brought out sharply if we compare the *Tractatus* with *The Philosophy of Logical Atomism*," M. Dummett, *Frege: Philosophy of Language*, 2nd ed., p. 679. On the second case, and in spite of the differences between Frege's semantics and Wittgenstein's pragmatics, there are also similarities between them, at least insofar as Frege's sense (*Sinn*) is essentially communica-

ble, as is Wittgenstein's meaning (understood as use). On this issue, cf. M. Dummett, "Frege and Wittgenstein," in I. Block, (ed.), *Perspectives on the Philosophy of Wittgenstein* (Oxford: Blackwell, 1981), pp. 31–42.

13. Cf. Strawson, *Meaning and Truth* (Oxford: Oxford University Press, 1970); reprinted in *Logico-Linguistic Papers* (London: Methuen, 1971), pp. 170–89.

14. Cf. Strawson, *Individuals*, part II, especially, pp. 13–166; and, to some extent, in Strawson, *Subject and Predicate in Logic and Grammar* (London: Methuen, 1974).

15. There are some cases, such as the topic of presupposition, where Strawson's position has a clear precedent in Frege, cf. W. J. Gonzalez, "La presuposición," in J. L. Lopez Aranguren, et al., *Filosofía, Sociedad e Incommunicación* (Murcia: Publicaciones Universidad de Murcia, 1983), pp. 157–73.

16. Cf. Strawson, "Construction and Analysis," in G. Ryle (ed.), *The Revolution in Philosophy* (London: Macmillan, 1956), pp. 97–110; and Strawson, "Analyse, Science et Métaphysique," in L. Beck (ed.), *La Philosophie analytique* (Paris: Editions de Minuit, 1962), pp. 105–38.

17. Cf. Strawson, *Analysis and Metaphysics*, p. 19. Cf. W. J. Gonzalez, "Elucidación filosófica y actividad analítica," *Daimon* 5 (1992): 201–10.

18. According to Dummett's interpretation, this is the case in Wittgenstein's early philosophy: "The *Tractatus* is a pure essay in the theory of meaning, from which every trace of epistemological or psychological consideration has been purged," Dummett, *Frege: Philosophy of Language*, 2nd ed., p. 679.

19. "He wholly rejected an epistemological approach to philosophical problems," P. T. Geach, "Frege," in G.E.M. Anscombe and Geach, *Three Philosophers* (Oxford: Blackwell, 1973), p. 173.

20. Strawson tries to connect Kant with the British empiricists when he interprets the Kantian theory of knowledge. This is a recent example: "So we are left with the result that the appearings, i.e. our temporally ordered representations or perceptions, really do occur in time, while what we are constrained to represent as bodies in space are really nothing apart from those representations themselves. In that case, the difference between Kant's idealism and that of Berkeley is not, after all, as great as he supposed," Strawson, "The Problem of Realism and the A Priori," in P. Parrini, (ed.), *Kant and Contemporary Epistemology*, p. 173.

21. Strawson, "My Philosophy," p. 4.

22. Cf. Strawson, *The Bounds of Sense*, pp. 21, 240, and 256–63.

23. This topic, which assumes that the objects of experience are genuinely spatio-temporal, is crucial for his theory of knowledge, cf. Strawson, *Subject and Predicate in Logic and Grammar*, pp. 15–16; Strawson, "Kant's New Foundations of Metaphysics," pp. 160–61; Strawson, "Sensibility, Understanding, and the Doctrine of Synthesis," p. 72; Strawson, "The Problem of Realism and the A Priori," p. 169.

24. "I admit to a *moderate* empiricism (as also to a *moderate* rationalism)," Strawson, letter to author, 14 September 1992.

25. "Elements of 'moderate rationalism' in my thinking are to be found mainly in my defense of 'intensional notions' like those of *necessity, property, proposition*, etc., all of which would be anathema to a scientifically minded empiricist such as Quine," Strawson, letter to author, 8 February 1993. On these issues, cf. Strawson, "Entity and Identity," in H. D. Lewis (ed.), *Contemporary*

British Philosophy, 4th series (London: Allen and Unwin, 1976), pp. 193–220; and Strawson, *Skepticism and Naturalism*, pp. 69–95.

It is interesting to point out that, according to Strawson, the debate on intensional notions (including meaning and necessity) is among the *nominalist* and the *realist* standpoints, cf. *Skepticism and Naturalism*, p. 93. This distinction is primarily from the theory of meaning (and the philosophy of logic) rather than from the theory of knowledge.

26. The problems of philosophy of logic which Strawson mentions—the debate on necessity, property, proposition, etc., the intensional notions—are not especially characteristic of the modern rationalism, the most influential philosophy on the European continent in the Baroque period. In addition, that idea of being (a moderate) rationalist, in terms of rejecting the (radical) claims of (logical) empiricists, changes completely the field where the *modern* rationalist used to work: this was the *theory of knowledge* rather than philosophy of logic or philosophy of language. (Some "classical" rationalists, such as G. Leibniz, de facto deal with philosophical problems on logic, but that is not *the core* of what is usually called *rationalism*.)

27. Cf. Strawson, "My Philosophy," p. 1.

28. Strawson, *Analysis and Metaphysics*, p. 52.

29. Strawson has shown a real mastery in this context, where he discusses central topics of contemporary analytic philosophy with B. Russell, J. L. Austin, H. P. Grice, and G. Warnock, among others, cf. Strawson, *Logico-Linguistic Papers*, especially, chapters 1, 3, 8, 9, 10, 11, and 12.

30. This fact has been presented by Dummett in terms of a clear contrast with modern philosophy: "Frege's basic achievement lay in the fact that he totally ignored the Cartesian tradition, and was able, posthumously, to impose his different perspective on other philosophers of the analytic tradition," M. Dummett, *Frege: Philosophy of Language*, 2nd ed., 1981, p. 667.

31. In this regard, the main lines of analysis have been drawn in W. J. Gonzalez, "Strawson's Post-Kantian Empiricism," in J. Hintikka, and K. Puhl, (eds.), *British Tradition in 20th Century Philosophy* (Vienna: Hölder-Pichler-Tempsky, 1995), pp. 249–57; especially, pp. 249–51 and 256.

32. On this issue, the important question here is not how Kantian is Strawson's Kant (i.e., the correct interpretation of *The Critique of Pure Reason*) but rather to what extent is Strawson a *Kantian*. Nevertheless, the interpretation given in *The Bounds of Sense* has been influential among the scholars devoted to Kant. In recent times, a discussion with the topics raised by *The Bounds of Sense* is in S. Bayne, "Objects of Representation and Kant's Second Analogy," *Journal of the History of Philosophy* 32, no. 3. (1994): 381–410; and S. Engstrom, "The Transcendental Deduction and Skepticism," *Journal of the History of Philosophy* 32, no. 3 (1994): 359–80.

33. Besides D. Hume, I. Kant is the author most often quoted in *Analysis and Metaphysics*, his last book. This is a symptom of Strawson's interests in dealing with theory of knowledge.

34. It covers the second part of *The Bounds of Sense*, cf. Strawson, ibid., pp. 47–152.

35. Cf. Strawson, "Imagination and Perception," in L. Foster, and J. W. Swanson (eds.), *Experience and Theory* (Amherst: University of Massachusetts Press, 1970); reprinted in Strawson, *Freedom and Resentment and Other Essays* (London: Methuen, 1974), pp. 45–65.

36. Cf. Strawson, "Sounds," in *Individuals*, pp. 59–86. For G. Evans, Strawson's position on *sounds*—a world without space—is de facto a defense of Kantian theses, cf. G. Evans, "Things without the Mind—A Commentary upon Chapter Two of Strawson's *Individuals*," in Z. Van Straaten (ed.), *Philosophical Subjects Essays Presented to P. F. Strawson* (Oxford: Clarendon Press, 1980), pp. 76–116; especially, pp. 77–94.

Kant recognizes a transcendental productive type of imagination, which appears when he deals with the schematism of the mind, cf. I. Kant, *Kritik der Reinen Vernunft*, ed. R. Schmidt (Hamburg: F. Meiner, 1956), A 140/B 179. However, Strawson's proposal does not follow that line, which distinguishes schema and image. For him, "Kant offers . . . complementary impossible tasks to the imagination and draws far-reaching metaphysical conclusions from their impossibility," *The Bounds of Sense*, pp. 205–6.

37. Strawson, *The Bounds of Sense*, p. 18.

38. In these relations, there are several similiarities between Strawson and J. Locke, cf. W. J. Gonzalez, *La Teoría de la Referencia*, pp. 223–30.

39. The role of transcendental arguments is studied by Strawson in connection with different problems, including those regarding skepticism and naturalism. In this case he points out that a transcendental argument claims that one type of exercise of conceptual capacity is a necessary condition of another. He accepts that some transcendental arguments are valid (e.g., self-ascription implies the capacity for other-ascription), cf. Strawson, *Skepticism and Naturalism*, pp. 21–23.

40. Besides Kant's transcendental arguments, Strawson also examines other *antinaturalistic* approaches, such as G. Leibniz's *Monads*. This "revisionary metaphysician" uses an alternative conceptual structure which, nevertheless, Strawson studies in order to shed light on our conceptual scheme, cf. *Individuals*, pp. 117–34. On the relations between their philosophies from a critical point of view, C. Brown, *Leibniz and Strawson* (Munich: Philosophie, 1990)

41. Cf. W. J. Gonzalez, *La Teoría de la Referencia*, p. 254.

42. Strawson, "Kant's New Foundations of Metaphysics," in D. Henrich, and R. P. Horstmann (eds.), *Metaphysik nach Kant?*, p. 155.

43. *The Bounds of Sense*, p. 11.

44. Strawson, *The Bounds of Sense*, p. 44.

45. *The Bounds of Sense*, p. 18. Cf. Gonzalez, *La Teoría de la Referencia. Strawson y la Filosofía Analítica*, pp. 267–70.

46. Cf. Strawson, *The Bounds of Sense*, pp. 22–23.

47. Cf. *The Bounds of Sense*, p. 22.

48. Cf. ibid., p. 18.

49. Strawson, ibid., p. 43.

50. *The Bounds of Sense*, p. 151.

51. Cf. Strawson, "Kant's New Foundations of Metaphysics," p. 159; "Sensibility, Understanding, and the Doctrine of Synthesis," in E. Förster (ed.), *Kant's Transcendental Deductions*, p. 72.

52. Cf. "Kant's New Foundations of Metaphysics," p. 161.

53. "Sensibility, Understanding, and the Doctrine of Synthesis," p. 72.

54. Strawson, ibid.

55. *The Bounds of Sense*, p. 16. Cf. Strawson, *Analysis and Metaphysics*, p. 52.

56. *Analysis and Metaphysics*, pp. 52–53.

57. Strawson, ibid.

58. *The Bounds of Sense*, p. 18.

59. *Analysis and Metaphysics*, p. 73.

60. Strawson, *Analysis and Metaphysics*, p. 5.

61. In the criticisms is implicit the rejection of H. Reichenbach's logical empiricism, an approach that Strawson does not mention. However, the differences between Carnap's original program and Reichenbach's empiricism in *Experience and Prediction* are stronger than the divergence between Carnap's neopositivism and Ayer's logical positivism. On the differences between logical empiricism and logical positivism, cf. W. J. Gonzalez, "Reichenbach's Concept of Prediction," *International Studies in the Philosophy of Science* 9, no. 1 (1995): 35–56; especially, pp. 38–43.

62. The reductive approach in philosophy is the focus of his chapter 2 of *Analysis and Metaphysics*, pp. 17–28. In addition, it is the leitmotif of a substantial part of his book *Skepticism and Naturalism*.

63. Cf. Strawson, *Individuals. An Essay in Descriptive Metaphysics*, p. 9.

64. *Skepticism and Naturalism*, p. 12.

65. Cf. Strawson, "My Philosophy," p. 16.

66. Cf. *Analysis and Metaphysics*, pp. 73–74.

67. Cf. Gonzalez, "Strawson's Post-Kantian Empiricism," p. 252.

68. "Russell repeats Locke's mistake with a difference when, admitting the inference from syntax to reality to the extent of feeling that he can rid of this metaphysical unknown only if he can purify language of the referring function altogether, he draws up his program for 'abolishing particulars'; a program, in fact, for abolishing the distinction of logical use which I am here at pains to emphasize," Strawson, "On Referring," *Mind* 59 (1950); reprinted in *Logico-Linguistic Papers*, p. 22.

69. Cf. Strawson, *Analysis and Metaphysics*, p. 20.

70. *Analysis and Metaphysics*, p. 26.

71. In fact, this approach is developed some years later, when Carnap's verificationism was moving towards "verifiability." Ayer's book is seven years posterior to the Manifesto: A. J. Ayer, *Language, Truth and Logic* (London: Gollancz, 1936).

72. Cf. Strawson, "Carnap's views on Constructed Systems versus Natural Language in Analytic Philosophy," in P. A. Schilpp (ed.), *The Philosophy of Rudolf Carnap* (La Salle, Ill.: Open Court, 1963), pp. 503–18; especially, p. 503.

73. On the relations of meaning and truth in Strawson, with special emphasis in the redundancy theory of truth, cf. W. J. Gonzalez, "Significado y verdad en P. F. Strawson," *Anuario filosófico* 16, no. 2 (1983): 129–39.

74. In his approach to *what is true* there is a belief-dependence: "a given judgement or belief is true insofar as things are in fact as one who makes that judgement or holds that belief thereby believes them to be," Strawson, *Analysis and Metaphysics*, p. 51.

75. Strawson, "Meaning and Truth," reprinted in *Logico-Linguistic Papers*, p. 189.

76. Cf. Strawson, "Does Knowledge have Foundations?", *Teorema*, monographic issue (1974): 99–110, especially, pp. 100–102.

77. Cf. H. Putnam, "Logical Positivism, the Kantian Tradition, and the Bounds of Sense," pp. 145–60.

78. Cf. *Analysis and Metaphysics*, pp. 72–73.

79. H. Putnam, "Logical Positivism, the Kantian Tradition, and the Bounds of Sense," p. 147.

80. *Analysis and Metaphysics*, p. 26.

81. *Skepticism and Naturalism*, p. 73.

82. Strawson, "Kant's New Foundations of Metaphysics," p. 157.

83. Cf. W. V. Quine, "Epistemology Naturalized," in *Ontological Relativity and Other Essays* (New York: Columbia University Press, 1969), pp. 69–90; especially, pp. 86 and 88–89.

84. Cf. Strawson, "Two Conceptions of Philosophy," in R. B. Barrett and R. F. Gibson (eds.), *Perspectives on Quine* (Oxford: B. Blackwell, 1990), pp. 310–18. Another example of important differences in concrete topics: Strawson, "Reference and its Roots," in L. E. Hahn and P. A. Schilpp (eds.), *The Philosophy of W. V. Quine* (La Salle, Ill.: Open Court, 1986), pp. 519–32.

85. Cf. Strawson, "Hilary Putnam, Logical Positivism, the Kantian Tradition, and the Bounds of Sense," in Sen and Verma, *The Philosophy of P. F. Strawson*, p. 415.

86. Cf. Strawson, *Skepticism and Naturalism*, p. 29.

87. *Analysis and Metaphysics*, p. 60.

88. *The Bounds of Sense*, p. 251.

89. *Analysis and Metaphysics*, p. 64.

90. Cf. W. J. Gonzalez, *La Teoría de la Referencia*, pp. 225–226, 228, 230, 268, 272–73, 276, and 279.

91. That Strawson accepts elements of the views which he explicitly rejects is particularly clear in his famous topic of reference. He strongly rejects Russell's theory of descriptions; but at the same time, understanding *identification* as "picking out" or "singling out," Strawson admits the main assumption of Russell's theory of knowledge, the conception which underlines his view on denoting: direct empirical knowledge as starting point for human knowledge; the certainty of knowledge connected with perception. So, his criticism is weaker than it seems to be. Cf. Gonzalez, *La Teoría de la Referencia*, pp. 287–93.

92. Cf. *The Bounds of Sense*, p. 18; Strawson, "Perception and its Objects," in G. F. Macdonald (ed.), *Perception and Identity* (London: Macmillan, 1979), pp. 41–60; and Strawson, *Skepticism and Naturalism*, pp. 42 and 44.

93. Cf. "Perception and its Objects," pp. 48–53.

94. Cf. A. J. Ayer, *The Central Questions of Philosophy* (London: Weidenfeld and Nicholson, 1973), pp. 68–111.

95. Cf. "Strawson's Post-Kantian Empiricism," pp. 252–53.

96. On the notion of "realism" and its different versions, from the point of view of science, W. J. Gonzalez, "El realismo y sus variedades: El debate actual sobre las bases filosóficas de la Ciencia," in A. Carreras (ed.), *Conocimiento, Ciencia y Realidad* (Saragossa: SIUZ-Ed. Mira, 1993), pp. 11–58.

97. Strawson, "The Incoherence of Empiricism," *The Aristotelian Society*, supp. vol. 66 (1992): 140–41.

98. Strawson, "The Incoherence of Empiricism," pp. 142–43.

99. Cf. "The Incoherence of Empiricism," p. 142. On the distinction between "action" and "behavior," cf. W. J. Gonzalez, "Rationality in Economics and Scientific Predictions: A Critical Reconstruction of Bounded Rationality and its Role in Economic Predictions," in A. Ibarra and T. Mormann (eds.), *Representations of Scientific Rationality*, Poznan Studies in the Philosophy of Science, v. 61 (Amsterdam: Rodopi, 1997), sect. 3; especially, pp. 225–26.

100. "The Incoherence of Empiricism," p. 143.

101. "I feel that I am closer to the views (the 'commonsense' views) of, e.g., G. E. Moore than to anything like 'classical' empiricism," Strawson, letter to the author, 14 September 1992.

102. Cf. Strawson, *Skepticism and Naturalism*, pp. 1–29.

103. These predicates are studied in the context of the concept of "person," cf. W. J. Gonzalez, "La primitividad lógica del concepto de persona,"*Anales de Filosofía* 1 (1983): 79–118.

104. Cf. Strawson, "Does Knowledge have Foundations?", pp. 99–110.

105. Cf. G. E. Moore, *Some Main Problems in Philosophy* (London: Allen and Unwin, 1953).

106. Cf. *Analysis and Metaphysics*, pp. 29–35.

107. Cf. Gonzalez, *La Teoría de la Referencia*, pp. 251–56.

108. In this regard, the main lines were established in Gonzalez, "Strawson's Post-Kantian Empiricism," pp. 253–55 and 257. There are also details in Gonzalez, *La Teoría de la Referencia*, pp. 270–73.

109. *Analysis and Metaphysics*, p. 32.

110. Ibid., p. 33.

111. Cf. Gonzalez, "Elucidación filosófica y actividad analítica," pp. 205–6. On the relation between analysis and metaphysics in Strawson, cf. Gonzalez, *La Teoría de la Referencia*, pp. 250–67.

112. Cf. *Individuals*, p. 9.

113. Strawson, *Skepticism and Naturalism*, p. 5.

114. Ibid., p. 5.

115. Cf. Strawson, "Knowledge and Truth," *Indian Philosophical Quarterly* 3, no. 3, (1976): 282.

116. "Knowledge and Truth," p. 282.

117. Strawson, "Sensibility, Understanding, and the Doctrine of Synthesis," pp. 75–76.

118. Ibid., p. 76.

119. Cf. *Skepticism and Naturalism*, p. 51.

120. Ibid., p. 67.

121. Cf. Strawson, ibid., pp. 51-53.

122. W. V. Quine, "Two Dogmas of Empiricism," *Philosophical Review* 60 (1951): 20–43.

123. One of these new naturalisms is in L. Laudan's Philosophy and Methodology of Science. On the characteristics of this naturalism and its differences with Quine, cf. Gonzalez, "El naturalismo normativo como propuesta epistemológica y metodológica," in Gonzalez (ed.), *El Pensamiento de L. Laudan. Relaciones entre Historia de la Ciencia y Filosofía de la Ciencia* (La Coruña: Publicaciones Universidad de La Coruña, 1998), pp. 7–57.

124. A. Rosenberg, "A Field Guide to Recent Species of Naturalism," *British Journal for the Philosophy of Science* 47 (1996): 2.

125. Ibid., p. 2.

126. Cf. Strawson, "Two Conceptions of Philosophy," pp. 312–13.

127. Cf. *Skepticism and Naturalism*, p. 68.

128. Ibid., p. 66. "We are, at least, physical systems the physical movements (not 'behavior') of which are the causal outcome of their physical stimulations and physical constitution, and every 'mental movement' of which (if I may use the expression) has a physical basis or realization. We can accept this as a

working assumption, while rejecting the crudely dualistic, or two-substance, picture of a kind of inner causal tennis-match between mind and body," Strawson, ibid., p. 67.

129. On this issue, cf. Gonzalez, "Strawson's Post-Kantian Empiricism," pp. 249–57; especially, pp. 255 and 257.

130. Cf. *Analysis and Metaphysics*, pp. 52–53.

131. In this regard, he wishes to make sure that the simple truth of the concept-user's awareness of reality in experience is not wrongly or inadequately understood, Cf. Strawson, letter to the author, 12 October 1996.

132. Cf. Gonzalez, "La primitividad lógica del concepto de persona," pp. 79–118; especially, pp. 81–87 and 106–18.

133. Cf. Gonzalez (ed.), *Acción e Historia. El objeto de la Historia y la Teoría de la Acción* (La Coruña: Publicaciones Universidad de La Coruña, 1996).

134. Cf. Gonzalez, "Towards a new Framework for Revolutions in Science," *Studies in History and Philosophy of Science* 27, no. 4 (1996): 607–25.

135. *Skepticism and Naturalism*, p. 27.

136. Cf. *Individuals*, pp. 56–57. On this problem, with a specific treatment of Strawson's approach, cf. N. Rescher, *Process Metaphysics* (Albany: State University New York Press, 1995); especially, pp. 60–64.

137. Cf. *Skepticism and Naturalism*, pp. 26–27.

138. Cf. Strawson, *Subject and Predicate in Logic and Grammar*, pp. 14–16.

139. Cf. "Perception and its Objects," pp. 56–57.

140. Cf. Strawson, ibid., p. 47.

141. Cf. *Subject and Predicate in Logic and Grammar*, p. 17.

142. On this issue, cf. Gonzalez, *La Teoría de la Referencia*, pp. 270–73.

ACKNOWLEDGEMENTS

This paper was prepared during a stay at the *Center for Philosophy of Science*, University of Pittsburgh, in 1996. Some ideas were presented in a Conference on the British tradition in the twentieth century, held in Kirchberg am Wechsel, Austria in August 1994.

I expressed my gratitude to Professor Nicholas Rescher and John McDowell for their comments on the paper as well as to Professor Peter F. Strawson for his kind remarks on this paper and for his letters making explicit some key points of his thought. I also acknowledge the Autonomous Community of Galicia, Spain, for the grant which made the completion of this work possible.

REPLY TO WENCESLAO J. GONZALEZ

I am grateful to Professor Gonzalez for his compendious, thoughtful, and well-documented study of those of my writings which bear on the theory of knowledge. As he surveys the history of our subject from the seventeenth century to the present, he detects a distinction between 'modern' and 'contemporary' approaches, the former emphasizing the problem of knowledge, the latter that of meaning. In my own work he finds elements of both; and, apropos of my acknowledged debt to a few great predecessors, he suggests that the work itself is characterized by a 'tendency to eclecticism', with an attendant risk of inconsistency. I am happy to see that he exonerates me from the latter charge and finally attributes to me a post-Kantian and nonreductionist version of empiricism, free from the failings of the classical variety.

He adds, however, I am sure rightly, that there is room for improvements; of which, he says, he will point out two. The first is my neglect of the historical dimension of human experience. He concedes that I do not neglect it entirely: for I "accept that the human world-picture is subject to change," mentioning, among other examples, the abandonment of the geocentric view of the universe, and of the Euclidean conception of physical space. Indeed I see no reason to dismiss the possibility that advances in natural science may produce further equally radical, or even more radical, modifications of our general world view. But equally I see no reason to doubt that certain things, certain categories, remain fixed: as the reality of the past, the existence of the external world and of other minds.

In this same connection Professor Gonzalez misreads me at one point. He says that I "reject completely" the category of process. But I do not. What I do reject is the attempt to eliminate the distinction between the category of process and that of thing or individual substance: the attempt either to absorb the latter into the former or to displace it in favor of a new category in which the two are fused. I do not think that

such an attempt, though not without some popularity among scientifically-minded philosophers, either could or should succeed.

The second case for improvement that Professor Gonzalez finds concerns the notion of 'concept'. His reservations on this point are not entirely clear to me; but, in general, he seems to fear that my handling of the notion may make concepts too subjective a matter, too little capable of objectivity of content. Now I certainly do not regard a concept as subjective in the sense in which a particular episode in the mental life of an individual is subjective. A concept must, as Gonzalez says, be accessible to thinkers in general, a shared or shareable possession. But, equally, a concept is not itself an object in nature, though objects in nature may fall under it. So far I think Professor Gonzalez and I are in complete agreement. But here we need a distinction: a distinction between the *concept* and, say, the *property* (the universal) of which it is a concept. The property is certainly objective; and is so whether we conceive of it as *ante rem* or as *in rebus* (as instanced) or as both. And since the property is precisely the *content* of the concept, the concept is not at risk of lacking objective content. But still we must insist on the distinction between concept and property—a distinction which becomes clear if we consider what it is, on the one hand, to possess (or exemplify) a property and what it is, on the other hand, to possess (or grasp) a concept. It is perfectly possible for someone, or something, to have a property and lack the concept of it; it is equally possible for someone to grasp the concept and lack the property. All things, of whatever category, animate, inanimate, or abstract, have properties; only conscious beings and cultures can be said to possess concepts. Concepts in this sense are mind-dependent, while properties (unless they are mental properties) are not; but this has no force to show that concept-possession falls in any way short of intellectual grasp of the objective realities which the concepts are concepts of.

There is, of course, much more to be said on this subject; but I trust I have said enough to dispel Professor Gonzalez's sense of a shortcoming in my understanding of the notion of 'concept'.

P.F.S.

18

Ernest Sosa

P. F. STRAWSON'S EPISTEMOLOGICAL NATURALISM[1]

I

Although many have tried refuting skepticism or showing it to be somehow senseless, no such attempt has proved stably successful. More broadly influential in recent decades has been the "naturalism" now attributed to Hume and to Wittgenstein.[2] Among those making this attribution is P. F. Strawson, himself an early exponent of the view. Strawson's distinctive thought on induction may now be seen as aligned with Hume's, although he finds in Hume "two levels of thought: the level of philosophical critical thinking which can offer us no assurances against skepticism; and the level of everyday empirical thinking, at which the pretensions of critical thinking are completely overridden and suppressed by Nature, by an inescapable natural commitment to belief: to belief in the existence of body and inductively based expectations."[3]

Hume's bi-level naturalism is thus more complex than Wittgenstein's, but also, in another way, more simple. What Hume explicitly recognizes as part of our human framework of inquiry—what we must "take for granted in all our reasoning"—includes only acceptance of an external world of bodies, and inductively formed beliefs. Wittgenstein for his part also recognizes a kind of commitment as "beyond being justified or unjustified; as it were, as something *animal*."[4] And he compares empirically testable beliefs to the waters of a river whose banks are framework commitments beyond justification.[5] However, Wittgenstein sees our cognitive establishment as more dynamic than does Hume: the river banks are partly rock, partly stones, partly sand. Its constituents can, some of them, after all become subject to doubt and modification, and some might even shift over time from one category to another.

Strawson nevertheless finds a deep community between Hume and Wittgenstein:

> They have in common the view that our "beliefs" in the existence of body and, to speak roughly, in the general reliability of induction are not grounded beliefs and at the same time are not open to serious doubt. They are, one might say, outside our critical and rational competence in the sense that they define, or help to define, the area in which that competence is exercised. To attempt to confront the professional skeptical doubt with arguments in support of these beliefs, with rational justifications, is simply to show a total misunderstanding of the role they actually play in our belief-systems. The correct way with the professional skeptical doubt is not to attempt to rebut it with argument, but to point out that it is idle, unreal, a pretense; and then the rebutting arguments will appear as equally idle; the reasons produced in those arguments to justify induction or belief in the existence of body are not, and do not become, *our* reasons for these beliefs; there is no such thing as *the reasons for which we hold* these beliefs.[6]

Wittgenstein wrote: "It is so difficult to find the *beginning*. Or better: it is difficult to begin at the beginning. And not to try to go further back."[7] This passage from Wittgenstein sums up the core of epistemological naturalism, as interpreted by Strawson: "To try to meet the sceptic's challenge, in whatever way, by whatever style of argument, is to try to go further back. If one is to begin at the beginning, one must refuse the challenge as our naturalist refuses it."[8] Strawson himself sums up in his own way:

> [The] point has been, not to offer a rational justification of the belief in external objects and other minds or of the practice of induction, but to represent skeptical arguments and counter-arguments as equally idle—not senseless, but idle—since what we have here are original, natural, inescapable commitments which we neither choose nor could give up.[9]

II

Epistemological naturalism seems a rather limited doctrine. It confronts only a limited skepticism, only a skepticism with regard to framework commitments: to the use of induction and to "beliefs" that there are external bodies, other minds, a determinate past, etc. This leaves standing the most radical skepticism regarding specific beliefs about the external world, the minds of others, the past, etc. It leaves standing, for example, the skepticism posed by Descartes about the specific question whether a real fire burns before him.

Is epistemological naturalism (EN) a successful response to skepticism directed against our framework propositions? What exactly is the

argument from Hume and Wittgenstein endorsed subsequently by Strawson?

Again, EN draws a distinction between two sorts of beliefs: first, those which are based on a particular reason or experience; second, those "which have a quite different character, alluded to by the figures of scaffolding, framework, background, substratum, etc." The second set of beliefs are not the products of any reasoning, no matter how implicit or subconscious. And the antiskeptical argument concerning them amounts to the following:

a. The general "beliefs" that there are bodies, that there are other minds, that there has been a determinate past–none of these is one that we choose or decide to have for a reason, none is based on inference or argument or reasoning. Further, we cannot help accepting them and retaining them.
b. Therefore, skeptical arguments against such beliefs are *idle*.
c. Therefore, such skeptical arguments are *negligible*, and indeed they are to be neglected.

Against such "beliefs" (commitments, claims, presuppositions, convictions, prejudices, "hinge propositions") skeptical arguments aim to show that they amount neither to knowledge nor even to justified beliefs. What for Strawson makes such skeptical arguments *idle* is presumably their inability, singly or in combination, to budge our framework beliefs. And from this it is supposed to follow that skeptical arguments are best ignored.

Compare now a moral skeptic who holds that it is not *wrong* to torture people for fun, arguing that such squeamishness is just a sign of weakness, that might is right, that the strong should feel no compunction about imposing their will to power, etc. How should we respond?

For most of us, there is no question of ever torturing someone for fun. Most of us would find it impossible to do that, to enjoy torturing just for its own sake. And the arguments of Thrasymachus or Nietzsche are not going to budge us (arguments, e.g., that the powerful need pay no heed to the welfare of the herd, nor to the demands of simple justice). Does this mean that those arguments are idle and negligible? Of course, if the only point such an argument could possibly have is to convince us of its conclusion, then if they could not possibly succeed in that, if follows that it is pointless to waste our time on them. They *are* then idle and negligible. However, even supposing that they could not succeed in convincing us, is there no other point that such arguments could have?

Might such arguments prompt inquiry into what it is that makes the wrong wrong? Might the skeptic prompt us to wonder *why* it is wrong to

torture for fun? Would it not be natural to wonder thus in response to the skeptic's challenge? Suppose, accordingly, that we do ask *why* it is wrong to torture for fun: "What *makes* that wrong?" This need manifest no real doubt, surely, nor is doubt required to prompt such a question.

Sometimes when we ask "Why would it be wrong to Ø?" we are in real doubt, and we are searching for reasons that would help us decide. That is the *practical* context in which we might ask such a question, the context of the agent deliberating. But there is also a *theoretical* context, the context of the commentator or theoretician, which requires no doubt that Ø-ing *would* be wrong. As commentator or theoretician (whether or not one is also the relevant agent) one needs no help in deciding *whether* it is wrong to Ø. Indeed the theoretical question may *presuppose* that it *is* wrong to Ø. Only then does the theoretical question arise as to *why* it is wrong, as to what *makes* it wrong.

But if the theoretician presupposes that it is wrong to Ø, then how can he respond helpfully to the moral skeptic who argues that it is *not* wrong? In proceeding as he does the theoretician would seem to be just begging the question. Is he not then agreeing with epistemological naturalism after all, and neglecting the skeptic's reasoning?

Not necessarily. Given the skeptic's arguments, the theoretician needs to explain how Ø-ing is wrong, what makes it wrong, *despite* those arguments. Many interesting issues can arise as part of that project, even when the wrongness of Ø-ing is as obvious as is that of torturing for fun. Consider:

a. Is our claim a factual claim, one that admits of truth or falsehood? If so, are we attributing an objective property of *wrongness* to a way of acting?
b. Is it fundamentally the pain inflicted that makes it wrong? (A surgeon inflicts pain, but does not necessarily act wrongly—nor does he necessarily torture.)
c. Is it the fact that the torture is inflicted without regard to the interests of the victim and just for the torturer's amusement, so that the torturer uses the victim just as a means? Is it *this* that makes it wrong?

And so on. At no point in any of such reasoning need there be any doubt that it *is* wrong to torture people just for fun, nor would most of us ever entertain any such real doubt. So the point of our theoretical inquiry need not be to help us decide such an issue. Our theoretical reflection has its own objectives, its own autonomous dynamics. (Of course that is not to say that it cannot ever have any practical implications.) It is aimed at understanding to the fullest extent possible the nature and conditions of right (and wrong) action (and its varieties).

Something analogous applies to epistemology as a traditional theoret-

ical inquiry aimed at understanding, with generality and depth, the nature, conditions, and extent of human knowledge. Here again, reflection so aimed need not arise from any real *doubt* that there is any such knowledge. Such reflection might spring only from that familiar source of theoretical inquiry: sheer curiosity. Insofar as any doubt might naturally accompany such curiosity in epistemology it would be doubt about the nature and conditions of human knowledge, and not *necessarily* doubt about its extent. (This is a crucial distinction to which we shall return.) Moreover, the same holds true when the scope of the inquiry is restricted, for example, to framework commitments about the external world, other minds, etc. (Nor is it crucial that we regard these as "knowledge," since much of the familiar epistemological problematic remains if we focus rather on justified or cognitively acceptable commitments, and what renders them acceptable, etc.)

It might be replied that epistemological naturalism does not reject epistemological reflection aimed at better understanding of the nature, conditions, and extent of human knowledge (both in general and also in various delimited domains). Epistemological naturalism recommends neglect *not* of such inquiry but only of the traditional skeptical arguments designed to cast doubt on our knowledge (in general or in delimited domains). One *can* engage in such inquiry about some presumed knowledge sans doubt that it *is* knowledge. Unshakeable conviction that it *is* knowledge would seem to render idle any skeptic's arguments against that supposed knowledge. Is it not then a waste of time to consider such arguments? What point could there be in considering them if one's mind is already made up?

The epistemological naturalist's reasoning seems to be this:

a. Take a proposition P of which we are convinced.
b. Suppose a skeptic advances an argument A against P.
c. To take A seriously we would need to try to come up with a counterargument C in favor of P.
d. Suppose, however, that P is a proposition that we accept beyond justification, perhaps as a framework conviction; suppose we accept it as an unshakeable commitment, one, moreover, that could never authentically be based on arguments or reasons.
e. In that case, it seems best to neglect argument A and any such skeptical argument.

Some skeptics have traditionally tried to induce *epoché*, suspension of belief, re a question (whether p). Most skeptics begin with a more limited aim, however, by arguing that we cannot possibly know whether p, since we cannot possibly attain well enough justified belief on the question whether p. In order to take seriously *such* arguments against our

conviction that p (supposing that is our conviction), must we come up with counterarguments or reasons in favor of our conviction and on the basis of which we can sustain our conviction?

Take Descartes's argument "against" our conviction as to what 3 and 2 add up to: namely, the argument that it is logically conceivable that an evil demon has it in his power to induce in us absolute and intuitive or direct conviction in whatever he wishes, even when it is quite false. Is there only one way to take that argument seriously: namely, to produce a counterargument in favor of the proposition that $3 + 2 = 5$, one on the basis of which we might then (continue to) believe that $3 + 2 = 5$?

We need to distinguish between the proposition that $3 + 2 = 5$ and the proposition that one knows or justifiably believes that $3 + 2 = 5$. At least in the first instance, our skeptic attacks just the *latter*. Taking his argument seriously does not obviously require us to produce a counterargument in favor of the *former*. Nor does it even require that we produce a positive counterargument in favor of the latter. Can't we, whether we do produce or even try to produce such a counterargument, in any case recognize the power of the skeptic's argument? Can't we be persuaded that it presents us at a minimum with a paradox? The best paradoxes are sets of propositions all of which seem most convincingly established although it is equally convincing that they cannot all be true. And if we do see the skeptic as a purveyor of paradox, then we might surely take his arguments seriously without needing to produce new arguments in favor of our favored paradox-enmeshed propositions. Instead we might take his arguments seriously by examining them for defects. We might search for an account of just where and how the skeptical arguments go wrong.

The foregoing applies even with regard to framework propositions such as the proposition that there is a physical world of bodies in space and time. Let that be proposition W. We need to distinguish W itself from the proposition that we know that W is true and from the proposition that we "acceptably," without irrationality or cognitive fault, or, in brief, "justifiedly" believe (take for granted, commit ourselves to, etc.) that proposition W. In symbols, we need to distinguish W itself from J(W).

What the skeptic normally attacks is, in the first instance, J(W) rather than W. The skeptic adduces arguments designed to demonstrate that Not-J(W). It is therefore implausible to suppose that we can take the skeptic's arguments seriously only by producing counterarguments in favor of W. At most, it might be plausible to suggest that we would need arguments in favor of J(W). But even this is doubtful. Surely we can take the skeptic seriously if we try to find fault with his argument, if we try to refute him. And refuting an argument *against* J(W), by finding fault with its premises or with its mode of inference, does not necessarily amount

to producing a positive argument *in favor* of J(W), much less one on the basis of which we might (continue to) believe J(W).

Ironically, Strawson himself *does* appear to take the skeptic's arguments against J(W) quite seriously, seriously enough to actually produce the following positive argument in favor of J(W).

P1. Our commitment to W is original, natural, nonoptional, not based on reasons.

P2. Arguments against such commitments are necessarily futile and therefore idle and negligible.

P3. Arguments in favor of such commitments are equally idle and negligible.

P4. Such commitments are hence acceptable in the absence of reasons or arguments.

P5. Our commitment to W is acceptable in the absence of reasons, and need not be defended by reasons that might counter the attacks of skeptics.

This seems to be an argument—however conclusive or compelling—in favor of J(W). But it is J(W), surely, that the skeptic attacks in the first instance. And EN does respond with a counterargument in favor of J(W) after all (whether this is counted as, indirectly, an argument in favor of W itself, or not).

In any case, the argument of EN in favor of J(W), and in favor of the acceptability of framework commitments, is weak. What we cannot help believing is one thing, what it is epistemically acceptable for us to believe is quite another. Many are the mechanisms of belief inducement that might produce unshakeable convictions in a true believer, with no semblance of epistemic justification. This is especially serious for the social naturalism of Wittgenstein, which includes, among framework commitments, socially induced commitments that give form to an epistemic practice. In any case, the fact that some conviction is socially induced beyond budging by rational means is no sufficient epistemic recommendation.

III

If EN is weak with regard to framework convictions shared by an epistemic community, it is weaker still when applied to the idiosyncratic beliefs in an individual belief system. Here EN has been defended in two ways: by attack on its main alternative—empiricist foundationalism—and by defense of EN more positively, though very briefly, perhaps from a Wittgensteinian perspective.

Empiricist foundationalism holds that individual contingent beliefs are acceptable or justified only if they have the support of reasoning or observation. Such foundationalism can be challenged to produce the observational foundations from which we reason our way to beliefs such as that 'lapin' is the French for 'rabbit', or that Napoleon was defeated at Waterloo. Such beliefs would seem justified in the absence of any observations, present or recalled, from which one might build a deductive or inductive argument that would justify them. These beliefs may also be claimed plausibly to be of a sort known too well to be based on arguments.

Having argued thus, Strawson does not himself so much as sketch any alternative to empiricist foundationalism. But elsewhere he shows that he may well think of such beliefs as significantly similar to framework propositions. He discusses the epistemology of framework propositions, as we have seen, and he draws a doctrine of epistemological naturalism from Hume and Wittgenstein as the best defense against the skeptic's attack. When he does so, Strawson also recognizes local and idiosyncratic propositions, and has this to say:

> [Wittgenstein] is not concerned only with the common framework of human belief-systems at large. He is also concerned to indicate what a realist picture of *individual* belief-systems is like; and in such a picture room must be found for, as it were, local and idiosyncratic propositions (like "My name is Ludwig Wittgenstein.") as elements in someone's belief-system which are, for him, neither grounded nor up for question.[10]

That passage stops short of explicitly suggesting that EN would defend such idiosyncratic beliefs also by appeal to the idleness of counterarguments, etc. If that is *not* how EN would defend such beliefs, however, then EN would remain a very limited epistemology with application only to some few general commitments. But, if that *is* how EN would defend such beliefs, then EN becomes even more implausible. The mere fact that some retail belief cannot be budged by reason might indicate only that it is pathological and not necessarily that it is acceptable and justified in the absence of argument.

IV

Epistemological naturalism might be defined as a kind of cognitive quietism that scorns activist attempts to justify our ordinary beliefs philosophically. Such practical quietism is compatible, however, with the theoretical activism of an epistemology aimed at explaining what gives our beliefs the cognitive status required to constitute knowledge. Even after meeting all proper plain challenges to a belief of one's own,

one might still properly wonder what renders it a cognitively apt, or justified, belief. This question might well remain. Attempting to answer it need *not* constitute a reversal of one's opinion that all proper plain challenges had already been met, *either* because such challenges had been issued and appropriately met, *or* because in the circumstances there *are* no such proper challenges. After all, this new challenge is not just a plain one, is not just one that arises in the normal course of events at the level of ordinary practical or intellectual life. The challenge now is rather distinctively philosophical. Of course, meeting this new challenge will presumably, in its own way, also enhance the epistemic quality of our target belief, but it will do so in a special mode proper to the philosophical reflection of the study or the seminar room, one that it is hardly for us to scorn.

ERNEST SOSA

BROWN UNIVERSITY
PHILOSOPHY DEPARTMENT
JULY 1997

NOTES

1. Since my graduate student days in the early sixties, I have admired Peter Strawson's work—for example, his book *Individuals*, and also the elegantly light but telling critique of foundationalism found most recently on pp. 91–96 of his *Analysis and Metaphysics* (Oxford: Oxford University Press, 1992). Although unpersuaded by his position on skepticism, I have found it a welcome and stimulating challenge, both in its own right and also for the light it throws on Hume and Wittgenstein. It will be my topic in what follows here.

2. In whose philosophy it takes a form more aptly titled "social naturalism."

3. *Skepticism and Naturalism: Some Varieties* (New York: Columbia University Press, 1985), pp. 12–13.

4. Ludwig Wittgenstein, *On Certainty* (Oxford: Basil Blackwell, 1969), par. 359.

5. Ibid., pars. 92–99.

6. *Skepticism and Naturalism*, pp. 19–20.

7. *On Certainty*, par. 471.

8. *Skepticism and Naturalism*, pp. 24–25.

9. Ibid., pp. 27–28.

10. Ibid., pp. 25–26.

REPLY TO ERNEST SOSA

Professor Sosa remarks, correctly, that I appeal to Hume and Wittgenstein in support of what he reasonably names my 'epistemological naturalism': the view that skepticism regarding such fundamental matters as the existence of external (i.e. physical) objects and the general reliability of induction is idle and does not call for rational rebuttal. He points out, also correctly, that the judicious skeptic does not argue against the *truth* of the 'beliefs' or 'propositions' in question; he argues, rather, that we do not *know* them to be true, that we are not *justified* in believing them to be true. And this, he suggests, does raise a serious theoretical, specifically philosophical, issue, which cannot be lightly dismissed, as the 'epistemological naturalist' supposes, on the rather weak ground that we cannot help holding these beliefs. Such a stance as that, though perhaps acceptable for practical purposes, would ill become us in our professional capacity, in our studies and seminars. We are at least required to examine, seriously and critically, the skeptical arguments.

Well, here is a case. But I have a doubt. I doubt whether Professor Sosa does justice to Wittgenstein's position or Hume's or even (if I may be so presumptuous as to associate myself with them) my own. It is not merely a matter of dismissing the demand for a justification of one's belief in a proposition on the ground that one can't help believing it. That would be weak indeed. The position is, rather, that the demand for justification is really senseless. Indeed both Hume and Wittgenstein, in their several and distinct ways, go further, questioning, in effect, the appropriateness of the ordinary concepts of 'belief' and 'proposition' in this connection. Thus Wittgenstein at one point says that 'There are physical objects' is nonsense—i.e. that the words do not express a genuine proposition at all. And Hume, starting, admittedly, from the flimsy basis of the classical empiricist epistemological premise, and giving an account, on this basis, of the causal origin of our 'belief' in

body (the existence of physical objects) concludes that the belief, so arrived at, is incoherent.

There is no need to follow either of these great men to the extent of embracing such extravagant conclusions. But the point underlying these excesses is the same in both cases and is made, by Wittgenstein, in a number of graphic phrases, some but not all metaphorical, quoted by me in the book, *Skepticism and Naturalism: Some Varieties*, to which Professor Sosa refers. I will not quote these again, but will simply refer the present reader to them or, better, to Wittgenstein's own *On Certainty*, from which they are derived. I myself changed the image slightly, representing the matters in question as constituting the boundary conditions of the exercise of our critical and rational competence, as 'defining, or helping to define, the area in which that competence is exercised'. Hume is more succinct, saying, simply, of the existence of body, that it is "a point we must take for granted in all our reasonings." (It is interesting to note that even Heidegger, with his conception of *Dasein*, was, in this matter, on to the truth.) And if we are moved to ask 'How does all this come about?', we cannot improve on Hume's answer: 'Nature'.

At one point Professor Sosa says: "Epistemological naturalism seems a rather limited doctrine. It confronts only a limited skepticism, only a skepticism with regard to framework commitments: to the use of induction and to 'beliefs' that there are external bodies, other minds, a determinate past, etc."

I find this a puzzling remark. For surely skepticism on these matters is precisely, and only, the kind of skepticism which has seemed of philosophical interest and importance. So I ask what reasons Professor Sosa offers in support of this judgment.

He offers two. One concerns particular or specific beliefs which an individual may form *within* the framework commitments in question. But of course the situation is quite different in the case of such beliefs as these, even when they are so deeply entrenched in an individual's belief system as to seem also 'exempt from doubt'. Wittgenstein gives, as an example of such, 'My name is Ludwig Wittgenstein'. But it was, I think, injudicious of him to associate even such as these with those framework or boundary matters discussed above. For these, unlike those, precisely are propositions such that a demand for justification for belief in them, although it would seem otiose to the individual concerned, would make perfectly good sense, and could, indeed, if pressed, be met by the production, from within the acknowledged framework, of evidence or argument. So this point really has no force to support Sosa's judgment.

The other reason Sosa offers in support of that judgment concerns

moral skepticism. Of a generalized skepticism here, often, though not exclusively, associated with doubt about human freedom, I have written in several places; but Professor Sosa does not discuss the views I express in these writings, so I too shall pass them over in silence. Indeed Professor Sosa seems himself to pass over in silence the question of generalized moral skepticism or to treat it as at best a way of introducing an autonomous theoretical investigation into the general structure of moral thinking. For the project of such a theoretical enquiry the epistemological naturalist can have nothing but approbation.

P.F.S.

19

Chung M. Tse

STRAWSON'S METAPHYSICAL THEORY OF SUBJECT AND PREDICATE

If a characterizing description is to be made of Strawson's philosophy it would be appropriate to say that the soul of Strawson's philosophy is a metaphysical theory of subject and predicate. For although Strawson has written or opined on a diversity of logico-linguistic topics and issues, he works consistently and schematically towards the solutions of some major problems about the subject-predicate distinction. Indeed, the majority of Strawson's philosophical activities have either expressed or implied interest in that direction. Among his major works, not only *Individuals* (1959), *Subject and Predicate in Logic and Grammar* (1974), *Introduction to Logical Theory* (1952), "Particular and General" (1953–54), "Singular Terms and Predication" (1961), "The Asymmetry of Subjects and Predicates" (1970), are avowed treatments of subject and predicate, but also *The Bounds of Sense* (1966), though declared to be an interpretation of Kant's first *Critique*, contains important, yet often unheeded by Strawson readers, ideas of subject and predicate.

Explicit statements aside, Strawson's metaphysical belief in the subject-predicate duality, in the present author's perception, subtly underlies the positions in issues or discussions he has joined in. It is known that Strawson has commented, mostly unsympathetically, to say the least, on Quine's proposal of logical regimentation, Tarski's formal semantics, Carnap's linguistic constructionism, Chomsky's transformational grammar, and others. Each case has its particularity that commands specific considerations and pertinent arguments, of course. But if we put them together and seek to find a general philosophical reason to explain why Strawson maintains the positions in those issues as he does, we might discover a generality that all the positions *otherwise* either pose or imply a challenge to Strawson's metaphysical belief in subject and

predicate. To illustrate we may take a case for brief consideration. There are good reasons told by Strawson for not endorsing the Ideal Language program,[1] still there may be one reason untold, possibly the most fundamental of all: In Strawson's metaphysics it is assumed that there is an immutable duality, being the basic structure of human thinking of which the subject-predicate distinction is but one of the manifested forms. Granted that, any attempt to artificially construct a logical or linguistic system must be founded on recognition of that duality, otherwise the constructed system will be incoherent with the natural way in which we are predisposed to form our experience. The Ideal Language philosophers do not recognize that duality.

It is absolutely worthwhile to attend to Strawson's metaphysical theory of subject and predicate. The purpose of this paper is to deliver a representation of the theory in a condensed form, with a view to its place in Strawson's philosophy. The theory is called metaphysical because it seeks to justify and explain the distinction, the notions, and the combination of logical subject and predicate on the basis of an epistemic-metaphysics. Its components mainly include a metaphysics, an epistemology, and an articulation of logical subject and predicate, incorporating diverse ideas Strawson entertains and discusses in different times and occasions. The presentation here proposed, then, will be a fabrication out of the scattered materials in a logical and not chronological manner. What immediately follows, is a statement about the problem of subject and predicate and its complexities Strawson endeavors to deal with.

Strawson takes upon himself the task of defending the subject-predicate distinction in logic and philosophy. For although the distinction has enjoyed a relatively comfortable time of tenure in classical logic, epistemology, and metaphysics since Aristotle, its status now faces severe attacks. F. P. Ramsey, one of the skeptics, argues that, of a two-term proposition, say, 'Socrates is wise', the subject and the predicate have "nothing to do with the logical nature of Socrates or wisdom,"[2] and that the distinction can be made differently depending on occasional needs, interests, and literary styles. Ramsey's argument in effect deprives the distinction of any logical or ontological significance, and therefore renders it an unnecessary, useless distinction in logic and philosophy. For Strawson, this poses a problem: "My question can be understood as precisely the question, *why* this use, this concept exists, the question *why* we inject a category distinction into logical terminology."[3] To answer the question is to give a justification for the existence of the distinction in logic, and an explanation why it cannot be made in an arbitrary way.

The problem of subject and predicate is not a simple one; it is in fact a cluster of many interrelated subproblems. Besides the question *why*,

which is the most vital, there is the problem as to formulating an effective criterion for distinguishing the subject from the predicate. Not that there are no available criteria; in fact there are many,[4] but rather that they either fail in cases or allow much room for arbitrary discretion.[5] It is, therefore, part of Strawson's task to set the distinction in a secure ground. Another problem has to do with the asymmetrical nature of subject and predicate. It is observed, for example, that a general term can play both the roles of a subject and a predicate whereas a singular term cannot, that *negation* of a proposition applies to the predicate but not to the subject, that there can be compound predicate but not compound subject.[6] These asymmetries must be explained to the effect that they do not happen to be so by mere convention or accident of some sort. Again, there is the problem of significance of predication. For, if the subject-predicate distinction is not an unnecessary, trivial distinction in logic, predication must mean more than just a coupling of words; '*y* is predicated of *x*' must carry some significant information. An exposition is called for. The list is not exhaustive of all the subproblems, but already includes the major ones. A theory of subject and predicate, in this case, Strawson's, must be able to coherently provide answers to those problems in accordance to systematic principles. What follows, is a representation of the theory.

The nucleus of Strawson's philosophy as a whole and key to his theory of subject and predicate is well stated in a passage in *The Bounds of Sense*. The passage is so important that we beg all pardons for quoting it in full length, as follows:

> The duality of intuitions and concepts is in fact but one form or aspect of a duality which must be recognized in any philosophy which is seriously concerned with human knowledge, its objects or its expression and communication. These are three different directions of philosophical concern rather than three different concerns. The theory of being, the theory of knowledge, and the theory of statement are not truly separable; and our duality necessarily appears in all three, under different forms. In the first, we cannot avoid the distinction between particular items and the general kinds or characteristics they exemplify; in the second, we must acknowledge the necessity of our both possessing general concepts and becoming aware in experience of things, not themselves concepts, which fall under them; in the third, we must recognize the need for such linguistic or other devices as will enable us both to classify or describe in general terms and to indicate to what particular cases our classifications or descriptions are being applied.[7]

Elsewhere, Strawson announces that "there is a massive central core of human thinking which has no history."[8] That central core can be none other than the duality. (For convenience's sake, it will be referred to as the *duality* hereafter.) The *duality in itself* has no name, but manifests in three forms: It appears as the dualities of particular and universal in

ontology, of particular item and concept in epistemology, and of subject and predicate in logic, or of uniquely referring expression and ascribing (or classificatory) expression in language. The three forms (or aspects) are internally interrelated in that any one of them necessarily leads to the others. Through the *duality*, ontology, epistemology, and logic form a unity as a "philosophical trio."[9]

Although the assumption of the *duality, per se,* is not our point of focus, it is vitally crucial for our present purpose and Strawson too, because it is exactly the one device by virtue of which explanations of logical subject and predicate can be made with reference to metaphysical beliefs. It admits, however, of no proof in a strict sense. Its tenability must derive from its ability to give a unity to the diverse fields of philosophy. To speak plainly, the assumption is expected to serve as a general, first principle according to which beliefs in the different fields can be *coherently* explained. Hence, coherence is the mark of the unity; and the achievement of the unity sustains the tenability of the assumption.

Strawson's metaphysics allows two categories of entity to exist (though not in the same sense of existence), namely, particular and universal. The ontology of particular mainly consists of the theses that there is a system of particulars, and that they, being inherently spatio-temporal items, each occupies a unique place in the one comprehensive space and time, and that material bodies and persons are the basic occupants. To prove, Strawson ingeniously constructs a version of the Kantian transcendental argument with his analytical seal affixed to it. He begins with the fact, as premise, that we successfully use such linguistic devices as demonstratives like 'here', 'now', and singular terms like proper names and definite descriptions to identify and re-identify individual things or persons that become topics of our discourses. But if such identifications and re-identifications are to be possible at all, it is necessary that there is such a system of individual things and persons as to be able to answer to those uniquely referring expressions. And, since positions in an embracing space-time are the only ultimate references that can guarantee the *uniqueness* of each particular (thing or person) required by those expressions, it follows that a spatiotemporal framework of particulars must be posited as a necessary condition, that is, a presupposition, of the possibility of the uniquely referential use of language. Material bodies and persons are honored as basic particulars insofar as they can be identified and re-identified independently, that is, without dependence on any other mediating identifications.[10]

With respect to universals Strawson has a number of interesting discussions.[11] Several theses are summarized as follows. First, the

category of universal includes such general things as numbers, states, qualities, relations, processes, species, among others; and is subdivided into sortal and characterizing universals.[12] Second, parallel to particulars, universals too form a framework which is defined in terms of, not spatiotemporal, but logical relations, viz., relations of inclusiveness/exclusiveness, of involvement/noninvolvement, and of hierarchical order. So, in contrast to the physical space in which particulars are, there is a logical space into which universals are organized. Third, universals are, and can be referred to by general terms without an empirical presupposition; the meaning of the general term being used suffices to identify a universal. And, lastly, universals do not have independent existence, nor can they be reduced to mere aggregates of particulars.[13]

Although particular and universal are distinctively different, they must be connected so as to constitute a fact. This is so partly because they are not self-sufficient. For, on the one hand, "there is no such thing as a pure particular,"[14] in other words, a particular is necessarily a particular instance of something general; it must belong to some universal. And this an "old truth," Strawson thinks.[15] On the other hand, a universal must be in direct or indirect possession of some particular(s) as its instance(s), or else it can make no claim to a place in reality.

Strawson employs a metaphor to describe the connection. Thus it is said that a universal collects some particulars. To be specific, a sortal universal collects particulars of the same sort, and a characterizing universal collects particulars having the same characteristic. To collect is to bring another entity or a multitude of other entities under said universal. Primarily, a universal collects particulars, and, by analogy, a universal may collect other universals.

Some puzzles may arise concerning Strawson's ontology. One puzzle concerns the connection between particular and universal. Not only the metaphor "to collect" really explains nothing, but it itself needs to be explained. For it is quite unclear as to what sort of a state of affair it is, how to collect, and why to collect. But most, if not all, of the unclarities will disappear once we turn to his theory of knowledge. Everything of the ontology of particular and universal can be paraphrased in, and explained in term of, epistemological vocabulary as the ontological and the epistemological are only different ways of talking about the same *duality*.

With respect to the epistemological dimension, it is necessary to pay some attention to Strawson's philosophical affiliation with Kant. For, although Strawson criticizes some of Kant's doctrines, particularly transcendental idealism and agnosticism about the concept of *thing-in-itself*, he shares, and to a certain extent relies upon, Kant's analysis of the fundamental structure of experience. According to Kant, the production

of knowledge, both empirical and a priori knowledge alike, requires the combination of two heterogeneous elements, namely, intuition and concept. Experience (i.e., empirical knowledge) is only possible when given intuitions, with space and time as a priori ,[16] are subsumed under concepts, or in Kant's technical terms, are brought to the synthetic unity of concepts. How this combination is made possible by and through our cognitive faculties, is indeed the main problem which the "Transcendental Analytic" of the *Critique of Pure Reason* is committed to resolve.

To that analysis of Kant's, Strawson responds, "we can surely acknowledge that we can form no conception of experience, of empirical knowledge, which does not allow of our becoming aware in experience of particular items which we are able to recognize or classify as instances of general kinds or characteristics."[17] In other words, "for experience to be possible at all, we must become aware of particular items and become aware of them as falling under general concepts."[18] So we may have the dominant thesis, or, as it were, the backbone, of Strawson's theory of knowledge run like this: There is the basic structure, hence the general feature, of experience, which is necessarily such that a particular item is brought into connection with a general concept. The thesis is at bottom nothing other than an exposition of the epistemological aspect of the *duality* of our conceptual scheme. .

Particular items, also known as "particular instances (of general concepts)," or "individual things" in Strawson's writings, are characteristically spatiotemporally individuated appearances; they are objects of perception, and, unlike the Kantian intuitions, they are located in a frame of *objective* (i.e., independent-of-mind) space and time. General concepts, sometimes called "general things," or "general types," are nonspatiotemporal entities; they are either concepts of kind or of property, serving as principles of organizing objects of perception. These two types of elements of knowledge, asymmetrical and heterogeneous as they are, must be combined in a certain way, otherwise knowledge is not possible. With Strawson, the combination (the connection) has been variously described as "we are aware of particulars as falling under concepts," "a particular is classified or characterized by a concept," "a concept is exemplified by a particular," "a particular is an instance of a concept." Thus, 'to fall under', 'to classify', 'to characterize', 'to exemplify', and 'to be an instance of' are locutions purporting to capture the specific relation of the two terms of the combination. They also signify an act of knowledge, that is, an act of connecting the two terms into a judgment. In brief, as Strawson puts it, "the fundamental form of affirmative judgment . . . is that in which we judge that some *general* concept has application in some *particular* case."[19]

The parallelisms between the ontology of particular and universal on

the one hand and the epistemology of perceptual object and general concept on the other, is too obvious to call for detailed elaboration. It suffices to reiterate that there are not two fields of things but only two sets of language about the same thing. But, it is important to emphasize again, the ontology and the epistemology are not mutually dependent on each other for viability; each has its own support from independent arguments and sources. So, while there is a sense in which Strawson offers a theory of being and a theory of knowledge, there is also a sense in which he presents just one epistemic-metaphysics.

Given the assumption of the triglot *duality* and with the epistemic-metaphysics set, rich resources are ready for the justification and explanations of logical subject and predicate.

On Strawson's theory, the subject-predicate distinction in logic is a manifested form of the *duality*. As the *duality* is the basic structure of conceptual knowledge, we can only think and conceive in that structure. That is to say, human knowledge, human thinking necessarily and basically proceed in the form of particular combined with universal, or empirical item combined with general concept, or again, subject combined with predicate. Strawson affirms, "the duality of subject and predicate must reflect some fundamental features of our thought about the world."[20] In logic, the duality of subject and predicate is a formal schemata, but this formal schemata is grounded in a corresponding structure of human thought; it is just a logical representation of that structure. So, unless the conceptual structure changes, the duality of subject and predicate will continue to be there even if the logical notation of it varies. We are assured that "there are categories and concepts which, in their most fundamental character, change not at all."[21] Inasmuch as the categories of particular and universal, of perceptual object and concept are necessary conditions of formation of experience and judgment, the categories of subject and predicate are necessary parts for the combination of symbols into meaningful atomic units. There are strong opinions that logic has nothing to do with ontology or experience. But it fares well to remind that logic, even taken as pure manipulation of symbols, is still itself a human thought in form, for the manipulation itself is a thinking in abstract symbols. Logic cannot do away with that formal structure of human thought. So, with Strawson's theory, the distinction of subject and predicate in logic has a kind of metaphysical necessity; it is not a mere historical, contingent fact; it cannot be eliminated anymore than can it be arbitrarily manipulated.

Strawson's theory not only justifies the status of the distinction in logic, it also provides for solutions of many problems about it.

An effective criterion for the distinction is needed. In this regard,

Strawson proposes what he calls "the category criterion."[22] The idea of the criterion consists in the recognition that "the foundation of the subject-predicate distinction lies in the difference of type or category of the terms introduced into this kind of proposition."[23] According to the criterion, expressions specifying particulars are primarily logical subject expressions as against expressions specifying universals. For instance, a singular term, when "assertively tied to"[24] a general term to yield a subject-predicate proposition, must be the logical subject of that proposition insofar as it does specify a particular. Such a singular proposition is the basic case, paradigmatic of predication. But why is it so stipulated? The reason lies in the following exposition of predication.

Predication is that in which a term is predicated of another term. Strawson's exposition is as follows: "The primary sense of 'y is predicated of x' is 'x is asserted to be non-relationally tied to y either as an instance of y or as characterized by y'."[25] With the assumption of the *duality* and the epistemic-metaphysics, the exposition virtually means that, when something is said to be predicated of something else, it is primarily the case that a particular is collected by a universal in the sense that the particular is either an instance of the universal if it is a sortal one, or characterized by the universal if it is a characterizing one. And this in turn can be explained by the epistemological fact that, when a basic predication occurs, it is the case that an object of perception is judged to be an exemplification of a general concept. In such a rendering, predication is not purely a matter of logic—it signifies a fact about reality, or a judgment about experience.

This being so, a singular proposition is *par excellence* a paradigm of subject-predicate propositions because it represents the fundamental form of judgment. The subject-predicate analysis, established *vis-à-vis* singular propositions may be applied, by analogous extension, to nonsingular, that is, general propositions, of which both terms are general terms. It is that a concept of the hierarchically lower type is judged to fall under another concept of a higher type on the strength of an analogy to the basic case. Hence a general proposition is allowed to be a subject-predicate proposition; and a general term, a logical subject, though in a derivative sense. The same explanation also applies to the asymmetry that a singular term can only be a logical subject whereas a general term may play two roles: that of a subject and that of a predicate.

Strawson's metaphysical theory of subject and predicate, as we have seen, goes well beyond the horizon of observation and analysis of behavior of linguistic expressions. It provides an explanation, a kind of metaphysical explanation, of why certain logical devices like 'Fx' and

linguistic expressions like singular term versus general term should behave the way they do. With the theory and other works, Strawson distinguishes himself from other analytic philosophers who are interested in describing language behavior or designing a perfect language. Moreover, the theory actualizes a complex construction of diverse elements, featuring Strawson's ingenuity. It incorporates metaphysics, epistemology, and logic; and at the same time, it weaves in threads from the Aristotelian, the Kantian, and the analytic traditions. In the field of contemporary philosophy of logic, Strawson's theory might seem unfashionable as it stands quite at odds with the popular thoughts of logical conventionalism, formalism, and pragmatism, which all either presume or procure a total detachment of logic and language from ontology of the traditional kind. Besides being a defense of the duality of subject and predicate, the theory as a whole can very well be regarded as an argument for the necessary connection between logic and language on the one hand and ontology on the other. And, lastly, it is only right that, in view of the fact that it mobilizes all major thoughts of Strawson's, the metaphysical theory of subject and predicate be judged the *soul* of the Strawsonian philosophy.

Chung M. Tse

Department of Philosophy
Tunghai University
November 1997

NOTES

1. For Strawson's criticisms, see his "Analysis, Science, and Metaphysics," in *La philosophie analytique* (Paris: Editions de Minuit, 1962), pp. 105–38; reprinted in Richard Rorty, ed., *The Linguistic Turn* (Chicago: University of Chicago Press, 1967), pp. 312–20.

2. F. P. Ramsey, "Universals," *Mind* 34 (1925): 401–17; reprinted in the author's *The Foundations of Mathematics* (New York: Harcourt, Brace, and Co.), p. 117.

3. P. F. Strawson, "A Reply to Mr. Sellars," *Philosophy and Phenomenological Research* 17 (June 1957): 443.

4. The distinction of topic and comment is traditionally accepted as a definien of the distinction of subject and predicate; and the distinctions, of singular and general term, complete symbol and incomplete symbol, argument and functor, denotative expression and predicative expression, percept and concept, have been discussed for the same purpose.

5. For Strawson's discussions, see his *Introduction to Logical Theory* (London: Methuen and Co., Ltd., 1952; reprinted 1967), pp. 143–46 and 170–94. See also his *Individuals* (London: Methuen and Co., Ltd., 1959), pp. 137–66; and *Subject and Predicate in Logic and Grammar* (London: Methuen and Co., Ltd., 1974), pp. 4–13.

6. See Strawson, "The Asymmetry of Subjects and Predicates," in *Language, Belief and Metaphysics*, vol. 1: *Contemporary Philosophic Thought*, edited by Howard E. Kiefer and Milton K. Munitz (New York: State University of New York Press, 1970); reprinted in P. F. Strawson, *Logico-Linguistic Papers* (London: Methuen and Co., Ltd., 1971), pp. 96–115.

7. P. F. Strawson, *The Bounds of Sense* (London: Methuen and Co., Ltd., 1966), p. 47.

8. *Individuals*, p. 10.

9. P. F. Strawson, "Logic, Epistemology, Ontology," in the same author's *Analysis and Metaphysics* (Oxford: Oxford University Press, 1992), p. 51.

10. For fine details and elaboration, see Strawson, *Individuals*, chapter 1.

11. See Strawson, *Individuals*, pp. 167–70 and 180–89; also by the same author, "Particular and General," "Singular Terms and Predication," and "The Asymmetry of Subjects and Predicates," all reprinted in *Logico-Linguistic Papers*.

12. There is a third kind, called feature universal, which we deliberately omit as it has no immediate relation to the distinction of subject and predicate.

13. Strawson carefully guards against Platonic realism on the one hand and reductionistic nominalism on the other.

14. Strawson, "Particular and General," *Proceedings of the Aristotelian Society* (1953-54); reprinted in *Logico-Linguistic Papers*, p. 35.

15. Ibid.

16. To be exact, objects of the outer sense are in both space and time whereas objects of the inner sense are in time only.

17. *The Bounds of Sense*, pp. 47–48.

18. Ibid., p. 72.

19. "Logic, Epistemology, Ontology," in *Analysis and Metaphysics*, p. 54. Strawson's italics.

20. *Subject and Predicate in Logic and Grammar*, p. 20.

21. *Individuals*, p. 10.

22. See *Individuals*, pp. 167ff. The category criterion is recapitulated in epistemologically slanted terminology in *Subject and Predicate in Logic and Grammar*, pp. 20–22.

23. *Individuals*, p. 161.

24. Ibid., p. 167.

25. Ibid., p. 171.

REPLY TO CHUNG M. TSE

Professor Chung M. Tse shows great discernment in identifying what he calls 'the soul' of my philosophy. Certainly, if any single issue, or cluster of issues, can be said to be central to my thought, it is precisely that of the metaphysical and epistemological foundations of the familiar logico-grammatical distinction between reference and predication or subject and predicate. Thus, as Professor Chung says, I have argued, on general metaphysical-epistemological grounds, both that it is the onto-logical distinction between particular and universal that provides the underlying ground of the standard logical distinction and that, among spatio-temporal particulars in general, it is substantial or relatively enduring space-occupying particulars which must be regarded as the primary or basic objects of reference.

As the Professor also remarks, this is not for me the end of the matter. Although the basic case of the reference-predication combination may, and should, be seen as that in which a single designated spatio-temporal particular is the object of reference and a general concept or universal is predicated of it, the combination in question admits of generalization, in two quite different directions, beyond this fundamental case.

First, the characteristic relation between a particular and a universal of which it is an individual instance may be reproduced at a higher level; one universal may itself be an individual instance of another. So designated universals themselves may, and do, figure as objects of reference and subjects of predication. If, as is widely held, to be an object of reference is the mark of an existent individual, an entity, then universals and, indeed, abstract objects generally (e.g., numbers, propositions, facts) must be recognized as such. More of this below.

The above is one direction of generalization of the reference-predication combination. I call it the trans-categorial dimension, since it transcends the limitation of the basic case to reference to particulars.

The other direction of generalization is certainly less ontologically

committing, and in a sense more familiar. It consists essentially in dropping the requirement of designation (i.e., individual identification) of the objects of reference. It is more familiar because it is a feature of the grammars both of standard logic and of natural language, though in quite different ways in the two cases. In standard logic the burden of reference may be carried (some would say should exclusively be carried) by the individual variable (the ghost of the individual designation or name) under standard ∀ or ∃ quantification. In natural languages, on the other hand, a whole host of plural expressions or of indefinite singular terms may form part of the subject term and hence help to specify, more or less indefinitely, the objects of reference. If we acknowledge, as we surely must, the legitimacy of these last forms of expression, we may reasonably call the second dimension of generalization trans-logical, since it transcends the forms of standard logic.

Taken together with the basic case, these two dimensions of generalization will encompass all that traditional grammars of natural languages would recognize as actual or potential subject-expressions.

Professor Chung correctly remarks that I allow the existence of two categories of entity, namely particular and universal; but he adds the qualification, 'though not in the same sense of existence'. I have some doubt about the qualification, in that it is by no means clear that I require a different *sense* of the word 'exist' in the two cases. Of course Professor Chung may not mean to suggest this. He may mean no more than that the vast difference between the two categories carries a correspondingly great difference in the implications of existence in each of them. The existence of a particular implies its real possession of some spatio-temporal location. The existence of a universal implies no more than the logical possibility of its possessing instances. Some, perhaps including Professor Chung, would strengthen the last requirement, going, beyond the logical possibility, to the reality, of such possession. This echoes, in part, the old 'ante rem' versus 'in rebus' debate. But in neither case would the difference in the implications of existence, for particulars and universals (abstract objects) respectively, require us to distinguish two different senses of 'existence'.

That said, it remains for me to thank Professor Chung for his sensitivity to my purposes and for the skill, lucidity, and elegance with which, by careful reference to a large range of my writings, he has condensed the essentials of my complex treatment of a complex matter into a small compass; and especially I applaud his recognition of and emphasis on the fact that at this highly general level ontology, epistemology and logic are indissolubly bound up with each other.

P.F.S.

20

John R. Searle

TRUTH: A RECONSIDERATION OF STRAWSON'S VIEWS[1]

I want to begin this discussion by acknowledging my enormous debts—personal, professional, and philosophical—to Peter Strawson. Of all the teachers and friends who have helped me in philosophy, he has had the greatest influence on my philosophical work and has been the greatest source of inspiration to me.

Strawson discusses the problem of truth in a number of important articles.[2] His views were, I believe, initially inspired by Frank Ramsey's version of the redundancy theory of truth.[3] Ramsey had argued that "true" does not stand for a special property but is linguistically redundant, because for any statement, to say that the statement is true is just to make the statement itself. To say for example that "snow is white" is true is to say no more and no less than that snow is white. The principle on which Ramsey's argument is based was later used by a large number of writers. For any statement S,

S is true if and only if p.

Where for "S" we substitute a quotation, or some other such mention of the statement, and for "p" we substitute the statement itself. For this reason the principle came to be called "disquotation." On the right-hand side we drop the quotes.

I believe Strawson was impressed by Ramsey's argument, and like Ramsey he rejects the correspondence theory of truth. But his own account goes far beyond Ramsey's position. He agrees with Ramsey that "true" does not describe a property shared by all true statements, but he thinks that "true" is not thereby rendered redundant. Two prominent theses in Strawson's work are, first, his analysis of "true," according to which to say of some statement that it is true is not to describe it, but to

perform one or more of the speech acts that would include endorsing, granting, conceding, admitting, etc.; and second, his attacks on the correspondence theory of truth, especially Austin's version of that theory. Strawson's conclusion is that "The correspondence theory requires not purification, but elimination" (Pitcher, p. 32).

So we have three positions: First, the correspondence theory, which Strawson rejects. Second, the redundancy theory, based on the argument from disquotation. And third, Strawson's own positive theory, sometimes misleadingly called the "performative theory of truth."

In this article I will not, except in passing, be concerned with "the performative theory." I have criticized it elsewhere.[4] Briefly, the criticism is that Strawson's analysis of "true" cannot be correct because it cannot account for occurrences of "true" where it does not occur as part of a simple categorical assertion, but is embedded in hypothetical, disjunctive, etc. sentences. Even if, as Strawson claims, "It is true that it is raining" is used in a way similar to "I endorse the claim that it is raining," all the same, "If it is true that it is raining then it is true that the ground is wet" does not mean anything remotely like "If I endorse the claim that it is raining, then I endorse the claim that the ground is wet." Similarly, "I wonder whether it is true that it is raining" does not mean anything remotely like "I wonder whether I endorse the claim that it is raining." And so on through countless other possibilities.

My primary aim in this article is to reopen these issues. I believe that there is a way of understanding the correspondence theory that is immune to Strawson's and Ramsey's objections. I also believe that this whole debate is a classic case of misunderstanding the ordinary functioning of the words "true," "fact," etc., and that with a proper understanding of the ordinary use of these terms many of the issues dissolve.

First I will state in a preliminary form the underlying intuition behind the correspondence theory. Then I will summarize three of Strawson's objections to the theory. Then I will give an account of truth and correspondence that I believe is immune to his objections; and then answer the objections. Finally, I will discuss some of the complexities in the notion of "fact."

I. What Is the Correspondence Theory of Truth?

There are many different versions of the correspondence theory and they are by no means all equivalent, but there is a basic intuition that, I believe, underlies all of them. I believe the intuitive idea is right. Some of

the formulations of the theory are wrong. The basic intuitive idea of the correspondence theory is that a statement is typically true if and only if there is some fact or state of affairs or condition in the world independent of the statement in virtue of which or because of which the statement is true. Statements are made true by something independent of the statement. So, for example, if I make the statement, "We have had an unusual amount of rain this winter in California," that statement will be true if and only if there is a sequence of weather events that constitute our having had an unusual amount of rain this winter in California. I said that a statement is *typically* true because of conditions in the world apart from the statement, but there are certain interesting exceptions. Sometimes the condition or fact that makes a statement true is not something independent of the statement but is part of the statement. So, if I say, for example, "this statement that I am now making is made in English." That statement is indeed true, but it is true not in virtue of something independent of the statement, but in virtue of some feature of the statement itself. However, though this requires us to alter our formulation of the correspondence theory, it does not seem to me in any way to weaken or challenge the fundamental intuition behind the correspondence theory, namely, that statements, when true, are true in virtue of something that makes them true. The statement sets conditions and will be true if and only if those conditions are satisfied. These conditions in virtue of which or because of which a statement is true are called "the truth conditions" of a statement, though the notion of a truth condition is not as clear as many people have supposed.

The most common formulation of the correspondence theory and the one that I will be concerned to clarify and defend is this:

A statement is true if and only if it corresponds to a fact.

This is sometimes put in the plural by saying that a statement is true if and only if it corresponds to *the facts*.

I should make it clear immediately that the correspondence theory is not an attempt to define "true" without using other semantic notions. If we tried to take this account as a *reductive definition* of "true" in nonsemantic terms, it would be circular because it uses such semantically loaded notions as "fact" and "correspond." Furthermore the metaphor of correspondence is certainly no clearer than the notion of truth itself, so the correspondence theory should not be seen as an attempt to reduce complex and obscure notions to simpler and clearer ones.

II. Strawson's Objections to the Correspondence Theory

Objection 1

The first Strawsonian objection that I will consider is a traditional one: The correspondence theory cannot account for negative, hypothetical, counterfactual and other sorts of statements that differ in logical form from singular categorical statements. He points out that the correspondence theory might seem to work for such favored cases as facts of the cat-on-the-mat-type; but, he says,

> Other species of a fact, however, have long been known to present more difficulty: the fact that the cat is not on the mat for example, or the fact that there are white cats, or that cats persecute mice, or that if you give my cat an egg it will smash it and eat the contents. Consider the simplest of these cases, that involving negation. With what type of state of affairs (chunk of reality) is the sentence "The cat is not on the mat" correlated by conventions of description? With a mat *simpliciter*? With a dog on a mat? With a cat up a tree? (Pitcher, p. 51).

Strawson continues,

> As objections to the correspondence theory of truth, these are familiar points; though to advance them as such is to concede too much to the theory. What makes them of interest is their capacity to reveal how such a theory, in addition to its intrinsic defects, embodies too narrow a conception of the fact stating use of language. (Pitcher, pp. 51–52)

As Strawson is aware this is an objection that adherents of the correspondence theory have long had to cope with. Russell wrote in a letter to the young Wittgenstein asking, are there negative facts? Wittgenstein reportedly shot back, "Of course not!"

Objection 2

In his debate with Austin, Strawson maintains that the correspondence theory cannot account for the relationship between language and reality because, as he says, the notion of fact has the word-world relationship built into it. I think that what he means by that, and what his examples illustrate, is that there is no way of identifying a fact independently of making a true statement. In order to state which fact a statement corresponds to, one has to state the statement itself. Facts, therefore, are not nonlinguistic items to which statements correspond if they are true, rather, the word "fact" is already, so to speak, linguistically permeated. Strawson sometimes describes facts as "pseudomaterial" correlates of true statements.

Strawson's point, in sum, is that there cannot be a genuine relation of correspondence or any other genuine relation between facts and true

statements because there is no way to identify the two elements indepen-
dently. Once you ask the question, Which fact?, the only way that
question can be answered is by stating a true statement. Strawson's point
is not epistemic but ontological. Facts do not have a mode of existence
that is independent of true statements.

The right model, on Strawson's account, for the relation of state-
ments to fact, is not representation and thing represented; rather the
relation of "fact" to "state truly" is more like that of internal accusatives
to their corresponding verbs. To say that a statement corresponds to a
fact is like saying that whenever someone wins, they win a victory. But
there are not two things, a winning and a victory, "victory" is just
another way of describing a winning. Strawson put this point by saying
"facts are what statements, when true, state. They are not what state-
ments are about." Thus it seems that, for Strawson, just as victories are
what winners, when they win, win; so facts are what statements, when
true, state. But the fact which a statement states, "is not something in the
world. It is not an object; not even (as some have supposed) a complex
object consisting of one or more particular elements (constituents, parts)
and a universal element (constituent, part)" (Pitcher, p. 37). Rather, "the
fact to which the statement 'corresponds' is the *pseudo*material correlate
of the statement as a whole" (p. 37).

What, then, is a fact for Strawson? He doesn't tell us. He is careful not
to say that a fact is just a true statement. Frege did hold such a view. For
Frege, facts just are true propositions. But that must be a mistake
because, for example, facts can function causally in a way that true
statements cannot. Consider: "The fact that Napoleon recognized the
danger to his left flank, caused him to move his troops forward." You
cannot make a parallel claim about the true statement. The true
statement that Napoleon recognized the danger to his left flank, didn't
cause anything.

Austin, on the other hand, clearly talks as if a fact is a kind of an
arrangement of objects or a matter of an object having a feature. His
favorite example is the fact that the cat is on the mat. Of course, Austin
would never say anything as crude as that facts are a matter of the
arrangement of objects or the possession by objects of features, but his
examples are typically of these types. In any case, his revised formulation
of the correspondence theory led to the next objection.

Objection 3

Austin wanted to purify the correspondence theory. To do this he gave a
statement of the theory that did not use the notion of a fact. In his
revised version of the correspondence theory he distinguishes two sorts

of conventions in language, descriptive conventions that correlate words with *types* of situations (where words here = sentences), and demonstrative conventions that correlate words with *historic situations* to be found in the world (and words here = statements). He then offers the following account of truth,

> a statement is said to be true when the historic state of affairs to which it is correlated by the demonstrative conventions (the one to which it "refers") is of a type with which the sentence used in making it is correlated by the descriptive conventions.[5]

Austin is aware that so far this only covers a restricted class of statements. On this conception, to see if a statement has the property of truth, you pick out a historic state of affairs with the demonstrative conventions and then you see if the state of affairs is of the type with which the sentence used in making the statement is correlated by the descriptive conventions. So, the historic state of affairs of the situation of the cat and the mat is picked out by the demonstrative conventions, and then you see if it is of the-cat-on-the-mat type, where that is the type with which the sentence used to make the statement is correlated by the descriptive conventions.[6]

In an article written after the original debate with Austin, Strawson produced a new objection to Austin's theory.[7] First he points out that there cannot be any conventions relating *statements* to states of affairs. Rather, conventions regarding *words* and *sentences* determine which statement is made in their utterances. Austin's account has to be restated to take account of this slip. But even so amended, and quite apart from the admittedly limited range of application of Austin's analysis, Strawson says the analysis cannot have any application *at all* as an analysis of truth. In a careful and subtle analysis he goes through all the possible ways of interpreting Austin and shows that none of them work. I won't repeat the whole argument here, but just mention what I believe is its most important point: On a natural interpretation of Austin the analysis will not work because you can only apply it to statements you already knew to be true. Unless the statement is already true, there is no "historic state of affairs" with which it is correlated. Suppose the statement is "the cat is on the mat." Well, then you take your demonstrative convention to pick out a situation. And what situation can you pick out with those demonstrative conventions? The only situation that that statement is uniquely qualified to identify by demonstrative conventions is the situation that the cat is on the mat. There isn't any further move you can make to see whether or not it satisfies some descriptive convention.

III. TRUTH, FACTS, AND CORRESPONDENCE

I want to make some general observations about the ordinary use of the expressions, "true" and "fact" and about how they might have evolved their present meaning. These remarks are intended as a series of observations about word usage with some etymological speculations about how those usages might have evolved.

"True" comes from the same etymological root as "trust" and "trustworthy," and all of these from the Indo-European root "deru" for tree, suggesting uprightness and reliability generally. There are not only true statements, but true friends (real or genuine friends), true emotions (sincerely felt, not fake), true heirs (rightful or legitimate), as well as true north, true trout (the Eastern brook trout is not a true trout, it is a char), knives that cut true, and true believers.

These various senses of "true" show family resemblances. If truth has some general connection to trustworthiness and reliability we need to ask: Under what conditions would we find a statement trustworthy or reliable? Obviously when it does what it purports to do, that is when it accurately states how things are. When it says things are thus and so, then it is reliable if and only if things really are thus and so. This is how we get the disquotation criterion for truth. The disquotation criterion gives us a general criterion of truth which is consistent with our intuition that truth implies accuracy, reliability, and trustworthiness. Aristotle articulated this conception when he said that to speak the truth is to say of what is that it is, and to say of what is not that it is not. In short, "truth" applied to statements is a term of assessment implying trustworthiness, and disquotation gives us a criterion of trustworthiness.

Now let us turn to "fact." We know definitely that this word is derived from Latin "factum," which is the neuter past participle of the verb "facere" meaning to do or to make. Hence, to mix three languages, one can say that the *factum* is the *thing done*, or the *fait accompli*. But so far this has no obvious connection with true statements. Here is the connection. Just as we need a general term, "true," for the feature of trustworthiness as it applies to statements, so we need a general term for what makes statements trustworthy, for what it is in virtue of which they are reliable. If it is true that the cat is on he mat there must be something in virtue of which it is true, something which makes it true. The disquotation criterion only tells us *for each case* what that something is. The something that makes it true that the cat is on the mat is just that the cat is on the mat. And so on for any true statement. What makes it true that grass is green is that grass is green, etc. *But we still need a general*

term for all of those somethings, for what makes it true that grass is green,
that snow is white, that 2 + 2 = 4 and all the rest. "Fact" has evolved to fill
this need. The word "fact" in English has come to mean that in virtue of
which true statements are true. This is why Strawson is right to think that
in order to specify a fact, in order to answer the question, "which fact?,"
we have to state a true statement. When it comes to specifying their
essence, facts can only be stated and not named. But it does not follow
that facts are somehow essentially linguistic, that they have the notion of
statement somehow built into them, or that they are in any sense
"pseudomaterial." On the contrary, on the account I have given they are
precisely not linguistic (except, of course, for the small but important
class of linguistic facts) because the whole point of having the notion of
"fact" is to have a notion for that which stands outside the statement but
which makes it true, or in virtue of which it is true, if it is true. On this
account facts are neither complex objects, nor are they linguistic entities,
rather they are *conditions*, specifically, they are conditions in the world
that satisfy the truth conditions expressed by statements. The word
"condition" has the usual process-product ambiguity; in this case the
ambiguity is between the *requirement* and the *thing required.* The
statement determines a truth condition as requirement and if satisfied
there will be something in the world as thing required.[8] For example, the
statement that the cat is on the mat expresses the truth condition as
requirement. If the statement is true there will be a condition in the
world that meets the requirement, and that condition is the fact that the
cat is on the mat. On this account we neither have nor need a thick
metaphysical notion of "fact." Anything sufficient to make a statement
true is a fact. Thus the fact that there are no three-headed cats is as much
a fact as the fact that the cat is on the mat.

For this reason, because of the definitional connection between fact
and true statement, there could not be an inconsistency between the
correspondence criterion of truth and the disquotational criterion.
"Fact" is defined as that in virtue of which a statement is true, and
disquotation gives *the form* of what makes each statement true by simply
repeating the statement. But if the statement is true, then repeating the
statement is the same as stating the fact. The disquotational criterion
tells us that the statement "The cat is on the mat" is true if and only if
the cat is on the mat. The correspondence criterion tells us that the
statement "The cat is on the mat" is true if and only if it corresponds to a
fact. But which fact? The only fact it could correspond to, if true, is the
fact that the cat is on the mat. But that is precisely the result given by the
disquotational criterion, because that is the fact stated by the right-hand
side of the disquotational sentence: the statement "the cat is on the mat"
is true if and only if the cat is on the mat. And this is also why in order to

know that it is true that the cat is on the mat, all we have to do is establish that the cat is on the mat. We don't have to establish *in addition* that the statement that the cat is on the mat corresponds to the fact that the cat is on the mat, because we have already established that correspondence when we established that the cat is on the mat. Strawson points out, correctly, that there is an internal relation between true statement and fact. It could not be that true statement if it did not state that fact.

With these points about "true" and "fact" in mind let us turn our attention to "correspondence." In what sense if any do true statements *correspond* to facts? Even if we grant that facts, though they have to be propositionally specified, are still not linguistic entities, all the same is there any sense to the notion of correspondence? How do we answer Strawson's objections on that score?

We need a general word for assessing success and failure in achieving fit for representations that have the word-to-world direction of fit, and those words, among others less important, are "true" and "false." We also need a general term for naming all those somethings specified on the right-hand side of disquotational sentences when the sentence specified on the left-hand side is true; that word is "fact." But grammatically we now need a verb for describing the relations between the statements and the facts when the statements are true.

Statements are true if and only if they blank the facts.

We need a word for "blank," and it should be just empty enough and vague enough to allow for all the different kind of ways in which statements can blank the facts, the ways which render the statement true. In English there are number of such verbs: "state," "fit," "match," "describe," and "correspond to" are five. It ought to arouse our suspicions that we have several nonsynonymous expressions for the same relation. What is going on? Statements set conditions of satisfaction, just as do orders, promises, etc. In the case of statements the condition is called a truth condition and if the condition is satisfied, the satisfying condition is called a fact. The relation then between true statement and fact is clear: it is one of satisfaction. The statement is satisfied if true, just as the order is satisfied if obeyed, etc. True statements are statements that stand in the satisfaction relation to facts. The relation called "correspondence" is more accurately described as "satisfaction." But this is a technical notion from the theory of intentionality, and ordinary language will tend to use words with meanings that already exist in the language. Hence the variety of "correspond," "state," "fit," "match," and "describe." The actual relation is one of satisfaction with the word-to-world direction of fit.

Just as we need a general term for all of the different features of the

world that can make statements true, so we need a general term for naming the ways in which true statements can accurately represent how things are in the world, and "corresponds to the facts" has evolved as such a general characterization of the satisfaction relation. "Corresponds to the facts" is a shorthand for the variety of ways in which statements, beliefs, etc. can accurately represent how things are, and that variety is the same as the variety of statements, beliefs, etc.

The hardest thing to keep in mind in this whole discussion is that we are dealing with a small bunch of tautologies and their entailments. Disquotation and the correspondence theory are trivially, tautologically true, hence any appearance of conflict must derive from our urge to misunderstand them. Just as the correspondence theory generates a false picture, because we do not adequately understand the actual use of these words, so disquotation generates a false picture, and for the same reason. The false picture generated by the correspondence theory is that a fact is some kind of complex object or arrangement of objects, and correspondence is some sort of picturing relationship or at least an isomorphism between statement and fact. We think that because we have a noun "fact" we must find a thing or object for which it stands. And we think that because we have a verb "corresponds" we must find some matching relationship between statement and fact. Misled by the surface grammar of the sentence we construe "A true statement is one which corresponds to the facts" on the model of "A good photograph is one that looks like its subject." I am arguing that if we look at how these words are actually used then a fact is a satisfied truth condition: it is the condition in the world in virtue of which or because of which a statement is true. "Truth" and "falsity" are names for success or failure in achieving satisfaction of statements (or beliefs), which have the word-to-world (or mind-to-world) direction of fit, just as "obedience" and "disobedience" are names for success or failure in achieving satisfaction of orders, which have the world-to-word direction of fit. "Correspondence" is useful as a metaphor because it is so empty. The fact that we use so many other nonsynonymous expressions—"fit," "match," "state," "describe," and even "square with"—to do the same job, should be a clue that "correspondence" is not being used literally. The actual relation between true statement and corresponding fact is one of satisfaction.

The false picture generated by disquotation is that there is no property of truth at all: "Snow is white" is true iff snow is white. "Grass is green" is true iff grass is green, and so on for every indicative sentence. On this view, there is no common property of truth, nothing in common to all these cases; there is nothing in common to both "Snow is white" and "Grass is green" in virtue of which they are both true. I am not, in this discussion, primarily concerned to refute this view but I want to call

attention to how wildly counterintuitive it is. No one would say that obeyed orders have nothing in common in virtue of which they are obeyed nor would they say that kept promises have nothing in common in virtue of which they are kept. It is just as far fetched to say that true statements have nothing in common in virtue of which they are true.

IV. Replies to Strawson's Objections

Reply to Objection 1

The fact that we are inclined to think that negative statements, hypotheticals, counterfactuals, etc. pose some special problem for the correspondence theory is a sure sign that we are misunderstanding how these expressions are used. What fact corresponds to the true statement that the cat is not on the mat? Obviously the fact that the cat is not on the mat. What fact corresponds to the true statement that if the cat had been on the mat the dog would have bitten it? Obviously the fact that if the cat had been on the mat the dog would have bitten it. And so on for every case. For every true statement there is a corresponding fact, not because God and Nature have given us a wonderful preestablished harmony but because we have evolved these words so they match in just this way. Once we avoid the mistake of thinking that a fact must be an object or complex of objects—a "chunk of reality," in Strawson's words—then these examples pose no difficulty for the correspondence theory.

Nonetheless, there are some interesting complexities and ambiguities in the notion of fact, and I will discuss these in section 5.

Reply to Objection 2

Strawson claims that the internal relation between fact and true statements makes it impossible that there should be such an entity as a fact independent of a true statement, and he concludes that if there are not two independent entities, then there cannot be a relation named by "correspondence." By now I hope my answer to these points is clear: There is indeed an internal relation between true statements and facts, because the word "fact" is designed precisely to specify those conditions in the world in virtue of which true statements are true. That is why there is a perfect match between the use of the expression "true statement" and the use of the expression "fact." That is why the word "fact" is, as linguists say, a factive nominalizer. Like "true statement" it always takes that-clauses. The true statement that the cat is on the mat perfectly matches the fact that the cat is on the mat. Nonetheless, this does not seem to me to show what Strawson thinks it shows. It does not

show that the fact that the cat is on the mat is not a nonlinguistic feature or condition in the world. On the contrary, as I just said, the notion of "fact" evolved precisely to have a device for naming those nonlinguistic conditions in the world in virtue of which linguistic entities such as statements, are true. To repeat the point, Strawson is right to state that there is an internal connection between true statement and fact—it is internal in the sense that it could not be *that* fact and *that* statement if they did not stand to each other in that relation—but he is wrong to think that this point is in any way an objection to the correspondence theory properly construed. It is only an objection to the correspondence theory if you think that a fact is some kind of an object. But it is not. Rather, a fact is a condition, it is a condition that such and such is the case. And the word "fact" has evolved precisely so that we can specify those conditions that exist in the world in virtue of which true statements are true. The internal connection between true statement and fact is not an objection to the correspondence theory, it is one of its consequences.

Reply to Objection 3

I think that in the debate with Austin over Austin's attempt to reformulate the correspondence theory in terms of demonstrative and descriptive conventions, Strawson has the better of the argument. Strawson convincingly shows that if you try to redefine the correspondence theory of truth in terms of a correlation between states of affairs identified demonstratively, and their features picked out descriptively, then Austin's effort fails. As Strawson says, it has no real application because you have to know that the statement is true before you can begin to inquire whether or not it actually satisfies the definition.

But I do not think that this succeeds in refuting the version of the correspondence theory that I have presented, or the one that Austin originally formulated when he said that we can hardly deny that a statement is true when it corresponds to the facts.

If I may offer a diagnosis, here is what I think happened. The correspondence theory is defined as the view that a statement is true iff it corresponds to a fact. Strawson saw, correctly in my view, that the theory cannot be right if it means what it appears to mean, i.e., if it means that truth is a matter of a matching relation between statements and complex "chunks of reality." On these grounds he, mistakenly in my view, gave up on the theory altogether. "The correspondence theory requires not purification but elimination."

Austin saw, again correctly in my view, that the correspondence theory must be right. So he, mistakenly in my view, tried to formulate a

more precise version of it in terms of descriptive and demonstrative conventions. This is where Austin went wrong: There is nothing wrong with the theory as it stands, provided you understand it correctly. In reformulating the theory, Austin fell into the trap of treating the predication of truth on the model of object and property. There is an object—the historical situation or state of affairs—and it has a property—it is of a type determined by the descriptive conventions. Strawson devastates this view by pointing out that once you have the "object" identified there isn't anything else to do. So Austin's revised theory has no application.

V. More about Facts

So far I have been doing a Wittgenstein-style therapeutic analysis. I have been arguing that there is nothing wrong with the correspondence theory or the words in which it is stated, but that we need to overcome our urge to misunderstand both the theory and the words. We think mistakenly that the theory implies a matching relation between statements and complex objects, that disquotation implies that there is no property of truth at all, that negatives, hypotheticals, etc. pose a problem for the correspondence theory, that the theory is inconsistent with the disquotation principle, etc. All of these are mistakes I hope to overcome, using methods of language analysis that I learned from P. F. Strawson and J. L. Austin. In this discussion, ordinary language is the ultimate court of appeal. But these very same methods of language analysis reveal an interesting tension that I now want to explore.

I said that on our ordinary conception of truth, for every true statement there is a corresponding fact. But facts do more than just match true statements; rather the statement is true *because of* or *in virtue of* the facts. In some sense we need to explore, the facts *make the statements true*. We thus have two concepts of "fact," or rather two strands within our single concept: A fact is a *disquotational correlate* of a true statement but at the same time a fact is a *truth maker* or *truth explainer* of true statements. The existence of these two strands produces a tension, almost an ambiguity, in our use of the word "fact." Normally the disquotational correlates and the truth makers are identical; but not always, as we shall shortly see.

I said that the word "fact" evolved to have a word to name the nonlinguistic correlate of true statement. As a remark about English usage, that seems to me correct. For every true statement, there is a corresponding fact. That is, as a matter of English usage, whenever there is a successful referring use of the expression, "the true statement that

p," there is a successful referring use of, "the fact that p." This is the disquotational correlate conception of fact. However, the word "fact" names the nonlinguistic correlate or condition in the world in virtue of which, or because of which, a statement is true. Now, these nonlinguistic correlates are part of the real world. But it is part of our notion of the real world that it is totally determinate. All the details are fixed. As Leibniz said somewhere "reality is that which is totally determinate." But statements are not in that way totally determinate, or rather, the statement allows a certain slack in what determinate features of the real world would constitute its truth condition. This, I believe, is the underlying reason why we feel there is a problem about negative facts or hypothetical facts. If I say "the cat is on the mat," then the actual fact in the world is one of a determinate cat being on a determinate mat at a specific location in space and time. But if I say "the cat is not on the mat," and we suppose that statement is true, then there is an indefinite range of different circumstances that could constitute the truth conditions of "the cat is not on the mat." Or rather, to put this point more precisely, we have a metaphysical urge to feel that the fact that the cat is not on the mat is not the real fact that makes the statement true. The real fact is, for example, the fact that that particular cat is right now standing right there in the kitchen. So, there is a condition in the world, the condition that the cat is not on the mat, but the way in which that condition exists, the way in which that condition is part of the world is by way of a determinate cat being in a determinate location at a specific time, and that location being somewhere other than on the mat. It is this metaphysical urge that prompted Wittgenstein's abrupt answer to Russell.

To put this point rather grandly, it is in the nature of language that it allows a slack in the determination of truth conditions by statements, but it is in the nature of reality that it allows no slack in anything. Strictly speaking this is as much a problem for affirmative as for negative statements. Just as there are an indefinite number of ways for the cat to be *not* on the mat, so there are an indefinite number of ways for it to be *on* the mat. But this does not bother us as much for affirmative as it does for negative statements because of the lesser slack allowed by the affirmative. We think that "the cat is on the mat" tells me exactly where the cat is, in the way that "The cat is not on the mat" does not. So we do not feel the tension in the singular affirmative as we do in other sorts of true statements (and corresponding facts).

It is also in the nature of language that it allows hypothetical, counterfactual, disjunctive, etc. statements, but it is in the nature of reality that these concepts have no application to it whatever. The tension arises because the word "fact" names conditions on the reality

side, and must do so in order to play its truth explainer role; but clauses of the form, "the fact that . . ." have to match the syntax of statements on the language side in order that facts can play their disquotational role. We are, in short, sometimes asking the word "fact" to do an impossible job and this is the deeper source of our philosophical confusions.

Let me illustrate this with an example.

1. If I drop this pen it will fall to the floor.
2. 1 is true.

Therefore, by disquotation

3. It is a fact that if I drop this pen it will fall to the floor.

So far so good, but if I ask myself, what fact *makes it the case* that 1 is true, I would answer not with 3, the disquotational correlate, but with 4, a truth explainer.

4. The pen is subject to a constant force of gravity.

This problem is manifested in another set of contrary intuitions that we have. Often we feel, with Austin, that a statement can fit the facts more or less, that a statement can fit the facts roughly. Thus we feel the statement "the earth is 93 million miles from the sun," can be approximately true because it approximately or roughly fits the actual facts regarding the distance between the earth and the sun. But now what about the statement "the earth is approximately 93 million miles from the sun," does that then fit the facts exactly? On the one hand, we feel the urge to say, yes it does fit the facts exactly, because it is exactly true that the earth is approximately 93 million miles from the sun, and thus the truth condition is satisfied (disquotational correlate). On the other hand, we are inclined to say, no, the very same fact to which the original statement corresponded only approximately, is the very same fact to which the statement about approximation also corresponds only approximately, and "approximately" there serves to describe the nature of the correspondence (truth explainer).

I do not see any resolution to this tension, but I want to remind the reader how pervasive it is as a source of philosophical problems. It comes up in the discussion of probability. (What fact corresponds to the true statement that it will probably rain tomorrow?) It famously comes up in ethics (What fact corresponds to the true statement that cruelty is evil?). It also comes up revealingly in the truth status of analytic propositions, and I will conclude this section by briefly showing how.

It is frequently said that analytic truths such as "All triangles have three sides" are in some sense linguistic truths, or true in virtue of meanings alone, or even truths about language. I think this doctrine is

confused. The true statement that all triangles have three sides is not about language, it is about triangles. And the fact that corresponds to it is not a linguistic fact at all; it is the fact that all triangles have three sides. Its truth condition is not in any way linguistic in nature. Nonetheless its truth is guaranteed by the meanings of the words used. The meaning of the statement is such that it cannot fail to be true, i.e., cannot fail to correspond to a fact. So what "makes it true" is linguistic in nature, but that linguistic nature operates by guaranteeing that there will be a fact which corresponds to it. The reason for the muddle is that the disquotational correlate (the fact that all triangles have three sides) is not the real truth explainer.

V. CONCLUSION

My aim in this article has been to reexamine Strawson's views on truth. I have come to conclusions that differ from his, but the whole approach is so much in the spirit of his work, and even in the spirit of his criticisms of the correspondence theory, that the modest version of the correspondence theory I present is one I hope he could accept.

JOHN R. SEARLE

DEPARTMENT OF PHILOSOPHY
UNIVERSITY OF CALIFORNIA, BERKELEY
APRIL 1998

NOTES

1. This article is a continuation of a line of argument begun in my book *The Construction of Social Reality* (New York: Free Press, 1995). Some of the ideas originally presented there are repeated and developed here.

2. "Truth," *Analysis* 9, no. 6 (1949). "Truth," *Proceedings of the Aristotelian Society*, supp. vol. XXIV (1950), reprinted in G. Pitcher (ed.), *Truth* (Englewood Cliffs, N.J.: Prentice Hall, 1964). "A Problem about Truth," in P. F. Strawson, *Logico-Linguistic Papers* (London: Methuen, 1971). "Truth: a Reconsideration of Austin's Views," *Philosophical Quarterly* 15 (1965), reprinted in *Logico-Linguistic Papers*.

3. "Facts and Propositions," *Proceedings of the Aristotelian Society*, supp. vol. VII (1927). Reprinted in *The Foundations of Mathematics* (London: Routledge and Kegan Paul, 1931).

4. "Meaning and Speech Acts," J. R. Searle, *Philosophical Review* 71 (1962).

5. "Truth," J. L. Austin, *Proceedings of the Aristotelian Society*, supp. vol. XXIV (1950). Reprinted in G. Pitcher (ed.), *Truth* (Englewood Cliffs, N.J.: Prentice Hall, 1964).

6. By the way, though Austin certainly did not admire Wittgenstein, this definition is oddly reminiscent of the distinction between the *Tatsache* and the *Sachverhalt* in the *Tractatus*. *Sachverhälter* are possible states of affairs and the sentences in the language pick them out. If the sentence is true, the *Tatsache* is the actual state of affairs which obtains.

7. "Truth: A Reconsideration of Austin's Views."

8. For more on this distinction see Searle, J. R. *Intentionality* (Cambridge: Cambridge University Press, 1983), p. 13.

REPLY TO JOHN SEARLE

I am grateful to John Searle for raising once again the issue of truth and for writing about it with his customary clarity, penetration, and forthrightness—and also for the agreeably ironic way in which his title echoes that of one of my own critiques of Austin. I agree with Searle on a number of points. I agree that my very first essays on truth contained an indefensible mistake, pointed out by many, and excluded by me from all of my subsequent writings on the subject—the mistake of supposing that to draw attention to one particular aspect of the use of the expression 'is true' was to give an exhaustive account of its meaning. Second, I agree that truth is a genuine property, 'true' a genuine predicate. And third, I agree that facts are not linguistic items.

Searle offers us a modest and carefully trimmed version of a correspondence theory of truth. In my view, it is not quite modest enough. Once a correspondence account is made modest enough, then everyone, including myself, does and must accept it. For consider. Everyone without exception would agree on the following biconditional: the proposition that Napoleon won the battle of Austerlitz is true if and only if Napoleon won the battle of Austerlitz. The first clause of the biconditional is about a proposition; it says of the proposition that it is true. The second clause is about Napoleon and a battle: it is about the world; it reports on a historical event and records, as it happens, a historical fact. The biconditional displays correspondence in its form, and affirms as a whole that the proposition is true if and only if such correspondence between proposition and fact obtains.

So what divides me from Searle? I agree with him that a proper understanding of the functioning of the words 'true' and 'fact' is the key to the problem. But the first thing of all is to be clear what the real subjects of the predicate 'true', as used in the present connection, actually are. The real or fundamental subjects of that predicate are

not, as adherents of the 'disquotational' view must hold, linguistic items. It is not sentences, types or tokens, that are the fundamental bearers of the properties of truth or falsity. It is not, when we speak, the words we use, but what we use them to say, that is in question. It is whatever may be believed, doubted, hypothesized, suspected, supposed, affirmed, declared, denied, alleged, etc. that is, or may be, true. Any of these verbs may be followed by a noun clause of the form, 'that p'; and it is precisely the items designated by these noun clauses that are the bearers of the properties of truth or falsity. We do not have, in common use, a general word for these items; for in practice we always use a nominalization of one of the verbs in question as the subject of the predicate (e.g., 'your belief', 'that allegation') or a noun phrase such as 'what he has just said' or even the form 'that p' itself. Philosophical custom supplies the deficiency with the term 'proposition' (which, of course, in ordinary nonphilosophical use, has a much more limited range of applications) or, more recently, 'propositional content'. Since I am no reformer, I will content myself with 'proposition'; and remark simply that, so understood, a proposition is not an inscription or an utterance or a type of inscription or utterance; it is an intensional, abstract entity, but nonetheless an item of a kind such as we constantly think of and refer to whenever we think of, or comment on, what someone has said or someone else has written, or a thought or a suspicion that has just entered our own heads. No general criterion of identity for such items? Never mind: we get on well enough and communicate well enough without one.

So what about facts? Searle is rightly careful to disclaim any view of facts as 'chunks of reality' or complex arrangements of objects in the world. He thins them down to 'conditions'—which marries happily with 'truth-conditions'. But, at least where a true empirical statement is concerned, he wants the relevant fact to be a condition 'in the world' which 'makes' the statement true or 'in virtue of which' the statement is true.

In my own view however, the thinning down has not gone far enough. The relevant fact is not something or anything 'in the world' which makes the proposition true. A proposition, an intensional abstract item, may have many properties: it may be simple or complex; it may entail or be incompatible with this, that, or the other proposition. It may also have the property of being true; and then it may properly be called 'a truth'; and this is what a fact is—a truth: just as much an intensional abstract entity as the proposition which 'fits' or 'corresponds to' it. What indeed could better fit the truth (fact) that p than the proposition that p? Once this is acknowledged, all the anxieties about negative, hypothetical, or disjunctive facts are dissipated at once—they vanish like a dream—

P. F. STRAWSON

without any need for the accurate and ingenious manoeuvres which Searle executes around the question. For of course there are truths of the form 'not-p', 'p or q', etc.

Doubts may remain. One is voiced by Searle himself when he remarks that facts can be causally efficacious; and no one wants to say that abstract intensional entities can be causally efficacious. Searle's example is: 'The fact that Napoleon recognized the danger to his left flank caused him to move his troops forward'. But we must tread carefully here. Let us grant that only worldly items, items in the world, can *act* causally, be causally efficacious; so facts, on my interpretation, cannot. They can, however, be causally *explanatory*; i.e., we can invoke one fact in explanation of another, as when we might say, in an improved gloss on Searle's sentence, 'Napoleon moved his troops forward *because* he recognized the danger to his left flank'. If we insist on identifying the causally *operative* thing, we must say it was indeed something in the world, namely the *event* of Napoleon's recognizing the danger to his left flank. Events are not facts. Here again language may mislead us—as it misled Austin in his 'Unfair to Facts'. Nominalizations are the logically deceptive forms here—two-faced creatures which can designate events, but can also designate facts. So we might be tempted to argue: (1) Napoleon's winning the battle of Austerlitz is a fact; (2) Napoleon's winning the battle is a definite concrete event in the world—it took place at a certain location on a certain date in 1805. Therefore the fact is nothing abstract but a concrete occurrence. The reasoning is broken-backed. The battle indeed was fought and won at a certain time and place. But the fact that the battle was fought and won by Napoleon at Austerlitz in 1805 did not take place anywhere at any time.

The doctrine that facts, like propositions, are intensional abstract objects might still appear shocking. For what could be more concrete than facts? The following may help us to see that it is not shocking at all, but simply correct: what the facts are facts *about* certainly are, in the relevant empirical cases, items or events in the world (Napoleon, his enemies, the battle). But aboutness, in the relevant sense, is precisely not a relation between one item in the world and others. The proposition, the assertion of which records the fact, is *about* the same concrete items; and the *aboutness* relation is necessarily the same in each case.

P.F.S.

PART THREE

BIBLIOGRAPHY OF
P. F. STRAWSON

Compiled by

P. F. STRAWSON

PREFACE TO THE BIBLIOGRAPHY OF P. F. STRAWSON

A. PARTIAL LIST OF WORKS ON THE PHILOSOPHY OF P. F. STRAWSON

1. Zak Van Straaten, ed., 1980. *Philosophical Subjects: Essays Presented to P. F. Strawson.* Oxford: Clarendon Press. The occasion was his sixtieth birthday, and twelve philosophers presented essays to which Professor Strawson replied: (1) A.J. Ayer: "Free-Will and Rationality"; (2) Jonathan Bennett: "Accountability"; (3) J.L. Mackie: "The Transcendental 'I'"; (4) Hidé Ishiguro: "The Primitiveness of the Concept of a Person"; (5) Gareth Evans: "Things without the Mind–A Commentary upon Chapter Two of Strawson's *Individuals*"; (6) John McDowell: "Meaning, Communication, and Knowledge"; (7) L. Jonathan Cohen: "The Individuation of Proper Names"; (8) W. V. Quine: "The Variable and Its Place in Reference"; (9) P. T. Geach: "Strawson on Subject and Predicate"; (10) David Wiggins: "What Would Be a Substantial Theory of Truth?"; (11) David Pears: "Intentions as Judgements"; (12) John R. Searle: "*Prima Facie* Obligations."

2. 1981. A special number of the Israeli journal, *Philosophia*, Vol. 10. "Comments and Replies."

3. Carlos E. Caorsi, ed. 1992. *Ensayos sobre Strawson.* Montevideo: Universidad de la Republica. Eight essays with replies.

4. Pranab Kumar Sen and Roop Rekha Verma, eds., 1995. *The Philosophy of P. F. Strawson.* New Delhi: Indian Council of Philosophical Research. Sixteen essays with replies, plus "My Philosophy" by Strawson, "P.F. Strawson: A Select Bibliography," and a biographical note. (1) Sibajiban Bhattacharyya: "Strawson on Subject and Predicate"; (2) Nirmalangshu Mukherji: "Identification"; (3) Roop Rekha Verma: "A Point about Reference"; (4) Michael Dummett: "Force and Convention"; (5) D. P. Chattopadhyaya: "Categorial Frameworks: Some Problems"; (6) Arindam Chakrabarti: "Non-particular Individuals"; (7) Hilary Putnam: "Logical Positivism, the Kantian Tradition, and the Bounds of Sense"; (8) Quassim Cassam: "Transcendental Self-Consciousness"; (9) Michael Luntley: "Thinking of Individuals: A Prolegomenon to any Future Theory of Thought"; (10) Akeel Bilgrami: "Self-Knowledge and Resentment"; (11) Sandhya Basu: "Strawson and Foundationalism"; (12) Pranab Kumar Sen: "On a Gentle Naturalist's Response to Skepticism"; (13) Bimal Krishna Matilal: "A Realist View

of Perception"; (14) Bijoy H. Baruah: "The Non-rational Foundation of Moral Reality"; (15) Rajendra Prasad: "Reactive Attitudes, Rationality and Determinism"; (16) Mark Platts: "The Metaphysics of Morals."

B. PARTIAL LIST OF HONORS

Fellow of the British Academy 1960. Foreign Honorary Member of the American Academy of Arts and Sciences 1971. Honorary Fellow of St. John's College, Oxford, 1973. Created Knight Bachelor 1977. Aristotelian Society President 1969-70. British Council Visitor to India 1979-80. Annual Lecturer of the Indian Council of Philosophical Research 1987-88. Woodbridge Lecturer at Columbia University 1983. Member of Academia Europaea 1992. Awarded F. Palacky Honorary Medal for Merit in the Social Sciences by the Academy of Sciences of the Czech Republic. Currently an Honorary Fellow Simultaneously of St. John's, University, and Magdalen Colleges, Oxford.

Variations on his well received Oxford course on "Analysis and Metaphysics: An Introduction to Philosophy, were delivered (1) as a course at the Collège de France, spring of 1985 (*Analyse et Metaphysique*), (2) as the Immanuel Kant Lectures in Munich, summer of 1985, (3) at Catholic University of America in Washington in September 1987, (4) as Sir Peter's contribution to the Sino-British Summer School in Philosophy in Beijing, 1988, and (5) as a final English version in Oxford in 1992.

C. PARTIAL LIST OF ACADEMIC APPOINTMENTS

Assistant Lecturer in Philosophy of North Wales, Bangor, 1946-47. Lecturer at University College, 1947-48. Fellow and Praelector in Philosophy, University College, Oxford, 1948-68. Promoted to Reader in 1966. Chair of Waynflete Professor of Metaphysical Philosophy and Fellow of Magdalen College, 1968-87. Visiting Professor at Duke University, 1955-56; Visiting Professor at Princeton University, 1960-61 and 1972. Visiting Professor at University of Colorado at Boulder, Fall 1991.

LEWIS EDWIN HAHN
EDITOR

DEPARTMENT OF PHILOSOPHY
SOUTHERN ILLINOIS UNIVERSITY AT CARBONDALE
MARCH 1998

BIBLIOGRAPHY OF
P. F. STRAWSON

A. BOOKS

1952 *Introduction to Logical Theory.* London: Methuen.
Translations:
Italian by A. Visalberghi. Turin: Einaudi, 1961.
Japanese. Tokyo: Horitsu Burka Sha, 1976.

1959 *Individuals: An Essay in Descriptive Metaphysics.* London: Methuen.
Translations:
German by F. Scholz. Stuttgart: Reclam, 1972.
French by A. Shalom and P. Ricoeur. Paris: Editions du Seuil, 1973.
Italian by E. Bencivenga. Milan: Feltrinelli, 1978.
Japanese by N. Nakamura. Tokyo: Misuzu Shobo, 1978.
Polish by B. Chwedenczuk. Warsaw: Wydawniczy Pax,1980.
Spanish by A. Suarez and L. Villanueva. Madrid: Taurus, 1989.

1966 *The Bounds of Sense: An Essay on Kant's Critique of Pure Reason.*
London: Methuen.
Translations:
Spanish by C. Luis-Andre. Madrid: Revista de Occidente, 1975.
German by E. Lange. Hain: 1981.
Italian by M. Palumbo. Roma-Baril: Laterza, 1985.
Japanese, 1987.

1971 *Logico-Linguistic Papers.* London: Methuen. Translations:
German (partial) by J. Schultz. Munich: List 1974.
French by J. Milner. Paris: Editions du Seuil, 1977.
Spanish by A. Suarez and L. Villanueva. Madrid: Tecnos, 1983.

1974 *Freedom and Resentment and Other Essays.* London: Methuen.
Subject and Predicate in Logic and Grammar. London: Methuen.

1985 *Skepticism and Naturalism: Some Varieties.* New York and London:
Columbia University Press and Methuen.
Translation:
German by M. Istase and R. Soskey. Frankfurt am Main: Athenäum
1987.

1985 *Analyse et Métaphysique.* Paris: J. Vrin.

1992 *Analysis and Metaphysics: An Introduction to Philosophy.* Oxford:
Oxford University Press.
Translations:
Spanish with an introduction by Vicente Santerix Vidarte. Barcelo-
na: Ediciones Paidos, 1997.

1997 *Entity and Identity.* Oxford: Oxford University Press.

B. ARTICLES

1948 "Necessary Propositions and Entailment Statements." *Mind.*
1949 "Truth." *Analysis.*
 "Ethical Intuitionism." *Philosophy.*
1950 "On Referring." *Mind.*
 Reprinted in:
 Conceptual Analysis, ed. A. G. N. Flew. London, 1952.
 The Theory of Meaning, ed. G. H. R. Parkinson. Oxford, 1968.
 Logico-Linguistic Papers.
 "Truth." *Proceedings of the Aristotelian Society.*
 Reprinted in:
 Logico-Linguistic Papers.
1953 "Particular and General." *Proceedings of the Aristotelian Society.*
 Reprinted in:
 Logico-Linguistic Papers.
 The Problem of Universals, ed. Andrew B. Schoedinger. New Jersey, 1992.
 Translation:
 Italian by L. Ulivi in *Gli Universali e la Formazione dei Concetti,* ed. Ulivi. Milan, 1981.
1954 "Wittgenstein's *Philosophical Investigations.*" *Mind,* Vol. 63.
 Reprinted in:
 Freedom and Resentment and Other Essays..
 "A Reply to Mr. Sellars." *Philosophical Review,* Vol. 63.
1955 "A Logician's Landscape." *Philosophy,* Vol. 30.
1956 "Construction and Analysis." In A.J. Ayer et al., *The Revolution in Philosophy.* London: Macmillan.
 Translation:
 Spanish by M. De Lledo in *La Revolucion en Filosofía.* Madrid, 1958.
 "In Defense of a Dogma" with H. P. Grice. *Philosophical Review,* Vol. 65: 141–58.
 Reprinted in:
 Necessary Truth, ed. L. W. Sumner and J. Woods, New York, 1969.
 Studies in the Way of Words, Grice, ed. Cambridge, Mass.: Harvard University Press, 1989.
 "Singular Terms, Ontology and Identity." *Mind,* Vol. 65: 433–54.
1957 "Logical Subjects and Physical Objects." *Philosophy and Phenomenological Research,* Vol. 17.

"Propositions, Concepts and Logical Truths." *Philosophical Quarterly*, Vol. 7: 15–25.
Reprinted in:
 Logico-Linguistic Papers.
"Metaphysics," (with H. P. Grice and D. F. Pears ed.) *The Nature of Metaphysics*, ed. D. F. Pears. London: Macmillan.
"Proper Names." *Proceedings of the Aristotelian Society*, Supp. Vol. 31.

1958 "On Justifying Induction." *Philosophical Studies.*

1960 "The Post-Linguistic Thaw." *Times Literary Supplement.*
Reprinted in:
 The British Imagination, ed. Arthur Crook. London: Cassell, 1961.
"Freedom and Resentment," *Proceedings of the British Academy*, Vol. 48.
Reprinted in:
 Studies in the Philosophy of Thought and Action, ed. Strawson. Oxford, 1967.
 Freedom and Resentment and Other Essays..
 Free Will, ed. G. Watson. Oxford, 1982.

1961 "Singular Terms and Predication." *Journal of Philosophy*, Vol. 58: 393–412.
Reprinted in:
 Philosophical Logic, ed. Strawson. Oxford, 1967.
 Words and Objections, ed. D. Davidson and J. Hintikka. Dordrecht, 1969.
 Logico-Linguistic Papers.
"Perception and Identification." *Proceedings of the Aristotelian Society*, Supp. Vol. 35.
Reprinted in:
 Freedom and Resentment and Other Essays.

1963 "Carnap's Views on Constructed Systems v. Natural Languages in Analytical Philosophy." In *The Philosophy of Rudolf Carnap*, ed. P. A. Schilpp. La Salle, Ill.: Open Court.

1964 "A Problem about Truth: A Reply to Mr. Warnock," in *Truth*, ed. G. Pitcher. Englewood Cliffs, N.J.: Prentice Hall.
Reprinted in:
 Logico-Linguistic Papers.
"Identifying Reference and Truth Values." *Theoria*, Vol. 30.
Reprinted in:
 Logico-Linguistic Papers.
Translation:
 Serbo-Croat by S. Grgas. Rijeka.
"Intention and Convention in Speech Acts." *Philosophical Review*, Vol. 73.
Reprinted in:

The Philosophy of Language, ed. J. Searle. Oxford, 1971.
Logico-Linguistic Papers.

1965 "Truth: A Reconsideration of Austin's Views." *Philosophical Quarterly*, Vol. 15.
Reprinted in:
Logico-Linguistic Papers.

1966 "Self, Mind and Body." *Common Factor*, Vol. 4.
Reprinted in:
Freedom and Resentment and Other Essays..
The Nature of Mind, ed. S. Rosenthal. Oxford and New York, 1991.
"Aesthetic Appraisal and Works of Arts." *The Oxford Review*, Vol. 3.
Reprinted in:
Freedom and Resentment and Other Essays.

1967 "Is Existence Never a Predicate?" *Critica*, Vol. 1.
Reprinted in:
Freedom and Resentment and Other Essays.
"Analysis, Science and Metaphysics." In *The Linguistic Turn*, ed. R. Rorty. Chicago: University of Chicago Press. Originally appeared in French 'Analyse, Science et Metaphysique' in *La Philosophie Analytique*, ed. Beck, *Colloques de Royaumont.*
Introduction to *Philosophical Logic*, ed. P. F. Strawson, *Oxford Readings in Philosophy.* Oxford: Oxford University Press.
Introduction to *Studies in the Philosophy of Thought and Action.* Oxford: Oxford University Press.

1968 "Bennett on Kant's Analytic." *Philosophical Review*, Vol. 77.

1969 "Meaning and Truth." *Proceedings of the British Academy.* Oxford: Oxford University Press.
Reprinted in:
Logico-Linguistic Papers.
"Grammar and Philosophy." *Proceedings of the Aristotelian Society*, 1969-70, Vol. 70.
"Body and Mind." *Linguistic Analysis and Phenomenology*, ed. W. Mays and S. C. Brown. London: Macmillan.

1970 "Imagination and Perception." In *Experience and Theory*, ed. L. Foster and J. W. Swanson. Amherst: University of Massachusetts Press.
Reprinted in:
Freedom and Resentment and Other Essays..
Kant on Pure Reason, ed. R. C. Walker. Oxford, 1982.
"Categories." In *Ryle: A Collection of Critical Essays*, ed. O. P. Wood and G. Pitcher. New York: Doubleday.
Reprinted in:
Freedom and Resentment and Other Essays.
"Phrase et Acte de Parole." In *Languages.*

"The Asymmetry of Subjects and Predicates." in *Language, Belief and Metaphysics*, ed. H. E. Kiefer and M. K. Munitz. New York: State University of New York Press.
Reprinted in:
Logico-Linguistic Papers.
"Chisholm on Identity through Time." *Language, Belief, and Metaphysics*, ed. H. E. Kiefer and M. K. Munitz. New York: State University of New York Press.

1972 "Self-Reference, Contradiction and Content-Parasitic Predicates." *Indian Review of Philosophy.*

1973 "Different Conceptions of Analytical Philosophy." *Tijdschrift voor Filosofie.*
Translation:
Polish by Tadeusz Szubka in *Rocniki Filozoficzni.* Lublin, 1986.
"Austin and 'Locutionary Meaning'." In *Essays on J.L. Austin*, ed. I. Berlin. Oxford: Clarendon Press.

1974 "On Understanding the Structure of One's Language." In *Freedom and Resentment and Other Essays.*
"Positions for Quantifiers." In *Semantics and Philosophy,* ed. M. K. Munitz and P. K. Unger. New York: New York University Press.
"Does Knowledge Have Foundations?" *Conocimiento y Creencia.*

1975 "Semantics, Logic and Ontology." *Neue Hafte für Philosophie.*
Translation:
Polish by Tadeusz Szubka in *Studi Filozoficzni,* 1987.
"Causation in Perception." In *Fact, Value and Perception.*
Reprinted in:
Freedom and Resentment and Other Essays.

1976 "Knowledge and Truth." *Indian Philosophical Quarterly*, Vol. 3, No. 3.
"Entity and Identity." In *Contemporary British Philosophy Fourth Series*, ed. H. D. Lewis. London: Allen and Unwin.
"Scruton and Wright on Anti-Realism." *Proceedings of the Aristotelian Society*, Vol. 77.

1979 "Universals." *Midwest Studies in Philosophy.*
"May Bes and Might Have Beens." In *Meaning and Use*, ed. A. Margalit. Dordrecht, Boston, and London: Reidel.
"Perception and its Objects." In *Perception and Identity: Essays Presented to A. J. Ayer*, ed. G. F. Macdonald. London: Macmillan.
Reprinted in:
Perceptual Knowledge, ed. J. Dancy. Oxford, 1988.

1980 "Belief, Reference and Quantification." *Monist.*
"P. F. Strawson Replies." In *Philosophical Subjects: Essays Presented to P. F. Strawson*, ed. Zak Van Straaten. Oxford: Clarendon Press.

1981 "Comments and Replies." *Philosophia*, Vol. 10.

1982 "Logical Form and Logical Constants." In *Logical Form, Predication and Ontology*, ed. P. K. Sen.

"'If' and '⊃'." In *Philosophical Grounds of Rationality, Intention, Categories, Ends*, ed. Richard E. Grandy and Richard Warner.

1983 "Liberty and Necessity." In *Spinoza, His Thought & Work*, ed. Nathan Rotenstreich and Norma Schneider. Jerusalem: The Israel Academy of Sciences and Humanities.

1985 "Causation and Explanation." In *Essays on Davidson*, ed. Bruce Vermazen and J. Hintikka. Oxford: Oxford University Press.

1986 "Direct Singular Reference: Intended Reference and Actual Reference." In *Wo steht die Analytische Philosophia Heute?*

"Reference and its Roots." In *The Philosophy of W. V. Quine*, ed. L. E. Hahn and P. A. Schilpp. La Salle, Ill.: Open Court.

1987 "Kant's Paralogisms: Self-Consciousness and the 'Outside Observer'." in *Theorie de Subjektivität*, ed. K. Cramer, F. Fulda, R.-P. Horstmann, U. Pothast. Frankfurt am Main: Suhrkamp.

"Concepts and Properties, or Predication and Copulation." *Philosophical Quarterly*, Vol. 37.
Translation: Spanish by M. Serratos and P. Ramos in *Critica*. Mexico, 1988.

1988 "Kant's New Foundations of Metaphysics." In *Metaphysik nach Kant*, ed. Dieter Henrich and R.-P. Horstmann. Stuttgart: Klett-Cotta.

"Ma Philosophie: son Développement, son Thème Central et sa Nature Générale." *Revue de Theologie et de Philosophie*, Vol. 120.

1989 "Sensibility, Understanding and the Doctrine of Synthesis: Comments on D. Henrich and P. Guyer." In *Kant's Transcendental Deductions*, ed. E. Forster. Stanford: Stanford University Press.

1990 "Two Conceptions of Philosophy." In *Perspectives on Quine*, ed. Robert Barrett and Roger Gibson. Oxford: Blackwell.

1992 "The Incoherence of Empiricism." *Proceedings of the Aristotelian Society*, Supp. Vol. 66.

"Comments on Some Aspects of Peter Unger's *Identity, Consciousness and Value*." *Philosophy and Phenomenological Research*, Vol. 42.

"Echoes of Kant." *Times Literary Supplement*, 1992, *The State of Philosophy*.

"Replies." In *Ensayos sobre Strawson*, ed. Caorsi. Montevideo.

"Knowing from Words." In *Knowing from Words*, ed. B. K. Matilal and A. Chakrabarti. Dordrecht: Kluwer Academic Publishers.

1994 "My Philosophy," and "Replies" to critics. In *The Philosophy of P. F. Strawson*, ed. P. K. Sen and R. K. Verma. New Delhi: Indian Council of Philosophical Research.

"Individuals." In *Philosophical Problems Today*, Vol. 1, ed. G. Fløistad. Dordrecht: Kluwer Academic Publishers.

"The Problem of Realism and the A Priori." In *Kant and Contemporary Epistemology*, ed. Paolo Parrini (a volume in the University of Western Ontario Series in Philosophy of Science). Dordrecht: Kluwer Academic Publishers.

1997 "Introduction," "Kant on Substance," and "Meaning and Context."
 In *Entity and Identity.* Oxford: Oxford University Press.

C. REVIEWS

1948 of Raphael, Daiches, *The Moral Sense* (*Philosophy*, Vol. 23)
 of Hocking, W.E. and others, *Preface to Philosophy* (*Philosophy*, Vol.
 23)
1949 of Ritchie, A.D., *Essays in Philosophy and Other Pieces* (*Philosophy*)
 of Joad, C.E.M., *Decadence* (*Philosophy*, Vol. 24)
 of Ewing, A.C., *The Definition of Good* (*Mind*, Vol. 58)
1950 of Boole, George, *The Mathematical Analysis of Logic* (*Philosophy*,
 Vol. 25)
1951 of Ambrose, A. and Lazerowitz, M., *Fundamentals of Symbolic Logic*
 (*Mind*, Vol. 60)
 of Black, M., *Language and Philosophy* (*Philosophy*, Vol. 26)
 of Prior, A.M., *Logic and the Basis of Ethics* (*Philosophy*, Vol. 26)
1952 of Flew, A.G.N., ed., *Logic and Language* (*Philosophy*, Vol. 27)
1953 of Fritz, O.A., *Bertrand Russell's Construction of the External World*
 (*Philosophy*, Vol. 28)
 of Von Wright, G.H., *An Essay in Modal Logic* (*Philosophy*, Vol. 28)
1954 of Osborne, H., *Theory of Beauty* (*Mind*, Vol. 63)
 of Linsky, L., *Semantics and the Philosophy of Language* (*Philosophy*,
 Vol. 29)
 of Reiss, S., *The Universe of Meaning* (*Philosophy*, Vol. 29)
 of Chastaing, M., *La Philosophie de Virginia Woolf* (*Mind*, Vol. 63)
1957 of Russell, Bertrand (ed. Marsh), *Logic and Knowledge* (*Essays
 1901–1950*) (*Philosophical Quarterly*, Vol. 7)
1959 of Perelman, Ch. and Olbrechts-Tyteca, L., *Traité de l'Argumentation*
 (*Mind*, Vol. 68)
1960 of Farrer, A., *The Freedom of the Will* (*Mind*, Vol. 69)
 of Pole, D., *The Later Philosophy of Wittgenstein* (*Philosophical
 Quarterly*, Vol. 10)
 of Wittgenstein, L., *The Blue and Brown Books* (*Philosophical Quar-
 terly*, Vol. 10)
1962 of Shwayder, D.S., *Modes of Referring and the Problem of Universals*
 (*Mind*, Vol. 71)
1965 of Abbagnano, N., *Storia della Filosofia* (*Mind*, Vol. 74)
 of Shoemaker, S., *Self-Knowledge and Self-Identity* (*Philosophical
 Quarterly*, Vol. 15)
1966 of Riverso, Emanuele, *Il Pensiero di Ludovico Wittgenstein* (*Mind*, Vol.
 75)

of Sorensen, H.S., *The Meaning of Proper Names* (*Mind*, Vol. 75)

of Shwayder, D.S., *The Stratification of Behaviour* (*Philosophical Quarterly*, Vol. 16)

1968 of Bennett, Jonathan, *Kant's Analytic* (*Philosophical Review*, Vol. 77)

of Zweig, Arnulf, *Kant's Philosophical Correspondence 1759-99* (*Philosophy*, Vol. 43)

1970 of Combes, Michael, *Le Concept de Concept Formel* (*Mind*, Vol. 79)

of Rosenbluth, Arturo, *Mind and Brain: A Philosophy of Science*, and Delgado, Jose, M.R. *Physical Control of the Mind*, and Young, Robert M., *Mind, Brain and Adaptation in the Nineteenth Century* (*New York Review of Books*, Vol. 15)

of Brown, D.G., *Action* (*Mind*, Vol. 79)

1971 of Meiland, J.W., *Talking About Particulars* (*Philosophical Quarterly*, Vol. 21)

of Quine, W.V., *Philosophy of Logic* (*Journal of Philosophy*, Vol. 68, No. 6)

1973 of Mackie, J.L., *Truth, Probability and Paradox* (*Times Literary Supplement*)

of Frege, Gottlob, ed. Bynum, *Conceptual Notation and*

of Geach, P.T., *Logic Matters* (*Times Literary Supplement*)

1974 of Harrison, Bernard, *Meaning and Structure: an Essay in the Philosophy of Language* (*Mind*, Vol. 82)

1975 of Haack, Susan, *Deviant Logic* (*Times Literary Supplement*)

of Bennett, Jonathan, *Kant's Dialectic* (*Philosophical Quarterly*, Vol. 25)

of Guttenplan, Samuel, ed. *Mind and Language* (*Times Literary Supplement*)

1976 of Putnam, Hilary, *Philosophical Papers*, Vols. I and II (*Times Literary Supplement*)

1977 of Blackburn, Simon, ed. *Meaning, Reference and Necessity* (*Philosophical Quarterly*, Vol. 27)

of Lewy, Casimir, *Meaning and Modality* (*Philosophy*, Vol. 42)

of Ayer, A.J., *A Part of My Life* (*Books and Bookmen*, Vol. 22, No. 12)

1978 of Margolis, Joseph, *Persons and Minds* (*Times Literary Supplement*, No. 3990)

1979 of Steiner, George, *Martin Heidegger and On Difficulty and Other Essays* (*New York Review of Books*, Vol. 26, No. 6)

1980 of Ryle, Gilbert, *On Thinking* (*Philosophical Quarterly*, Vol. 30)

1981 of Nagel, Thomas, *Mortal Questions* (*New York Review of Books*, Vol. 28, No. 3)

of Davidson, Donald, *Essays on Actions and Events* (*Times Literary Supplement*, No. 4026)

of Wiggins, David, *Sameness and Substance* (*Mind*, Vol. 89)

of Cargile, James, *Paradoxes: a Study in Form and Predication* (*Mind*, Vol. 89)

1982 of Bieri, Horstmann, Kruger eds. *Transcendental Arguments and Science* (*Journal of Philosophy*, Vol. 80)

of Ayer, A.J., *Philosophy in the 20th Century* (*London Review of Books*)

of Loar, Brian, *Mind and Meaning* (*Times Literary Supplement*, No. 4, 135)

of Quine, W.V., *Theories and Things* (*London Review of Books*)

1983 of Kripke, Saul, *Wittgenstein on Rules and Private Language* (*Times Literary Supplement*, No. 4, 167)

1984 of Russell, Bertrand, *Collected Papers Volume I, Cambridge papers 1888–99* (*Times Literary Supplement*, No. 4, 218)

of Davidson, Donald, *Inquiries into Truth and Interpretation* (*London Review of Books*)

of Parfit, Derek, *Reasons and Persons* (*New York Review of Books*, Vol. 31, No. 10)

1986 of Nagel, Thomas, *The View from Nowhere* (*New Republic*)

1987 of Wright, C., Realism, *Meaning and Truth* (*Mind*, Vol. 95)

1989 of Schiffer, Stephen, *Remnants of Meaning* (*Times Literary Supplement*)

1992 of Guyer, Paul, ed., *The Cambridge Companion to Kant*. Cambridge: Cambridge University Press.

INDEX